J.-F. Millet

For
William Morris Hunt,
Martin Brimmer,
Quincy Adams Shaw,
and all the Boston collectors
who treasured Millet's work
in his own lifetime.

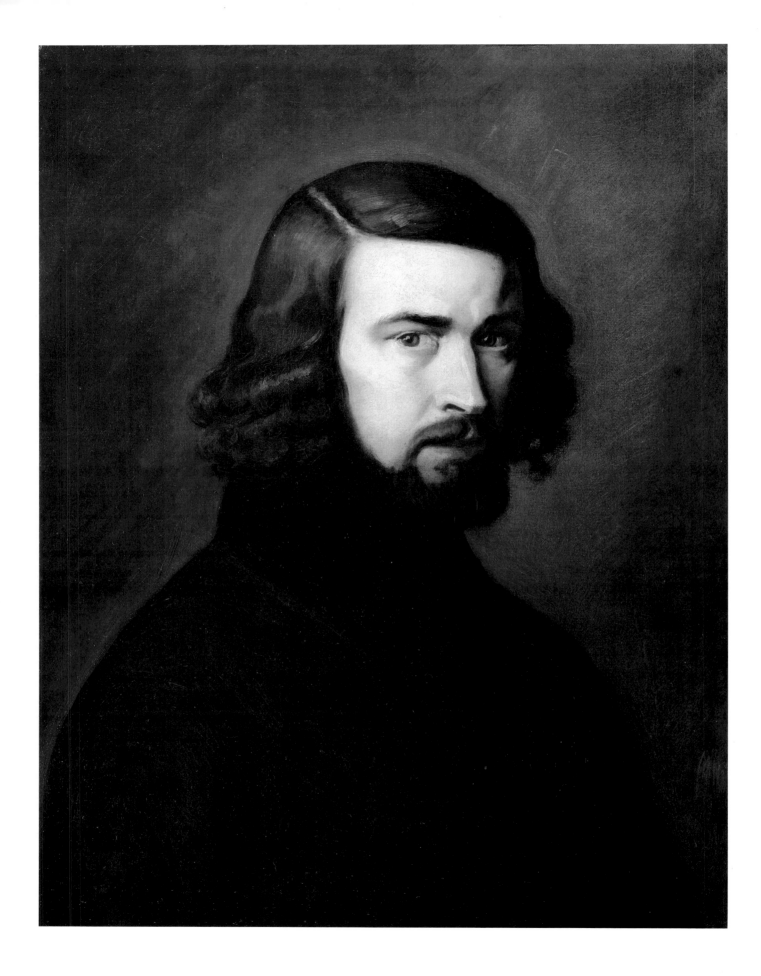

Jean-François Millet

by Alexandra R. Murphy

with contributions by
Susan Fleming and Chantal Mahy-Park

Museum of Fine Arts Boston

Distributed by
New York Graphic Society Books
Little, Brown and Company, Boston

Contents

Copyright © 1984
by the Museum of Fine Arts, Boston, Massachusetts
Library of Congress catalogue card no. 83-63521
ISBN 0-87846-237-6 (paper)
0-87846-242-2 (cloth)
Printed in U.S.A. by Acme Printing Co.,
Medford, Massachusetts
Designed by Carl Zahn
Frontpiece:
Self-Portrait, about 1840-1841, oil on canvas
(cat. no. 1)
Cover illustration:
The Sower, 1850, oil on canvas (cat. no. 18)

Preface

The work of Jean-François Millet is familiar both to art lovers and to the general public around the world. Many people, young and old, from Japan and the United States to the countries of Europe, have grown up knowing the images of *The Angelus* or *The Sower*, many even without being conscious of the painter's name. Millet's strong images of French peasants, workers, domestic laborers, and married couples are unforgettable, and his stature as one of the finest painters of the nineteenth century is undeniable.

This is, astonishingly, the first broad survey of Millet's work ever mounted in the United States. More surprising still, the exhibition consists entirely of Millets collected in Boston. The great body of the 150 works shown here are drawn from the permanent collection of this Museum, and even the small group of important loans are pictures that, with one exception, were purchased originally by Boston collectors. The exception is, of course, *The Angelus*, one of the painter's masterpieces, which has been lent for this occasion by the Louvre through the very kind offices of its director, M. Hubert Landais, and the chief curator of paintings, Michel Laclotte. But this, too, is in a sense a Boston picture, for it was originally commissioned from the artist by Thomas Gold Appleton of this city.

Boston's taste has always been individualistic and courageous, and the city's collectors and patrons have had their favorites whose works constitute the strengths of the Museum's collections. One thinks of the magnificent holdings of the Impressionists, and especially of Monet's work, the result of widespread collecting here in the late nineteenth century. In the American field, we can point to preeminent collections of the works of John Singleton Copley, the ablest painter of the colonial period, and of William Morris Hunt, whose work was seen in depth in our memorial exhibition of 1979. Hunt was the painter-teacher who rejected New York's Anglophilic, Ruskinian taste and who led Boston instead to the radical work of his French teacher, Millet. The first American to appreciate Millet, he bought *The Sower* (cat. no. 18) in 1851; *Harvesters Resting* (cat. no. 39), which Hunt encouraged Martin Brimmer to buy in 1853, was shown at the Boston Athenaeum in the following year – only the second occasion that any of Millet's work was seen outside of France. Hunt was instrumental in helping to shape the taste of the great collectors who followed him, including Martin Brimmer, Peter Chardon Brooks, and Quincy Adams Shaw. Indeed, the Shaw collection – having come to the Museum in 1917 – now forms the cornerstone of our holdings, for it includes twenty-seven oil paintings by Millet and an equal number of the artist's extraordinary brilliant pastels – altogether an unmatched group. In addition to Shaw's legacy, gifts and bequests from over forty families have built our collection. And the effort to bring together in this city the most comprehensive selection of Millet's work still goes on, as witnessed by two recent purchases by the William I. Koch Foundation of a superb pastel and a most important late study (cat. nos. 129 and 152).

Millet's work was highly influential. In Boston, it affected Hunt, Babcock, and other local artists, and it helped reaffirm a preference in this city for art that was profoundly spiritual, while being subtly colored and technically innovative. In France, his work was well known to the Impressionists (notably Renoir and Cézanne) and Van Gogh copied several of the paintings and pastels now in the Museum's collection.

The catalogue for this exhibition has been written by Alexandra Murphy, Assistant Curator of Paintings, and her colleagues in the Paintings Department. Her long research on the artist comes to fruition here in the insightful catalogue entries. The project was directed initially by John Walsh, Jr., and more recently by Theodore E. Stebbins, Jr., John Moors Cabot Curator of American Paintings.

The Museum of Fine Arts is deeply grateful to the Nippon Television Network Corporation of Japan, which shared in the expense of preparations for the exhibition and is sponsoring a tour of five Japanese cities following the showing in Boston. This is the third exhibition of European paintings from the MFA collection that has been sponsored by the Nippon Television Network Corporation and the Yomiuri Newspapers. In sending the works to Japan the Museum acknowledges international esteem for the profundity and beauty of Millet's achievement.

JAN FONTEIN
Director

Acknowledgments

There can be no better way to open a catalogue of this kind – a catalogue that proudly celebrates the permanent collection of the Museum through a special exhibition – than to thank the nearly one hundred benefactors whose gifts and loans have made the Museum of Fine Arts so rich a center for the appreciation of the work of Jean-François Millet. The prescience and the enthusiasm that went into forming their collections in the nineteenth century (and continues today) is extraordinary. In five years of coming to know Millet and his work through the broad portal of the Museum's collection, it has been made clear to me again and again how amazingly knowing were the choices made by those collectors, and how thoughtfully each complemented the selections of friends or predecessors. Nowhere else can so comprehensive a tribute to Millet's lifetime of work be brought together so easily. We gratefully acknowledge the Boston collectors, living and dead, whose own joy in Millet's work has made ours possible.

My thanks go especially to our director, Jan Fontein, who realized well before I did how much I would enjoy the incomparable opportunity to study and to present the Museum's Millet collection for the first time. His suggestion, some five years ago, first launched our Millet research efforts and helped secure the significant support of the National Endowment for the Humanities, as well as the generous assistance of Nippon Television Network Corporation, to fund our study.

That any of us today can see Millet with a clearer eye than was possible twenty years ago is to the credit of Professor Robert L. Herbert, whose seminal exhibition at the Museum of Fine Arts in 1962, "Barbizon Revisited," returned Millet and many of his contemporaries to us after years of art historical disinterest. His masterful work on Millet has been the ever-present standard to which our catalogue aspires, and I am especially grateful for his counsel and his friendship.

Colleagues at the Musée du Louvre have been generous of their time, their interest, and their access to that museum's superb Millet collections. Roseline Bacou, Conservateur of the Cabinet des Dessins, has made it possible for us to study the splendid drawings and many letters in her care, and Jacques Foucart, Conservateur of the Département des Peintures, has put the extensive archives of the Service d'Etude et Documentation at our disposal, going far beyond professional generosity to help me study inaccessible Millet paintings in the Louvre. Georges Richard of the Musée J. F. Millet in Barbizon has been extremely helpful, and the assistance of Marie-Cécile Comerre, Librarian of the Société des Commisseurs-Priseurs de Paris, has been invaluable. Madame Cécile Alverge, Librarian of the Musée de Cahors, and Monsieur L. Claval, Librarian of the Société des Etudes de Cahors, were indispensable in our search for "Monsieur Calmette," of the Museum's Millet letters. Charles Durand-Ruel has been incomparably generous in sharing with us the archives of his family's firm.

The staff of the Museum of Fine Arts Library, under Nancy Allen, has been extremely supportive, especially Bonnie Porter, who has excelled at obtaining elusive books and research materials. At both the Witt Library of the Courtauld Institute and the Frick Art Reference Library, the staffs were especially helpful during the intensive photographic study sessions that began and closed our research.

For both the research and the catalogue, the Museum's Photographic Services Department undertook a major campaign of new photography. Alan Newman, John Woolf, and John Lutsch photographed the entire collection in black and white and color; Thomas Lang and Joseph Logue have handled all the printing; other members of the department have borne the exceptional documentation burden that such extensive new photography has generated. Patrice O'Donoghue, Jane Lewis, Jenni Rodda, and Michelle O'Malley have been unfailingly helpful; and Janice Sorkow, Manager of Photograpic Services, has been a particular friend among colleagues, providing invaluable advice and assistance, as well as the interest and enthusiasm that is so important in maintaining the momentum of so large a project.

Time and again, Pat Marr has helped with the complexities of writing our cata-

logue on a word processor, and Beverly Lombard and Robert Taylor have cheerfully devoted weekend and evening hours to help us meet deadline after deadline.

The advice and skilled direction of Judith Downes and Tom Wong of the Museum Design staff have produced the quietly elegant exhibition installation that would have so satisfied Millet.

The entire Department of Prints and Drawings welcomed me and my Millet problems with friendly enthusiasm and a sense of shared purpose. Eleanor Sayre blessed our incursions into the realm of works on paper with good cheer, and Sue Reed and Barbara Shapiro taught me far more than I have been able to absorb. I am very grateful to them and to Cliff Ackley, who provided a measured perspective on numerous occasions. Roy Perkinson, Conservator of Works on Paper, and Elizabeth Lunning, Assistant Conservator, undertook the truly staggering task of examining, treating, rematting and remounting the Museum's entire Millet pastel collection at the same time they began my tutelage in pastel technique and paper conservation; Joan London assisted them. Leslie Iredell made the new gilt mats that restore the pastels to something much closer to their original presentation, and David Ross prepared the large and diverse collection of drawings, watercolors, and prints for photography and for an attractively integrated exhibition. Jerri Nelson, Conservation Intern at the Fogg Art Museum, undertook an extensive examination of the Boston pastels, creating an index of related papers and selected pigments and drawing media that has proved extremely useful in developing an accurate chronology for these drawings.

I want especially to thank Theodore E. Stebbins, Jr., John Moors Cabot Curator of American Paintings, for his broad support for our work and specifically for his advice and help to me in shaping the scholarly presentation of our catalogue. Helen Hall has brought a patient and painstaking care to the proofreading of our vast stacks of galleys; Patricia Loiko has resolved an undefinably wide range of adminstrative complications so well that we almost never noticed them; and Pamela Tabbaa and Trevor Fairbrother contributed a measure of order to the hectic last weeks. Graham White provided the marvelously drawn maquettes with which we have planned the exhibition design, and Sarah McPhee undertook the preparation of labels. The Paintings Conservation staff, under the direction of Alain Goldrach, Conservator, examined and treated our Millet paintings and the skillful conservation of Alain, Frank Zuccari, and Sarah Walden has given back to many of the collection's most beautiful pictures a clarity and a sparkle that had been marred by decades of dust and old varnish. James Barter's careful restorations have made it possible to exhibit the entire Quincy Adams Shaw Collection in its distinctive nineteenth-century frames and his friendly help in unframing and examining the paintings so many times over is especially appreciated.

Preparing a catalogue that could serve as a permanent scholarly reference for the Museum's entire Millet collection and, at the same time, offer a general introduction to Millet's life and work has been a complicated project of several years standing. Anne Schirrmeister, as my first research assistant, launched a comparative photograph archive and the dossiers on individual paintings and pastels; and Susan Fleming, my research assistant for the past three years, has helped compile those dossiers in addition to preparing her essay on the Boston Millet collectors. Jeffrey Sturges, Lucy Livingston, Mary Wickes, and Elizabeth Levene, have been particularly helpful with the various aspects of our research effort. Chantal Mahy-Park translated the collection of Millet letters and manuscript material belonging to the Museum and provided extensive notes with which they are published herein; Ruth Morse undertook the dossiers for the drawings; and Katherine Prum began the immense task of studying the William Perkins Babcock print collection.

Although I bear the responsibility for the final content of the catalogue entries, a number of other contributors deserve mention: Nancy Olsen wrote substantial portions of the entries for *Coming Storm*, *Rabbit Warren*, and *Primroses/Dandelions*; Holly Richardson should be singled out particularly for *Young Woman Churning Butter*, *Shepherdess and Flock at Sunset*, *Newborn Lamb*, and *Path through the Wheat*; while Susan Fleming is to be commended for her work on *Winter Evening*, *Shepherdesses Watching a Flight of Wild Geese*, and *After the Day's Work*. Mark Palmer's remarkable empathy with the word processor and his high regard for accuracy and clarity have been immeasurably valuable in our final year of writing and editing, and I am especially grateful for his indefatigable good nature.

Judy Spear has edited the catalogue with care and a commitment to our shared goals that has given me the opportunity to actually enjoy watching the work come together in a presentation form; and in the carefully constructive attention she has given to my own writing, I have learned and grown. Carl Zahn designed and directed the publication of the book with thoughtful skill and careful attention, and his interest and encouragement must stand, next to Millet's extraordinary art, as the principal sustaining force behind this catalogue.

ALEXANDRA R. MURPHY

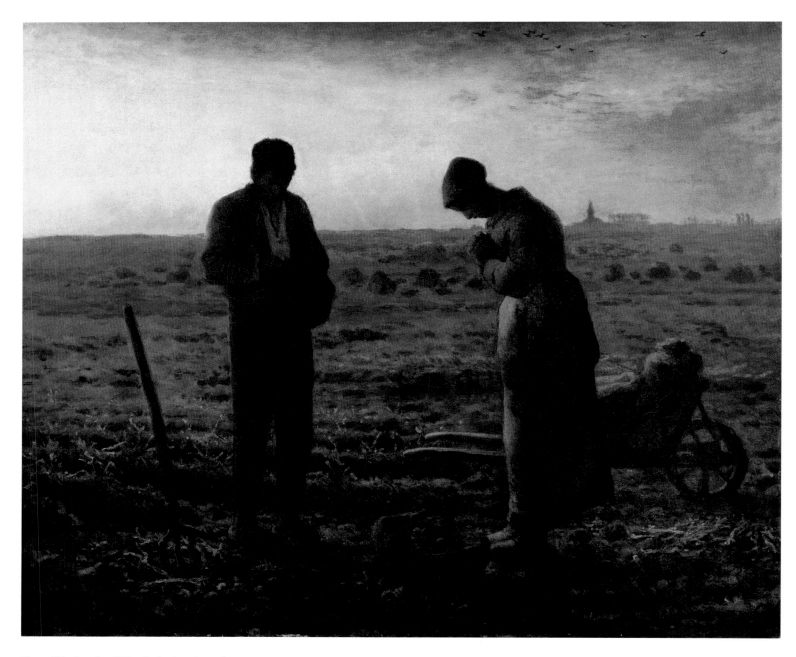

Fig. 1. *The Angelus (L'Angélus)*, 1854-1859, oil on
canvas, 55.5 x 66.0 cm., Musée du Louvre, Paris.
The Angelus *was commissioned from Millet by
Thomas Gold Appleton, a Boston collector who had
studied with Constant Troyen, a Barbizon animal
painter and a friend of Millet's. However it took Millet
nearly two years to finish the composition, and Apple-
ton tired of waiting for it. Later in the centenary year
of the French Revolution, the* Angelus *became the
focus of a hard-fought auction competition between the
American Art Association and a group representing
the French nation. Although the Americans acquired
the picture at that time, it was subsequently sold back
to the French, and now belongs to the French
National Collection in the Musée du Louvre. In the
century since 1889,* The Angelus *has become the
world's most widely recognized French painting.*

The Boston Patrons of Jean-François Millet

By Susan Fleming

When a flamboyant Antonin Proust, Fine Arts Minister of France, outbid James Sutton of the American Art Association for Jean-François Millet's *Angelus* (fig. no. 1) at the Secretan sale on July 1, 1889, the French audience was ecstatic. Millet's most celebrated painting had been secured for the Louvre and for the French nation. Having failed to recognize Millet's genius until much of his work was in American private and public collections, France was now making a conscious effort to preserve for its people the masterpieces still at home. Unfortunately, however, the French Chamber of Deputies would not honor Proust's bid of 553,000 francs and he was forced to relinquish the picture to Sutton, the underbidder. Yet another work by Millet was lost to the Americans, whose collections already included *Harvesters Resting* (cat. no. 39), *Man Grafting a Tree* (Gemäldegalerie, West Berlin), *Newborn Calf* (Art Institute of Chicago), *Buckwheat Harvest* (cat. nos. 150 and 142, oil and pastel versions), *Noonday Rest* (cat. no. 113), two versions of *The Sower* (one, cat. no. 18), and the *Man with a Hoe* (private collection), to cite a few.[1]

The following year, however, Alfred Chauchard, department store magnate, paid 800,000 francs to the American Art Association to reclaim the coveted *Angelus* for his nation and to this day it remains in the Louvre. Also in 1890, Bischoffsheim's sale of *Gleaners* to Madame Pommery for a price below that offered by an American drew national coverage and acclaim in *Le Temps* (September 29, 1890).[2] The new owner patriotically vowed that the picture would become the property of the Louvre at her death[3].

Despite their heroic efforts, the French had waited too long to acquire much of the best of Millet's work, for by 1889 there were more than 125 paintings and pastels and thirty drawings owned in the city of Boston. Of that number, four paintings and twenty drawings had already been given to the Museum of Fine Arts, and in the next months a campaign would be launched to secure one of Millet's own rare self-portraits for the Museum collection. Private patrons such as Peter Chardon Brooks, Henry Sayles, Frederic Ames, Quincy Adams Shaw, and Martin Brimmer owned a third of all Millet's ambitious Salon paintings, and the most comprehensive selection of Millet's pastels anywhere was spread through several collections in the city. That Boston should have become such a center of interest in Millet for America and the world requires some explanation.

Millet in Boston

Bostonians had begun traveling to Barbizon to patronize Millet in the early 1850s, almost two decades before other Americans and the French took serious interest in his work. Several of Millet's first significant sales were made to Bostonians who were too new at acquiring art yet to be called collectors. Throughout the thirty years of correspondence between Millet and his Parisian patron-biographer Alfred Sensier references to visiting Bostonians are recurrent. The diaries and travel memoirs left by many of these people make clear that early on it became a must for Bostonians visiting Paris to journey to Barbizon to meet Millet, whether or not they were able to buy his paintings. In 1875, following Millet's death, Bostonians were prominent among the small number of private collectors bidding on their own behalf at the auction of Millet's studio contents and, shortly thereafter, the sale of the pastel and drawing collection formed by Emile Gavet.

The Great Collectors: Hunt, Brimmer, and Shaw

The Millet holdings in Boston by 1889 belonged to no fewer than thirty collectors, three of whom deserve particular credit for establishing Millet's name in their city – the painter William Morris Hunt; Martin Brimmer, a philanthropist and the first president of the Museum of Fine Arts; and Quincy Adams Shaw, a gentleman entrepreneur. Their similar backgrounds – Harvard educations (classes of 1844, '45, and '49, respectively), upbringings in affluent families, extensive travel abroad – brought them together socially in Paris in the early 1850s and a shared interest in art established ties among them that lasted for their lifetimes. Each man was, however, unique in his lifestyle and attitude toward the art he collected.

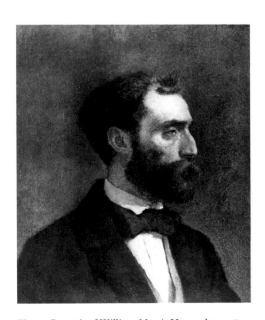

Fig. 2. *Portrait of William Morris Hunt*, about 1854, oil on canvas, 22 x 18 in., Smith College Museum of Art, Northampton, Massachusetts.
This portrait by Millet was painted at the beginning of a long friendship, when Hunt was thirty years old.

Hunt left college in his junior year (1843) to make a Grand Tour of Europe that extended into a nine-year sojourn, during which he pursued a career as an artist, first in sculpture, then in painting. After five years of study in Thomas Couture's Paris studio, Hunt left in 1851 for Barbizon to work with Millet. He remained there for two years, studying Millet's working methods and philosophy, which he would later translate to students and friends at home. For Hunt, Millet's pictures had "infinity beyond them," and he recalled: "When I came to know Millet I took broader views of humanity, of the world, of life. His subjects were real people who had work to do. His fields were fields in which man and animals worked."[4] Hunt was not the first Boston-born artist to be attracted to the artists' colony on the edge of Fontainebleau Forest for he was encouraged to go there by William Perkins Babcock, himself a former Couture student who had settled in Barbizon soon after Millet in 1849, never to leave the area.[5]

On his arrival in Barbizon Hunt wrote of Millet: "I found him working in a cellar, three feet underground, his pictures mildewing with the dampness, as there was no floor. I bought as much of his work as I could."[6] His first purchase was *The Sower* (cat. no. 18), acquired for only sixty dollars. At the 1853 Salon, Hunt was accompanied by his friend Martin Brimmer, who was then studying at the Sorbonne. Hunt bought *Shearing Sheep* (cat. no. 43), *Shepherd and Flock* (cat. no. 40), and Martin Brimmer purchased Millet's masterpiece, *Harvesters Resting (Ruth and Boaz)* (cat. no. 39). Hunt continued to buy the artist's work and he encouraged Bostonians visiting Paris to do the same. On later visits to France, he would deliver Bostonians' orders for new paintings to Millet personally.

Hunt's paintings executed in Barbizon of gleaners, sheepshearers, and working peasants are testaments to Millet's influence. In terms of style Hunt favored opaque surfaces and broadly expressed forms and light. Works from this period such as *The Girl at the Fountain* (Metropolitan Museum of Art, New York) and *The Marguerite* (Museum of Fine Arts, Boston) were attacked by *New York Times* art critic Clarence Cook as being mere "copies and reminders" of his "unfortunate association" with the French Masters.[7] He was also accused of having acquired the "morbid French manner."[8] Bostonians discounted Cook's criticism as ignorant and continued to admire Hunt.

In 1855, soon after his return home, Hunt married Louisa Perkins, daughter of the wealthy merchant Thomas Handasyd Perkins. This marriage provided him entry into Boston's most elite social circles, where Hunt's first-hand knowledge of the art and artists he was advocating gave his opinions particular weight, as did his own collecting habits (he owned at least twelve Millet paintings).[9] In addition, his strong personality and eccentric nature made him a popular figure and Boston society was taken by him. He was the only artist admitted to the prestigious Saturday Club, whose membership roll included the names of Ralph Waldo Emerson, Henry Wadsworth Longfellow, Oliver Wendell Holmes, Nathaniel Hawthorne, Charles Eliot Norton, Henry James, Thomas Gold Appleton, and Martin Brimmer. As Bostonians revealed in the 1881 *Memorial History of Boston, 1630-1880*, "Our interest in art continued to be of a respectable but rather languid kind, until stirred afresh by the arrival among us of one whose genius gave him authority to speak while his enthusiasm compelled all to listen – William Morris Hunt."[10] They commissioned him to paint their portraits and he became the city's most respected artist. He was also a popular teacher whose *Talks on Art* (1875 and 1883), a collection of classroom comments and dialogue transcribed by a student, Helen Knowlton, reveal his genius in that role. New England historian Van Wyck Brooks commented that in the 1850s "Boston corresponded to Plato's city, a population that was not too large to hear the voice of a single orator."[11] In the arts, William Morris Hunt was that voice, as he began to guide the new generation of Boston collectors through three decades.

When Martin Brimmer exhibited *Harvesters Resting* at the Athenaeum in 1854, it was the first Millet publicly shown in Boston (and only the second to be exhibited outside the French Salons). At the time Boston collections were still dominated by the largely questionable old master paintings, portraits, and pictures with religious or classical subjects by contemporary American artists. There were few genre scenes, and

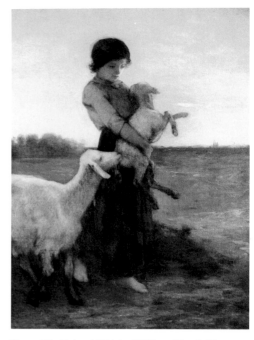

Fig. 3. *The Belated Kid*, by William Morris Hunt, 1857, oil on canvas, 54 x 38½ in., Museum of Fine Arts, Boston (Bequest of Miss Elizabeth Howes, 1907, 07.135).
Jean-François Millet's influence on William Morris Hunt's early choice of subject matter and style is evident in works such as this one begun in Barbizon and finished in Boston. However, Hunt added a level of sentiment not found in Millet's work.

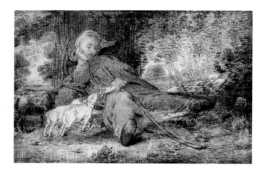

Fig. 4. *Young Girl Feeding Lambs*, by William Perkins Babcock, charcoal on paper, 26 x 39 cm., private collection, Boston.
The Boston-born painter William Perkins Babcock was working in Barbizon by 1849, and he remained there until his death in 1899. Drawings such as this reflect Millet's influence on the young artist, who would become one of his closest friends and a regular partner for nightly domino games. Babcock's later work is usually closer to that of another of Millet's friends, Narcisse Virgile Diaz.

Fig. 5. *Portrait of Martin Brimmer*, by Sarah Wyman Whitman, 1894-1896, oil on canvas, 24 x 20 in., Museum of Fine Arts, Boston (Gift of Mrs. Richard Morris Hunt and Mrs. Sarah Wyman Whitman, 19.143).
This portrait-sketch of Martin Brimmer was painted a few years before his death in 1898, and served as the study for the finished portrait now owned by Harvard College. Sarah Wyman Whitman, an early pupil of William Morris Hunt's, was a very close friend of Brimmer's.

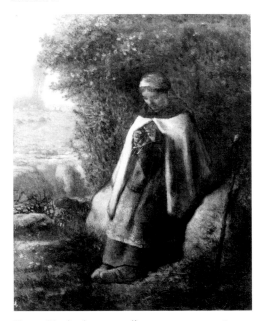

Fig. 6. *Shepherdess*, 1856, oil on canvas, 35.5 x 28 cm., Cincinnati Art Museum.
Edward Wheelwright, a classmate of William Morris Hunt's at Harvard, studied with Millet in Barbizon in 1855 and commissioned this painting after Millet showed him an identical one that he had promised to another party. When the second painting was finished, Millet allowed Wheelwright to choose between the two. Without being able to distinguish the earlier work from the later, he picked the one he had first admired. It was not unusual for Millet to repeat compositions for interested buyers.

landscape was just beginning to gain popularity.[12] In 1855 Brimmer lent a second work, *Knitting Lesson* (cat. no. 58), which was characterized in the New York-based *Crayon* as "an earnest, though affectedly feeble peasant group,"[13] and in 1857 a third, *Washerwomen* (cat. no. 62). When the *Knitting Lesson* was shown again in 1858 it was accompanied by Edward Wheelwright's Millet, *Shepherdess* (fig. no. 6; acquired while Wheelwright studied with Millet in 1855-1856); the first representations of Diaz, Rousseau, and Troyon exhibited at the Athenaeum; and several works by Americans who had studied in Barbizon – William Morris Hunt, Edward Wheelwright, Winckworth Allan Gay, and William James Stillman. This was the largest group of Barbizon and Barbizon-inspired works yet presented to the Boston public. The exhibition brought little critical response but served as an early indication of the city's progressive collecting traits.

In the 'seventies Brimmer added a number of other works to his collection: *Daphnis and Chloe* (pastel, private collection, England), *Woman Milking a Cow* (private collection, Japan), *Rabbits at Sunrise* (private collection, England), *Buckwheat Harvest* (pastel, cat. no. 142), *Sewing Lesson* (cat. no. 151), and twenty drawings. Most were purchased at either the Millet sale or the Emile Gavet sale, both of which Brimmer attended in Paris in 1875, bidding on his own behalf at the latter.

After some youthful years immersed in the art world of Paris Brimmer returned home to pursue law. He served in both the House of Representatives and the Senate, and became a great philanthropist, sitting on the boards of many institutions (including the Harvard Corporation and Massachusetts General Hospital) and presiding over the Museum of Fine Arts for twenty years after its 1876 opening.[14] Samuel Elliot of The Saturday Club eulogized Brimmer in 1896 as a gentle man devoted to public service.[15]

He was a special man who saw art as "the great instrument in man's education," "a means of expressing thoughts, feelings, aspirations, ideals, life, its larger relations."[16] Millet, Brimmer believed, "made visible the endurance and the pathos which are not the product of an age or an accident but as wide and lasting as humanity."[17]

Brimmer owned work by Copley, Stuart, and Constable, among others, but he felt the closest affinity to Millet. More of a romantic than either Hunt or Shaw, he was deeply moved by Millet's life as sentimentalized by his biographer, Alfred Sensier, and saw Millet as "God's instrument" for "interpreting His work in the world."[18] Brimmer, much of whose own life was devoted to public service, felt that art should serve to enlighten. He believed Millet's art did exactly that. At the opening of the Museum in 1876 he made a gift of a painting, *Sewing Lesson* (cat. no. 151), and a pastel *Daphnis and Chloe* (private collection, England) as well as his Millet drawing collection.

Quincy Adams Shaw, in contrast to William Morris Hunt and Martin Brimmer, was a private man. He did give generously to public causes, and of course he supported the arts in Boston. His involvement with the Museum of Fine Arts began at its conception in 1870. With Martin Brimmer, H. P. Kidder, and J. M. Sears (all fellow Millet collectors) he initiated the Museum building fund with his gift of $5,000. Yet he never served as a trustee of the Museum or contributed to it other than as benefactor and lender. Likewise, Boston's various art clubs and organizations never interested him, although he was surrounded by people involved in them. He was a maverick who lived his life in a style few could emulate.

Shaw was born in 1825, the ninth of Robert Gould and Elizabeth Parkman Shaw's eleven children. His family was as prosperous as it was large, and he grew up in the bosom of Boston society. In the spring of 1845, following his graduation from Harvard, he crossed the uncharted Oregon Trail with his cousin and friend Francis Parkman. While Parkman viewed the trip from the perspective of a scholar, Shaw saw it as "pure sport."[19] His choice for the subtitle of Parkman's book *The Oregon Trail*, published the next year, was "A Summer's Journey Out of Bounds," an appropriate description of what he had considered "a tour of curiosity and amusement."[20] A trip to Syria, Egypt, and Palestine followed his American adventures[21] and after a seven-year stay in Paris (1851-1858), during which time he may have begun to acquire French paintings, Shaw returned to Boston. Within two years he married Pauline Agassiz, daughter of Harvard's eminent Swiss-born scientist Louis Agassiz and step-daughter of Boston educator Elizabeth Cary Agassiz, Radcliffe's first president. Their wedding

trip to France in 1860 is reported to have included an introduction to Millet at Barbizon, but the event is not documented.

During the 'sixties, Shaw entered into a business venture that made his fortune, purchasing undeveloped copper mines in Michigan and then with the help of his brother-in-law, scientist Alexander Agassiz, making them highly profitable.[22] At his death in 1908 he was said to be the "richest man in New England, worth between twenty and thirty million dollars, and Boston's largest individual tax payer."[23]

In 1867 Millet first mentioned Shaw's name in passing to Alfred Sensier when recounting a visit to his studio by a group of Americans.[24] Later he told Sensier that one of the Americans was very keen on buying his still life *Pears* (cat. no. 110), but the painter was not willing to sell it and it remained with him until his death. Since Shaw later bought it directly from Millet's widow, it may well have been he who had tried to obtain it twenty years earlier. The next time Shaw visited Millet, in 1872, he insured his ability to buy the painting of his choice by commissioning the subject. Millet recorded the event in a letter to Sensier (January 8, 1872): "An American gentleman and lady M. and Madame Shaw, of Boston, came a little while ago to ask me for a picture which I have promised to paint for them. They chose *Priory at Vauville* (cat. no. 149) as the subject from among the drawings they saw here."[25]

In 1874, Boston dealers Doll and Richards recorded the sale of five Millet paintings – *Two Reclining Figures* (cat. no. 11), *The Sower* (cat. no. 18), *Man Turning over the Soil* (cat. no. 17), *Shearing Sheep* (cat. no. 43), and *Shepherd and Flock* (cat. no. 40) – for the account of William Morris Hunt to Quincy Adams Shaw. In the next few years (probably by 1876), Shaw would amass the largest holding of Millet's work in the United States. Only the James Staats Forbes collection in England, which included one hundred drawings, surpassed Shaw's in size, although it never rivaled it for the importance of Millet's paintings, and unfortunately it was dispersed in the early part of this century. Shaw's collection remains mostly intact today at the Museum of Fine Arts, Boston, as a gift from his estate.

Of the fifty-four paintings and pastels by Millet that were definitely in Shaw's possession by the late 'seventies, twenty came from the Emile Gavet sale held in Paris at the Hôtel Drouot (June 11-12, 1875). Shaw is not listed in the auction records as having purchased anything at the sale, but thirteen works were bought by Eugène Détrimont, a dealer and frame-maker employed by Millet himself.[26] In all likelihood, Détrimont was buying on Shaw's behalf. Another Shaw agent in Paris seems to have been M. Legrand. Four works from the Sensier sale (Hôtel Drouot, December 10-18, 1877) were acquired by Legrand and almost immediately took their place among those in Shaw's collection. In the year of the Gavet sale, Shaw placed his entire painting collection on loan to both the Museum of Fine Arts and the Boston Athenaeum in the tradition of Bostonians leaving the city for several months. Quite possibly Shaw was in Paris for the Gavet viewing and remained there to oversee his affairs. Aside from the Doll and Richards sale record and a receipt for *Priory at Vauville*, no other documents can be found to date his collecting. However, in 1881, an article on Shaw's Millets by *Art Amateur's* Boston correspondent "Greta" appeared in the September issue of that magazine and offered new insight into his collection. Up until that time, Shaw's collection had been known to only a few. In *Art Treasures in America*, Edward Strahan commented, "the veil of privacy which would other-wise hang inpenetrably over the gallery has been removed by an account issued – allegedly by permission – in a public magazine....and making use of 'Greta's' information our work may properly convey to the community the facts about one of the most exquisite cabinets of a special kind of art in the world. Mr. Shaw has the finest collection of works by J.F. Millet."[27]

With the *Art Amateur* article and Strahan's tome Shaw's Millets were documented, but still were actually seen by only a few. When five of his paintings – *Shearing Sheep* (cat. no. 43), *Cliffs Near Gruchy* (cat. no. 145), *End of the Hamlet of Gruchy II* (cat. no. 111), *Potato Planters* (cat. no. 97), and *Buckwheat Harvest* (cat. no. 150) – were lent to the 1889 Barye exhibition in New York's American Art Association Gallery, they brought this response from the press: "Mr. Shaw's Millets have been unknown to us save by reputation and their appearance here has fairly taken our connoisseurs off

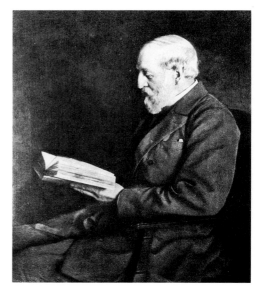

Fig. 7. *Quincy Adams Shaw*, photograph, about 1900

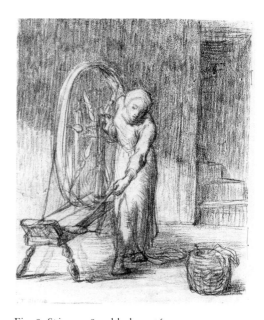

Fig. 8. *Spinner*, 1850, black conté crayon on paper, 37.5 x 29.2 cm., private collection.
Formerly in the collection of Pauline Agassiz Shaw (Mrs. Quincy A. Shaw), this drawing served as an early study for Standing Spinner *(cat. no. 59), also owned by the Shaws. The few Millet drawings acquired by them were not intended as museum pieces, as were the artist's pastels and paintings in their collection, but as works of art for more private appreciation, and they remained in the family.*

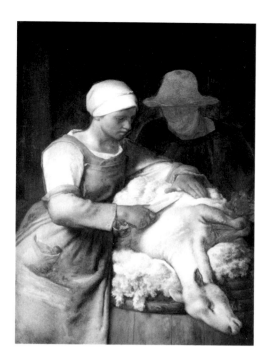

Fig. 9. *Sheepshearers*, 1861, oil on canvas, 154.5 x
114.0 cm., private collection, Boston.
*One of Millet's most well-received Salon pictures, this
work was compared by critics, in 1861, to works by
Renaissance masters such as Raphael. In his beautiful
pairing of green and rose in the woman's sleeve and the
tonal delicacy of her face, Millet's ability as a great
colorist is clearly demonstrated. Peter Chardon Brooks,
a Boston collector, purchased the painting in the
'seventies.*

their feet. We have seen no group of Millets illustrating so perfectly the artist's powers as a painter's painter or his ability as a colorist."[28]

In painting every phase of Millet's development, from the 'forties through the 'seventies, is represented by at least one work, and the pastels, perhaps the greatest part of Shaw's collection, reveal his mastery of the medium during the years of his contract with Emile Gavet in the 1860s. Shaw created, in a relatively short period of time, the most comprehensive Millet collection formed anywhere, when the painting collections of his Boston friends and acquaintances are best characterized as diverse and eclectic. In the 1880s and 1890s, Shaw bought several beautiful Millet drawings (later sold by his family), and toward the end of his life he directed his Paris agent to seek out documents, purchasing the large number of letters to Theophile Silvestre, Emile Gavet, and Urbain Calmette that form the most important reservoir of Millet biographical material outside the Louvre (see Appendix); he also gathered Millet criticism in France from the 'fifties through the 'seventies. Shaw was possessive about his pictures and offered no indications, either in writing or verbally, of his motivation for collecting Millet. Though he owned a large number of works by other important painters – including Corot, Troyon, Rousseau, Delacroix, and a large number of Italian Renaissance masters from Cima to Veronese – he dedicated most of his energy to putting together the Millet holdings.

Perhaps Shaw's interest in Millet came partially through his wife. We know that Pauline Agassiz Shaw owned Millet drawings in her own right, and it is to Pauline that her sister and brother-in-law, the Henry Lee Higginsons, dedicated a Millet pastel from their collection when it was bequeathed to the MFA (*Shepherdess with her Flock and Dog*, cat. no. 108). Furthermore, she was active in establishing kindergartens and day nurseries in Boston during the eighties, when educational journals, many with religious imput, were singing Millet's praises. From his images to his life story, Millet was considered to be a good example to children, and his art was used to teach them the dignity of labor.[29] It is interesting to note that of the fifty Millets hanging in Shaw's Jamaica Plain home, the largest concentration of them, twenty-one pastels, were exhibited in the schoolroom.

In addition to Brimmer and Shaw, many of Boston's less well known Millet collectors were also introduced to his art by Hunt. The Allston Club, which Hunt founded and presided over during its brief two-year existence (1866 through 1867) sponsored two exhibitions of Barbizon and Barbizon-inspired works by both French and American painters. The club's members and lenders were friends of Hunt's, sharing his contagious enthusiasm for the artists. Millet – though outnumbered by Corot, Hunt, Winckworth Allan Gay, and Troyon – was represented in Allston Club shows by pictures lent from the collections of Hunt, Brimmer, Edward Wheelwright, E. Adams Doll of Doll and Richards Gallery, and Henry Sayles. Though it was not exhibited with the Allston Club, Sayles owned one of Millet's three 1861 Salon entries, *Tobit Waiting* (Nelson-Atkins Gallery, Kansas City, fig. no. 10), which he probably bought on Hunt's recommendation. Another of Hunt's comrades and patrons, Peter Chardon Brooks, brought a second of Millet's 1861 Salon paintings to Boston with his purchase of *The Sheepshearers* (private collection, Boston, fig. no. 9). Dr. Henry C. Angell, a patron of Hunt's and the author of a short biography on Hunt, acquired in 1875 one of the few nudes in Boston collections and the only one by Millet in the Museum, *Seated Nude* (cat. no. 10).

The Millets presented to the Museum by Martin Brimmer, Mrs. S. D. Warren, Reverend Frederick R. Frothingham, Quincy Adams Shaw, Ida Agassiz Higginson, Dr. Henry Angell, Mr. and Mrs. Robert Dawson Evans, and Mrs. John Ames represent only a small percentage of the total once in Boston. Many works are still family holdings, but a number have left the city as families became dispersed throughout the country. In addition, works have been sold from family collections in recent years. However, Millet patronage has not ceased in Boston. One Boston collection, the William I. Koch Foundation, has recently made two acquisitions, both on loan to the Museum of Fine Arts: one a pastel that has been with a local family since the Gavet sale in 1875 (cat. no. 129), the other a beautiful study for the last major composition worked on by the artist (cat. no. 152).

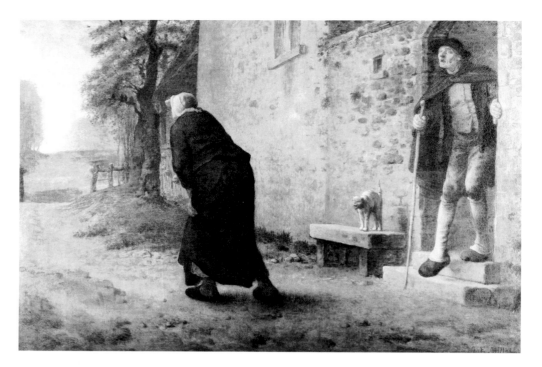

Fig. 10. *Tobit Waiting*, 1860-1861, oil on canvas, 33¼ x 47¾ in., Nelson-Atkins Gallery, Kansas City. *This painting depicting the story of Tobit and Anna, a subject that had fascinated Rembrandt, was purchased by Allston Club member Henry Sayles, a friend of Hunt's, who collected Barbizon-inspired paintings by French artists as well as by many of the Boston painters who had worked with or admired Millet.*

Fig. 12. *Woman Baking Bread*, about 1852-1854, black conté crayon on paper, 37 x 30.5 cm., Misses Aimée and Rosamond Lamb, Boston. *In this early drawing of a woman placing loaves in an oven, Millet brought to activities of everyday life the powerful figure types of Michelangelo. It was acquired in Paris around 1890 by a young Boston couple, Mr. and Mrs. Horatio Lamb, who bridged two Boston collecting traditions by buying a painting by Claude Monet on the same visit.*

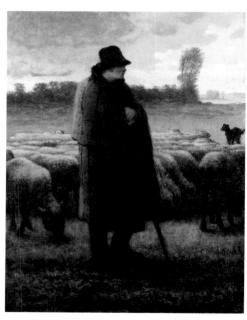

Fig. 11. *Shepherd and Sheep*, about 1855, oil on panel, 34 x 26 cm., Museum of Fine Arts, Boston (Lent by Frances Rutledge Parker, William Amory Parker III, and Oliver Ames Parker, grandchildren of Elise Ames Parker, 4.1981). *During the 'fifties and 'sixties, three shepherds roamed the Chailly plain with their large flocks and Millet encountered them frequently on his twilight walks. Wrapped in bulky cloaks, their majestic forms fascinated Millet and they became one his most repeated subjects.*

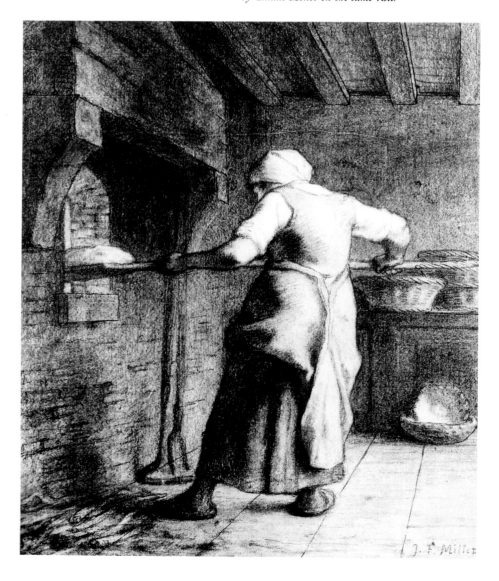

Millet in Other American Collections

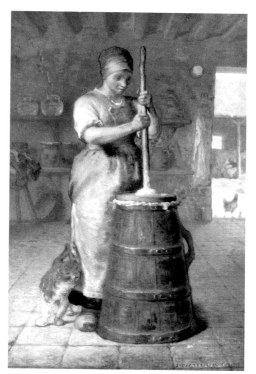

Fig. 13. *Butter Churner*, 1869-1870, oil on canvas, 98.5 x 62.3 cm., Malden Public Library.
This painting appeared in the Salon of 1870, the last Salon in which Millet would be represented. The monumental figure is the culminating image in the artist's numerous representations of butter churners begun in the 'forties (see cat. no. 20). Once in the great Secretan collection in Paris, it was brought to Boston by Frederick L. Ames in the 'nineties, and it was assured a permanent home in greater Boston collections when it was acquired by the Malden Public Library in 1962.

Whereas Millet collecting became established in Boston by the 1870s, elsewhere in the United States his popularity did not peak until the 'eighties and 'nineties, to a certain extent in tandem with his popularity in France. Even Boston's cultural rival, New York's Metropolitan Museum of Art, had no Millets until 1915. As Boston artist Mary Macomber (1861-1916) reported of the Metropolitan in the *Boston Transcript*: "It is...strange that modern painters from over the sea who arrive with great noise can almost fill a room with their works, while the modest peasant finds no place in the permanent collection of the museum of the nation's art center. A room filled with Millet's work would, I think, have a better effect on the future of American art."[30]

Still, there was a small number of private collectors in New York and elsewhere around the country who appreciated Millet early on. Philadelphia's Adolph E. Borie purchased *The Raker* (Metropolitan Museum of Art, New York) in the late 'sixties. William T. Walters, Baltimore's preeminent collector, started buying Millet's works in Paris by the late 'seventies and possibly earlier. The *Newborn Calf* (Art Institute of Chicago), a painting that was much criticized in the 1864 Salon reviews, was in the collection of Henry Probasco of Cincinnati by 1873. In New York, August Belmont owned examples of the Barbizon school, including works by Troyon, Rousseau, Corot, Diaz, Dupré, and Millet by 1857, just a few years after these artists were introduced in Boston. The most famous Millets outside Boston, those of William H. Vanderbilt (six paintings and two pastels), came in the 'eighties. Still, New York lacked the cultural and artistic homogeneity that Boston possessed. Moreover, the nature of Boston and New York collections was very different. Boston collections were generally small, carefully formed, often with works purchased directly from the artist, and intended as an integral part of a home.[31] When a friend asked Quincy Adams Shaw why he kept his pictures in his house and not in a private picture gallery, he responded, "Why should I build a picture gallery? I sit quietly in my rooms and enjoy looking at the walls upon which the pictures are hung."[32] In contrast, James Jackson Jarves had commented in the early 'sixties, "Private galleries in New York are becoming almost as common as private stables."[33] The typical Boston collector was long established in his city both socially and financially, and art collections were not viewed as symbols of wealth or status as they often were by newly rich New Yorkers. As Martin Brimmer observed somewhat smugly when he was shown the Secretan Collection in Paris, on June 29, 1889, before the *Angelus* auction: "Today I have seen Secretan's great collection made on the Vanderbilt principle of buying the dearest – perhaps as good a way as any obvious one of spending surplus millions – only an obvious way is not always the best."[34] It was not Boston's way.

One prominent New Yorker, the antithesis of her Boston counterparts, was Mary Jane Sexton Morgan, wife of shipping and railroad magnate Charles Morgan. In the years following her husband's death, the early 1880s, she started forming an enormous art collection that was auctioned after her own death in 1886. As the *New York Times* reported before the sale, "Mrs. Morgan collected quickly and without great knowledge of the objects she was acquiring."[35] Her paintings, last to be acquired and thought to be the best part of her holdings, numbered 240 and included ten Millets. Mrs. Morgan's sale at the American Art Association attracted thousands. From its preview through the six-day sale (March 1-6, 1886), it received daily press coverage in the *New York Times*. Some of the nation's greatest collectors – Walters of Baltimore, William Rockefeller of New York, and Charles Crocker of California – were in attendance, and Millet was popular with them. Crocker bought *Wool Carder* (in a few years he would add *Man with a Hoe* to his collection). Rockefeller successfully bid on *Gathering Beans* and *Spinner* (he already owned *Man Grafting a Tree*). Knoedler and Co. bought *Woodcutters* and *Spaders*.

There was new wealth in the country and collecting art was in vogue. However, connoisseurship did not rise correspondingly with the large numbers of new collectors. There were collectors in New York and elsewhere around the country who understood Millet's worth as an artist; however, as evidenced by the Morgan sale, there were still many people who saw in him only sentimentalism or religious parallels

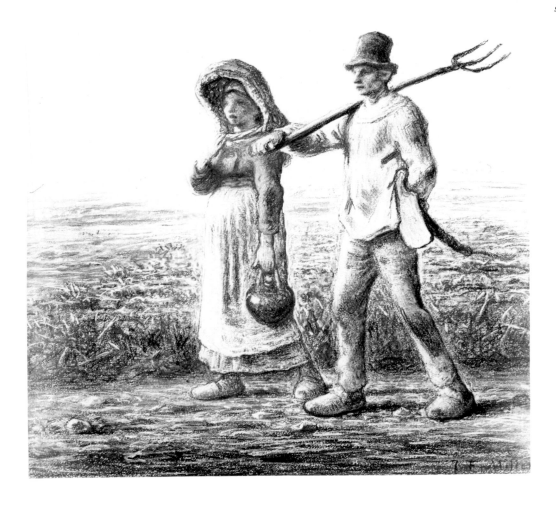

Fig 14. *Peasant Couple Going to Work,* 1866, pastel on paper, 46 x 39 cm., private collection, Boston. *This pastel of a young couple is the final version of a theme that Millet took up shortly after his arrival in Barbizon (see also cat. no. 106). It was drawn for Emile Gavet in 1866 and was acquired at the Gavet sale on behalf of a Boston collector whose descendants still treasure it.*

and were even more attracted to lesser painters who prettified the subjects that Millet presented directly.

By the late 'eighties and 'nineties, interest in Millet spread in a ripple effect from Boston across the country to the Midwest and California. At the Chicago Exposition in 1893, Millet and the Barbizon school were well represented. From Boston, the MFA's *Young Shepherdess* (cat. no. 141), a gift in 1876 from Samuel Dennis Warren,[36] and Peter Chardon Brooks's large *Sheepshearers* (fig. no. 9) were sent. Three small works from the Alfred Corning Clark collection in New York were included; California's railroad king William Crocker lent his famous *Man with a Hoe;* and from the host city *Killing the Hog* (National Gallery of Canada, Ottawa) and *Newborn Calf* (Art Institute of Chicago) were lent by Charles Yerkes and Mrs. Henry Fields, respectively. Chicago social leaders the Potter Palmers would soon acquire their Millets, many of which were later given by them to the Art Institute of Chicago and form the nucleus of that museum's Millet collection today.

Cultural Currents Underlying Boston's Taste for Millet

Why was Boston the birthplace for American interest in Millet? The simplest answer is that Bostonians in France during the 'forties and/or 'fifties – William Babcock, William Morris Hunt, Edward Wheelwright, Martin Brimmer, and Quincy Adams Shaw –

happened to be the first group of Americans exposed to Millet and the Barbizon School. But there are several other reasons that Bostonians were intellectually primed in the late 'fifties and early 'sixties to embrace the Barbizon artists. During the 1850s, America was undergoing what has been termed a literary "Renaissance."[37] Its protagonists were Ralph Waldo Emerson (1803-1881) and Henry David Thoreau (1817-1862), New Englanders raised near Boston and Harvard educated. Their message was one of democracy, both for man and in nature. Emerson proclaimed, "I embrace the common, I explore and sit at the feet of the familiar, the low."[38] The Boston painter and critic Edward Wheelwright tells us in his invaluable article on Millet from 1876 that Millet had read translations of Emerson, supplied by William Morris Hunt.[39] But while Wheelwright does not record for us the artist's reaction to the Concord poet, it is not hard to see parallels with Emerson's philosophy in a painter who could ask: "Doesn't each thing in creation have its own role to play at a certain time and a certain place? Who would dare claim that a potato is inferior to a pomegranate?"[40] and who felt that "the whole of nature is offered to men of character and their genius helps them choose not the things assumed the most beautiful but the ones that are perfect in their place."[41] In any event, to those who championed Emersonian ideals or simply perceived greatness in nature, Millet's and the Barbizon School's work was well received. Naturalistic subject matter as Millet, Rousseau, Diaz, Troyon, Jacque, and Corot presented it was compatible with the New England character that was developing. The Transcendentalist philosophical and moralistic outlook toward nature espoused by Emerson and Thoreau was not that of the average man, but a fascination with and an admiration of nature was definitely born of it and it helped to feed the emerging New England character.[42]

Walt Whitman (1819-1892), a poet close to the New England tradition and influenced by Emerson, though New York born, considered Millet "A whole religion in himself: The best of democracy, the best of all well-bottomed faith is in his pictures. The man who knows his Millet needs no creed."[43] Whitman likened his collection of poems *Leaves of Grass* (1855) to Millet, saying that they were "Millet in another form."[44] (His poems about plowmen, the commonplace, unseen buds, twilight, etc., are repeatedly paralleled in Millet's choices of subject and emphasis.) It is interesting to note, in this regard, that *Leaves of Grass* was attacked in 1856 with the criticism that "all things in Nature are not alike, beautiful, or to be loved and honored by song."[45] Millet's *Newborn Calf* and *Man with a Hoe* had been dismissed by critics in New York and Paris for the same reasons and it has also been claimed that Whitman's and Millet's "authentic kinship lay in the similarity of their inspiration."[46] Walt Whitman would have agreed with Millet's statement, "Art began to decline from the moment that the artist did not lean directly and naively upon nature."[47] For Whitman, Millet's art based on humanity and nature captured the French rural tradition and consequently the meaning of the French Revolution.[48] He wondered if America would ever have "such an artist out of her own gestation, body, soul," and went on to specify the essential qualities defining the highest American traditions of nature and democratic values in art.[49] In retrospect, it may be said that the long line of painters upholding those traditions, such as Winslow Homer, owe their ready acceptance in large part to the Boston patrons of Millet.

1. [Robert L. Herbert], *Jean-François Millet* (London: Arts Council of Great Britain, Hayward Gallery exhibition catalogue, 1976), p. 90. Little-known at the time, the *Angelus* was really a Boston painting, having been commissioned by Thomas Gold Appleton in 1857, although he had never taken the delivery.

2. Ibid.

3. [Robert L. Herbert], *Jean-François Millet* (Paris: Editions des Musées Nationaux, Grand Palais exhibition catalogue, 1975), p. 105.

4. Martha A. S. Shannon, *Boston Days of William Morris Hunt* (Boston: Marshall Jones Company, 1923), p. 40.

5. Peter Bermingham, *American Art in the Barbizon Mood* (Washington, D. C.: Smithsonian Press, exhibition catalogue, 1975), p. 22. Winckworth Allan Gay was the first to arrive in 1847. He left after four years of study with Constant Troyon. Thomas Gold Appleton also studied with Troyon in Barbizon in the late 'forties. Later Hunt would send a Harvard classmate, Edward Wheelwright, there to study with the master in the 'fifties.

6. William Morris Hunt, "Talks on Art" in *On Painting and Drawing* (New York: Dover Publications, 1976), p. 169.

7. *Boston Transcript* (October 11, 1879).

8. "Boston Athenaeum," *Crayon* 2 (July 11, 1855), p. 24.

9. Helen M. Knowlton, *The Art Life of William Morris Hunt* (Boston: Little, Brown, and Company, 1899), p. 75. Unfortunately, several of the best, "nest eggs for the children," as he called them, were burned in his studio during the great Boston fire of 1872.

10. Arthur Dexter, "The Fine Arts in Boston," in *The Memorial History of Boston, 1630-1880* (Justin Winter, ed., Boston: James Osgood and Co., 1881), vol. 4, p. 399.

11. Van Wyck Brooks, *New England: Indian Summer, 1865-1915* (New York: E. P. Dutton & Co., 1940), p. 50.

12. Robert F. Perkins, Jr., and William Gavin III, ed., *The Boston Athenaeum, Art Exhibition Index, 1827-1874* (Boston: The Library of the Boston Athenaeum, 1980).

13. "Boston Athenaeum," *Crayon* 2 (July 11, 1855), p. 24.

14. For discussion see *Harvard University Magazine* (1896), vol. 4, pp. 476-479.

15. Ralph Waldo Emerson, *The Early Years of the Saturday Club, 1855-1870* (Boston: Houghton Mifflin Company, 1918), p. 370.

16. Martin Brimmer, "Address Delivered at Bowdoin College Upon the Opening of the Walker Art School, June 7, 1894" (Boston: Houghton Mifflin Company, 1894), pamphlet, p. 2.

17. Ibid., p. 10.

18. Ibid., p. 33.

19. Mason Wade, ed., *The Letters of Francis Parkman* (New York: Harper and Brothers, 1944), p. 386.

20. Ibid.

21. Wilbur R. Jacobs, ed., *The Letters of Francis Parkman* (Boston: Massachusetts Historical Society, 1960), p. 71. In a letter to their mutual friend, Charles Eliot Norton of June 15, 1850, Francis Parkman wrote that he had just received a letter from Quincy Shaw dated at Marseilles, describing his recent five-month stay in the East. Parkman recounted that "he [Shaw] was evidently highly pleased, though he expresses an unmeasured contempt for the people and considers the whole affair as rather tame and unadventurous."

22. *Harvard Graduates Magazine* 18 (June 1910), no. 72, p. 597.

23. *Boston Transcript* (June 13, 1908); obituary cited in "Harvard Memorial Biography," Class of 1845, Harvard Archives.

24. Letter from Millet to Alfred Sensier (November 1867), Cabinet des Dessins, Musée du Louvre, Paris.

25. Etienne Moreau-Nélaton, *Millet raconté par lui-même* (Paris: Henri Laurens, 1921), vol. 3, p. 84.

26. J. B. C. Corot's painting *Dante and Virgil Enter the Inferno*, which Quincy Adams Shaw purchased specifically as a gift to the MFA at its opening in 1876, was obtained from Détrimont.

27. Edward Strahan, *The Art Treasures of America* (Philadelphia: G. Barrie, 1879-1882; second edition, New York: Garland Publishing, Inc., 1977), p. 86.

28. *Boston Evening Transcript* (July 22, 1889).

29. *Fifty Years of Boston, A Memorial Volume Issued in Commemoration of the Tercentenary of 1930* (Boston: Tercentenary Commission), p. 474.

30. *Boston Transcript* (July 7, 1899).

31. Alexandra R. Murphy, "French Paintings in Boston: 1800-1900," essay in *Corot to Braque: French Paintings from the Museum of Fine Arts, Boston* (Boston: Museum of Fine Arts, exhibition catalogue, 1977), p. xviii.

32. *Quincy Adams Shaw Collection* (Boston: Museum of Fine Arts, exhibition catalogue, 1918), p. 34.

33. Quoted in Russell Lynes, *The Taste-Makers* (New York: Harper & Brothers, 1949), p. 38.

34. Letter from Martin Brimmer to Sarah Wyman Whitman, Paris, June 29, 1889, Archives of American Art, no. 265.

35. "Mrs. Mary J. Morgan Sale," *New York Times* (March 6, 1886).

36. Mr. and Mrs. Samuel Dennis Warren had complemented Brimmer's Millet gifts at the opening of the Museum with the *Young Shepherdess* (cat. no. 141) from their own collection. Mrs. Warren added four more Millets to her collection by the 'nineties and in 1892 gave the Museum a pastel, *Killing the Hog* (cat. no. 142).

37. See F. O. Matthiessen, *American Renaissance* (New York: Oxford University Press, 1941).

38. Ibid., p. 39.

39. Edward Wheelwright, "Personal Recollections of Jean François Millet," *Atlantic Monthly* 38 (September 1876), no. 227, p. 206.

40. Alfred Sensier and Paul Mantz. *La Vie et l'oeuvre de J.-F. Millet* (Paris: A. Quantin, 1881), p. 393.

41. Ibid.

42. Bermingham, op. cit., p. 36.

43. Matthiessen, op. cit., p. 602.

44. Ibid.

45. "Studies from the Leaves," *Crayon* 3 (January 1856), p. 31.

46. Matthiessen, op. cit., p. 602.

47. Ibid.

48. Ibid.

49. Malcolm Cowley, ed., *The Works of Walt Whitman*, vol. 2, *The Collected Prose* (New York: Funk & Wagnalls, 1948), p. 181.

Chronology

1814

October 4, Jean-François, first child, born to Jean-Louis-Nicolas and Aimée-Henriette-Adélaïde Henry Millet. The painter's family were respected, modestly successful members of the small peasant community of Gruchy, forming the coastal limit of the village of Gréville, 17 km. west of Cherbourg.

With his family's support, Millet received an unusually good education, mainly under the tutelage of two village priests. He acquired an enduring mastery of Latin and a lifetime thirst for reading. Throughout the rest of his life, his command of the works of ancient writers such as Virgil or modern authors (from Shakespeare through Thoreau) continually surprised and impressed friends and visitors alike.

1833

Millet's talents having been noticed by his family, he was sent to Cherbourg to study with the local portrait painter Bon Dumouchel; he returned home frequently to assist with farm duties.

1835

Full-time study under Lucien-Théophile Langlois, a pupil of Baron Gros, in Cherbourg.

1837

With support of Langlois and others, Millet received a stipend from the city of Cherbourg that allowed him to study in Paris. He was admitted to the Ecole des Beaux-Arts in the studio of Paul Delaroche, a very successful history painter.

1839

Competed unsuccessfully for the *Prix de peinture* and may have left the Ecole shortly thereafter. In December, Cherbourg terminated his scholarship. His first submission to the official Salon exhibition, *Saint Anne Teaching the Virgin* (current location unknown), was rejected.

1840

Submitted two portraits to Salon, one of which was accepted. Returned to Cherbourg to set himself up as a portraitist.

1841

Married Pauline-Virginie Ono (see cat. no. 2); they moved to Paris, where Millet found success elusive.

1843

A painting and a pastel refused by Salon.

1844

Pauline died of consumption; Millet returned to Cherbourg.

1845

Accompanied by Catherine Lemaire (see cat. no. 12), a domestic servant he met in Cherbourg, Millet moved for several months to Le Havre, where he painted portraits and small genre scenes. Late in the year he returned to Paris with Catherine.

1846

Began friendship with Constant Troyon and Narcisse Diaz, modestly successful painters of animal, genre, and landscape pictures. Able occasionally to sell a painting to dealers such as Durand-Ruel or DesForges. Daughter Marie, first child, born in July.

1847

Millet's circle of friends included artists Charles Jacque, Honoré Daumier, and Théodore Rousseau. He met government bureaucrat Alfred Sensier, who became a lifetime friend and supporter, later his biographer. *Oedipus Taken down from the Tree* (National Gallery, Ottawa) provided first significant Salon success. Second daughter, Louise, born in July.

1848

Louis Philippe deposed by revolution and provisional Republic established; further uprisings bloodily suppressed. Salon was unjuried, and Millet's *Winnower* (National Gallery, London) was acquired by an official of the new government. Louvre galleries were rehung, giving new attention to French artists, as well as to painters of realistic subject matter.

1849

Millet completed *Harvesters* (Musée du Louvre, Paris) for a state commission. First son, François, born in January or February. Small painting of peasant woman exhibited at Salon (see cat. no. 13). In June Millet left Paris with his family and settled in Barbizon.

1850

Sensier began formalized arrangement, providing paint, canvases, and some money in return for paintings and drawings; he continued to sell other works to dealers, friends, etc. Fourth child, Marguerite, born in October. Millet sent *The Sower* (cat. no. 18) and *Haymakers* (Musée du Louvre, Paris) to Salon; Courbet presented *Stonebreakers* and *Burial at Ornans*.

1851

Coup d'état replaced Republic with Louis Napoleon, who established Second Empire.

1853

Salon included Millet's *Harvesters Resting* (cat. no. 39), *Shearing Sheep* (cat. no. 43), and

Shepherd and Flock at the Edge of the Forest, Evening (cat. no. 40); Millet was awarded a second-class medal. *Harvesters Resting* purchased by Martin Brimmer of Boston, the latter two Salon entries purchased by William Morris Hunt of Boston. Millet's mother died; he returned to Gruchy for first time since 1845. Civil marriage to Catherine Lemaire witnessed by Boston painters William Morris Hunt and William Perkins Babcock, who became acquainted with Millet perhaps as early as 1851 and were now close friends. Series of woodblock engravings, "Work of the Fields," published by *L'Illustration* (prints later to be copied by Vincent van Gogh, John Singer Sargent, Paul Cézanne, and others).

1854

Visited Gruchy with his entire family. *Twenty-Seventh Annual Exhibition* at Boston Athenaeum included *Harvesters Resting*, lent by Brimmer, first painting by Millet to be exhibited in United States.

1855

Edward Wheelwright of Boston arrived in Barbizon, with letters from Hunt, to study with Millet for nine months. Wheelwright later returned to Boston, bringing Millet's *Shepherdess* (fig. no. 6); wrote an important firsthand account of Millet's methods. Millet began a series of etchings (cat. nos. 63-73). *Man Grafting a Tree* (Neue Pinakothek, Munich; see also cat. no. 60) exhibited at Exposition Universelle; other pictures sent by Millet rejected.

1856

Daughter Emilie born in March.

1857

The Angelus (fig. no. 1) commissioned by Thomas Gold Appleton, Boston. At the Salon, *Gleaners* (Musée du Louvre, Paris) was highly controversial. Son Charles born in June.

1859

Woman Pasturing her Cow (Musée de l'Ain, Bourg-en-Bresse) included in Salon; *Death and the Woodcutter* (Ng Carlsberg Glyptothek, Copenhagen) rejected, but shown in a friend's studio. Strong criticism of Millet. Daughter Jeanne born in March.

1860

Several Millet paintings exhibited in art galleries at 26 Boulevard des Italiens. Millet entered contract with Ennemond Blanc and Arthur Stevens for twenty-five paintings in return for monthly stipend for three years. One of first paintings for Blanc and Stevens, the large *Sheepshearers* (fig. no. 9), exhibited by them in Brussels.

1861

Tobit Waiting (fig. no. 10) and *Sheepshearers* in Salon; *Sheepshearers* a major critical success for Millet. Son Georges born in October.

1862

Potato Planters (cat. no. 97) exhibited by dealer Georges Petit.

1863

Salon included *Man with a Hoe* (private collection, United States), which was bitterly criticized. First year of Salon des Refusés. Daughter Marianne, ninth and last child, born.

1864

Commission received for large decorative paintings of the Four Seasons for a Paris mansion. Salon included *Newborn Calf* (Art Institute of Chicago), which was severely criticized, and the large *Shepherdess* (Musée du Louvre, Paris), which was well received. Millet awarded first-class medal.

1865

Emile Gavet began commissioning pastels, eventually to form an extraordinary collection of 90 of Millet's greatest drawings and pastels (see cat. nos. 112-115, 128-138, 140).

1866

End of the Hamlet of Gruchy II (cat. no. 111) in Salon. Allston Club (Boston) annual exhibition included *The Sower*, lent by Hunt, as well as Courbet's *Quarry* (Museum of Fine Arts, Boston). Millet and his wife visited Vichy in the hopes of improving her health. Landscape became considerably more important in his work, and he made a large number of drawings and watercolors of the region (see cat. nos. 117-127) in this and two subsequent summers.

1867

Millet's fame and importance firmly established by major showing of his work at Exposition Universelle, including the *Gleaners*, *Angelus*, and *Potato Planters* (cat. no. 97). Millet and wife again traveled to Vichy. Théodore Rousseau, who had become Millet's closest friend in Barbizon, died after serious illness.

1868

Frédéric Hartmann, previously a major patron of Rousseau, commissioned *Four Seasons* (see cat. no. 150) for 25,000 francs. Millet was named Chevalier de la Légion d'Honneur, thanks in large part to efforts of Théophile Silvestre (see letters from Millet to Silvestre of August 21, 1867, and December 31, 1867).

1869

The Musée de Marseille bought Millet's *Woman Feeding her Child*, his first work to enter a public museum (two earlier state purchases do not appear to have been publicly exhibited after acquisition).

1870

Elected to Salon jury by fellow artists. *Butter Churner* (fig. no. 13) and *November* (destroyed) are the last paintings Millet submitted to the Salon. Fleeing the Franco-Prussian War, he and his family settled in Cherbourg and Gréville for sixteen months. *Cliffs near Gruchy* and *Fishing Boat* (cat. nos. 145 and 146) painted during this stay.

1871

Millet returned to Barbizon in November. Late in year, Quincy Adams Shaw and his wife, Pauline Agassiz Shaw, visited Millet and commissioned *Priory at Vauville* (cat. no. 149).

1872

Millet's paintings were exhibited regularly by Durand-Ruel, who in recent years had become his major dealer; important Millet paintings were reaching prices of 15-20,000 francs at auction sales.

1874

Along with Puvis de Chavannes and others, Millet received commission to paint scenes from the life of Saint Geneviève, patron saint of Paris, for the Panthéon, an exceptionally important official recognition. Failing health prevented work beyond preliminary drawings. First Impressionist exhibition held in Paris.

1875

January 3, religious marriage to Catherine. January 20, Millet died. May 10-11, sale of works from his studio. June 11-12, Gavet collection of pastels was sold, following a month's exhibition attended by Vincent van Gogh, et al. At least forty works from Gavet sale acquired for Boston collections.

1876

Millet's *Sewing Lesson* (cat. no. 151) and twenty drawings, purchased at the studio sale, were presented to the Museum of Fine Arts, Boston, by Martin Brimmer. *Young Shepherdess* (cat. no. 141), also acquired from the artist's sale, was given to the Museum the following year by Samuel D. Warren.

Catalogue

Dimensions and Materials

For oil paintings, dimensions are those of the panel or canvas support, unless design and support differ by more than two centimeters, in which case both dimensions are given. For drawings and watercolors the sheet size is given. Dimensions are from the lower left corner, with height preceding width.

Identification of the black drawing media used by Millet is not consistent throughout the catalogues describing his drawings. Although many of the same drawings are described elsewhere as black chalk, charcoal, or other similar media, our examinations have usually revealed black conté crayon.

When no paper color is given for drawings, pastels, watercolors, or prints, the paper is white or off-white. Colored primings are listed for oil paintings only when they can be clearly identified.

In the *Provenance* section, a comma between two owners designates confirmed passage of a picture from one to the other. When that direct connection cannot be established, a semicolon is used. The word "with" distinguishes the holder as a dealer.

In *Exhibition History*, the number following the date of an exhibition refers to an entry in the catalogue; when no number is given, no catalogue was produced. During the Second World War, a number of paintings from the Museum of Fine Arts were placed on extended loan throughout this country; such showings are included in the exhibition history, although, in general, these loans were not part of special exhibitions.

Under *Related Works* are listed all paintings, drawings, pastels, and prints by Millet that are related both in theme and in composition to the work in question in the order in which we believe they were created. Objects in the Museum's collection are included in the list in order to indicate their chronological position. We define working drawings as follows: compositional sketches are works that include significant suggestion of the composition as a whole, while the term "studies" is used to identify drawings dealing with only a single figure or a limited aspect of the final composition. Compositional studies are especially complete preparatory drawings, usually immediately prior to a finished work.

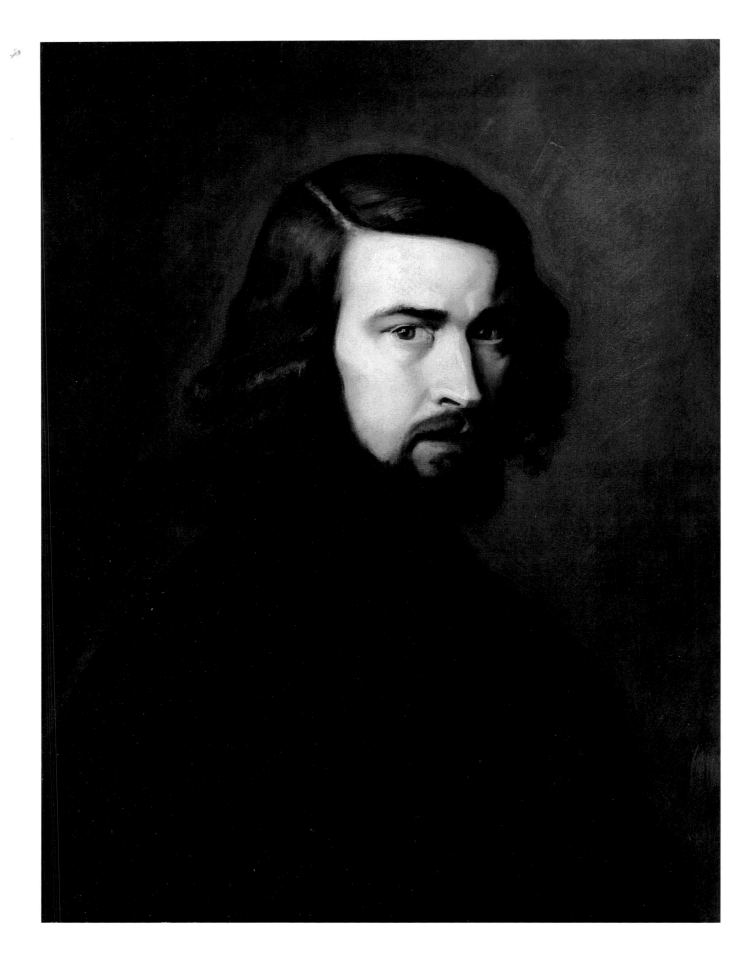

1
Self-Portrait
About 1840-1841
Oil on canvas
63.5 x 47.0 cm. (25 x 18½ in.)
Lower left: J. F. Millet
Gift by contribution, 1893
93.154

Self-portraits are rare in Millet's oeuvre, and only four (two of them drawings) are known, all dating from the 1840s, the beginning of his career as a professional artist.[1] Boston's self-portrait, painted about 1840-1841, is probably the first of the four and, with its uneasy mix of provincial straightforwardness and Parisian affectation, it marks Millet's coming of age as a painter. The painting was acquired in 1893 from the artist's family by a group of Boston subscribers, nearly all Millet collectors or admirers, who wished to join the artist's own image to the small, but growing number of his works belonging to the Museum.

The first son of peasants, Millet was raised to work his family's land in Gruchy, a tiny hamlet outside Cherbourg, on the Normandy coast. But his talent for drawing was recognized and appreciated by his family, who had already encouraged his uncommonly good, albeit erratic, education. In 1833, Millet began intermittent studies with a Cherbourg portrait painter while continuing an active role on the family farm; but in 1837, at 23, he left the homestead in care of his mother, grandmother, and younger brothers and moved to Paris, aided by a scholarship from the city of Cherbourg, to study painting in earnest. By 1839, he considered himself ready to present his talent for public judgment, but the jury for the annual Salon exhibition rejected his painting *Saint Anne Teaching the Virgin to Read*.

The next year, Millet submitted two portraits, one of which was accepted, one rejected, a reasonably good debut for a young artist; that winter he returned to Cherbourg to establish himself as a portraitist, the only kind of artist who might hope for modest employment in the provincial city. It is to this brief interlude in Cherbourg that the Boston self-portrait is usually dated, primarily for its relation to a group of portraits (including his other painted self-portrait) Millet executed during this period for the family of his bride-to-be, Pauline-Virginie Ono.[2] The self-portrait that belonged to the Ono family appears securely dated to the period around Millet's marriage in 1841, and Robert Herbert regards the Boston painting as slightly later.[3]

Certainly Boston's picture displays a greater self-assurance than is found in the Cherbourg picture, especially in details such as the sharp highlights on the nose and cheek, and in the strong shadowing of the left side, which gives an ominous look to the artist. But it also depicts an almost gaunt, certainly melancholic, young man in a casual dark jacket with dark velvet collar and with full beard, the archetypal young Romantic who peopled Murger's *Vie de la Bohème* – the artist of Paris. It is a self-image appropriate to a young single artist in the capital, not to an aspiring portraitist in Cherbourg. The hesitant handling of the Cherbourg self-portrait, which had been used to date it before the Boston version, is likely to be a result of that portrait's destination (the artist's soon-to-be in-laws) and to the unaccustomed costume: starched shirt, more formal coat and cravat, and clean-shaven chin.

Notes
1. The three others are in the Musée Thomas Henry, Cherbourg (formerly Ono-Biot family; oil on canvas, 73 x 60 cm., and charcoal on paper, 49 x 31 cm.) and the Musée des Beaux-Arts, Rouen (charcoal and black crayon on paper, 56.2 x 45.6 cm.).
2. This group of portraits, including two of Pauline Ono Millet as well as her brother and other family members, remained in the Ono-Biot family until they were presented to the Musée Thomas Henry in 1915.
3. [Robert L. Herbert], *Jean-François Millet* (Paris: Editions des Musées Nationaux, Grand Palais exhibition catalogue, 1975), p. 34.

Provenance
Pierre Millet (the artist's brother), Boston, sold 1893.

Exhibition History
Schaeffer Galleries, New York, "Self-Portraits," 1940, no. 30.
Museum of Fine Arts, Boston, "Portraits through Forty-Five Centuries," 1941, no. 141.
Cleveland Museum of Art, "Style, Truth and the Portrait," 1963, no. 79.

References
Hurll, Estelle M. *Jean-François Millet.* Boston: Houghton Mifflin, 1900, p. 93.
Constable, W.G. "A Portrait by Jean François Millet of His First Wife." Boston: Museum of Fine Arts *Bulletin* 43 (1945), no. 251, p. 4, fig. 3.
Edgell, George Harold. *French Painters in the Museum of Fine Arts: Corot to Utrillo.* Boston: Museum of Fine Arts, 1949, illus. p. 18.
Lepoittevin, Lucien. *Jean-François Millet, I, Portraitiste.* Paris: Leone Laget, 1971, no. 37.
[Herbert, Robert L.] *Jean-François Millet.* Paris: Editions des Musées Nationaux, Grand Palais exhibition catalogue, 1975, p. 34.

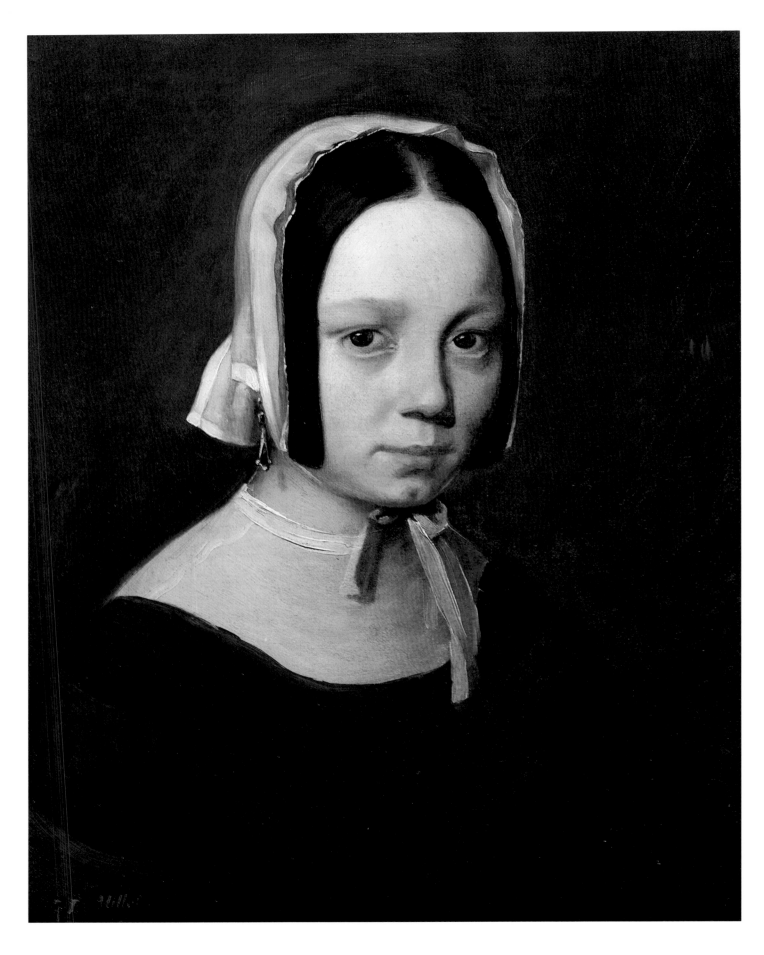

2
Madame J.-F. Millet (Pauline-Virginie Ono)
1841
Oil on canvas
41.8 x 32.3 cm. (16½ x 12¾ in.)
Upper right: J. F. M.
Stamped, lower left: J. F. Millet[1]
Tompkins Collection. Arthur Gordon
Tompkins Fund, 1944.
44.73

Pauline-Virginie Ono (1821-1844), the daughter of a Cherbourg tailor, became Millet's first wife in November of 1841. This early portrait is the first of several paintings of Pauline, her brother, and other family members[2] that trace Millet's labored, but ultimately brilliant progress in a period of only two or three years, toward major, albeit often unrecognized, stature among nineteenth-century portraitists.

During his years of Paris study, Millet had spent part of every spring and summer in Gruchy and Cherbourg; when he finally broke with his Parisian master, Paul Delaroche, during the winter of 1840-1841, Millet returned to Cherbourg, hoping to establish himself as a portrait painter there. He was quickly recognized with the commission for a posthumous portrayal of the recently deceased mayor, but this promising official recognition soon evolved into a bitter quarrel between Millet and the city councillors, who refused the finished portrait, finding it quite unlike the subject (whom Millet had never known).[3] Although the affair left Millet angry and cost him much favor among his older Cherbourg supporters, Alfred Sensier claims it made him a hero of sorts among younger citizens, and brought him a number of portrait commissions from living sitters, including Pauline Ono.[4]

The simplicity of the bust-length, three-quarter pose echoes Millet's *Self-Portrait* (cat. no. 1), but Pauline's restrained costume (a shawl that once covered her arms was painted out by the artist) and modest cap provide a regular contour and light surround for the face that emphasize her direct gaze with an assurance lacking in the artist's own image. To offset the solemnity of the pose, Millet added strong painterly accents in the edging, hem, and ribbons of the cap. In Millet's later portraits of Pauline, who died in 1844 of consumption, she is more fashionably dressed and, in the brilliantly colored and broadly painted half-length in the Musée Thomas Henry, even provocative. Yet it is in this early, straightforward version that Millet attained the combination of provincial simplicity and Parisian artistry that make the best of his Cherbourg portraits so powerful.

It is tempting to see in this discreet, charming portrait, which belonged to Millet and remained in his family's possession until the death of his second wife in 1894, the occasion of his first acquaintance with Pauline Ono, but the likelihood that a young, unmarried woman of Pauline's modest means might have commissioned her own portrait in 1840s Cherbourg is not great. It is more probable that Millet was introduced to Pauline through her brother, Armand Ono, who was Millet's own age and by family records was represented in a Millet portrait of 1840-1841.[5] The Boston portrait was undoubtedly painted at the artist's own request, and must have represented the seriousness of his intentions toward the young woman.

Notes

1. In France, works left in an artist's studio at the time of his death were customarily stamped with a facsimile of his signature or other specially created seal to establish their authenticity. Several of Boston's Millet paintings bear the red signature stamp used on works sold posthumously from the studio in 1875, while most of the drawings carry one of several initial stamps, J. F. M, that were created for the drawings. In Millet's case, a second set of stamps for paintings and drawings was created at the time another group of works were sold following the death of his widow in 1894. Signed paintings such as this would not normally require a stamp, but the dark signature may have gone unnoticed beneath discolored varnish in 1894.

2. Given in 1915 by the Ono-Biot family to the Musée Thomas Henry, Cherbourg.

3. *Colonel Javian* is now in the Musée Thomas Henry, Cherbourg. See Etienne Moreau-Nélaton, *Millet raconté par lui-même* (Paris: Henri Laurens, 1921), vol. 1, pp. 33-43, for a discussion of the affair and Millet's correspondence with the councillors.

4. Alfred Sensier and Paul Mantz, *La Vie et l'oeuvre de J.-F. Millet* (Paris: A. Quantin, 1881), p. 76.

5. Musée Thomas Henry, Cherbourg. Robert Herbert is unpersuaded by the sitter's identification (*Jean-François Millet* [Paris: Editions des Musées Nationaux, Grand Palais exhibition catalogue], 1975), p. 37.

Provenance

Jean-François Millet; Madame J.-F. Millet (sold Hôtel Drouot, Paris, April 24-25, 1894, no. 2), bought by Savary; Edgar Degas (sold Galerie Georges Petit, Paris, March 26-27, 1918, no. 82), bought by Max Moos, Geneva (until 1944); with Niveau Gallery, New York.

References

Constable, W. G. "A Portrait by Jean François Millet of His First Wife." Boston: Museum of Fine Arts *Bulletin* 43 (1945), no. 251, pp. 2-4, illus. p. 1.

Edgell, George Harold. *French Painters in the Museum of Fine Arts: Corot to Utrillo*. Boston: Museum of Fine Arts, 1949, p. 19, illus. p. 18.

Lepoittevin, Lucien. *Jean-François Millet, I, Portraitiste*. Paris: Léonce Laget, 1971, no. 52, illus.

Huyghe, René. *La Relève de l'Imaginaire*. Paris: Flammarion, 1976, illus. no. 365, p. 345.

[Herbert, Robert L.] *Jean-François Millet*. Paris: Editions des Musées Nationaux, Grand Palais exhibition catalogue, 1975, p. 35.

3
Three Travelers (Travelers on the Road to Emmaus)
About 1838-1840
Black chalk on blue paper
45.0 x 65.4 cm. (17¾ x 25¾ in.)
Recto: *Training Grape Vines* (cat. no. 86)
Gift of Quincy Adams Shaw through
Quincy A. Shaw, Jr., and Mrs. Marian
Shaw Haughton, 1917
17.1528

As the tattered, brittle edges recount, Millet kept this large drawing with him for more than twenty years before tacking it down to use the other side for a pastel, *Training Grape Vines*, sometime in the 1860s. The scale of the figures who dominate this page so fully, their carefully worked out relationships in space and movement, and the considerable care in their execution argue that this was a preliminary work for a painting of substantial ambition. Very few of Millet's earliest pictures survive, and this drawing must have been especially important to have been preserved so long by an artist who routinely reused his papers and canvases, as well as whatever scraps fell to hand when he wanted to record an idea.[1]

Millet made many pictures of weary travelers on featureless roads or deserts early in his career. In the smaller pictures intended for private collectors, the figures were usually anonymous and timelessly clothed, without a specific story, but for pictures of major importance – either for the Salon or government commission – he sought a biblical source.[2] Christ's journey to Emmaus following his Resurrection, unrecognized by his two disciples, would have provided an ideal conjunction of significant, historical subject matter (as expected by the Parisian art audience) with deeply felt, personal experience for a young artist, whose journey had only recently begun with his 225-mile-walk from Gréville to Paris.

Precisely dating this drawing must depend on conjecture, for the style and scale are without direct precedent in Millet's work as it survives today. The use of figures drawn first as nudes, then clothed, suggests the period in Delaroche's Ecole des Beaux-Arts studio, where drawing from the nude was a major step in creating a composition, or in the years thereafter when he frequented the independent Studio Suisse to continue nude studies. And the problems in drawing – the unconvincing foreshortening of the central figure's right arm, the confusion where the right-hand traveler's head overlays the central figure's shoulder – also argue for a date during Millet's student years in Paris, between 1838 and 1840. Such a date is supported by the figure type – elongated, slender, sharply angled – which is characteristic of Millet before the period of his *manière fleurie* (see cat. no. 5), although he returned to a softened, more fluid version of these mannered figures in the late 1840s.

Notes
1. *Oedipus Taken Down from the Tree* (National Gallery, Ottawa) of 1847 is painted over a fragment of the *Saint Jerome* refused by the Salon the preceding year; even a painting as late as the *Young Shepherdess* (cat. no. 141) of 1870 is reputed to be painted over an earlier work. Millet's drawings are found on papers of exceptional quality, as well as on the backs of inexpensive popular prints, *images d'Epinal,* and official documents; and two images on one sheet are often separated by many years.
2. See, for example, *Wanderers* (Denver Art Museum) or *Hagar and Ishmael* (Rijksmuseum Mesdag, The Hague).

Provenance
Alfred Sensier (sold Hôtel Drouot, Paris, December 10-18, 1877, no. 201), bought by Legrand, probably for Quincy Adams Shaw, Boston.

Related Works
Compositional sketch of shepherd giving directions to travelers, black crayon on rose-gray paper, 20.2 x 27.0 cm., Cabinet des Dessins, Musée du Louvre, Paris (GM 10308).
Shepherd Giving Directions to Travelers, black conté crayon on gray paper, 22.3 x 28.8 cm., British Museum, London.

These two drawings seem to mediate between Boston's early drawing and the pastel *Shepherd Directing Travelers* (Corcoran Gallery of Art, Washington, D. C.) of 1857. As Herbert suggests, Millet may well have alluded to himself (and perhaps Jacque, the two artists known to have walked to Barbizon in 1849) in the figures of travelers asking directions of a shepherd on the Chailly plain (*Jean-François Millet* [Paris: Editions des Musées Nationaux, Grand Palais exhibition catalogue, 1975], p. 94). The Louvre drawing, much earlier than the Corcoran pastel, continues the use of a bearded traveler, as in the Boston drawing, and the figures are similarly clothed in both pictures.

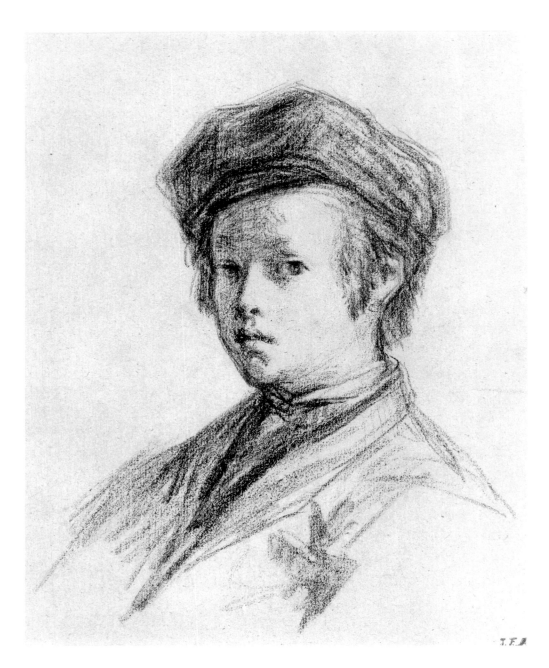

4
Portrait of a Young Boy
About 1848
Black conté crayon on paper
26.8 x 21.3 cm. (10½ x 8⅜ in.)
Stamped, lower right: J. F. M
Gift of Mrs. J. Templeman Coolidge, 1946
46.595

This portrait, which captures the distrustful gaze of its young sitter so sensitively, belongs to the period of portrait drawings that brackets Millet's move to Barbizon in 1849. It appears to be a preliminary life study for a larger, more highly finished portrait of the same child now in the Fogg Art Museum. Although Millet had begun his professional career in Cherbourg as a portrait painter, he gave up portraiture when he returned to Paris in 1845, probably because of the considerable social difficulties facing a young artist from a provincial background. As his known portraits of the late 1840s all represent members of his immediate circle (see cat. no. 12), it is very likely that this drawing depicts the child of a close acquaintance, rather than a formal commission.

Millet's growing facility with his crayon medium, where false lines cannot readily be erased, is evident in the distinction between the studied touch used for the face and the broad, vague lines that establish the child's costume. But he was still working within a refined, learned style, not yet exploiting his greasy medium for the variety of strokes and touches that mark later works with his distinctive individuality.

The studies on the verso, which are by style two or three years earlier, demonstrate Millet's technical accomplishment more impressively: the startling *mise en page*, with a woman's hand and wrist coming forward from the shoulder of another figure, and the generally softer technique accented by a few bold touches stabbed on to establish the child's cowlick, reflect a confident artist enjoying the exercise of preparatory designs. The stylized sexual ambiguity of the figure and the graceful droop of the hand are characteristic of Millet's many renderings of Daphnis and Chloe or nymphs bathing in the forest during the years 1845-1846, and the drawing may have been used, with a shift in the position of the figure, for the *Offering to Pan* (Musée Fabre, Montpellier).

Provenance
Studio of the artist; Mrs. J. Templeman Coolidge, Boston.

Related Works
Cat. no. 4:
Portrait of a Young Boy, black conté crayon with white highlights on paper, 18⅛ x 11⅝ in., Fogg Art Museum, Harvard University, Cambridge.
Cat. no. 5:
Offering to Pan, oil on canvas, 40½ x 11½ in., Musée Fabre, Montpellier.

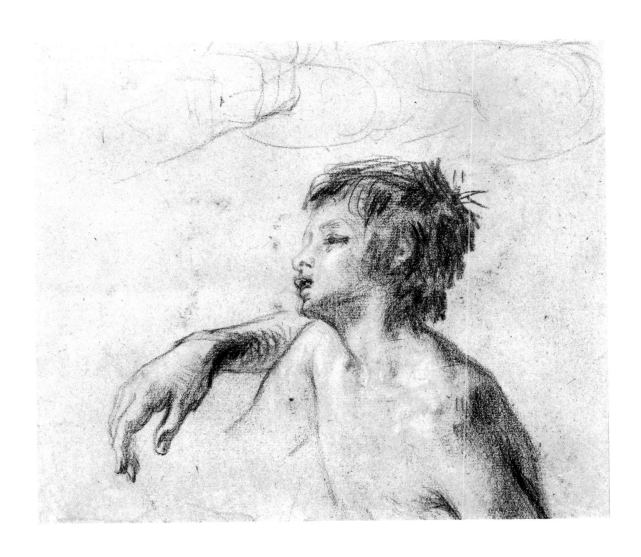

5
Studies of the head and shoulders of a boy
and of a hand
About 1845-1846
Black conté crayon, heightened with white
conté crayon on paper
[verso of cat. no. 4]

6
Woman Reclining in a Landscape
About 1846-1847
Oil on canvas
18.8 x 33.2 cm. (7⅜ x 13⅛ in.)
Lower left: J. F. Millet
Gift of Quincy Adams Shaw through
Quincy A. Shaw, Jr., and Mrs. Marian
Shaw Haughton, 1917
17.1481

In the often desperate need that haunted Millet and his young family during the Paris years of 1845-1849, he turned increasingly to small, single-figure pictures. With their modest price and often mildly erotic flavor they stood a better chance of attracting a purchaser than the larger, more complex works he was submitting to the official Salon exhibitions; more important, they served as finished studies in which he continued to acquire the skills of his trade. Such a picture is the *Woman Reclining in a Landscape*, whose humble ambitions are expressed with a painterly suppleness and naturalistic color scheme that date it to about 1847.

In addition to the portraits that Millet had painted in Cherbourg and Le Havre during 1844-1845, he had had some success with small multifigured genre scenes that were closely dependent upon the work of the eighteenth-century French painters Watteau and Fragonard, as well as with slightly larger works that combined more Italianate old master subjects and coloring with a flickering technique of small, heavy paint touches. His first biographer, Alfred Sensier, dubbed this Millet's *manière fleurie*, or florid style, for both the ruddy orange coloring and the complex buildup of the paint surface that characterize it.

Millet had acquired his taste for such subjects and his high-keyed palette earlier in Paris, where a new market of small collectors had helped launch a broad revival of interest in the pretty, light, and wholly imaginative subject matter that had characterized French painting before the Revolution brought the call for a more serious art. In Cherbourg and Le Havre, Millet seems to have found a ready market for these pictures, as he was able to accumulate some 900 francs to fund his return to Paris at the end of 1845.

Back in Paris, Millet continued in this manner, developing a more original repertoire of idealized rural imagery and mythological subject matter that he explored both in oil and in pastel, but he faced greater competition in the capital and commercial success remained elusive. By 1846, he had begun to look for both a more salable subject matter and for images that would be more satisfying to his artistic ambitions. To replace the invented child-like figures of his earlier work, he began to paint adult female figures, more closely observed and more naturalistically rendered. Pictures such as the *Woman Reclining* (or slightly later, *Peasant Girl Day-Dreaming*, cat. no. 9) have the air of studies from the clothed model

for which a simple landscape surround has been created. Forced to re-create what he had actually seen, Millet had to find a more adaptable, descriptive style of brushwork than the heavily laden, albeit very beautiful, almost abstract touches of color that he had utilized in the past. His brushstrokes became longer, more fluid, echoing the forms they defined. Only with greater painterly draftsmanship at his command would he return to the heavy, multilayering that appealed so much to his sensual enjoyment of paint.

Provenance
Quincy Adams Shaw, Boston.

Exhibition History
Museum of Fine Arts, Boston, "Quincy Adams Shaw Collection," 1918, no. 23.

7
Two Bathers Climbing from a Pool
About 1846-1848
Black conté crayon on paper
15.5 x 11.9 cm. (6⅛ x 4¾ in.)
Gift of Walter Gay, 1927
27.510

Two Bathers is a compositional sketch, a drawing in which Millet explored possibilities of pose and setting before undertaking a larger, final work. In this instance, the pose, with both bathers stretched along the bank and seen from behind, was later abandoned for a more compact pair of figures facing each other, as the higher bather supports the figure crawling from the pool. In the final image, a small oil painting (Musée du Louvre, Paris), Millet further altered his first idea, using a man and woman rather than two female bathers.

When Millet took up a new idea for a painting or drawing, his method of working began with small, rapid drawings, usually more schematic than this, noting many variations of an activity or image. As he began to focus on a specific image, he might make numerous compositional sketches, increasingly refining the specific pose on which he had settled until he was ready to begin a second series of drawings, more careful studies of individual figures. Such a thorough, step-by-step procedure was the most valuable remnant of Millet's official training at the Ecole des Beaux-Arts, and it marked him in later years as an anomaly among the group of Barbizon artists with whom he was associated, most of whom were self-taught and favored a more direct compositional method that relied heavily on painting skills rather than on drawing to unify a work of art.

Provenance
Walter Gay, Boston.

Related Works
Two Bathers Climbing from a Pool, cat. no. 7.

Two Bathers, oil on panel, 28.0 x 19.0 cm., Musée du Louvre, Paris.

Bathers, pastel on paper, 43.0 x 33.0 cm., Musée du Lille. The composition falls between the Boston and Paris works, with two female bathers posed as in the Paris painting, in a landscape dependent upon the Boston drawing. Both the pastel treatment and the style of the figures, however, suggest a later date, perhaps in the 1860s; however, the pastel's authenticity has been questioned ([Robert Herbert], *Jean-François Millet* [Paris: Editions des Musées Nationaux, 1975, Grand Palais exhibition catalogue], p. 60). As the invention of the Lille pastel is unarguably Millet's own, it may reflect a lost drawing intermediate to the two works above or the Lille image itself may be an early drawing, now significantly altered.

Woman Seated against a Tree is the only known compositional sketch for an especially successful painting by Millet, *The Abandoned One* (Paine Art Center, Oshkosh), better known by its French title, *La Delaissée*. The subject is one that Millet painted frequently (see *Peasant Girl Day-Dreaming*, cat. no. 9, or *Shepherdess Sitting at the Edge of the Forest*, cat. no. 13) – a young woman pausing along a forest road to ponder a situation or sadness unknowable to the viewer – but it is in the Oshkosh painting that Millet achieved his most effective rendering of the theme.

The Boston drawing broadly defines the final composition for Millet's painting, but between the two images the artist made a number of important changes. The young woman in the drawing wears an undefined dress that emphasizes her breasts and gives the appearance of bare arms, suggesting, with her lethargic pose, a sexuality that may be the root of her sorrow. In the painting, she is clothed in contemporary peasant dress, modestly buttoned to the neck, and wearing a household worker's apron. When added to the bonnet that covers her hair and her tensely upright pose, the changes present an image of innocence, as well as deeply felt sadness. While these are alterations that affect the mood of the painting, the last change – the decision to eliminate much of the upper height of the forest, increasing the scale and significance of the figure in the setting – is a strictly artistic one. Their cumulative effect moved Millet's work toward a more naturalistic rendering of his theme.

Provenance
Studio of the artist; Olive Simes, Boston.

Related Works
Woman Seated against a Tree, cat. no. 8.
Study for the woman's feet, crayon on paper, 12.4 x 16.1 cm. (London art market in the 1960s, current location unknown).
La Delaissée, oil on canvas, 35.5 x 26.5 cm., Paine Art Center, Oshkosh.

References
The Barbizon Heritage. Oshkosh: Paine Art Center (exhibition catalogue), 1970, illus.
[Herbert, Robert L.] *Jean-François Millet*. Paris: Editions des Musées Nationaux, Grand Palais exhibition catalogue, 1975, p. 71.

8
Woman Seated against a Tree
(study for *The Abandoned One*)
About 1849-1850
Black conté crayon on paper
21.0 x 12.6 cm. (8¼ x 5 in.)
Stamped, lower right: J. F. M
Gift of Miss Olive Simes, 1945
45.685

14

9
Peasant Girl Day-Dreaming
1848
Oil on panel
22.5 x 16.5 cm. (8⅞ x 6½ in.)
Lower left: J. F. Millet
Gift of Quincy Adams Shaw through Quincy A. Shaw, Jr., and Mrs. Marian Shaw Haughton, 1917.
17.1483

Alfred Sensier recorded that Millet painted *Peasant Girl Day-Dreaming* in 1848 following a frightening bout with rheumatic fever. Although the picture was offered at a price of only thirty francs, no Paris dealer would take it and eventually it was purchased by a friend of the artist (possibly Sensier himself).[1] Millet's financial state was disastrous in 1848; with his ill health and the general chaos in Paris surrounding the revolution, his situation could only be described as desperate. It is no wonder that one of his first efforts to put the bright colors and light imagery of his Rococo-revival phase behind him, in a search for more serious subject matter, should be an image of loneliness and dejection.

The young woman's distaff and the spindle dangling from her fingertips identify Millet's subject as a shepherdess, for even more than sheep in eighteenth- and nineteenth-century French painting it is the implements of spinning that make a shepherdess. While her loose-fitting, bright-colored clothing is still some distance from the heavy, well-washed garments of the peasants among whom Millet himself had grown up, she has come several steps closer to reality than her predecessors in Millet's work, who wore impossibly laced, low-cut corselets inherited from the invented peasant garb of Boucher and other eighteenth-century artists.

But at the same moment that Millet began reaching for a more realistic, original framework for his paintings, he reiterated the importance that he attached to traditional subject matter by casting his shepherdess in the classic pose of the allegorical female figure of unhappiness and lost purpose. With her work abandoned in her lap, her head propped on one hand, and her gaze directed blankly beyond the picture, the young woman is a nineteenth-century version of sixteenth-century images of Melancholia.[2]

With the subdued, naturalistic coloring of the setting and the soft, fluid brushwork, Millet established an important shift in his technique that would prove as fundamental as the new seriousness of his themes.

Notes

1. Alfred Sensier and Paul Mantz, *La Vie et l'oeuvre de J.-F. Millet* (Paris: A. Quantin, 1881), p. 104.

2. For a probable source for Millet's painting, see Cornelis Bloemaert's engraving after *Melancholia* or *Terra* by Abraham Bloemaert.

Provenance

Baron E. de Beurnonville (sold Hôtel Drouot, Paris, April 29, 1880, no. 42); Quincy Adams Shaw, Boston.

Exhibition History

Museum of Fine Arts, Boston, "Quincy Adams Shaw Collection," 1918, no. 24.

References

Sensier, Alfred, and Mantz, Paul. *La Vie et l'oeuvre de J.-F. Millet*. Paris: A. Quantin, 1881, pp. 104-105.

Cartwright, Julia M. *Jean-François Millet, his Life and Letters*. London: Swan Sonnenschein & Co., 1896, p. 82.

Moreau-Nélaton, Etienne. *Millet raconté par lui-même*. Paris: Henri Laurens, 1921, vol. 1, p. 67, fig. 41.

10
Seated Nude (Les Regrets)[1]
About 1847-1848
Oil on panel
25.2 x 18.4 cm. (9⅞ x 7¼ in.)
Lower right: J F Millet
Henry C. and Martha B. Angell Collection. Gift of Martha B. Angell, 1916
19.97

As Millet struggled to move beyond the limitations of his *manière fleurie* – a charming balance of bright color and imaginary figures, but a style that could not sustain the major subject matter and ambitious scale to which he aspired – he made repeated recourse to the two great masters he most admired, Michelangelo and Poussin. This superb nude is a copy, in reverse and with the arms changed, of a figure in Michelangelo's Deluge scene from the Sistine Chapel ceiling, which Millet could only have known from a reproduction.[2]

In the works of Poussin and Michelangelo, which he studied at the Louvre, or from prints, Millet found both inspiration for his own compositions and the challenge that sustained his commitment to his own art. Copying old master works had been a prominent part of his training in Cherbourg and later in Delaroche's studio, but these early student copies were of entire paintings and had benefited him primarily as aids to picture composition and patterns of coloring. During the late 1840s, his copying was much more specific and directed at comprehending the human figure as the essential three-dimensional form. His formal training had been adequate for portraiture and picture-making as he had practiced it in Cherbourg, but to achieve major, convincing works of realistic complexity, he came to realize that he would have to arm himself with greater skill at rendering the human body.

Even without the knowledge of Millet's precise source for this painting, his debt to Michelangelo would be apparent in the powerful, muscular form of the female figure, so solidly rendered. Works such as the *Woman Reclining* (cat. no. 6) or *Peasant Girl Day-Dreaming* (cat. no. 9) might have been posed by Millet's wife, but it is highly doubtful that she would have sat for a serious study of the nude figure. Without the benefit of models or studio instruction, limited as he was by meager resources and family responsibility, Millet must have found the origin for most of his nude paintings in great works of the past.

That Millet still needed the tutelage of a greater master is evident in the uncertain passage of the woman's upraised right arm, which he had to invent to adapt Michelangelo's model to the vaguely sylvan setting. Millet himself understood the role that nude figures played in his art at this time, commenting on the large painting he submitted to the Salon of 1847, *Oedipus Taken Down from the Tree* (National Gallery, Ottawa), featuring a naked child and a partially clothed man and woman: "It was just a pretext to practice the nude and luminous modeling, a small thing like journeymen used to make to establish their mastery."[3]

Notes
1. Although the painting has borne the title *Les Regrets* for almost 100 years, it is doubtful that Millet himself sought such a moralistic justification for his nude studies.
2. Robert L. Herbert, "Millet Reconsidered," *Museum Studies* (Art Institute of Chicago) 1 (1966), p. 56.
3. Quoted in Alfred Sensier and Paul Mantz, *La Vie et l'oeuvre de J.-F. Millet* (Paris: A. Quantin, 1881), p. 95. Many of the nineteenth-century writers who sought to enshrine Millet as a painter of moral and uplifting subject matter were unable to relate his many nudes to his art, and often went so far as to deny them. It is common in Millet literature to find the explanation that he was embarrassed by these works and that he undertook them only to put bread on the family table.

Provenance
Alfred Sensier, Paris; with Durand-Ruel, Paris; acquired in Paris by J. Foxcroft Cole, Boston, for Henry C. Angell, Boston (1875).

Exhibition History
Copley Society, Boston, "The French School of 1830," 1908, no. 18.
Museum of Fine Arts, Boston, "Opening Exhibition, Evans Memorial Galleries," 1915.
Wadsworth Atheneum, Hartford, "The Nude in Art," 1946, no. 37.
Busch-Reisinger Museum, Harvard University, Cambridge, "William Babcock," 1954.
Wildenstein & Co., London, "J.-F. Millet," 1969, no. 11.

Related Works
Female nude, seen from the back, black chalk on paper, 27.0 x 19.8 cm., Art Institute of Chicago (1952.61). The heavy black outline of the figure corresponds so perfectly to the Boston painting that the drawing must have been transferred by incising or rubbing.
Seated Nude (Les Regrets), cat. no. 10.
Nymph and Cupid, oil on panel, 13¼ x 7⅜ in., current location unknown (sold William Buchanan, American Art Association, New York, April 18, 1912, no. 18, illus.). From a reproduction, the work appears to be by another hand, probably based on the drawing now in Chicago, available by the early 1900s through reproductions of Henri Rouart's collection.

References
Angell, Henry C. *Records of William M. Hunt*. Boston: James R. Osgood, 1881, pp. 14-15.
Moreau-Nélaton, Etienne. *Millet raconté par lui-même*. Paris: Henri Laurens, 1921, vol. 1, p. 57, fig. 34.
Gsell, P. *Millet*. Paris, 1928, fig. 34.
Herbert, Robert L. "Millet Reconsidered." *Museum Studies* (Art Institute of Chicago) 1 (1966), p. 56.

11
Two Reclining Figures
About 1848
Oil on canvas, 72.8 x 100.2 cm. (28⅝ x 39½
in.)
Gift of Quincy Adams Shaw through
Quincy A. Shaw, Jr., and Mrs. Marian
Shaw Haughton, 1917
17.1482

From the seated woman on the left, this unfinished painting can be dated to the years around 1848, when the figure style of Michelangelo and the technique of a contemporary French painter, Thomas Couture, had a strong influence on Millet's work. As the picture exists today, it reflects at least two separate campaigns of painting: the seated woman and the partially visible figure at her feet were the first composition to take form on this canvas; the young man represents a process of additions and overpainting that were undertaken later by Millet and possibly by other hands, to bring the unfinished picture to a more acceptable degree of completion.[1]

Too little of the original picture remains to identify the subject, but the painting must represent an abandoned work of some importance for the artist, perhaps even a first attempt at a major Salon entry for 1848. Millet made a clear distinction between small paintings intended for private collectors and large ambitious works with which he hoped to make his name at the Salon exhibitions or through government commissions; although this picture is hardly large by the standard of the grand *machines* that dominated Salon gallery walls, it would have been a major work in Millet's *oeuvre*.[2]

Because of the probable date of this canvas, efforts to identify it have centered on the question of whether it might represent either a first composition for the *Captivity of the Jews in Babylon*, which Millet exhibited in 1848 (and had been lost until its recent rediscovery beneath the *Young Shepherdess*; see cat. no. 141), or a related theme, set aside when he took up that composition. Millet often sought themes for major works in biblical stories, and Old Testament images of abandonment and tragic wandering were important to him in the years around 1848. For a government commission in 1848, he proposed a large painting of Hagar and Ishmael in the desert, and the remnants of the first stage of this painting – a rather melancholy woman in a barren, nondescript landscape – suggest that the picture was originally an image in that same vein. Since the *Captivity of the Jews* was the most complex work Millet had yet exhibited – a multifigured composition depicting captive Jewish women refusing the commands of their Roman captors to sing – and as the description left us by Alfred Sensier is not inconsistent with the image remaining on this canvas, it is quite possible that Millet attempted the Salon painting in this format before enlarging it.[3]

The central figure of the composition, the young woman in the foreground, appears to rest by the edge of a large hole in the ground, perhaps a well. She is painted with the loose, broad strokes of thick, nearly dry paint that Couture recommended to his pupils for quickly laying in a composition. Her face was probably brought to a greater finish at the time the figure of the young man behind her was added, painted in the more fluid style that Millet employed concurrently. X-ray examination suggests a large building or city wall in the background on which the young man is partially superimposed. Taken alone, the female figure might have served as any of a number of biblical heroines; together, the two figures recall Millet's many compositions of young harvesters trysting in the shade of a grain stack. The third figure, huddled at the feet of the seated woman and grimacing in pain, adds a much more ominous note. Subsequently covered with a dog or dogs,[4] she was painted on the same dark, almost black ground that underlies the woman and background elements.

Notes

1. There is some possibility that as many as three campaigns of work are represented on this canvas, none of them ever completed. Because Millet scraped away parts of the earliest picture(s) and also used a ground containing a large concentration of lead white as a base for the addition of the central male figure, x-ray examination cannot resolve the series of images adequately. Given the very uneven balance in which the three figures now exist, as well as the fact that each reflects a different type of Millet's early figure styles, it is possible that after rejecting his original work on this canvas Millet used it not to start another painting but as a kind of sketch sheet testing large-scale figures for other compositions. If Millet did use this canvas on three occasions, the earliest was probably a multifigure composition utilizing the canvas vertically, so that the figure depicted as lying on its side on the lower right might once have been standing or seated, bent at the waist, in a wholly different composition.

2. Seldom did Millet work on a canvas of more than four feet in either dimension, the important exception being several large wall paintings undertaken in 1863, approximately eight feet in height. For an artist striving for recognition within the Parisian art world, this is not large in scale; and when compared with the work of Gustave Courbet, the artist to whom Millet was most often linked in the critical Salon years of the 1850s, his work seems deceptively modest in intention.

3. The painting is described as featuring three women, veiled in black, and their soldier-captors before a towered city wall, with a river flowing through the composition (Alfred Sensier and Paul Mantz, *La Vie et l'oeuvre de J.-F. Millet* [Paris: A. Quantin, 1881], pp. 105-106).

4. The earliest photograph of the painting, datable to the first decade of this century, before the picture entered the Museum collection, justifies the original title, *Two Reclining Figures*, as there is no indication of the third figure. Although the dogs are not legible as such in the photograph, they are remarked upon in an early conservation record in the archives of the Department of Paintings. Subsequent conservation work has aimed at removing areas of paint that could not be attributed to Millet himself.

Provenance

Purchased from the artist by William Morris Hunt, Boston (about 1853); sold through Doll and Richards, Boston, to Quincy Adams Shaw, Boston (1874).

Exhibition History

Museum of Fine Arts, Boston, "Quincy Adams Shaw Collection," 1918, no. 5.

References

Guiffrey, Jean. "Tableaux Français conservés au Musée de Boston et dans quelques collections de cette ville." *Archives de l'Art Français* n. s. 7 (1913), p. 548.

Boime, Albert. *Thomas Couture and the Eclectic Vision*. New Haven: Yale University Press, 1980, p. 433.

12
Madame J.-F. Millet (Catherine Lemaire)
About 1848-1849
Black conté crayon with white highlights
on paper
55.8 x 42.8 cm. (22 x 16⅞ in.)
Lower left: J. F. Millet
Gift of Mrs. Henry Lee Higginson, 1921
21.283

This beautiful crayon portrait of Catherine Lemaire, Millet's companion since shortly after the death of his first wife, Pauline, in 1844, dates to the second period of portrait-making in Millet's career, during the years 1847-1849. Unlike the commissioned portraits executed in oil during his first years as a professional artist, the drawings done at the end of the 1840s all represent close friends of the artist and share an immediacy and intimacy that derive from the intention as well as the technique of their execution.

Unlike the more quickly rendered *Portrait of a Young Boy* (cat. no. 4), which was probably a preliminary study for a portrait, this drawing was carefully carried to completion without sacrificing a sense of spontaneity. Catherine's features were built up from precise, light hatching rubbed to soften the lines into shadow, while slight touches of white crayon or chalk were added on the cheekbone and nose to echo the light that glints off the dense crayon strokes of her hair. Contrasting with the delicacy of individually rendered eyelashes are the loose strands of hair drawn with a ragged, fuzzy line. Summary, heavy crayon strokes that form a folded shawl and move out into a shadow provide a device to hold the viewer's attention on Catherine's delicate face, for a masterfully focused image.

Catherine Lemaire (1827-1894) was a household servant, thirteen years Millet's junior when she met the artist in Cherbourg in 1844, where he had returned following his first wife's death in Paris that year. In 1845 they moved together to Le Havre, possibly to protect his family from knowledge of their liaison, perhaps to seek a larger city in which to ply his trade as a portraitist. Catherine remained with Millet for the rest of his life, bearing nine children in twenty years, in a union first acknowledged by a civil marriage in 1853. Very little is known of her: she is seldom mentioned in the hundreds of letters that provide the basic record of Millet's life and this is the only portrait as such that Millet left of her, although she is represented in numerous genre drawings in the role of peasant mother or housekeeper. Several commentators, citing Catherine's inability to read or write, or her grave expression in the one family photograph that survives, have speculated that the marriage could not have been a happy one for Millet.[1] But in this sensitive depiction of an attractive, gentle woman, already older than her years, and in the many paintings depicting husbands and wives as parallel cultivators of field and hearth, Millet has probably left a stronger record of the nature of his marriage than his modest ways would have admitted to paper.

Notes
1. In particular, see Denys Sutton, "The Truffle Hunter," in *J.-F. Millet* (London: Wildenstein and Co., exhibition catalogue, 1969), p. vi.

Provenance
Possibly H. Atger (Hôtel Drouot, Paris, March 12, 1874, no. 78); with Georges Petit, Paris; possibly Barbédienne (Hôtel Drouot, Paris, April 27, 1885, no. 78); Henry Lee Higginson, Boston; Mrs. Henry Lee Higginson, Boston.

Exhibition History
Phillips Collection, Washington, D.C., "Drawings by J. F. Millet," 1956.
Jewett Arts Center, Wellesley College, "Barbizon Works: Paintings and Drawings," 1967.
Grand Palais, Paris, "Jean-François Millet," 1975, no. 13 (also Hayward Gallery, London, 1976, no. 9).

Related Works
Lithograph reproduction by Yves and Barret.

References
Sensier, Alfred, and Mantz, Paul. *La Vie et l'oeuvre de J.-F. Millet*. Paris: A. Quantin, 1881, illus. p. 83.
Cartwright, Julia M. *Jean-François Millet, his Life and Letters*. New York: MacMillan Company, 1896, pp. 71-72.
Moreau-Nélaton, Etienne. *Millet raconté par lui-même*. Paris: Henri Laurens, 1921, vol. 1, p. 82, fig. 54.
Constable, W. G. "A Portrait by Jean François Millet of His First Wife." Boston: Museum of Fine Arts *Bulletin* 43 (1945), illus. p. 2.
Sutton, Denys. "The Truffle Hunter." *J. F. Millet*. London: Wildenstein and Co., exhibition catalogue, 1969, p. vi, illus. fig. 3.
"Jean-François Millet et ses amis." Tokyo: Yomiuri Shimbun 1970, illus.
Lepoittevin, Lucien. *Jean-François Millet, I, Portraitiste*. Paris: Léonce Laget, 1971, no. 101, illus.
Barbizon au Temps de J.-F. Millet. Barbizon: Municipalité de Barbizon, Salle des Fêtes exhibition catalogue, 1975, illus. p. 65 (from lithograph and wrongly identified as Collection Georges Petit).
Lévêque, Jean-Jacques. *L'Univers de Millet*. Paris: Henri Scrépel, illus. p. 70.
Pollack, Griselda. *Millet*. London: Oresko, 1977, p. 37, no. 14, illus.

13
Shepherdess Sitting at the Edge of the Forest
About 1848-1849
Oil on canvas
32.4 x 24.76 cm. (12¾ x 9¾ in.)
Lower right: J. F. Millet
Gift of Quincy Adams Shaw through
Quincy A. Shaw, Jr., and Mrs. Marian
Shaw Haughton, 1917
17.1484

The *Shepherdess Sitting at the Edge of the Forest* may well have been Millet's sole entry in the Salon of 1849,[1] making the unpretentious image an important landmark in the artist's movement away from the idealized pastoral subjects that had given his earlier paintings the flavor of such eighteenth-century masters as Watteau or Fragonard. In Millet's search for a more realistic subject matter and a more personalized style, the modest ambitions of that small picture must have represented a moment of extraordinary self-doubt.

Following the major and controversial paintings Millet had shown the preceding year,[2] so slight a Salon submission as the *Shepherdess* represented an unusual backing off, especially for a young artist still very much in need of a strong public reputation. For months Millet had planned to be represented by a large painting, *Hagar and Ishmael in the Desert* (Rijksmuseum Mesdag, The Hague), which he had begun as a commission for the new republican government. Shortly before the Salon, however, he abandoned that picture, finishing instead a large painting, *Haymakers Resting* (Louvre, Paris), to fulfill the official command. Even that second painting did not make it into the Salon, apparently withdrawn from the competition by Millet himself.[3]

Instead, Millet presented only a painting no bigger than two hands, as he described it,[4] of ambiguous subject. His figure may well be a shepherdess – she has the customary staff, although no sheep – or she may be a cowherd, or even, as Sensier suggested, simply a *Little Traveler*.[5] But by no means can she be seen as a continuation of the eighteenth-century image of the shepherdess, a charming young girl placed in a forest setting to suggest the innocence of nature and youth concurrently. This peasant girl has paused, with no road behind her, no destination ahead. The forest around her is dark and impenetrable, her pose without useful task makes her appear abandoned, tired, and somber. Millet may not have known where this painting would lead him but, unquestionably, he was announcing that he was not going back to the rococo decorations he had favored for so many years. And indeed, during the month following the opening of the Salon, Millet, with Catherine Lemaire and their three children and fellow artist Charles Jacque, hastily left Paris, settling without previous plan in the small village of Barbizon, on the edge of the Fontainebleau Forest.

Notes
1. Listed in the Salon catalogue as simply *Seated Peasant Woman*, but described by Millet himself some years later as a shepherdess, the Salon painting has been identified with cat. no. 13 by Etienne Moreau-Nélaton (*Millet raconté par lui-même* [Paris: Henri Laurens, 1921], vol. 1, p. 33) and Robert L. Herbert ("Millet Reconsidered," *Museum Studies* 1 [1966]). Documentation for 1849 Salon entries, however, is unusually confused, and it is not clear whether the title and dimensions used to identify no. 2655 – *Repos* (elsewhere *Paysanne Assise*), 31 x 36 cm. – as the Boston painting are correctly paired or whether the dimensions refer to frame or canvas size. For a summary of the problem, see T.J. Clark, *The Absolute Bourgeois/Artists and Politics in France, 1848-1851* (London: Thames and Hudson, 1973), pp. 197-198, n. 11.
2. The Salon of 1848 included Millet's attempt at a serious history picture, *Captivity of the Jews in Babylon* (see cat. no. 141) and the large, much-noticed painting of a winnower straining against the weight and dreariness of his task.
3. Clark, op. cit.
4. "Quelques lettres inédites de J.-F. Millet," *Gazette des Beaux Arts* 3rd ser., 26 (July 1901), p. 77.
5. Alfred Sensier and Paul Mantz, *La Vie et l'oeuvre de J.-F. Millet* (Paris: Quantin, 1881), p. 105.

Provenance
Purchased from the artist by William Morris Hunt, Boston (about 1853), sold through Doll and Richards, Boston, to Quincy Adams Shaw, Boston (1874).

Exhibition History
Probably Salon, Paris, 1849, no. 1490.
Museum of Fine Arts, Boston, "Quincy Adams Shaw Collection," 1918, no. 15.

Related Works
A wood engraving, drawn by Millet and cut by his brother Jean Baptiste, shows the same figure, in an open landscape with sheep.

References
Sensier, Alfred, and Mantz, Paul. *La Vie et l'oeuvre de J.-F. Millet*. Paris: A. Quantin, 1881, p. 114.
Cartwright, Julia M. *Jean-François Millet, his Life and Letters*. London: Swan Sonnenschein & Co., 1896, p. 92.
Knowlton, Helen M. *The Art Life of W. M. Hunt*. Boston: Little, Brown and Company, 1899, p. 98.
Marcel, Henri. "Quelques lettres inédites de J. F. Millet." *Gazette des Beaux Arts* III 26 (July 1901), p. 77.
Guiffrey, Jean. "Tableaux Français conservés au Musée de Boston et dans quelques collections de cette ville." *Archives de l'Art Français* n. s. 7 (1913), p. 548.
Moreau-Nélaton, Etienne. *Millet raconté par lui-même*. Paris: Henri Laurens, 1921, vol. 1, p. 77, fig. 48.
Herbert, Robert L. "Millet Rediscovered." *Museum Studies* (Art Institute of Chicago) 1 (1966), p. 33.

14
Landscape Sketch with Road
About 1848-1850
Black conté crayon on laid paper
12.8 x 12.2 cm. (5 x 4¾ in.)
Stamped, lower right: J. F. M
Gift of Walter Gay, 1927
27.511

15
Forest with Shepherdess and Sheep
1849-1850
Oil on panel
27.3 x 14.9 cm. (10¾ x 5¾ in.)
Lower right: J. F. Millet
Gift of Quincy Adams Shaw through
Quincy A. Shaw, Jr., and Mrs. Marian
Shaw Haughton, 1917
17.1486

The broad, even strokes that define this rapid landscape sketch date the drawing to the years around 1850, and the simple compositional elements – a foreground footpath or roadway, rising ground with a few prominent trees in the central plane, and a distant screen of trees to close the space – are typical of the settings used by Millet in many early rural images set in an unspecified locale.

Millet often walked or rested in the countryside, without a sketchbook, studying intently the figures he encountered or the landscape before him, preferring to record it later, from memory. In the studio, he would fill large pages with many sketches of figures at a wide range of tasks, repeating and overlapping them until a particular composition captured his full attention. As he worked an image up into a painting or a finished drawing, he would have to create a suitable landscape background or interior setting. This small drawing is probably a studio attempt to create such a setting, rather than the record of a specific site. Only later, on return trips to Gruchy, when he wished to make a careful record of a particular landmark (cat. no. 48), or in Vichy, when he drew rapid, annotated pencil studies (cat. no. 119), did Millet draw landscapes directly from nature.

Provenance
Studio of the artist; probably purchased from the artist's family by Walter Gay, Boston.

It took Millet some time to anchor his art firmly in his new life at Barbizon, and he spent much of 1849 and 1850 taking the measure of the landscape before him — the vast and varied terrain of the ancient Forest of Fontainebleau and the flat, open, and intensively cultivated Plain of Chailly — and reworking images begun long before in Paris. He started only a few new paintings in 1849, one of them this small panel depicting a shepherdess watching her sheep graze in the undergrowth along one of the roads that split the forest.

Unlike earlier pictures of shepherdesses in Millet's oeuvre — where an attractive young woman, like as not without flock, was essentially a symbol of abandonment or distress – this painting records an actual scene in the forest. Millet's attention was concentrated on the great height of the closely spaced trees that edge the road sharply, dwarfing the unruly bunch of sheep who chew the undergrowth or wander along the roadside. The shepherdess is simply one more detail of an image culled from Millet's long hours of direct observation in the forest. So insignificant is the figure in this sheeptending scene that for a century she has been described as a shepherd, her identity returned to her only by discovery of a letter from Millet to Alfred Sensier, of November 1849, which records his newest paintings.[1]

The house Millet had rented with its kitchen plot was separated from the forest by a narrow expanse of household gardens and uncultivated wild that provided his first acquaintance with the landscape and characters whom he would make so much his own during the next twenty-five years. Here, after finishing a day's work raising the family's vegetables in the morning and painting during the afternoon, Millet spent the last hours of sunlight studying the juncture of forest and plain, a landscape dramatically different from the rolling, loosely wooded pasturelands he had worked in Normandy. And for a peasant who had known cows and sheep to graze freely in hedge-enclosed family fields, even the shepherdesses, faggot gatherers, and women tending cows who peopled the forest edge proved to be new creatures.

Notes

1. Archives of the Cabinet des Dessins, Musée du Louvre, Paris.

Provenance

Alfred Sensier (sold Hôtel Drouot, December 10-18, 1877, no. 53), bought by A. Legrand probably for Quincy Adams Shaw, Boston.

Exhibition History

Museum of Fine Arts, Boston, "Quincy Adams Shaw Collection," 1918, no. 9.

Related Works

Landscape study, black chalk on paper, Musée Bonnat, Bayonne.

16
Faggot Carriers on the Edge of Fontaine-bleau Forest
About 1850
Black conté crayon on wove paper
23.0 x 35.0 cm. (9 x 13¾ in.)
Stamped, lower left: J. F. M
Verso stamped: VENTE MILLET
Gift of Martin Brimmer, 1876
76.436

In the faggot gatherers that people so many of his scenes of the Chailly plain and the edges of Fontainebleau Forest, Millet found an image that he would steadily refine into a synonym for the monotony and near desperation he saw in man's existence.[1] In a letter contemporary with this drawing, he described his first acquaintance with a scene that would haunt him for more than twenty years:

> You are seated under the trees experiencing all the well-being, all the tranquillity that you can enjoy; then you catch sight, coming down a little footpath, of a poor figure laden with a faggot. The unexpected and always striking way in which this figure appears before you takes you back unwillingly to the unhappy condition of mankind, to the fatigue. It always gives an impression like that La Fontaine expresses in his fable of the woodcutter: 'What pleasure has he had since he was born? Is there a poorer man on this round earth?'[2]

Collecting dead branches from the forest floor for firewood was an occupation traditionally left to the oldest women of a family or, by communal custom, to the most destitute members of a rural community. At the end of the day, the accumulated sticks would be bundled into a large faggot, often far taller than the bearer, who would have to bend double simply to lift her burden from the ground. The faggot gatherers leaving the Bas Bréau area of the Forest, nearest the road to Barbizon, would have been a frequent sight for Millet, who spent the end of his own day, when the light had passed from his studio, walking in the forest or on the plain.

In this early drawing that Millet kept among his studio possessions until his death, it is just that striking moment, as the first of three faggot gatherers breaks out of the forest into a clearing, her two companions still masked by trees behind her, that he chose to record. The viewer's placement is Millet's own, well into the open foreground, away from the forest edge, but Millet assured that the faggot carrier would not be lost in the landscape by setting her on a height that raises her burden above the treeline behind her, and by framing the scene with the prominent trunks of foreground trees. As successful as his composition is, Millet's use of the crayon medium had not yet attained the mastery of light and space that would mark his great drawings of the following decade.

Notes
1. For a masterful reworking of the same theme, see *Faggot Gatherers Returning from the Forest* (cat. no. 57), of about 1854.
2. Letter to Alfred Sensier (February 1, 1851; quoted in Etienne Moreau-Nélaton, *Millet raconté par lui-même* [Paris: Henri Laurens, 1921], vol. 1, p. 91).

Provenance
Millet studio sale (Hôtel Drouot, Paris, May 10-11, 1875, no. 117), bought by Richard Hearn for Martin Brimmer, Boston.

References
Wickenden, Robert J. "Millet's Drawings at the Museum of Fine Arts, Boston." *Print-Collector's Quarterly* 4, part 1 (1914), p. 26.

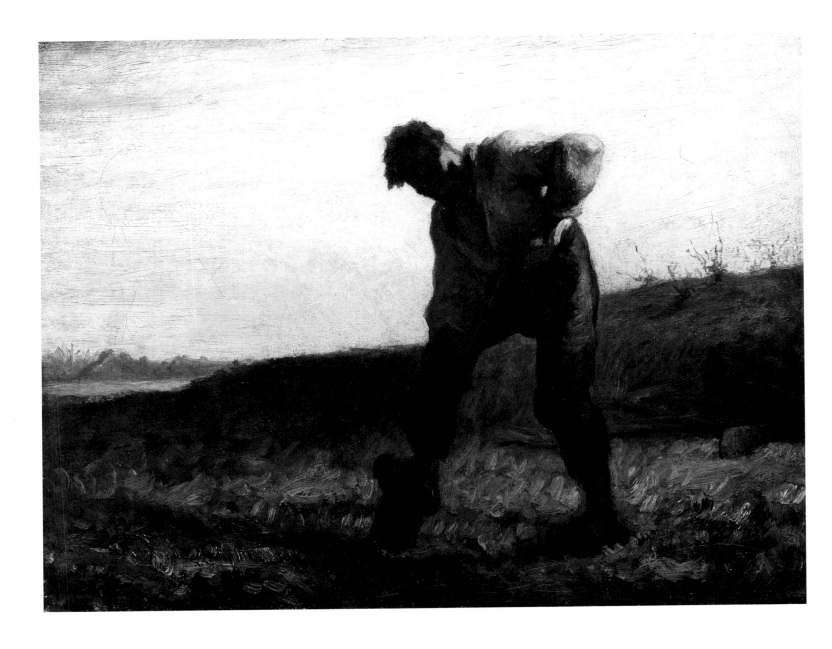

17
Man Turning over the Soil (Le Bêcheur)
About 1847-1850
Oil on canvas
25.0 x 32.5 cm. (9⅞ x 12¾ in.)
Lower right: J. F. Millet
Gift of Quincy Adams Shaw through
Quincy A. Shaw, Jr., and Mrs. Marian
Shaw Haughton, 1917
17.1488

The painting *Man Turning over the Soil* represents the uncertain beginning of an image that occupied Millet for nearly twenty years, through numerous drawings, an unfinished painting, and two distinct print versions, finally culminating in 1866 in the masterful large pastel *Two Men Turning over the Soil*, also in Boston's collection (cat. no. 116). In those twenty years, the image of two men working in tandem to wrest their livelihood from the earth would change very little for Millet, who simply refined and steadily strengthened the basic composition established in this first painting.

In all his versions of this theme, Millet's diggers are engaged in one of the most physically demanding of the peasant's tasks: preparing the harvested fields for the next crop's sowing. Hardened by a season of growing and trampled during the recent harvest, the soil must be turned over and broken up in order to fold under the stubble of vegetation as fertilizer and to make the loosened ground more receptive to sown seed. This is the task, obviously, for which the plow was invented, but small, widely separated peasant plots that would barely sustain a family could not support work animals as well, and only the larger farms on the Chailly plain were plowed.

Robert Herbert dates the conception of this painting to 1847-1848, during Millet's years in Paris, when he began work on a number of drawings of men digging or working the earth with picks.[1] The painting born of those drawings was left unfinished, to be taken up again by Millet only after his move to Barbizon, when financial pressures and his slowness in generating new images forced him back to earlier works. For pictures begun in the period before Barbizon, Millet must have drawn heavily on his own memories of life in Normandy, as well as on drawings of peasants and quarry workers studied on the outskirts of Paris. The man digging in this early version of the theme works in an ill-defined landscape that might be either Normandy or Barbizon (or neither), although the definitive image, reached in the etching of 1855-1856, clearly takes place on the Plain of Chailly (see cat. no. 69).

It is significant that Millet's interest in scenes of backbreaking labor should predate the revolution of 1848, since it is the important role of the urban laborer in that revolution and the strategic support of the peasantry in subsequent disturbances that is so often credited with attracting artistic and social concern to the plight of the hard-pressed rural French. There is no question that the revolution and its vocal aftermath – the raging "Social Question" of the poor – sustained Millet's commitment to his new imagery, but his interests had clearly shifted before the bloody days of July.

The direct relationship between this early painting of a single laborer digging in the field and the large, late pastel *Two Men Turning over Soil* became clear only in 1978, when infrared photography of the painting disclosed a second figure, subsequently painted out by Millet, which corresponds closely to the figure on the left in the pastel. With his companion eliminated, the single figure dominates the somber, placeless landscape as an emblematic image of toil, generalized and simplified, anticipating the much larger *Sower* of the same year.

Notes
1. Robert L. Herbert, in a letter of September 29, 1977, in the files of the Department of Paintings, Museum of Fine Arts, Boston. In addition to several drawings mentioned under Related Works for the late pastel version of this theme (cat. no. 116), two drawings, one of men working with picks (Ashmolean Museum, Oxford) and one with hoes (current location unknown) clearly belong to Millet's transition from his rococo manner, and may even be as early as 1845-1846.

Provenance
Purchased from the artist by William Morris Hunt, Boston (about 1853), sold through Doll and Richards, Boston, to Quincy Adams Shaw, Boston (1874).

Exhibition History
Museum of Fine Arts, Boston, "Quincy Adams Shaw Collection," 1918, no. 20.

Related Works
See complete listing under cat. no. 116.

References
"'Greta's' Boston Letter." *Art Amateur* 5 (September 1881), no. 4, p. 72.
Knowlton, Helen M. *The Art Life of William Morris Hunt*. Boston: Little, Brown and Company, 1899, p. 98.
Guiffrey, Jean. "Tableaux Français conservés au Musée de Boston et dans quelques collections de cette ville." *Archives de l'art Français* n. s. 7 (1913), pp. 547-548.
Additional references listed under cat. no. 116.

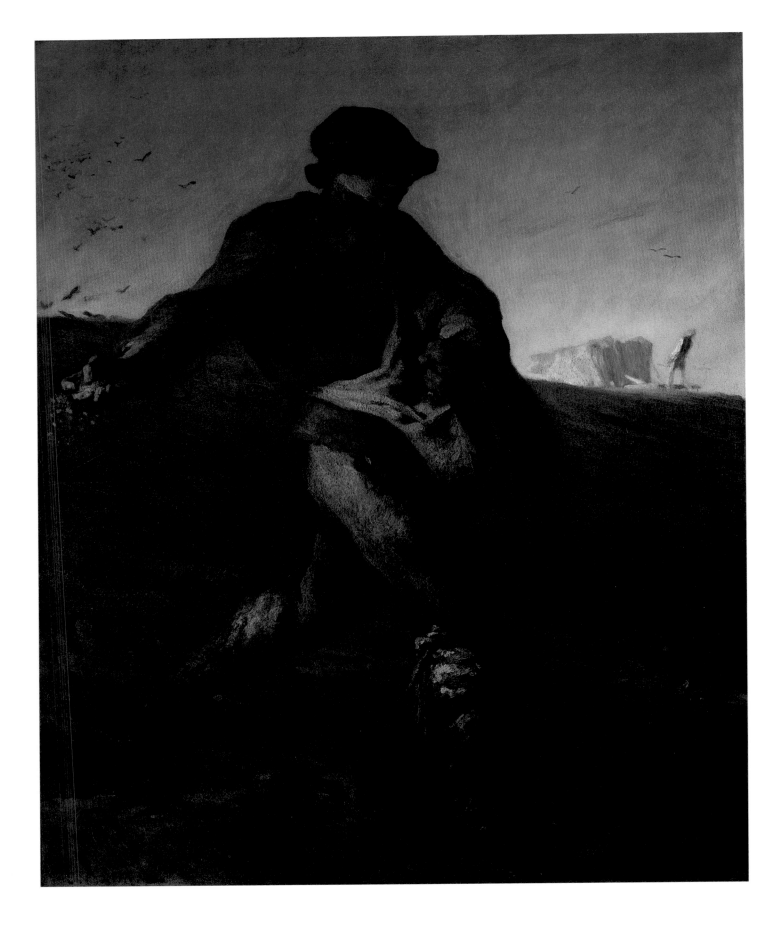

18
The Sower
1850
Oil on canvas
101.6 x 82.6 cm. (40 x 32½ in.)
Lower left: J. F. Millet
Gift of Quincy Adams Shaw through
Quincy A. Shaw, Jr., and Mrs. Marian
Shaw Haughton, 1917.
17.1485

The Sower is Millet's first great masterpiece, the culmination of many years of work toward mastery of his art, as well as an announcement of the new terrain on which he would henceforth launch his talents.[1] At the Salon of 1850-1851, *The Sower* brought him his most significant public recognition to date from critics who read surprisingly contradictory intentions in the painting but nonetheless acknowledged the seriousness of his ambitions and the promise of his skills.[2] As the earliest of the trio of iconic paintings – with *The Gleaners* and *The Angelus* (both Musée du Louvre, Paris) – that symbolizes his *oeuvre* across many different cultures, *The Sower* is a powerful image, readily comprehensible in its specific content, but looming, threatening, and finally irresolvably mysterious.

With a length of cloth tied across his chest and gathered up in his left hand to form a bag for the seed grain, the sower strides across the broken ground of a Norman hillside. Behind him, another farmer rides an ox-drawn harrow as it closes the soil over the sown grain. The sower's legs are wrapped in straw for warmth, and his cap is pulled down over his ears, for the sowing of winter wheat is done in November. The last rays of a setting sun dissolve the harrower and his team in ruddy light and cast the sower's face in dark, almost impenetrable, shadow.

Sowing is the penultimate act of faith in man's battle to earn his daily bread, for potentially edible grain is flung to the winds, in the hope of harvests far beyond the control of the sower. In Catholic France, the sower often began his task by crossing himself, or by forming a cross with a handful of grain flung into the air in two strokes. After reaping, sowing is the most frequently reproduced agricultural activity, and, among countless prototypes, the illustration for October in the *Très Riches Heures* of the Duke of Berry, depicting a similar sower – capped, wearing leggings, and holding his seed bag in his left hand – is often suggested as a source for Millet.[3] But as with so many of his images, *The Sower* is more likely to have evolved from the conflation of several well-studied visual memories.[4]

Millet's earliest version of the sowing theme is a small painting (belonging to his *manière fleurie*) of a child-like figure who sows his seed with his left hand, far above a sweep of shore resembling the view from the heights of Gruchy toward Cherbourg.[5] About 1846-1847, he created a larger composition featuring a small, hunched sower

Fig. 15. *The Sower*, about 1846-1847, oil on canvas, 94 x 60 cm., National Gallery of Wales, Cardiff.

set against a steeply rising hillside capped by two standing oxen (fig. 15). Then, working from the basic compositional elements of that painting, he began the more monumental picture usually identified as the version now in Boston.[6] In this, the definitive image of the series, the sower dominates the entire canvas, rising above the hillside behind him in a purposeful, commanding stride that accommodates the distinctive gestures of sowing to the elegantly powerful physical types of ancient Greek and Roman sculpture.

The Sower is masterfully drawn, with allusions to Michelangelo and Florentine painting, as well as the Apollo Belvedere, in the carefully counterbalanced twists of torso and thighs. The startling evening light conveyed by gray-blues slipping into pale pinks (echoing the stronger blues and reds of the sower) demonstrates Millet's concurrent role as a highly inventive colorist endeavoring to straddle the battle lines so firmly drawn in contemporary painting studios between Ingresque draftsmen and Delacroix-loyal colorists. But for his own art and the history of French painting, *The Sower's* greatest significance is the fundamental break that Millet made in applying these skills to the rendering of a commonplace rural activity. Unlike the numerous small-scale genre scenes of peasants that frequently found a place in the Salon, *The*

Sower makes no apologies for presenting a contemporary French peasant with the dignity and declamatory power of a historical figure.

During the fall of 1850, fellow painter Charles Jacque saw the first version of *The Sower* as Millet worked on it, and informed friends in Paris that it was certain to be a triumph.[7] So it is surprising that Millet should have decided, shortly thereafter (probably late in October or in November of 1850),[8] to set aside the first painting, on which he had been working since 1847,[9] in order to take up a new version. Alfred Sensier explained the undertaking with the comment that Millet was surprised that the first canvas was too short to accommodate the figure adequately, and Etienne Moreau-Nélaton was more specific, noting Millet's concern that the sower's hand came too close to the frame.[10] However, for an artist so careful in drawing, it is difficult to believe that he would not have noticed such a problem before the virtual completion of a painting. For Millet to have undertaken so substantial a revision of a Salon entry, with so little time to bring the second work to the degree of finish of the first, argues that he was not simply correcting a flawed design but attempting more deliberate distinction between quite different conceptions of *The Sower*.[11]

Boston's version of *The Sower* is off-center on the canvas, striding emphatically forward, his right arm flung powerfully back in counterbalance to the paired diagonals of left arm and right thigh. Sunlight, striking from behind, emphasizes the length and direction of these opposed gestures, strengthening the rhythmic quality of the sower's movements. In the second *Sower*, increased picture space was gained by moving the figure toward the center of the painting (the canvases themselves differ by no more than two centimeters[12]), thus sacrificing the powerful momentum of the earlier picture. The second sower is placed slightly lower on the horizon, drawn down into the furrowed field, his head turned into his shoulder, his legs crossed at a shallower angle, and his sowing arm brought forward and down toward his body.

The changes are wholly consistent with one great shift of movement in the painting, all the gestures contributing toward a more circular motion, as if the sower were about to turn on axis to continue back up the hillside. If, as Sensier implied, Millet was virtually finished with his first large *Sower* before he began the second, he

would have been in a position to choose, before the Salon, whether he wanted to stress the emblematic, commanding gesture of the sower or substitute a less strident, but perhaps more realistic, figure. From the reactions of critics who commented on the painting at some length, admiring the powerful grace of the figure but expressing dismay at the unusually heavy impasto – characteristics more readily recognized in the Boston *Sower* – and from Millet's own choice of the Boston image as the model for his lithographic reproduction of the Salon painting, it appears likely that in the end he returned to his original conception (see cat. no. 19).

When *The Sower* was exhibited, it attracted a considerable amount of attention, with at least nineteen critics commenting on it in their reviews.[13] For the most part, reactions were favorable, although the critics differed widely in their understanding of the picture. De Chennevières, an important conservative critic, admired the "beauty, poetry and grace" of the figure,[14] while Clément de Ris praised the picture as "an energetic study full of movement."[15] The thick, heavily worked surface disconcerted most of the critics, and the otherwise favorably impressed Gautier described the technique as "Millet's trowel scrappings."[16] But even more than technique and style, the critics felt compelled to address the image itself: almost to a man, they were struck by "the strangeness and power of the figure,"[17] although after acknowledging the inescapable presence of the sower, they remained uncertain what he represented. Fizelière saw a religious dignity in the figure who stood "Alone, in the middle of bare and newly turned ground, as if he understood the grandeur of his mission,"[18] Sabatier-Ungher saw "the Modern Demos," (the Greek personification of the common man),[19] where Desplaces felt Millet had "vilified the sower."[20] Several critics alluded to other commentators who found the painting socialist or a protest on behalf of the modern proletariat, but these remarks are not recorded in the major press.

Throughout his life, Millet was adamant that he painted without political intention,[21] yet, to paint any large-scale picture of a peasant in 1850 with no thought to the reaction it might entail would have been ingenuous; and as unpolitical as he might have been, he was not naive. His personal road from stock Salon imagery of Saint Jerome and Babylonian captives to *The*

Sower had been too difficult for him *not* to recognize the challenge he was posing his viewers.

The single most important result of the revolution of 1848, one from which Paris was still reeling, had been the enfranchisement of all male citizens, an extraordinarily dramatic change from the substantial property qualifications that had so severely limited suffrage in the past. The prospect of an electorate legitimately demanding retribution for years of excessive taxation or exploitation at the hands of urban lawmakers and landowners was an ever-present fear in the capital.[22] No depiction of a peasant large enough to be noticed in the Salon would pass without some kind of political reaction; and a peasant who moved resolutely across a darkened plain, wearing a red shirt, with his face hidden and unreadable in shadow, was unquestionably a challenging, if not threatening, image.[23]

But in 1850, after more than a decade in Paris, Millet was still rediscovering rural life, trying to reconcile his recollections of the peasant's lot in Normandy during the 1830s with the realities of the Chailly plain in the 1850s. Announcing his new commitment to realistic art, *The Sower* cried not for uprising or defiance – ideas superimposed upon it by later generations – but for simple recognition, for an accommodation of the peasant and his role within the history-defining repertoire of the Salon. With *The Sower*, Millet brought the archetypal peasant from the background of so many paintings to the foreground of a picture of his own, thereby reinstating the three-quarters of the French population who earned their daily bread (as well as the bread of the other quarter) by the sweat of their brows in the main cultural forum of the day. Not since the appearance of the wool carders and the diggers and the reapers on the portals of the great cathedrals of France had the peasant taken his place so prominently among the powers of the nation.

Notes

1. It is also, quite literally, the first Boston Millet, acquired by William Morris Hunt after the Salon of 1850, before he had become a close friend of the artist.

2. Although the Boston *Sower* has been widely reproduced and discussed in the context of the Salon and critical reaction to the exhibited painting, most writers today, following Moreau-Nélaton's 1921 biography of Millet, have accepted

Fig. 16. *The Sower*, 1850, oil on canvas, 101 x 82.7 cm., Yamanashi Prefectural Museum.

the version of *The Sower* belonging to the Yamanashi Prefectural Museum (fig. 16) as the painting shown in the Salon of 1850. But neither of the two versions of *The Sower*, now virtually identical in size, corresponds to no. 2221 in the Salon register (*Un Semeur*, 140 x 110 cm. framed; about 112-120 x 82-90 cm. with a frame of 10 to 14 cm. on a side – not only larger overall but also higher in proportion to width than is the case for either the Boston or the Yamanashi picture). Lacking any evidence, however, for another, lost, version, it is very likely that at least one of the existing pictures was cut down following the Salon. Without definitive documentation, the identity of Millet's 1850 Salon entry must be viewed as an open question.

Perhaps this is the moment at which to raise the traditional histories of the two paintings. From Hunt, who believed he had acquired the Salon version (and in several years of close friendship with Millet had ample opportunity to confirm that belief), onward, commentators familiar with the Boston *Sower* identified it as the Salon picture until the publication of the Moreau-Nélaton biography. During the same period, none of the successive owners of the second version – Sensier, Durand-Ruel, or Cornelius Vanderbilt – named *it* as the Salon picture, and at the Vanderbilt sale in 1945 the Boston picture was specifically cited as the Salon work (Parke-Bernet, New York, April 18-19, 1945, no. 58).

The present writer contends that the evidence to identify the picture in Japan with the Salon painting is insufficient and that, for reasons discussed below and on p. 35, it is very likely that the Boston painting *did* figure in that exhibition.

3. See H. W. Janson and Dora Jane Janson, *History of Art* (New York: Harry N. Abrams, 1962), p. 485. Now the most widely recognized illuminated manuscript, *Les Très Riches Heures* of Jean, Duc de Berry, illustrated by the Limbourg brothers, was

not in France at the time *The Sower* was created and was unknown even to major bibliophiles of the day. However, the Limbourgs' illustrations had spawned a number of derivative manuscripts, and the harrowing figure on the same page does suggest that Millet knew one of these.

4. His earliest interest in the theme was probably awakened by the first old master version he is likely to have encountered: a bent, tattered sower framed against a hillside in the large painting *Autumn* by Jacopo Bassano in Musée Thomas Henry, Cherbourg, opened in 1835.

5. Current location unknown (see Lucien Lepoittevin, *Jean-François Millet, II, L'Ambiguité de l'image* [Paris: Léonce Laget, 1973], fig. 66).

6. We have continued the practice of distinguishing the Boston and Yamanashi *Sowers* as the first and second versions, respectively, as we believe the designations reflect the order in which the compositions were created, although not necessarily the sequence in which they were brought to completion.

7. See Etienne Moreau-Nélaton, *Millet raconté par lui-même* (Paris: Henri Laurens, 1921), vol. 1, p. 86.

8. That Hunt bought his painting not from Millet himself but from a color merchant who was holding it in lieu of payment is an anecdote often mentioned in the literature on both artists but never fully investigated. Pigment and canvas dealers were often framemakers, and it is possible, given the late hour at which Millet began his second version, that he had sent the first version to be framed for the Salon, only to have it precluded from exhibition by a framemaker who demanded payment for purchases outstanding.

9. Alfred Sensier (*La Vie et l'oeuvre de J.-F. Millet* [Paris: A. Quantin, 1881], p. 100) records seeing an *ébauche* (large-scale painted sketch) for *The Sower* in Paris in 1847.

10. Sensier, op. cit., pp. 125-126; Moreau-Nélaton, op. cit., vol. 1, p. 86.

11. T. J. Clark, *The Absolute Bourgeois/Artists and Politics in France, 1848-1851* (London: Thames and Hudson, 1973), pp. 93-94. Clark is the first to carefully consider the significant changes between the two paintings; however, it is not clear that Millet was attempting, as Clark infers, to alter the painting toward an image less threatening to the Salon audience. To that date, none of Millet's works had been criticized for affronts to bourgeois sensibilities, and there is no reason to doubt his genuine surprise when critics of the painting later singled out its brutal character or suggested that it was a revolutionary emblem.

12. Boston: 101.6 x 82.6 cm.; Yamanashi: 101 x 80.7 cm. Both pictures have been relined (affixed to a second, strengthening canvas), obliterating the original tacking margins. The Yamanashi painting was cut down from 106 x 84.5 cm. while in the possession of the Provident National Bank, but whether it had ever been larger still is unrecorded. The Boston painting retains traces of primed, unpainted canvas on its upper and right edges, suggesting that they correspond to the original margins, while the bottom and left edges show no such evidence; thus, had the painting been made smaller before the slight reduction necessary in

relining, those cuts would have to have been limited to two sides. However, the two sides are precisely those that would have provided extra (perhaps considered later to be unnecessary) space around the sower's hand and right foot.

13. Clark, op. cit., p. 94.

14. Paul de Chennevières, *Lettres sur l'art français* (Argentan, 1851).

15. Léon Clément de Ris, salon review in *L'Artiste* (February 1, 1851).

16. Théophile Gautier, salon review in *La Presse* (March 15, 1851).

17. Paul Haussard, salon review in *Le National* (April 1, 1851).

18. Albert de la Fizelière, salon review in *Le Siècle* (April 15, 1851).

19. F. Sabatier-Ungher, salon review in *La Démocratic pacifique*, n.d.

20. Auguste Desplaces, salon review in *L'Union*, January 29, 1851.

21. Sensier, op. cit., p. 130; Moreau-Nélaton, op. cit., vol. 2, pp. 137-138.

22. Maurice Agulhon, *The Republican Experiment/1848-1852*, trans. by Janet Lloyd (Cambridge: Cambridge University Press, 1983), especially pp. 95-104.

23. The bourgeois horror of red was as profound as it was senseless at mid-century. Since the revolution of 1792, the color red has been associated in France with terror, rebellion, and any left-leaning political thought arguing for human rights above property rights. Combined with blue and white, it calls up the tricolor flag of *republican* France (as opposed to the white *royalist* flag), reinforcing in many minds the notion of a deliberate political affront. But red, white, and blue were inescapable in peasant dress, and balancing the three hues satisfactorily is a fundamental artistic lesson. Most important, color schemes arranged around poles of red and blue are an identifying characteristic of French painting from Poussin through Lebrun and Chardin into the nineteenth century. It is their *Frenchness*, not a republican allegiance, that Millet's peasants proclaim.

Provenance

Purchased from the artist by William Morris Hunt, Boston (about 1851-1852), sold through Doll and Richards, Boston, to Quincy Adams Shaw, Boston (1874).

Exhibition History

Salon, Paris, 1850-1851, no. 2221.

Allston Club, Boston, "First Exhibition," 1866, no. 23.

Allston Club, Boston, "Second Annual Exhibition," 1867, no. 89.

Copley Society, Boston, "One Hundred Masterpieces," 1897, no. 63.

Museum of Fine Arts, Boston, "Quincy Adams Shaw Collection," 1918, no. 1.

Portland Art Museum (Oregon), "75 Masterworks," 1967-1968, no. 9.

National Collection of Fine Arts, Washington, D.C., "American Art in the Barbizon Mood," 1975, no. 8.

Grand Palais, Paris, "Jean-François Millet," 1975, no. 55 (Hayward Gallery, London, 1976, no. 36).

Related Works
Sower, oil on canvas, current location unknown (see Lucien Lepoittevin, *Jean-François Millet* [Paris: Léonce Laget, 1973], vol. 2, fig. 66). Early image in Millet's *manière fleurie*.

Sower, oil on canvas, 94 x 60 cm., National Museum of Wales, Cardiff. Composition similar to final version, but figure much smaller in relation to hillside.

Compositional sketch in horizontal format, pencil on paper, 4.9 x 6.6 cm., Cabinet des Dessins, Musée du Louvre, Paris (GM10581).

Compositional sketch in horizontal format, black conté crayon on paper, 36 x 47 cm., current location unknown (see Hôtel Drouot, Paris, February 28, 1936, no. 92).

Compositional sketch, black conté crayon on paper, 18 x 12 cm., current location unknown (Paris art market, 1976).

Compositional sketch, squared for transfer, pencil on paper, 47.5 x 31 cm., current location unknown (Swiss art market in 1975).

Study of outstretched arm, black conté crayon on paper, 9 x 11.9 cm., Cabinet des Dessins, Musée du Louvre, Paris (GM10574).

Sower, cat. no. 18.

Sower, oil on canvas, 101 x 80.7 cm., Yamanashi Prefectural Museum.

Sower, cat. no. 19.

Compositional sketch, cat. no. 76.

Figure study, cut at knees, black conté crayon on paper, 16.7 x 17.0 cm., Cabinet des Dessins, Musée du Louvre, Paris (GM10580).

Finished drawing, pen and ink on paper, 30.0 x 22.0 cm., private collection, Paris.

Compositional sketch (for transfer?), black conté crayon on paper, 104 x 81 cm., current location unknown (see Bernheim sale, Galerie Charpentier, June 7, 1935, no. 11).

Sower, unfinished oil on canvas, 107 x 86 cm., Carnegie Institute, Pittsburgh.

Sower in a vertical Barbizon landscape, pastel and black conté crayon on paper, 45.5 x 35.5 cm., private collection, Pittsburgh.

Sower in a vertical Barbizon landscape, pastel and black conté crayon on paper, 18½ x 14¾ in., Clark Art Institute, Williamstown.

Sower in a horizontal Barbizon landscape, pastel and black conté crayon, 35 x 41 cm., private collection, Japan.

Sower in a horizontal Barbizon landscape, pastel and black conté crayon on paper, 41 x 51 cm., Walters Art Gallery, Baltimore.

References
"'Greta's' Boston Letter." *Art Amateur* 5, no. 4 (September 1881), p. 72.

Sensier, Alfred, and Mantz, Paul. *La Vie et l'oeuvre de J.-F. Millet*. Paris: A. Quantin, 1881, pp. 123-127.

Yriarte, Charles. *J.-F. Millet*. Paris: Jules Rouam, 1885, p. 26.

Michel, André. "J.-F. Millet et l'exposition de ses oeuvres a l'Ecole des Beaux-Arts." *Gazette des Beaux-Arts* 2nd ser., 36 (July 1887), p. 22.

Durand-Gréville, E. "La Peinture aux Etats-Unis." *Gazette des Beaux-Arts* 2nd ser., 36 (July 1887), p. 68; (September 1887), p. 253.

Muther, Richard. *The History of Modern Painting*. London: Henry & Co., 1895, vol. 2, pp. 376, 380.

Michel, André. *Notes sur L'Art Moderne/Peinture*. Paris: Armand Colin et Cie., 1896, p. 57.

Cartwright, Julia M. *Jean-François Millet, his Life and Letters*. London: Swan Sonnenschein & Co., 1896, pp. 110-112.

Naegely, Henry. *J. F. Millet and Rustic Art*. London: Elliot Stock, 1898, pp. 100-111.

Knowlton, Helen M. *Art Life of William Morris Hunt*. Boston: Little, Brown & Co., 1899, pp. 10, 98.

Gensel, Walther. *Millet und Rousseau*. Bielefeld and Leipzig: Velhagen & Klasing 1902, p. 37.

Moore, A. Hudson. "The Barbizon School." *Chautauquan* (January 1903), p. 426.

Staley, Edgcumbe. *Jean-François Millet*. London: George Bell and Sons, 1903.

Muther, Richard. *J.F. Millet*. Berlin: Julius Bard, 1904, pp. 29, 30.

Peacock, Netta. *Millet*. London: Methuen & Co., 1905, pp. 65-66.

Tomson, Arthur. *Jean-François Millet and the Barbizon School*. London: George Bell and Sons, 1905, pp. 65-66.

Turner, Percy M. *Millet*. London: T. C. and E. C. Jack, n.d. [1910], pp. 27, 64.

Jacque, Charles. "Recollections of Millet." *Century Magazine* (August 1911), p. 491.

Guiffrey, Jean. "Tableaux Français conservés au Musée de Boston et dans quelques collections de cette ville." *Archives de l'art Français* n. s. 7 (1913), p. 547.

Leprieur, Pierre, and Cain, Julien. *Millet*. Paris: Librairie Centrale des Beaux-Arts, 1913, p. 38.

"The Quincy Adams Shaw Collection." Boston: Museum of Fine Arts *Bulletin* 16 (April 1918), pp. 12, 14, illus. p. 11.

Moreau-Nélaton, Etienne. *Millet raconté par lui-même*. Paris: Henri Laurens, 1921, vol. 1, pp. 85-87, fig. 61; vol. 3, pp. 115-116.

Shannon, Martha A. *Boston Days of William Morris Hunt*. Boston: Marshall Jones, 1922, pp. 34-37.

Gsell, Paul. *Millet*. Translated by J. Lewis May. New York: Dodd, Mead and Co., 1928, pp. 28-29, fig. 10.

Gilbert, Ariadne. "The Peasant-Painter: Jean-François Millet." *Popular Biography* 1, no. 5 (March 1930), p. 76.

Edgell, George Harold. *French Painters in the Museum of Fine Arts: Corot to Utrillo*. Boston: Museum of Fine Arts, 1949, p. 19, illus. p. 17.

Herbert, Robert L. *Barbizon Revisited*. Boston: Museum of Fine Arts, exhibition catalogue, 1962, pp. 46, 150.

"Peasant Painter." *MD* (August 1964), illus. p. 167.

Herbert, Robert L. "Millet Reconsidered." *Museum Studies* (Art Institute of Chicago) 1 (1966), p. 46.

Durbé, Dario, and Damigella, Anna Maria. *La Scuola di Barbizon*. Milan: Fratelli Fabbri, 1969, pp. 20, 95, pl. XXVIII.

Herbert, Robert L. "City vs. Country: The Rural Image in French Painting from Millet to Gauguin." *Artforum* 8 (February 1970), no. 6, p. 47, illus. p. 47.

Nochlin, Linda. *Realism*. London: Penguin Books, 1971, p. 115, illus. no. 60.

Bouret, Jean. *L'Ecole de Barbizon*. Neuchâtel: Editions Ides et Calendes, 1972, color illus. p. 181.

Clark, T. J. *The Absolute Bourgeois/Artists and Politics in France, 1848-1851*. London: Thames and Hudson, 1973, pp. 79, 82, 93-96, 181, fig. 64.

Clark, Kenneth. *The Romantic Rebellion*. London: Harper & Row, 1973, p. 298, fig. 229.

Chamboredon, Jean-Claude. "Peinture des rapports sociaux et invention de l'éternel paysan: Les deux manières de Jean-François Millet." *Actes de la recherche en sciences sociales* 17/18 (November 1977), pp. 11-12.

Fermigier, André. *Millet*. Geneva: Skira, 1977, pp. 39-40, 42, 107, illus. in color p. 38.

Pollock, Griselda. *Millet*. London: Oresko Books, 1977, pp. 15-16, 40, fig. 19 and plate II.

Boime, Albert. *Thomas Couture and the Eclectic Vision*. New Haven: Yale University Press, 1980, p. 433.

Canaday, John. *Mainstreams of Modern Art*. New York: Holt, Rinehart and Winston, 1981 (second edition), pp. 164-166, fig. 203.

Meixner, Laura L. *An International Episode: Millet, Monet and their North American Counterparts*. Memphis: The Dixon Gallery and Gardens, exhibition catalogue, 1982, p. 73.

Brettell, Richard R., and Brettell, Caroline B. *Painters and Peasants in the Nineteenth Century*. Geneva: Skira, 1983, pp. 33-35, 84, illus. p. 34.

19
The Sower
Delteil 22, second state
1851
Lithograph on beige oriental paper
19.7 x 16.0 cm. (7¾ x 6¼ in.)
Gift of Frederick Keppel, 1906
M20606

Although the critical reception *The Sower* had received at the Salon was decidedly mixed, it had attracted considerable attention, and in 1851 *l'Artiste*, the most important French art journal of its day, planned to publish a reproduction of the painting created by Millet himself.

Millet had made at least one earlier lithograph, a sentimental cover for a song sheet, during the difficult days of 1848, but this drawing for *l'Artiste* would have been his first major work in any print medium. Since lithographs may be drawn directly on the stone with a black crayon very much like the conté crayons Millet used for his drawings, the technique was not wholly alien to his regular working methods. But translating a painting into black and white, especially a painting with the complex color scheme of *The Sower*, was a difficult endeavor. The short, overlaid strokes of the crayon provided a convincing representation of the furrowed field, against which the more heavily rendered hatching and strong outline of the figure produced a powerful silhouette. Defining the backlit figure, and especially the complex draping of the seed bag over his left arm, was considerably harder, and Millet's command of lithographic means was not broad enough yet to succeed completely. The faintly drawn oxen and farmer on the harrow capture the dissolving character of strongly angled light (rendered with broad, fluid strokes of paint in the original work) quite well, but it was more difficult for Millet to re-create the twilight effect of the painting, for on pale paper the open sky to the right of the figure seems more suggestive of sunrise.[1]

When proofs were made from the stone, Millet was dissatisfied and refused to allow the print to be published. Neither of his principal biographers, Alfred Sensier and Etienne Moreau-Nélaton, mentions the lithograph, and we do not know what displeased the artist, but virtually all known impressions of the stone were made after his death.

In view of the questions that surround the identity of Millet's entry at the Salon of 1850-1851 (see cat. no. 18), it is quite significant that he chose to work from the earlier of the two 1850s paintings when reproducing the image. The print depicts a sower with his right arm thrown back in a taut line, while his forward movement is emphasized with the stronger, paired diagonals of his upper body and right leg, a deliberate return to the greater monumentality that characterized the painting. By choosing the Boston version to be reproduced, Millet himself provided a powerful argument that it was, in fact, the painting in the Salon.

Notes
1. A number of the posthumous prints from this stone address this problem by using tinted papers.

References

Lebrun, Alfred. "Catalogue de l'oeuvre gravé de J.-F. Millet." In Sensier, Alfred, and Mantz, Paul. *La Vie et l'oeuvre de J.-F. Millet.* Paris: A. Quantin, 1881, no. 23, p. 381.

Delteil, Loys. *Le Peintre-graveur illustré (XIX et XX siècles, I, J.-F. Millet, et al..* Paris: Delteil, 1906, no. 22.

Melot, Michel. *L'Oeuvre gravé de Boudin, Corot, Daubigny, Dupré, Jongkind, Millet, Théodore Rousseau.* Paris: Arts et Métiers Graphiques, 1978, no. 22, p. 241.

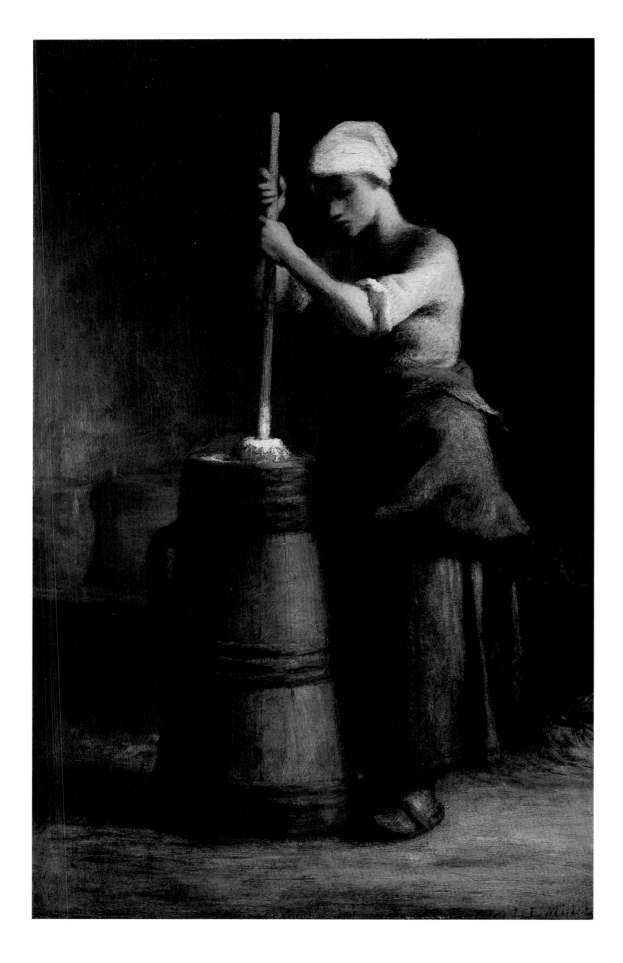

20
Young Woman Churning Butter
About 1848-1851
Oil on panel
57.0 x 35.8 cm. (22⅜ x 14⅛ in.)
Lower right: J. F. Millet
Gift of Mrs. John S. Ames, 1966
66.1052

Among the many themes of the peasant laborer that captured Millet's interest, several images inspired repeated treatment throughout his entire career, but in no other does the image of the peasant and her task change as substantially as in his pictures of women making butter. In *Young Woman Churning Butter*, the second of three oil paintings depicting the churning theme, Millet presented the butter churner as a paradigm of lifelong monotony compounded by the immediate repetitiveness of the simple churning motions. Yet by his etching of 1855-1856, the butter churner has taken on the air of the contented cat who curls against the churn at her feet (see cat. nos. 64 and 65).

A comparison of the Boston painting, completed in 1851,[1] with an earlier painting, the *Butter Churner* (formerly Montreal, Musée des Beaux Arts), attests to the rapid transformation of Millet's style in the years 1848 to 1851. While the loose touch and flickering light of the Montreal churner, datable to 1847-1848, bear traces of the *manière fleurie*, Millet's rococo-inspired style of the early to middle 1840s, the Boston painting is marked by a more disciplined brushwork that permits definite contours and interior modeling, yet unifies the image in a dark, velvety atmosphere. Light seems to mold the figure softly against the somber background, while the elemental colors of her blue overskirt, white blouse, and red sash reinforce the timeless anonymity of the figure.

As the Montreal *Churner* attests, Millet derived his image from Chardin, whose rediscovery (like that of the Le Nain brothers) by artists and critics around the revolution of 1848 fitted easily into Millet's own appreciation of eighteenth-century painting and his growing interest in realistic subject matter. The influence of Chardin's isolated and immobile figures monumentalized in routine tasks endured throughout Millet's career. Strong, specific links between the Montreal painting and Chardin's *Scullery Maid* (destroyed; see variant in Hunterian Gallery, Glasgow), a work that is likely to have been known to Millet at this time,[2] are found in costume (bonnet, apron, and rolled sleeves), elongated figure type, sharp facial features, and pose. Each figure is portrayed in profile, bending wearily over a barrel-like object in a configuration that conveys formally the extent to which the woman's life revolved around her work.

Following the Montreal version by only a year or two, Boston's *Young Woman*

Churning Butter represents a considerable advance toward greater monumentality in Millet's approach to the theme. The Boston panel is much larger than the earlier painting, but, more significant, the scale of the figure within the composition has been increased. Changes in the churner herself impart a new solidity and autonomy to the figure. Overt signs of strain shown by the earlier churner are replaced by a sense of simple strength and repetitive gesture that suggests the subject's cheerless acceptance of her endlessly monotonous task. Although this second version is less dependent on Chardin in specific details, it is closer to the older master in its classical calm and the sculptural presence of the figure joined to her churn.

In Millet's last images of a woman churning – an etching of 1855-1856 (cat. no. 65), a pastel of 1866, and a final painting shown in the Salon of 1870 (see fig. no. 13) – he changed the image dramatically, an unusual occurrence, since most of his repetitions involve a process of steady strengthening of an initial conception (see for instance, his contemporary versions of men turning over the soil, cat. nos. 17 and 116). The slender young woman was replaced by a stocky, older woman with sturdier arms and coarser features, wearing more identifiably nineteenth-century costume. In the later painting, light enters the room evenly, revealing a wealth of genre detail. The emblematic isolation achieved in the Boston picture, which so powerfully identified the woman with her task, has been displaced by a more harmonious melding of a specific butter churner with her richly detailed surroundings.

Images like the butter churner or the milkmaid must have held a special resonance for Millet beyond their formal simplicity. Long after settling in Barbizon, he continued to title his series of milkmaids *laitières normandes*; and while he never explicitly identified his butter churner as a Norman image, she, too, probably belonged to youthful memories of La Manche. Millet's native Cotentin peninsula was known for its superior dairy industry, and Norman butter (marketed through Isigny) was chief among the *beurres de luxe* imported from the provinces to Paris throughout the nineteenth century.[3]

The anonymity of the surroundings created for Millet's first two painted butter churners leaves unresolved the important question for whom the women toil; butter, as a saleable luxury item, was seldom con-

sumed in most peasant households.[4] The large capacity of the churn and the long shelves of jugs appearing in later versions of the theme suggest, moreover, a commercial enterprise whose success is measured in the pleasant robustness of the churning figure. The darkened background in Boston's painting agrees with a contemporary description of the life of the dairy maid that records the start of her day at one a.m.[5] For several of his other images of women working, Millet took great care to explain that they were intended as women happily laboring for their own families, but in this instance, the *Young Woman Churning Butter* may well have struck Millet as a suitable female equivalent of the *Cooper Tightening Staves on a Barrel* (cat. no. 24), an image of the contemporary worker.

Notes

1. In a letter to Sensier, postmarked May 16, 1851, Millet asked to have a number of frames made, including one of 57.5 x 36.5 cm., destined for a painting of a butter churner that Millet described as "not bad" (Archives, Cabinet des Dessins, Musée du Louvre, Paris). Moreau-Nélaton has confused this painting with the watercolor *Butter Churner* of similar size, as Millet himself made reference to two watercolors of unidentified subject in the same paragraph that discusses the painting (Etienne Moreau-Nélaton, *Millet raconté par lui-même* [Paris: Henri Laurens, 1921], vol. 1, p. 93, fig. 75).

2. One of three known versions of this theme belonged to François and Camille Marcille during the nineteenth century and was lent to a major exhibition on the Boulevard Bonne-Nouvelle in 1848, at which time a reproduction of the work was published in *L'Illustration* by a critic who described Chardin as a "brutal realist" (February 5, 1848, p. 561). Charles Jacque, a good friend of Millet's in the late 1840s, made an etching after an engraving of another version of the painting.

3. Jean Augustin Barral, *Le bon Fermier, aide-mémoire de cultivateur...* (Paris: Librarie agricole de la maison rustique, 1861, 2nd ed.), p. 1340; and Maurice Agulhon, Gabriel Desert, and Robert Speckin, *Apogée et crise de la civilisation paysanne*, vol. 3 of *Histoire de la France rural* (under direction of Georges Duby and Armand Wallon) (Paris: Editions du Seuil, 1976), p. 230.

4. Eugen Weber, *Peasants into Frenchmen, The Modernization of Rural France, 1870-1914* (Stanford: Stanford University Press, 1976), p. 134.

5. Joseph Mainzer, "La Laitière," *Les Français peints par eux-mêmes/Encyclopédie morale du dix-neuvième siècle* (Paris: L. Curner, 1840-1842), vol. 4, p. 236.

Provenance

Marquis de la Rochebousseau [pseudonym, probably for a dealer or dealers] (sold Boulevard des Italiens, Paris, May 5-8, 1873, no. 27); M. Laurent-Richard (sold Hôtel Drouot, Paris, May 23-24, 1878, no. 50); Mary J. Morgan (sold American Art Association, New York, March 5, 1886, no. 170), bought by Charles Crocker; with Knoedler Gallery, New York and/or William Schaus, New York; John S. Ames, Boston, Mrs. John S. Ames.

Exhibition History

University of Maryland Art Gallery, College Park, "Hommage à Baudelaire," 1968, unnumbered.

Related Works

Butter Churner, oil on panel, 29.0 x 16.5 cm., formerly Musée des Beaux Arts, Montreal.

Compositional study, charcoal (?) with white highlights on paper, 36 x 23 cm., private collection, Paris.

Finished drawing with woman to left of churn, black chalk on paper, 39.7 x 24.9, Musée des Beaux-Arts, Budapest.

Finished drawing, crayon and watercolor on paper, 38 x 23.5 cm., private collection, Paris.

Figure study, black chalk on paper, 48 x 28.5 cm., current location unknown (see Cardon sale, Le Roy, Brussels, April 24-25, 1912, no. 74).

Young Woman Churning Butter, cat. no. 20.

Finished drawing with churn standing in large pan, black conté crayon on paper, 28.5 x 18.5 cm., Metropolitan Museum of Art, New York.

Compositional sketch known only from reproduction in *L'Image*, April 1897.

Woman Churning Butter, cat. no. 64.

Woman Churning Butter, cat. no. 65.

Finished drawing, black conté crayon on paper, 36 x 25.5 cm., current location unknown (see *J.-F. Millet* [London: Wildenstein and Co., exhibition catalogue, 1969], no. 31).

Compositional sketch, black conté crayon on paper, 20.7 x 15 cm., Cabinet des Dessins, Musée du Louvre, Paris (GM10688).

Compositional study squared for transfer, black conté crayon on paper, 28.6 x 18.0 cm., Cabinet des Dessins, Musée du Louvre, Paris (GM10687).

Butter Churner, pastel and black conté crayon on paper, 96 x 60 cm., Musée du Louvre, Paris (RF1578).

Butter Churner, oil on canvas, 98.5 x 62.3 cm., Malden Public Library, Massachusetts.

Butter Churner with chicken in doorway, pastel on paper, 10 x 6 in., current location unknown (sold William Buchanan, American Art Association, New York, April 18, 1912, no. 24). Appears very questionable in reproduction.

References

[Herbert, Robert L.] *Jean-François Millet*. Paris: Editions des Musées Nationaux, Grand Palais exhibition catalogue, 1975, p. 212.

21
Capture of the Daughters of Daniel Boone and James Callaway
Not listed by Delteil; first state
1851
Lithograph with tint stone on wove paper
36.0 x 53.5 cm. (14⅛ x 21 in.)
Bequest of William Perkins Babcock, 1900
B4312

22
Rescue of the Daughters of Daniel Boone and James Callaway
Delteil 25, first state
1851
Lithograph with tint stone on wove paper
36.0 x 53.0 cm. (14⅛ x 20⅞ in.)
Bequest of William Perkins Babcock, 1900
B4601

Among Millet's distinctively coiffed Norman spinners or the shepherds of the Chailly plain, it is more than a little startling to discover Daniel Boone in battle with the Indians of the American frontier. During the 1840s and 1850s, however, financial hardship drove the artist to accept several highly unusual commissions, among them a project for large-scale lithographs illustrating the exploits of American pioneer heroes. The commission had originally been given to the Swiss artist Karl Bodmer, a friend and fellow resident of Barbizon, who in turn recruited Millet. For many years, Millet's part in these little-known prints was thought to have been limited to drawing figures following Bodmer's design,[1] but the recovery of four of Millet's lost drawings for the lithographs confirms that the works were wholly designed by him, and there is no reason to

doubt that he was responsible for the execution of the pair of lithographs in question here.

Drawing for commercial publication was a new and demanding challenge for Millet and in a letter of July 19, 1851, to a friend from his Parisian days, he protested: "I have to tell you about what I'm doing now, since I'm sure you will never guess – I am making drawings of savages....Oh, if only I were a millionaire, never again would I take on such a task!"[2] It wasn't, however, the unusual subject matter that troubled him – James Fenimore Cooper's *Last of the Mohicans* and Chateaubriand's *Atala* had been among his favorite reading during his student days in Cherbourg, and he probably shared in the general French fascination with the American "natural savage."[3] Instead, as he went on to explain, it was the publisher's expectations that were so difficult to meet:

I don't know if this whole thing will go through, because it has to be done under conditions that bother me. First the drawings in question have to be very finicky, because they're for prints. But that's not all: it's necessary besides that they be as slick as possible, and for two weeks now I've been making myself take Schopin, Gué or Guet – I don't know which – in the Journal des Modes *seriously, as well as Widal or Landelle, etc., etc., etc. That's the truth. Only, I swear, to my shame, I don't think I can do it. Bodmer submitted one of them on which I had done my very best in that style. I was foolish enough to think, before the publisher saw it, that I could do battle with those gentlemen mentioned above! bah! When the publisher (who is Goupil on the Boulevard) saw it, the expression on his face was not satisfaction. He thought the drawing was good, but unfortunately, it was a work of art, and that, above all,*

was what had to be avoided at any cost because this publication was meant for Americans, and what it had to be above all was "cute"! I work as hard as the dickens to do something that I won't ever be able to do well. Bodmer is going to have to get somebody else in all probability. Americans! you're pretty smooth for your age.[4]

Although Millet identified a "voyageur Americain" and Benjamin Poff Draper (who quotes Bodmer on the subject) mentions a St. Louis publisher as the commissioner, the prints were probably commanded as well as issued by Goupil, a major French publishing firm.[5] They were to have been part of a much larger set, but only four lithographs, these two Daniel Boone scenes and two others illustrating the lives of Major Samuel McColloch and Simon Butler, were issued. The published editions, bearing legends in both French and English, were printed by Lemercier for

Goupil and copyrighted in the United States by William Schaus in 1852.[6] Goupil, whose recently established New York shop was already quite successful with lithographs after famous European paintings, may have wished to capitalize on the sensation made by George Catlin's Indian Gallery (a traveling exhibition of paintings and live Indians that visited Paris in 1845-1846) or he may simply have wanted a more indigenous subject matter for his new clientele.

A successful painter and illustrator, well known for scenes of American Indians drawn from first-hand experience,[7] Bodmer was a logical choice for such a commission; Millet's participation in the project is harder to explain. The published lithographs bear the line "Composed and Drawn on Stone by K. Bodmer," but on a set of proofs of the four lithographs Bodmer noted that Millet drew the figures.[8] The combined evidence of drawings and lithographs substantiate, however,

Millet's authorship of the entire commission, under Bodmer's signature.

Bodmer may have been particularly busy or perhaps he just wished to do Millet a favor by bringing the struggling younger artist into the project.[9] But it is also quite likely that he realized he was not the artist for the commission in question. His own works, whether paintings or prints, seldom included figures of substantial size, and he must have recognized that this type of literary illustration required something quite different from the broad landscape views he favored. Bodmer's own recollection to Loys Delteil indicated that he provided Millet with the texts to be illustrated as well as "a sketch."[10] The very complete, but not highly finished, drawings for three of the lithographs, all signed by Millet, are inarguably by Millet himself. But it would be very difficult to see in any one of these preliminary drawings the work referred to by Millet in his letter, the drawing finished to the best of his ability in the style of the

Journal des Modes. Since the Daniel Boone lithographs both present a number of details quite typical of Millet (and which, at least in the case of the *Rescue*, are not evident in the drawing), it is probable that Millet's difficult quest to master a *pommadé* style described his effort to make the finished drawings, either directly on the stone or on specially treated paper to be transferred to the lithographic stone.[11]

Millet's hand is more immediately obvious in the second of the two prints, the *Rescue*, where the two young women in the background are only slightly more delicate sisters to Millet's earliest butter churner or his seamstresses of 1848. The frontiersman who embraces his daughter is a facial type found in several of Millet's early woodcutter images and the Indian being stabbed in the neck alongside the fleeing girls is a reprise of a Millet drawing of a woodcutter resisting Death (Cabinet des Dessins, Musée du Louvre, Paris). The stabbing scene is not included in the drawing for the *Rescue* and the figure/facial types are not clearly enough defined to allow the hypothesis that another, more skilled lithographic artisan worked from Millet's drawing to create the final print. The connection to Millet and his work of the 1840s is not as readily apparent in the other Daniel Boone lithograph, the *Capture*, which is also more finished in its detail than the preceding one. However, while the tightly drawn faces of the young victims, with their large eyes and tiny rosebud mouths, are difficult to reconcile with Millet's work in the 1850s, they are simply more smoothly finished versions of the young nymphs in his pastels and paintings of 1845-1846.[12] Their poses, with emphatic gestures featuring bare forearms and delicate hands, have a significant precedent in Millet's *Captivity of the Jews in Babylon*, a recently recovered Salon work of 1848 (see cat. no. 141). The Indians in the *Capture* are readily related to Bodmer's work, as is the composition with a foreground expanse of water and lush forest. If a case were to be made for Bodmer's direct participation in the project at all, this lithograph would be the most likely of the group to depend on a sketch by the older artist.

Technically, the lithographs are very skillfully crafted. Millet manipulated a striking range of values from purest white to a dense black; he made regular use of broad areas of light or dark to set off individual figures and to organize complex events; and, above all, he mastered the shaping of forms, joining well-drawn silhouettes to a finely honed technique of hatching and patterning that overcomes the problem that particularly handicapped him in the execution of the lithograph of *The Sower*.

The incidents Millet illustrated are usually attributed to Cooper's *Last of the Mohicans* (and the novel does include a similar episode), but attention to such details as an Indian "noiseless and stealthy as a serpent, who crawled down the bank until he reached the rope that hung from the bow…" suggests that Millet's source was actually a more recent account of the Kentucky pioneers, John M. Beck's *Life of Daniel Boone*, published in 1847. The Daniel Boone material would also have been available in general histories of Kentucky, sources that would have provided the subjects for other lithographs in the series as well.[13]

Notes

1. Alfred Lebrun (in his "Catalogue de l'oeuvre gravé de J.-F. Millet," published in Alfred Sensier and Paul Mantz, *La Vie et l'oeuvre de J.-F. Millet* [Paris: A. Quantin, 1881]) does not mention any of the four published lithographs. Loys Delteil (in *Le Peintre-graveur illustré* [Paris: Delteil, 1906], vol. 1, unpaged) accepts only the *Rescue* and *Simon Butler* as by Millet. De Cost Smith (in "Jean-François Millet's Drawings of American Indians," *Century Magazine* 80 [May 1910], pp. 78-84), although accepting a close collaboration between Millet and Bodmer, is the first to suggest that Millet might well have carried his drawings through to prints: "Yet, while seemingly dependent upon Bodmer for his knowledge of costume and types, Millet's Indians, as well as the other figures in these pictures, however disguised by accessories, fairly bristle with Millet's peculiarities of style" (p. 84). Robert Herbert (in *Jean-François Millet* [Paris: Editions des Musées Nationaux, Grand Palais exhibition catalogue, 1975], pp. 178-179) argues that "Millet was the author of the entire compositions and not of the figures alone; however, he probably did not himself draw them on the stone." Michel Melot agrees unreservedly with Herbert (in *L'Oeuvre gravé de Boudin, Corot, Daubigny, Dupré, Jongkind, Millet, Théodore Rousseau* [Paris: Arts et Métiers Graphiques, 1978], p. 290).

2. Millet to Louis-Alexandre Marolle, July 19, 1851, Archives of the Cabinet des Dessins, Musée du Louvre, Paris; quoted in Etienne Moreau-Nélaton, *Millet raconté par lui-même* (Paris: Henri Laurens, 1921), vol. 1, pp. 96-97.

3. Alfred Sensier and Paul Mantz, *La Vie et l'oeuvre de J.-F. Millet* (Paris: A. Quantin, 1881), p. 39.

4. Millet to Marolle, cited above.

5. Benjamin Poff Draper, "American Indians – Barbizon Style; The Collaborative Paintings of Millet and Bodmer," *Antiques* 44 (September 1943), pp. 108-109. In Draper's account, the St. Louis publisher cancelled his commission when he discovered that Millet was working on it. As a number of mistakes concerning Millet are made in the article and the quotations from Bodmer are not cited, Draper's work must be viewed with a measure of skepticism.

6. The lithographs were issued as *Annals of the United States Illustrated – The Pioneers*. William Schaus was Goupil's agent in New York as well as an independent dealer.

7. Bodmer's first important work was a series of drawings illustrating the travel memoirs of Prince Maximilian Weid-Neuwied, *Reise in das innere Nord-America in den Jahren 1832 bis 1834* (Coblenz: J. Hoelscher, 1839-1841), two volumes with atlas.

8. Avery Collection, Print Room, New York Public Library.

9. Earlier, Bodmer had purchased from Millet his Salon painting of 1847, *Oedipus Taken down from the Tree* (Ottawa, National Gallery).

10. Delteil, op. cit., under Millet 26.

11. This was a procedure frequently used for lithographic illustrations, and a method that should not have posed any practical difficulties for an artist so committed to drawing as Millet.

12. See for example, *Nymphs and Fauns in the Forest*, Phoenix Art Museum.

13. John M. Peck, *Life of Daniel Boone* (Boston: Little, Brown and Company, 1847), pp. 58-60. The extended description of the capture of the three girls in a canoe can be traced back to Col. John Floyd's account of the incident in a letter of July 1776. Of the five Indians portrayed in the *Capture*, one wears a more elaborate headdress, which corresponds to the version of the story used by Peck, describing the captors as four Indians from one tribe and one from a different tribe. Cooper's story has only two young women and no canoe.

Related Works (cat. no. 21):
Drawing, black conté crayon on paper, 34 x 50 cm., current location unknown (sold, Paul Marmontel, Hôtel Drouot, Paris, January 25-26, 1883, no. 193, and probably the drawing *Indian Attack* or *Incident from "The Last of the Mohicans,"* 15 x 21½ in., last known in a private collection, Boston, 1920s).

Related Works (cat. no. 22):
Drawing, black and brown conté crayons on paper, 44 x 58 cm., Yale University Art Gallery, New Haven.

References (for both cat. nos. 21 and 22)
Delteil, Loys. *Le Peintre-graveur illustré*. Paris: Delteil, 1906, vol. 1, Millet 25 and Millet 26.

Smith, De Cost. "Jean-François Millet's Drawings of American Indians." *Century Magazine* 80 (May 1910), pp. 78-84.

Moreau-Nélaton, Etienne. *Millet raconté par lui-même*. Paris: Henri Laurens, 1921, vol. 1, pp. 96-98.

Draper, Benjamin Poff. "American Indians – Barbizon Style; The Collaborative Paintings of Millet and Bodmer." *Antiques* 44 (September 1943), pp. 108-110.

[Herbert, Robert L.] *Jean-François Millet*. Paris: Editions des Musées Nationaux, Grand Palais exhibition catalogue, 1975, pp. 178-180.

Melot, Michel. *L'Oeuvre gravé de Boudin, Corot, Daubigny, Dupré, Jongkind, Millet, Théodore Rousseau*. Paris: Arts et Métiers Graphiques, 1978, p. 290.

23
Young Woman Spinning
1850-1852
Sanguine conté crayon on laid paper
25.7 x 17.3 cm. (10⅛ x 6¾ in.)
Stamped, lower left: J. F. M
Charles Hitchcock Tyler Fund, 1963
63.141

Young Woman Spinning is unusually complete for Millet, far more detailed than most of his drawings, and although there are a number of paintings of spinners in his oeuvre that can be dated to the same period, this drawing appears to be quite independent of them. Far from being a working drawing for a painting, it displays a blend of skillfully controlled execution with visibly calculated revision that suggests it was intended to appeal to drawing connoisseurs. The irregular, but confident outlines of the spinner's left sleeve, the heavily refocused lines of the spinning wheel platform that contrast with the open areas of the woman's skirt, the soft, stringy quality of the wool being pulled from the spindle – all these details reflect Millet's increasing sensitivity to his drawing medium and his capacity to suggest differences in texture, movement, and light with changes in the quality and emphasis of his line.

With the exception of the portraits executed around 1847-1849 (cat. nos. 4 and 12), Millet had used drawings almost exclusively as working stages in the development of an idea for his paintings. Whether the pages were randomly covered with rapid, overlaid memories of figures and scenes studied during his evening walks, or neatly balanced with careful, completely thought-out compositions, Millet regarded these sheets as little more than notations, to be set aside (or gathered up by admiring friends, as the case might be) when he had finished with them. Sometime in his first years in Barbizon, however, perhaps at the urging of Sensier, who had admired his portrait drawings, Millet began to create drawings that are technically step-children in his art – not readily identifiable with other painting or drawing projects – larger and far more detailed than was necessary for figure studies or compositional aids, but still quite free in their execution.

Something of the significance of these drawings for Millet must be contained in his surprising shift in medium. For most of his drawings since his student days, he had preferred to use black conté crayon, a slightly greasy commercial preparation that resembled natural black chalk but adhered to paper more cleanly. For a short time around 1850, however, Millet experimented with a sanguine (red-brown) conté crayon, creating a small number of especially luminous drawings. Sanguine chalk was closely associated with several old master draftsmen, notably Michelangelo and Watteau, whom Millet greatly admired,[1] and it seems

clear that in pictures such as *Young Woman Spinning*, worked in two shades of sanguine, Millet was determined to develop his draftsmanship for its own sake, seeking a balance of appealing execution with satisfying composition that might be turned to commercial advantage.

Notes

1. Although the black conté crayons that Millet favored are distinguished according to hardness with a numbering system created by their inventor, Nicolas-Jacques Conté, the varieties of sanguine conté crayons are identified by the names of artists or periods famous for their red chalk drawings: Sanguine Watteau, Sanguine Medici, Sanguine Florentine, etc.

Provenance

Studio of the artist; with Alfred Strolin, Paris, 1963.

24
Cooper Tightening Staves on a Barrel
About 1848-1852
Oil on canvas
46.4 x 38.9 cm. (18¼ x 15¼ in.) – support
45.1 x 33.0 cm. (17¾ x 15¼ in.) – design[1]
Lower left: J. F. Millet
Gift of Quincy Adams Shaw through Quincy A. Shaw, Jr., and Mrs. Marian Shaw Haughton, 1917
17.1500

Cooper Tightening Staves on a Barrel, as its title suggests, is not a portrait of an individual worker, but instead the representation of an anonymous artisan identified only by the trappings of his trade. Millet's focus on a single figure, deeply engrossed in his task, ties his painting to a long and continuing French tradition of popular imagery that illustrated the labors of the months or the industries of distant provinces with workers surrounded by their tools. But unlike his contemporaries or his predecessors, Millet minimized anecdotal detail or regional idiosyncrasy to celebrate the skilled laborer himself. As in the similar paintings of *Young Woman Churning Butter* (cat. no. 20) and the *Standing Spinner* (cat. no. 59), he sought the most telling gesture of a task, subordinating background incidents to a timeless image joining work and worker inseparably.

Millet's *Cooper* has reached the critical stage in barrel-making, forcing down the hoops that will hold the staves tightly against one another to preserve the barrel's shape as well as its water-tightness. Dressed in the leather apron that identifies his trade over the blue tunic worn by French peasant and artisan alike, he braces himself to swing his mallet against the wedge in his left hand. His shadow, thrown against the immense barrel by light entering over his shoulder, functions as an extension of himself, suggesting the forward movement of his body that will complete the blow. With this clever summary of the cooper's repeated back-and-forth swing as he moves around the barrel, Millet captured both the physical drain of the work and its monotony. The young cooper's face is barely defined by the light at his back, and his whole form is pulled into the silhouette of the barrel by his outstretched left arm. Even more effectively than *Young Woman Churning Butter*, the *Cooper* powerfully identifies the worker with the task, forming a unified image of the cooper and his barrel. From such simplicity of composition, Millet's quiet colors and dark interior draw a monumentality that so far exceeds the earlier images of which it was born that the *Cooper* must be seen, alongside *The Sower*, as one of his most successful, modern images of the timeless universality of labor.

The sources that might have prompted the *Cooper*, which Robert Herbert argues was reworked over a four-year period spanning the revolution of 1848,[2] are many. Prints of single figures engaged in the typical activities of daily life, or demonstrating a distinctive regional task or costume, were

a mainstay of illustrated magazines such as *L'Illustration* or *Magasin pittoresque*, which became increasingly popular during the middle decades of the nineteenth century. Expanding an eighteenth-century tradition,[3] entire books were published with such illustrations, each accompanied by a lengthy text – sometimes a quasi-scholarly treatise explaining the task in all its variations, sometimes a chatty, fictive account of the character traits of individuals drawn to a task or typical of a far-off region. Behind the print traditions of recent centuries lay the illustrated books of hours created in fifteenth-century Burgundy, with their masterful calendars illustrated with seasonal rural labors, and the great secular sculptural programs recording crafts and monthly tasks on the less sacred regions of the Gothic cathedrals.

Coopers are occasionally used as secondary symbols for the months of August or September, which are normally identified with the labors of the grape harvest and wine making, and Millet may have found inspiration in fifteenth-century hours or nineteenth-century almanacs. Or his choice of the cooper may have stemmed from his Norman past, where coopers played a prominent role, providing the barrels for the cider of the countryside. His inspiration may have been more recent, in the form of a popular song, "Le Tonnelier" ("The Cooper") by Pierre Dupont. The virtually simultaneous publication of Dupont's song and the appearance of Millet's painting reflect the new interest and grudging respect that was granted the urban worker in the years following his dramatic intervention in the revolution of 1848. The cooper, in particular, provided a powerful image of the Parisian worker, his mythic significance ensured by centuries of identification with wine-making, and his modern importance established by the vast increase in commerce requiring his skills.

Notes

1. For nearly all the paintings in this collection, the dimensions of the design and its canvas or panel support either coincide or are so close as to justify the use of the support for the principal dimension. However, in a number of cases, Millet began his work on a canvas prepared for one set of dimensions, only to keep his final design a good deal smaller on one or more sides, in which case we have provided both sets of dimensions. In a number of letters alerting Sensier to his need for frames for nearly finished paintings, Millet declined to cite exact dimensions because he wished to wait until completion before deciding exactly how to define the final image. In this instance, the uncompleted margins to left and right were misunderstood to be part of the image, and were left uncovered by the frame, which was probably added in the late 1860s. These unpainted or, more often, partially painted edges can be distracting and may give a clumsy, damaged appearance to otherwise well-preserved paintings.

2. [Robert L. Herbert], *Jean-François Millet* (Paris: Editions des Musées Nationaux, Grand Palais exhibition catalogue, 1975), p. 111.

3. See Edmé Bouchardon, *Etudes prises dans le bas peuple ou les cris de Paris* (Paris: Fessard, 1737-1746), second suite, fig. 11.

Provenance

Constant Troyon (sold Hôtel Drouot, Paris, January 22-February 1, 1866, no. 564), bought by A. Legrand; Quincy Adams Shaw, Boston.

Exhibition History

Museum of Fine Arts, Boston, "Quincy Adams Shaw Collection," 1918, no. 17.

Grand Palais, Paris, "Jean-François Millet," 1976, no. 69 (Hayward Gallery, London, 1976, no. 45).

Cleveland Museum of Art, "The Realist Tradition, French Painting and Drawing, 1830-1900," 1980-1981, no. 31.

Related Works

Compositional sketch, sanguine conté crayon on paper, 40 x 27 cm., current location unknown.

Very finished compositional study, sanguine conté crayon on paper, 29 x 17 cm., Musée Bonnat, Bayonne.

Compositional sketch, sanguine conté crayon on paper, about 22 x 14.5 cm., private collection, Minnesota.

Study of figure, pencil on paper, 36.3 x 46 cm., current location unknown (London art market, 1960s).

Study of figure, study of legs, pencil on paper, 36.3 x 46 cm., current location unknown (London art market, 1960s).

Study of figure, ink on paper, 24.2 x 18.8 cm., Cabinet des Dessins, Musée du Louvre, Paris (GM10601).

Cooper Tightening Staves on a Barrel, cat. no. 24.

References

Guiffrey, Jean. "Tableaux Français conservés au Musée de Boston et dans quelques collections de cette ville." *Archives de l'art Français* n. s. 7 (1913), p. 547.

Moreau-Nélaton, Etienne. *Millet raconté par lui-même*. Paris: Henri Laurens, 1921, vol. 2, p. 124, fig. 181.

Borowitz, Helen O. *Notes on the Exhibition, The Realist Tradition, French Painting and Drawing, 1830-1900*. Cleveland: Cleveland Museum of Art, 1980, p. 21.

Meixner, Laura L. *An International Episode: Millet, Monet and their North American Counterparts*. Memphis: The Dixon Gallery and Gardens, exhibition catalogue, 1982, p. 73.

25
Three Men Shearing Sheep in a Barn
About 1852
Oil on canvas mounted on panel
24.5 x 39.3 cm. (9⅝ x 15½ in.)
Lent by Enid Hunt Slater, 1914
73.14

This small, unfinished work is Millet's earliest attempt to create a painting from a typical Barbizon activity that had captured his attention, probably preceding by only a few months the vertical, two-figure sheep-shearing composition that he settled on later in 1852 for a Salon entry (see cat. no. 43). As a work set aside when he redefined the image, it provides an important insight into Millet's methods in these early years. With a new sureness in his technical abilities, the most difficult challenge he faced was turning the visual inspirations of rural life into subject matter that satisfied his search for an art that would be significant and enduring without betraying the truths of daily existence.

This painting must have been one of Millet's first pictures with a wholly Barbizon subject matter. The shepherds, shepherdesses, and faggot gatherers, although set in the shadows of the Bas Bréau section of Fontainebleau Forest or trudging across the vast Chailly plain (and, increasingly, taking on new meanings dependent upon the social and economic problems of the specific region), had predecessors in his art before he arrived in the village. Many of the paintings he brought to completion in the early 1850s, such as *Man Turning over the Soil* (cat. no. 17), originated in studies made while he was still in Paris; others, such as the *Young Woman Churning Butter* (cat. no. 20), were inspired by memories of Normandy. But there are no drawings or other records to suggest that this composition had any history before the execution of the present panel. Unlike most of Millet's other pictures of workers composed in this period (which usually isolate a single figure at his task, concentrating on a gesture and a pose that monumentalize the activity), this composition with three figures in different attitudes has the slightly disjunct air of a scene recorded just as it had been observed.

For Millet, who was attracted to activities linked to timeless rural tradition, or to those presenting workers in heroic poses, sheepshearing was a predictable choice. It was an annual event, heralding the arrival of the warm months of summer, still performed in the 1850s with the same specialized shears used for the purpose in the middle ages, when it figured in illustrated calendars as the typical activity of the month of May. But even with such an important tradition behind him, Millet often found organizing a picture from the raw experience a difficult problem.

The three figures work independently of each other, united only by the sheep ranged across the room at their feet. The two bending men, echoing each other's pose, move in unison to shear animals whose distinctive forms are muffled by the mound of fleece that piles around them; the man entering through the doorway – broadened to provide space for the rapidly sketched sheep – lifts a sheep with its feet tied together onto the shearing room floor. The poses of the bending figures are reminiscent of sheaf binders in a number of Millet's harvest scenes of 1851-1852, and he may have adapted a drawing from such a work. The figure in the doorway, balancing his burden with shoulders thrown back, typifies the straining but poised gestures that Millet studied with such interest in every laboring scene.

The most unusual aspect of the picture is the interior setting, whose corners and doorways enframe the separate incidents. The stagelike foreground distances the figures, as if for further study. Contrary to his habit of pondering an image until he understood it in all its essentials, the additive nature of *Three Men Shearing Sheep* suggests that it is an uncommon effort to resolve, in paint, the various problems of pose and setting that Millet usually worked out separately in numerous pencil or crayon studies before he took up a paintbrush.

The painting belonged to William Morris Hunt, a Boston painter who admired Millet and worked with him in Barbizon in the early 1850s. A copy made by Hunt, probably as an exercise to study Millet's technique, is also in the collection of the Museum.

Provenance
Acquired from the artist by William Morris Hunt, Boston (about 1853), the estate of Hunt, Enid Hunt Slater, Executrix.

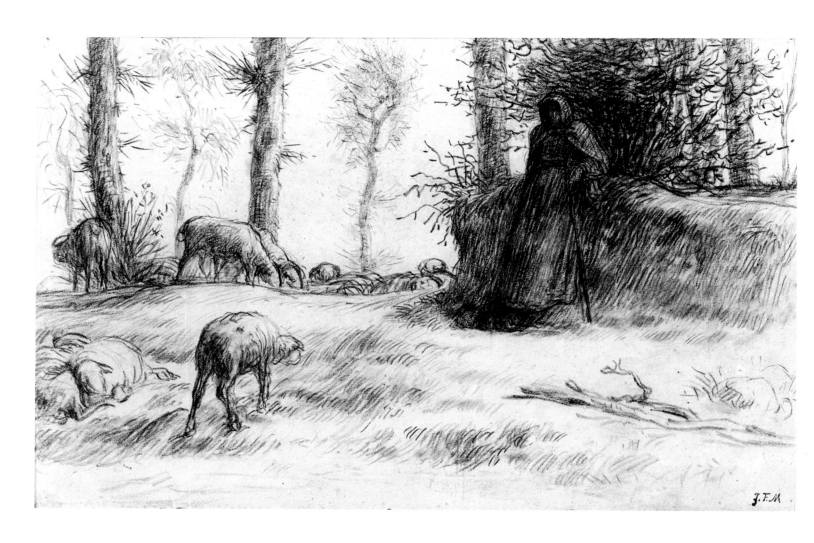

26
Landscape with Shepherdess and Sheep, Winter
About 1850-1852
Black conté crayon on wove paper
19.9 x 31.0 cm. (7⅞ x 12¼ in.)
Stamped, lower right: J. F. M
Stamped, verso: VENTE MILLET
Gift of Martin Brimmer, 1876
76.438

This carefully elaborated drawing, quite satisfying in its own right, is actually a preliminary compositional study for a painting of approximately the same size, now in the Victoria and Albert Museum, London. It is one of the first of Millet's sheepherding scenes to be based on direct observation on the edges of the Forest of Fontainebleau. In the bored shepherdess, gazing off beyond her flock, it establishes a motif that will reappear in Millet's shepherdess scenes throughout the next twenty years.

Millet's earliest Barbizon painting of a shepherdess (cat. no. 15), emphasized the forest, reducing the shepherdess and her flock to tiny presences at the base of the towering trees. In this drawing, shepherdess, sheep, and forest edge are brought into a more easy balance, with an open, loose composition that carries the conviction of a scene observed, not invented. But the greatest break with Millet's several images of shepherdesses that predate his arrival in Barbizon (for instance, cat. no. 13) comes in the figure of the shepherdess herself. As her physical presence in the picture is

diminished, she becomes one element of a complex, realistic scene, rather than an allegorical conveyance for misery or abandonment, or loss of purpose. In a scene such as this, the lethargy in her pose is readily explained by her lack of useful occupation as her sheep roam placidly around her.

Technically, the drawing, which can be dated about 1850-1852, shows Millet coming into his own as a draftsman, manipulating his crayon with considerable variation throughout the different objects rendered. As his daily walks brought him a better understanding of forest activities and a familiarity with local plants and landscape formations, he invented, of necessity, a technical vocabulary that could record his observations more accurately. For the sheep, whose individual features are lost in the flock or confused by foreshortening as they descend the hillocks, he favored loose, rounded strokes, often left unconnected or allowed to merge into the similar marks establishing the hummocks of the grassy forest floor. In this winter scene, the trees and bushes are bare, but sharp spiky

strokes distinguish the tree branches from the short, irregular branches of bushes. Finally, in the evening shadows, the shepherdess seems almost to merge into the embankment on which she leans heavily, her skirt and the talus alike shadowed with long, thick strokes of the crayon.

Provenance

Millet studio sale (Hôtel Drouot, Paris, May 10-11, 1875, no. 126), bought by Richard Hearn for Martin Brimmer, Boston.

Exhibition History

Fisher Gallery, University of Southern California, Los Angeles, "Barbizon School," 1962.

Related Works

Landscape with Shepherdess and Sheep, Winter, cat. no. 26.
Shepherdess, oil on canvas, 8 x 12⅝ in., Ionides Collection, Victoria and Albert Museum, London.

References

Wickenden, Robert J. "Millet's Drawings at the Museum of Fine Arts, Boston." *Print-Collector's Quarterly* 4, part 1 (1914), p. 12, illus. p. 13.

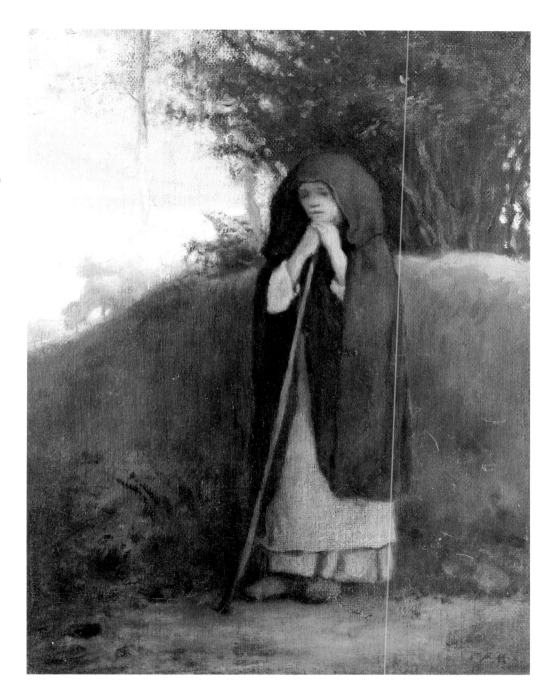

27
Shepherdess Leaning on her Staff
About 1852-1853
Oil on canvas
29.2 x 21.9 cm. (11½ x 8⅔ in.)
Lower right: J. F. M.
Robert Dawson Evans Collection. Bequest of Mrs. Robert Dawson Evans, 1917
17.3245

Shepherdess Leaning on her Staff begins the sequence of paintings and drawings that would become Millet's most frequently repeated image – a single shepherdess, shaded by trees, rocks, or hedges, while her sheep graze behind her on the open plain. A veritable trademark for the more personal side of Millet's art, small paintings such as this were destined for the private collector and were among the first of his works to gain an appreciative audience. Throughout the 1850s and 1860s, later versions of this image would open up the landscape, and display Millet's steadily growing skill as a draftsman and colorist

(fig. no. 6 and cat. nos. 75, 82, 92, and 147) but the essential components of the composition, as well as Millet's special interest in the character of the shepherdess, are all established in this early painting of 1852-1853.

In the prominence accorded the shepherdess, this painting has its origins in Millet's imaginary paintings of the shepherdess as an allegorical figure of melancholy (cat. no. 13), but his earlier image has been tempered by his hours spent observing the real shepherdesses of Chailly plain (cat. no. 26). In the present painting, the young woman's presence in the wild of the forest edge is readily explained by the sheep grazing behind her, although she still wears the blank, distant gaze of introspective loneliness that typified her sisters of the late 1840s. She rests beside a talus, or embankment, that divides the cultivated fields from the forest edge or the areas of scrub bushes among which her sheep may graze. While her garb and her setting are more naturalistic than in previous versions, her heavily hooded cloak retains an almost medieval air. Millet has not yet picked out the details of costume and landscape that so precisely place his later shepherdesses in their century and their countryside.

Instead, what is most directly proclaimed in this picture is Millet's aspiration to rival the great sculptors of form in French painting history, whose solidly rendered human figures give order to all around them. Enveloped in her simple costume, her figure masked by the dark blue cloak above a stiff overskirt-cum-apron that restrains her looser petticoat, Millet's shepherdess might have stepped from the portals of the cathedral at Chartres or Amiens. She is too common to have graced the canvases of classicists such as Poussin or David, but her simple, massive form and restrained colors give a timeless dignity to her bearing that challenges the Arcadian beauties who tended sheep in paintings of earlier centuries.

The shepherdess is a traditional character of rural life who had become much more common in France during the eighteenth and nineteenth centuries. Frequently portrayed in art and literature as vulnerable, abandoned, and sexually available or misused, the shepherdess puzzled and fascinated Millet. Her acceptance of her solitary existence challenged him to decipher its meaning. Again and again in his letters to Sensier and conversations recorded by friends, Millet stressed the necessity of *com-*

prehending an image before he could transcribe it truly. With this early rendering of a shepherdess, Millet began his process of exploring and knowing an important motif. He narrowed his composition to its critical elements, but the melancholy of his shepherdess suggests that he still needed to understand his subject through concepts of moral judgment.

Provenance

Purchased from the artist by William Morris Hunt, Boston (probably before 1855); George Gregerson, Providence, Rhode Island; sister of George Gregerson; with Robert C. Vose Galleries, Boston (1898); purchased by Robert Dawson Evans, Boston (1907); Mrs. Robert Dawson Evans, bequeathed to the Museum with life interest to the Misses Abby and Belle Hunt, Boston.

Exhibition History

Worcester Art Museum (Massachusetts), "First Loan Exhibition," 1898, no. 151.

Related Works

Finished drawing, charcoal heightened with white on paper, 39.7 x 28.1 cm., Graphische Sammlung, Staatsgalerie, Stuttgart.

Study for shepherdess, black conté crayon on paper, 30.7 x 19.6 cm., Musée des Beaux Arts, Dijon.

Study for shepherdess, charcoal on paper, 22.5 x 13 cm., current location unknown (see Sotheby Parke Bernet, London, June 29, 1977, no. 204).

Shepherdess Leaning on her Staff, cat. no. 27.

Shepherdess leaning against a tree, black conté crayon on paper, 34.2 x 20.5 cm., Art Institute of Chicago. Adapts shepherdess to different composition.

References

Staley, Edgcumbe. *Jean-François Millet*. London: George Bell and Sons, 1903, p. 23.

28
Girl Tending a Cow
About 1852-1853
Black conté crayon on wove paper
19.3 x 14.0 cm. (7⅝ x 5½ in.)
Stamped lower right: J. F. M
Stamped, verso: VENTE MILLET
Bequest of Reverend Frederick Frothingham, 1894
94.317

Late in 1852, Millet's friend and supporter Alfred Sensier succeeded in securing for him a state commission, worth a thousand francs, for a painting of unspecified subject. Millet had several paintings well in hand, intended for the next Salon (see cat. nos. 39, 40, and 43), but for some time he had been thinking about a new composition – a young woman pasturing her cow – and he chose to undertake a wholly different subject rather than simply complete an earlier work. *Girl Tending a Cow* is a compositional sketch for that commission, which Millet did not finally complete until 1858.

Until now, Millet's choice of subjects had strongly reflected rural imagery of the past, favoring timeless tasks represented by medieval sculptors or Renaissance illustrators, or depicted in traditional illustrations of the Four Seasons. Although his pictures were always grounded in the life around him in Barbizon and in his memories of Normandy, they also established a continuity with centuries of work on the land. With *Girl Tending a Cow*, however, Millet took up a particularly contemporary theme, the landless peasant forced to accompany her cow as it grazed, to prevent it from straying into the fields or pastures of another. Young girls from struggling families, for whom the cow represented their only stake in the farming community, spent endless, mindless hours, leashed to the large, wandering bovines, prodding or pushing them to keep them along the free highways or uncultivated wastes and out of the furrows of more prosperous neighbors. This was a theme without precedent in the art of the past, for traditionally all the animals of a community had grazed together daily on the fallow land under the eye of a hired herdsman.[1]

It is not clear that Millet himself recognized the social conflict that underlay this subject at the time he took it up. In his first drawing (Museum Boymans-van Beuningen, Rotterdam) for the proposed painting, a young peasant girl sits along the roadside, deeply engrossed in her knitting,

while her proportionately too-small cow grazes behind her. When he sent the sketch to Sensier, he tempered his enthusiastic response with a cynical remark, "I don't think this composition can be considered ferociously demagogic, although, on the whole, an old sock might be susceptible to rather populistic exhalations."[2] But Millet's humor seems to reflect his still puzzled response to criticism of *The Sower* (cat. no. 18) rather than a real understanding of his subject's fate, or the forces that had trapped her.

Only in the later Boston drawing did he present the young woman standing, prepared to follow the cow as it leads. His understanding of the disastrous effects that the loss of communal rights (such as grazing, gathering, and gleaning) meant for the peasants of the broad plain of Chailly was hampered by his experiences of the very different traditions of Normandy, oriented toward larger individually owned farms; it is only as his work grew in naturalism that it also grew in the potence of its content. The final painting (turned over to the state only in 1858 and dispatched to the museum in Bourg-en-Bresse[3]) shows the young woman, led by her cow, confined to the narrow strip of waste land used for turning plows at the end of a field. Behind her spreads the vast, empty plain of Chailly, unavailable to her and her animal.

Technically, the drawing reflects Millet's method of creating from memory, rather than direct observation. The figure and her animal are probably taken from individual studies, combined here with a sketch of the forest to help him visualize a new composition. Although his young woman changed in pose and character as he worked through several composition changes, he kept one successful image of the cow in mind throughout and only its relative size changes.

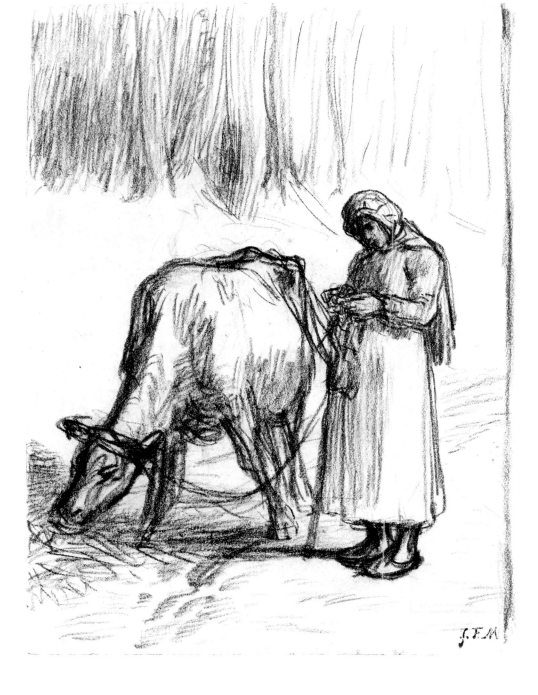

Notes

1. The breakdown of the communal farming system, whereby all the fields belonging to members of the community were worked according to a jointly determined schedule of planting, was taking place all over France throughout the nineteenth century, as larger farmers and more successful peasants fought for freedom from the constraints of a community calendar and the obligations to the poorer members of the commune that such a system entailed. One result of the lifting of restrictions on the use of the land was the loss of open pasture for all community cows; when anyone could raise crops on his land as he chose, there was no assurance that adequate pasture would remain for the families without land of their own. The loss of communal grazing for those whose existence

was marginal at best was catastrophic and contributed directly to the widespread depopulation of rural areas.

2. Millet to Sensier, probably December 6, 1852, Archives of the Cabinet des Dessins, Musée du Louvre, Paris; quoted in part in Etienne Moreau-Nélaton, *Millet raconté par lui-même* (Paris: Henri Laurens, 1921), vol. 1, pp. 108-109.

3. A museum in a more mountainous region less likely to understand the painting's complex meaning.

Provenance

Madame J.-F. Millet (sold Hôtel Drouot, Paris, April 24-25, 1894, no. 133), bought by Reverend Frederick Frothingham, Milton, Massachusetts.

Related Works

Girl Tending a Cow, cat. no. 28.

Girl Pasturing Her Cow, oil on canvas, 73 x 93 cm., Musée de l'Ain, Bourg-en-Bresse.

References

Peacock, Netta. *Millet*. London: Methuen & Co., 1905, p. 131.

29
Seated Harvesters I
(sketch for *Harvesters Resting*)
1851-1853
Black conté crayon on wove paper
8.9 x 14.0 cm. (3½ x 5½ in.)
Gift of Walter Gay, 1927
27.572

Provenance

Walter Gay, Boston.

30
Seated Harvesters II
(sketch for *Harvesters Resting*)
1851-1853
Black conté crayon on wove paper
8.6 x 13.7 cm. (3⅜ x 5⅜ in.)
Stamped, lower right: J. F. M
Lucy Dalbiac Luard Fund, 1980
1980.222

Provenance

Studio of the artist; Mr. and Mrs. Herbert Brussel (sold Sotheby Park Bernet, New York, June 3, 1980, no. 136).

31
Boaz
(study for *Harvesters Resting*)
1851-1853
Black conté crayon on wove paper
12.7 x 18.1 cm. (5 x 7⅛ in.)
Stamped, lower right: J. F. M
Bequest of Mrs. Martin Brimmer, 1906
06.2424

Provenance

Studio of the artist; Mrs. Martin Brimmer, Boston.

References

Wickenden, Robert J. "Millet's Drawings at the Museum of Fine Arts, Boston." *Print-Collector's Quarterly* 4, part 1 (1914), p. 22.

32
Woman's Back
(study for *Harvesters Resting*)
1851-1853
Black conté crayon on wove paper
31.8 x 24.5 cm. (12½ x 9⅝ in.)
Edwin E. Jack Fund, 1961
61.628 (verso)

Provenance

Studio of the artist; acquired from G. Bhyne (said to be descended from the artist) by Leicester Galleries, London (1920).

33
Man Seated in Foreground I
(studies for *Harvesters Resting*)
1851-1853
Black conté crayon on wove paper
31.8 x 24.5 cm. (12½ x 9⅝ in.)
Stamped, lower center: J. F. M
Edwin E. Jack Fund, 1961
61.628 (recto)

Provenance

Studio of the artist; acquired from G. Bhyne (said to be descended from the artist) by Leicester Galleries, London (1920).

34
Man Seated in Foreground II
(studies for *Harvesters Resting*)
1851-1853
Black conté crayon on blue-gray laid paper
31.0 x 27.1 cm. (12¼ x 10⅝ in.)
Stamped, lower left: J. F. M
Edwin E. Jack Fund, 1961
61.629 (recto)

Provenance

Studio of the artist; acquired from G. Bhyne (said to be descended from the artist) by Leicester Galleries, London (1920).

References

Herbert, Robert L. "Millet Revisited." *Burlington Magazine* 104 (July 1962), p. 302, fig. 25.

35
Man Leaning over Bale of Grain
(studies for *Harvesters Resting*)
1851-1853
Black conté crayon on blue-gray laid paper
31.0 x 27.1 cm. (12¼ x 10⅝ in.)
Edwin E. Jack Fund, 1961
61.629 (verso)

Provenance

Studio of the artist; acquired from G. Bhyne (said to be descended from the artist) by Leicester Galleries, London (1920).

34

54

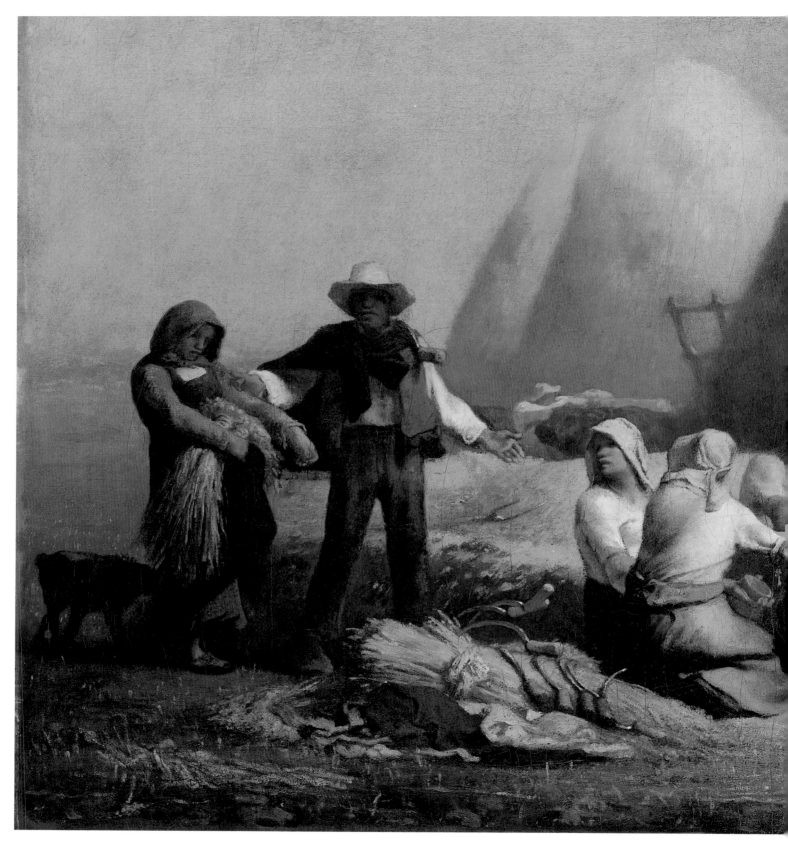

39

57

36
Man Seated on Bale of Grain
(studies for *Harvesters Resting*)
1851-1853
Black conté crayon on blue-gray laid paper
30.0 x 30.5 cm. (11¾ x 12 in.)
Edwin E. Jack Fund, 1961
61.624 (verso; see also cat. no. 49)

Provenance
Studio of the artist; acquired from G. Bhyne (said
to be descended from the artist) by Leicester Gal-
leries, London (1920).

37
Two Men Seated on a Bale of Grain
(study for *Harvesters Resting*)
1851-1853
Black conté crayon on blue-gray laid paper
31.1 x 42.2 cm. (11¼ x 16⅝ in.)
Stamped, lower right: J. F. M
Edwin E. Jack Fund, 1961
61.630 (recto; see also cat. no. 50)

Provenance

Studio of the artist; acquired from G. Bhyne (said
to be descended from the artist) by Leicester Gal-
leries, London (1920).

J. F. M

38
Man Leaning over a Bale of Grain II
(studies for *Harvesters Resting*)
1851-1853
Black conté crayon on wove paper
29.3 x 20.0 cm. (11½ x 7⅞ in.)
Stamped, center right: J. F. M
Edwin E. Jack Fund, 1961
61.627

Provenance
Studio of the artist; acquired from G. Bhyne (said
to be descended from the artist) by Leicester Gal-
leries, London (1920).

39
Harvesters Resting (Ruth and Boaz)
1850-1853
Oil on canvas
67.4 x 119.8 cm. (26½ x 47⅛ in.) – support
62.8 x 119.9 cm. (24¾ x 47⅛ in.) – design
Lower right: J. F. Millet 1853 (largely
effaced in 1970s cleaning)
Bequest of Mrs. Martin Brimmer, 1906
06.2421

For Millet, *Harvesters Resting* was the most
important work he ever painted: the pic-
ture over which he labored longest and for
which he made the greatest number of pre-
paratory sketches and studies,[1] the only
painting he ever dated,[2] and the first work
to win him official recognition in the form
of a second-class medal at the Salon of 1853.
It is his true masterpiece, in the old sense
of a special work submitted to demonstrate
command of his craft, and the picture in
which he consciously set out to rival his
heroes of painting, Michelangelo and Pous-
sin. Most important, it is the picture in
which he moved from emblematic imagery
of peasant life to the issues of contempo-
rary social history.

A leading critic, Paul de Saint-Victor,
described the painting as "a Homeric idyll
translated into the local dialect....Just in
time, here is the poetry and the majesty of
the populace. You will find yourself struck
with respect before these simple peasants
....[who are]superbly ugly, brutal, and
primitive."[3] By the refined standards of
most Salon paintings, Millet's peasants –
leaning forward with their hands to their
mouths, staring across spoons poised in
mid-air, or clumsily resisting inclusion in
the group – were inelegant and common;
and given the Parisian tendency to see in
the French peasant more animal than man,
"brutal" was a typical critical reaction. But
Saint-Victor's most telling comment is his
recognition of the painting as an age-old
story brought powerfully up to date. With
Harvesters Resting, Millet put the cumula-
tive weight of centuries of historic tradi-
tion, as well as his personal version of old
master craftsmanship, behind a plea for res-
olution of the great Social Question of the
1850s.

Millet's interest in depicting harvesters at
their noonday meal preceded his adaptation
of the Ruth and Boaz theme[4] (his original
title for this painting), for there exist a
large number of drawings, datable to 1847-
1848, of small groups of figures standing or
seated at the base of a grain stack, relaxing
and eating from a common bowl, with

their sickles left to one side.[5] These early drawings may reflect Millet's walks on the outskirts of Paris or memories of Normandy, although he ultimately adapted his picture to reflect the prevailing rural order of Chailly. It was a standard procedure for him to seek a biblical source when he had found an event or scene he wished to translate into a major work (see cat. no. 3); and for a harvesting scene he would not have had far to look: the theme of Ruth and Boaz (a story that most critics recognized in the final work) appears frequently in Western art.[6] It was particularly well known to Millet and his French audiences through the beautiful painting *Ruth and Boaz: Summer* by the seventeenth-century master Nicolas Poussin, an artist he especially admired.[7]

The story is that of Ruth, from the Book of Ruth in the Old Testament, a young Moabite woman who married into another tribe and, according to custom, went to live with her husband's family. Her widowed mother-in-law, Naomi, lived with them and when Ruth lost her husband as well, the two women were left on their own. By law and by custom, Ruth was entitled to return to her own family, but she loyally took on the burden of support and protection for her mother-in-law. Alone, they returned to Bethlehem, Naomi's homeland, where Ruth could only provide for them by gleaning in the field of a wealthy relative – that is, by following behind the harvesters to gather any blade of grain that escaped their sheaves. She was noticed by the landowner, Boaz, who invited her to join his harvesters for their meal, and who, when he learned of her loyalty and tireless hard work, took her for his own bride.[8]

Alfred Sensier recalls that in 1849 the first new work Millet executed in Barbizon was a picture of Ruth and Boaz drawn on the walls of his studio.[9] Shortly thereafter, he must have begun the series of compositional drawings, using figures in vaguely ancient dress, that now belong to the Musée Bonnat in Bayonne. The first indication that Millet actually had a painting of the theme underway comes in a letter to Sensier of October 18, 1851, when he mentioned that sketches and life studies for a *Ruth and Boaz* canvas were going well.[10]

With fourteen large foreground figures, *Harvesters Resting* is the most complex painting Millet ever made. It is a composition in the grand tradition, in which understanding of the painting's subject is conveyed primarily by the interrelation of human figures and their gestures, not by anecdotal details of setting or costume. The ambitions behind such a demanding picture must have been very high, and Millet labored at the project through all the careful steps he had learned in Delaroche's studio for the preparation of a major history painting.[11] He tried out several versions of the composition in large drawings, and gradually the setting shifted from tree-shaded, hilly countryside reminiscent of Poussin's Italianate composition to the flat, deep plain of Chailly, where only grain stacks provided shelter from the sun.

When he arrived at the basic composition, the standing figures of Ruth and Boaz connected to the group of seated harvesters by Boaz's outstretched arm, he turned his attention to the circle of laborers that spreads across two-thirds of the foreground. So large a group of figures was a direct challenge to the tradition of Poussin – who in so many of his works shaped his foreground spaces with large groups of irregularly placed figures whose poses and gestures related each to the next in complicated rhythms – which provided the standards of composition still honored by the Ecole des Beaux-Arts.[12] Millet made a number of small sketches of the group as a whole (cat. nos. 29 and 30) before returning to the development of the complete composition. In a large drawing of mixed media (black conté crayon, pastel, gouache and oil on paper; Cabinet des Dessins, Musée du Louvre, Paris) each figure was carefully drawn, following the compositional sketches, and colored to explore relations of hue and costume throughout the composition. Then he took up work on the individual figures in turn. Each was studied in the nude (cat. no. 32) and then carried through a series of careful drawings (cat. nos. 31, 33, 35, 36, 37, 38) in which pose and costume were refined or corrected from direct observation and even details of feet or hands were worked again and again (cat. no. 38). While Millet may have used a studio mannequin or works of art to study some of the poses or costumes,[13] the care and character conveyed by drawings such as the superb study of shadows on Boaz's face in cat. no. 31, or the sheet of heads now in the Snite Gallery at Notre Dame University, are evidence of living models. Then, before transferring final drawings to his canvas, Millet reduced them to simple, definitive outlines (cat. no. 37), which he might rework further as many as six or seven times, shifting segments of the broken outline that is characteristic of his drawing at this stage, to alter almost imperceptibly the placement of a foot or a fold of drapery (cat. no. 34).[14] Finally, when absolutely satisfied with the silhouette and the interior details of each figure, he would rub the back of the drawing with black crayon and carefully retrace the outlines onto the primed canvas surface of his painting.

In the earlier oil- and pastel-colored *ébauche* (or sketch),[15] Millet had worked out the basic pattern of color for the picture, established in the final painting in the paired figures of Ruth and Boaz, she in a range of range of blues, he in a complex interplay of ruddy browns and yellows. The harvesters, lesser protagonists in the drama, all wear shirts in a range of weathered whites, while their pants, skirts, hats, hoods, and protective oversleeves are worked out in innumerable variations of blue and red-brown. The pink-yellow mist that hangs in the air, warming all the colors, reflects the heat and graindust-drenched atmosphere in which the harvesters work. In the heavily worked paint surfaces, built up of hundreds of small touches of color, Millet continued all the care he had taken with his drawings as he labored to preserve powerful silhouettes while shaping the figures in the round.[16]

Such careful, labored preparation of a major painting was official studio practice, as taught by the Ecole des Beaux-Arts, but by 1850 very few artists were following the practice so assiduously, and certainly none of the artists of Millet's own circle. But his own commitment to the grand tradition, as he absorbed it in Cherbourg and in Delaroche's studio, and his own ambition "to make pictures that mattered"[17] did not allow him to settle for less, especially when the work in question followed on the heels of his encouraging reception at the Salon of 1850 (see cat. no. 18), and when he knew he had chosen subject matter and compositions that begged comparison with his cherished idols.

From the beginning of his work, Millet had favored a different aspect of the Ruth story than that used by most artists before him, choosing the moment at which Boaz invites the young woman to eat with his harvesters, rather than the moment of introduction used by Poussin.[18] In addition to choosing distinctly modern dress, he consciously diminished the distinctions of costume that had usually differentiated the wealthy landowner from his foreman, his

laborers, and finally the young gleaner.[19] Millet's Boaz is not the owner of the prosperous farm that requires at least thirteen workers to harvest its acres and has produced the mountains of grain that close off the background; he is literally a middleman, a *métayer* (or sharecropping farmer) who worked the lands on behalf of an absent, probably city-dwelling, landlord, with laborers employed by the day for special tasks such as the harvest. He invites a reluctant Ruth, prodded by the nudging of the dog, to join the circle of harvesters who, she seems to sense, might otherwise disdain her company.

In biblical times and well into the nineteenth century, gleaning had been a time-honored right open to all members of the community when the harvests were finished, although usually practiced only by those too old to work their own land or those too poor. But with the changing emphasis from farms supporting single families to large enterprises producing surpluses of food for nonproductive city populations, gleaning and other general privileges that cut into production or hindered optimum use of the land were first restricted by law or social opprobrium, then outlawed by individual communities. As new inheritance laws and the pressure of larger-farm owners increasing their acreage cut average farm size far below the minimum needed to sustain a family, more and more peasantry found themselves in need of communal rights at exactly the time those rights were under greatest attack.[20] During the 1830s and 1840s, the numbers of desperately poor soared dramatically in the countryside, and in the highly productive agricultural plains close to Paris, a new phenomenon developed: migrant families or single workers seeking refuge in the no-man's land of the forest before the last resort of moving into the Parisian slums. As the political reforms of 1848 were more or less absorbed by the realities of the Second Empire,[21] the Social Question of the poor, who seemed to lack any meaningful place in society, became a pressing issue.

Although there is no villain yet in Millet's plea for the inclusion of the poorest of the poor within the community of France, his presentation of the Social Question certainly strained the common, Parisian understanding of the situation, which in another time-honored tradition blamed the victims for their plight. By casting his gleaner as Ruth, long an image of feminine strength, virtuous character, loyalty, and

willingness to work,[22] Millet argued for the recognition of those virtues in the abandoned or desperate poor of his own day, and for reconciliation across the classes, not further forced distinctions among them.

Notes

1. Nearly 50 sheets of preparatory drawings, both sketches for the composition as a whole and studies of individual figures, are known today and references or descriptions exist for still more.

2. Photographs document the now very damaged signature at lower right as *J. F. Millet 1853*. Only one other finished Millet work is dated, the nearly contemporary presentation drawing for his government commission of 1852 (Musée Boymans-van-Beuningen, Rotterdam; see cat. no. 28). (The many small watercolors of Vichy, which are dated but not necessarily signed, were intended as studies of season or year, not as a matter of pride or identification.) Millet's painted signatures are quite vulnerable and many have been damaged or totally effaced in otherwise cautious cleaning. He would not finish his paintings until he could see them in their frames, and, as his letters speak routinely of finishing or adjusting Salon paintings at friends' studios in Paris, the pictures were probably protected during the transit from Barbizon with at least a light coat of varnish. Even a thin layer would have prevented a signature from bonding to the paint beneath, and might also have suggested to some conservators a later, false addition. For Millet's concern about dust and damage during travel, see letter to Calmette of December 14, 1859.

3. Paul de Saint-Victor, salon review in *Le Pays* (August 13, 1853).

4. Millet may have been attracted to the theme by a painting he remembered from Cherbourg: Jean-Louis Demarne's *Haymakers' Lunch* (Musée Thomas Henry), which includes several details that reappear in *Harvesters Resting*. During his early years in Barbizon he often turned to earlier artists for guidance in shaping the subject matter of his daily life into paintings.

5. See, for instance, the pen-and-ink sketches of harvesters eating beneath a haystack (Cabinet des Dessins, Musée du Louvre, Paris [GM10307]), identified by the Louvre as studies for *Harvesters Resting*, but probably an independent project, since the sketches predate the painting considerably and have little relation to the final composition. Although the sequence of Related Works included with this entry suggests that most of the compositional sketches of seated harvesters were made after Millet's development of the basic two-part (Ruth and Boaz and seated harvesters) image, it is quite possible that the circle of seated figures developed fairly independently of the Ruth and Boaz theme. One of the most complete figure groups related to the Boston painting, the drawing sold at Christie's in 1970, includes several poses and motifs that continued into the final work but it is centered on its page with no suggestion of a missing Ruth and

Boaz and includes no harvesters looking away from their meal.

6. The story of Ruth appears often as thematic justification for a picture depicting Summer and grain harvests, or as subject matter introducing images of grain and bread in decorative schemes for dining rooms. The story of Ruth would have appealed to Millet as a time-honored subject readily adaptable to secular presentation, but initially it might also have held a more personal meaning. He had long favored stories and images of abandoned women or women quietly bearing betrayal, a recollection of his mother's and grandmother's stoic acceptance of their fate when he, the eldest son and only child old enough to manage the family farm, set off for Paris to study in 1837.

7. One of a set of Four Seasons originally commissioned for the Duc de Richelieu, *Ruth and Boaz* had been part of the Louvre Collection from its opening, and nineteenth-century catalogues indicate that it was regularly on exhibition.

8. As the wife of Boaz, she gave birth to Obed, father of Jesse, from whom the family of David and ultimately Christ was descended.

9. Alfred Sensier and Paul Mantz, *La Vie et l'oeuvre de J.-F. Millet* (Paris: A. Quantin, 1881), p. 119.

10. Archives of the Cabinet des Dessins, Musée du Louvre, Paris.

11. Millet was concerned about rendering so many figures and early in May of 1851, he asked Sensier to find him a life-size lay figure (a mannequin) that he could dress in modern clothing and use to study poses. The figure arrived in Barbizon broken and caused Millet a great deal of trouble with joints that didn't move properly (see letters from Millet to Sensier, March 24 and October 18, 1851, and others, Archives of the Cabinet des Dessins, Musée du Louvre, Paris).

12. Robert L. Herbert (*Jean-François Millet* [Paris: Editions des Musées Nationaux, Grand Palais exhibition catalogue, 1975], p. 95) has noted that several of the figures in Millet's painting derive from Poussin's *Eucharist* (from the "Seven Sacraments" series, Collection of the Earl of Ellesmere, Scotland).

13. In particular, the seated man in the foreground, who figures in an exceptionally large number of drawings and who owes much of his ultimate character to Michelangelo, is based on an exquisite *académie* (or nude study) by David in the Musée Thomas Henry, Cherbourg.

14. For a sensitive and thought-provoking discussion of Millet's use of drawing for preparatory works such as these, see Robert L. Herbert, "Millet Revisited I," *Burlington Magazine* 104 (July 1962), p. 302.

15. Cabinet des Dessins, Musée du Louvre, Paris (R.F.4182). The finished painting never returned to Millet after the Salon, having been acquired by the young Bostonian Martin Brimmer at the urging of William Morris Hunt. Consequently the *ébauche* became an especially treasured work for Millet, the only object he ever declined to sell his friend and patron Alfred Sensier (see the very firm refusal, Millet to Sensier, December 6, 1852, Archives of the Cabinet des Dessins, Musée du Louvre, Paris). At Millet's death, the sketch was given by his family to William Perkins Babcock, the Boston expatriate who had lived in Barbizon since 1849 and become one of Millet's closest friends; Babcock returned it,

following the death of Millet's widow, to serve as the featured centerpiece of the second Millet studio sale. It was acquired then by Walter Gay, another Boston artist, who later presented it to the Louvre.

16. In addition to its debt to David, mentioned above, this figure pays tribute to the powerfully muscular figures of Michelangelo's *Last Judgment* and the Sistine Ceiling. Given the unusual number of studies used to prepare it, the figure must have represented Millet's effort to rival Michelangelo's "haunting" ability to "tell with just a simple figure all the good and evil of mankind" – Millet's description of a drawing, then known as *The Fainting Man*, which entered the Louvre in 1850 (see Alfred Sensier and Paul Mantz, *La Vie et l'oeuvre de J.-F. Millet* [Paris: A Quantin, 1881], p. 53).

17. Etienne Moreau-Nélaton, *Millet raconté par lui-même* (Paris: Henri Laurens, 1921), vol. 2, p. 132.

18. The moment depicted by Poussin occurs when the patriarchal Boaz meets the young woman, presented to him by one of his laborers. Contemporaries of Millet, Puvis de Chavannes and Charles Gleyre, both used the Ruth and Boaz theme at virtually the same time as Millet – Puvis in the dining room of his brother's home at Brouchy (see *Puvis de Chavannes* [Paris: Editions des Musées Nationaux, Grand Palais exhibition catalogue, 1976], pp. 37-43, no. 10), Gleyre for an oil painting, now lost (see reproduction, *Charles Gleyre ou les illusions perdues* [Winterthur: Kunstmuseum, exhibition catalogue, 1974], fig. 74). But they used ancient dress and stuck closely to the standard iconography of the theme.

19. In an early drawing (now in a private collection), Boaz wore a brass-buttoned jacket; it was part of the pile of clothing and sickles at his feet in still another drawing (Yale University Art Gallery, New Haven), and was finally innocuously tied around his shoulders with the buttons out of sight.

20. The 1830s and 1840s saw extraordinary economic and social change in France, change tacitly recognized in the redistribution of power instituted or promised by the revolutions of 1848. The Industrial Revolution made itself fully felt in France only after the Napoleonic wars, and the first half of the nineteenth century can be characterized as a period of catching up with England and Germany, with a consequent reordering of resources and redistribution of disposable wealth. Change that was welcomed as progress in the cities, however, was by 1853, beginning to be recognized as calamity in the countryside. The essential problems of grain, bread, and ultimately survival continued to oppress the peasantry, and large numbers of peasants were forced to leave rural areas that could not support them to seek work in cities that were not prepared to accommodate them. The population of Paris, which had grown by only one and a half percent between 1790 and 1831, then doubled between 1831 and 1861; and with the evidence of so large a mass of sorely tried, poverty-battered countrymen literally at their feet, Parisians were forced to acknowledge that the prosperity of the Second Empire was not being distributed equitably. For the social and economic situation in France at mid-century, see Robert L. Herbert, "City vs. Country: the Rural Image in French Painting from Millet to Gauguin," *Artforum* 8 (February 1970), pp. 44-55, and Ernest Labrousse, "The Evolution of Peasant Society in France from the Eighteenth Century to the Present," *French Society and Culture since the Old Regime*, translated by David Landes, edited by Evelyn M. Acomb and Marvin L. Brown, Jr. (New York: Holt, Rinehart and Winston, 1966), pp. 43-66.

21. Bourgeois fear of an enfranchised peasantry was somewhat assuaged by the conservative deputies elected by most rural communities and by the overwhelming popular support for Louis Napoléon in 1850. With the *coup d'état* that proclaimed Napoléon emperor in 1851, many of the political issues that had burned so hotly for three years became moot.

22. Miriam Braverman of the Museum of Fine Arts, Boston, staff has called my attention to the fact that Ruth wears a blue dress, blue being the color traditionally associated with the Virgin. Her blue kerchief is fashioned into a loose hood that resembles the traditional draped cloak of the Virgin as well. In her role as mother of Obed and therefore a founder of the Tree of Jesse, Ruth was an Old Testament prefiguration of the Virgin, also admired for her modesty and willing acceptance of her lot, and thus Millet's conflation of the two women adds another layer of religious argument to his plea.

Provenance
Purchased from the artist by Martin Brimmer, Boston (1853), Mrs. Martin Brimmer (1894).

Exhibition History
Salon, Paris, 1853, no. 837.
Athenaeum, Boston, "Twenty-seventh Exhibition," 1854, no. 120.
Athenaeum, Boston, "Thirty-third Exhibition," 1859, no. 166.
Athenaeum, Boston, "Thirty-fourth Exhibition," 1859, no. 71.
Allston Club, Boston, "First Exhibition," 1866, no. 21, as *Noon*.
Exhibited frequently at the Museum of Fine Arts, Boston from 1876 until time of bequest, 1906.
Jewett Art Center, Wellesley College, Wellesley, 1945.
Addison Gallery, Phillips Academy, Andover, Massachusetts, 1945.
Fort Worth, "Centennial Exhibition," 1949, no. 5.
Los Angeles County Fair Association, Pomona, California, "Masters of Art from 1790 to 1950," 1950, unnumbered, as *The Reapers*.
Museum of Fine Arts, Houston, "Corot and his Contemporaries," 1959, unnumbered.
Wadsworth Atheneum, Hartford, "Harvest of Plenty," 1963.
Yomiuri Shimbun, Tokyo, "Jean-François Millet et ses Amis," 1970, no. 2.
Grand Palais, Paris, "Jean-François Millet," 1975, no. 59 (Hayward Gallery, London, 1976, no. 38).
Cleveland Museum of Art, "The Realist Tradition: French Painting and Drawing, 1830-1900," 1980, no. 49.

Related Works
Compositional sketch with Ruth and Boaz entering from left and four harvesters seated on two levels beneath a tree, black conté crayon on paper, 26.6 x 37.7 cm., Musée Bonnat, Bayonne.
Compositional sketch of three figures seated on hummocks, black conté crayon on paper, 6.2 x 4.5 cm., Ashmolean Museum, Oxford.
Compositional sketch of Boaz welcoming Ruth, probably cut from the following drawing, black conté crayon on paper, 26.4 x 18.9 cm., Musée Bonnat, Bayonne.
Compositional sketch of harvesters seated beneath a tree, black conté crayon on paper, Musée Bonnat, Bayonne.
Compositional sketch of harvesters beneath a tree, black conté crayon on paper, 15 x 26 cm., current location unknown (see Christie's, London, April 17, 1970, no. 27).
Compositional sketch of two harvesters seated around a bowl, black conté crayon on paper, 19.5 x 26.5 cm., private collection, Paris.
Fragment of a compositional sketch of harvesters seated, black conté crayon on paper, Musée Bonnat, Bayonne.
Compositional study, Ruth and Boaz entering from right with harvesters seated beneath grain stacks, pastel, oil, watercolor, and black chalk on paper, 48.0 x 86.2 cm., Cabinet des Dessins, Musée du Louvre (RF 4182).
Compositional sketch of seated harvesters, cat. no. 29.
Compositional sketch of seated harvesters, cat. no. 30.
Compositional sketch of seated harvesters, black conté crayon on paper, 4.8 x 10.3 cm., current location unknown (Paris art market 1960s).
Compositional sketch of seated harvesters, black conté crayon on paper, 5.2 x 9.8 cm., current location unknown (Paris art market 1960s).
Compositional sketch of seated harvesters, black chalk on paper, 7.0 x 8.8 cm., Cabinet des Dessins, Musée du Louvre, Paris (GM10684).

Study of Ruth and Boaz, black conté crayon on gray paper, 26.0 x 24.5 cm., Cabinet des Dessins, Musée du Louvre, Paris (GM10556).

The following studies of individual figures are arranged from left to right, moving clockwise through the group of seated harvesters. Within the studies for each figure, individual sheets are listed in probable sequence of execution.

Study of Ruth standing in place, black conté crayon on paper, 31.0 x 15.5 cm., Fondation Custodia (coll. F. Lügt), Institut Néerlandais, Paris.
Study of Ruth walking forward, black conté crayon on paper, current location unknown (see Alfred Sensier and Paul Mantz, *La Vie et l'oeuvre de J.-F. Millet* [Paris: A. Quantin, 1881], p. 143).

Studies of hand and arm of Boaz, black conté crayon on gray paper, 26.0 x 24.5 cm., Cabinet des Dessins, Musée du Louvre, Paris (GM10556 verso).

Studies for gesture and jacket, right arm of Boaz, black conté crayon on paper, 31.1 x 18.8 cm., private collection, New York.

Study for *Boaz*, cat. no. 31.

Additional studies on sheets principally concerned with other figures.

Woman's Back, cat. no. 32.

Two studies of woman holding jug, black conté crayon on paper, 30.3 x 46.0 cm., Yale University Art Gallery, New Haven.

Studies of a woman holding jug, black conté crayon on paper, 16.7 x 28.7 cm., private collection, London.

Study of woman holding jug, current location unknown (see Sotheby, London, June 29, 1967, no. 31).

Study of woman holding jug, probably traced from above, black conté crayon on paper, 30.3 x 36.0 cm., Yale University Art Gallery, New Haven.

Study of woman holding jug with sheaf of grain to her left, black conté crayon on paper, 24 x 21 cm., current location unknown.

Study of seated female harvester, left center, black conté crayon on paper, 20.5 x 13.0 cm., current location unknown (sold Henri Rouart, Galerie Manzi Joyant, Paris, December 17-18, 1912, no. 20).

Study of head of woman, black conté crayon with white highlights on paper, 13.0 x 8.5 cm., Art Institute of Chicago.

Study of harvester crouching with right arm on knee, with studies of the foreground harvester and studies of Ruth, black conté crayon on paper, 35 x 53.2 cm., current location unknown (London art market in 1960s).

Studies of harvester spooning from bowl, harvester to right with hands to mouth, hands holding spoon, and Boaz's left hand, black conté crayon on paper, 11 x 17 in., private collection, Norfolk, Virginia.

Study of harvester spooning from bowl, 24.4 x 31.6 cm., black conté crayon on paper, Snite Gallery, Notre Dame University, South Bend.

Studies of heads for harvester crouching, harvester spooning from bowl, and harvester seated on bale of grain and leaning forward, 24.4 x 31.6 cm., black conté crayon on paper, Snite Gallery, Notre Dame University, South Bend.

Study for hooded figure in right center, study for Boaz, black conté crayon on paper, 10 x 9½ in., current location unknown (see Converse sale, Anderson Galleries, New York, November 7-8, 1923).

Two Men Seated on a Bale of Grain, cat. no. 37.

Study of a man seated on a bale of grain, black conté crayon on paper, 29.3 x 45.5 cm., Art Gallery, Hamilton, Ontario.

Studies of harvester seated to right holding spoon, black conté crayon on paper, 30 x 32.2 cm., current location unknown (London art market, 1960s).

Fragment of a study of harvester seated to right holding spoon, black conté crayon on paper, 16 x 15.1 cm., current location unknown (London art market in 1960s).

Study of feet for harvester leaning over bale of grain, cut from following drawing, black conté crayon on paper, 8.4 x 14.1 cm., current location unknown (London art market in 1960s).

Study of legs and torso, black conté crayon on paper, 8.7 x 12.3 cm., Cabinet des Dessins, Musée du Louvre, Paris (GM10472 verso).

Study of figure leaning over a bale of grain, cat. no. 35.

Studies of harvester leaning over bale on grain, black conté crayon on paper, 25.4 x 21.5 cm., Musée Bonnat, Bayonne.

Study of figure leaning over bale of grain, foot of foreground harvester, cat. no. 38.

Study of foreground harvester with bare back, black conté crayon on paper, 20.4 x 16.3 cm., Musée Bonnat, Bayonne.

Study of foreground harvester, black conté crayon on paper, 20.1 x 31.2 cm., current location unknown (London art market in 1960s).

Studies of foreground harvester, cat. no. 33.

Study of foreground harvester with shirt, black conté crayon on paper, 20.5 x 17.7 cm., Musée Bonnat, Bayonne.

Studies of foreground harvester, cat. no. 34.

Study of foreground harvester, black conté crayon on paper, 41 x 28.5 cm., current location unknown (London art market 1970s).

Study of pile of clothing, black conté crayon on paper, 7 11/16 x 12¼ in., Yale University Art Gallery, New Haven.

References

Couturier, P.L. *Millet et Corot*. Saint-Quentin, 1876.

Wheelwright, Edward. "Personal Recollections of Jean François Millet." *Atlantic Monthly* 38 (September 1876), p. 261.

Strahan, Edward. *Art Treasures of America*. Philadelphia: George Barrie, 1879, vol. 3, pp. 81-82.

Sensier, Alfred, and Mantz, Paul. *La Vie et l'oeuvre de J.-F. Millet*. Paris: A. Quantin, 1881, pp. 141-144.

Claretie, Jules. *Peintres et sculpteurs contemporains*. Paris: Librairie des bibliophiles, 1882, first series, pp. 87-88.

Durand-Gréville, E. "La Peinture aux Etats-Unis." *Gazette des Beaux Arts* 2nd ser., 36 (July 1887), p. 67.

Stranahan, C. H. *A History of French Painting*. New York: Scribner, 1888, pp. 374-375.

Breton, Jules. *La Vie d'un artiste*. English edition, New York, 1890, pp. 224-225.

Mollett, John W. *The Painters of Barbizon*. London: Sampson, Low, Marston, Searle & Rivington, 1890, p. 29.

Thomson, David Croal. *The Barbizon School of Painters*. London: Chapman and Hall, 1890, p. 226.

Le Livre d'or de J.-F. Millet par un ancien ami. Paris: Ferroud, 1891.

Cartwright, Julia M. *Jean-François Millet, his Life and Letters*. London: Swan Sonnenschein & Co., 1896, pp. 124-125, 370.

Michel, André. *Notes sur L'Art Moderne/Peinture*. Paris: Armand Colin, 1896, p. 44.

Naegely, Henry. *J.-F. Millet and Rustic Art*. London: Elliot Stock, 1898, p. 73.

Breton, Jules. *Nos Peintres du siècle*. Paris: Société d'Edition Artistique, 1899, pp. 150-152.

Knowlton, Helen M. *Art Life of William Morris Hunt*. Boston: Little, Brown and Company, 1899.

Gensel, Walther. *Millet und Rousseau*. Bielefeld and Leipzig: Velhagen & Klasing, 1902, p. 38.

Alexandre, Arsène; Keppel, Frederick; and Holme, C. J. "Corot and Millet." *Studio* special issue (1902-1903).

Marcel, Henry. *J.-F. Millet*. Paris: Henri Laurens, 1903, pp. 36-37.

Staley, Edgcumbe. *Jean-François Millet*. London: George Bell and Sons, 1903, p. 17.

Peacock, Netta. *Millet*. London: Methuen & Co., 1905, pp. 73-74.

Tomson, Arthur. *Jean-François Millet and the Barbizon School*. London: George Bell and Sons, 1905, pp. 64, 68.

Leprieur, Paul, and Cain, Julian. *Millet*. Paris: Librairie Centrale des Beaux-Arts, 1913, pp. 42-43.

Wickenden, Robert J. "Millet's Drawings at the Museum of Fine Arts, Boston." *Print-Collector's Quarterly* 4, part 1 (1914), p. 22.

Bryant, Lorinda Munson. *What Pictures to see in America*. New York: John Lane Company, 1915.

Moreau-Nélaton, Etienne. *Millet raconté par lui-même*. Paris: Henri Laurens, 1921, vol. 1, pp. 99-100, 104-105, 110-114, 116, fig. 86; vol. 2, pp. 1, 122; vol. 3, p. 115.

Gsell, Paul. *Millet*. Translated by J. Lewis. New York: Dodd, Mead, 1928, p. 32.

Tabarant, Adolphe. *La Vie artistique au temps de Baudelaire*. Paris: Mercure de France, 1942, p. 200.

Drawings by Jean-François Millet. London: Arts Council of Great Britain, exhibition catalogue, 1956.

Herbert, Robert L. "Millet Reconsidered." *Museum Studies* (Art Institute of Chicago) 1 (1966), p. 36.

Herbert, Robert L. "City vs. Country: the Rural Image in French Painting from Millet to Gauguin." *Artforum* 8 (February 1970), p. 50.

Whitehill, Walter Muir. *Museum of Fine Arts, Boston: A Centennial History*. Cambridge: Belknap Press, 1970, vol. 1, p. 370.

Bouret, Jean. *L'Ecole de Barbizon*. Neuchâtel: Editions Ides et Calendes, 1972, p. 177, color reproduction.

Pollock, Griselda. *Millet*. London: Oresko Books, 1977, pp. 46-47, fig. 24.

Meixner, Laura L. *An International Episode: Millet, Monet and their North American Counterparts*. Memphis: The Dixon Gallery and Gardens, exhibition catalogue, 1982, pp. 16, 21, 32, 72, fig. 7.

40

Shepherd and Flock at the Edge of the Forest, Evening
1853
Oil on canvas
60.0 x 49.5 cm. (23⅝ x 19½ in.)
Lower right: J. F. Millet
Gift of Quincy Adams Shaw through
Quincy A. Shaw, Jr., and Mrs. Marian
Shaw Haughton, 1917
17.1490

In addition to *Harvesters Resting*, Millet sent two smaller paintings representing very different sides of his art to the Salon in 1853. One of them, *Shepherd and Flock at the Edge of the Forest, Evening*, was a reworking of an earlier Barbizon sheep-herding scene, cat. no. 15. Unlike either the complexly polemical *Harvesters Resting* (cat. no. 39) or the tiny, exquisitely colored *Shearing Sheep* (cat. no. 43), *Evening* (as most critics called it) is a daringly simple record of the half-light of nightfall and of quiet.

During his first year or two in Barbizon, Millet had spoken repeatedly to Sensier of his desire to paint landscapes that would express his own sense of wonder at the beauty and stillness of the great forest; nonetheless, landscape painting played very little part in his oeuvre until 1853, when he undertook his first serious efforts at subordinating figurative subject matter to problems of atmosphere and mood. Despite its generally warm reception at the Salon, however, *Shepherd and Flock at the Edge of the Forest* had few successors in his art until he returned again to landscape painting in 1866.

Today very damaged by the deterioration of the pigments,[1] the painting still retains something of the poetry most critics appreciated in it in 1853. With a very limited palette of blues, browns, and grays, Millet stressed the contrast between the bare tree trunks and the great empty distance beyond, into which all light and color in this painting seems to be drawn. Only faint hints of pink light the sky near the horizon. The solitary shepherd, watching from a rock at the edge of the forest, is a mediator between two very differently characterized worlds.

Millet's fascination with twilight, which forced the observer to look more carefully and closely at even the most common objects, is partially explained by his commitment to draftsmanship – to isolating in black and white the most telling forms and silhouettes of objects and gestures. But he was also drawn to the quiet that descended

on the woodlands and plains as all but the shepherds returned to the village at the end of the day. To Sensier, he explained, "It's never the joyous side [of life] that shows itself to me; I don't know where that is, I haven't ever seen it. What I know of happiness is the quiet, the silence that you can savor so deliciously, either in the forests, or in the fields...."[2]

Millet found a particular reassurance in the endlessly repetitive quality of the events that took place at this hour; and *Evening* is as much a commitment to preserving the symbols of the past as it is to grappling with the scenes immediately around him. His solitary shepherd, framed between the tall, young trees of the forest edge and a sheepfold typical of Chailly, stares off into the sky in the pose of so many shepherds receiving the announcement of Christ's birth.

Notes

1. The large, gaping cracks that mar much of the sky record Millet's use of bitumen, a pigment that never adequately dried and pulled the layers of paint above it into patchy blocks as it shrank. Bitumen, which became popular among French painters early in the nineteenth century, offered the artist a very attractive range of golden browns, preferable to the muddier shades available by mixing other colors, but it was very unstable and had been abandoned by most painters by mid-century.

2. Millet to Sensier, February 1, 1851, Archives of the Cabinet des Dessins, Musée du Louvre, Paris, quoted in Alfred Sensier and Paul Mantz, *La Vie et l'oeuvre de J.-F. Millet* (Paris: A. Quantin, 1881), p. 130.

Provenance

Purchased from the artist by William Morris Hunt (1853), sold through Doll and Richards, Boston, to Quincy Adams Shaw, Boston (1874).

Exhibition History

Salon, Paris, 1853, no. 838.

Museum of Fine Arts, Boston, "Quincy Adams Shaw Collection," 1918, no. 10.

Related Works
Compositional sketch of figure, black conté crayon on paper, 8.1 x 4.7 cm., Cabinet des Dessins, Musée du Louvre, Paris (GM10587).

Compositional sketch, black conté crayon on paper, 13.3 x 8.3 cm., current location unknown.

Compositional sketch, pencil on paper, 18.5 x 13.8 cm., Cabinet des Dessins, Musée du Louvre, Paris (GM10588).

Finished drawing, black conté crayon on paper, 39 x 30 cm., Fogg Art Museum, Harvard University, Cambridge.

References
"'Greta's' Boston Letter." *Art Amateur* 5, no. 4 (September 1881), p. 72.

Sensier, Alfred, and Mantz, Paul. *La Vie et l'oeuvre de J.-F. Millet.* Paris: A. Quantin, 1881, p. 143.

Mantz, Paul. *Catalogue descriptif...J.-F. Millet.* Paris: A. Quantin, 1887, p. 18.

Knowlton, Helen M. *Art-Life of William Morris Hunt.* Boston: Little, Brown and Company, 1899, p. 98.

Cartwright, Julia. *Jean-François Millet: His Life and Letters.* London: Swan Sonnenschein, 1902, p. 125.

Rolland, Romain. *Millet.* London: Duckworth & Co., 1902, pp. 80-82.

Peacock, Netta. *Millet.* London: Methuen & Co., 1905, p. 74.

Moreau-Nélaton, Etienne. *Millet raconté par lui-même.* Paris: Henri Laurens, 1921, vol. 1, pp. 110, 116-17, fig. 90.

41
Shepherd and Flock on the Edge of a Hill, Twilight
About 1852-1854
Black conté crayon on wove paper
19.2 x 31.0 cm. (7½ x 12¼ in)
Stamped, lower right: J. F. M
Gift of Reverend and Mrs. Frederick Frothingham, 1893
93.1466

Shepherds trailed by their flocks appear along the horizon of many of Millet's drawings and pastels during the 1850s and 1860s, and this record of one of his many twilight walks is the source for background details in two more finished works, *End of the Day* (cat. no. 42) and *Watering Cows* (cat. no. 100). After two years of prowling the forest edge, Millet was now so familiar with motifs such as the shepherd and his straggling sheep that he could summarize them with forms that are almost caricatural in their simplicity.

Using the rising slope to mask the setting sun, Millet pressed the twilight contrasts of black and white to a surprisingly abstract point. The composition is aligned along the ridge of the hill, with trees, figure, and sheep so strongly silhouetted that the light seems almost to glow through them. In the unusual consistency of his crayon strokes, through shepherds, sheep, and densely spaced bushes alike, one can see the tentative origins of the extraordinary black crayon technique that marked his drawings at the end of the decade (see cat. no. 78).

This is one of Millet's earliest images of a shepherd that can be securely identified with the Barbizon countryside, representing, as the catalogue of his studio sale indicates, the heights of La Plante à Biau, a hilly, recently replanted stand of trees along the edge of the Plain, just outside the village.[1] At least three sizable sheep herds were housed on the Plain of Chailly around the village of Barbizon, in addition to the smaller flocks tended by young girls.[2] During Millet's many hours of observation at the forest edge, he would frequently have encountered the shepherds moving from one grazing ground to another, usually in the hilly or rocky regions unsuitable for cultivation even by the desperate peasantry. Unlike the small family flocks that he had known in Normandy, installed within hedge-enclosed fields, these lonely attendants with their large wandering herds of sheep preserved a centuries-old nomadic tradition. Wrapped in the long, heavy striped woolen cloak (a *limousine*) that was their trademark (see fig. no. 11), living in the open or alongside their flocks in small huts attached to the enclosed sheepfolds, the shepherds were mysterious figures whose connections to the Barbizon community were tenuous at best.

Notes
1. Millet studio sale, lot no. 123: *Berger passant son troupeau sur les hauteurs de la Plante à Biau.* The catalogue of the studio sale was compiled by members of Millet's family, Alfred Sensier, and Charles Tillot (a Barbizon painter and friend), and has proved over time to be unusually reliable. Robert Herbert has suggested a drawing now in a private collection as lot 123 in the sale, but the receipt issued to the Frothinghams in 1875 (now in the Museum of Fine Arts archives) establishes the fact that this drawing is that item (*Jean-François Millet* [Paris: Editions des Musées Nationaux, Grand Palais exhibition catalogue, 1975], pp. 230-231).
2. Edward Wheelwright, "Personal Recollections of Jean-François Millet," *Atlantic Monthly* 38 (September 1876), pp. 264-265.

Provenance
Millet studio sale (Hôtel Drouot, Paris, May 10-11, 1875, no. 123), bought by Reverend Frederick Frothingham, Milton, Massachusetts.

Related Works
End of the Day, cat. no. 42.
Peasant Girl with Two Cows, cat. no. 100.

42
End of the Day
About 1852-1854
Black conté crayon with white highlights
on blue-gray laid paper
23.6 x 33.1 cm. (9¼ x 13 in.)
Stamped, lower right: J. F. M
Gift of Martin Brimmer, 1876
76.439

For Millet, who loved the seeping dark of twilight, and whose daily obligations left him only the sunset hours to wander the plain, tired workers gathering up their tools to return to distant village homes, or shepherds seeking nighttime shelter for their flocks, were constant occurrences, subjects he came to know intimately. As powerful reminders of the continuity of rural tasks since time out of mind, they had an inherent solemnity that fascinated him, yet as he struggled to make art out of the events he had witnessed, he was often at a loss for a way to utilize the new visual material before him in Barbizon.

The high art of Poussin or Michelangelo might offer him specific poses for his figures or patterns for composing them, but there was very little precedent in the grand tradition for the subject matter Millet set out to paint. Several times during his career, he organized series of images around the more popular almanac themes of the Four Seasons or the Four Hours (or times) of the day (see cat. nos. 46 and 47 or 142). The present drawing is his first effort to create an emblematic image of the close of the day, rooted in the realities of the contemporary rural life he shared.

This early rendering of the theme incorporates three activities of early evening – husband donning his jacket, wife loading the donkey with the harvested vegetables, and shepherd and flock seeking a sheltered area for the night. All three events are equally realized, in isolation of each other, spread across the hillside. A page of compositional sketches for this drawing, now in the Louvre, shows how Millet shifted the foreground figures among several configurations, almost at random, without reaching one that clearly dominated. Only the shepherd and his flock, borrowed from an independent drawing (cat. no. 41), remained constant throughout the page.

When Millet brought the different elements together in *End of the Day*, the very minimal details of the shepherd and flock were reduced to even more shadowy substance by rubbing the crayon strokes to blend one element into another, in order to fit them to a darker drawing of a later hour.

While carried to a considerable degree of completion, this drawing was never signed, and one must assume that Millet considered it either unsuccessful or not quite finished. When he returned to the idea a few years later, for a set of the Four Hours to be published, he focused on the gesture of the departing laborer alone – removing the woman and donkey from the composition, raising the foreground figure above the horizon, and more clearly subordinating the new background details that reiterated the evening hour.

Provenance

Millet studio sale (Hôtel Drouot, Paris, May 10-11, 1875, no. 125), bought by Richard Hearn for Martin Brimmer, Boston.

Exhibition History

Phillips Collection, Washington, D.C., "Drawings by J. F. Millet," 1956.

Related Works

Shepherd and Flock on the Edge of a Hill, Twilight, cat. no. 41.
Compositional sketches, black conté crayon on paper, 18.9 x 27.4 cm., Cabinet des Dessins, Musée du Louvre, Paris (GM10363).
End of the Day, cat. no. 42.
Compositional sketch, black conté crayon on paper, 13.2 x 17.5 cm., Cabinet des Dessins, Musée du Louvre (GM10642), shifts figure of man to center of composition and changes landscape background for subsequent versions of theme.

43
Shearing Sheep
1852-1853
Oil on canvas
40.7 x 24.8 cm. (16 x 9¾ in.)
Lower right: J. F. Millet
Gift of Quincy Adams Shaw through Quincy A. Shaw, Jr., and Mrs. Marian Shaw Haughton, 1917
17.1489

Shearing Sheep, part of Millet's very successful entry at the Salon of 1853 (see also cat. nos. 39 and 40), is one of the most exquisitely executed paintings that he ever created. Within a very precisely organized space, which holds attention on the figures while introducing sufficient background detail to convey a convincing locale, Millet displayed a skill in draftsmanship and a sensitivity to color nuance that gave to the commonplace and the clumsy a lasting grandeur. Just as *Harvesters Resting* demonstrated his power to make history paintings of conflicts in rural society, the *petite tondeuse*[1] established his ability to create a *morceau* (an art lover's treat) out of the life around him.

Sheepshearing had caught Millet's eye a year or two earlier, when he undertook a very different composition of two men shearing sheep in a barn (cat. no. 25). The present painting, which begins a series of several drawings and paintings that culminates in *Sheepshearers* of 1860 (fig. 9; one of Millet's most admired paintings), was probably suggested by activities at one of the large farms on the western edge of Barbizon. The sheepshearers work beneath a small hut that shelters them and a stack of grain. A complicated framework of corner posts, turning fence, and distant farm buildings provides a specificity of place that is quite modern, and sets these shearers apart from the more emblematic workers of preceding years, whose surroundings were subordinated to their task.

In his new attention to the details of setting, however, Millet did not sacrifice the monumentality of his figures. The asymmetrical placement of the hut creates space that emphasizes the large sculptural form of the figures around their barrel. With great care hidden behind the air of a scene exactly observed, Millet shaped the figures into a single pyramidal unit, the barrel (a platform for their work) both dividing and joining them. The silhouette of the group moves smoothly through the woman's arched back and neck and into her companion's hat, following his arm down to the barrel. Just where her white-scarved head bends outward over the sheep, the corner post behind anchors her to the background. The figures are perfect foils – the woman young and intent, the man, his face lined and hard, appearing to advise or scold. As she leans into her task with care and caution, he braces to restrain the sheep's kicking feet and their gestures interlock.

Although the picture is worked heavily, with many small touches of paint, Millet restrained the thick impasto that often threatened to obscure his figures (see *The Sower*, cat. no. 18). His great love for the silhouetting *traits* over which he labored so carefully is celebrated in the dark lines that strengthen his design at strategic points – to delimit the young shearer's bodice, shape her boldly jutting elbow, and establish her nearly lost profile – then disappear beneath the paint. But the glory of this gemlike painting is the finely wrought pattern of color that sustains the careful drawing in the complex role of shaping three-dimensional forms across a small flat surface. Against the limited earthy tones of his rural setting, Millet produced a rhythmic pattern of lights and darks and coloristic complements that is worthy of France's greatest colorist, Eugène Delacroix, a slightly older artist whom he much admired. A simple draped fold of the woman's red-orange overskirt, tucked up at her waist, and the man's blue peasant tunic provide the most distinctive areas of color in the painting and control the complex variations of blue and red that are picked up across the entire surface – in details of the woman's costume, the blue-shadowed pink flesh of the shorn sheep, the faint blues and oranges that highlight the barrel and shape the setting sun in the background, and even in the muddied touches of the ground on which they stand.

Notes

1. Many of Millet's paintings are known by catchwords or invented titles. His two great sheepshearing paintings, the present one, of 1853, and the last version, from 1860 (private collection, Boston; fig. 9) have regularly been distinguished in the literature on Millet mainly on the basis of their relative size. But the adjectives *grande* and *petite* in this case are also a reflection of the French critical tradition that ascribes very different values to large paintings that are intended for public display and small pieces especially created for the discerning collector. Not many artists succeeded with both types of painting.

Provenance

Purchased from the artist by William Morris Hunt, Boston (1853), sold through Doll and Richards, Boston, to Quincy Adams Shaw, Boston (1874).

Exhibition History

Salon, Paris, 1853, no. 839.

American Art Association, New York, "The Works of Antoine-Louis Barye...his Contemporaries and Friends," 1889, no. 551.

Museum of Fine Arts, Boston, "Quincy Adams Shaw Collection," 1918, no. 18.

Related Works

Finished drawing, with shearer kneeling and man seated on basket, black conté crayon on paper, 30.0 x 35.5 cm., City Art Gallery, Plymouth. First version of theme.

Study of standing woman shearing, black conté crayon on paper, 10.4 x 7.1 cm., Cabinet des Dessins, Musée du Louvre, Paris (GM10499).

Engraving by Adrian Lavieille from a drawing by Millet for *L'Illustration*, February 5, 1853.

Compositional sketch, pencil on paper, 7¾ x 5¾ in., current location unknown (New York art market, 1970).

Compositional study and studies of standing woman shearer, pencil and black conté crayon on paper, 21.2 x 24.2 cm., Cabinet des Dessins, Musée du Louvre, Paris (GM10431).

Study of hands and shears, sanguine chalk on paper, 11.0 x 13.7 cm., Cabinet des Dessins, Musée du Louvre, Paris (GM10589).

Shearing Sheep, cat. no. 43.

Sheepshearing, oil on canvas, 40.6 x 25.5 cm., Art Institute of Chicago.

Sheepshearers, charcoal and wash, brown ink on paper, 29.5 x 22.5 cm., Metropolitan Museum of Art, New York.

Compositional sketch of sheepshearers, pen and ink on paper, 14.7 x 10.6 cm., Cabinet des Dessins, Musée du Louvre, Paris (GM10350).

Sheepshearers flanked by trees in landscape, watercolor and pen and ink on paper, 36 x 27.5 cm., current location unknown (see van Heukelom sale, Amsterdam, October 12, 1937, no. 35).

Compositional sketch, known only from reproduction in Alfred Sensier and Paul Mantz, *La Vie et l'oeuvre de J.-F. Millet* (Paris: A. Quantin, 1881), p. 216.

Compositional study, black conté crayon on paper, 22.7 x 20.0 cm., Cabinet des Dessins, Musée du Louvre, Paris (GM10372).

Studies of woman sheepshearer, black conté crayon on paper, 14.5 x 17.8 cm., Cabinet des Dessins, Musée du Louvre, Paris (GM10389).

Sheepshearers (see fig. no. 9), 164.5 x 114.0 cm., private collection, Boston.

An unfinished painting (oil on panel, 8 x 4½ in.), William Rockhill Nelson Gallery of Art – Atkins Museum of Fine Arts, Kansas City. Very close to the Lavieille engraving, but does not appear to be from Millet's hand.

References

Sensier, Alfred, and Mantz, Paul. *La Vie et l'oeuvre de J.-F. Millet*. Paris: A. Quantin, 1881, pp. 143-145.

Hunt, William Morris. "Talks on Art," compiled by Helen M. Knowlton. Boston: Houghton, 1875 and 1883.

"'Greta's' Boston Letter." *Art Amateur* 5, no. 4 (September 1881), p. 72.

Burty, Philippe. *Maîtres et petits maîtres*. Paris: G. Charpentier Editions, 1877, p. 285.

Durand-Gréville, E. "La Peinture aux Etats-Unis," *Gazette des Beaux-Arts* 2nd ser., 36 (July 1887), p. 68.

Muther, Richard. *The History of Modern Painting*. London: Henry & Co., 1895-1896, vol. 2, p. 376.

Cartwright, Julia M. *Jean-François Millet, his Life and Letters*. London: Swan Sonnenschein & Co., 1896, pp. 125, 134.

Knowlton, Helen M. *Art Life of William Morris Hunt*. Boston: Little, Brown and Company, 1899, pp. 10, 13, 99.

Gensel, Walther. *Millet und Rousseau*. Bielefeld and Leipzig: Velhagen & Klasing, 1902, p. 38.

Rolland, Romain. *Millet*. London: Duckworth & Co., 1902, pp. 80, 83.

Marcel, Henry. *J.-F. Millet*. Paris: Henri Laurens, 1903, p. 37.

Peacock, Netta. *Millet*. London: Methuen & Co., 1905, p. 74.

Guiffrey, Jean. "Tableaux Français conservés au Musée de Boston et dans quelques collections de cette ville." *Archives de l'art Français* n. s. 7 (1913), p. 547.

Moreau-Nélaton, Etienne. *Millet raconté par lui-même*. Paris: Henri Laurens, 1921, vol. 1, pp. 107-108, 110, 116-117.

Shannon, Martha A. S. *Boston Days of William Morris Hunt*. Boston: Marshall Jones, 1923, p. 38.

Edgell, George Harold. *French Painters in the Museum of Fine Arts: Corot to Utrillo*. Boston: Museum of Fine Arts, 1949, p. 19, illus. p. 20.

Meixner, Laura L. *An International Episode: Millet, Monet and their North American Counterparts*. Memphis: The Dixon Gallery and Gardens, exhibition catalogue, 1982, pp. 19, 73.

44
Women Sewing by Lamplight (La Veillée)
1853-1854
Oil on canvas
35.0 x 27.0 cm. (13¾ x 10½ in.)
Lower right: J. F. Millet
Gift of Quincy Adams Shaw through
Quincy A. Shaw, Jr., and Mrs. Marian
Shaw Haughton, 1917
17.1492

For more than a century, *Women Sewing by Lamplight* has been entitled *The Vigil*, or *The Watchers*, in a mistranslation of its French title, *La Veillée*. The mistake is understandable, for images of two women sitting up by lamplight might well suggest a wake for the dead, or a fearful watch over a sick child. But a *veillée* in rural France could be a much more lighthearted activity – although always a productive one. On long winter evenings, to spare the costs of heating and lighting all the houses in a commune, neighbors would congregate at each family's house in turn, to share the warmth and good company and to pursue an evening's work of sewing, repairing tools, or making baskets.[1] The distinctive *marmottes* (close-fitting scarves) worn by the young seamstresses identify them as women of the area around Barbizon, rather than Normandy, but a gathering of chatting, good-natured women hard at work, sewing or spinning, was an image Millet often equated with his mother and grandmother in Gruchy.

In a very dark interior, seated before a large, curtained bed (another reminiscence of Gruchy), the two women are intent upon their sewing. Working close together, for warmth and light, they are both dressed in several layers of bulky clothing – evidenced by the red cuff beneath the yellow sleeve of the woman on the left. Their old-fashioned oil lamp marks the peak of the pyramidal form they define, their stool its foremost corner. The lamp's yellow glow gives everything within its arc a golden tint, but the softer light reflected up from the linens on the young seamstresses' laps is all the illumination their bent faces receive. In such a deliberately dark setting, shaping solid forms was especially difficult, and a forceful contour may have seemed a useful precaution to the artist. But the thick ink lines that he used to reinforce his preliminary drawing have become distractingly apparent in areas where they were covered only by a thin layer of paint. In an effort to find a satisfactory balance between defining lines and shaping colors, Millet (occasionally quite an experimental artist)

may well have intended the heavy outline to appear at least faintly in the finished painting.

Women Sewing by Lamplight was painted in the winter following his mother's death, in 1853, as one of a pair of paintings with *Seated Spinner* (cat. no. 45), commissioned by a Belgian collector.[2] It was unusual at this time for Millet to attract a patron from outside Alfred Sensier's circle of friends and acquaintances, but Paul van Cuyck had apparently seen a painting by Millet, *Seamstresses* (private collection, London), and wanted to acquire two of similar size and subject.[3] The request prompted an unusual exchange between Millet and Sensier, for Millet sought his advice on the price offered –

As for the Dutchman....The price of 500 francs isn't to be scoffed at, as much as one might want to; but I would like, if it could be done, to get my prices up a little bit.... If it doesn't embarrass you, can you try for a price of 600 francs, as if I really would not do them both for so little? Then, if it becomes clear that he won't go past 500, let him think that you'll try to convince me to do it at that price. All that's pretty complicated. But I'm caught between two fears: that of disgusting him and scaring him away, and that of working forever at such low prices. Oh God! all this certainly doesn't show much class. Maybe I should just say that I won't do it for less than 600....It isn't so much for 100 francs more or less that I'm hanging on, but mostly because 300 francs a painting sounds, in my opinion, an awful lot better than 250....[4]

Millet's life was difficult throughout the 'fifties, but for a few months 1854 offered a respite of sorts – van Cuyck agreed to the higher price, and a patron of Rousseau's, a retired clerk, became enamored of several of Millet's small drawings and paintings and commissioned several works at one time.

Notes
1. Eugen Weber, *Peasants into Frenchmen: The Modernization of Rural France, 1870-1914* (Stanford: Stanford University Press, 1976), pp. 413-418.
2. Paul van Cuyck, a collector who may have doubled as a dealer, lived in Belgium and frequented Paris; he may have been either Dutch or Belgian.
3. Sensier had arranged to hang *Seamstresses* in the Fine Arts Ministry, where he worked, precisely for the purpose of attracting possible commissions for the artist.
4. Millet to Sensier, November 15, 1853, Archives of the Cabinet des Dessins, Musée du Louvre, Paris. Quoted in Etienne Moreau-Nélaton, *Millet raconté par lui-même* (Paris: Henri Laurens, 1921), vol. 2, pp. 3-4.

Provenance
Paul van Cuyck, Belgium; Laurent Richard (sold Hôtel Drouot, Paris, May 23-25, 1878, no. 52); Quincy Adams Shaw, Boston.

Exhibition History
Museum of Fine Arts, Boston, "Quincy Adams Shaw Collection," 1918, no. 11.

Related Works
Compositional sketch, black conté crayon on paper, 4⅛ x 4 in., Detroit Institute of Arts.
Compositional sketch, black conté crayon on paper, current location unknown (see Léonce Bénédite, *Jean-François Millet* [London: William Heinemann, 1906], pl. 13).
Studies of seated women sewing, several studies of woman's head in profile, black conté crayon on paper, 32.5 x 50.1 cm., current location unknown (London art market, 1961).
Studies of bed curtains, hanging clothing rack, and woman's figure, black conté crayon on paper, private collection, Cambridge, England.
Studies of hands, black conté crayon on paper, 33.5 x 28.2 cm., Cabinet des Dessins, Musée du Louvre, Paris (GM10590).
Study of woman on right squared for transfer, black conté crayon on paper, 22.8 x 16.7 cm., Cabinet des Dessins, Musée du Louvre (GM10305).
Compositional study, black conté crayon on paper, 12½ x 9½ in., private collection, England.
Finished drawing, black conté crayon on paper, 12 13/16 x 10 7/16 in., Worcester Art Museum (Massachusetts), (1962.38).
Women Sewing by Lamplight, cat. no. 44.
Tracing, black conté crayon on paper, 16.9 x 13.4 cm., Cabinet des Dessins, Musée du Louvre, Paris (GM10494).
Women Sewing by Lamplight, cat. no. 70.
Women Sewing by Lamplight, cat. no. 71.

References
"'Greta's' Boston Letter." *Art Amateur* 5, no. 4 (September 1881), p. 72.
Staley, Edgcumbe. *Jean-François Millet*. London: George Bell and Sons, 1903, p. 39.
Guiffrey, Jean. "Tableaux Français conservés au Musée de Boston et dans quelques collections de cette ville." *Archives de l'art Français* n. s. 7 (1913), p. 547.
Moreau-Nélaton, Etienne. *Millet raconté par lui-même*. Paris: Henri Laurens, 1921, vol. 2, p. 3, fig. 93.

45
Seated Spinner (Emélie Millet)
1854
Oil on panel
35.2 x 26.8 cm. (13⅞ x 10½ in.)
Lower right: [...] F. Millet
Gift of Quincy Adams Shaw through
Quincy A. Shaw, Jr., and Mrs. Marian
Shaw Haughton, 1917
17.1498

The *Seated Spinner* originated in a careful portrait drawing of Emélie Millet (Montreal Museum of Art), the oldest and the closest to Millet of his three younger sisters. He had drawn the portrait during his return to Gruchy in the spring of 1853 following his mother's death, his first visit in nearly ten years; that fall he used it as the model for this small painting, commissioned as a pair with *Women Sewing by Lamplight* (cat. no. 44) by a Belgian collector, Paul van Cuyck.

Spinning and carding wool belong to the recollections of his mother and grandmother that haunted Millet's dreams during his unhappy first years in Paris. He explained to Alfred Sensier that his earliest memory as a child was of waking to the whirr of spinning wheels and delighting in the bits of woolen fluff that danced in beams from the windows; later, tired and frightened in Paris, he dreamed of the women of Gruchy gathered in the family home, carding, spinning, and crying together over his lost soul.[1] Besides serving as a remembrance of his sister, the drawing of Emélie spinning flax[2] was probably also a tribute to all the Millet women – his mother, grandmother, aunt – whom he felt he had wronged by leaving.

In adapting the drawing from a portrait to a more anonymous genre scene, Millet changed the features of the sitter, giving her a softer profile and making her appear younger, although he continued the use of the distinctive bonnet that identifies her as a young woman from the Cotentin peninsula of Normandy. In addition, he shifted the large wooden cupboard that stands behind Emélie in the drawing to the side wall in the painting, to create a space similar to that of *Women Sewing by Candlelight*, who have a large, curtained bed at their left.[3] The subject matter of a young woman spinning and the detailed setting, down to spoons hanging in racks on the back of window shutters, all recall seventeenth-century artists such as Nicolas Maes or Pieter de Hooch; but the scale of the spinner, dominating her surroundings, is more typical of nineteenth-century painting. It is to

these years around 1853-1854 that Millet's first serious study of old master Dutch painting should be dated.

There is no natural light source within the painting – the shutters behind the spinner are tightly closed – but Millet continued the strong side lighting that characterized the drawing, freely manipulating the light to give the young woman a greater solidity than might otherwise be expected in the dark interior of a centuries-old farmhouse. The low-key color composition has a carefully refined and controlled air. The soft blue-greens of her bodice and her stockings and the rose-gray of her skirt recall the color schemes of Chardin, especially with the addition of her black scarf.

The thin paint of much of the background and of the spinning wheel, which has become more transparent with time, reveals a strong perspective underdrawing and a highly detailed wheel; the heavy, reworked outlines of the Montreal portrait suggest that Millet transferred the drawing to his panel by incising. He visibly strengthened the working drawing on the panel with a fluid medium, perhaps an ink mixed with sizing, so that he did not have to worry about losing the guidance of his careful design as he began to cover it with paint.[4]

The identification of this picture with the *Spinner* created for van Cuyck is established by a small compositional sketch in the Cabinet des Dessins, Musée du Louvre, Paris, which is very close to the Boston painting. Although both Alfred Sensier and Etienne Moreau-Nélaton had left the question of the complement to *Women Sewing by Candlelight* unresolved,[5] the inscription *Hollandais* (Dutchman – Millet's catchword for van Cuyck) in the artist's hand on the drawing confirms that this is the second of a pair of pictures ready for the collector-dealer in late January 1854. Therefore, the drawing of Emélie must date not to the summer of 1854, as previous authors have claimed, but to the May 1853 visit to Gruchy – which makes the painting one of the most precisely dated of Millet's works.[6]

Notes

1. Alfred Sensier and Paul Mantz, *La Vie et l'oeuvre de J.-F. Millet* (Paris: A Quantin, 1881), pp. 14, 45.

2. The small wheel, used by a seated spinner, and the characteristic, stringy hank of raw fiber on the distaff, distinguish this spinner from one spinning wool.

3. The cupboard was especially beloved by Millet and was the one tangible piece of property that he claimed as his share of the family inheritance in

1853, leaving his portion of the house and lands to his brothers and sisters still in Normandy.

4. The unusual drawing medium, to which the subsequent paint layers did not adequately adhere, may have been chosen to preserve the outline in the final work.

5. Sensier, op. cit., p. 152, and Etienne Moreau-Nélaton, *Millet raconté par lui-même* (Paris: Henri Laurens, 1921), vol. 2, p. 3.

6. Moreau-Nélaton (op. cit., vol. 2, p. 123) dates the drawing to 1854 and the painting to around 1855.

Provenance

Paul van Cuyck, Belgium (sold Hôtel Drouot, Paris, February 7-10, 1866, no. 28); at some time with Gustave Templaere, Paris; Baron E. de Beurnonville (sold Hôtel Drouot, Paris, April 29, 1880, no. 39); Quincy Adams Shaw, Boston.

Exhibition History

Museum of Fine Arts, Boston, "Quincy Adams Shaw Collection," 1918, no. 14.

Related Works

Compositional sketch, chalk on paper, 12.4 x 8.8 cm., Cabinet des Dessins, Musée du Louvre, Paris (GM10313).

Finished drawing, black chalk with white highlights on buff paper, 13¼ x 11½ in., Musée des Beaux-Arts, Montreal.

Seated Spinner (Emélie Millet), cat. no. 45.

A variant of the Montreal drawing, on the London art market in the 1960s, does not appear to be by Millet.

References

Cartwright, Julia. *Jean-François Millet, his Life and Letters*. London: Swan Sonnenschein & Co., 1902, p. 319.

Art Amateur 48 (January 1903), p. 33.

Staley, Edgcumbe. *Jean-François Millet*. London: George Bell and Sons, 1903, p. 39.

Guiffrey, Jean. "Tableaux Français conservés au Musée de Boston et dans quelques collections de cette ville." *Archives de l'art Français* n. s. 7 (1913), p. 547.

Moreau-Nélaton, Etienne. *Millet raconté par lui-même*. Paris: Henri Laurens, 1921, vol. 2, pp. 3, 123, fig. 175.

46
Study for *Gleaners*
1852-1853
Black conté crayon on wove paper
27.6 x 19.4 cm. (10⅞ x 7½ in.)
Stamped, lower right: J. F. M
Gift of Martin Brimmer, 1876
76.440

Alfred Sensier, Millet's first biographer, was not only one of his closest friends; he also took on the role of agent, seeking out collectors and commissions for the struggling painter. The small circle of acquisitive admirers that he created for the artist, chiefly his own friends and acquaintances in the fine arts bureaucracy, included Alfred Feydeau, an architect and collector, who gave Millet one of his first important commissions in 1852, an order for four paintings of the seasons. This drawing is a study for *Gleaners*, representing Summer of that series, and the following painting, *In the Vineyard* (cat. no. 47), represents Spring.[1]

Gleaning is frequently used to portray summer, and Millet had included it earlier in an illustration of August that was etched by Charles Jacque; gleaning is also at the heart of the Ruth and Boaz story in *Harvesters Resting* (cat. no. 39). But it is in Feydeau's Four Seasons that Millet brought the gleaning subject to the forefront of the image for the first time.

The Boston drawing is the second compositional sketch that Millet made in developing the image, breaking with an earlier sketch (private collection, Surrey) by shifting from a seated to a standing figure on the right. Often in his multiple-figure drawings, he would summarize a complex action by posing several figures in a series of continuous gestures. The added upright figure, who pauses as if reluctant to join in, implies the bending posture necessary for gleaning and conveys more forcefully the tiring quality of this work than do the two bent figures alone. With the parallel poses and outstretched arms of the women picking up grain, Millet emphasized their forward movement and the fact that they must continue across the entire field in this position to acquire the few blades of grain in their left hands. One woman clutches her grain behind her back, as if to press against the pain of continual bending. In subsequent sketches and studies, Millet narrowed the foreground of the composition and moved the gleaners, slightly increased in scale, closer to the wagon behind them.

In the background, five men are piling grain high into stacks to dry. Although a later version of *Gleaners* (1857; Musée du Louvre, Paris) would emphasize the contrast between the immense harvest and the tired women with their meager clutches of grain, this drawing (and the painting for which it is a study) did not yet isolate the gleaners from the harvesting activities behind them or force a recognition of tension or disjunction between their act and that of the harvesters. To many a casual observer, unfamiliar with the strict indigence requirements that had come to govern gleaning in France by mid-century, the poverty of the tired women is not self-evident.

The relatively innocuous content of the other three pictures in this Four Seasons series makes it clear that Millet had not yet fully realized the impact of the subject matter. His concurrent use of the gleaning theme in *Harvesters Resting* had been a plea for reconciliation and generosity, and, although this drawing combines the contrast of rich and poor that was at the heart of the ultimate *Gleaners* composition, that conflict was not yet so starkly emphasized.

Notes

1. *Woodcutter* and *Woman Burning Leaves* (both Musée du Louvre, Paris) have been suggested as *Winter* and *Autumn*, respectively, in this series ([Robert Herbert], *Jean-François Millet* [Paris: Editions des Musées Nationaux, Grand Palais exhibition catalogue, 1975], p. 148). Although this pair of paintings was also commissioned by Feydeau at approximately the same time as cat. nos. 46 and 47, it appears more likely that the remaining images in the Four Seasons series were *Women Gathering Apples* (Arnot Art Gallery, Elmira, New York), as suggested by Etienne Moreau-Nélaton (*Millet raconté par lui-même* [Paris: Henri Laurens, 1921], vol. 1, p. 93), and *Woodcutter and his Wife* (current location unknown), a drawing of which is reproduced by Charles Yriarte (*J. F. Millet* [Paris: Jules Rouam, 1885], p. 22). These two images, both appropriate seasonal subjects and close in size to the known paintings, share a similar *mise en page*, with foreground and background activities, as well as figures of a scale commensurate with those in *Gleaners* and *In the Vineyard*. They are also earlier than the pair of larger-scale figures suggested by Herbert, and therefore more likely to be part of the series.

Provenance

Millet studio sale (Hôtel Drouot, Paris, May 10-11, 1875, no. 157), bought by Richard Hearn for Martin Brimmer, Boston.

Exhibition History

Phillips Collection, Washington, D.C. "Drawings by J. F. Millet," 1956.
Arts Council of Great Britain, London, "Drawings by J. F. Millet," 1956, no. 38.
Minneapolis Institute of Arts, "Millet's Gleaners," 1978, no. 9.

Related Works

Compositional sketch of right-hand gleaner seated, black conté crayon on paper, 25.4 x 17.8 cm., private collection, Surrey.

Study for *Gleaners*, cat. no. 46.

Compositional sketch with more strongly vertical format, pencil on paper, 11.6 x 7.3 cm., Cabinet des Dessins, Musée du Louvre, Paris (GM10347).

Studies of gleaners' arms, black conté crayon on paper, 28.5 x 22.5 cm., Yale University Art Gallery, New Haven (1961.9.61).

Entire composition with perspective lines, pencil on paper, 39.9 x 28.6 cm., Cabinet des Dessins, Musée du Louvre, Paris (GM10602).

Summer, the Gleaners, oil on canvas, 38.0 x 29.5 cm., private collection, New York.

Summer, the Gleaners, oil on canvas, 40.0 x 28.6 cm., Museum of Fine Arts, Springfield, Massachusetts (39.04).

Finished drawing, black conté crayon on paper, 28.3 x 22.0 cm., British Museum, London.

For works related to earlier, horizontal composition, and to the Salon painting of 1857 (*Gleaners*, Musée du Louvre, Paris), see *Millet's Gleaners* (Minneapolis: Minneapolis Institute of Arts, exhibition catalogue, 1978).

References

Wickenden, Robert J. "Millet's Drawings at the Museum of Fine Arts, Boston." *Print-Collector's Quarterly* 4, part 1 (1914), p. 18, illus. p. 21.

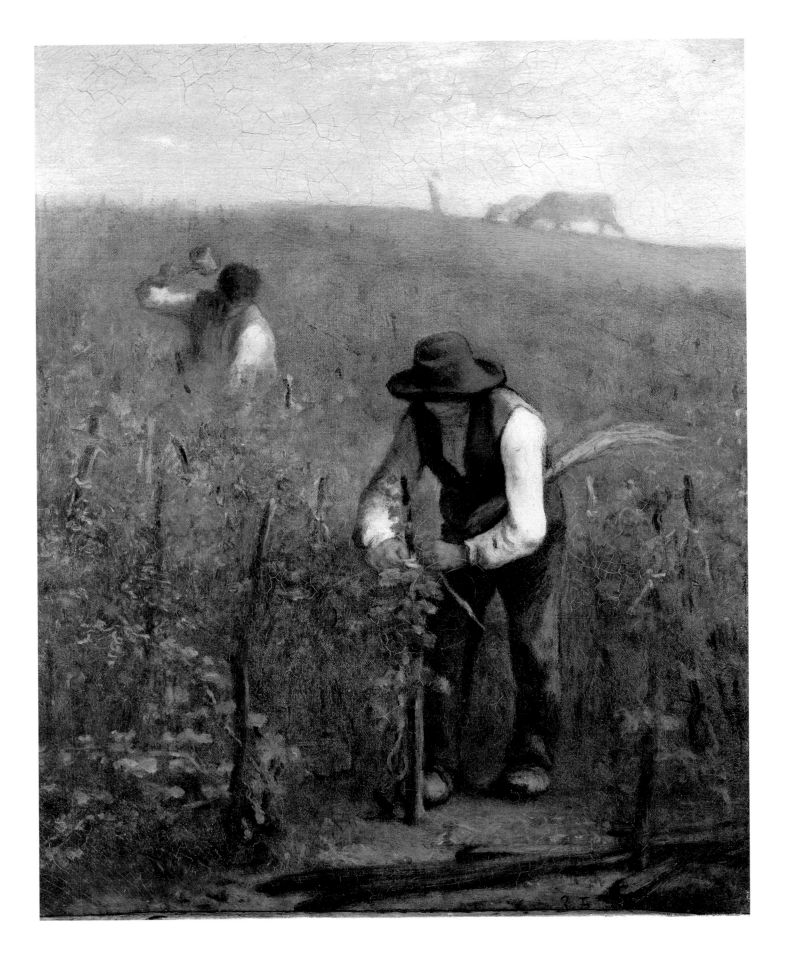

47
In the Vineyard
1852-1853
Oil on canvas
37.6 x 29.6 cm. (14¾ x 11⅝ in.)
Lower right: J. F. Millet
Gift of Quincy Adams Shaw through
Quincy A. Shaw, Jr., and Mrs. Marian
Shaw Haughton, 1917
17.1487

In the Vineyard represents Spring in a series of the Four Seasons commissioned from Millet by Alfred Feydeau about 1852. Two figures are at work in a sloping vineyard: a boy, halfway down the incline, pounds stakes into the ground, while his fellow worker, a much older man, performs the more demanding task of tying the grape vines to the supporting poles.

Pruning or tying up grapevines is a typical seasonal task for Spring, often paired with a Summer scene of the grain harvest, allowing allusions to the basic staples of existence, food and drink, and to the Christian symbolism of the Eucharist. For this series, Millet paired his male vine tenders with women gleaning after the wheat harvest (see cat. no. 46).

Although the distinctive, light atmosphere created by the acidic greens of the vines and a sky touched with pinks suggests spring and fresh new growth, the composition has an awkward, cramped feeling. With its zig-zag of figures into the composition and up to the high horizon, *In the Vineyard* repeats the landscape of his early *Sower* (National Gallery of Wales, Cardiff, fig. 15). To enforce a sense of distance, a tiny woman wrapped in a white cape and wearing a scarlet cap stands before two grazing cows at the top of the hillside. Millet's skills as a shaper of landscape lagged far behind his ability as a figural draftsman, and one of the more difficult problems for him, as he developed a repertoire of rural images, was creating suitable settings.

Provenance
Commissioned from the artist by Alfred Feydeau, Paris; Alfred Sensier (sold Hôtel Drouot, Paris, December 10-18, 1877, no. 45); Quincy Adams Shaw, Boston.

Exhibition History
Museum of Fine Arts, Boston, "Quincy Adams Shaw Collection," 1918, no. 19.

Related Works
Man tying up grapevines, black chalk on gray paper, 19.3 x 13.0 cm., Cabinet des Dessins, Musée du Louvre, Paris (GM10294).

Finished drawing, black chalk with white highlights on paper, 36.5 x 28 cm., private collection, Zurich.

In the Vineyard, cat. no. 47.

Finished drawing, black conté crayon and watercolor on paper, 9 x 7 in., current location unknown (London art market, 1961). From reproductions, the authenticity of this work is difficult to judge.

References

Sensier, Alfred, and Mantz, Paul. *La Vie et l'oeuvre de J.-F. Millet*. Paris: A. Quantin, 1881, pp. 133-134.

Guiffrey, Jean. "Tableaux Français conservés au Musée de Boston et dans quelques collections de cette ville." *Archives de l'art Français* n. s. 7 (1913), p. 147.

Moreau-Nélaton, Etienne. *Millet raconté par lui-même*. Paris: Henri Laurens, 1921, vol. 1, p. 93, fig. 68.

[Herbert, Robert L.]. *Jean-François Millet*. Paris: Editions des Musées Nationaux, Grand Palais exhibition catalogue, 1975, p. 119.

J. F. M

executed back in Barbizon. The distinctive, conically roofed well in this drawing, featured in a number of Millet's later paintings and pastels, stood at the corner of the building used by his family as a stable and granary, across from the family's home.[2]

For this notation of a cherished motif, Millet's sketch is quick and cursory. He made little effort to define the cylindrical shape of the well, or to articulate the windows and doors of the building behind, but he did accurately record the placement of the well and its scale in relation to the stable building, two points that he would later alter frequently. Interestingly, in this initial drawing, Millet suggested the most important adjustment that he would introduce when he incorporated the site into other works: the great exaggeration of the well's scale relative to the faintly indicated figure climbing the steps to the left. The well and stable building still stand in Gruchy, and the well is no more than eight feet high. Yet repeatedly, Millet would dwarf a figure drawing water or feeding chickens (see cat. no. 101) with a well that appears to be at least twice her height. Commenting on this artistic license, Robert Herbert suggests that Millet subordinated his real knowledge of the well to his childhood recollections of a much more imposing structure.[3]

Notes

1. On the verso are studies of shellfish baskets and nets, probably not by Millet.

2. In addition to the painting in the Ionides Collection of the Victoria and Albert Museum, London, for which this drawing is probably the basic compositional study, Millet made a pastel featuring the well (Etienne Moreau-Nélaton, *Millet raconté par lui-même* [Paris: Henri Laurens, 1921], vol. 3, fig. 257), two pastels of the well and the stable building (one of them cat. no. 101), and a number of pictures of women drawing or carrying water from a well closely based on the well at Gruchy.

3. [Robert L. Herbert], *Jean-François Millet* (Paris: Editions des Musées Nationaux, Grand Palais exhibition catalogue, 1975), p. 240.

Provenance

Studio of the artist; acquired from G. Bhyne (said to be descended from the artist) by Leicester Galleries, London (1920).

Related Works

Well of the Stables at Gruchy, cat. no. 48.

Compositional sketch, black conté crayon on paper, 9 x 5.6 cm., current location unknown (Paris art market, 1960s).

Finished drawing, pencil on paper, current location unknown.

Well at Gruchy, oil on canvas, 15¾ x 12¾ in., Ionides Collection, Victoria and Albert Museum, London.

48
Well of the Stables at Gruchy[1]
1854
Black conté crayon on wove paper
24.4 x 15.7 cm. (9⅝ x 6⅛ in.)
Stamped, lower left: J. F. M.
Edwin E. Jack Fund, 1961
61.625

Millet seldom drew landscapes directly from nature, preferring to work from memory after carefully studying the motif or subject. In the summer of 1854, however, during his first extended stay in Gruchy since 1845, he made numerous drawings of the countryside – many of which seem to have been drawn directly on the site – intended for use in paintings and drawings

49
Perspective study of a woman drawing water for a cow, compositional studies of buildings, and a study of a figure descending stairs
About 1853-1854
Black conté crayon on blue-gray laid paper
30.0 x 31.8 cm. (11¾ x 12½ in.)
Stamped, lower center: J. F. M
Edwin E. Jack Fund, 1961
61.624 (recto; see also verso, cat. no. 36)

The conical roof on the well in the principal sketch suggests that this page of drawings originated in Normandy, as did the preceding picture (cat. no. 48). This farmyard scene, however, is superimposed on a Barbizon motif, the old stone gate of the Porte aux Vaches, opening onto the Forest of Fontainebleau (see cat. no. 131), emphasizing the very different role these drawings played in Millet's work. Unlike the sketch

of the well at Gruchy, which recorded a precise site for later use, this page of several drawings demonstrates Millet's practice of working up compositions from memory, moving from subject to subject, back in his studio.

The very quick rendering of the edge of the forest that centers the sheet, underlying the scenes of the woman with her cow on the left and the courtyard at the center

right edge of the page, suggests that the page was first used by Millet about 1853, when he made both a drawing (Cabinet des Dessins, Musée du Louvre, Paris) and a painting of the Porte aux Vaches (Philadelphia Museum of Art). The several small drawings of farm buildings along the right side of the page appear to have been added next, since the sharply foreshortened building on the left in the two enframed scenes suggests a preliminary stage of the composition finally worked out in greater detail on the left.

This principal drawing was modified substantially, as Millet worked on it. Traces of the original composition remain, showing the peasant woman, once to the left of the well, farther back in a composition of smaller scale. The perspective schema[1] overlying this sketch suggests that Millet seriously intended to pursue it further, but, although carried here to a relatively complete composition, it does not seem to have been translated into either a painting or a finished drawing.

Millet may well have made use of this sheet on several occasions, as the very different subjects indicate; or, as seems often to have been the case, he may have found redrawing a familiar scene such as the Porte aux Vaches an effective way to begin creating while new ideas and memories took shape in his mind.

Notes

1. The puzzling figure in the doorway of the building is not a participant in the composition but the almost caricatural human form that Millet used to establish scale in his drawings. See cat. no. 50 for another, clearer example.

Provenance

Studio of the artist; acquired from G. Bhyne (said to be descended from the artist) by Leicester Galleries, London (1920).

Related Works

Perspective studies, 16 x 15.1 cm., current location unknown (London art market 1960s). Additional drawings of courtyard, including small drawing with well.

50
Perspective studies of figures around cart and figures in a farmyard
About 1854
Black conté crayon on blue-gray paper
25.1 x 28.6 cm. (9⅞ x 11¼ in.)
Edwin E. Jack Fund, 1963
61.630 (verso)

These two small sketches – one probably representing a harvesting scene, the other a scene in the courtyard of a farm – are compositional drawings in which Millet explored problems of scale. When he had an image well in mind and the poses of the figures established, he would often make several separate sketches to create a setting and to ensure the correct spatial relationships between carefully studied figures and an often wholly invented background. Particularly when working with scenes on the flat, nearly featureless Chailly plain or a forest interior lacking buildings or other objects of definable size, it was critically important that figures be in proportion to each other and to their distance from the viewer.

As an aid, Millet used a stylized human figure, usually placed at the left edge of a composition. He would draw the figure on the baseline of the picture space and the height of the form would then determine the horizon line. Figures placed at any point in the composition would then be scaled to the angle between the horizon line and a second line drawn from Millet's selected vanishing point to the feet of the schematic figure.

Provenance

Studio of the artist; acquired from G. Bhyne (said to be descended from the artist) by Leicester Galleries, London (1920).

51
Man with a Flail
About 1854
Black conté crayon on wove paper
14.2 x 5.4 cm. (5⅝ x 2⅛ in.)
Stamped, lower right: J. F. M
Gift of Mrs. John Alden Carpenter, 1963
63.2699

Millet also used drawings to study the human figure in action, often making dozens of small sketches exploring every gesture of a task, then refining specific gestures until he was satisfied that he had captured the essential, most characteristic movements. *Man with a Flail* is one such

study, probably once part of a larger sheet of many studies,[1] for a scene of men threshing grain. Although difficult to date with precision, it may well belong to Millet's summer in Gruchy, for outdoor threshing was a characteristic activity of the buckwheat harvest, which he associated with Normandy rather than the Chailly plain, where other grades of wheat were more common.

In such small studies, where Millet made no effort to hide changes, his working methods and intentions can be followed quite readily. Although he did not change the basic pose of the figure in the course of the drawing, he altered the position of the figure's right leg, bringing it farther forward and slightly to the side. Along with the straightened angle of the flail, the change emphasizes the thresher's forward movement as he swings the flail down against the grain at his feet.

Notes

1. With the exception of a tiny notebook used for landscape studies during his visit to Vichy in 1866 (see cat. nos. 120-122), Millet preferred large pages for his working drawings, and seems to have favored loose sheets over bound sketchbooks. Many of these sheets have since been cut up, presumably to create a number of salable drawings or to separate a major sketch from the lesser, distracting ones.

Provenance

Studio of the artist; Mrs. John Alden Carpenter, Manchester, Massachusetts.

52
Woman Digging Clams
About 1854
Graphite on wove paper
19.1 x 14.0 cm. (7½ x 5½ in.)
Stamped, lower right: J. F. M
Gift of Mrs. John Alden Carpenter, 1963
63.2698

One of very few pictures of life by the sea in Millet's work, this unusual drawing must have been made during one of his return visits to his birthplace of Gruchy in La Manche, the western peninsula of Normandy, which is famous for its shellfish. Standing on one of the broad, flat beaches that alternate with rocky cliffs along the Norman coast, the woman is about to insert the long, distinctively hooked pole that is used to pull the French variant of razorback clams from the sand.

While the subject matter of this drawing can be connected with Millet more readily

50

51

52

J.F.M

J.F.M

than may at first seem possible for an artist so field- and forest-bound, its style poses problems. The placement of a figure study in its early, unresolved stages within a broad landscape composition is not typical of Millet's working methods, nor is the emphasis on surface descriptions rather than general contours. And a clumsiness in details such as the face or the irregularity of the shading patterns is not easily reconciled with Millet's usual facility by the mid-1850s, the most likely period for the drawing. These inconsistencies may reflect a hurried effort to record simultaneously a number of aspects of a subject new in Millet's work – or, along with a drawing of shellfish baskets on the verso of a drawing of the well at Gruchy (cat. no. 48), this sketch may have been made by one of Millet's younger brothers, two of whom were eager to follow his path as an artist.

Provenance
Studio of the artist; Mrs. John Alden Carpenter, Manchester, Massachusetts.

Related Works
Fisherwoman, black conté crayon on paper, 19.1 x 11.8 cm., Museum of Art, Rhode Island School of Design, Providence. Same woman, carrying hook, net, and creel, and walking uphill, is slightly more convincingly by Millet.

53
Millet's Family Home at Gruchy
1854
Oil on canvas
59.7 x 74.0 cm. (23½ x 29 in.)
Stamped, lower right: J. F. Millet
Gift of the Reverend and Mrs. Frederick A. Frothingham, 1893
93.1461

This view of *Millet's Family Home at Gruchy*, looking down the hamlet's single street toward the sea, was painted during Millet's return to Normandy for the summer of 1854, following the deaths of his mother and grandmother. Although he probably intended to complete the work, it was, for some reason, left unfinished and remained in his studio until his death.

Like the drawing of the well that stood just across the road (see cat. no. 48), the painting was a record of a treasured memory to be taken back to Barbizon, where Millet might use it as a model and color reference for later pictures. The building is the same one depicted in a pastel drawing (cat. no. 102), the house in which Millet was born and in which members of his family still lived. His presence in Normandy at that time had been prompted by the need to divide up the inheritance left at his mother's death, which included a share in the family property and house.

For this painting, Millet chose an unusual view, with the broad, overgrown embankment filling more than half the painting and blocking the view of the house beyond. The partially finished figure standing in the far corner of the enclosure above the embankment suggests that perhaps he had originally intended to add other figures or an activity of some kind in the foreground.

Provenance
Millet studio sale (Hôtel Drouot, Paris, May 10-11, 1875, no. 14), bought by Reverend Frederick Frothingham, Milton, Massachusetts.

Exhibition History
Hillyer Art Gallery, Smith College, Northampton, 1926.
American Federation of Arts, New York, "The Road to Impressionism," 1964, no. 37.

References
Peacock, Netta. *Millet*. London: Methuen & Co., 1905, illus. p. 5.
Moreau-Nélaton, Etienne. *Millet raconté par lui-même*. Paris: Henri Laurens, 1921, vol. 2, p. 13, fig. 99.

85

54
Woman with Two Cows
Delteil 14, fourth state
About 1855
Etching on pale green wove paper
9.1 x 15.2 cm. (3⅝ x 6 in.)
Signed in the plate
Frederick Keppel Memorial Bequest, 1913
M23380

55
Three sketches: woman laying out wash,
man leaning on a spade, and seated peasant
Delteil 2, only state
About 1855
Etching in brown ink on laid paper
9.3 x 15.0 cm. (3⅝ x 5⅞ in.)
Special Print Fund, 1916
M26215

56
Man Leaning on a Spade
Delteil 3, only state
About 1855
Etching on laid paper
8.5 x 6.8 cm. (3⅜ x 2⅝ in.)
Frederick Keppel Memorial Bequest, 1913
M23379

Millet's circle of friends included several printmakers and, on a number of occasions, he provided drawings for them to translate into engravings or woodcuts. Precisely when he began making etchings himself, however, is a matter of conjecture. Michel Melot has recently dated the prints in question here to 1847 or 1848, the years when Millet was living in Paris and on close terms with Charles Jacque, a printmaker and painter,[1] but it is more likely that they were undertaken a few years later, probably about 1855. In the winter of 1855, Millet undertook his first work in etching intended for commercial publication (see cat. nos. 63-73), and these three early efforts were probably exercises to acquire the skills for the craft.[2]

Man Leaning on a Spade and *Woman with Two Cows* both depend on compositions on which Millet was working during his first years in Barbizon, and the etchings could conceivably have been made as early as 1850-1852. *Woman Laying out Wash*, the principal image on a plate of three sketches, cannot date before 1854, however, as it depends upon a drawing that was created during Millet's visit to Gruchy in that year. Similarities in the handling of all three etchings suggest that they were probably completed in close succession, which argues for a date of about 1855 for the group.

The two small sketches – a seated figure and a man leaning on a spade – on the composite plate and *Woman with Two Cows* all reveal an artist ill at ease with the etching needle, drawing in short, straight strokes cut rather harshly into the plate. In the sketch of the washerwoman, individual lines are freer, but virtually every contour was worked twice. Only in *Man Leaning on a Spade* does Millet's touch become lighter and more varied, bringing to the etching more of the spontaneity of a drawing.

Notes

1. Michel Melot, *L'Oeuvre gravé de Boudin, Corot, Daubigny, Dupré, Jongkind, Millet, Théodore Rousseau* (Paris: Arts et Métiers Graphiques, 1978), pp. 287-288. Only two of Millet's etchings are likely to predate 1850. *Sheep Grazing*, which Alfred Lebrun ("Catalogue de l'oeuvre gravé de J.-F. Millet," Alfred Sensier and Paul Mantz, *La Vie et l'oeuvre de J.-F. Millet* [Paris: A. Quantin, 1881], p. 371) dated to 1849, perhaps on the basis of information from Charles Jacque (whose signature is falsely scratched into the plate), can be dated stylistically before the move to Barbizon. The other work, a tiny etching of a fishing boat, is so singular that any attempt to date it relative to other work in the medium seems futile.

2. Edward Wheelwright ("Personal Recollections of Jean François Millet," *Atlantic Monthly* 38 [September 1876], p. 271), who lived in Barbizon from October 1855 through June 1856, working under Millet's direction, remembers the artist making "frequent trips to Paris to learn the art of etching" during the winter.

Cat. no. 54:
Related Works

Compositional sketch, black chalk on paper, 5.6 x 9.9 cm., Cabinet des Dessins, Musée du Louvre, Paris (GM10415).

Compositional sketch, black conté crayon on paper, 16.1 x 17.8 cm., current location unknown (London art market, 1960s).

Woman with Two Cows, cat. no. 54.

Cat. no. 55:
Related Works

Woman Laying out Wash, black conté crayon on paper, current location unknown (sold collection of M. and Mme. A[lain], Hôtel Drouot, Paris, November 23-25, 1911, no. 113).

Three sketches: woman laying out wash..., cat. no. 55.

Woman Laying out Wash, oil on canvas, 38.4 x 27.9 cm., private collection, Tokyo.

Cat. no. 56:
Related Works

Compositional sketch, pencil on light brown paper, 7.0 x 5.5 cm., Ashmolean Museum, Oxford.

Man Leaning on a Spade, cat. no. 56.

57
Faggot Gatherers Returning from the Forest
About 1854
Black conté crayon on wove paper
28.6 x 46.7 cm. (11¼ x 18⅜ in.)
Stamped, lower right: J. F. M
Verso stamped: VENTE MILLET
Gift of Martin Brimmer, 1876
76.437 (recto; see also cat. no. 61)

Faggot gatherers, a common sight around the edge of Fontainebleau Forest well into the twentieth century, appear frequently in Millet's work, often as vague silhouettes on the horizon or small figures well back in a shepherding scene on the Chailly Plain. However, in this beautiful drawing, a work that falls ambiguously between Millet's working compositional sketches and his carefully finished drawings for the collector, the women have been made the subject in their own right. Bent under loads of branches as tall as they are, they emerge from the edge of the forest with dragging steps. Just as Millet implied the weight of their heavy burden with the strong angle of the first woman's advance, so he emphasized the slowness of their progress with the long line of the walking stick, which seems about to slip from her hand.

Faggot carriers were among the first of the many peasants living at the very difficult margins of rural life to attract Millet's attention after he arrived in Barbizon. His earliest wood gatherers, drawn in Paris, were old men derived from traditional illustrations. As he became more familiar with the wretched women belonging to the forest population around Barbizon, he began to draw the young wives of the landless woodcutters, who collected fallen wood not for their own families but for sale in the village for a meager income. Even this menial activity was being threatened by changing laws and customs, which had begun to restrict access to most of the privately owned woodlands of France and selected state forests as well.

The barely articulated tree trunks, merging in a screen that absorbs the gatherers in the background and fades into the upper part of the page long before the trees can be defined with foliage and branches, demonstrate Millet's fascination with manipulating a minimum of means to create light and texture. The abstract patterning effect, unusual in his work, can be compared to the broad, flat screen of trees in one of his first important landscape drawings, the *Porte aux Vaches, Winter* (Cabinet des Dessins, Musée du Louvre, Paris) of 1853. Although *Faggot Gatherers Returning from the Forest* belongs to the first years of Millet's stay in Barbizon, it remained in his studio and formed the basis for several later images of Winter.[1]

which absorbed him from the mid-1860s until his death (*Jean-François Millet* [Paris: Editions des Musées Nationaux, Grand Palais exhibition catalogue, 1975], p. 215). But both the basic composition and the scale of figures to setting in the late works are so close to the Boston drawing that it seems clear that cat. no. 57 provided the initial design. The most significant change from the drawing to the pastel and the oil painting is the substitution of Barbizon's Porte aux Vaches wall for the range of trees, a choice that provides both the deeper, more specific space required for a large painting and a suitable device for introducing the drifts of snow that distinguish the later works as seasonal illustrations.

Provenance

Millet studio sale (Hôtel Drouot, Paris, May 10-11, 1875, no. 127), bought by Richard Hearn for Martin Brimmer, Boston.

Exhibition History

Phillips Collection, Washington, D.C., "Drawings by J. F. Millet," 1956.

Arts Council of Great Britain, London, "Drawings of J. F. Millet," 1956, no. 51.

Grand Palais, Paris, "Jean-François Millet," 1975, no. 172 (Hayward Gallery, London, no. 96).

Related Works

Faggot Carriers on the Edge of Fontainebleau Forest, cat. no. 16.

Compositional sketch for *Winter, the Woodgatherers*, black conté crayon on paper, 28.2 x 38.2 cm., current location unknown (Paris art market, 1973).

Winter, The Woodgatherers, pastel on paper, 72 x 93 cm., current location unknown.

Winter, The Woodgatherers, oil on canvas, unfinished, 78.7 x 93 cm., National Museum of Wales, Cardiff.

References

Peacock, Netta. *Millet*. London: Methuen & Co., 1905, illus. p. 63.

Wickenden, Robert J. "Millet's Drawings at the Museum of Fine Arts, Boston." *Print-Collector's Quarterly* 4, part 1 (1918), p. 26, illus. p. 27.

Rewald, John. *History of Impressionism*. New York: Museum of Modern Art, 4th rev. ed., 1973, illus. p. 96.

Herbert, Robert L. "Millet Revisited, I." *Burlington Magazine* 104 (July 1962), pp. 301-302, illus. no. 35, p. 304.

Bouret, Jean. *L'Ecole de Barbizon*. Neuchâtel: Editions Ides et Calendes, 1972, illus. p. 188.

Clark, Kenneth. *The Romantic Rebellion: Romantic versus Classical Art*. London: Harper & Row, 1973, p. 294, illus. no. 225, p. 293.

Clark, T. J. *The Absolute Bourgeois/Artists and Politics in France, 1848-1851*. London: Thames and Hudson, 1973, p. 80, illus. no. 59.

Lévêque, Jean-Jacques. *L'Univers de Millet*. Paris: Henri Scrépel, 1975, illus. p. 46.

Pollack, Griselda. *Millet*. London: Oresko Books, 1977, illus. no. 39, p. 60.

Notes

1. Robert Herbert sees no direct connection between this drawing and the pastel and the oil painting that depict Winter in Millet's two sets of the Four Seasons (see Related Works, below),

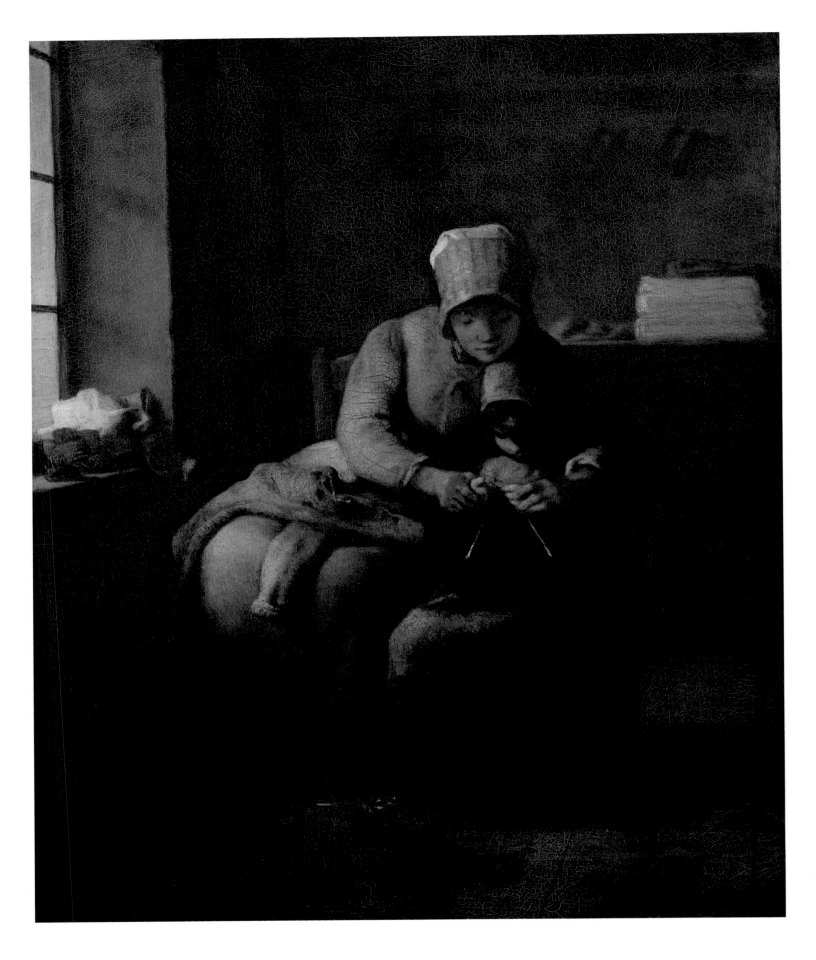

58
Knitting Lesson I
About 1854
Oil on canvas
47.0 x 38.1 cm. (18½ x 15 in.)
Lower right: J. F. Millet
Bequest of Mrs. Martin Brimmer, 1906
06.2423

The soft side lighting that quietly colors this intimate scene of a mother teaching her young daughter to knit reflects the impact of seventeenth-century Dutch genre painting on Millet. His first introduction to the Northern tradition of quiet interior scenes of family life or household tasks, which became increasingly important for him during the 1850s, probably came through the work of an eighteenth-century French artist, Jean-Siméon Chardin, who shared many of the same themes. Charles Jacque (with whom Millet had moved to Barbizon in 1849) made several reproduction prints after Chardin, as well as original etchings highly influenced by a wide range of Dutch masters, and it may have been he who encouraged Millet's interest – or together both artists may simply have been drawn into the widespread revival of interest in these earlier masters that paralleled the nineteenth century's growing attention to all kinds of realistic subject matter. In any event, by the early 1850s, Millet was well familiar with the work of Dutch artists such as Rembrandt, Vermeer, Maes, and the Ostades.[1]

While the subject matter and the simple interior setting, lit by filtered daylight, demonstrate Millet's debt to old masters of Holland, the importance he attached to creating sculpturally strong figure groups and his preference for muted color schemes reflect the very French interpretation he brought to his image. Comparably dressed in heavy muffling clothes, drawn together by the woman's solicitous gesture, the mother and daughter form a tightly united block. The strong angle of the light, falling across the mother's right arm and catching just a fragment of the child's face, reiterates the mother's movement and holds the viewer's interest to the foreground. Still-life items, like the basket of yarn on the window ledge, the folded linen on the cupboard, and the scissors on the floor are sufficiently detailed to complement the picture's theme but generalized enough to remain subordinate to the principal details: careful hands upon hands, emphasized by the light-catching needles, the mother's chin resting on her daughter's head as she peers over at her work, the subtle pairing of their similar bonnets.

Millet's first Salon entry – refused by the jury – was the painting *St. Anne Teaching the Virgin to Read* (current location unknown), painted in 1837, and the variety of mother-daughter teaching themes that continue throughout his career (see also *Reading Lesson*, cat. no. 80, and *Sewing Lesson*, cat. no. 151) suggests that he found the subject an appealing one; with six daughters of his own, he would have had ample opportunity to observe such an intimate exchange. *Knitting Lesson I* is his first painting of the subject to be depicted in a contemporary setting, and the most beautiful of the many images of this theme. In a modest household, amid the careful trappings of a simple life, Millet convincingly localized the values of permanence, continuity, and grace.

Notes
1. Works by Chardin or the Dutch artists were accessible to Millet in the collections of the Louvre – particularly after the reinstallation of the galleries in 1848 – but he was also a great collector of prints by these masters, as well as reproductions after their work.

Provenance
Martin Brimmer, Boston (1854 or 1855), Mrs. Martin Brimmer (1898).

Exhibition History
Boston Athenaeum, "28th Exhibition," 1855, no. 79.
Exhibited frequently at the Museum of Fine Arts, Boston, from 1876 until time of bequest, 1906.
Fogg Museum of Art, Harvard University, Cambridge, "French Art of the Nineteenth Century," 1942.
Museum of Arts and Sciences, Norfolk, Virginia, 1942.
Copley Society, Boston, "Barbizon School," 1968.

Related Works
Finished drawing, black conté crayon on paper, 33 x 29.2 cm., private collection, Kent, England.
Knitting Lesson I, cat. no. 58.
Knitting Lesson, oil on panel, 41.5 x 31.9 cm., Clark Art Institute, Williamstown, Massachusetts.
Knitting Lesson II, cat. no. 81.

References
Strahan, Edward. *Art Treasures of America*. Philadelphia: George Barrie, 1879, vol. 3, p. 81.
"'Greta's' Boston Letter." *Art Amateur* 5, no. 4 (September 1881), p. 72.
Durand-Gréville, E. "La Peinture aux Etats-Unis." *Gazette des Beaux-Arts* 2nd ser., 36 (July 1887), p. 67.
Hurll, Estelle M. *Jean-François Millet*. Boston: Houghton Mifflin & Co., 1900, pp. 7, 12.
Guiffrey, Jean. "Tableaux Français conservés au Musée de Boston et dans quelques collections de cette ville." *Archives de l'art Français* n. s. 7 (1913), p. 550.
Moreau-Nélaton, Etienne. *Millet raconté par lui-même*. Paris: Henri Laurens, 1921, vol. 2, p. 78, fig. 147.
Edgell, George Harold. *French Painters in the Museum of Fine Arts: Corot to Utrillo*. Boston: Museum of Fine Arts, 1949, p. 19, illus. p. 20.

59
Standing Spinner
About 1850-1855
Oil on canvas
46.5 x 38.1 cm. (18¼ x 15 in.) – support
45.3 x 32.5 cm. (17⅞ x 12¾ in.) – design
Lower right: J. F. Millet
Gift of Quincy Adams Shaw through
Quincy A. Shaw, Jr., and Mrs. Marian
Shaw Haughton, 1917
17.1499

Women spinning wool or flax in a house-hold setting (using wheels of all sizes) or outdoors (with a distaff and spindle) occur repeatedly in Millet's work, with variations reflecting the different locales he represented. In a method of working that is very typical, his spinners develop out of many levels of meaning: a personal significance, a traditional reading, the art of the past, and immediate, practical experience pulled together in one image. When Millet spoke of a new idea for a painting or drawing, he frequently explained to Sensier that he would need time to consider the subject fully, to truly comprehend it, before he could reach the essentials that would make the image complete. More than just fumbling justifications, these explanations genuinely represent the patterns of thinking and working that characterize Millet's art.

Spinning was an activity that Millet associated with his mother and grandmother in Gruchy and, although it figured in the nightmares of his arrival in Paris, it was generally a happy image (see cat. no 44). In a tradition that continued well through Millet's day, spinning was used to designate womanhood in so many depictions of Eve, the Virgin, and anonymous shepherdesses that the word distaff became a synonym for female.[1] During his own lifetime, however, spinning, although still practiced in many peasant homes, was a dying skill as industrially produced fabrics gained popularity throughout France.

The spinner in the present painting turns the large wheel that was commonly used for spinning wool from a carded coil of fabric to a loose thread. At her side, several coils of woolen fiber, carded to draw all the fibers into line, lie on the shelf of her spinning wheel, while the basket beneath holds full spindles. Wool was spun in both Gruchy and Barbizon, but this young spinner's *marmotte* (head scarf) identifies her with the area of central France that included the Chailly plain.

The first conceptions of this figure – drawings – depict a pretty, rather stylized young woman typical of Millet's work of 1850-1852 (see fig. 8), awkwardly leaning into her task. And the rather bare setting of the painting, against a flat wall, is characteristic of Millet's pictures such as *Butter Churner* or *Cooper* (cat. nos. 20 and 24), also of the very early 1850s. But the simple silhouette and solidly sculptural form of the spinner herself, whose shoulder line has been visibly corrected from the more cramped pose of the drawing, belongs to the years of 1854-1855 in Millet's *oeuvre*, as does her simpler, more commanding pose. The unusual color scheme, with so many unrelated hues softly paled with white pigment, is difficult to relate to other works by the artist, and gives the painting a brightness and airy quality that many of his interiors lack. When added to the special beauty of the young woman's face and scarf, the coloring conveys an air of quiet well-being that brings the *Standing Spinner* closer to Millet's family interiors than to his other images of work.

Notes
1. The archetypal image equating spinning and womanhood on the trumeau of Nôtre Dame's main portal depicts Adam digging and Eve spinning – reminders of the fate to which they had fallen from the Garden.

Provenance
J. W. Wilson (sold Hôtel Drouot, Paris, April 27-28, 1874, no. 114); Quincy Adams Shaw, Boston.

Exhibition History
Museum of Fine Arts, Boston, "Quincy Adams Shaw Collection," 1918, no. 13.
Museum of Fine Arts, Boston, "Barbizon Revisited," 1963, no. 65.
Grand Palais, Paris, "Jean-François Millet," 1975, no. 75 (Hayward Gallery, London, 1976, no. 50).
Museum of Fine Arts, Boston, "Corot to Braque: French Paintings from the Museum of Fine Arts," 1979, no. 15.
Dixon Gallery and Gardens, Memphis, "An International Episode: Millet, Monet, and their North American Counterparts," 1982, no. 3.

Related Works
Compositional sketch with spinner seen from the side and woman carding in the right background, black conté crayon on paper, 24.0 x 17.4 cm., Cabinet des Dessins, Musée du Louvre, Paris (GM10390).
Compositional sketch of spinner seen from the rear, black conté crayon on paper, 9.1 x 5.7 cm., Cabinet des Dessins, Musée du Louvre, Paris (GM10318).
Figure study, black conté crayon on paper, 25.6 x 11.9 cm., Cabinet des Dessins, Musée du Louvre, Paris (GM10320).
Compositional study with woman carding in right background, black conté crayon on paper, 37 x 27.5 cm., current location unknown (see Haviland sale, Georges Petit, Paris, June 2-3, 1932, no. 34).

Compositional study with stairway to the right, black conté crayon on paper, 37.5 x 29.2 cm., current location unknown (see Sotheby Parke Bernet, New York, November 21, 1980, no. 113).
Compositional sketch with woman carding in right background, black conté crayon on paper, 15 x 10 cm., Musée Grobet-Labadie, Marseilles.
Compositional sketches, black conté crayon on paper, 14.2 x 9.8 cm., Cabinet des Dessins, Musée du Louvre, Paris (GM10319).
Studies of figure with perspective lines, black conté crayon on paper, 35 x 53.2 cm., current location unknown (see Sotheby's, London, April 20, 1978, no. 438).
Study of a figure, pencil on paper, 24.0 x 9.5 cm., current location unknown (see Alfred Sensier and Paul Mantz, *La Vie et l'oeuvre de J.-F. Millet* [Paris: A. Quantin, 1881], p. 15).
Standing Spinner, cat. no. 59.

References
Moreau-Nélaton, Etienne. *Millet raconté par lui-même*. Paris: Henri Laurens, 1921, vol. 2, pp. 122, 123, fig. 174.
Fermigier, André. *Millet*. Geneva: Skira, 1977, p. 85, illus. p. 84.
Meixner, Laura L. *An International Episode: Millet, Monet and their North American Counterparts.* Memphis: The Dixon Gallery and Gardens, exhibition catalogue, 1982, pp. 25-28.

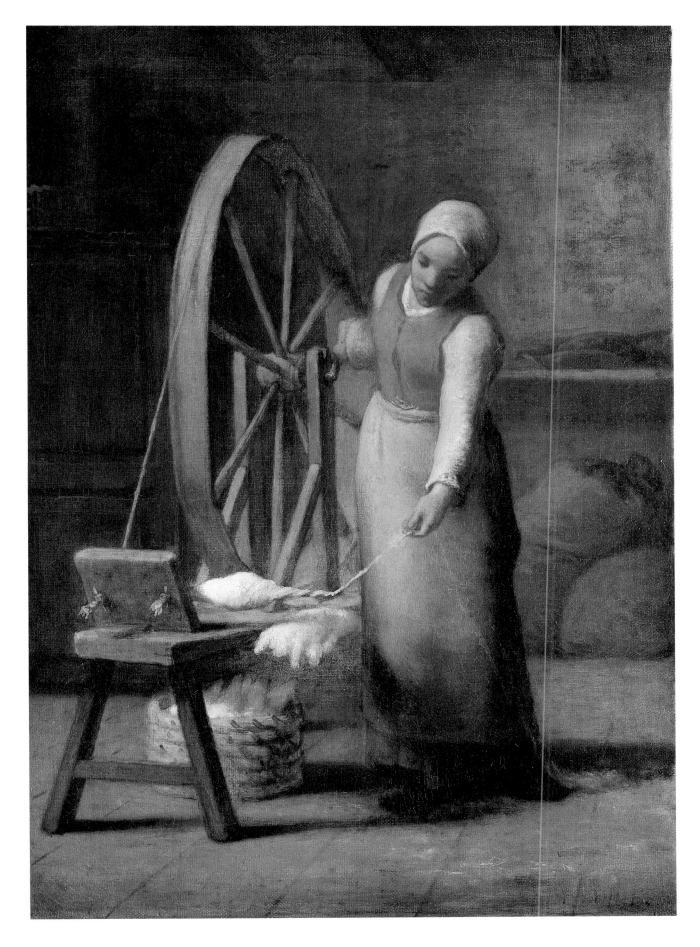

60
Woman Holding a Child
(studies for *Man Grafting a Tree*)
About 1855
Black conté crayon on paper
31.5 x 37.5 cm. (12⅜ x 14¾ in.)
Gift of Quincy Adams Shaw through
Quincy A. Shaw, Jr., and Mrs. Marian
Shaw Haughton, 1917
17.1503 (verso)

Woman Holding a Child is a page of studies for Millet's entry at the Exposition Universelle in 1855, *Man Grafting a Tree* (Neue Pinakothek, Munich). The painting celebrates a famous Virgilian verse: *insere, Daphne, piros; carpent tua poma nepotes* (graft your pear tree, Daphnis; your children and their children will gather the fruit). A recognition of the satisfactions that in some part offset the hardships of life – the growth of one's family and the increasing value of well-tended lands – the painting reflected Millet's own greater peace and pleasure with his growing family. Although these more intimate subjects were usually destined for private collectors, *Man Grafting a Tree*, with its origin in the

great pastoral poetry of Rome, the *Georgics* of Virgil, was sufficiently dignified to merit Salon scale.

Although both figures of *Man Grafting a Tree* are in contemporary peasant dress, the pose of the mother and child (so reminiscent of French Gothic statues of the Virgin and Child, with the child held high on her hip and the overskirt gathered up across her figure) shows Millet merging nineteenth-century realism with classic inspiration and medieval form. Found on the back of another family garden scene, cat. no. 87, these quick sketches are probably studies from life, made after Millet had a rough idea of the pose he wished to use. The two drawings on the left side of the

page show him exploring alternate arrangements of the mother's arms, while the study of her skirt (utilizing the page – which has been cut down – in the other direction) is an attempt to drape modern costume to correspond with an artistic prototype.

Provenance

Alfred Sensier (sold Hôtel Drouot, Paris, December 10-18, 1877, no. 198), bought by Legrand, probably for Quincy Adams Shaw, Boston.

Related Works

Compositional sketch on page of sketches, pencil on paper, 18.5 x 13.8 cm., Cabinet des Dessins, Musée du Louvre, Paris (GM10588 verso).

Compositional sketch, pencil on paper, 28.8 x 17.0 cm., Cabinet des Dessins, Musée du Louvre, Paris (GM10321).

Compositional sketch, black chalk on paper, 5.6 x 8.5 cm., Cabinet des Dessins, Musée du Louvre, Paris (GM10322).

Compositional sketch, black chalk on paper, 6.9 x 5.5 cm., Cabinet des Dessins, Musée du Louvre, Paris (GM10323).

Compositional sketch, black chalk on paper, 9.5 x 6.0 cm., Cabinet des Dessins, Musée du Louvre, Paris (GM10324).

Compositional sketch, black chalk on paper, 11.1 x 8.5 cm., Cabinet des Dessins, Musée du Louvre, Paris (GM10325).

Compositional sketch, black chalk on paper, 18.6 x 15.5 cm., Cabinet des Dessins, Musée du Louvre, Paris (GM10326).

Figure study for man, black chalk on paper, 7.2 x 4.6 cm., Cabinet des Dessins, Musée du Louvre, Paris (GM10327).

Woman Holding a Child, cat. no. 60.

Studies for hands and arms of woman, black conté crayon on paper, 16.0 x 24.8 cm., current location unknown (London art market, 1970s).

Studies for hands and arms of woman, pencil on paper, 6.6 x 12.6 cm., current location unknown (London art market, 1970s).

Man Grafting a Tree, oil on canvas, 81 x 100 cm., Neue Pinakothek, Munich.

References

This drawing has not been published previously. For a discussion of the painting and other related drawings, see [Robert L. Herbert], *Jean-François Millet* (Paris: Editions des Musées Nationaux, Grand Palais exhibition catalogue, 1975), pp. 97-100.

61
Woman Holding Laundry[1]
(study for *Washerwomen*)
1854-1855
Black conté crayon (?) on wove paper
28.6 x 46.7 cm. (11¼ x 18⅜ in.)
Stamped, lower right: VENTE MILLET
Recto stamped: J. F. M
Gift of Martin Brimmer, 1876
76.437 (verso; see also cat. no. 57)

62
Washerwomen
About 1855
Oil on canvas
43.5 x 53.8 cm. (17⅛ x 21⅛ in.)
Lower right: J. F. Millet
Bequest of Mrs. Martin Brimmer, 1906
06.2422

Although in Barbizon Millet lived at the heart of the revolution taking place in French landscape painting during the 1840s and 1850s, and his closest friend, Théodore Rousseau, was the most important figure in that revolution, he himself created very few landscape paintings before the mid-1860s. By 1855, however, he was giving increasing prominence to the landscape backgrounds of his figure pictures, and in works such as *Washerwomen*, the balance between his tired workers and the sunset-tinged pond challenges the academic distinctions between landscape and figure paintings.[2]

This is a composition on which Millet had been working for some years, perhaps since 1851-1852, and the oil painting follows a series of sketches and finished drawings in which the figures become increasingly sculptural and solid, and the landscape grows in prominence, becoming deeper and simpler. Millet made no dramatic changes in his figures as he worked from a crayon and watercolor version (Khalil Museum, Cairo) through a large compositional study (current location unknown) to a finished black crayon drawing (private collection, Melbourne), whose sharply reinforced outlines suggest that it may have served as a model for the Boston painting. But the small changes in the laundresses occurring steadily throughout the several drawings reflect his evolving figure types during the four or five years over which he worked on the theme: their costumes became simpler and heavier, their bodies more powerful, and their features more rounded and generalized. *Woman Holding Laundry* (cat. no. 61) comes late in the sequence of figure studies, immediately prior to the Melbourne composition, as Millet reached the simple, smooth silhou-

ettes characteristic of his figures around 1855 (see cat. 59).

With the straight stance, braced arm, and distant gaze of the woman receiving the heavy, wet linens, Millet conveyed the weight of her burden as well as her resigned acceptance of a task to which her body is well accustomed. Silhouetted against the sky, lifting the laundry to her companion's shoulders, the second woman brings a note of carefully poised grace to their labor, in which no movements are wasted. Drawing the figures together in a bold foreground unit, Millet set their softly colored, shadowed forms against the simple horizontal spread of a surprisingly vibrant landscape. He had steadily expanded the background from his first version of the composition, increasing the space on the left and the breadth of the sky above, until the empty sweep of pond occupied nearly as much of the image as the washerwomen themselves. The stark structure of parallel bands of sky, embank-

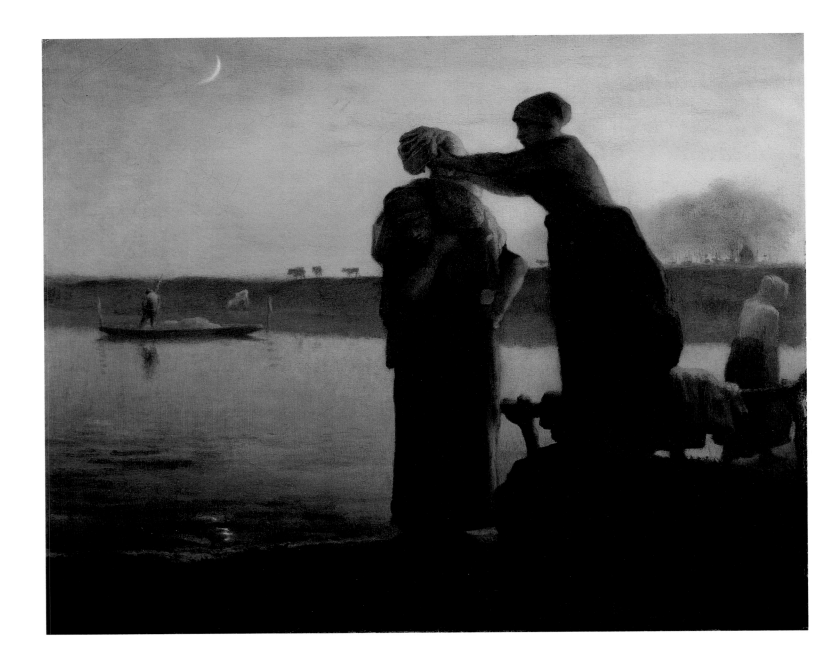

ment, and pond surface is softened by the cows along the horizon, a man dredging for sand, and ripples breaking near the shore. Figures and landscape are unified by Millet's interweaving of the sky's turquoise and pink-gold tones throughout the garments of the washerwomen.

Notes

1. This drawing, hidden by a lining that strengthens the drawing on the recto of the sheet, is visible under infrared light.

2. Combining landscape and figural compositions in virtually equal measure is uncommon in the hierarchical French tradition, which provided for either figure paintings to which landscape was simply a descriptive addition or landscapes with small, subordinate figure groups.

Cat. no. 61:

Provenance

Millet studio sale (Hôtel Drouot, Paris, May 10-11, 1875, no. 127 verso), bought by Richard Hearn for Martin Brimmer, Boston.

Cat. no. 62:

Provenance

Martin Brimmer, Boston (by 1857), Mrs. Martin Brimmer, Boston (1896).

Exhibition History

Athenaeum, Boston, "Thirtieth Exhibition," 1857, no. 230.

Athenaeum, Boston, 1860, no. 235.

Exhibited frequently at the Museum of Fine Arts, Boston, from 1876 until time of bequest, 1906.

Museum of Fine Arts, Springfield, Massachusetts, "Barbizon Painters," 1938-1939, no. 6.

St. Botolph Club, Boston, 1940.

Fine Arts Center, Colorado Springs, 1940.

Connecticut College for Women, New London, 1940.

Museum of Arts and Sciences, Norfolk, Virginia, 1942.

Paul Rosenberg & Co., New York, "The 19th Century Heritage," 1950, no. 15.

Art Gallery, Vassar College, 1955.

Grand Palais, Paris, "Jean-François Millet," 1975, no. 78 (Hayward Gallery, London, 1976, no. 52).

Museum of Fine Arts, Boston, "Corot to Braque: French Paintings from the Museum of Fine Arts, Boston," 1979, no. 16.

Related Works

Compositional sketch for landscape with figure in boat, black conté crayon on paper, 6.2 x 9.5 cm., Cabinet des Dessins, Musée du Louvre, Paris (GM10632).

Compositional sketch for landscape with figure in boat, with trees on horizon to left, black conté crayon on paper, Museum Boymans-van Beuningen, Rotterdam.

Finished drawing of landscape with figure in boat, trees to left, watercolor on paper, 17.4 x 28.5 cm., British Museum, London.

Compositional sketch of washerwomen in landscape, black conté crayon on paper, 13.5 x 16.8 cm., Cabinet des Dessins, Musée du Louvre, Paris (GM10631).

Finished drawing, black conté crayon with watercolor on paper, 32.0 x 45.5 cm., Khalil Museum, Cairo.

Tracing of above drawing, black conté crayon on paper, 34.0 x 46.0 cm., Musée des Beaux-Arts, Dijon.

Study of woman with laundry on her shoulder, black conté crayon on paper, 10.6 x 5.4 cm., Cabinet des Dessins, Musée du Louvre, Paris (GM10336).

Compositional sketch adapting pose of woman holding laundry, current location unknown (see Julia M. Cartwright, "The Drawings of Jean-François Millet in the Collection of Mr. James Staats-Forbes," *Burlington Magazine* 5 [April 1904], p. 61).

Study of woman placing laundry, black conté crayon on paper, 27.7 x 19.4 cm., Musée Bonnat, Bayonne.

Study of woman holding laundry, black conté crayon on paper, 7.9 x 5.5 cm., Ashmolean Museum, Oxford.

Woman Holding Laundry, cat. no. 61.

Finished drawing, black conté crayon and pen and ink on paper, 33 x 42 cm., private collection, Melbourne.

Washerwomen, cat. no. 62.

Finished drawing in vertical format with full moon, no boat, black conté crayon with white crayon on paper, 43 x 36 cm., private collection, Zurich.

Finished drawing in vertical format with full moon, rowboat to right, black conté crayon with white crayon on paper, 43 x 30.5 cm., Memorial Art Gallery, University of Rochester.

References

Durand-Gréville, E. "La Peinture aux Etats-Unis." *Gazette des Beaux-Arts* 2nd ser., 36 (July 1887), p. 67.

Strahan, Edward. *Art Treasures of America*. Philadelphia: George Barrie, 1879, vol. 3, p. 81.

Peacock, Netta. *Millet*. London: Methuen & Co., 1905, p. 119.

Guiffrey, Jean. "Tableaux Français conservés au Musée de Boston et dans quelques collections de cette ville." *Archives de l'Art Français* n. s. 7 (1913), pp. 533-552.

Huyghe, René. *La Relève de l'imaginaire*. Paris: Flammarion, 1976, fig. 372.

Fermigier, André. *Millet*. Geneva: Skira, 1977, p. 84, illus. p. 85.

Pollack, Griselda. *Millet*. London: Oresko Books, 1977, p. 55, fig. 33.

63
Woman Sewing beside a Window
Delteil 9, second state
1855-1856
Etching on antique laid paper
10.4 x 7.4 cm. (4⅛ x 2⅞ in.)
Frederick Keppel Memorial Bequest, 1913
M28670

In late 1855, at the urging of Alfred Sensier, Millet began a series of etchings from his own designs for commercial publication. Sensier hoped to make the artist's work better known with inexpensive prints and to bring in badly needed money for him; Millet hoped to find in the etching process a faster way of making a work of art.[1] *Woman Sewing beside a Window* is probably the first of six to eight etchings made in 1855-1856, from which a set of five (including the present example) were published by August Delâtre in 1858.[2]

The nineteenth century saw a tremendous revival of interest in all graphic media in France, in large part because widespread prosperity encouraged people of modest means to collect art of some kind, if only humble reproductions. Toward the middle of the century, the taste for high-quality craftsman prints – lithographs or engravings made by skilled artisans after drawings or paintings by other artists – was challenged by a renewed interest in the etching technique among many of the younger painters or draftsmen. With the ease of direct execution that etching offered, these artists were able to make and to control the quality of their own printed images. Charles Jacque was a leader in the etching revival in the 1840s, and Millet collected etchings by 1855.

Woman Sewing beside a Window, similar in composition to *Knitting Lesson I* (cat. no. 58), belongs to Millet's Dutch-inspired subject matter of the mid-1850s. With a single solid form and a variety of light effects, it provided a good first image for a new engraver. Millet attained an effective balance of black and white, and shaded his figures convincingly, but the touch throughout the etching is relatively unvaried, with little differentiation of materials.

Notes

1. Edward Wheelwright, "Personal Recollections of Jean François Millet," *Atlantic Monthly* 38 (September 1876), p. 271.

2. Robert Herbert does not include this among the original publication group (*Jean François Millet* [Paris: Editions des Musées Nationaux, Grand Palais exhibition catalogue, 1975], p. 167). However,

Sensier's comment, in correspondence to Millet (February 8, 1858), that the "little one" was thought lost because it was hidden in the bundle by the other four can only relate to this plate, which is distinctly smaller than others in the group (quoted in Michel Melot, *L'Oeuvre gravé de Boudin, Corot, Daubigny, Dupré, Jongkind, Millet, Théodore Rousseau* [Paris: Arts et Métiers Graphiques, 1978], p. 287.

Related Works

Compositional study, black conté crayon with white chalk on paper, 8.7 x 11.6 cm., Museum of Art, Rhode Island School of Design, Providence.
Woman Sewing beside a Window, cat. no. 63.

References

Burty, Philippe. "Les Eaux-fortes de M. J.-F. Millet." *Gazette des Beaux-Arts* 1st ser., 11 (September 1861), p. 265-266.

Lebrun, Alfred. "Catalogue de l'oeuvre gravé de J.-F. Millet." In Sensier, Alfred, and Mantz, Paul. *La Vie et l'oeuvre de J.-F. Millet*. Paris: A. Quantin, 1881, no. 10, p. 372.

Delteil, Loys. *Le Peintre-graveur illustré (XIX et XX siècles), I, J.-F. Millet, et al.*. Paris: Delteil, 1906, no. 9.

Melot, Michel. *L'Oeuvre gravé de Boudin, Corot, Daubigny, Dupré, Jongkind, Millet, Théodore Rousseau*. Paris: Arts et Métiers Graphiques, 1978, no. 9, p. 287.

J.F.M

64
Study for *Woman Churning Butter*
1855-1856
Pencil and black conté crayon on tracing paper
20.2 x 14.6 cm. (8 x 5¾ in.)
Gift of Martin Brimmer, 1876
76.435

65
Woman Churning Butter
Delteil 10, first state
1855-1856
Etching on wove paper
18 x 11.8 cm. (7⅛ x 4⅝ in.)
Gift of Mr. and Mrs. Edward Wheelwright, 1913
M23318

With *Woman Churning Butter*, Millet's skills as an etcher began to come into line with his abilities as a draftsman: he became freer and more inventive, making better use of the medium to advance his designs. The preparatory drawing for this work, cat. no. 64, shows Millet establishing in crayon several of his strategies for creating different densities of black in his etching, notably the various patterns of loose hatching that overlay objects along both walls and a variety of short strokes for the shadows on his figures.

Woman Churning Butter substantially recasts Millet's earlier painting of the same theme (cat. no. 20). Here, the woman churning has the solid, bulky form characteristic of his female types in the mid-1850s, and she works in a larger, more airy space. Seen straight on, her quiet gaze and steady arms belie the suggestions of exhaustion and boredom that characterized the earlier churners in his *oeuvre*, and the contented cat stretching against her ankles adds a note of casualness to the scene.

This fresh impression was given by Millet in 1856 to Edward Wheelwright, a Boston painter studying in Barbizon, who later presented it to the Museum. Such documentary evidence for dating the prints is of importance to later historians, because Millet was not always happy with the way his plates were printed (and besides numerous impressions made by various printers during Millet's own lifetime, some of his plates continued to be printed after his death). A very early impression such as this is likely to have been made directly under his supervision, thus coming closest to his own sense of how the prints should look. Most of the impressions made of the present series of etchings (cat. nos. 63, 65, 67, 69, 71, 72, 73) were executed by August

Delâtre, a highly skilled and respected printer, but one prone to ink the plates too heavily for Millet's taste.

Cat. no. 64:
Provenance
Millet studio sale (Hôtel Drouot, Paris, May 10-11, 1875, no. 185), bought by Richard Hearn for Martin Brimmer, Boston.

Exhibition History
Phillips Collection, Washington, D.C., "Drawings by J. F. Millet," 1956.
Arts Council of Great Britain, London, "Drawings by Jean-François Millet," 1956, no. 26.

Cat. nos. 64 and 65:
Related Works
Study for *Woman Churning Butter*, cat. no. 64.
Woman Churning Butter, cat. no. 65.
For works before and after the etching, see complete list under cat. no. 20.

Cat. no. 65:
References
Burty, Philippe. "Les Eaux-fortes de M. J.-F. Millet." *Gazette des Beaux-Arts* 1st ser., 11 (September 1861), p. 266.

Lebrun, Alfred. "Catalogue de l'oeuvre gravé de J.-F. Millet." In Sensier, Alfred, and Mantz, Paul. *La Vie et l'oeuvre de J.-F. Millet*. Paris: A. Quantin, 1881, no. 11, p. 372.

Delteil, Loys. *Le Peintre-graveur illustré (XIX et XX siècles), I, J.-F. Millet, et al.*. Paris: Delteil, 1906, no. 10.

Melot, Michel. *L'Oeuvre gravé de Boudin, Corot, Daubigny, Dupré, Jongkind, Millet, Théodore Rousseau*. Paris: Arts et Métiers Graphiques, 1978, no. 10, p. 287.

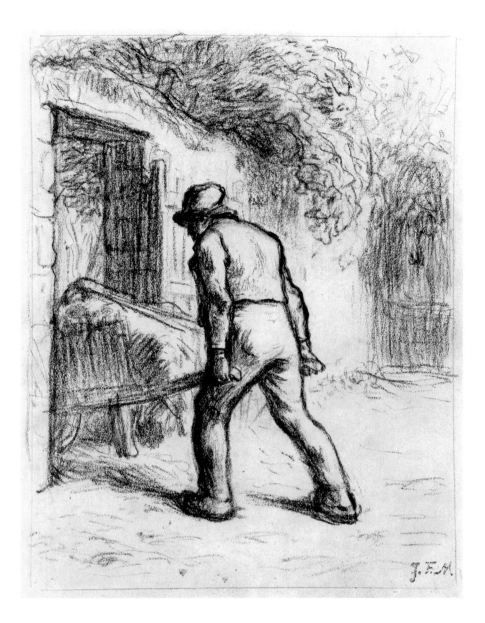

Like the preceding etching, *Man with a Wheelbarrow* is an image well worked out in earlier drawings and paintings, leaving Millet free to concentrate on the technical challenges of his media. Even so, the exceptional gains in his skills in so short a time are surprising. Millet manipulated his etching needle here with all the sureness he had with a pen or crayon, and he rendered the solid figure and spaces of the complicated garden scene with a vocabulary of touches that bring the small surface to life. The heavy, strengthened outline of the figure in the preparatory drawing (cat. no. 67) probably reworked in the transfer process from drawing to plate, contrasts with the sleeker, less intrusive outline of the print. Broken at intervals, thinner, and often establishing a sense of line only with carefully aligned hatching marks, the silhouette is maintained without cutting the figure off from the space he inhabits – one of the special challenges for a painter working in a black-and-white medium.

Cat. no. 66:
Provenance
Millet studio sale (Hôtel Drouot, Paris, May 10-11, 1875, no. 158), bought by Richard Hearn for Martin Brimmer, Boston.

Related Works
Compositional sketch, black conté crayon on paper, 11.2 x 7.4 cm., Cabinet des Dessins, Musée du Louvre, Paris (GM10585).

Man with a Wheelbarrow, oil on canvas, 37.8 x 45.4 cm., Indianapolis Museum of Art.

Figure study, black conté crayon on paper, 24.6 x 16.2 cm., current location unknown.

Finished drawing, black conté crayon on paper, 32.5 x 26.7 cm., current location unknown (New York art market, 1970s).

Compositional sketch, black conté crayon on paper, current location unknown (see Léonce Bénédite, *The Drawings of Jean-François Millet* [London: William Heinemann, 1906], unnumbered plate).

Compositional sketch (counterproof of previous sketch), black conté crayon on tracing paper, 10.4 x 12.9 cm., Cabinet des Dessins, Musée du Louvre, Paris (GM10298).

Compositional study, black conté crayon on paper, 29.8 x 21.0 cm., Cabinet des Dessins, Musée du Louvre, Paris (GM10297).

Study for *Man with a Wheelbarrow*, cat. no. 66.

Man with a Wheelbarrow, cat. no. 67.

References

Peacock, Netta. *Millet*. London: Methuen & Co., 1905, illus. p. 40.

Wickenden, Robert J. "Millet's Drawings at the Museum of Fine Arts, Boston." *Print-Collector's Quarterly* 4, part 1 (1914), pp. 14, 16, illus. p. 17.

References

Burty, Philippe. "Les Eaux-fortes de M. J.-F. Millet." *Gazette des Beaux-Arts* 1st ser., 11 (September 1861), pp. 265-266.

Lebrun, Alfred. "Catalogue de l'oeuvre gravé de J.-F. Millet." In Sensier, Alfred, and Mantz, Paul. *La Vie et l'oeuvre de J.-F. Millet*. Paris: A. Quantin, 1881, no. 12, p. 372.

Delteil, Loys. *Le Peintre-graveur illustré (XIX et XX siècles), I, J.-F. Millet, et al.*. Paris: Delteil, 1906, no. 11.

Melot, Michel. *L'Oeuvre gravé de Boudin, Corot, Daubigny, Dupré, Jongkind, Millet, Théodore Rousseau*. Paris: Arts et Métiers Graphiques, 1978, no. 11, p. 287.

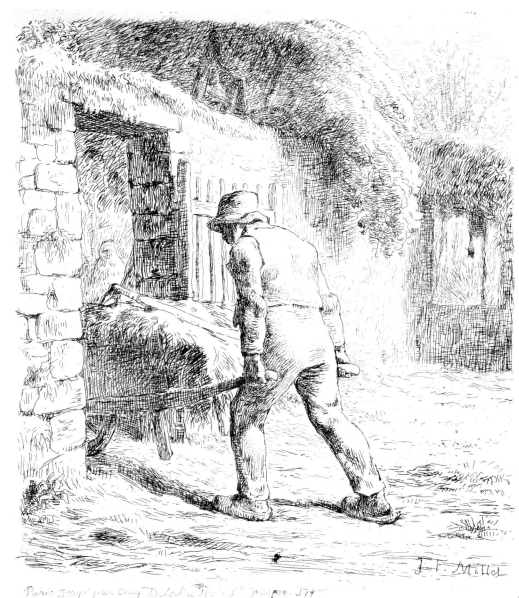

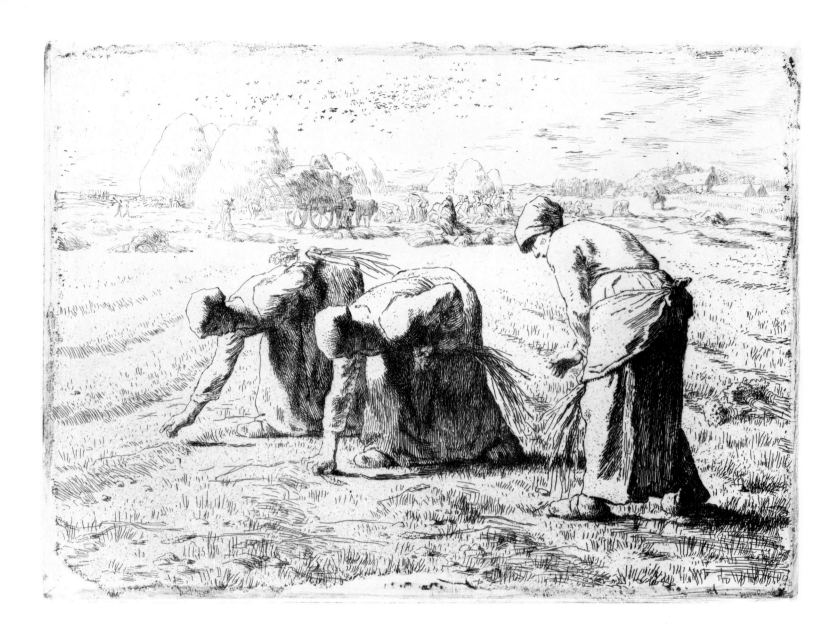

68
Gleaners
Delteil 12, first state
1855-1856
Etching on wove paper
19.0 x 25.3 cm. (7¼ x 10 in.)
Bequest of Mrs. Horatio G. Curtis
27.1380

Millet's earliest etchings were based on compositions that he had worked out in another medium (thus, essentially reproductions, however high their quality), but he soon began to use the technique for completely new works. *Gleaners* and *Two Men Turning over the Soil* (cat. no. 69), both themes that had interested Millet for some time, were reorganized and drawn as large, multifigure compositions designed specifically for etchings, prior to their use for paintings or pastels. For both etchings he worked from full-scale, but hardly detailed drawings, inventing a great deal on the plate and creating his graphic shorthand for grain stalks and flocks of birds as he worked.

The essential components of *Gleaners* had been suggested by Millet's earlier *Summer* image of 1854 (see cat. no 46), but for the etching, he made a critical shift to a horizontal format and substantially rearranged his composition. The three gleaners, spread somewhat farther apart, occupy the foreground, with the harvested field extending far to all sides of them. In the background, a secondary composition, considerably enlarged from the earlier painting, includes eight great grain stacks and dozens of harvesters,[1] with one of the large farms between Chailly and Barbizon to the right. The considerable expansion of Millet's cast, as well as of the arena in which they work, particularizes his image, providing a sense of specific place, of characters and time. The three women no longer glean immediately in the shadow of the harvesters, whose task they had appeared to complete in an orderly, peaceful way; now they are dramatically removed from the harvest, distanced and isolated from the activity beyond. Their meager bundles of grain, dropped to one side, contrast with the great prosperity behind, as they continue their deadening toil.

Millet's new gleaning image is conceived with a basic monumentality that lent it easily to later enlargement for a painting (1857; Musée du Louvre, Paris). The gleaners are large, sculpturally convincing forms, carefully related to their composition with a pattern of heavy shadows that directs the viewer through the three figures and around the center of the harvest scene behind. Millet placed the left- and right-hand gleaners so that their hands or scarved heads physically connect them with the harvest, overcoming the deep recession of the plain to link the events in a formal unity.

Notes
1. The mounted figure in the back[...] *garde champêtre*, or field warden, [...] of local usage and the rights of gl[...] abused.

Related Works
For the origin of this theme in Mill[...] cat. no. 46.

Compositional study for the etching, 17.5 x 26.5 cm., Baltimore Museum of Art (George A. Lucas Collection, Maryland Institute College of Art).

Gleaners, cat. no. 68.

Gleaners, oil on canvas, 83.5 x 111.0 cm., Musée du Louvre, Paris (R.F. 592).

References
Burty, Philippe. "Les Eaux-fortes de M. J.-F. Millet." *Gazette des Beaux-Arts* 1st ser., 11 (September 1861), pp. 264, 266.

Lebrun, Alfred. "Catalogue de l'oeuvre gravé de J.-F. Millet." In Sensier, Alfred, and Mantz, Paul. *La Vie et l'oeuvre de J.-F. Millet*. Paris: A. Quantin, 1881, no. 13, p. 373.

Delteil, Loys. *Le Peintre-graveur illustré (XIX et XX siècles)*, I, *J.-F. Millet, et al.*. Paris: Delteil, 1906, no. 12.

Melot, Michel. *L'Oeuvre gravé de Boudin, Corot, Daubigny, Dupré, Jongkind, Millet, Théodore Rousseau*. Paris: Arts et Métiers Graphiques, 1978, no. 12, p. 287.

Peel here to fold

P2 2

© 2004 USPS

Peel here to fold

103

© 2004 USPS

Peel here to fold

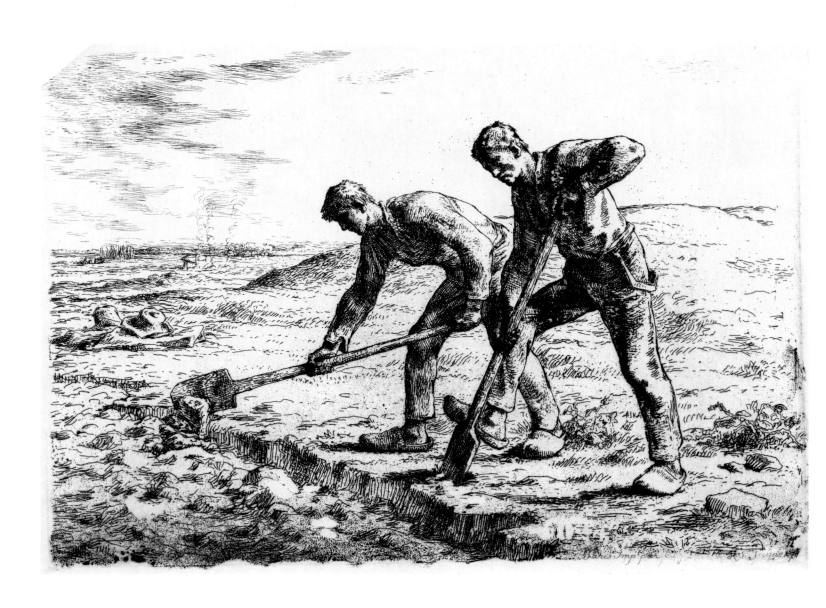

69
Two Men Turning over the Soil
Delteil 13, fourth state
1855-1856
Etching on antique laid paper
23.5 x 33.5 cm. (9¼ x 13⅛ in.)
Gift of William Norton Bullard, 1923
23.1176

Tilling the earth has been an archetype for man's fate since the Book of Genesis, and in these laborers Millet saw the realization of the Creator's oath to Adam: "By the sweat of thy brow shalt thou eat thy daily bread." The theme of two men working at the back-breaking, monotonous task of opening up the soil for planting had compelled the artist's attention even before he left Paris for Barbizon in 1849 (see cat. no. 17); he often drew one or both of the digging men on pages of random compositional thoughts. In 1855, with this etching in mind, he took up the image again, bringing it to a powerful completion. Undertaking a composition specifically to be produced as a print was new to Millet and confirms his remark that he looked upon etching not just as a means of reproduction but as a way of creating original work.[1]

Millet prepared his etching with a long series of drawings, resolving the basic relationship of the two figures' actions and studying each man separately in several drawings. Then, on the plate, he deepened the landscape and drew the background scene, adding details directly. In both *Men Turning over the Soil* and *Gleaners* (cat. no. 68), he developed a number of distinctive drawing strokes and dots to suggest a range of different materials and textures, without becoming simply imitative. In the lower left foreground, the pitting characteristic of a poorly varnished plate is worked into the design with a slight toning that heightens the appearance of newly opened soil. Spaces and figures are left very open and light, and in these early impressions of good quality, Millet's preference for lightly inked prints that displayed his adroit line is well substantiated.

Two later versions of *Two Men Turning over the Soil* – an unfinished painting (Tweed Gallery, University of Minnesota, Duluth) of about 1855 and the monumental pastel (cat. no. 116) of 1866 – are both derived from this much smaller print.

Notes
1. Edward Wheelwright, "Personal Recollections of Jean François Millet," *Atlantic Monthly* 38 (September 1876), p. 271.

Related Works
Compositional sketch, black conté crayon on paper, 22.5 x 33.5 cm., private collection, Paris.
Compositional study, black conté crayon on paper, 24 x 33 cm., private collection, Lugano.
Compositional study, black conté crayon on paper, 23.6 x 33.5 cm., Musée Bonnat, Bayonne.

Two Men Turning over the Soil, cat. no. 69. For complete listing, see cat. no. 116.

References
Burty, Philippe. "Les Eaux-fortes de M. J.-F. Millet." *Gazette des Beaux-Arts* 1st ser., 11 (September 1861), pp. 264, 266.
Lebrun, Alfred. "Catalogue de l'oeuvre gravé de J.-F. Millet." In Sensier, Alfred, and Mantz, Paul. *La Vie et l'oeuvre de J.-F. Millet*. Paris: A. Quantin, 1881, no. 14, pp. 373-374.
Delteil, Loys. *Le Peintre-graveur illustré (XIX et XX siècles)*, I, *J.-F. Millet, et al*. Paris: Delteil, 1906, no. 13.
Melot, Michel. *L'Oeuvre gravé de Boudin, Corot, Daubigny, Dupré, Jongkind, Millet, Théodore Rousseau*. Paris: Arts et Métiers Graphiques, 1978, no. 13, p. 287.

70
Study for *Women Sewing by Lamplight*
1855-1856
Black conté crayon on tracing paper
19.6 x 15.2 cm. (7¾ x 6 in.)
Lower right: J. F. M.
Lawrence Fund, 1905
05.108

71
Women Sewing by Lamplight
Delteil 14, only state
1855-1856
Etching on antique laid paper
15.0 x 11.0 cm. (5⅞ x 4⅜ in.)
Otis Norcross Fund, 1914
M25449

Women Sewing by Lamplight (cat. no. 71) reproduces a painting of the preceding year (cat. no. 44), and addresses a very difficult problem – representing two figures in a dark interior – at virtually the beginning of Millet's work in etching. He himself was dissatisfied with the print, finding it too black for his taste, and did not allow it to be published. The flatness of the rendering of the hand and the crumpled sewing of the righthand seamstress suggests that he did not yet have command of an adequately varied range of patterns and touches to convey the modulations of light and dark necessary for the subject, nor did he possess the technical facility to terminate the acid bath before the plate had been too deeply etched.

Cat. no. 70, preliminary to the etching, is a careful drawing, on a pale, semitranslucent paper, used by Millet to reduce the painting to a size suitable for a print. To obtain the reversed image necessary for his etching, he probably turned it over against a window and traced it onto another sheet (Cabinet des Dessins, Musée du Louvre). The second drawing, rubbed with sanguine conté crayon on the back, was then traced onto the varnished plate. When the Boston drawing was first published in 1914, Robert Wickenden called attention to Millet's meticulous practice of noting the *base* of the lamp on the floor, behind the two overlapped skirts, in order to carefully align the shadows thrown by the lamp.[1] An effect quite lost in the very dark print, such precision was nonetheless typical even when Millet was re-creating an image he had drawn several times before.

Notes
1. Wickenden, Robert J. "Millet's Drawings at the Museum of Fine Arts, Boston." *Print-Collector's Quarterly* 4, part 1 (1914), pp. 20, 22.

Cat. no. 70:

Provenance

Purchased from William O. Cole, New York
(1905).

Exhibition History

Phillips Collection, Washington, D.C., "Drawings
by J.F. Millet," 1956.

Cat. nos. 70 and 71:

Related Works

For complete listing see *Women Sewing by Lamp-
light (La Veillée)*, cat. no. 44.

Figure study for women, black conté crayon on
paper, current location unknown (see Léonce
Bénédite, *The Drawings of Jean François Millet*
[London: William Heinemann, 1906], unnumbered
plate).

Study for *Women Sewing by Lamplight*, cat. no. 70.

Compositional study (counterproof of previous
work), 16.9 x 13.4 cm., Cabinet des Dessins, Musée
du Louvre, Paris (GM10494).

Women Sewing by Lamplight, cat. no. 71.

Cat. no. 71:

References

Burty, Philippe. "Les Eaux-fortes de M. J.-F. Mil-
let." *Gazette des Beaux-Arts* 1st ser., 11 (September
1861), pp. 265, 266.

Lebrun, Alfred. "Catalogue de l'oeuvre gravé de J.-
F. Millet." In Sensier, Alfred, and Mantz, Paul. *La
Vie et l'oeuvre de J.-F. Millet*. Paris: A. Quantin,
1881, no. 15, p. 374.

Delteil, Loys. *Le Peintre-graveur illustré (XIX et
XX siècles), I, J.-F. Millet, et al.*. Paris: Delteil, 1906,
no. 14.

Melot, Michel. *L'Oeuvre gravé de Boudin, Corot,
Daubigny, Dupré, Jongkind, Millet, Théodore Rous-
seau*. Paris: Arts et Métiers Graphiques, 1978, no.
14, p. 287.

72
Woman Carding Wool
Delteil 15, only state
1855-1856
Etching on gray-green laid paper
24.5 x 16.5 cm. (9⅝ x 6⅝ in.)
Bequest of W. G. Russell Allen, 1960
60.680

Woman Carding Wool is the most monu-
mental image Millet created in the etching
medium, a powerful, large-scale figure who
dominates the complex collection of acces-
sories that explain her craft. With feet
braced, and leaning heavily into her repeti-
tive motions, she harks back to Millet's
work images of 1848-1852. The etching is
based on a remarkably beautiful drawing
(private collection, Tokyo), which superim-
poses a detailed life study of the carder's
face onto the basic compositional study for
the print. The carefully hatched shadows of
the face suggest that the life study was
done specifically with the etching in mind.
Throughout the print, the masterful place-
ment of large areas of light and dark,
which draw the viewer's eye around the
image and back to the woman's tired gaze,
is complemented by an inventive range of
needle strokes conveying the heavy, nubby
material of her costume as convincingly as
the soft, free wool in the basket at her side.
It is startling to learn from two early cata-
loguers of Millet's prints that he himself
was dissatisfied with the etching, and con-
sidered withholding it from publication.[1]

Notes

1. Philippe Burty, "Les Eaux-fortes de M. J.-F. Mil-
let," *Gazette des Beaux-Arts* 1st ser., 11 (September
1861), p. 263, and Alfred Lebrun, "Catalogue de
l'oeuvre gravé de J.-F. Millet," in Sensier, Alfred,
and Mantz, Paul, *La Vie et l'oeuvre de J.-F. Millet*
(Paris: A. Quantin, 1881), p. 374.

Related Works

Compositional sketch for a picture including both
a woman carding and a standing spinner, black
conté crayon on paper, 24.0 x 17.4 cm., Cabinet
des Dessins, Musée du Louvre, Paris (GM10390).
Compositional sketch, black conté crayon on paper,
25.7 x 17.6 cm., Art Institute of Chicago.
Compositional sketch with large study of face,
black conté crayon on paper, 24.6 x 16.2 cm., pri-
vate collection, Tokyo.
Woman Carding Wool, cat. no. 72.
Woman Carding Wool, oil on canvas, 89.5 x 73.5 cm.,
private collection, Washington, D. C.

References

Burty, Philippe. "Les Eaux-fortes de M. J.-F. Mil-
let." *Gazette des Beaux-Arts* 1st ser., 11 (September
1861), pp. 263-266.

Lebrun, Alfred. "Catalogue de l'oeuvre gravé de
J.-F. Millet." In Sensier, Alfred, and Mantz, Paul.
La Vie et l'oeuvre de J.-F. Millet. Paris: A. Quantin,
1881, no. 16, p. 374.
Delteil, Loys. *Le Peintre-graveur illustré (XIX et
XX siècles), I, J.-F. Millet, et al.* Paris: Delteil, 1906,
no. 15.
Melot, Michel. *L'Oeuvre gravé de Boudin, Corot,
Daubigny, Dupré, Jongkind, Millet, Théodore Rous-
seau.* Paris: Arts et Métiers Graphiques, 1978, no.
15, pp. 287-288.

73
Young Woman Tending Geese
Delteil 16, only state
1855-1856
Drypoint on antique laid paper
14.2 x 12.0 cm. (5⅝ x 4¾ in.)
Otis Norcross Fund, 1914
M25450

Young Woman Tending Geese is a drypoint
print, made from a plate on which the art-
ist directly scratched his drawing with a
sharp tool. Millet matched the rapid, direct
technique with a very loose, open drawing,
leaving a great deal of white space to con-
vey the sunshine of his outdoor scene and
rendering figure and geese alike with a very
broken, elusive line. The liveliness of the
print parallels his compositional sketches —
and indeed, it is adapted from a larger,
very free, unfinished sketch of the same
subject (current location unknown), rather

than from one of the more detailed, finished drawings that served as models for his etchings. The burr (or ridge raised as the drawing tool forces metal out of the plate) catches a great deal of ink, contributing to the very rich, dark lines reminiscent of Millet's pen-and-ink sketches. The print has considerable charm and a naiveté that makes it very appealing today, but for the artist, it probably seemed too unfinished to have any commercial value, and it remains the only drypoint in his *oeuvre*.

Related Works

Compositional sketch, black conté crayon on paper, current location unknown (known only from nineteenth-century photograph by Braun).

Young Woman Tending Geese, cat. no. 73.

References

Burty, Philippe. "Les Eaux-fortes de M. J.-F. Millet." *Gazette des Beaux-Arts* 1st ser., 11 (September 1861), p. 266.

Lebrun, Alfred. "Catalogue de l'oeuvre gravé de J.-F. Millet." In Sensier, Alfred, and Mantz, Paul. *La Vie et l'oeuvre de J.-F. Millet.* Paris: A. Quantin, 1881, no. 17, p. 374.

Delteil, Loys. *Le Peintre-graveur illustré (XIX et XX siècles), I, J.-F. Millet, et al.* Paris: Delteil, 1906, no. 16.

Melot, Michel. *L'Oeuvre gravé de Boudin, Corot, Daubigny, Dupré, Jongkind, Millet, Théodore Rousseau.* Paris: Arts et Métiers Graphiques, 1978, no. 16, p. 288.

74
End of the Hamlet of Gruchy I
1856
Oil on canvas
46.5 x 55.9 cm. (18¼ x 22 in.)
Lower right: J. F. Millet
Gift of Quincy Adams Shaw through Quincy A. Shaw, Jr., and Mrs. Marian Shaw Haughton, 1917
17.1501

Millet's summer-long return to Gruchy in 1854 had produced a large stock of drawings (see cat. no. 48) and a few unfinished paintings and studies of his birthplace (see cat. no. 53) that provided him, once back in Barbizon, with Normandy subject matter for many new works over the next several years. *End of the Hamlet of Gruchy I*, reflecting his conflicting feelings about his homeland, was painted during 1856 from a drawing (now lost) and an unfinished painting (Rijksmuseum Kroller-Müller, Otterlo).

The site of the *End of the Hamlet*, noted on Millet's map of Gruchy (see Letters), is still identifiable today, overlooking the ocean at the point at which the village's single street ends and a spread of cliff-top pasture begins. In several letters explaining a larger, later version of this painting (cat. no. 111 – his Salon picture of 1866), Millet spoke wistfully of the child, held up beside an elm tree to view the sea, who had no idea of any other life beyond the limits of the village; and he pondered the durability of the sturdy tree, buffeted and gnawed by the wind into its stunted shape, which held its ground because its roots were well anchored in the Norman soil.

See also *End of the Hamlet of Gruchy II* (cat. no. 111).

Provenance

Possibly Monsieur P., Perpignon; Quincy Adams Shaw, Boston.

Exhibition History

Museum of Fine Arts, Boston, "Quincy Adams Shaw Collection", 1918, no. 3.

Related Works

Compositional sketch with trees and buildings at both sides, black conté crayon on paper, 23.5 x 31.5 cm., private collection, Paris.

Finished drawing, black conté crayon on paper, 29 x 36 cm., current location unknown (see Goerg sale, Hôtel Drouot, Paris, May 30, 1910, no. 129).

Millet's Birthplace at Gréville (incorrectly identified), oil on canvas, 46 x 56 cm., Rijksmuseum Kroller-Muller, Otterlo.

End of the Hamlet of Gruchy I, cat. no. 74.

End of the Hamlet of Gruchy II, cat. no. 111.

References

Sensier, Alfred, and Mantz, Paul. *La Vie et l'oeuvre de J.-F. Millet.* Paris: A. Quantin, 1881, p. 167.

Peacock, Netta. *Millet.* London: Methuen & Co., 1905, p. 80.

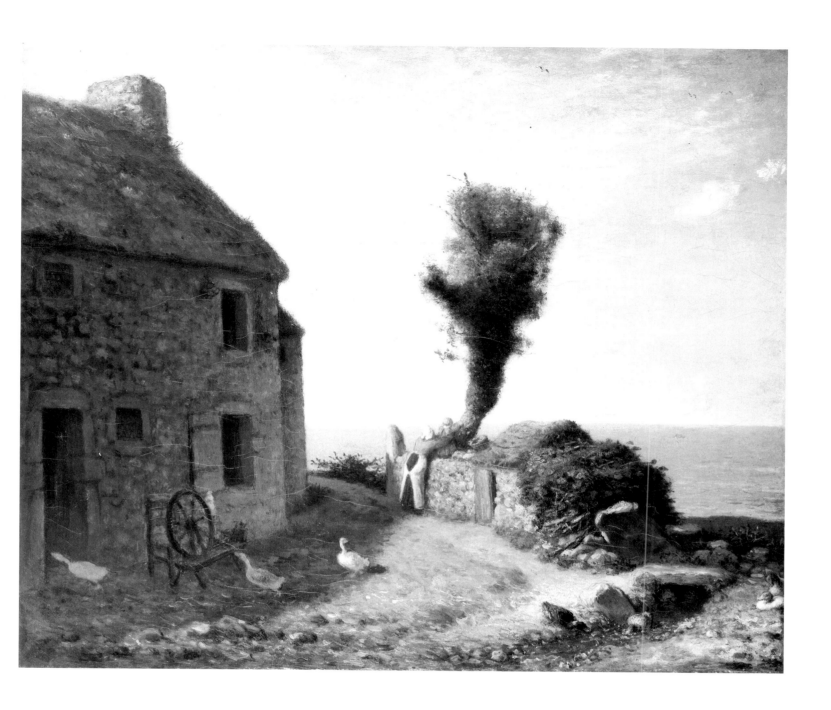

III

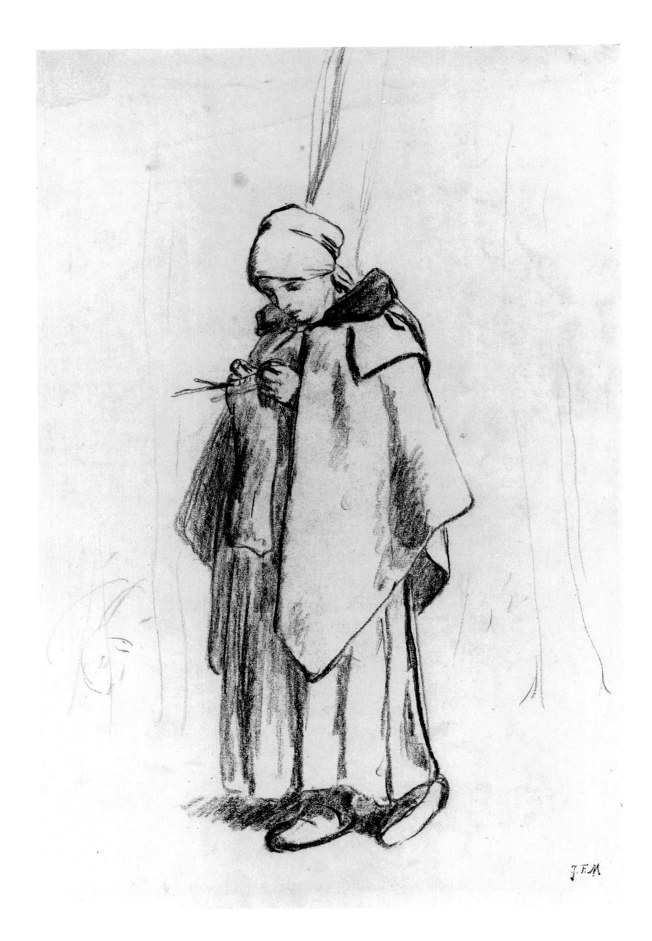

J.F.M

75
Shepherdess Knitting
(study for Shepherdess Knitting beside a Tree)
About 1856-1858
Black conté crayon on wove paper
35.2 x 22.5 cm. (13⅞ x 8⅞ in.)
Stamped, lower right: J. F. M
Gift of Martin Brimmer, 1876
76.432

A young shepherdess standing deeply engrossed in her knitting, while her flock grazes nearby, was perhaps Millet's favorite subject during the 1850s and appears in two pastels, two drawings, and a masterful etching in the Museum's collection. This study is a preliminary drawing for the painting *Shepherdess Knitting beside a Tree*, once in the collection of Mrs. Samuel D. Warren of Boston.[1] Millet had established his basic composition for the subject just after the middle of the decade in a painting of a shepherdess leaning against a rock (fig. 6), after which he returned frequently to the theme, working many variations on the young woman's pose or her surroundings.

The strong dichotomy between the carefully drawn, quite finished shepherdess and the cursory rendering of the forest and sheep behind her indicates that this drawing represents a halfway point in Millet's preparation for a new painting. The Museum's drawing was preceded by at least one small sketch establishing the shepherdess's relationship to the wooded background that replaced the rocky hedge of the earlier painting, and then Millet turned his attention to the central figure, tracing or transferring her rough outline from another drawing, or perhaps even from a painting that had preceded this one. The precision of the drawing, with very few changes, argues against this being either a sketch from life or a working drawing created from the imagination. Changes in the details of the shepherdess's pose would have been made at this point, if Millet had intended any; then, as the central element of his new composition, the shepherdess would have been transferred, in turn, to the painting surface.

Notes

1. See Related Works below; although both the Millet studio sale and Robert Wickenden ("Millet's Drawings at the Museum of Fine Arts, Boston," *Print-Collector's Quarterly* 4, part 1 [1914], p. 10) identify this drawing as a study for the etching *Shepherdess Knitting (La Grande Bergère)* (cat. no. 93), it precedes the etching by at least four or five years.

Provenance

Millet studio sale (Hôtel Drouot, Paris, May 10-11, 1875, no. 198), bought by Richard Hearn for Martin Brimmer, Boston.

Exhibition History

Phillips Collection, Washington, D. C., "Drawings by J. F. Millet," 1956.

Related Works

Compositional sketch of a shepherdess knitting beside a tree, black conté crayon on paper, 10.7 x 7.0 cm., Cabinet des Dessins, Musée du Louvre, Paris (GM10515).
Shepherdess Knitting, cat. no. 75.
Shepherdess Knitting Beside a Tree, oil on canvas, 14 x 9 in., current location unknown (see Mrs. S. D. Warren sale, American Art Association, New York, January 8-9, 1903, no. 76).

References

Peacock, Netta. *Millet*. London: Methuen & Co., 1905, illus. p. 89.
Wickenden, Robert J. "Millet's Drawings at the Museum of Fine Arts, Boston," *Print-Collector's Quarterly* 4, part 1 (1914), pp. 10, 12, illus. p. 2.

76
The Sower
About 1858
Black conté crayon on rose-gray laid paper
22.7 x 16.1 cm. (8⅞ x 6⅜ in.)
Stamped lower right: J. F. M
Gift of Martin Brimmer, 1876
76.441

This drawing of a sower, more naturalistic than the monumental 1850 painting (cat. no. 18) in its details of loose, modern clothing, was created about 1858. Along with a drawing on similar paper in the collection of the Louvre, this was probably a preparatory work for an unusual, large pen-and-ink reworking of Millet's first masterpiece – perhaps a special commission or a gift for a friend.[1]

Boston's drawing is the first version of the sower theme in which the figure wears a more specifically contemporary costume, a loose overshirt with buttoned cuffs on its full sleeves and shapeless heavy trousers. In a series of pastels undertaken a few years later, Millet would carry his image even further from the large-scale, emblematic quality achieved in the painting by placing a smaller figure derived from the present drawing within a vast field identified by Chailly's old stone tower on the horizon.

The heavy, reworked outlines of this drawing are an indication that Millet used it as the model or template for another work. When he was satisfied with a preparatory drawing he would often rub the back of it with chalk or crayon, which would transfer the outlines of the image to another surface when he retraced them with heavy pressure.

Notes

1. This drawing has been considered a preliminary work for both the paintings of 1850 and the pastels of 1865, but the combination of the low horizon line with modern costume details places it between the two groups. As it remained in Millet's studio, however, it is possible that it was reused around 1865 for one of the pastels.

Provenance

Millet studio sale (Hôtel Drouot, Paris, May 10-11, 1875, no. 120), bought by Richard Hearn for Martin Brimmer, Boston.

Exhibition History

Phillips Collection, Washington, D. C., "Drawings by J. F. Millet," 1956.
Arts Council of Great Britain, London, "Drawings by Jean-François Millet," 1956, no. 57.
Fisher Gallery, University of Southern California, Los Angeles, "Barbizon School," 1962.

77
First Steps
1858-1859
Black conté crayon on taupe laid paper
14.2 x 21.4 cm. (5⅝ x 8⅜ in.)
Stamped, lower right: J. F. M
Stamped, verso: VENTE MILLET
Gift of Reverend and Mrs. Frederick
Frothingham, 1893
93.1465

First Steps is one of several compositional sketches that Millet used to develop a finished drawing of the same title in 1858-1859. The many small drawings reworking the design show him grappling with the placement of father and child and with the arrangement of the garden that encloses them. He progressively closed the distance between the two figures to make the child's short walk more plausible and he lowered the observer's viewpoint to decrease the garden's size and to give the entire scene a greater intimacy.

The decade of the 1850s had been very difficult for Millet financially and 1859 was especially hard. He was doing far more work in drawing than he had at the beginning of the decade, but he was having little luck in broadening his very small circle of supportive collectors. Sensier, who was charged with trying to sell the works Millet was producing, encouraged him to find more appealing subject matter and to brighten his black crayon drawings with more color. The response is a telling reminder of his slow, difficult process of generating new images for his work:

> *I am going to make as many drawings as I can, and so far as possible, ones that catch the intimate side of life. But as you've said yourself, you have to have a little calm to stop the rush of time on one idea when it comes to you. Until it's been in your head long enough to concentrate itself, you cannot give the real essentials of it.*[1]

In his search for intimate subject matter, Millet must have turned to his favorite old masters, as well as to his own backyard. *First Steps* was inspired by a drawing by Rembrandt, *The Pancake Woman* (Cabinet des Dessins, Musée du Louvre, Paris), which features a young mother supporting a small child, in a pose identical to that in the Boston drawing.

Related Works
The Sower, cat. no. 76.
Figure study of sower cut at knees, possibly transferred from above drawing, black conté crayon on violet paper, 16.7 x 17.0 cm., Cabinet des Dessins, Musée du Louvre, Paris (GM10580).
Finished drawing, pen and ink on paper, 30.0 x 22.0 cm., private collection, Paris.
For complete listing of earlier and later images of *The Sower*, see cat. no. 18.

References
Peacock, Netta. *Millet*. London: Methuen & Co., 1905, illus. p. 44.
Wickenden, Robert J. "Millet's Drawings at the Museum of Fine Arts, Boston." *Print-Collector's Quarterly* 4, part 1 (1914), p. 10, illus. p. 11.

Notes

1. Millet to Alfred Sensier, April 2, 1859 (Archives of the Cabinet des Dessins, Musée du Louvre, Paris); quoted in Alfred Sensier and Paul Mantz, *La Vie et l'oeuvre de J.-F. Millet* (Paris: A. Quantin, 1881), p. 196.

Provenance

Millet studio sale (Hôtel Drouot, Paris, May 10-11, 1875, no. 171), bought by Reverend Frederick Frothingham, Milton, Massachusetts.

Exhibition History

Fisher Gallery, University of Southern California, Los Angeles, "The Barbizon School," 1962.

Related Works

Compositional sketch (with other subjects), black conté crayon on paper, 9.3 x 14.7 cm., Cabinet des Dessins, Musée du Louvre (GM10345 verso).

Compositional sketch with father to right, pencil on paper, 7.8 x 14.3 cm., Cabinet des Dessins, Musée du Louvre, Paris (GM10640).

Figure study of mother and child, black conté crayon on paper, 20.0 x 11.7 cm., Cabinet des Dessins, Musée du Louvre, Paris (GM10359).

Figure study of mother and child, black conté crayon on paper, 5.3 x 9.3 cm., Cabinet des Dessins, Musée du Louvre, Paris (GM10367 verso).

Compositional sketch with mother and child, black conté crayon on paper, 13.2 x 9.8 cm., Cabinet des Dessins, Musée du Louvre, Paris (GM10360).

Compositional sketch, black conté crayon on blue paper, 10.2 x 13.5 cm., Cabinet des Dessins, Musée du Louvre, Paris (GM10639).

Compositional sketch, black conté crayon on paper, 13 x 20 cm., current location unknown.

Finished drawing, black conté crayon on paper, 31 x 43 cm., current location unknown.

Compositional sketch, black conté crayon on paper, 8.2 x 10.4 cm., Cabinet des Dessins, Musée du Louvre, Paris (GM10638).

First Steps, cat. no. 77.

Figure studies of father, black conté crayon on paper, 18 x 20 cm., current location unknown (see Sotheby Parke Bernet, London, November 27, 1980, no. 75A).

First Steps, black conté crayon and pastel on paper, 63 x 75 cm., private collection, Germany.

First Steps, black conté crayon and pastel on paper, 29.5 x 36.0 cm., Cleveland Museum of Art.

First Steps, watercolor over crayon on paper, 27 x 36 cm., current location unknown, does not appear in reproduction to be from Millet's hand.

References

Staley, Edgcumbe. *Jean-François Millet*. London: George Bell and Sons, 1903, p. 26.

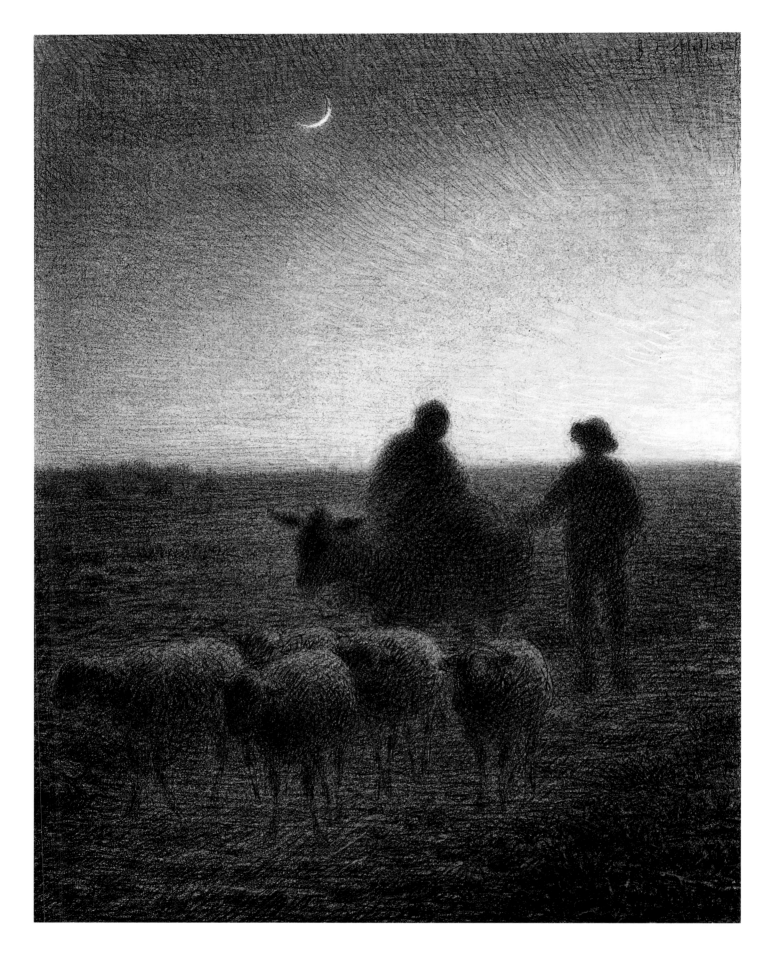

78
Twilight
About 1859-1863[1]
Black conté crayon and pastel on buff wove paper
50.5 x 38.9 cm. (19⅞ x 15⅜ in.) – design
55.0 x 42.9 cm. (21⅝ x 16⅞ in.) – support
Upper right: J. F. Millet
Gift of Quincy Adams Shaw through Quincy A. Shaw, Jr., and Mrs. Marian Shaw Haughton, 1917
17.1518

Twilight is an exceptional drawing in Millet's own *oeuvre* – and in the history of nineteenth-century draftsmanship as well. Although many of his drawings from throughout the 1850s show him exploring various ways of suggesting solid forms without strong, confining silhouettes (see cat. no. 41, for instance), in no other work is three-dimensional expression so dependent on line used as a toning technique, not a delimiting one. Millet literally reversed the traditional uses of line and color in *Twilight*, shaping his figures and animals with complex webs of short, sharp lines, and using light touches of color to establish or reinforce edges. Only in the sky, where the slivered white moon is the most assertive line in the painting, and blue strokes overlie the black hatching in the dark upper corner, does color assert itself – although still in the nature of lines subordinate to the overall black patterning.

The man and woman in Millet's drawing move across a nearly featureless plain, the horizon broken only by their silhouettes and an almost indistinguishable stand of trees. Despite the softly stated allusion to the Holy Family fleeing into Egypt (carried by an image of a cloak-enshrouded woman seated on a donkey and accompanied by a man on foot), Millet's drawing records a peasant family returning from a market day with sheep they had hoped to sell. The conflation of secular family and Holy Family occurs frequently in Millet's art from the late 1850s onward, as a device to dignify simple labors and to relate unfamiliar subject matter to the realm of higher art (see cat. no. 97).

Millet's powerful opposition of the bright moon, encircled by dark sky, with the intense radiance drawn away by the setting sun underlines his fascination with the luminous effects of approaching evening. Remnants of sunlight soften the silhouette of the peasant woman in a flickering band that sets her off from the plain behind, while light glows through the lower half of her companion, dissolving his legs into the field across which he walks. Strokes of deep blue pastel define the edge of his shoulders where the sunlight glances across his tunic.

Notes

1. For want of any directly comparable work in Millet's *oeuvre*, dating *Twilight* is unusually difficult. Robert Herbert has argued persuasively that the picture is most reasonably understood within the context of Millet's black crayon drawings of 1857-1860 (*Jean-François Millet* [Paris: Editions des Musées Nationaux, Grand Palais exhibition catalogue, 1975], p. 141.), and comparison with works

such as *Morning Toilette* (cat. no. 82) sustains the argument for a date around 1860. Stylistic details such as the very linear addition of color over a screen of black in the sky, or the use of a lozenge-like cross-hatching to build figures and animals, however, bear comparison with similar details in *Return of the Flock* (cat. no. 109), usually dated to 1863 on the basis of Millet's pastel technique. Moreover, recent examination of the papers and pigments used in Millet's pastels and crayon drawings in the Boston collection indicates that *Twilight* and *Return of the Flock* are drawn on identical papers and the proposed dating for *Twilight* has been extended accordingly. (Jerri Nelson, conservation intern at the Fogg Art Museum, Harvard University, has examined the Boston pastels and conducted analyses of selected pigment samples. A report of her findings is on record in the Archives of the Department of Paintings.)

Provenance

Emile Gavet (sold Hôtel Drouot, Paris, June 11-12, 1875, no. 27), bought by Détrimont, probably for Quincy Adams Shaw, Boston.

Exhibition History

Rue St. Georges 7, Paris, "Dessins de Millet provenant de la Collection M. G.," 1875, no. 41.

Museum of Fine Arts, Boston, "Quincy Adams Shaw Collection," 1918, no. 53.

Museum of Fine Arts, Boston, "Barbizon Revisited," 1963, no. 65.

New Jersey State Museum, Trenton, "Focus on Light," 1967, no. 58.

Grand Palais, Paris, "Jean-François Millet," 1975, no. 98 (Hayward Gallery, London, 1976, no. 78).

References

Guiffrey, Jean. "Tableaux Français conservés au Musée de Boston et dans quelques collections de cette ville." *Archives de l'art Français* n. s. 7 (1913), p. 547.

Sutton, Denys. "The Truffle Hunter." *J.-F. Millet.* London: Wildenstein & Co., exhibition catalogue, 1969, p. xiii.

Fermigier, André. *Millet.* Geneva: Skira, 1977, p. 100, illus. p. 99.

Leymarie, Jean; Monnier, Geneviève; and Rose, Bernard. *History of an Art: Drawing.* New York: Skira Rizzoli, 1979, illus. p. 190.

Chu, Petra ten-Doesschate. "Into the Modern Era: The Evolution of Realist and Naturalist Drawing." In Weisberg, Gabriel. *The Realist Tradition: French Painting and Drawing, 1830-1900.* Cleveland: Cleveland Museum of Art, exhibition catalogue, 1980, pp. 29-30, fig. 47.

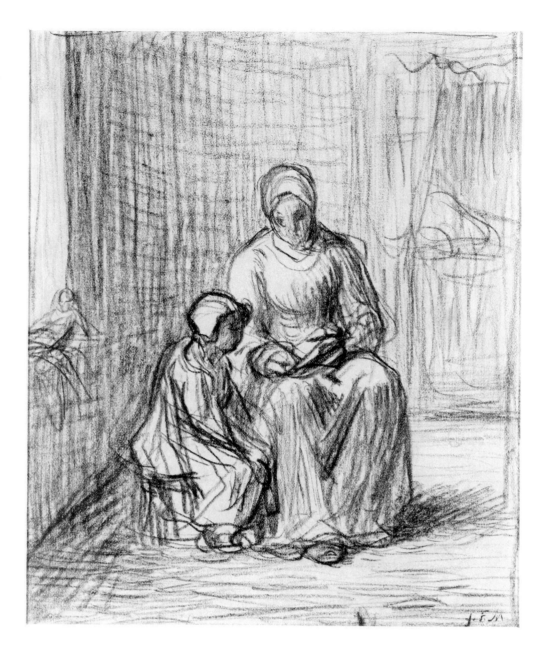

79
Study for *Reading Lesson*
About 1860
Black conté crayon on wove paper
18.5 x 14.4 cm. (7¼ x 5⅝ in.)
Stamped, lower right: J. F. M.
Stamped, verso: VENTE MILLET
Gift of Reverend and Mrs. Frederick
Frothingham, 1893
93.1464

80
Reading Lesson
About 1860
Black conté crayon on wove paper
33.0 x 26.3 cm. (13 x 10⅜ in.)
Lower right: J. F. Millet
Francis Welch Fund, 1980
1980.4

Reading Lesson is a charming example of the highly finished black crayon drawings of quiet, personalized subject matter that were virtually the only works of art Millet was able to sell in the decade from 1855 to 1865.

The composition harks back to *Knitting Lesson I* (cat. no. 58) in its broad subject matter, but Millet's interest had moved away from the concentrated monumentality of the earlier mother and child group. In this later drawing, the figures are smaller in scale, and, with the child's hands clasped on her lap and her mother seated on a much higher level, their interchange is less intimate. Such a presentation is in keeping with the traditional origin of the theme in images of Saint Anne Teaching the Virgin (which Millet himself had used for his first Salon entry in 1839); it may also reflect Millet's own distinctions between the skills of reading and knitting and the gestures necessary to teach them both. (He frequently reiterated his belief that every activity had its own gestures that had to be thoughtfully observed and absorbed by the artist.)

A comparison of the preliminary compositional sketch (cat. no. 79) with the finished drawing provides several insights into Millet's manner of working. The essentials of figure placement, architectural setting, and broad patterns of light and shade are established in the sketch. But for the finished drawing, Millet turned the mother slightly toward her child, whose hands are clasped rather than braced on her knees. The result is a movement from the hierarchical toward the intimate. A note of poignancy recorded both in the sketch and in the drawing is the child's doll, left aslant on the window ledge as she turns toward the activities of growing up.

Despite a few staunchly supportive critics, Millet's public reputation declined from Salon to Salon until 1861, and returned to the level of his 1853 reception only in 1864. The financial difficulties he faced were very real and played a significant part in turning his efforts increasingly to drawing rather than painting. His highly finished drawings, as small works intended for a specialized group of private collectors, were generally well received among that small circle, but they were otherwise very poorly known. Not until the Gavet sale in 1875, after Millet's death, did his black crayon drawings attract wide attention. Although they were less costly than the more time-consuming work in oils, he often found even these objects difficult to sell.

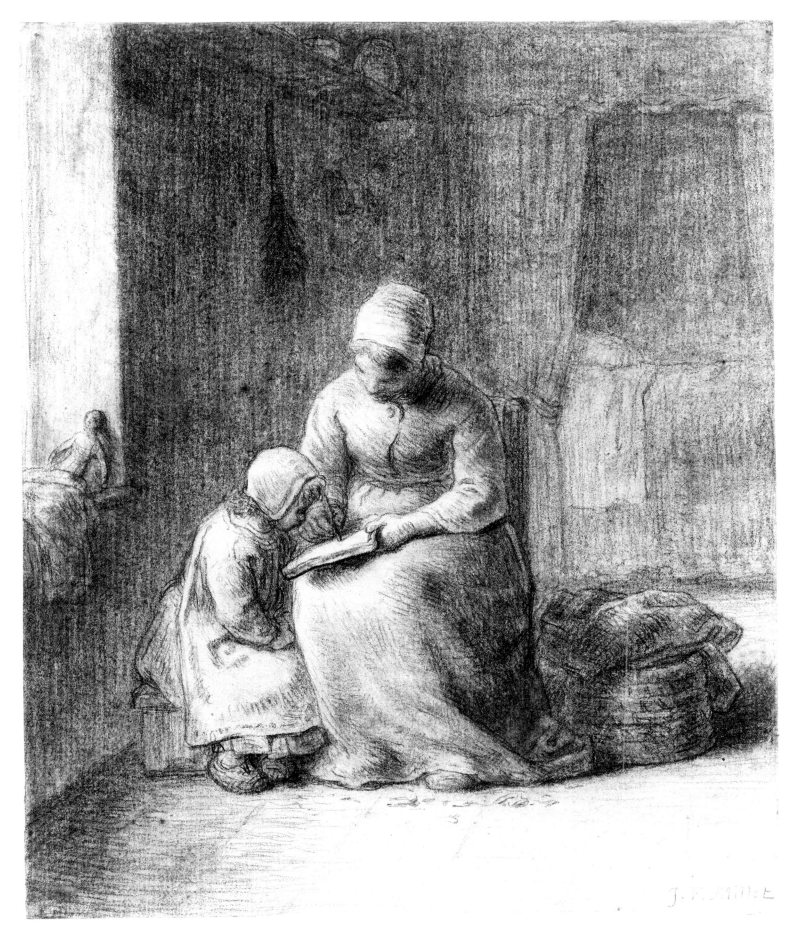

Cat. no. 79:

Provenance

Millet studio sale (Hôtel Drouot, Paris, May 10-11, 1875, no. 196), bought by Reverend Frederick Frothingham, Milton, Massachusetts.

References

Wickenden, Robert J. "Millet's Drawings at the Museum of Fine Arts, Boston." *Print-Collector's Quarterly* 4, part 1 (1914), pp. 22, 24, illus. p. 25.

Cat. no. 80:

Provenance

Emile Gavet (sold Hôtel Drouot, Paris, June 11-12, 1875, no. 32), bought by Détrimont, probably for Quincy Adams Shaw, Boston; with Childs Gallery, Boston, 1980.

Cat. nos. 79 and 80:

Related Works

Study for *Reading Lesson*, cat. no. 79.

Reading Lesson, cat. no. 80.

Reading Lesson, black conté crayon on paper, current location unknown (known only from nineteenth-century photograph by Braun).

81
Knitting Lesson II
About 1860
Oil on panel
40.4 x 31.5 cm. (15⅞ x 12⅜ in.)
Lower right: J. F. Millet
Gift of Quincy Adams Shaw through Quincy A. Shaw, Jr., and Mrs. Marian Shaw Haughton, 1917
17.1504

Bright colors, woolen scraps scattered on the floor, and a cat lapping milk in the background all contribute to an informal, unstudied air that sets *Knitting Lesson II* apart from Millet's earlier version of the theme (cat. no. 58). The carefully structured intimacy of the mother and daughter in the 1854 painting is replaced here by a more casual interchange between a young woman and a child too old to be her own. In the interval between the two works, Millet began to ease his careful references to past masters in favor of more open acknowledgment of direct observation.

Millet made little change in the basic composition of *Knitting Lesson*, but his attention turned from the general to the specific. The window now provides a broader light that opens up the whole room, taking away the dramatic focus of the earlier painting. Details of the rural household – the spoonrack on the window shutter, the cloak hanging in the corner, the coffee pot in the background – have multiplied, declaring the individuality of the household, rather than its typifying simplicity. And the two young protagonists of this unadorned daily event are singled out from Millet's other generalized young knitters with carefully specific faces and the blond curls escaping from the younger girl's cap.

In 1860, when this painting was lent to a Parisian exhibition, it belonged to Narcisse Diaz, one of Millet's oldest friends and the godfather of his son Charles. If the painting had been intended for Diaz, a family intimate, from the beginning, it would have been quite possible for the two young girls represented to be Millet's own daughters, Marie and Marguerite – who would have been about fourteen and nine years old, respectively, in 1860 – or Marguerite and the young woman who lived with the family as household help for Catherine Millet.[1]

Notes

1. In recent years, several authors have cited the presence of a "maid" in the Millet entourage as evidence that his financial plight in the late 1850s

was largely a myth and as a serious contradiction to Millet's claim to be "simply a peasant" (see notably T. J. Clark, *The Absolute Bourgeois: Artists and Politics in France, 1848-1851* [London: Thames and Hudson, 1973], p. 75). In fact, young girls or boys working as household or field help outside their own families (in return for room and board and a very minimal payment) were a common feature of the peasant social order in nineteenth-century France (see Emile Guillaumin, *La Vie d'un simple* [Paris: Editions Stock, 1943] or Tina Jolas and Françoise Zonabend, "Tillers of the Fields and Woodspeople," in *Rural Society in France: Selections from "Annales Economies, Sociétés, Civilisations,"* translated by Elborg Forster and edited by Robert Forster and Orest Ranum [Baltimore and London: Johns Hopkins University Press, 1977], p. 131, n. 9).

Provenance

Narcisse-Virgile Diaz, Paris (by 1860); Quincy Adams Shaw, Boston.

Exhibition History

26 Boulevard des Italiens [gallery operated by Martinet], Paris, 1860.
Museum of Fine Arts, Boston, "Quincy Adams Shaw Collection," 1918, no. 16.

Related Works

Finished drawing, black conté crayon on paper, 33 x 29.2 cm., private collection, Kent, England.

Knitting Lesson I, cat. no. 58.

Finished drawing with doll on window ledge and irons on wall, black conté crayon on paper, current location unknown.

Knitting Lesson, oil on panel, 41.5 x 31.9 cm., Clark Art Institute, Williamstown, Massachusetts.

Finished drawing without cat, black conté crayon on paper, 34 x 27.5 cm., private collection, Pittsburgh.

Compositional sketch, black conté crayon on paper, 23.1 x 16.7 cm., Cabinet des Dessins, Musée du Louvre, Paris (GM10648).

Knitting Lesson II, cat. no. 81.

Page of compositional sketches including a knitting lesson, black conté crayon on paper, 13.1 x 20.6 cm., Cabinet des Dessins, Musée du Louvre, Paris (GM10649).

Knitting Lesson, oil on canvas, 101.0 x 82.6 cm., Saint Louis Art Museum.

References

Astruc, Zacharie. *Beaux-Arts. Le Salon intime, exposition au Boulevard des Italiens*. Paris: Poulet-Malassis et de Broise, 1860, p. 67.

"'Greta's' Boston Letter." *Art Amateur* 5, no. 4 (September 1881), p. 72.

Guiffrey, Jean. "Tableaux Français conservés au Musée de Boston et dans quelques collections de cette ville." *Archives de l'art Français* n. s. 7 (1913), p. 547.

Moreau-Nélaton, Etienne. *Millet raconté par lui-même*. Paris: Henri Laurens, 1921, vol. 2, p. 78, fig. 147.

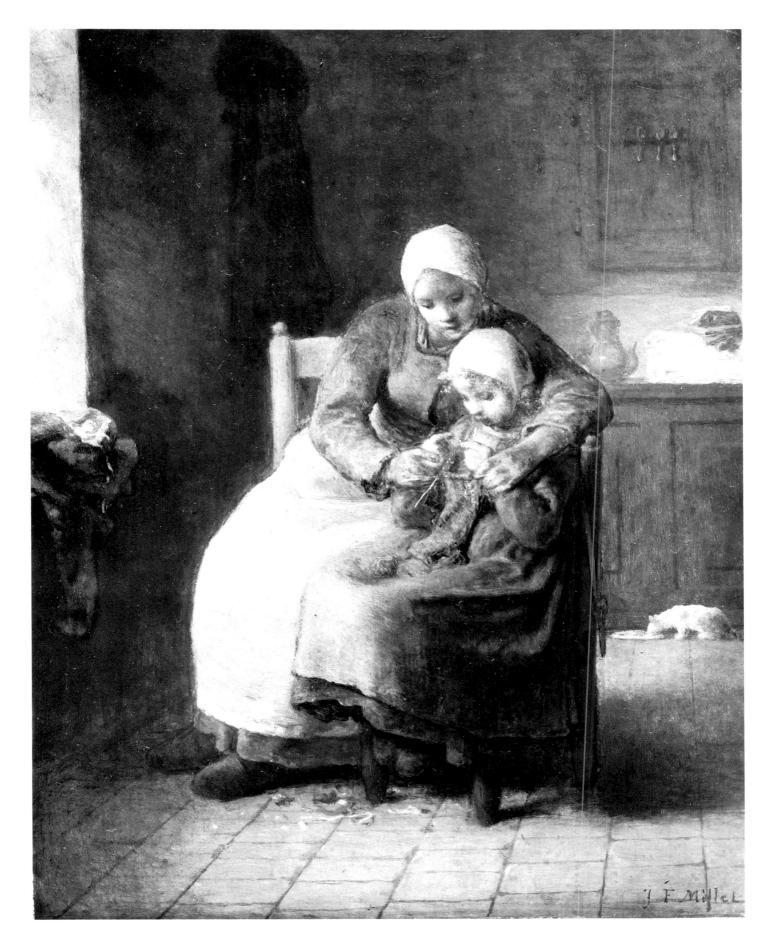

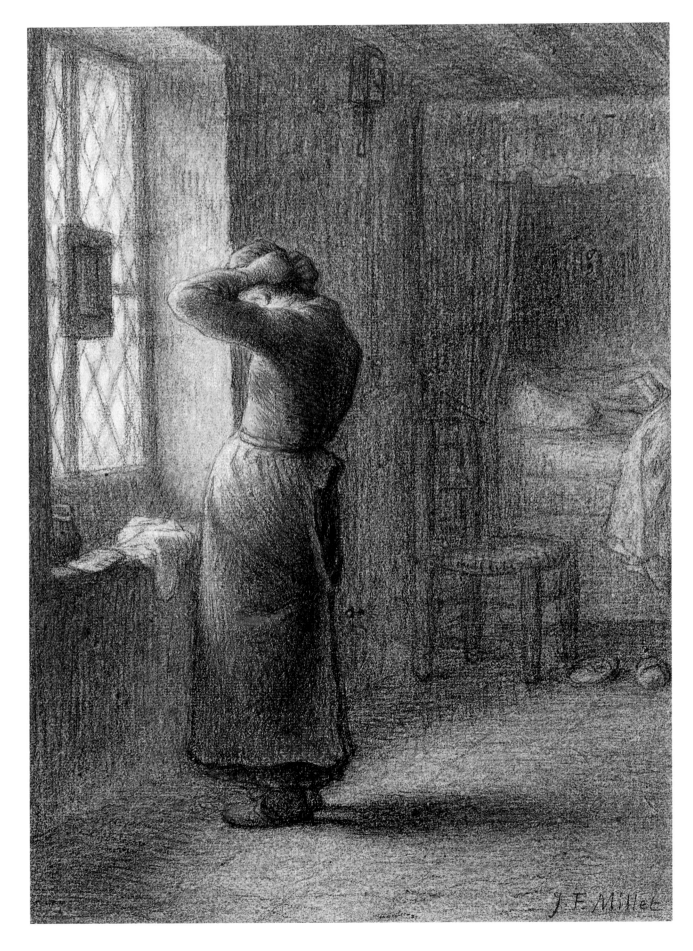

82
Morning Toilette
About 1860-1862
Black conté crayon and pastel on laid paper
37.1 x 25.7 cm. (14⅝ x 10⅛ in.)
Lower right: J. F. Millet
Gift of Quincy Adams Shaw through
Quincy A. Shaw, Jr., and Mrs. Marian
Shaw Haughton, 1917
17.1502

Morning Toilette, an unassuming drawing of great beauty, is an anomaly in Millet's work. Such an intimate look at one of his growing daughters in a moment of self-contained personal attention (rather than in a role as mother, child, helpmate, or mistress of a household) is without precedent in Millet's art. Only one other work – a contemporary drawing of a young woman seated beside a bed, pinning up her hair (private collection, Paris), which may be a first idea for this composition – shows Millet exploring the private world of the women who shared his life.

The seventeenth-century Dutch origins of this drawing in crayon and pastel are suggested by the curtained bed and leaded window – real objects of the artist's life, just as they were also characteristic features of Northern interiors painted two hundred years earlier – and the pose before both a mirror and a window specifically recalls Vermeer's *Woman with a Pearl Necklace* (Gemäldegalerie, Berlin), then in the collection of Théophile Thoré, a critic and friend recently returned from political exile. But Millet forced the contrast between his picture and its source, stressing the simplicity of the interior, the modesty of the dress, and the limited *toilette* items of face cloth and water pitcher on the window ledge – as against the opulently austere interior Vermeer had used, featuring a tapestry-heaped table and an oriental vase. While Vermeer's young woman posed self-consciously for the artist, Millet's daughter's back is turned and her face is hidden by her upraised arms.

The quiet mood of early light owes much to Millet's own softly rubbed crayon technique with hints of color where the light emphasizes an edge or brings out a nuance. The young woman's bodice is a mustard yellow, her apron blue, but only in small touches, dramatizing the appeal of color for its own sake, not as a necessary element of form.

Provenance
Alfred Sensier (sold Hôtel Drouot, Paris, December 10-18, 1877, no. 192), bought by Legrand, probably for Quincy Adams Shaw, Boston.

Exhibition History
Museum of Fine Arts, Boston, "Quincy Adams Shaw Collection," 1918, no. 43.

Related Works
Compositional sketch, pencil on paper, 26.1 x 21.0 cm., current location unknown (London art market, 1960s).
Figure study, black conté crayon on paper, 35.0 x

10.5 cm., Cabinet des Dessins, Musée du Louvre, Paris (GM10498).
Morning Toilette, cat. no. 82

References
Strahan, Edward. *Art Treasures of America*. Philadelphia: George Barrie, 1879, vol. 3, pp. 86-87.
"'Greta's' Boston Letter." *Art Amateur* 5, no. 4 (September 1881), p. 72.
Guiffrey, Jean. "Tableaux Français conservés au Musée de Boston et dans quelques collections de cette ville." *Archives de l'art Français* n. s. 7 (1913), p. 548.

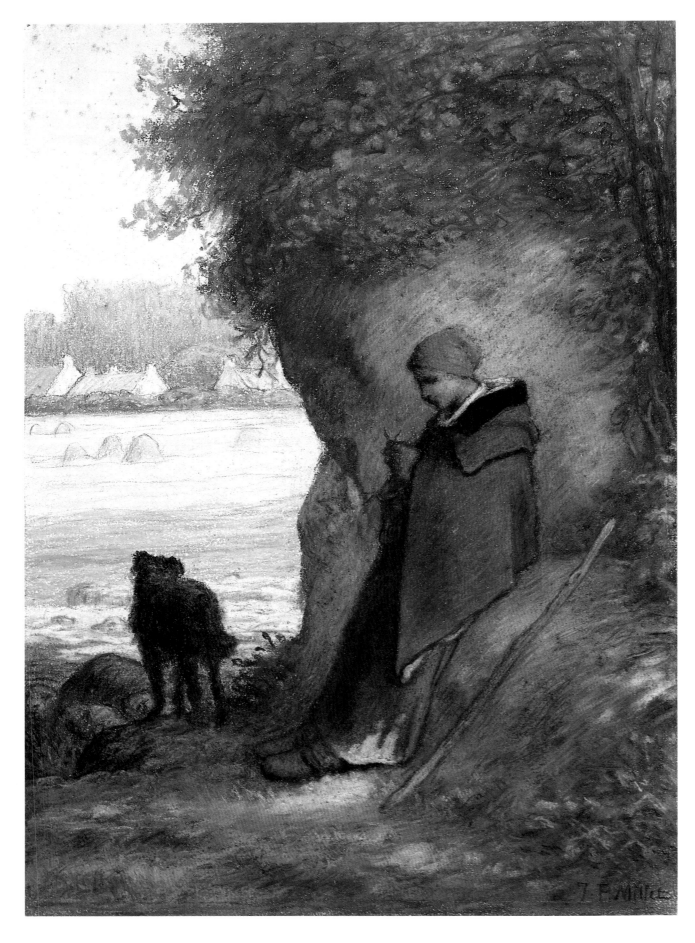

83
Shepherdess Knitting, outside the Village of Barbizon
About 1860-1862
Pastel over black conté crayon on laid paper
40.2 x 28.5 cm. (15⅞ x 11¼ in.)
Lower right: J. F. Millet
Gift of Quincy Adams Shaw through Quincy A. Shaw, Jr., and Mrs. Marian Shaw Haughton, 1917
17.1494

The heavily applied, intense color and the use of black chalk or crayon only for underlying outlines mark this *Shepherdess Knitting* as an anomaly in Millet's pastel work. A young shepherdess resting in a sheltered, shaded area while her flock grazes in a deeper, more open space behind her is quite typical of Millet's work in the 1850s. Along with a variant executed in watercolor, the *Shepherdess Knitting* reflects Millet's initial efforts to reincorporate color into his graphic work after more than a decade of drawing almost exclusively with black crayon.

Pastels had been an important part of Millet's artistic repertoire between 1840 and 1845, but he had abandoned the medium and its rococo associations as his work became increasingly realistic. During the early 1850s he experimented with colored chalks or crayons on occasion, but most of his finished drawings executed throughout the decade were created solely with black crayon.[1] Color began to make a sustained reappearance only around 1858-1859, in tiny isolated touches in works such as *Twilight* (cat. no. 78). Alfred Sensier, who had been acting as Millet's agent in Paris for some time, had pleaded with the artist in that year to brighten his work in order to make the drawings more attractive to private collectors; and between 1860 and 1863 Millet began to reexplore both the pastel and watercolor media, and to rethink the balance of painterly and draftsmanly skills in his art.

When Millet turned his attention again to pastels, it was quite logical that he should begin in a style he had already mastered, adapting it to his new interests and skills. The heavy, blended surfaces of the figure and the foliage surrounding her, and even the intense blue, lavender, and salmon hues of her costume, belong securely to the eighteenth-century pastel style that Millet had favored during the 1840s. The background landscape, however, constructed with paler chalks lightly applied in long strokes over a black crayon drawing, gives some hint of the direction that his pastel use would follow in the next decade.

With its watercolor variant, this is the only version of Millet's 1850s shepherdess to show the village of Barbizon so distinctly in the background, most of the others taking place on the vast open plain or the shadowy edges of the forest. Sheepherding was one of the few rural tasks that breached the barrier between forest and field, whose inhabitants often had no commerce with each other in the nineteenth century. In this early pastel, Millet delineated, in unusual detail, the red roofs and chimneys of Barbizon, establishing the fact that, in spite of her wandering work, this shepherdess belongs to a particular place.

Notes
1. Alfred Sensier and Paul Mantz, *La Vie et l'oeuvre de J.-F. Millet* (Paris: A. Quantin, 1881), p. 150. Edward Wheelwright ("Personal Recollections of Jean François Millet," *Atlantic Monthly* 38 [September 1876], p. 272) mentions seeing only one pastel (earlier and badly effaced) in Millet's studio in 1855-1856.

Provenance
Possibly M. Atger (sold Hôtel Drouot, Paris, March 12, 1874, no. 80); Quincy Adams Shaw, Boston.

Exhibition History
Museum of Fine Arts, Boston, "Quincy Adams Shaw Collection," 1918, no. 39.

Related Works
Sleeping Shepherdess, watercolor on paper, current location unknown (see Etienne Moreau-Nélaton, *Millet raconté par lui-même* [Paris: Henri Laurens, 1921], fig. 187; same composition with shepherdess sleeping against rock rather than knitting).

References
Guiffrey, Jean. "Tableaux Français conservés au Musée de Boston et dans quelques collections de cette ville." *Archives de l'art Français* n. s. 7 (1913), p. 547.
Cary, Elisabeth Luther. "Millet's Pastels at the Museum of Fine Arts, Boston." *American Magazine of Art* 9, no. 7 (May 1918), p. 265.

84
Study of a gardener with a watering can
About 1860
Pencil over black conté crayon on laid paper
26.4 x 21.4 cm. (10⅜ x 8⅜ in.)
Stamped, lower left: J. F. M
Gift of Mrs. John Alden Carpenter, 1963
63.2700

Millet placed a very high value on finding the right pose and gesture for each of the figures in his compositions, often making a half dozen studies with only very modest alterations before he was satisfied enough to transfer the ultimate drawing to his canvas or paper for the final composition. The simple strokes or *traits* that defined his figures were of great importance to him when he began to paint or color a work, and he would preserve them until the last minute, covering them with paint or crayon only when everything else was painted.

The study of a gardener watering plants is a preliminary work for a finished drawing (private collection, London), following a compositional sketch in the Louvre. This particular outline drawing, rubbed with heavy black crayon across the back of the sheet, was the last refinement of a figure, prepared for transfer to the final surface of either a drawing or a painting. To copy his drawings Millet either held them against a light source, such as a window, and traced them; or, when preparing a canvas or a panel, he rubbed the back of the drawing with crayon or chalk, laid it down on the surface to which he wished to transfer it, then carefully retraced the drawing. The pressure of his pencil or crayon would deposit traces of the black chalk on the new surface, which Millet would then rework or strengthen.

Provenance
Studio of the artist; Mrs. John Alden Carpenter, Manchester, Massachusetts.

Related Works
Compositional sketch of a man watering a garden, black conté crayon on paper, 11.1 x 14.4 cm., Cabinet des Dessins, Musée du Louvre, Paris (GM10486).
Study of a gardener, cat. no. 84.
Finished drawing, black conté crayon and brown ink with white highlights on buff paper, 39.3 x 31.3 cm. (sight), private collection, London.

85
Study for *Gardener*
About 1860
Black conté crayon on gray laid paper
23.2 x 14.9 cm. (9⅛ x 5⅞ in.)
Stamped, lower right: J. F. M
Edwin E. Jack Fund, 1961
61.626

At a time when the most advanced painters were moving away from the precise, succinct draftsmanship demanded by French academic practice toward a freer application of color, often without any preliminary drawing at all, Millet's dedication to drawing is especially noteworthy. This drawing and the similar study that precedes it (cat. no. 84) are examples of the ultimate simplicity to which he often refined his figure drawings before transferring them.

Millet's care in creating the figure of this gardener, bending to set out a row of young plants, is particularly interesting, since the finished work for which it was intended, a drawing entitled *Gardener*,

gives the appearance of being rapidly, directly recorded from life.

Provenance
Studio of the artist; acquired from G. Bhyne (said to be descended from the artist) by Leicester Galleries, London (1920).

Related Works
Compositional sketch with only a gardener, black conté crayon on paper, 10.4 x 12.9 cm., Cabinet des Dessins, Musée du Louvre, Paris (GM10299).
Compositional sketch with woman and children in background, pencil on paper, 12.3 x 15.4 cm., Cabinet des Dessins, Musée du Louvre, Paris (GM10727).
Figure study of the gardener, black conté crayon on paper, 18.3 x 13.2 cm., Kunsthalle, Bremen.
Figure study of the gardener, black conté crayon on paper, 21.1 x 13.3 cm., Yale University Art Gallery, New Haven.
Study for *Gardener*, cat. no. 85.
Gardener, black conté crayon on paper, current location unknown (see A. Alexandre, F. Keppel, and C. Holme, "Corot and Millet," *Studio* special issue [1902-1903], fig. M-27).

86
Training Grape Vines
About 1860-1864
Pastel on blue-gray wove paper
43.8 x 64.1 cm. (17¼ x 25¼ in.)
Gift of Quincy Adams Shaw through
Quincy A. Shaw, Jr., and Mrs. Marian
Shaw Haughton, 1917
17.1528 (recto; see also cat. no. 3)

Training Grape Vines is one of Millet's most successful efforts at exploiting the pastel medium without relying on the structure of an underlying black crayon drawing. The spring-flushed garden lends itself beautifully to the loose application of pastel, and the surface, rich with dense layerings of color, is lush and painterly. So unusually bold a pastel (virtually unknown because it belonged to Alfred Sensier rather than Emile Gavet, the principal patron for Millet's pastels[1]) is very difficult to date in Millet's *oeuvre*. The subject grew out of his many scenes of men working in their family gardens, which entered his repertoire about 1858. Experimentation with the pastel medium suggests a date no earlier than 1860, however, and the unusual, open horizontal format relates the work to his forays in landscape painting around 1864.

Tying up vines, used earlier by Millet as a symbol for Spring (cat. no. 47), is here expanded as the organizing theme for an emerging spring landscape, executed in an almost impressionistic technique of dabs and rubbings of pure color. The unusual composition, aligning horizontal bands of grape trellis, garden wall, and distant forest, organizes Millet's space intelligibly, without necessitating complex drawing, and provides a framework for his very free pastel work. In the grassy foreground, strong strokes of bright green and ocher are rubbed into one another. In the middle ground, dominated by the gnarled fruit-tree, the technique is softer and individual strokes disappear into large masses of foliage heightened by small touches of strong blue-greens, white, and even black; in the far distance, forest and tilled field of almost indeterminate hue, set off the sparkling trees before them. Along the trellis and above the wall, surprising dashes of uncommonly bright pinks, salmons, and acid greens convey the sparkle of flowering plants, and, in the orchard beyond, touches of pink and blue suggesting blossoming trees float free of any definable object.

In its complexity of color, freedom of pastel application, and simple composition, *Training Grapes Vines* looks directly forward to Millet's stunning oil painting *Spring* (Musée du Louvre, Paris), the greatest landscape in his *oeuvre*, and to the compositional and technical innovations of France's next generation of landscape painters, the Impressionists.

Notes

1. Sensier, who had been acquiring Millet paintings and drawings since their first acquaintance, had an extraordinary ability to recognize works of special beauty or seminal importance. Among other works from the inventive years of 1860-1863, he also owned *Morning Toilette* (cat. no. 82) and *Peasant Woman Watering her Cow* (cat. no. 105).

Provenance

Alfred Sensier (sold Hôtel Drouot, Paris, December 10-18, 1877, no. 201), bought by Legrand, probably for Quincy Adams Shaw, Boston.

Exhibition History

Hirschl and Adler, New York, "Corot and His Contemporaries," 1965, no. 41.
Museum of Fine Arts, Boston, "Quincy Adams Shaw Collection," 1918, no. 32.

Related Works

Study of a man tying up vines, seen from the side, black conté crayon on gray paper, 18.2 x 8.0 cm., Cabinet des Dessins, Musée du Louvre, Paris (GM10583).

Study of a man tying up vines, seen from the side and cut off at knees, black conté crayon on gray paper, 16.8 x 8.1 cm., Cabinet des Dessins, Musée du Louvre, Paris (GM10584).

Training Grape Vines, cat. no. 86.

References

Guiffrey, Jean. "Tableaux Français conservés au Musée de Boston et dans quelques collections de cette ville." *Archives de l'art Français* n. s. 7 (1913), p. 548.

87
In the Garden
About 1860
Watercolor and pastel over black conté
crayon on laid paper
31.5 x 37.5 cm. (12⅜ x 14¾ in.)
Lower right: J. F. Millet
Gift of Quincy Adams Shaw through
Quincy A. Shaw, Jr., and Mrs. Marian
Shaw Haughton, 1917
17.1503

In a typical Barbizon kitchen garden, modeled broadly on Millet's own,[1] a young woman pauses from her mending to gaze off beyond the beehives that form one edge of a vegetable plot. Behind her, a young child, who cannot be older than three, relieves her guardian from the task of keeping the family's chickens out of the garden and out of mischief. The wary birds, poised at the entrance to the garden, seem to size up the determination of their young adversary, while they heed the upraised rod in her tiny hands. Such simple, intimate details of everyday life were precisely what Alfred Sensier rightly guessed collectors might appreciate from Millet's hand,[2] and this charming drawing dates to the years around 1860, when he created a number of appealing family scenes.

In the Garden is executed in a complex mix of media that is typical of Millet's work at the turn of the decade. Carefully drawn in great detail in a black medium that is probably a very hard conté crayon, the composition was then colored with both pastels and watercolor washes, with a few touches of a denser, gouache-like color. The use of the black crayon to create even the shadows on the young woman's face and shoulder makes it very clear that Millet originally conceived this subject as a black crayon drawing, to which the color is decidedly an added element. But his light touch and carefully integrated use of watercolor and pastel give the scene an airy, open quality not always found in such additive works. Thin watercolor washes establish the basic color pattern throughout the drawing, which Millet then accented selectively with touches of deeper watercolors and pastel. The range of muted greens and yellow browns that shape the garden and the thatch-roofed house beyond set off the stronger blues and oranges of the figures and emphasize such small color notes as the child's rosy cheeks or the unidentifiable yellow items beside the young woman's skirt.

Notes

1. See the pastel and crayon drawing of a woman and three young girls in a small cabbage patch with beehives behind, identified as the Millet garden by Charles Tillot, a painter and Millet family friend, in his sale (Hôtel Drouot, Paris, May 14, 1887, no. 31); and Edward Wheelwright's description of the homes and gardens of Barbizon ("Personal Recollections of Jean François Millet," *Atlantic Monthly* 38 [September 1876], pp. 259-260).

2. *In the Garden* belonged to Alfred Sensier, who frequently used pastels or drawings in his own collection to entice friends and collectors, and a rep-

lica of almost the exact dimensions (private collection, Connecticut) was probably made in response to a commission received through Sensier.

Provenance

Alfred Sensier (sold Hôtel Drouot, Paris, December 10-18, 1877, no. 198), bought by Legrand, probably for Quincy Adams Shaw, Boston.

Exhibition History

Museum of Fine Arts, Boston, "Quincy Adams Shaw Collection," 1918, no. 37.

Related Works

In the Garden, cat. no. 87.

In the Garden, black conté crayon and pastel on paper, 12½ x 14⅜ in., private collection, Connecticut.

References

Guiffrey, Jean. "Tableaux Français conservés au Musée de Boston et dans quelques collections de cette ville." *Archives de l'art Français* n. s. 7 (1913), p. 548.

88
Sabots and Winnowing Basket
1850s or 1860s
Black conté crayon on green wove paper
8.7 x 7.0 cm. (3⅜ x 2¾ in.)
Stamped, lower right: J. F. M
Gift of Mrs. John Alden Carpenter, 1963
63.2695

This small drawing, depicting a corner of a barn, with *sabots* (wooden shoes) and a winnower's basket on the floor and a grain sieve hanging on the wall, is hard to identify with any larger Millet composition, although the elements appear individually as background details in different paintings or drawings, such as *Bird Trapper* (cat. no. 129). Alfred Sensier records that Millet would frequently make quick little drawings of wooden shoes or a few sheaves of grain on the threshing room floor as souvenirs for visitors,[1] and were this a more finished drawing, it would have served nicely as such a gift. The intial stamp indicates that it was among Millet's studio holdings at the time of his death, however, and it must simply have been a quick compositional sketch jotted down for later use.

Notes
1. Alfred Sensier and Paul Mantz, *La Vie et l'oeuvre de J.-F. Millet* (Paris: A Quantin, 1881), pp. 182-183.

Provenance
Studio of the artist; Mrs. John Alden Carpenter, Manchester, Massachusetts.

89
Study for *Woman Feeding a Child*
1861
Black conté crayon on laid paper
15.4 x 12.8 cm. (6 x 5 in.)
Stamped, upper right: J. F. M
Gift of Martin Brimmer, 1876
76.434

90
Woman Feeding a Child
Delteil 17, third state
1861
Etching on pale gray antique laid paper
15.8 x 12.7 cm. (6¼ x 5 in.)
Gift of Misses Aimée and Rosamond Lamb, 1973
1973.57

Woman Feeding a Child was commissioned by Philippe Burty to illustrate an article on Millet's etchings he had written for the *Gazette des Beaux-Arts*, an important, recently established art journal that had championed Millet in previous Salon reviews. Using the loose style of short strokes and very personalized hatching patterns he had adopted to reproduce drawings or create independent etchings, the etching broadly records Millet's 1861 Salon entry of the same title (Musée des Beaux-Arts, Marseille). Burty was prompted to comment: "...it is greatly to be desired that M. J.-F. Millet himself might reproduce all his compositions in this way. His talent is too personal not to lose something in a reproduction by someone else."[1]

Burty accompanied Millet when the plate was bitten in the studio of Félix Bracquemond, one of the most knowledgeable

etchers of the period, and he records Millet's final touch to the plate – two drops of pure acid, applied directly to the heads of the woman and child, washed off almost immediately, but strong enough to produce the sharp highlights on both faces.[2]

Mediating between a large painting of rather fine finish and a small etching, the preparatory drawing (cat. no. 89) became a virtually independent work. It is more detailed than most of Millet's working drawings for prints, utilizing a style and shadowing patterns closer to the finished crayon works than to the distinctive shorthand with which he rendered the etching.

Notes

1. Philippe Burty, "Les Eaux-fortes de M. J.-F. Millet," *Gazette des Beaux-Arts* 1st ser., 11 (September 1861), p. 265.
2. From Burty's account of the visit to Bracquemond's studio, published by Maurice Tourneux in *Revue rétrospective*, 1892, quoted in Loys Delteil, *Le Peintre-graveur illustré (XIX et XX siècles)*, I, J.-F. Millet, et al. (Paris: Delteil, 1906), no. 17.

Cat. no. 89:

Provenance

Millet studio sale (Hôtel Drouot, Paris, May 10-11, 1875, no. 205), bought by Richard Hearn for Martin Brimmer, Boston.

Exhibition History

Phillips Collection, Washington, D. C., "Drawings by J. F. Millet," 1956.
Fisher Gallery, University of Southern California, Los Angeles, "Barbizon School," 1962.

Related Works

Feeding the Child, oil on canvas, 114 x 99 cm., Musée des Beaux-Arts, Marseille.
Study for *Woman Feeding a Child*, cat. no. 89.
Counterproof of cat. no. 89, retouched with black conté crayon and white crayon on paper, 17.2 x 13.6 cm. (image: 15.3 x 12.8 cm.), Cabinet des Dessins, Musée du Louvre, Paris (GM10651).
Woman Feeding a Child, cat. no. 90.
A large, finished drawing of this subject in brush and india ink (Fitzwilliam Museum, Cambridge, England) does not appear to be from Millet's hand.

References

Peacock, Netta. *Millet*. London: Methuen & Co., 1905, illus. p. 44.
Wickenden, Robert J. "Millet's Drawings at the Museum of Fine Arts, Boston." *Print-Collector's Quarterly* 4, part 1 (1914), pp. 16, 18, illus. p. 7.

Cat. no. 90:

References

Burty, Philippe. "Les Eaux-fortes de M. J.-F. Millet." *Gazette des Beaux-Arts* 1st ser., 11 (September 1861), pp. 265, 266, no. IX.
Lebrun, Alfred. "Catalogue de l'oeuvre gravé de J.-F. Millet." In Sensier, Alfred, and Mantz, Paul. *La Vie et l'oeuvre de J.-F. Millet*. Paris: A. Quantin, 1881, pp. 374-376, no. 18.

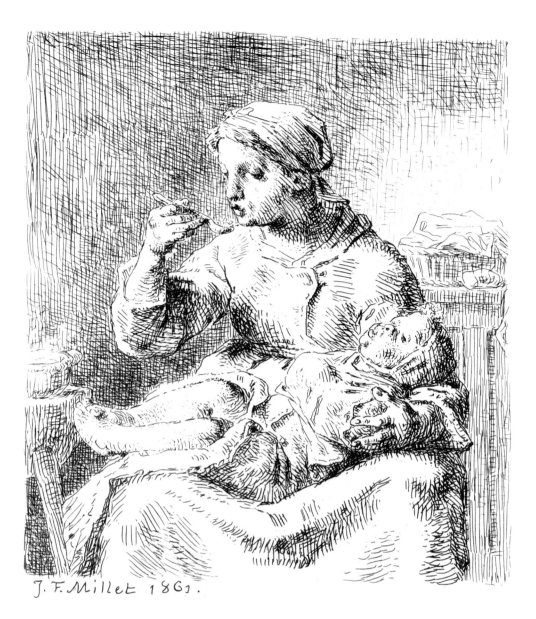

J. F. Millet 1861.

Delteil, Loys. *Le Peintre-graveur illustré (XIX et XX siècles)*, I, J.-F. Millet, et al.. Paris: Delteil, 1906, no. 17.

[Herbert, Robert L.] *Jean-François Millet*. Paris: Editions des Musées Nationaux, Grand Palais exhibition catalogue, Paris, 1975, p. 170.

Melot, Michel. *L'Oeuvre gravé de Boudin, Corot, Daubigny, Dupré, Jongkind, Millet, Théodore Rousseau*. Paris: Arts et Métiers Graphiques, 1978, no. 17, p. 288.

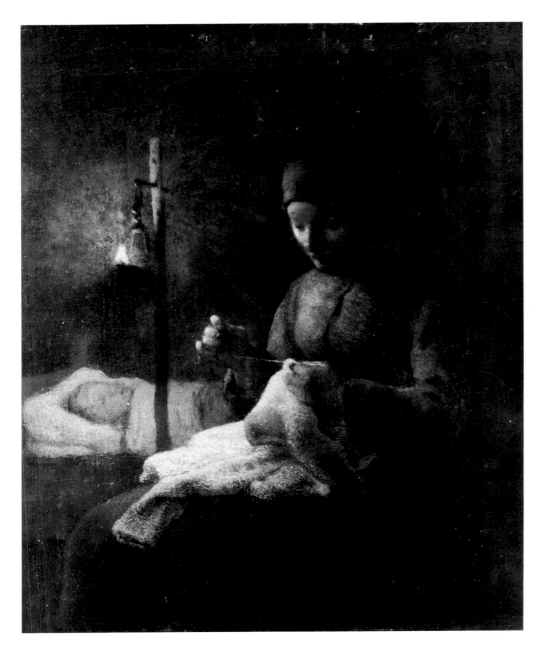

91
Woman Sewing beside her Sleeping Child
About 1858-1862
Oil on panel
34.0 x 27.2 cm. (13⅜ x 10¾ in.)
Lower right: J. F. Millet
Gift of Quincy Adams Shaw through
Quincy A. Shaw, Jr., and Mrs. Marian
Shaw Haughton, 1917
17.1493

The heavily wrought surface of this small painting, built up with hundreds of tiny, thread-like touches of color, reflects Millet's tendency to work and rework even the simplest compositions, until the forms and the colors finally satisfied him. *Woman Sewing beside her Sleeping Child* was one of the paintings turned over to two Belgian dealers, Arthur Stevens and Ennemond Blanc, in 1862, as part of a long-term arrangement they had undertaken with Millet in 1860. But as with so many of the pictures for Blanc and Stevens, *Woman Sewing* had been begun earlier, in the late 1850s, and was brought to completion to meet the demands of their contract.

Just as the quality of natural light changing with the dying day provided the impetus for so many of Millet's twilight images of the plain or forest, so the flickering lamps or fireplace in small farmhouse interiors frequently drew his attention. In 1854, he had created a small painting of two women sewing by the light of a small oil lamp (cat. no. 44) and *Woman Sewing* recombines several elements of that composition in a more monumental image. Before a curtained bed that closes off the background of the painting, a woman in a heavy blue-green blouse mends a white shirt while her child sleeps beside her. Between them, a smoky oil lamp brightens just the small corner they inhabit, casting a faint pink glow across their faces. Millet made only one small change in the composition as he worked on the panel: a shift in the position of the woman's right arm and hand. The thickness of the paint surface, however, reflects numerous touches and retouches, as he continually readjusted the changing color of his seamstress's head scarf, the mending massed on her lap, and the swell of her bodice as the light moves across her figure. With a delicacy of handling that is seldom associated with Millet, he balanced the bright light dissolving the woman's right profile with a pink highlight on her left cheek.

Provenance

With Ennemond Blanc and Alfred Stevens, Paris (1862); Quincy Adams Shaw, Boston.

Exhibition History

Museum of Fine Arts, Boston, "Quincy Adams Shaw Collection," 1918, no. 12.

Related Works

Woman Sewing (Madame Millet), drawing, black conté crayon on paper, current location unknown.

Woman Sewing, oil on canvas, 33 x 25 cm., Musée du Louvre, Paris (R. F. 1593).

Finished drawing, black conté crayon on paper, current location unknown (see Etienne Moreau-Nélaton, *Millet raconté par lui-même* [Paris: Henri Laurens, 1921], vol. 2, fig. 129).

Woman Sewing beside her Sleeping Child, cat. no. 91.

Woman Sewing by Lamplight, oil on canvas, 100.7 x 81.9 cm., Frick Collection, New York.

The finished drawing in the collection of the Birmingham City Museum and Art Gallery is a forgery by Charles Millet. A stiffer, less finished figure study in the Staatliche Museum, Lindau, may also be his work.

References

"'Greta's' Boston Letter." *Art Amateur* 5, no. 4 (September 1881), p. 72.

Guiffrey, Jean. "Tableaux Français conservés au Musée de Boston et dans quelques collections de cette ville." *Archives de l'art Français* n. s. 7 (1913), p. 547.

Moreau-Nélaton, Etienne. *Millet raconté par lui-même*. Paris: Henri Laurens, 1921, vol. 2, pp. 74, 103, fig. 165.

92
Study for *Shepherdess Knitting (La Grande Bergère)*
1862
Black conté crayon on wove paper
31.4 x 24.2 cm. (12⅜ x 9½ in.)
Gift of Mrs. J. Templeman Coolidge, 1946
46.594

93
Shepherdess Knitting (La Grande Bergère)
Delteil 18, only state
1862
Etching on buff laid paper
32.0 x 24.0 cm. (12⅝ x 9 in.)
Gift of Gordon Abbott, 1921
M28708

After several paintings that worked variations on the theme of a shepherdess knitting with her flock grazing nearby, which Millet had begun in 1855 (see fig. no. 6), he took up the subject again in 1862 for a large etching of great beauty. The major preparatory study for the etching, often known as *La Grande Bergère* because of its size, is a black crayon drawing sufficiently finished to appear to be a completed work.

Millet worked out his new version of the composition (at exactly the scale at which it would be reproduced) in a drawing that effectively combined a considerably finished figure with a background retaining the energy and freedom of a sketch. Although he usually kept working drawings, he was satisfied enough with this preliminary work to give or sell it to one of his important collectors of the 1860s, the musician Paul Marmontel.

The composition of the shepherdess knitting that Millet chose for the etching has an openness that sets it near the end of the development of this theme. To give a wider view of the plain, Millet cut back the embankment behind the shepherdess severely; to emphasize her face, which is drawn with great delicacy, he enframed it with just a few, sparsely leaved saplings, instead of the thick foliage that he had used in earlier paintings. The horizon is much lower than in his earliest versions, a change that allowed him to exploit the coloristic limitations of a print; with the large expanse of sky created in this way, he offset the intense black areas of the shadowed shepherdess.

In adapting his drawing to an etching, Millet boldly drew on the large plate with a needle to create a web of broken strokes that capture the energy of the sketch and suggest the fluidity of a pen-and-ink drawing. The hatching patterns that shape the sheepdog or define the shepherdess's skirt

and cape are bold and eye-catching, while the embankment is covered with strokes that are chaotic in their freedom and varied density but establish the irregular soil wall convincingly.

Millet's early prints had had a modest success, and when his paintings and drawings began to attract more consistent popular notice, Alfred Cadart, the publisher and founder of the Société des Aquafortistes,[1] solicited his work. Although the circumstances of the original commission for this plate are unclear, its considerable size, almost twice as large as most of Millet's earlier etchings, argues that Cadart may have sponsored or at least suggested the making of the print. In any event, once the plate was etched, Cadart was actively interested in issuing prints from it.[2]

Notes

1. An organization that issued etchings by a number of the leading artists of the day.

2. Robert Herbert suggests that Cadart requested the plate (see *Jean-François Millet* [Paris: Editions des Musées Nationaux, Grand Palais exhibition catalogue, 1975], p. 171), while Michel Melot claims that the commission is unrecorded (see *L'Oeuvre gravé de Boudin, Corot, Daubigny, Dupré, Jongkind, Millet and Théodore Rousseau* [Paris: Arts et Metiers, 1978], p. 288).

Cat. no. 92:
Provenance

Paul Marmontel (sold Hôtel Drouot, Paris, January 25-26, 1883, no. 187); John Templeman Coolidge, Jr., Boston (by 1908), Mrs. J. Templeman Coolidge, Boston.

Exhibition History

Copley Society, Boston, "The French School of 1830," 1908, no. 103.

Phillips Collection, Washington, D. C., "Drawings of J. F. Millet," 1956.

Newark Museum, "Nineteenth Century Master Drawings," 1961, no. 19.

Cat. nos. 92 and 93:
Related Works

Study of a dog, black conté crayon on paper, 8 x 7.2 cm., Art Institute of Chicago.

Study for *Shepherdess Knitting*, cat. no. 92.

Shepherdess Knitting (La Grande Bergère), cat. no. 93.

Study for *Shepherdess Knitting*, black conté crayon on paper, 33.6 x 24.4 cm., current location unknown (sold Christie's, New York, May 28, 1982, no. 232). Tracing of the etching used to transfer the image to the following painting.

Young Shepherdess, oil on canvas, 14 x 10 in., Art Institute of Chicago.

A counterfeit etching exists, very close to the original in composition, but very awkward in technique.

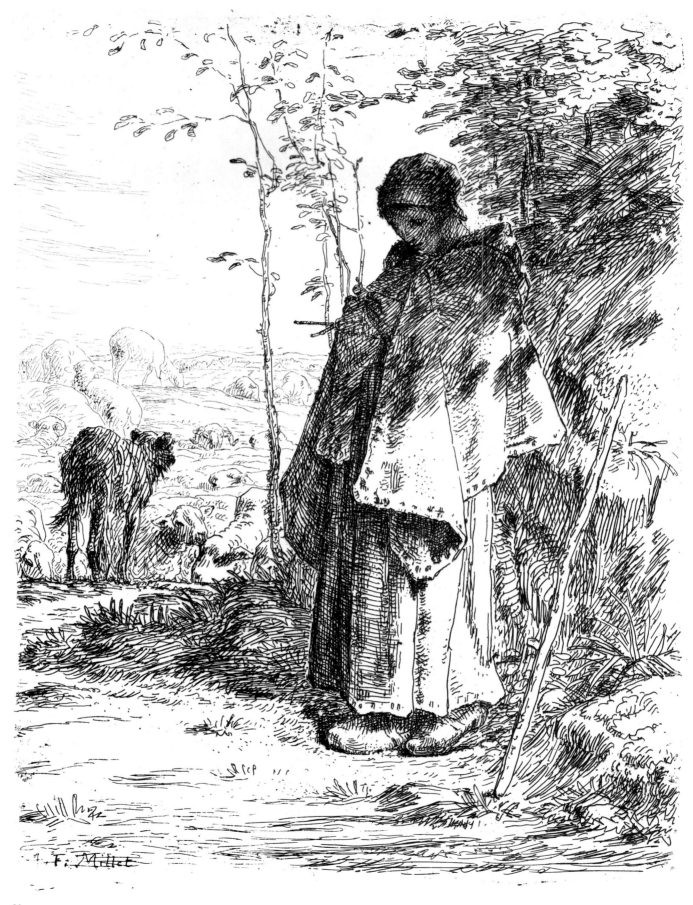

Cat. no. 93:

References

Lebrun, Alfred. "Catalogue de l'oeuvre gravé de J.-F. Millet." In Sensier, Alfred, and Mantz, Paul. *La Vie et l'oeuvre de J.-F. Millet*. Paris: A. Quantin, 1881, p. 376, no. 19, illus. p. 378.

Delteil, Loys. *Le Peintre-graveur illustré (XIX et XX siècles), I, J.-F. Millet, et al.*. Paris: Delteil, 1906, no. 18.

[Herbert, Robert L.]. *Jean-François Millet*. Paris: Editions des Musées Nationaux, Grand Palais exhibition catalogue, 1975, p. 171.

Melot, Michel. *L'Oeuvre gravé de Boudin, Corot, Daubigny, Dupré, Jongkind, Millet and Rousseau*. Paris: Arts et Métiers, 1978, no. 18, p. 288.

94
Study for *Woman Pouring Water into Milk Cans*
1862
Black conté crayon, incised with pencil, on tracing paper
30.8 x 19.7 cm. (12⅛ x 7¾ in.)
Stamped, lower right: J. F. M.
Gift of Martin Brimmer, 1876
76.433

95
Woman Pouring Water into Milk Cans
Delteil 28, only state
1862
Cliché-verre (glass-plate print)
28.4 x 22.2 cm. (11⅛ x 8¾ in.)
Gift of Mrs. Josiah Bradlee, 1902
M19358

The round, copper milk cans being filled with water in this print and its preparatory drawing were a distinctive feature of Normandy that reappears in numerous works by Millet. The *cliché-verre*, or literally glass-negative, print derives from a painting that he created in the 1850s (current location unknown). With his composition well established in that painting, Millet needed to make only cursory notations of the well and courtyard in the drawing, focusing his attention on a careful rendering of the figure, which was then transferred to the glass plate by incising – visible in the pencil reinforcement of the figure's silhouette.

Combining aspects of photography and etching, *clichés-verre* were a nineteenth-century addition to graphic media,[1] introduced to a number of Barbizon artists by Corot, who had learned the process from its inventor, Adalbert Cuvelier, a photographer from Arras.[2] Millet made his glassplate prints with the assistance of Cuvelier's son Eugène, who settled in Barbizon in 1859.

Notes

1. A printing procedure whereby sensitized photographic paper is placed under a transparent glass plate that has been covered with a prepared ground – printer's ink or smoked collodion – and drawn on with a sharp quill pen. The glass is then placed in direct sunlight, which transfers the drawn lines to the light-sensitive paper. The resulting image, though flat when compared with an etching, has a greater overall tonality and can be reproduced in great numbers.

2. Elizabeth Glassman, "Cliché-verre in the 19th Century," in *Cliché-verre: Hand-Drawn, Light-Printed* (Detroit: Detroit Institute of Arts, exhibition catalogue, 1980), p. 30.

Provenance

Millet studio sale (Hôtel Drouot, Paris, May 10-11, 1875, no. 166), bought by Richard Hearn for Martin Brimmer, Boston.

Cat. no. 94:

Exhibition History

Phillips Collection, Washington, D. C., "Drawings by J. F. Millet," 1956.

Arts Council of Great Britain, London, "Drawings by Jean François Millet," 1956, no. 43.

References

Wickenden, Robert J. "Millet's Drawings at the Museum of Fine Arts, Boston." *Print-Collector's Quarterly* 4, part 1 (1914), p. 14.

Cat. nos. 94 and 95:

Related Works

Compositional sketch, black conté crayon on paper, 24.2 x 18.4 cm., Cabinet des Dessins, Musée du Louvre, Paris, (GM10342).

Compositional sketch, black conté crayon on paper, verso rubbed with sanguine conté crayon, 30.6 x 23.0 cm., Cabinet des Dessins, Musée du Louvre, Paris (GM10621).

Compositional sketch, black conté crayon over traces of sanguine on paper, 26.2 x 17.3 cm., Art Institute of Chicago.

Woman Pouring Water into Milk Cans, oil painting, current location unknown (recorded in Zacharie Astruc, *Beaux-Arts. Le Salon intime, exposition au Boulevard des italiens* [Paris: Poulet-Malassis et de Broise, 1860], pp. 66-67).

Study for *Woman Pouring Water into Milk Cans*, cat. no. 94.

Woman Pouring Water into Milk Cans, cat. no. 95.

Woman Pouring Water into Milk Cans, pastel with black conté crayon on paper, 29 x 23.0 cm., private collection, West Germany.

Woman Pouring Water into Milk Cans, pastel and black conté crayon on paper, 44.0 x 34.3 cm., Musée du Louvre, Paris (R. F. 3969).

Finished study of figure, black conté crayon heightened with white, 28 x 21.5 cm., current location unknown (sold Sotheby's, London, March 24, 1982, no. 436). A study concentrated on the figure with only minimal setting was a working procedure for Millet, not a form normally used for presentation drawings. From a photograph, this unusual work appears slightly stiff, but it may be an effort by Millet to create a salable drawing form that preserved a greater sense of his working methods.

Cat. no. 95:

References

Lebrun, Alfred. "Catalogue de l'oeuvre gravé de J.-F. Millet." In Sensier, Alfred, and Mantz, Paul. *La Vie et l'oeuvre de J.-F. Millet*. Paris: A. Quantin, 1881, p. 382, no. 26, illus. p. 383.

Delteil, Loys. *Le Peintre-graveur illustré (XIX et XX siècles), I, J.-F. Millet, et al.*. Paris: Delteil, 1906, no. 28.

Melot, Michel. *L'Oeuvre gravé de Boudin, Corot, Daubigny, Dupré, Jongkind, Millet, Théodore Rousseau*. Paris: Arts et Métiers Graphiques, 1978, p. 290, no. 28.

96
Motherly Precaution
Delteil 27, only state; 1921 Sagot-Le Garrec edition
1862
Cliché-verre (glass-plate print)
28.7 x 22.6 cm. (11¼ x 8⅞ in.)
Samuel Putnam Avery Fund, 1923
M29809

Paintings by Brueghel or drawings by Rembrandt provided precedent for Millet's unusual subject in this print – a mother lifting the skirts of her child, to protect them while he urinates from the doorstep. *Motherly Precaution* enlarges upon many details of sixteenth- and seventeenth-century paintings in which young children and adults relieve themselves in a courtyard corner, as the greater activities of the day go on about them. But Millet's straightforward acceptance of a commonplace event draws the viewer's attention to the nexus of family life expressed in such a ritual: the contrast between the little boy's clutching hand upon his mother's sturdy wrist, or the curiosity of his sister's glance intersecting her mother's watchful gaze.

Adapted from a finished drawing and a painting dating from 1855-1857, *Motherly Precaution* was redrawn for a *cliché-verre* in 1862. For the present image and *Woman Pouring Water* (cat. no. 95), Millet employed the creative vocabulary of his etchings, translating drawings onto glass plates with the cross-hatchings, randomly aligned short strokes, and dots that he had developed for his work on copper plates. While the impression of *Woman Pouring Water* (cat. no. 95) was probably made under Millet's own supervision, this example of *Motherly Precaution* was printed posthumously around 1921 by Maurice Le Garrec, who had acquired the glass plates from Millet's friend and adviser for the prints, Eugène Cuvelier.

Related Works
For a complete listing of the works related to this image, which includes a painting and a large number of preparatory drawings, see the special *dossier* reproducing eight objects ([Robert L. Herbert], *Jean-François Millet* [Paris: Editions des Musées Nationaux, Grand Palais exhibition catalogue, 1975], pp. 151-157).
Compositional study, pen and ink on paper, 27.8 x 21.8 cm., private collection, Paris.
Compositional sketch, black conté crayon heightened with white on paper, 28.0 x 20.9 cm., Cabinet des Dessins, Musée du Louvre, Paris (R. F. 23599).
Motherly Precaution, cat. no. 96.

References
Lebrun, Alfred. "Catalogue de l'oeuvre gravé de J.-F. Millet." In Sensier, Alfred, and Mantz, Paul. *La Vie et l'oeuvre de J.-F. Millet*. Paris: A. Quantin, 1881, p. 382, no. 25.
Delteil, Loys. *Le Peintre-graveur illustré (XIX et XX siecles), I, J.-F. Millet, et al.*. Paris: Delteil, 1906, no. 27.

[Herbert, Robert L.] *Jean-François Millet*. Paris: Editions des Musées Nationaux, Grand Palais exhibition catalogue, 1975, p. 172.
Melot, Michel. *L'Oeuvre gravé de Boudin, Corot, Daubigny, Dupré, Jongkind, Millet, Théodore Rousseau*. Paris: Arts et Métiers Graphiques, 1978, no. 27, p. 290.

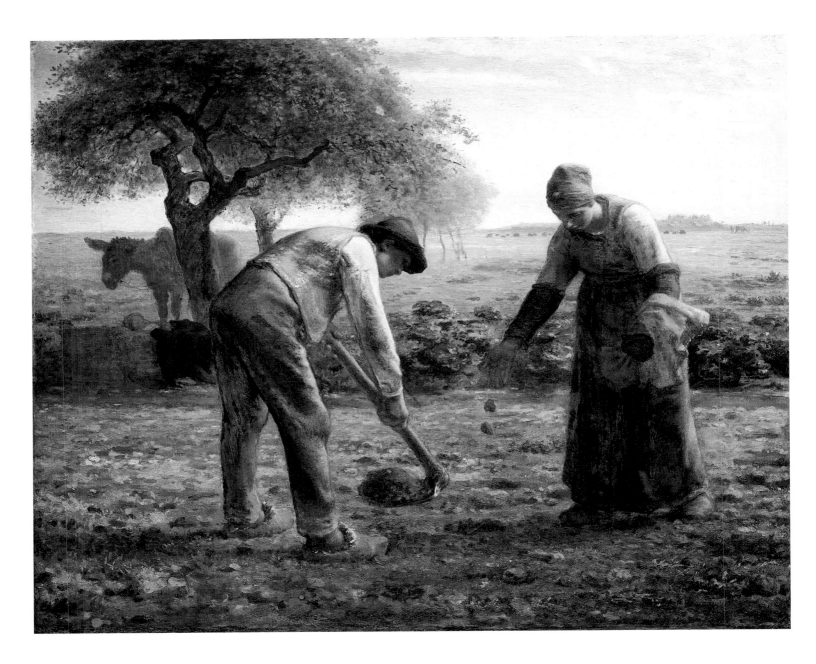

97
Potato Planters
1861-1862
Oil on canvas
82.5 x 101.3 cm. (32½ x 39⅞ in.)
Lower right: J. F. Millet
Gift of Quincy Adams Shaw through
Quincy A. Shaw, Jr., and Mrs. Marian
Shaw Haughton, 1917
17.1505

Of several large paintings that date from the early years of Millet's contract with the Belgian art dealers Arthur Stevens and Ennemond Blanc, *Potato Planters* is the most successful, the harsh reality of its subject belied by the flickering beauty of its setting. The arrangement Millet signed with Stevens and Blanc in 1860 had guaranteed him a small monthly income in return for delivery of a fixed number of paintings; although the contract ultimately proved a difficult bargain, from which he fought for release until 1866, it provided him early in the decade with the impetus to undertake or complete a number of significant, large paintings conceived much earlier.

The potato planting theme had first drawn Millet's attention about 1850, when he made a relatively finished crayon drawing depicting a man digging holes in which a woman and child bury seed potatoes. However, the artist did not pursue this uncommon image further until late 1861, when (as his letters to Rousseau and Sensier indicate[1]) he produced the Boston painting in an unusually concentrated burst of energy, finishing it in time for an exhibition organized by Georges Petit in May 1862.

Pictures of planting and harvesting grain have a long history quite independent of Millet and realist art of the nineteenth century, but artistic interest in the cultivation of potatoes is virtually unknown before Millet's work.[2] Potatoes had been grown extensively on the European continent since the middle of the previous century, although in France they were generally scorned as a food crop and even considered by many to be unfit for animals. Yet, by the 1850s cultivation of potatoes for human consumption was spreading rapidly throughout central France. In a country where for centuries the color and the grade of bread a man consumed had marked his social status, Millet's straightforward recognition of the significance of potatoes as a bread substitute offered a threatening proof of the desperate plight of a laboring poor who were dropping beneath the level of subsistence generally accorded to animals.

When *Potato Planters* was exhibited in 1862, several writers addressed that threat by decrying the vulgarity of the painting's subject. Millet, who had found a monumental dignity in these potato planters, drafted a response to his critics, unpublished in his lifetime, in which he asked,

"Why should the work of a potato planter or a bean planter be less interesting or less noble than any other activity? It ought to be recognized that there isn't any nobility or baseness except in the manner of understanding or representing such things, and not in the things themselves."[3]

In accepting the harsh reality inherent in his subject, Millet chose to move beyond it to examine the beauty that coexisted with the desperate hunger. The man and woman, their relationship as husband and wife suggested by the child sleeping in the background, work silently. From their rhythmic gestures Millet created an interlocked pair of solid, simplified figures that contrast with the richly colored Chailly plain that isolates them and their task. The figures themselves, their shadowed faces sculpted without any trace of the harshness or the vacant stare that made so many other Millet peasants impenetrable and threatening, are deeply absorbed in their work and convey neither resentment nor exhaustion. The soil they till is a complex range of browns, ochers, and purples that fade softly into the rich foliage setting off the peasant's plot from the plain beyond.

In such a luminous setting, the secondary group of the sleeping child and placid donkey suggest both a golden age of agricultural society, in subtle counterpoint to the truths of the peasants' poverty, and the humble example of the Holy Family, beset with the difficult tasks of daily life.

Notes

1. Archives of the Cabinet des Dessins, Musée du Louvre, Paris, quoted in Alfred Sensier and Paul Mantz, *La Vie et l'oeuvre de J.-F. Millet* (Paris: A. Quantin, 1881), pp. 223, 225, 226.

2. For the only use of the potato theme prior to Millet's painting, see Gustave Brion's *Potato Harvest during the Flooding of the Rhine in 1852, Alsace*, 1852, oil on canvas, 98 x 132 cm., Musée des Beaux-Arts, Nantes (see Gabriel Weisberg, *The Realist Tradition: French Painting and Drawing, 1830-1900* [Cleveland: Cleveland Museum of Art, exhibition catalogue, 1980], p. 129, illus. p. 128).

3. Quoted in Etienne Moreau-Nélaton, *Millet raconté par lui-même* (Paris: Henri Laurens, 1921), vol. 2, pp. 110-111.

Provenance

With Ennemond Blanc and Arthur Stevens (1862); with Francis Petit (1862); M. Soultzener (1867); anonymous owner (sold as part of the de Hauff sale, Hôtel Drouot, Paris, March 13, 1877, no. 26); Quincy Adams Shaw, Boston (by 1879).

Exhibition History

Cercle de l'Union Artistique, Paris, 1862, organized by Georges Petit.

Exposition Universelle, Paris, 1867, no. 479.
American Art Association, New York, "The Works of Antoine-Louis Barye...his Contemporaries and Friends," 1889, no. 554.
Museum of Fine Arts, Boston, "Quincy Adams Shaw Collection," 1918, no. 4.
Grand Palais, Paris, "Jean François Millet," 1975, no. 159 (Hayward Gallery, London, 1976, no. 84).
Museum of Fine Arts, Boston, "Corot to Braque: French Paintings from the Museum of Fine Arts, Boston," 1979, no. 18.

Related Works

Finished drawing of man, woman and child planting (or harvesting) potatoes, black conté crayon on paper, current location unknown (see A. Alexandre, F. Keppel, and C. J. Holme, "Corot and Millet," *Studio* special issue [1902-1903], fig. M-4).
Compositional sketch with man and woman reversed within a fenced yard, black conté crayon on paper, 8.8 x 11.0 cm., Cabinet des Dessins, Musée du Louvre, Paris (GM10384).
Compositional sketch, similar to final grouping, current location unknown (see *L'Image* [April 1897], p. 199).
Compositional sketch establishing final composition, current location unknown (see *Le Second Empire à Nice* [Nice: Musée Masséna, exhibition catalogue, 1931], p. 24).
Study of man and woman, black conté crayon on paper, 6.6 x 10.5 cm., Musée des Beaux-Arts, Dijon (DG462).
Studies of man digging, black conté crayon on paper, 28.5 x 22 cm., current location unknown (London art market, 1969).
Study of man digging, black conté crayon on paper, 28.1 x 22.3 cm., Musée Bonnat, Bayonne.
Study of man digging, black conté crayon on paper, 19.2 x 14.2 cm., Cabinet des Dessins, Musée du Louvre, Paris (GM10385).
Potato Planters, cat. no. 97.
Man digging beneath a tree, pastel and black conté crayon on paper, 15 x 10½ in., Burrell Collection, Glasgow Art Gallery (a copy, not by Millet, of lefthand portion of painting).

References

Wheelwright, Edward. "Personal Recollections of Jean-François Millet." *Atlantic Monthly* 38 (September 1876), p. 264.
Strahan, Edward. *Art Treasures of America*. Philadelphia: George Barrie, 1879, vol. 3, p. 27.
"'Greta's' Boston Letter." *Art Amateur* 5, no. 4 (September 1881), p. 72.
Sensier, Alfred, and Mantz, Paul. *La Vie et l'oeuvre de J.-F. Millet*. Paris: A. Quantin, 1881, pp. 221-223, 225-226, 233, 301, 303.
Michel, André. "J.-F. Millet et l'exposition de ses oeuvres à l'Ecole des Beaux-Arts." *Gazette des Beaux-Arts* 2nd ser., 36 (July 1887), p. 6.
Mollett, John W. *The Painters of Barbizon*. London: Sampson, Low, Marston, Searle & Rivington, 1890, pp. 116, 119.
Roger-Miles, L. *Le Paysan dans l'oeuvre de J.-F. Millet*. Paris: Georges Petit, 1895, illus.

Cartwright, Julia M. *Jean-François Millet: his Life and Letters*. London: Swan Sonnenschein, 1896, pp. 216-217, 220, 223, 230, 301.

Masters in Art, Millet. Boston, 1900, p. 35, pl. 10.

Hurll, Estelle M. *Jean-François Millet*. Boston: Houghton Mifflin, 1900, pp. 12, 18.

Marcel, Henri. "Quelques Lettres inédites de J.-F. Millet." *Gazette des Beaux-Arts* 3rd ser., 26 (July 1901), p. 76.

Gensel, Walther. *Millet und Rousseau*. Bielefeld and Leipzig: Velhagen & Klasing, 1902, pp. 48-49.

Thomson, David Croal. *The Barbizon School of Painters*. London: Chapman and Hall, 1902, pp. 235, 241.

Marcel, Henry. *J.-F. Millet*. Paris: Henri Laurens, 1904, p. 60.

Staley, Edgcumbe. *Jean-François Millet*. London: George Bell and Sons, 1903, pp. 24, 67.

Muther, Richard. *J.-F. Millet*. English ed., New York, 1905, p. 32.

Peacock, Netta. *Millet*. London: Methuen & Co., 1905, p. 102.

Diez, Ernst. *Jean-François Millet*. Bielefeld and Leipzig: Velhagen & Klasing, 1912, p. 89, illus.

Guiffrey, Jean. "Tableaux Français conservés au Musée de Boston et dans quelques collections de cette ville." *Archives de l'art Français* n. s. 7 (1913), p. 547.

Cox, Kenyon. *Artist and Public*. New York: Charles Scribner's Sons, 1914, pp. 61-62, illus. p. 59.

"The Quincy Adams Shaw Collection." Boston: Museum of Fine Arts *Bulletin* 16, no. 94 (April 1918), p. 14, illus. p. 13.

Moreau-Nélaton, Etienne. *Millet raconté par lui-même*. Paris: Henri Laurens, 1921, vol. 2, pp. 73, 104, 108-111, 119, 122, fig. 164; vol. 3, pp. 19, 25.

Brandt, P. *Schaffende Arbeit und Bildende Kunst*. Leipzig: Alfred Kröner, 1928, p. 227.

Constable, W. G. *Art Collecting in the United States of America*. London: Thomas Nelson and Sons, 1964, fig. 8.

Reverdy, Anne. *L'Ecole de Barbizon, l'évolution du prix des tableaux de 1850 à 1960*. Paris: Mouton, 1973, p. 32.

Fermigier, André. *Millet*. Geneva: Skira, 1977, p. 104, illus. p. 106.

Chamboredon, Jean-Claude. "Peinture des rapports sociaux et l'invention de l'éternel paysan: Les deux manières de Jean-François Millet." *Actes de la recherche en sciences sociales* 17/18 (November 1977), pp. 16, 17, illus. p. 17.

J.F.M

98
Study of a man's head
About 1862
Black conté crayon on laid paper
11.9 x 9.0 cm. (4⅝ x 3¾ in.)
Stamped, lower center: J. F. M
Stamped, lower right: VENTE MILLET
Gift of Mrs. John Alden Carpenter, 1963
63.2697

This drawing of a man's head is one of three known studies for the same figure, and is probably a carefully reworked tracing of the upper of two similar heads on a page belonging to the Louvre. The changes made from head to head show Millet working from a particularized drawing, which may well be drawn from life, toward a more generalized face with the features broadened and softened and the grim expression muted. Since the Boston drawing is both more simplified and rendered with fairly cursory efforts at shadowing, it probably represents a transfer stage in the drawing sequence, the point at which by tracing or rubbing, Millet would have recorded the rough outlines and features of a subject on the paper or canvas to be used for the final work.

Provenance
Millet studio sale (Hôtel Drouot, Paris, May 10-11, 1875, possibly no. 188); Mrs. John Alden Carpenter, Manchester, Massachusetts.

Related Works
Two studies of a man's head, black conté crayon on paper, 29.0 x 18.0 cm., Cabinet des Dessins, Musée du Louvre, Paris (GM10489).

Study of a man's head, cat. no. 98.

99
Peasant Girl with Two Cows
1863
Black conté crayon with pastel on laid paper
29.7 x 47.0 cm. (11¾ x 18½ in.)
Lower right: J. F. Millet
Gift of Quincy Adams Shaw through Quincy A. Shaw, Jr., and Mrs. Marian Shaw Haughton, 1917
17.1516

During the 1850s, images of young women tending cows (which first appeared in Millet's work shortly after his arrival in Barbizon) became one of his most important subjects for social comment, culminating in the controversial Salon entry of 1859, *Woman Pasturing her Cow* (Musée de l'Ain, Bourg-en-Bresse), which posed a young woman and her beast against the vast, harvested fields that they could not enter. In the following decade, images of young women and cows continue as a very important part of Millet's repertoire, but their tone, in the smaller format of pastels and paintings for private collectors, becomes far less strident. In *Peasant Girl and Two Cows*, from 1863, Millet matter-of-factly recorded the barren, hummocky waste on which the young animal tender grazes her cows, and acknowledged the approaching winter season with the hood pulled over her head for warmth, but he made no effort to politicize her plight.

The palely colored plain, framing the bright localized color of the cows and the young woman's blue skirt, reflects an early moment in Millet's revival of pastel drawing, as he adapted comparatively restrained colors to a carefully rendered black crayon drawing. The broad sweeps of white pastel in the sky, and the muddying of colors rubbed into each other in the young woman's cape and the grassy foreground, are techniques that rapidly disappear from his pastel drawings over the next years.

The young woman's distinctive cape, with its dark edging and decorative layering at the shoulders, corresponds to the costume of a milkmaid illustrated in the popular series of articles *Les Français peints par eux-mêmes*.[1] Millet certainly knew this successful publication; the appearance of the cape on so many of his cowherds and shepherdesses suggests, moreover, that it was one of the typical costumes that he collected for inclusion in his pictures.[2] The precision in recording items of dress and even details of fabrics contributes to the sense of specific time and place so carefully

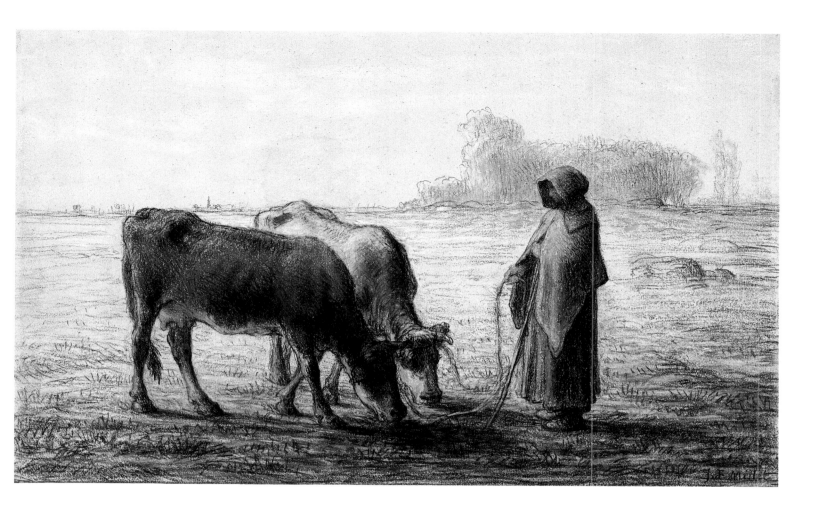

balanced against timeless subject matter
and classicizing compositions throughout
his work in the 1850s and 1860s – a measure
of modernity that many of his city-bound
critics often failed to recognize.

Notes

1. See *Les Français peints par eux-mêmes; Encyclopédie morale du dix-neuvième siècle* (Paris: L. Curmer, 1840-1842), vol. 5, p. 233.

2. See *Woman Pasturing her Cow* (Musée de l'Ain, Bourg-en Bresse), or *Shepherdess and Flock* (Musée du Louvre, Paris).

Provenance

Emile Gavet (sold Hôtel Drouot, Paris, June 11-12, 1875, no. 39), bought by Détrimont, probably for Quincy Adams Shaw, Boston.

Exhibition History

Museum of Fine Arts, Boston, "Quincy Adams Shaw Collection," 1918, no. 34.

References

Guiffrey, Jean. "Tableaux Français conservés au Musée de Boston et dans quelques collections de cette ville." *Archives de l'art Français* n. s. 7 (1913), p. 547.

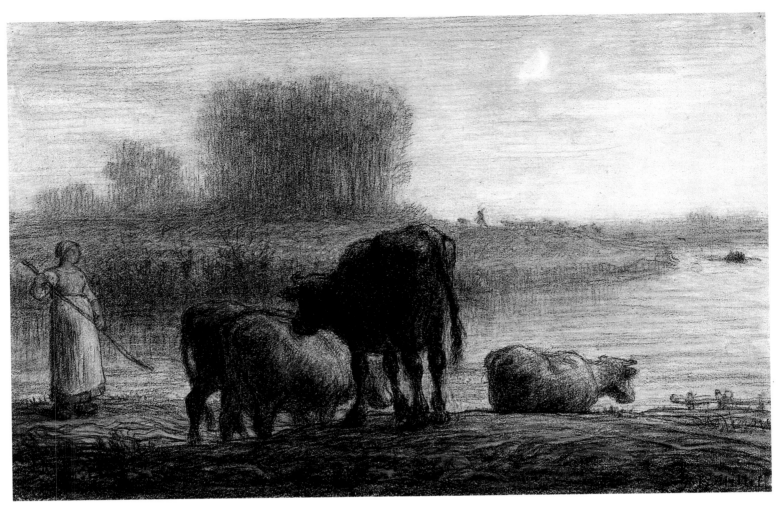

100
Watering Cows
1863
Black conté crayon with pastel on laid paper
30.8 x 46.4 cm. (12⅛ x 18¼ in.)
Lower right: J. F. Millet
Gift of Quincy Adams Shaw through Quincy A. Shaw, Jr., and Mrs. Marian Shaw Haughton, 1917
17.1515

The soft gray light of dusk (effected with the use of black crayon across virtually the entire paper surface, rubbed to blend the individual strokes into misty masses) and the presence of the shepherd leading his flock to shelter (borrowed from an earlier drawing, cat. no. 41) relate this work to Millet's many scenes of twilight from the mid-1850s. *Watering Cows* also reflects the renewed prominence of the Chailly landscape in his drawings, after a period of concentration on figural imagery and intimate household garden scenes. In a clear line of descent from traditional sources, the depiction of several cows at a stream recalls the seventeenth-century master Claude Gellée (Le Lorrain), for whom lines of cows winding down a river bank so frequently supplied the pastoral content for his classical landscapes.

The compositional sketch from which this drawing was created, showing the cowherd swinging her stick at her lagging animal (Musée Bonnat, Bayonne), is closely related in composition and landscape details to a series of drawings that record washerwomen and women carrying water.

All of the drawings, in turn, proceeded from Millet's landmark painting *Washerwomen* of about 1855 (cat. no. 62).

Provenance
Emile Gavet (sold Hôtel Drouot, Paris, June 11-12, 1875, no. 87), bought by Détrimont, probably for Quincy Adams Shaw, Boston.

Exhibition History
Museum of Fine Arts, Boston, "Quincy Adams Shaw Collection," 1918, no. 35.

Related Works
Study of cows, pencil on paper, 11.4 x 11.8 cm., Kunsthalle, Bremen.
Shepherd and Flock on the Edge of a Hill, cat. no. 41.
Compositional sketch with woman shaking a stick, black conté crayon on paper, 22.2 x 32.8 cm., Musée Bonnat, Bayonne.
Compositional sketch, black conté crayon on paper, 22.2 x 36 cm., Cabinet des Dessins, Musée du Louvre, Paris (GM10733).
Watering Cows, cat. no. 100

References
Guiffrey, Jean. "Tableaux Français conservés au Musée de Boston et dans quelques collections de cette ville." *Archives de l'art Français* n. s. 7 (1913), p. 547.

101

House with a Well at Gruchy
About 1863
Pastel over black conté crayon heightened
with pen and ink on wove paper
32.2 x 43.2 cm. (12⅝ x 17 in.)
Lower right: J. F. Millet
Gift of Quincy Adams Shaw through
Quincy A. Shaw, Jr., and Mrs. Marian
Shaw Haughton, 1917
17.1496

102

Millet's Birthplace at Gruchy
About 1863
Pastel over black conté crayon heightened
with pen and ink on wove paper
31.2 x 45.5 cm. (12¼ x 17⅞ in.)
Lower right: J. F. Millet
Gift of Quincy Adams Shaw through
Quincy A. Shaw, Jr., and Mrs. Marian
Shaw Haughton, 1917
17.1495

103

Manor House near Gréville
About 1863
Watercolor and pastel over black conté
crayon heightened with pen and ink on
wove paper
34.3 x 45.5 cm. (13½ x 17⅞ in.)
Lower right: J. F. Millet
Gift of Quincy Adams Shaw through
Quincy A. Shaw, Jr., and Mrs. Marian
Shaw Haughton, 1917
17.1497

Millet's native Normandy provided him with a continuing source of imagery throughout his lifetime. These three colored drawings record scenes very familiar to him from his youth: the stone farmhouse in Gruchy in which he grew up, the stable-granary building just across the way with its distinctive well (see cat. no. 48), and a seventeenth- or eighteenth-century manor house from the vicinity of neighboring Gréville, which was probably the largest building in the area other than the church. Based on studies made during his return visits to Gruchy in the mid-1850s, these three finished works date to 1863, when Millet was experimenting with different techniques for color drawing.

The compositions of all three pictures are drawn in black conté crayon (although traces of pencil in the foliage of cat. no. 101 suggest that there may be cursory pencil sketches underneath). *Manor House* was then colored with broad washes of watercolor, and worked with touches of stronger watercolor throughout, notably in the foreground. To preserve the underlying drawing, Millet worked back through the composition, re-creating outlines with pen and ink in free calligraphic strokes that often depart exuberantly from the edges of the washes. The two views of the Millet homestead feature a more complex black crayon drawing, with shading and detail established before color was added in pastel. Millet took up his crayon as well as black ink to emphasize or simplify outlines, although in these drawings he was more selective in his use of the pen, limiting it to the geese in the foreground and areas where he tightened the shaping of buildings or trees (cat. no. 102).

The complex combination of techniques that gives these three drawings the air of objects repeatedly reworked did not endure in Millet's *oeuvre*. As he refined the balance of pastel and black crayon in his drawings, he set aside the use of watercolor until the Vichy landscapes of 1866-1868 (cat. nos. 117-127).

Cat. no. 101:
Provenance
With Moureau, Paris (1865); Félix-Bien-aimé Feuardent, Paris (1878); Quincy Adams Shaw, Boston.

Exhibition History
Cercle de l'Union Artistique, Paris, 1865.
Galerie Durand-Ruel, Paris, "Maîtres Modernes," 1878, no. 273.
Museum of Fine Arts, Boston, "Quincy Adams Shaw Collection," 1918, no. 28.

Related Works
Compositional sketch with woman pouring water into cans, black conté crayon on paper, 33 x 44 cm., current location unknown (sold M. F[euardent], Hôtel Drouot, Paris, April 23, 1934, no. 47).
House with a Well at Gruchy, cat. no. 101.
House with a well at Gruchy with clothing drying on a hedge, black conté crayon and pastel on paper, 37.0 x 46.0 cm., Musée Fabre, Montpellier.

References
Cary, Elisabeth Luther. "Millet's Pastels at the Museum of Fine Arts, Boston." *American Magazine of Art* 9 (May 1918), p. 266, illus. p. 267.
Guiffrey, Jean. "Tableaux Français conservés au Musée de Boston et dans quelques collections de cette ville." *Archives de l'art Français* n. s. 7 (1913), p. 548.
Moreau-Nélaton, Etienne. *Millet raconté par lui-même*. Paris: Henri Laurens, 1921, vol. 2, p. 139, fig. 2.

Cat. no. 102:
Provenance
With Moureau, Paris (1865); Félix-Bien-aimé Feuardent, Paris (1878); Quincy Adams Shaw, Boston.

Exhibition History
Cercle de l'Union Artistique, Paris, 1865.
Galerie Durand-Ruel, Paris, "Maîtres Modernes," 1878, no. 272.
Museum of Fine Arts, Boston, "Quincy Adams Shaw Collection," 1918, no. 27.

References
Guiffrey, Jean. "Tableaux Français conservés au Musée de Boston et dans quelques collections de cette ville." *Archives de l'art Français* n. s. 7 (1913), p. 548.
Cary, Elisabeth Luther. "Millet's Pastels at the Museum of Fine Arts, Boston." *American Magazine of Art* 9 (May 1918), p. 266.
Moreau-Nélaton, Etienne. *Millet raconté par lui-même*. Paris: Henri Laurens, 1921, vol. 1, p. 10; vol. 2, illus. p. 139.

Cat. no. 103:
Provenance
Quincy Adams Shaw, Boston.

Exhibition History
Museum of Fine Arts, Boston, "Quincy Adams Shaw Collection," 1918, no. 29.

Related Works
Compositional sketch, crayon reworked in ink on paper, 9.5 x 15.0 cm., Cabinet des Dessins, Musée du Louvre, Paris (GM10768).
Manor House near Gréville, cat. no. 103.

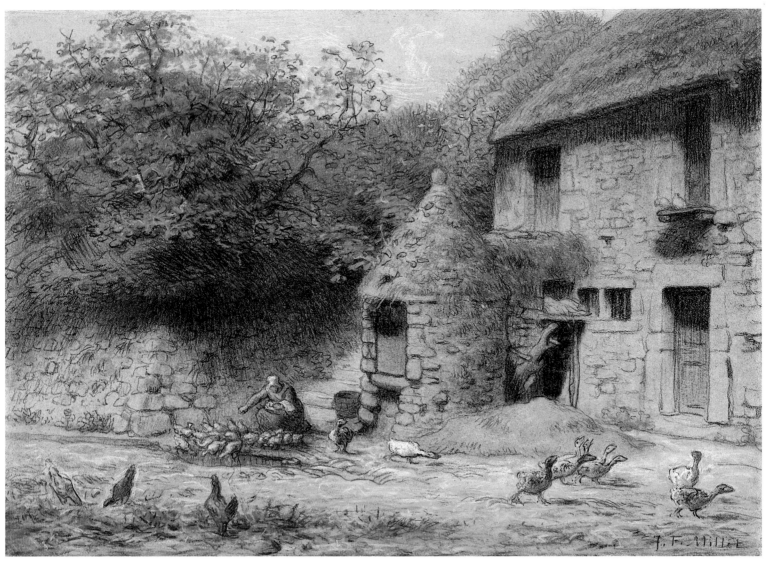

101

148

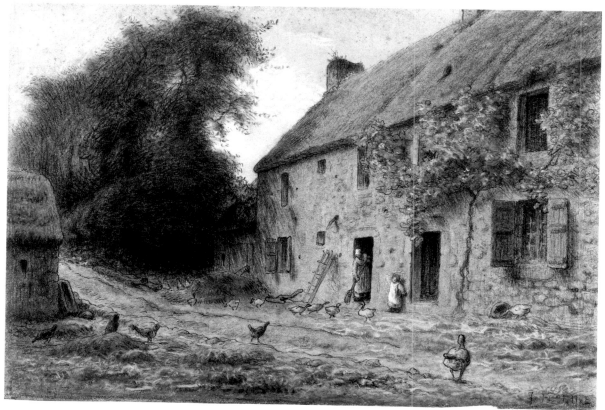

102

103

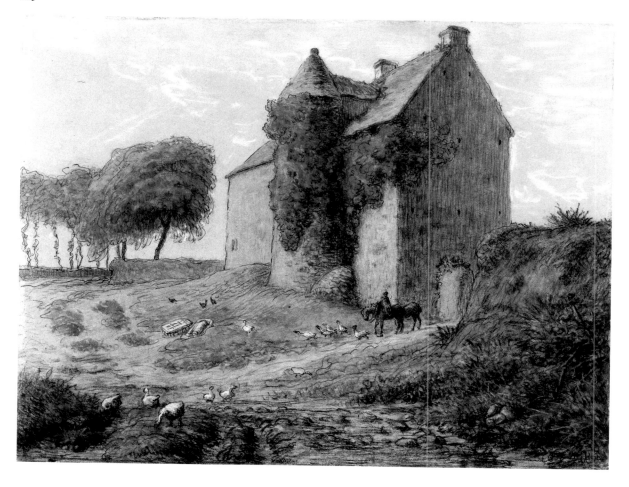

104
Man Turning over the Soil
Delteil 31, first state
1863
Woodcut on buff oriental paper
14.0 x 10.5 cm.
M23390

When Millet took up the unfamiliar medium of woodcut engraving as part of a proposed project of illustrations for the rural idylls of the classical Greek poet Theocritus, he began with a very familiar subject: a man digging.[1] Although the book project eventually came to nought, this unfinished woodcut provides an unusual opportunity to study Millet's working method as he tackled a new and challenging problem.

In choosing woodblocks as the medium for these illustrations, Millet was being deliberately old-fashioned, for woodcuts had been virtually abandoned for artistic printmaking since the fifteenth- and sixteenth-century German masters – Dürer, Holbein, and Schongauer – whom Millet much admired. Using what was considered a rather primitive means of reproduction, Millet consciously exploited the harshness of the medium to underline the simplicity and rural universality of Theocritus' imagery.

For the smaller format of a book illustration, he brought together in one figure the two diggers of his earlier composition (cat. no. 69), combining the deeply bent, compact form of one man with the specific movement of the second as he forces the spade into hard-packed soil. He also simplified and diminished the vast landscape of the engraving, even reducing the pile of hats and jackets of the earlier image to a single hat at the digger's side. The result is a simpler, powerful figure, close in conception and impact to the single digger of his much earlier painting (cat. no. 17).

This proof of unknown date is printed from the unfinished block, with its random and erratic working of the background recording Millet's uncertainty in the new medium. The figure is solidly drawn, although the outline breaks disturbingly in several places and details such as face and hands appear to have been beyond the artist's control of unfamiliar tools.

Notes
1. The illustration project had been suggested by a young classical scholar, Michael Chassaing, who shared Millet's love for the idyllic rural imagery of Virgil, Ovid, and Theocritus. The two collaborators hoped a Paris publisher might be persuaded to issue a new edition if Millet's sample prints were sufficiently impressive.

References
Lebrun, Alfred. "Catalogue de l'oeuvre gravé de J.-F. Millet." In Sensier, Alfred, and Mantz, Paul. *La Vie et l'oeuvre de J.-F. Millet*. Paris: A. Quantin, 1881, no. 30, p. 384, illus. p. 385.

Delteil, Loys. *Le Peintre-graveur illustré (XIX et XX siècles)*, I, *J.-F. Millet, et al.*. Paris: Delteil, 1906, no. 31.

Melot, Michel. *L'Oeuvre gravé de Boudin, Corot, Daubigny, Dupré, Jongkind, Millet, Théodore Rousseau*. Paris: Arts et Métiers Graphiques, 1978, no. 31, p. 291.

105
Peasant Watering her Cow
About 1863
Oil paint and black conté crayon on pink prepared canvas
46.0 x 55.5 cm. (18⅛ x 21⅞ in.)
Lower right: J. F. M.
Gift of Quincy Adams Shaw through Quincy A. Shaw, Jr., and Mrs. Marian Shaw Haughton, 1917
17.1509

Executed with an oil paint so fluid that it resembles watercolor and reveals Millet's very broad crayon drawing, *Peasant Watering her Cow* stands alone in Millet's painted *oeuvre*. The effect is of a softly colored drawing, but there is no reason to consider it a sketch or an otherwise unfinished work. Given the clear distinctions Millet usually made between preparatory objects and finished works of art, it is quite significant that he signed this unusual painting, the best indication that he considered it finished. (The fact that he used his initials singles it out as an object on another level than paintings signed with his full name.)

Peasant Watering her Cow is usually dated to 1863, when Millet mentioned working on a painting of similar subject with the dealers Blanc and Stevens in mind.[1] Such a date is certainly consistent with his experimentation with color in pastel and watercolor drawings (see cat. nos. 83 and 86); and both the composition and the overall color scheme recall other works in both oil and pastel of the same period. But the generally accepted standards for a "finished" work of art that still prevailed in Paris in 1863 make it very difficult to see this as an object intended for the marketplace. So unusual a technique, no matter how beautiful, suggests a private patron, and the presence of the painting in the sale of Alfred Sensier's collection in 1877 suggests that he may well have owned the work from the start.[2]

The most exceptional aspect of this painting is the emphasis on draftsmanship: line superimposes definition on unstructured touches of paint (in background details such as the shepherd and flock or distant buildings) and crayon strokes that define or model are revealed through the paint across the entire surface. The unusual pink ground is treated as a draftsman might use a colored paper, visible between pastel strokes, establishing the overall color of the finished work. At a time when even popular newspapers mocked the controversies surrounding the relative importance of line or color in a painting,[3] *Peasant Water-*

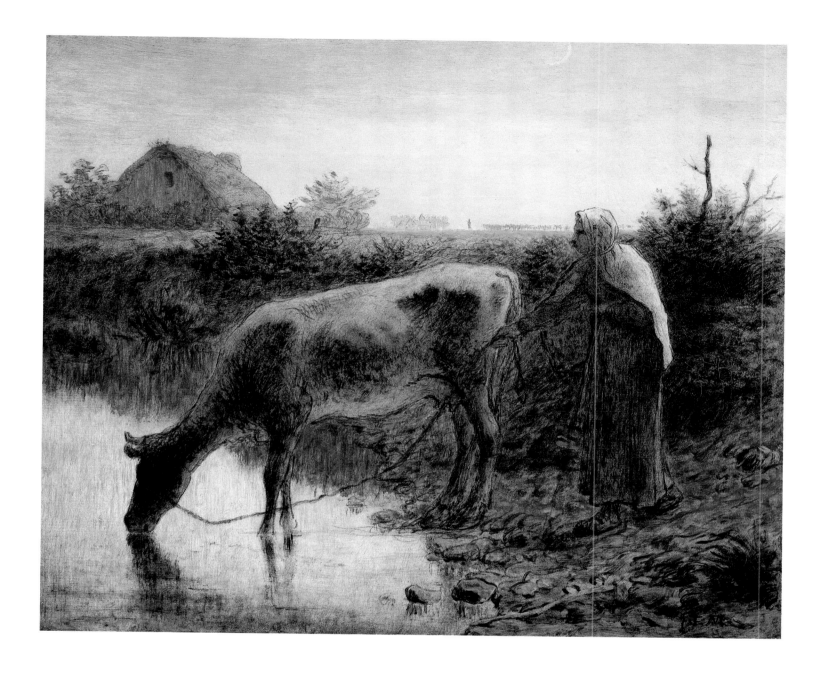

ing her Cow offers a very modern alternative.

The subtle beauty of the painting is in strange opposition to the content of the image, for young women following single, rather scrawny, cows along the wastes of the fields had become a vehicle for social comment for Millet (see cat. nos. 28 and 99), who used them as a means of alluding to the plight of poverty amid plenty. But in *Peasant Watering her Cow* Millet seemed content to suggest a simple mood of melancholy, rather than desperation; in his later version of this same image, cat. no. 148, he returned to a more ominous interpretation.

Notes

1. Letter from Millet to Alfred Sensier, February 3, 1863 (Archives of the Cabinet des Dessins, Musée du Louvre, Paris), quoted in Etienne Moreau-Nélaton, *Millet raconté par lui-même* (Paris: Henri Laurens, 1921), vol. 2, p. 120.

2. See note, cat. no. 86.

3. For a very accessible summary of the debate and its widespread impact, see John Rewald, *The History of Impressionism* (New York: Museum of Modern Art, 4th rev. ed., 1973), pp. 19-25.

Provenance

Possibly with Ennemond Blanc, Paris (about 1863); Alfred Sensier (sold Hôtel Drouot, Paris, December 10-18, 1877, no. 52), bought by A. Legrand, probably for Quincy Adams Shaw, Boston.

Exhibition History

Museum of Fine Arts, Boston, "Quincy Adams Shaw Collection," 1918, no. 8.

Related Works

Compositional sketch, black conté crayon on paper, 7.3 x 8.0 cm., Cabinet des Dessins, Musée du Louvre, Paris (GM10415).

Compositional sketch, black conté crayon on paper, about 2½ x 4¾ in., current location unknown.

Compositional sketch with woman watering cow in wooded area, black conté crayon on paper, 13.8 x 16.4 cm., Cabinet des Dessins, Musée du Louvre, Paris (GM10399 verso).

Figure studies of a woman, studies of cows, black conté crayon on paper, 17.3 x 13.8 cm., Cabinet des Dessins, Musée du Louvre, Paris (GM10417).

Finished drawing, black conté crayon on paper, 30 x 38 cm., private collection, Boston.

Peasant Watering her Cow, cat. no. 105.

Woman Watering her Cow, black conté crayon and pastel on paper, 31 x 46 cm., private collection, New Hampshire.

Woman Watering a Cow, pastel and black conté crayon on paper, 37 x 45 cm., current location unknown (New York art market, 1978).

Compositional sketch, black conté crayon on paper, 19.2 x 20.3 cm., Art Institute of Chicago.

Peasant Watering her Cow, Evening, cat. no. 148.

From photographs, a drawing in black crayon with pastel of a woman watering her cow, current location unknown (New York art market, 1970s), does not appear to be from Millet's hand.

References

Guiffrey, Jean. "Tableaux Français conservés au Musée de Boston et dans quelques collections de cette ville." *Archives de l'art Français* n. s. 7 (1913), p. 547.

Moreau-Nélaton, Etienne. *Millet raconté par lui-même*. Paris: Henri Laurens, 1921, vol. 2, p. 120 (not fig. 177, as indicated).

106
Peasant Couple Going to Work
Delteil 19, third state
1863
Etching on laid paper
38.5 x 30.8 cm. (15⅛ x 12⅛ in.)
Harriet Otis Cruft Fund, 1921
M28393

In their passage across the unpromising thistle-ridden, rock-strewn terrain, this man and wife have been compared to Adam and Eve, expelled from Paradise and condemned to live out life in difficult toil.[1] The woman shades her face against the early morning sun with the basket in which she will gather potatoes – the staple of the peasant's diet – and carries a jug filled with water. Her husband walks beside her with a pitchfork across his shoulder and a hoe slung through his arm. Beyond, a plowman approaches on his horse with a second in tow, and their machine awaits them on the left. (The figure of the plowman was used almost concurrently for a pastel, *After the Day's Work*, cat. no. 107).

Peasant Couple Going to Work was commissioned from Millet in 1862 by a group of ten friends and patrons that included fellow artist Théodore Rousseau and critic Philippe Burty.[2] Organized by Alfred Sensier, the *Société des Dix* (Society of Ten), as he dubbed it, was symptomatic of the rapidly growing interest in print collecting that had previously produced such organizations as the *Société des Aquafortistes* (which Millet had already been invited to join during the preceding year) to sponsor and exhibit etchings. For their sponsorship, Millet's patrons received the first ten impressions, individually signed and dedicated by the artist. Before the print was completed, Sensier was planning a *Société des Vingt* for another etching.

Millet set to work on the print late in November 1863, beginning by "purifying"[3] his drawings of an image he had first undertaken for a painting in 1850-1851 (Glasgow Art Museum). Along with an unusually large number of preparatory drawings, he made several proofs of individual details (Davison Art Center, Wesleyan University, Middletown) as he worked on the etching. The plants and rocks of the beaten path and plain offered an ample field for the very free, exuberant drawing that he had introduced in the background of *La Grande Bergère* (cat. no. 93), while the activities on the plain invited more precise, delicate draftsmanship. The figures are rendered with all the variety of

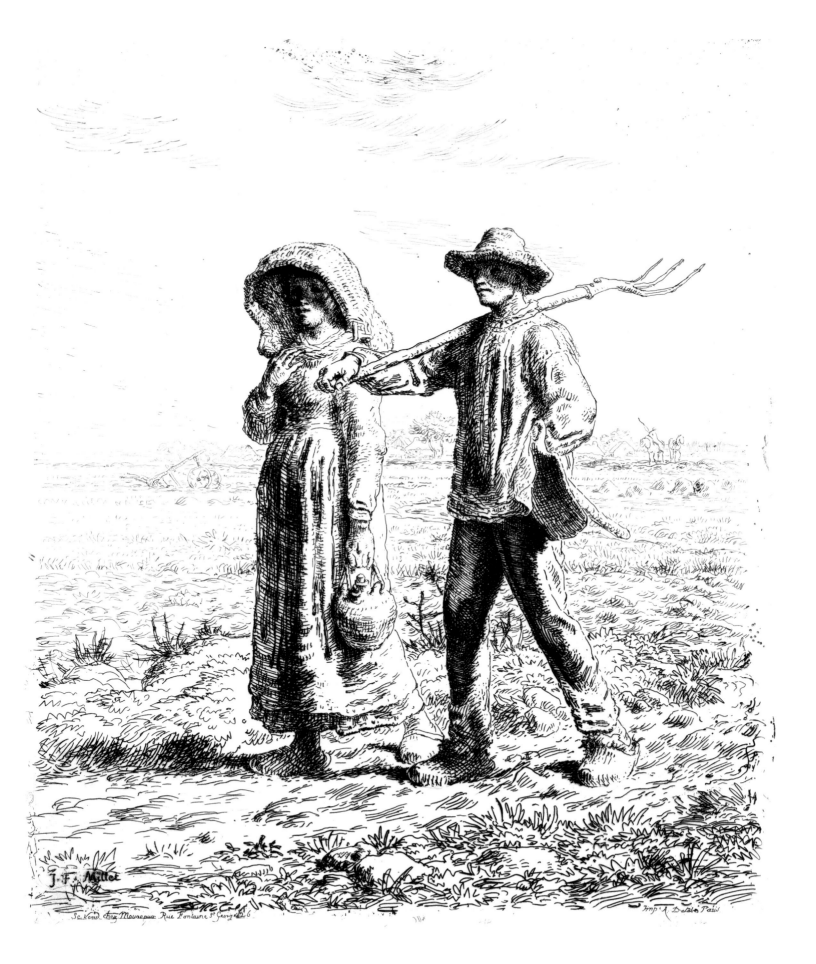

Se Vend chez Moureaux Rue Fontaine St George 26 Imp. A. Delâtre Paris

153

touch and pattern explored in earlier etchings, but are now ordered with a restraint that made possible the unusually complex details of clothing and expression. In the left margin is a small drawing of a nude, designed perhaps to amuse the original commissioners, and allowed to remain on the plate for subsequent printings; a second nude is tucked into the foliage at the bottom of the page.

Notes

1. [Robert L. Herbert], *Jean-François Millet* (Paris: Editions des Musées Nationaux, Grand Palais exhibition catalogue, 1975), p. III.

2. Ibid., p. 173.

3. Millet to Sensier, November 8, 1863 (Archives of the Cabinet des Dessins, Musée du Louvre, Paris).

Related Works

Compositional sketch, pen and ink on paper, 9.5 x 7.0 cm., Cabinet des Dessins, Musée du Louvre, Paris (GM10292).

Compositional sketch, black conté crayon on paper, 40 x 30 cm., current location unknown (see Viau sale, Hôtel Drouot, Paris, December 11, 1942, no. 26).

Sheet of studies of man, his hand, basket, black conté crayon on paper, 22.5 x 36.0 cm., Cabinet des Dessins, Musée du Louvre, Paris (GM10293).

Going to Work, oil on canvas, 56 x 46 cm., Glasgow Art Museum.

Going to Work, oil on canvas, 56 x 46 cm., Cincinnati Art Museum.

Compositional sketch, pen and ink on paper, 15.0 x 13.0 cm., Cabinet des Dessins, Musée du Louvre, Paris (GM10577).

Compositional sketch cut at knees of figure, black conté crayon on paper, 13.2 x 20.2 cm., Cabinet des Dessins, Musée du Louvre, Paris (GM10579).

Compositional sketch, black conté crayon on paper, 23 x 18 cm., Art Institute of Chicago.

Studies of man, right arm of woman, black conté crayon on paper, 30.7 x 23.3 cm., Cabinet des Dessins, Musée du Louvre, Paris (GM10578 recto and verso).

Compositional study, black conté crayon with white on paper, 36.5 x 27.0 cm., current location unknown (sold Beurdeley sale, Georges Petit, Paris, December 1-2, 1920, no. 323).

Compositional study, black conté crayon on paper, 39.5 x 30.5 cm., private collection, Tokyo.

Compositional study with study of woman's face, black conté crayon on paper, 40 x 29 cm., Musée National des Beaux-Arts, Algiers.

Peasant Couple Going to Work, cat. no. 106.

Peasant Couple Going to Work, pastel and black conté crayon on paper, 46 x 39 cm., private collection, Boston.

References

Lebrun, Alfred. "Catalogue de l'oeuvre gravé de J.-F. Millet." In Sensier, Alfred, and Mantz, Paul. *La Vie et l'oeuvre de J.-F. Millet*. Paris: A. Quantin, 1881, no. 20, pp. 376, 378, 380, illus. p. 379.

Delteil, Loys. *Le Peintre-graveur illustré (XIX et XX siècles)*, I, *J.-F. Millet, et al.*. Paris: Delteil, 1906, no. 19.

[Herbert, Robert L.] *Jean-François Millet*. Paris: Editions des Musées Nationaux, Grand Palais exhibition catalogue, 1975, pp. 173-174.

Melot, Michel. *L'Oeuvre gravé de Boudin, Corot, Daubigny, Dupré, Jongkind, Millet, Théodore Rousseau*. Paris: Arts et Métiers Graphiques, 1978, no. 19, pp. 15, 288-289.

107
After the Day's Work
About 1863
Black conté crayon and pastel on paper
37.0 x 45.7 cm. (14⅝ x 18 in.)
Lower right: J. F. Millet
Gift of Quincy Adams Shaw through
Quincy A. Shaw, Jr., and Mrs. Marian
Shaw Haughton, 1917
17.1507

Millet, who especially loved nightfall and spent hours on the Chailly Plain after he finished his day's painting, once remarked, "It is astonishing toward the approach of night how grand everything on the plain appears, especially when we see figures silhouetted against the sky. They look like giants."[1] He also commented "Half-light is necessary in order to sharpen my eyes and clear my thoughts – it has been my best teacher."[2] In *After the Day's Work*, the quality of light, even more than the man's demeanor, saturates the composition with an aura of quietude and resignation.

The impact of the central image – a weary laborer seated sideways atop an old farmhorse, leading his other plowhorse home – is truly startling, for it seems to loom into the viewer's space. Against the flat plain that recedes endlessly, bathed in moonlight radiating from the sun-like white moon high in the sky, the forms become silhouettes – large masses barely articulated, yet able to evoke strong moods. Positioned in the extreme foreground, the laborer and his horses appear elongated, disproportionately large in comparison with prominent background details: a shepherd leading his flock across the plain toward their evening's enclosure. The forced juxtaposition of the shepherd with the horse's nose seems almost to mock perspective, making the main image more powerful.

In an earlier version of this composition (private collection, Japan), executed in oil, the forms of the returning plowteam appear more naturalistically defined. Set farther back in the composition, somewhat lower to the horizon, they are less looming in the painting. When Millet took the composition up a second time, he called forth all the mastery of the black medium that he had acquired in so many years of crayon drawings, to experiment with shadow and atmospheric effects. Throughout the picture, Millet relied on cross-hatching and banks of softly rubbed, short diagonal lines to create a range of grays and blacks that make all but the least use of color quite unnecessary.

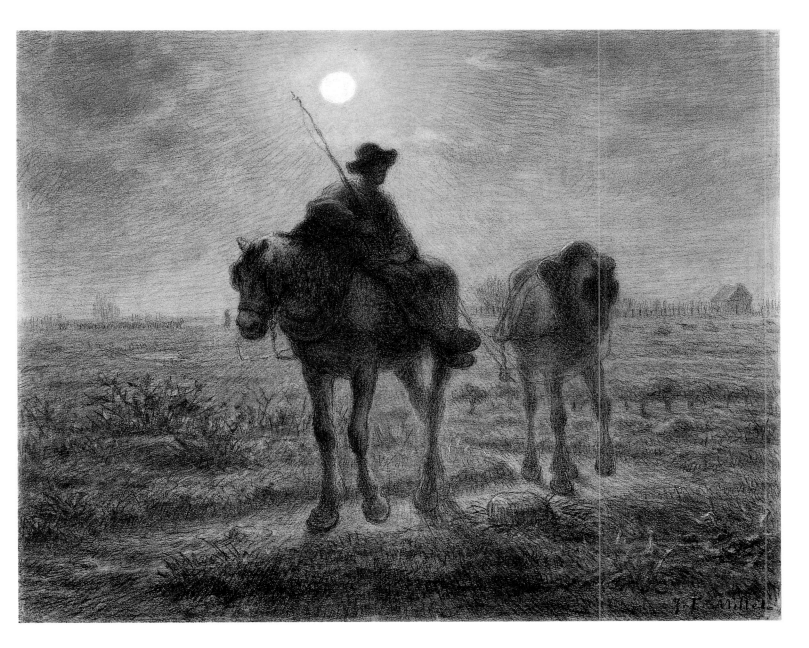

The sweep of lines generated by the moon passes on into the landscape, pulling all the energy of the drawing into the central figures.

About ten years later, Millet adapted the figure of the first horse and his rider to a new composition of a woman atop a donkey, with her husband walking alongside and slightly behind, in the position of the second horse.[3] But it is the initial image, the peasant and two horses, that became one of the most telling details Millet used to identify the Chailly plain, appearing in the right background of the etching *Peasant Couple Going to Work* (cat. no. 106) and in the pastel *Return of the Flock* (cat. no. 109), to name just two examples in this collection.

Notes

1. Pierre Millet, "The Story of Millet's Life at Barbizon," *Century* 45 (April 1894), p. 909.

2. Julia M. Cartwright, *Jean-François Millet, his Life and Letters* (London: Swan Sonnenschein & Co., 1896), p. 164.

3. *Return from the Fields*, oil on canvas, private collection, Japan.

Provenance

Possibly with Moureau, Paris (1865); Quincy Adams Shaw, Boston.

Exhibition History

Possibly Cercle de l'Union Artistique, Paris, 1865.
Museum of Fine Arts, Boston, "Quincy Adams Shaw Collection," 1918, no. 10.

Related Works

Studies of a peasant with two horses, black conté crayon on paper, 12.1 x 20.6 cm., Cabinet des Dessins, Musée du Louvre, Paris (GM10392).

Compositional sketch, black conté crayon on paper, 15.3 x 20.3 cm., Cabinet des Dessins, Musée du Louvre, Paris (GM10660).

Return from the Fields, oil on canvas, 44 x 62.2 cm., private collection, Japan.

After the Day's Work, cat. no. 107.

References

Burty, Philippe. *Maîtres et petits maîtres*. Paris: G. Charpentier, 1877, p. 307.

Guiffrey, Jean. "Tableaux Français conservés au Musée de Boston et dans quelques collections de cette ville." *Archives de l'art Français* n. s. 7 (1913), p. 548.

Moreau-Nélaton, Etienne. *Millet raconté par lui-même*. Paris: Henri Laurens, 1921, vol. 2, pp. 139, 170, fig. 176.

Pollack, Griselda. *Millet*. London: Oresko Books, 1977, p. 65, fig. 42.

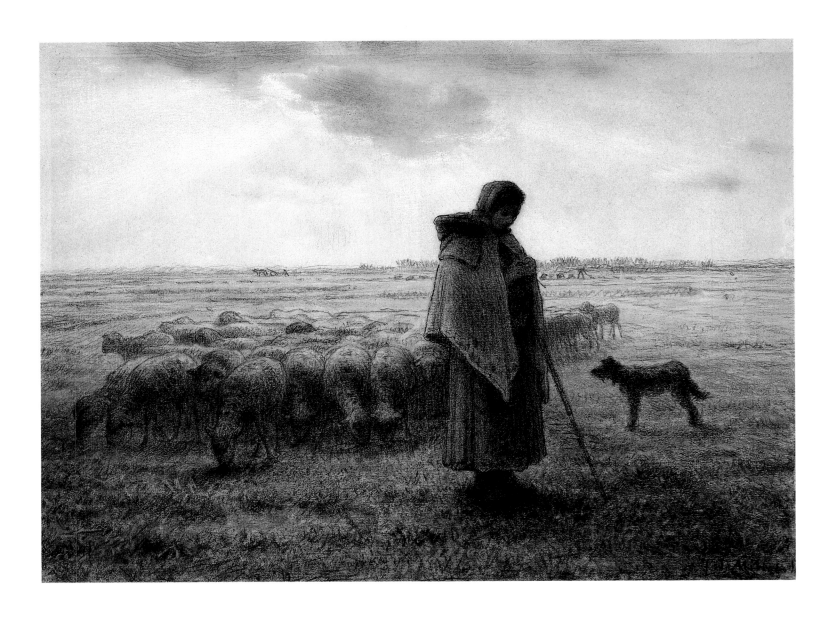

108
Shepherdess with her Flock and Dog
1863-1865
Black conté crayon and pastel with pen and black ink on laid paper
37.2 x 50.2 cm. (14⅝ x 19¾ in.)
Lower right: J. F. Millet
Bequest of Mrs. Henry L. Higginson in Memory of her sister, Pauline Agassiz Shaw, 1935
35.1162

Shepherdess with her Flock and Dog repeats, virtually without change, the composition of Millet's first uncontested Salon success, *Shepherdess and Flock* (Musée du Louvre, Paris), an oil painting exhibited in 1864. The critic Jules Castagnary summed up the popularity of the picture thus:

> Those who accuse him of exaggerating, as he pleases, the ugliness of our peasants will be satisfied this time; the young shepherdess has all the beauty and even all the rustic grace appropriate to her position and her race....the sheep are at home on this plain and the shepherdess belongs to her sheep as much as they belong to her.[1]

As Castagnary predicted, even conservative critics admired the painting and before the end of the Salon, the government itself tried unsuccessfully to purchase it.[2] Although Millet's other entry that year, *Newborn Calf* (Art Institute of Chicago), was not at all well received, the Salon of 1864 marked a substantial shift in his popular reception. Three versions of *Shepherdess and Flock*, in pastel, probably all executed within two or three years of the painting, affirm the popularity of the image, as well as the developing demand for Millet's work in general.

Even while under the contract with Blanc and Stevens, Millet continued to rely on drawings to supplement that income (which was often unreliable), explaining to Blanc in 1863: "My time is occupied as before, as I told you while I was in Paris, in making drawings....Since I haven't any other resources to live on, I find myself forced to continue with them."[3] Repetitions of the Salon painting may, therefore, have been made in the hope of future sales, or Millet may have drawn them in answer to specific commissions.[4] Robert Herbert has quoted a letter from Alfred Sensier of July 1864, in which he urged Millet to capitalize on the success of his Salon painting "which charmed everyone....Make some more idylls."[5]

Marking a new period of classicism in Millet's art, *Shepherdess with her Flock and Dog* is, in fact, an idyll. As a straightforwardly descriptive account of a rural commonplace, it is an unassertively modern addition to the great pastoral tradition that Millet loved (and with which he was particularly engaged in the mid-1860s, rereading his favorite Latin verse and its later derivations).[6] The shepherdess's nineteenth-century cape, her dog, and the vast plain around her were distinctive of the contemporary southern Ile de France, but in her role as patient guardian of a flock, she might have stepped from Virgil's pages, or even those of his Greek predecessor Theocritus. Demure and attractive, she was no threat to critics who had been horrified the preceding year by Millet's *Man with a Hoe*.

Notes
1. *La Grand Journal*, May 15, 1864; cf. Alfred Sensier and Paul Mantz, *La Vie et l'oeuvre de J.-F. Millet* (Paris: A. Quantin, 1881), p. 268.
2. It had already been sold to a private collector. See correspondence between Millet and H. Courmand, Directeur de l'Administration des Beaux-Arts, May 20 and 23, 1864 (Sensier, op. cit., pp. 264-265).
3. Letter from Millet to Ennemond Blanc, August 23, 1863, quoted in Etienne Moreau-Nélaton, *Millet raconté par lui-même* (Paris: Henri Laurens, 1921), vol. 2, p. 141.
4. *Shepherdess with her Flock and Dog*, which belonged to Emile Gavet, Millet's voracious pastel patron, was probably created in 1864 or 1865, before the association between the two men began. Gavet apparently bought drawings and pastels by Millet from earlier collections as well as commissioning new works himself. Alternatively, it is possible that Millet had the pastel on hand, unsold, and used it to fill one of Gavet's stock orders for twenty or more pastels.
5. [Robert L. Herbert], *Jean-François Millet* (Paris: Editions des Musées Nationaux, Grand Palais exhibition catalogue, 1975), p. 202.
6. Millet was encouraged in his return to the classics by the interest of a young scholar, Michel Chassaing, who became a close friend during the 1860s.

Provenance
With Barbédienne, Paris (?); Emile Gavet (sold Hôtel Drouot, Paris, June 11-12, 1875, no. 68); bought by Détrimont, probably for Quincy Adams Shaw, Boston, Pauline Agassiz Shaw, Boston, Ida Agassiz Higginson (Mrs. Henry L.), Boston (by 1897).

Exhibition History
Rue St. Georges 7, Paris, "Dessins de Millet provenant de la Collection M. G.," 1875, no. 30.
Copley Society, Boston, "One Hundred Masterpieces," 1897, no. 38.
Copley Society, Boston, "French School of 1830," 1908, no. 101.

Related Works
Study of head of shepherdess, black conté crayon on paper, 11.5 x 10.7 cm., Cabinet des Dessins, Musée du Louvre, Paris (GM10662).
Shepherdess and Flock, oil on canvas, 81 x 101 cm., Musée du Louvre, Paris.
Shepherdess, pen and ink on paper, private collection, The Hague.
Shepherdess and Flock, pastel on paper, 35.5 x 46.3 cm., current location unknown (see Secretan sale, Sedelmeyer, Paris, July 1, 1889, no. 101).
Shepherdess and Flock, pastel on paper, 39.4 x 50.8 cm., Walters Art Gallery, Baltimore.
Shepherdess with her Flock and Dog, cat. no. 108.
Shepherdess and Flock, black conté crayon and pastel on paper, 64.5 x 86.5 cm., current location unknown (see Doria sale, Georges Petit, Paris, May 8-9, 1899, no. 462). Turns shepherdess toward the viewer for new composition known in several versions.

References
[Herbert, Robert L.] *Jean-François Millet*. Paris: Editions des Musées Nationaux, Grand Palais exhibition catalogue, 1975, p. 142.

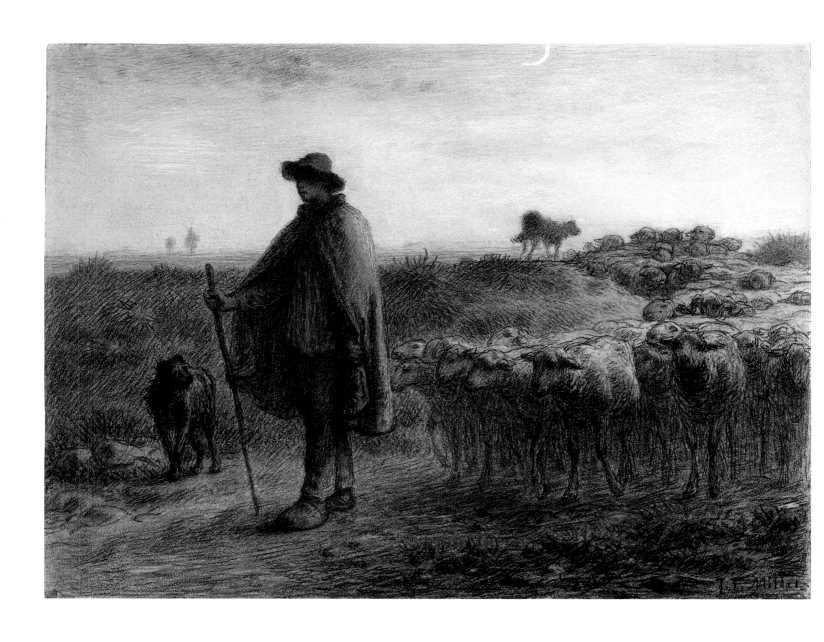

109
Return of the Flock
About 1863-1864
Black conté crayon and pastel on paper
38.7 x 50.3 cm. (15¼ x 19¾ in.)
Lower right: J. F. Millet
Gift of Quincy Adams Shaw through
Quincy A. Shaw, Jr., and Mrs. Marian
Shaw Haughton, 1917
17.1506

As Millet began to develop a personalized pastel technique, using the colored medium in consonance with black crayon drawing, he shaped figures and spaces with open networks of black line interwoven with complementary patterns of bright pastels that had been anticipated from the beginning of the drawing. The color schemes of *Return of the Flock* and contemporary drawings such as *After the Day's Work* (cat. no. 107) revolve around the ever-present black drawing, which keeps potentially clashing hues in balance within a gray framework. In so tightly organized a scheme, isolated areas of color, such as the sweep of blue distance along the horizon, become especially resonant, intensified by Millet's repeated use of similar shades in sky and figure.

For the subject matter and the structure of these intricately balanced works of the mid-1860s, Millet favored easily identified pastoral themes and simple, classical compositions that offset the vast spaces of the plain and sky with large figures and broad movements. Holding aside his cloak in an almost courtly gesture, the shepherd in *Return of the Flock* leads his sheep across the plain as if he were a religious figure heading a procession, oblivious of all behind him. Among a mass of merging forms, randomly scattered heads break away, giving definition to a tide of sheep almost indistinguishable from the landscape. In their winding progress Millet created an echo of the crescent moon, joining figure, animals, and landscape in subtle interplay.

Provenance

With Moureau, Paris (about 1863); Emile Gavet (sold Hôtel Drouot, Paris, June 11-12, 1875, no. 61); possibly Barbédienne (sold Hôtel Drouot, Paris, April 27, 1885, no. 76); Quincy Adams Shaw, Boston.

Exhibition History

Cercle de l'Union Artistique, Paris, 1865, lent by Moureau.

Museum of Fine Arts, Boston, "Quincy Adams Shaw Collection," 1918, no. 51.

Related Works

Return of the Flock, cat. no. 109.

Finished study of the figure, black conté crayon and pastel on paper, 40 x 28 cm., Carnegie Institute, Pittsburgh, is by Jean-Charles Millet and Paul Cazot.

References

Chesneau, Ernest. "Jean-François Millet." *Gazette des Beaux-Arts* 2nd ser., 11 (May 1875), p. 435, illus. p. 433.

Guiffrey, Jean. "Tableaux Français conservés au Musée de Boston et dans quelques collections de cette ville." *Archives de l'art Français* n. s. 7 (1913), p. 547.

Moreau-Nélaton, Etienne. *Millet raconté par lui-même*. Paris: Henri Laurens, 1921, vol. 2, pp. 139, 170.

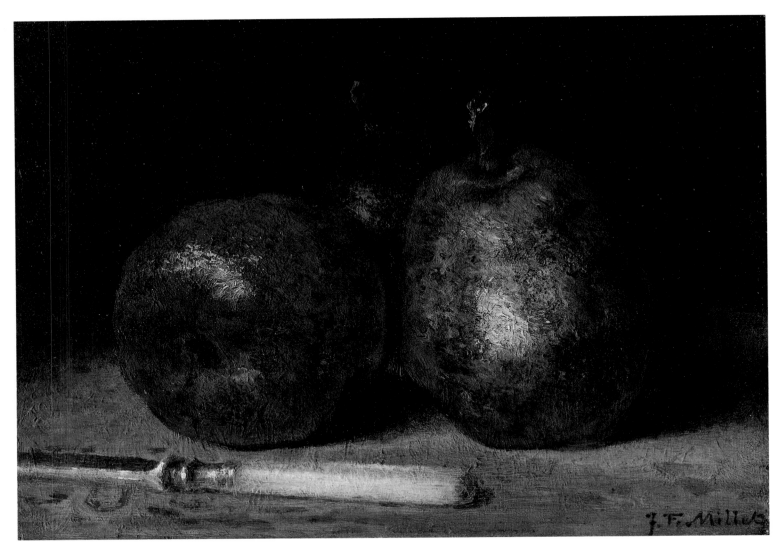

110
Pears
About 1862-1866
Oil on panel
18.5 x 25.5 cm. (7¼ x 10 in.)
Lower right: J. F. Millet
Gift of Quincy Adams Shaw through
Quincy A. Shaw, Jr., and Mrs. Marian
Shaw Haughton, 1917
17.1519

Pears is one of only three still-life paintings in Millet's *oeuvre*.[1] Significantly, it is a direct tribute to Jean-Siméon Chardin, the eighteenth-century French artist whose inspiration also underlies so many of Millet's figure scenes of the late 1840s and early 1850s (see, for instance, *Young Woman Churning Butter*, cat. no. 20).

The precise date of *Pears* is difficult to determine with certainty. Traditionally it had been dated to 1867, but Millet's own reference to the work in a letter to Alfred Sensier, as a picture well known to his friend and patron, suggests that it must have been completed some time earlier.[2] More likely is a date in the mid-1860s, when the revival of interest in Chardin's still lifes was at its peak in Paris.[3]

The strong similarities in composition that can be found in Millet's painting and Chardin's *Three Pears, Walnuts, Glass of Wine and Knife*, (Paris, Musée du Louvre)[4] suggest a direct derivation from the earlier work, which Millet could have seen in the collection of Dr. Louis La Caze,[5] a collector whose pictures were available to young artists before their donation to the Louvre in 1869. Millet simplified the older master's composition by dispensing with the nuts and wine glass, eliminating the table edge, and bringing the pears to the forward plane of the painting. The result is a monumentalization of three common pears in which the viewer's interest is focused on the richly red- and green-colored surface textures of the fruit and their powerful, three-dimensional solidity. As in so many of his single-figure and simple rural themes, Millet succeeded in presenting mundane experience as a type of elemental, universal significance. When Wyatt Eaton, an American art student, saw the painting in 1873, he recalled a direction he attributed to Millet himself: "One must make use of the trivial to express the sublime."[6] The small still life further prompted him to write, "I found all the tones of a landscape, in the twisted stems I seemed to see the

weather worn tree, and the modeling of the fruit was studied and rendered with the same interest that he would have given to a hill or a mountain or to the human body."[7]

Notes

1. The others are *Still Life with Leeks* of 1860-1864 (Rijksmuseum, H.W. Mesdag, The Hague) and *Still Life with Turnips* of 1866 (Musée National des Beaux-Arts, Algiers).

2. Letter from Millet to Alfred Sensier, January 7, 1867 (Archives of the Cabinet des Dessins, Musée du Louvre, Paris); quoted in Etienne Moreau-Nélaton, *Millet raconté par lui-même* (Paris: Henri Laurens, 1921), vol. 3, p. 17.

3. John W. McCoubrey, "The Revival of Chardin in French Still-life Painting, 1850-1870," *Art Bulletin* 46 (March 1964), pp. 39-53.

4. In addition to the Louvre painting, see also *Cat Stalking a Partridge and a Hare Left near a Soup Tureen* (Metropolitan Museum of Art, New York) and *Carafe, Silver Goblet, Peeled Lemon, Apple and Pears* (Staatliche Kunsthalle, Karlsruhe), as two of many. *Three Pears, Walnuts, Glass of Wine and Knife* is reproduced and discussed at length in Pierre Rosenberg, *Chardin, 1699-1799* (Cleveland: Cleveland Museum of Art, exhibition catalogue, 1979), no. 129, pp. 352-353.

5. La Caze, an amateur artist whose large collection was open to friends and artists during his lifetime and then bequeathed to the Louvre in 1869, probably acquired the painting at a Paris auction in 1862. See Paul Mantz, "La Collection La Caze au Musée du Louvre," *Gazette des Beaux-Arts*, 3rd ser. (1870), pp. 17-18.

6. Wyatt Eaton, "Recollections of J.F. Millet with Some Account of His Drawings for His Children and Grandchildren," *Century* (May 1889), p. 92.

7. Ibid.

Provenance

Madame J.-F. Millet, Barbizon; Quincy Adams Shaw, Boston.

Exhibition History

Museum of Fine Arts, Boston, "Quincy Adams Shaw Collection," 1918, no. 22.

References

Eaton, Wyatt. "Recollections of Jean-François Millet with Some Account of His Drawings for His Children and Grandchildren." *Century* 38 (May 1889), p. 92.

Guiffrey, Jean. "Tableaux Français conservés au Musée de Boston et dans quelques collections de cette ville." *Archives de l'art Français* n. s. 7 (1913), p. 547.

Moreau-Nélaton, Etienne. *Millet raconté par lui-même*. Paris: Henri Laurens, 1921, vol. 3, p. 17, fig. 242.

Heise, Carl Georg. "Amerikanische Museen." *Kunst und Künstler* 23, 6 (March 1925), illus. p. 225.

III
End of the Hamlet of Gruchy II
1866
Oil on canvas
81.5 x 100.5 cm. (32⅛ x 39⅝ in.)
Lower right: J. F. Millet
Gift of Quincy Adams Shaw through Quincy A. Shaw, Jr., and Mrs. Marian Shaw Haughton, 1917
17.1508

My goal was to show the habitual peacefulness of [Gruchy], where each act, which would be nothing anywhere else, here becomes an event. The woman sat her child next to her on a small chair while she was spinning, but the child got bored, and to amuse him the woman picked him up and sat him on the little wall where he plays, maybe plucking the little leaves that grow on the huge elm tree or looking here and there on the ocean....I would like to have the power to express for the viewer the thoughts that must enter, for life, the mind of a young child who has never experienced anything other than what I have just described, and how this child, later in his life, will feel completely out of place in a city environment.[1]

With these words, Millet tried to explain to Théophile Silvestre, a contemporary art critic, the complex of feelings that were absorbed into *End of the Hamlet of Gruchy II*, his Salon painting of 1866. Based on a study dating from his last visit to Gruchy, twelve years earlier, *End of the Hamlet* depicts the coastal limit of his Norman birthplace, marked by a weathered elm that had stood on the site for as long as Millet and his family could remember. In the resistance of the tree to the punishing winds that wracked the cliffs at Gruchy, held fast by roots deep in Norman soil, he found a symbol to sustain his own determination to succeed; but in the analogy of a little child satisfied to cling to the tree, surveying all the world as he knows it, it also represented Millet's fundamental ambivalence about the rightness of his decision ever to have left his homeland.

An earlier letter to Silvestre, who was planning to write about the painting prior to its upcoming sale, had been filled with reminiscences of Gruchy:

The village stands on rocky cliffs in a hollow of land opening northward toward the sea. Almost all the houses are one story high, covered with straw except for one or two that are covered with coarse slates. The masonry is of gray stone, as

hard as steel. The door and window jambs and their lintels are made of granite (salmon-gray) that comes from the quarries located nearby inland. It is a real event in this village to see someone who is not from here. The place is so quiet, so lonely, that the cry of a goose or the cackle of a hen takes on immense importance. The view in the village is obviously obstructed by the houses, but going down toward the sea, suddenly one faces the great marine view and the boundless horizon. Near the last house, an old elm stands against the infinite void. How long has this poor old tree stood there beaten by the north wind? I have heard the old people say that they have always known it as I saw it. It is not very tall, nor very big, since it has always been gnawed by the wind, but it is rugged and knotty....after the fields, the cliff stands against the sea. Imagine the impressions that one can get from such a place. Clouds rushing through the sky, menacingly obscuring the horizon, boats sailing to faraway lands, tormented, beautiful, etc., etc.[2]

Millet seldom spoke of his own feelings about Gruchy and the complex of family, friends, and homeland he had left behind when he began his journey to Paris in 1837, but they provided an undercurrent running through many of his paintings during the 1840s and 1850s (see, for instance, cat. no. 3 and cat. no. 45). However, he had never identified himself as fully with a painting as he did with *End of the Hamlet*. While he was working on the Salon version – he had already painted or drawn three smaller finished versions of virtually identical compositions (see cat. no. 74) – in 1865 and 1866, he was called back once more to the village prior to the death of his sister Emélie and he discovered that the elm had given in to the lashing winds of the Channel coast. To a letter telling Alfred Sensier of Emélie's impending death, he added, "Everywhere broken trees cover the ground, and among them is my old elm that I had counted on seeing again. That's the way of everything, and us, too. My poor Sensier, I am quite sad."[3]

Given that so many personal experiences are conflated in the image, it is not difficult to understand the painstaking care with which Millet executed the painting – even sending it to the Salon unvarnished, so that he might continue to work upon it after the exhibition.[4] With tiny thread-like touches of paint, the landscape is built up until it flickers with color and energy. Tiny

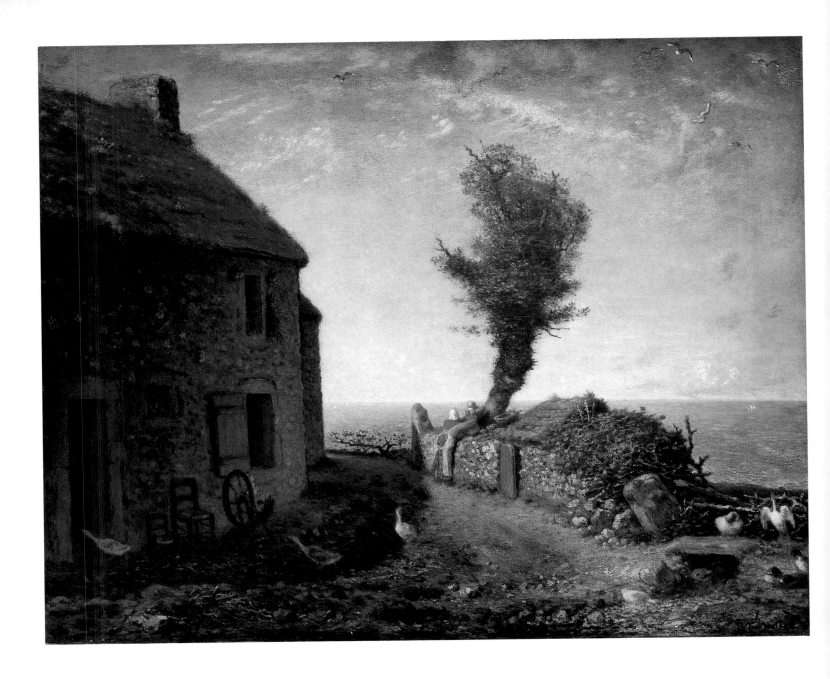

162

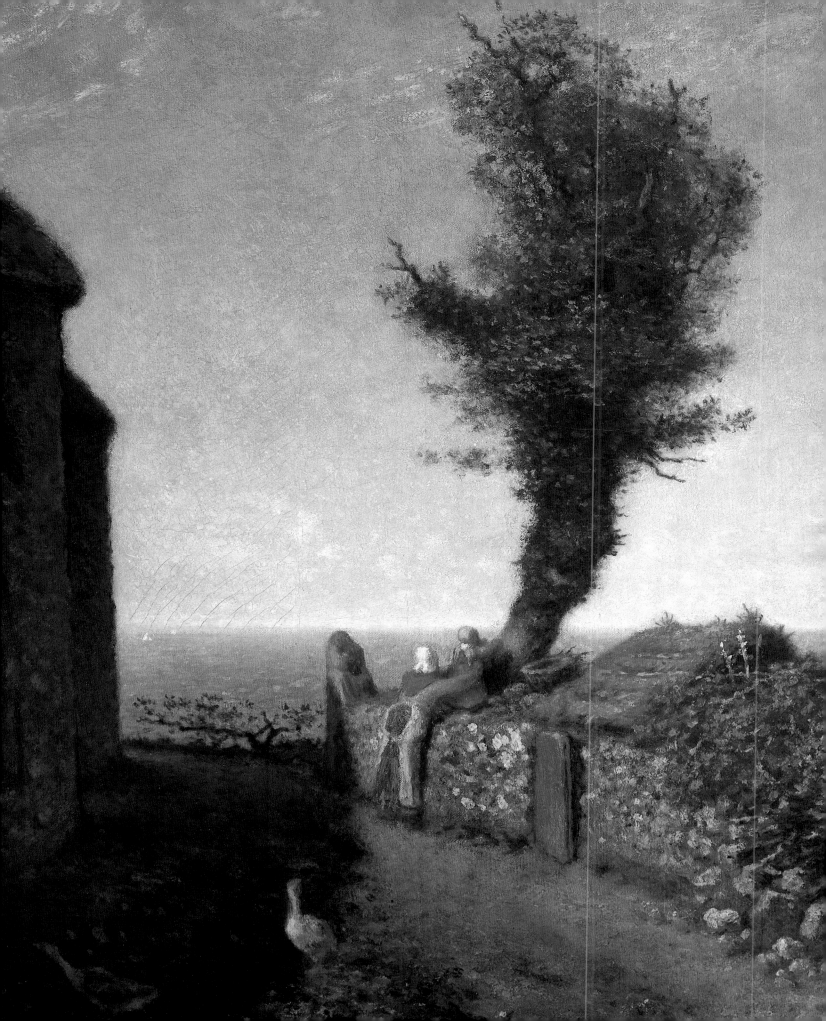

sparks of color light the roof of the homestead, where a wildflower has taken root, and the foreground is flecked with rich oranges and yellows that stress the vibrance of the light-struck, rippling turquoise stream. The old wall and its overgrowth are lovingly piled with touches of color. But it is in the old elm and the cloud-strewn sky swirling around the tree that Millet invested his most intense energies. Bathed by yellow sunlight, the rugged, stunted tree reaches out in all directions, while the sky is touched with lavenders and roses that reflect light breaking through the soft silver clouds.

Notes

1. See letter from Millet to Silvestre, April 20, 1868.

2. See letter from Millet to Silvestre, April 18, 1868.

3. Letter from Millet to Alfred Sensier, February 6, 1866, Archives of the Cabinet des Dessins, Musée du Louvre, Paris. Quoted in Alfred Sensier and Paul Mantz, *La Vie et l'oeuvre de J.-F. Millet* (Paris: A. Quantin, 1881), p. 291.

4. Sensier, op. cit., pp. 292-293.

Provenance

Paul Marmontel (sold Hôtel Drouot, Paris, May 11-14, 1868, no. 55); with Brame, Paris; Jean-Baptiste Faure (sold 26 Boulevard des Italiens, Paris, June 7, 1873, no. 26); with Durand-Ruel, Paris; Quincy Adams Shaw, Boston.

Exhibition History

Salon, Paris, 1866, no. 1376.

American Art Association, New York, "The Works of Antoine-Louis Barye... his Contemporaries and Friends," 1889, no. 553.

Museum of Fine Arts, Boston, "Quincy Adams Shaw Collection," 1918, no. 2.

Related Works

See cat. no. 74.

References

About, E. *Le Petit Journal* (1866).

Piedagnel, Alexandre. *J.-F. Millet*. Paris: Cadart, 1876, pp. 62, 80.

Burty, Philippe. *Maîtres et petits maîtres*. Paris: G. Charpentier, 1877, p. 281.

Strahan, Edward. *Art Treasures of America*. Philadelphia: George Barrie, 1879, vol. 3, p. 86.

Sensier, Alfred, and Mantz, Paul. *La Vie et l'oeuvre de J.-F. Millet*. Paris: A. Quantin, 1881, pp. 290-294, 311.

Durand-Gréville, E. "La Peinture aux Etats-Unis." *Gazette des Beaux-Arts* 2nd ser., 36 (July 1887), p. 68.

Cartwright, Julia M. *Jean-François Millet, his Life and Letters*. London: Swan Sonnenschein, 1896, pp. 290-292, 309.

Marcel, Henry. "Quelques Lettres inédites de J.-F. Millet." *Gazette des Beaux-Arts* 3rd ser., 26 (July 1901), p. 74-78.

Gensel, Walther. *Millet und Rousseau*. Bielefeld and Leipzig: Velhagen & Klasing, 1902, p. 58.

Rolland, Romain. *Millet*. London: Duckworth & Co., 1902, p. 107.

Peacock, Netta. *Millet*. London: Methuen & Co., 1905, pp. 116-118.

"The Quincy Adams Shaw Collection." Boston: Museum of Fine Arts *Bulletin* 16 (April 1918), p. 16, illus. p. 15.

Moreau-Nélaton, Etienne. *Millet raconté par lui-même*. Paris: Henri Laurens, 1921, vol. 2, p. 182; vol. 3, pp. 1, 2, 5, 53, 91, fig. 214.

Tabarant, Adolphe. *La Vie artistique au temps de Baudelaire*. Paris: Mercure de France, 1942, p. 383.

Fermigier, André. *Millet*. Geneva: Skira, 1977, p. 19. illus.

112
Shepherdesses Watching a Flight of Wild Geese
1866
Pastel and black conté crayon on paper
57.2 x 41.9 cm. (22½ x 16½ in.) – design
61.0 x 48.0 cm. (24 x 18⅞ in.) – support
Lower right: J. F. Millet
Gift of Quincy Adams Shaw through Quincy A. Shaw, Jr., and Mrs. Marian Shaw Haughton, 1917
17.1512

In *Shepherdesses Watching a Flight of Wild Geese*, Millet created one of his most original, yet timelessly apt images of peasant life. Its success was immediate, for during the month that the original pastel rested with Sensier before delivery, it attracted considerable attention, ending in commissions for two replicas and an offer from another Millet collector, Charles Forget, to trade his beloved Delacroixs for the pastel.[1] This last tribute would have been especially meaningful for Millet, himself an admirer of Delacroix as the greatest colorist in French painting.

Completed in April 1866 for Emile Gavet, this third version of the theme reveals only small changes in the original composition, but as so often happened with Millet's repetitions, the cumulative effect of his studied alterations is to strengthen substantially both the dramatic effect and the classic simplicity of the image.

In all three versions, two shepherdesses are surprised by the passage of wild geese overhead, a sight filled with far-reaching implications for those whose life is directed by nature's cycles, but one that, at the same time, provides reassurance of life's enduring continuity. To emphasize a modern immediacy within the eternal symbolism of his theme, Millet introduced a narrative quality rare in his art, replacing the solitary guardian of most of his sheepherding images with the unexpected presence of two shepherdesses as witnesses.

Both women have been sitting beneath the last gold and coral leaves clinging to a sheltering hedge, knitting while their sheep grazed in an open field. With the sound of the approaching geese, one of them jumps up, spilling her knitting along the embankment. Her right hand raised to shield her eyes from the sun that glances off her sleeve and skirt, she extends the other arm toward her companion to guard against any movement that might disturb the scene taking place above them. Her arms echo the V-formation of geese and unite her ges-

ture with the seated figure slowly bending backward to heed her warning.

In both versions from the preceding years, the standing figure had been placed at an angle to the picture plane, and her companion sat more nearly upright, with her head thrust back awkwardly to watch the sky, poses that emphasized the momentary quality of the interruption. In this final composition, the standing figure stretches across the picture, physically directing the viewer's gaze along her own, while the seated figure leans more gracefully into the embankment, tilting her head in a pose that joins a harmonious movement to the appearance of greater concentration. With her feet firmly pulled together, the statuesque standing shepherdess reminded the critic Théophile Silvestre of a Murillo saint.[2] Even the landscape and the sheep were altered over the three versions, with the addition of a long stand of bare trees on the horizon and the cutting back of the hedge to bring the sheep closer to their guardians.

While Millet's compositional changes moved progressively toward greater simplicity and an ease of gesture that endowed the event with quiet grandeur, his brilliant juxtapositions of complementary colors create a controlled sparkle across a deliberately low-value scene. The oranges and golds of the fallen leaves are mingled with olive touches on the hedge and blended into the many blues and greens of the ragged plain. The seated shepherdess's yellow-gold cape partially covers her turquoise blouse, balanced against a startlingly pink-mauve skirt. Her companion's dark blue skirt and orange sleeves dim into gray in the shadow, but flash with strong light where they catch the sun.

The overall autumnal twilight is conveyed by the black and pale blue hatching of the sky, brightened toward the horizon by strong touches of yellow and a pale turquoise. The color scheme might well have been borrowed directly from Delacroix, perhaps from his Saint-Sulpice murals unveiled only a few years earlier in 1861.[3] The rich, deliberately muted use of color, along with the polished simplicity of the figures, establishes Millet's complete mastery of his pastel medium.

Notes

1. Etienne Moreau-Nélaton, *Millet raconté par lui-même* (Paris: Henri Laurens, 1921), vol. 2, p. 175.

2. Théophile Silvestre, annotated catalogue of the exhibition "Dessins de Millet provenant de la Collection M. G.," Rue St. Georges 7, Paris, April-May 1875, in the Archives of the Museum of Fine Arts, Boston.

3. That Delacroix was of special interest to Millet during the 1860s is evidenced by his determined desire to acquire some souvenirs of Delacroix at the latter's studio sale in 1863. See Etienne Moreau-Nélaton, *Millet raconté par lui-même* (Paris: Henri Laurens, 1921), vol. 2, pp. 153-154. Delacroix's murals in the Chapel of the Angels at Saint-Sulpice are particularly remarkable for their overall purple-gray tonality encompassing unusually strong contrasts of complementary colors.

Provenance

Commissioned from the artist by Emile Gavet (sold Hôtel Drouot, Paris, June 11-12, 1875, no. 24), bought by David; Quincy Adams Shaw, Boston.

Exhibition History

Rue St. Georges 7, Paris, "Dessins de Millet provenant de la Collection M. G.," 1875, no. 34.

Museum of Fine Arts, Boston, "Quincy Adams Shaw Collection," 1918, no. 38.

Related Works

Compositional study, with study of seated shepherdess on verso, black conté crayon on paper, 32 x 24 cm., current location unknown (Paris art market, 1938).

Compositional sketch, shepherdesses on right, horizontal format, black conté crayon on paper, 12.5 x 16 cm., current location unknown (sold Sotheby's, London, November 23, 1983, no. 583).

Compositional sketch with one standing shepherdess, one seated shepherdess facing left, pencil on paper, 5½ x 7½ in., current location unknown (New York art market, 1979).

Compositional sketch, both women with arms raised, horse among flock of sheep in middle ground, direction of geese reversed, black conté crayon on paper, 25.6 x 21.3 cm., Ashmolean Museum, Oxford.

Seated shepherdess, black conté crayon on paper, 26.4 x 18.9 cm., Musée Bonnat, Bayonne.

Studies of standing shepherdess, black conté crayon on paper, 19.5 x 21.4 cm., Musée Bonnat, Bayonne.

Shepherdesses Watching a Flight of Wild Geese, pastel and black conté crayon on paper, 14½ x 11¾ in., private collection, France.

Seated shepherdess, black conté crayon on paper, 25 x 18 cm., current location unknown (sold Sotheby's, London, May 12, 1968, no. 13).

Shepherdesses Watching a Flight of Wild Geese, pastel and black conté crayon on paper, 25⅝ x 16½ in., private collection, Zurich.

Life study of seated shepherdess, black conté crayon on paper, 20.5 x 17.7 cm., Musée Bonnat, Bayonne.

Study of seated shepherdess, black conté crayon on tracing paper, 53.6 x 38 cm., Cabinet des Dessins, Musée du Louvre, Paris (R. F. 23608).

Shepherdesses Watching a Flight of Wild Geese, cat. no. 112.

References

Chesneau, Ernest. "Jean-François Millet." *Gazette des Beaux-Arts* 2nd ser., 11 (May 1875), p. 435.

Sensier, Alfred, and Mantz, Paul. *La Vie et l'oeuvre de J.-F. Millet*. Paris: A. Quantin, 1881, p. 315.

Cartwright, Julia M. *Jean-Francois Millet, his Life and Letters*. London: Swan Sonnenschein, 1896, p. 311.

Tomson, Arthur. *Jean-François Millet and the Barbizon School*. London: George Bell and Sons, 1903, p. 99.

Guiffrey, Jean. "Tableaux Français conservés au Musée de Boston et dans quelques collections de cette ville." *Archives de l'art Français* n. s. 7 (1913), p. 547.

Moreau-Nélaton, Etienne. *Millet raconté par lui-même*. Paris: Henri Laurens, 1921, vol. 3, p. 4, fig. 220.

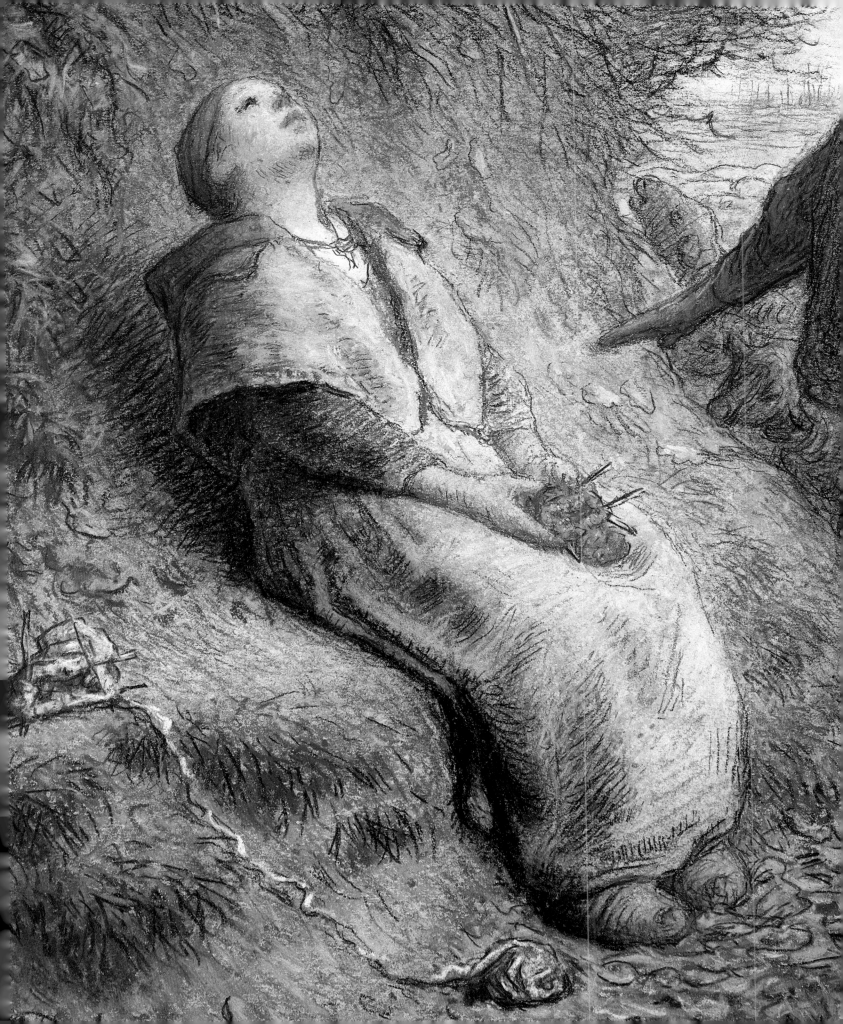

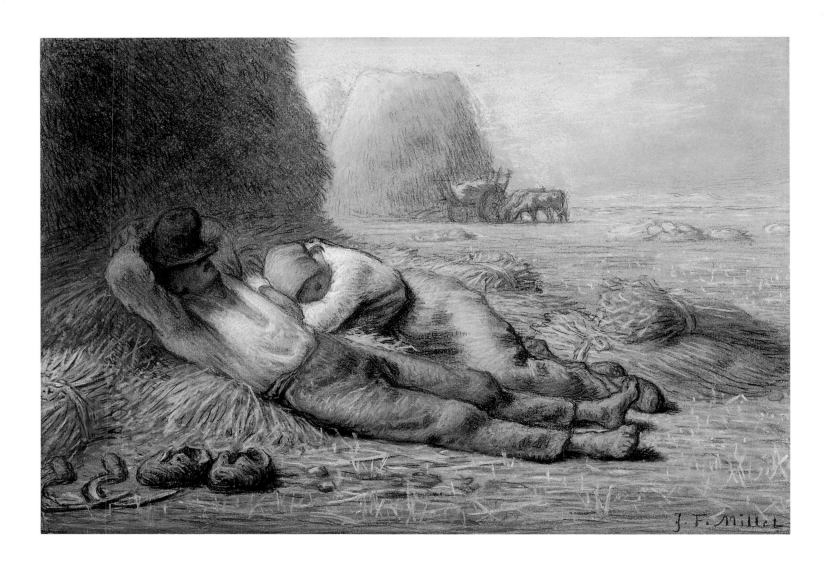

113
Noonday Rest
1866
Pastel and black conté crayon on buff wove
paper
28.8 x 42.0 cm. (11⅜ x 16½ in.) – design
41.3 x 52.5 cm. (16¼ x 20⅝ in.) – support
Lower right: J. F. Millet
Gift of Quincy Adams Shaw through
Quincy A. Shaw, Jr., and Mrs. Marian
Shaw Haughton, 1917
17.1511

On the great wheat-producing plains of central France, the peasant's working day could last from about 4 a.m. until 7 p.m. (and even later during the harvest), broken only by meals and a period of rest during the heat of the noonday sun. In the shade of a haystack – source of both their livelihood and their exhaustion – two peasants, a young man and woman, sleep side by side unaware of each other. The golden-brown tonality of the buff-colored paper beneath the deep yellow pastel strokes of the haystacks and grain sheaves (given so much prominence by the artist's close viewpoint) establishes the pervasive heat of August. Even the peasants' tanned skin reflects their life in the sun. The bundles of hay that echo their sleeping positions and the pairing of other objects – two grazing cows beside a wheat rick, the haystacks in the background, and the man's *sabots* resting next to the couple's sickles – reinforce the viewer's awareness of the two figures as a couple. *Noonday Rest*, which derived most immediately from a drawing Millet had provided for a set of the Four Hours of the Day, ultimately looks back to many of his pastoral compositions of the 1840s, peopled with nymphs or mythological lovers lying together in a sylvan glade or exchanging confidences beneath a a sheltering tree. But with the translation into a contemporary setting, such an idyllic relationship has been transformed by the young couple's exhausting labor.

Noonday Rest formed part of the first group of pastels that Millet provided for Emile Gavet, a Parisian architect and financier who, after buying a number of Millet's paintings and drawings in the art marketplace, approached Millet with a sizable commission late in 1865. Gavet wanted to command his entire pastel production, for which he was prepared to pay a fee per drawing greater than Millet otherwise received, and he was happy to leave the selection of subject matter to the artist himself. Millet was essentially pleased with the guarantee of a market for his pastels,

but was wary of contracts and of any concession of his freedom to create or sell as he pleased. He and Gavet settled on an initial order for twenty drawings or pastels, and Gavet immediately provided a selection of good quality papers.[1]

Notes
1. See Millet's letters to Gavet and Etienne Moreau-Nélaton, *Millet raconté par lui-même* (Paris: Henri Laurens, 1921), vol. 2, pp. 174-176.

Provenance
Commissioned from the artist by Emile Gavet (sold Hôtel Drouot, Paris, June 11-12, 1875, no. 60), bought by Détrimont, probably for Quincy Adams Shaw, Boston.

Exhibition History
Rue St. Georges 7, Paris, "Dessins de Millet provenant de la Collection M. G.," 1875, no. 25.
Museum of Fine Arts, Boston, "Quincy Adams Shaw Collection," 1918, no. 46.
Grand Palais, Paris, "Jean-François Millet," 1975, no. 159 (Hayward Gallery, London, 1976, no. 84).

Related Works
Compositional sketch with figures on the right, pencil on paper, 5.6 x 6.3 cm., Cabinet des Dessins, Musée du Louvre, Paris (GM10637).
Finished drawing, pen and ink on paper, current location unknown (see Charles Yriarte, *J.-F. Millet* [Paris: Jules Rouam, 1885], p. 52).
Figure study of a woman, black conté crayon on paper, 22.5 x 32.3 cm., Cabinet des Dessins, Musée du Louvre, Paris (GM10361).
Figure study of a woman, black conté crayon on paper, 13.5 x 18.7 cm., Cabinet des Dessins, Musée du Louvre, Paris (GM10363).
Young Woman Sleeping in Landscape, finished drawing, pen and ink on paper, 11¹¹/₁₆ x 16⅝ in., Fogg Art Museum, Harvard University, Cambridge.
Figure study of a man, black conté crayon on paper, 20.0 x 26.0 cm., Musée des Beaux-Arts, Dijon.
Studies of a man's feet, legs, black conté crayon on paper, 14.3 x 10.1 cm., Cabinet des Dessins, Musée du Louvre, Paris (GM10670 verso).
Compositional study squared for transfer, black conté crayon on paper, City of Fontainebleau.
Finished drawing, black conté crayon on paper, 26 x 39 cm., current location unknown (see Etienne Moreau-Nélaton, *Millet raconté par lui-même* [Paris: Henri Laurens, 1921], vol. 2, fig. 140).
Engraving by Adrien Lavieille.
Compositional study, figures on the left, black conté crayon on paper, 14.5 x 22.5 cm., current location unknown (see *Zomer Tentoonslelling...* [Amsterdam: E. J. van Wisselingh and Co., exhibition catalogue, 1933], no. 11).
Noonday Rest, cat. no. 113.

References
Chesneau, Ernest. "Jean-François Millet." *Gazette des Beaux-Arts* 2nd ser., 11 (May 1875), p. 435.
Burty, Philippe. *Maîtres et petits Maîtres*. Paris: G. Charpentier, 1877, p. 307.
Yriarte, Charles. *J.-F. Millet*. Paris: Jules Rouam, 1885, pp. 14, 30.
Guiffrey, Jean. "Tableaux Français conservés au Musée de Boston et dans quelques collections de cette ville." *Archives de l'art Français* n. s. 7 (1913), p. 547.
Moreau-Nélaton, Etienne. *Millet raconté par lui-même*. Paris: Henri Laurens, 1921, vol. 3, p. 4, fig. 215.
Fermigier, André. *Millet*. Geneva: Skira, 1977, p. 58, illus. no. 41.
Pollack, Griselda. *Millet*. London: Oresko Books, 1977, p. 64, fig. 41.

114
Newborn Lamb
1866
Pastel on paper
40.4 x 47.1 cm. (15⅞ x 18½ in.) – design
45.6 x 56.3 cm. (18 x 22⅛ in.) – support
Lower right: J. F. Millet
Gift of Quincy Adams Shaw through
Quincy A. Shaw, Jr., and Mrs. Marian
Shaw Haughton, 1917
17.1513

During the mid-1860s, Millet's work began to achieve general critical acceptance and a measure of popular success, in part because his own interests shifted to less threatening themes and to more purely artistic problems of color and composition. Many of his pictures of this period, in fact, were well received because of the ease with which highly sentimental interpretations could be attached to his celebration of primal peasant concerns. In this pastel, the culminating composition of several versions, the newborn lamb, the youthful shepherdess, and the anxious ewe establish a complete cycle of life that underlines the interdependence of men and animals in rural daily life.

Millet had depicted a parallel theme just two years earlier, in his controversial *Newborn Calf* of 1864 (Art Institute of Chicago). There, two men carried a calf in from the fields on a litter, leading a procession that included the mother cow and a peasant woman. The painting prompted Millet's last Salon scandal, angering critics who saw in the solemnity of the artist's image reminiscences of golden calves and pagan idolatry.[1] For the *Newborn Lamb*, he returned to a more conventional expression of the theme of birth, taking up a traditional image of innocence he had already explored around the time his first child was born in 1846.[2] In the colorful, imaginary world of his *manière fleurie*, he had depicted a young girl carrying home a tiny lamb, accompanied by two naked, dancing children.

When he next treated the subject, in a drawing of 1860, he suppressed the painting's allegorical mood, replacing the nudity and flourishes with humble peasant clothes and a realistic, particularized setting. With the basic organization of his image established by two drawings and a subsequent pastel, Millet concentrated, in the Boston pastel of 1866, on strengthening the essentially circular arrangement of the three protagonists to emphasize their interrelation-

ship. He broadened the originally vertical composition to a horizontal format and turned the shepherdess inward to meet the gaze of the ewe. The contour of the ewe's back, as she stretches her head up toward her lamb, forms the bottom arc of a circle that continues through the young girl into the arching branches of the hedge and finally through the warped gate propped against a tree. The rounded opening to the fields beyond echoes the circle of connections, underscoring the cyclical content of the image.

For the setting of all the 1860s versions, Millet had chosen the primeval overgrowth and swinging gate so distinctive of hedgerows that divide the Norman countryside. The most notable addition in the new pastel, the gorse (furze) bush with its yellow flowers that balances the broader landscape on the right, is a specific recollection of the Gruchy hedgerows.[3] And while the changes in this last version are clearly directed toward formal reinforcement of the theme, the impetus for the modifications was probably a specific experience in Millet's recent return to his native village. Adjusting and reworking a Norman image celebrating life may well have been his means of accepting the loss of his treasured sister Emélie, whose death had drawn him back to his home in early 1866.

Notes
1. Alfred Sensier and Paul Mantz, *La Vie et l'oeuvre de J.-F. Millet* (Paris: A. Quantin, 1881), p. 265; cf. [Robert L. Herbert], *Jean-François Millet* (Paris: Editions des Musées Nationaux, Grand Palais exhibition catalogue, 1975), pp. 205-206. The urban bourgeoisie of the Second Empire found incomprehensible (or at best, primitive) the reverence with which peasants viewed the birth of their animals and the implications that were read into the *Newborn Calf* were nearly as threatening as those that were popularly attached to *Man with a Hoe*. As late as 1887, Zola could present a peasant household in which the cow and the wife go into labor simultaneously, contrasting the attention focused on the cow, for whom a veterinarian is called, to the woman who gives birth to a daughter forgotten in a corner (Zola, *The Earth*, translated by Douglas Parmée [Harmondsworth, England: Penguin Books, 1980], pp. 253-264).
2. For a typical nineteenth-century interpretation of the theme see Adolphe William Bouguereau's *Innocence* (also titled *L'Agneau nouveau-né*) of 1873, featuring a Madonna-like figure holding a sleeping child and a watchful lamb in her arms, adding distinctive Christian meanings to the complex image (Marius Vachon, *W. Bouguereau* [Paris: A. Lahure, 1900], p. 52).
3. A source of fodder, gorse acquires its characteristic shape from the efforts of sheep to eat around its sharp thorns and the tenacious shrub was used

widely in Europe to fortify windbreaks and as boundary markers.

Provenance
Commissioned from the artist by Emile Gavet (sold Hôtel Drouot, Paris, June 11-12, 1875, no. 66); Quincy Adams Shaw, Boston.

Exhibition History
Rue St. Georges 7, Paris, "Dessins de Millet provenant de la Collection M. G.," 1875, no. 22.
Museum of Fine Arts, Boston, "Quincy Adams Shaw Collection," 1918, no. 36.

Related Works
Newborn Lamb, oil on canvas, current location unknown (see Etienne Moreau-Nélaton, *Millet raconté par lui-même* [Paris: Henri Laurens, 1921], vol. 1, fig. 36). Earliest version of theme, with shepherdess semi-nude and accompanied by two children.
Compositional sketch in vertical format, black conté crayon on paper, 12.9 x 10.4 cm., Cabinet des Dessins, Musée du Louvre, Paris (GM10650).
Study of young woman walking, black conté crayon on paper, 29 x 22.3 cm., Cabinet des Dessins, Musée du Louvre, Paris (GM10370).
Study of girl carrying lamb, black conté crayon on paper, 25 x 15 cm., current location unknown (see Hazard sale, Galerie Georges Petit, December 1-3, 1919, no. 358).
Study of lamb in woman's arms, black conté crayon on paper, 20 x 30.3 cm., current location unknown (London art market, 1960s).
Newborn Lamb, black conté crayon on paper, 41.9 x 31.7 cm., William A. Clark Collection, Corcoran Gallery of Art, Washington, D. C.
Newborn Lamb, black conté crayon on paper, current location unknown.
Newborn Lamb, cat. no. 114.
Shepherdess in a Forest, pastel on paper, 16.5 x 20 cm., current location unknown (appears in reproduction to be a copy by another hand after the Boston pastel).

References
Burty, Philippe. *Maîtres et petits maîtres*. Paris: G. Charpentier, 1877, p. 302.
Strahan, Edward. *Art Treasures of America*. Philadelphia: George Barrie, 1879, vol. 3, p. 86.
Guiffrey, Jean. "Tableaux Français conservés au Musée de Boston et dans quelques collections de cette ville." *Archives de l'art Français* n. s. 7 (1913), p. 547.
Moreau-Nélaton, Etienne. *Millet raconté par lui-même*. Paris: Henri Laurens, 1921, p. 7, fig. 222.
Meixner, Laura L. *An International Episode: Millet, Monet and their North American Counterparts*. Memphis: The Dixon Gallery and Gardens, exhibition catalogue, 1982, pp. 21-22, fig. 6.

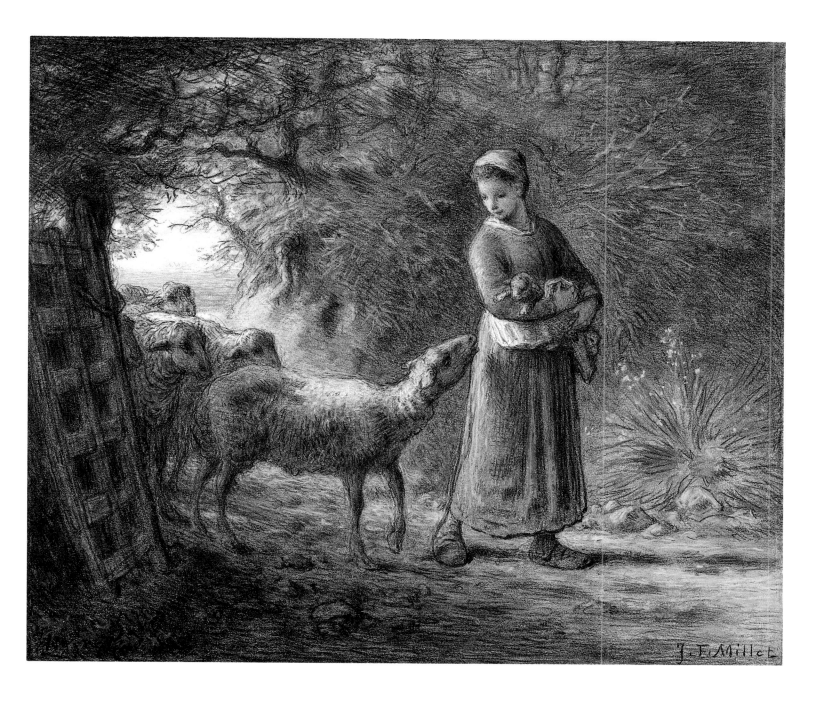

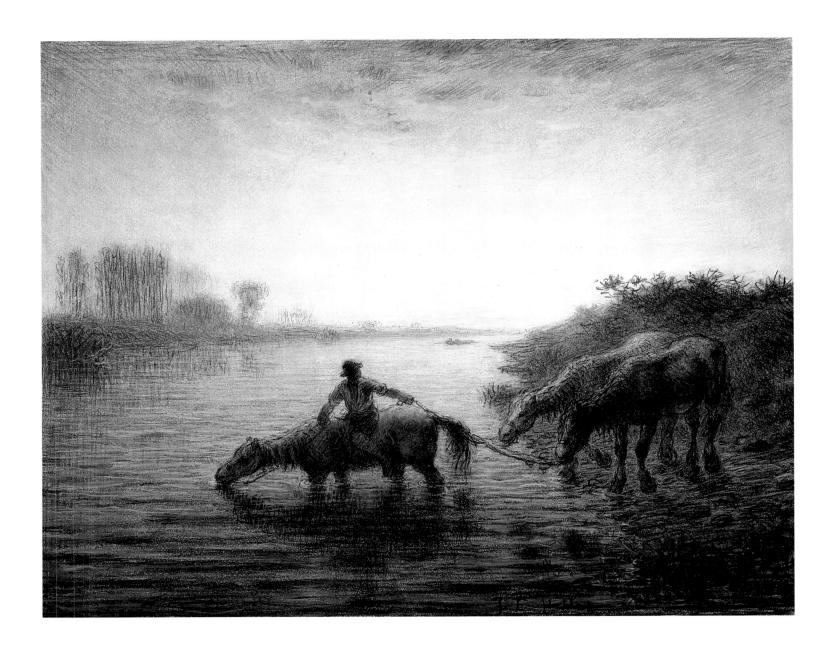

115
Watering Horses: Sunset
1866
Pastel and black conté crayon on paper
37.5 x 47.6 cm. (14¾ x 18¾ in.) – design
42.9 x 52.9 cm. (16⅞ x 20⅞ in.) – support
Lower center: J. F. Millet
Gift of Quincy Adams Shaw through
Quincy A. Shaw, Jr., and Mrs. Marian
Shaw Haughton, 1917
17.1514

By the mid-1860s, as Japanese prints and album-books began to become available to the Parisian art world, Millet and Rousseau were part of a broad circle of collectors (including August Delâtre, Millet's printer, and Philippe Burty, a supportive art critic) who were strongly interested in Japanese design. While Japanese conventions for depicting space or organizing landscape elements had an important impact on Rousseau's landscape painting around 1865, Millet was initially drawn to the works by their unusual color effects. *Watering Horses*, ready for Emile Gavet just prior to Millet's departure for Vichy in 1866, introduces to his art a highly unusual color scheme borrowed from Japanese wood block prints of Hiroshige or Hokusai and their followers.

The pastel originated in a black crayon drawing (private collection, Paris) of the same theme, created in the late 1850s – one of the large group of landscape scenes depicting washerwomen and animals being led to water along the Seine near Melun, to the north of Barbizon.[1] But while the later work continues the basic composition of the drawing, figures, animals, and landscape have been reorganized around the dramatic afterglow of a sunset that colors all beneath it. In the long tradition of dramatic French sunset painting stretching back to Claude Gellée, there is no precedent for Millet's opposition of strong pinks and turquoises united in a strongly yellowed atmosphere. The peasant, his horses, and the landscape around them are drained of nearly all independent color as the striking sunset and its reflection in the river begin to give way before a seeping dusk that moves into the drawing from the foreground.

The convention of defining a sky with a strong band of color across the upper limit of a landscape, leaving the horizon uncolored or very open to set off the objects before it, was an aspect of Japanese design without a ready equivalent in the European painting tradition, as was the frequent opposition of distinctive blue-greens against pink, even red, skies; and as Millet's own interests in landscape construction and color effect deepened in the late 1860s, he often had recourse to Japanese inspiration.[2]

While the use of color in *Watering Horses* derives from ideas outside Millet's own art, the strong sinuous strokes establishing the contrasting reflections in the river surface come directly from his own very graphic coloration in earlier pastels. The shaggy manes of the horses and the faint screen of trees on the far side of the river demonstrate his efforts to reestablish the role of black crayon as an element distinct from color in his more confident pastel technique.

Notes
1. In an annotated copy of the catalogue for the exhibition of a selection of pastels owned by Emile Gavet, Théophile Silvestre identifies *Watering Horses* as a recollection of the river at Melun (see cat. no. 112, n. 2).
2. Even the figure's costume in *Watering Horses* recalls Japanese peasant dress: loose, open-necked shirt and baggy pants rolled above the knees.

Provenance
Emile Gavet (sold Hôtel Drouot, Paris, June 11-12, 1875, no. 20), bought by Détrimont, probably for Quincy Adams Shaw, Boston.

Exhibition History
Rue St. Georges 7, Paris, "Dessins de Millet provenant de la Collection de M. G.," 1875, no. 23.
Museum of Fine Arts, Boston, "Quincy Adams Shaw Collection," 1918, no. 33.

Related Works
Horses Drinking at the Edge of the River, black conté crayon heightened with pastel, 31 x 44 cm., private collection, Paris.
Watering Horses: Sunset, cat. no. 115.

References
Guiffrey, Jean. "Tableaux Français conservés au Musée de Boston et dans quelques collections de cette ville." *Archives de l'art Français* n. s. 7 (1913), p. 547.
Moreau-Nélaton, Etienne. *Millet raconté par lui-même*. Paris: Henri Laurens, 1921, vol. 3, p. 7, fig. 227.

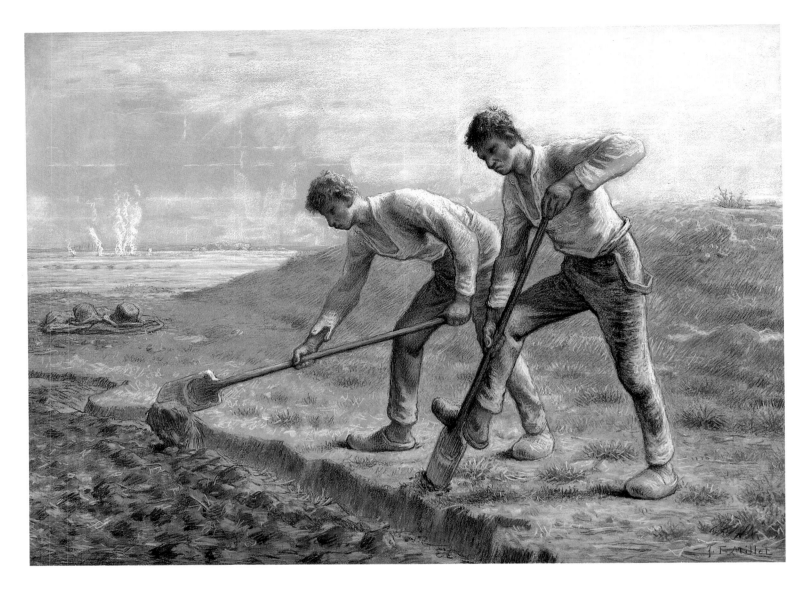

116
Two Men Turning over the Soil
1866
Pastel and black conté crayon on buff
paper
69.9 x 94.5 cm. (27½ x 37¼ in.) – design
72.6 x 97.3 cm. (28⅝ x 38¼ in.) – support
Lower right: J. F. Millet
Gift of Quincy Adams Shaw through
Quincy A. Shaw, Jr., and Mrs. Marian
Shaw Haughton, 1917
17.1510

In the carefully alternated rhythms that define two diggers – one who bends to move forward to spill his spadeful of earth, and another who rises up on his *bêche* to force it into the hard-packed ground – Millet captured the repetitive, mind-numbing nature of fundamental manual labor. Pairing a father and son, similarly dressed, set against the seemingly endless sweep of plain (of which they have opened only a small segment in the foreground), he conveyed his sense of the endless drudgery that is man's birthright. For Millet, tilling the soil was the ultimate reduction of all labor and the fundamental symbol for life's tragic irony. Having defined the meaning of his own life in a continual effort to refine and perfect his work, he empathized with those who labored so hard at work of little inherent satisfaction and no definable advancement, without even the certainty of a minimal return.

Two Men Turning over the Soil, redrawn in pastel in 1866 from an etching of 1855-1856 (cat. no. 69), is Millet's culminating version of a theme that entered his work with his earliest efforts to study real life in Paris around 1846.[1] For this large pastel executed on the scale of his major paintings, he probably squared an impression of that etching in order to transfer it, much enlarged, onto the pastel sheet (a corresponding square transfer grid is visible in the sky, where it collected a heavy deposit of white chalk). Although the basic compositions have remained the same, Millet made two important changes that reinforce his theme: the two similarly aged young men that figured in the print version have been altered to individuals clearly differentiated by age, but sharing a distinctive facial resemblance. And the difference between the hilly, rocky area marked by irregular tufts of grass, in which these peasants work, and the vast, flat plain beyond is emphasized by the strong dividing edge of the sloping hillside.

Millet's use of pastel in *Two Man Turning over the Soil* brings the picture closer to his work in oil paint than to his smaller pastels of the same date. Black crayon, applied in parallel strokes or careful outlines, is used for shading and shaping the figures in a more familiar use of the medium than the distinctive webs and cross-hatching that he employed in so many contemporary drawings. The colors are applied broadly, rubbed and highlighted in patterns closer to oil technique than to the very graphic style of *Return of the Flock* (cat. no. 109), for instance. The

rich greens and yellows of the untilled ground and the softly blended pinks and blues that establish the breadth of the plain give the landscape an appealing springtime quality (tilling the soil lasted through the winter into March and April) and it is only the sullen grimace on the older man that puts the beauty of the mundane landscape back into the perspective of backbreaking labor. Where Millet had found it necessary to underline the plight of his early digger (cat. no. 17) with a barren landscape and dark, earthy, almost dreary colors, *Two Men Turning over the Soil* recognizes his complexly ambivalent attitude toward subject matter: well aware of the pain and despair behind such a scene, he was nonetheless able to recognize the beauty amid which the tillers labored.

Notes
1. See discussion under cat. no. 17.

Provenance
Commissioned from the artist by Emile Gavet (sold Hôtel Drouot, Paris, June 11-12, 1875, no. 49), bought by Détrimont, probably for Quincy Adams Shaw, Boston.

Exhibition History
Rue St. Georges 7, Paris, "Dessins de Millet provenant de la Collection de M. G.," 1875, no. 10.
Museum of Fine Arts, Boston, "Quincy Adams Shaw Collection," 1918, no. 41.
Grand Palais, Paris, "Jean-François Millet," 1975, no. 124 (Hayward Gallery, London, no. 101).

Related Works
Compositional sketch with two men facing left, black conté crayon on paper, current location unknown (known only from nineteenth-century photograph by Braun).
Compositional sketch, black conté crayon on paper, 7.4 x 12 cm., Cabinet des Dessins, Musée du Louvre, Paris (GM10408).
Man Turning over the Soil, cat. no. 17.
Compositional sketch, black conté crayon on paper, 21 x 28.2 cm., current location unknown (see *J.-F. Millet* [London: Wildenstein and Co., exhibition catalogue, 1969], no. 24).
Finished drawing, black conté crayon heightened with white, 24.8 x 34.9 cm., private collection, New York.
Compositional sketch with two men facing right, black conté crayon on paper, 11 x 15 cm., private collection, London.
Compositional sketch, black conté crayon on blue-gray paper, 18.7 x 23.5 cm., British Museum, London.
Sheet of studies for the etchings *Two Men Turning over the Soil* and *The Gleaners*, pencil on paper, 14.9 x 11.2 cm., Cabinet des Dessins, Musée du Louvre, Paris (GM10623).

Figure study of bending man, black conté crayon on paper, 20 x 16.4 cm., Cabinet des Dessins, Musée du Louvre, Paris (GM10407).
Figure study of bending man, black conté crayon on paper, 20.4 x 23.3 cm., Cabinet des Dessins, Musée du Louvre, Paris (GM10624).
Figure study of man with foot on spade, pencil on paper, 25.5 x 21.0 cm., Cabinet des Dessins, Musée du Louvre, Paris (GM10622).
Compositional study, black conté crayon with white highlights on rose-beige paper, 31.5 x 30.2 cm., private collection, Paris.
Compositional study, black conté crayon on paper, 22.5 x 33 cm., private collection, Paris.
Compositional study, black conté crayon on paper, 24 x 33 cm., private collection, Tokyo.
Compositional study, with studies of hands and man with foot on spade, black conté crayon on paper, 23.5 x 33.6 cm., Musée Bonnat, Bayonne.
Two Men Turning over the Soil, cat. no. 69.
Two Men Turning over the Soil, unfinished oil on canvas, 81 x 100 cm., Tweed Gallery, University of Minnesota, Duluth.
Two Men Turning over the Soil, cat. no. 116.

References
Strahan, Edward. *Art Treasures of America*. Philadelphia: George Barrie, 1879, vol. 3, p. 86.
"'Greta's' Boston Letter." *Art Amateur* 5 (September 1881), no. 4, p. 72.
Yriarte, Charles. *J.-F. Millet*. Paris: Jules Rouam, 1885, illus. p. 15.
Michel, André. "J.-F. Millet et l'exposition de ses oeuvres à l'Ecole des Beaux-Arts." *Gazette des Beaux-Arts* 2nd ser., 36 (July 1887), p. 22.
Michel, André. *Notes sur L'Art Moderne /Peinture*. Paris: Armand Colin, 1896, p. 57.
Knowlton, Helen M. *Art-Life of William Morris Hunt*. Boston: Little, Brown and Company, 1899, p. 98.
Peacock, Netta. *Millet*. London: Methuen & Co., 1905, p. 85.
Bartlett, Truman H. "Millet's Return to His Old Home, with Letters from Himself and His Son." *Century* 86 (July 1913), p. 333, illus.
Guiffrey, Jean. "Tableaux Français conservés au Musée de Boston et dans quelques collections de cette ville." *Archives de l'art Français* n. s. 7 (1913), p. 547.
Cary, Elisabeth Luther. "Millet's Pastels at the Museum of Fine Arts, Boston." *American Magazine of Art* 9, no. 7 (May 1918), pp. 266, 269.
Moreau-Nélaton, Etienne. *Millet raconté par lui-même*. Paris: Henri Laurens, 1921, vol. 3, p. 13, fig. 233.
The Letters of Vincent van Gogh to his Brother. London: Constable & Co., 1927, vol. 1, p. 230.
Edgell, George Harold. *French Painters in the Museum of Fine Arts: Corot to Utrillo*. Boston: Museum of Fine Arts, 1949, p. 19, illus. p. 21.
Fermigier, André. *Millet*. Geneva: Skira, 1977, p. 50, illus. p. 47.
Pollack, Griselda. *Millet*. London: Oresko Books, 1977, p. 70, fig. 46.

117
Farm at Vichy
1866
Pen and brown ink over pencil on wove
paper
13.4 x 20.9 cm. (5¼ x 8¼ in.)
Stamped, lower left: J. F. M
Lower right: *Vichy 12 juin/1866.*
Stamped, verso: VENTE MILLET
Gift of Martin Brimmer, 1876
76.430

118
Chestnut Trees near Cusset
1866
Pen and brown ink with green pencil (?)
over pencil on antique laid paper
17.9 x 24.1 cm. (7 x 9½ in.)
Stamped lower left: J. F. M
Lower right: *près Cusset*
Inscribed, variously throughout in pencil:
*vert foncé / labouré a la houe par mottes /
niché de touffes / vert gris foncé / carrière /
vert / près verts / chemin* (in brown ink)
Stamped, verso: VENTE MILLET
Gift of Martin Brimmer, 1876
76.429

119
Country Road with Culvert
1866-1867
Pen and ink over pencil on wove paper
13.3 x 20.9 cm. (5¼ x 8¼ in.)
Stamped, lower right: J. F. M
Stamped, verso: VENTE MILLET
Gift of Martin Brimmer, 1876
76.431

120
Trees along a Rocky Stream Bed
1866-1867
Watercolor and pen and brown ink over
pencil on wove paper
5.4 x 10.4 cm. (2⅛ x 4⅛ in.)
Stamped, lower left: J. F. M
Gift of Martin Brimmer, 1876
76.423

121
House with a Fence
1866-1867
Watercolor and pen and brown ink over
pencil on wove paper
5.3 x 10.4 cm. (2⅛ x 4⅛ in.)
Stamped, lower left: J. F. M
Along lower edge: *palassade en avant
terrain/gazonneux*
Bequest of Reverend Frederick Frothing-
ham, 1894
94.315

117

118

119

122
Trees beside a Pool
1866-1867
Watercolor and pen and brown ink over
pencil on wove paper
5.3 x 10.4 cm. (2⅛ x 4⅛ in.)
Stamped, lower left: J. F. M
Gift of Martin Brimmer, 1876
76.426

123
Road from Malavaux, near Cusset
1867
Watercolor and pen and brown ink over
pencil on laid paper
11.2 x 16.2 cm. (4⅜ x 6⅜ in.)
Stamped, lower right: J. F. M
Along lower edge: *près Cusset/route du
Malavaux 12 juin*
Gift of Martin Brimmer, 1876
76.425

124
Orchard Fence near Vichy
1867
Watercolor and pen and brown ink over
pencil on laid paper
11.2 x 16.2 cm. (4⅜ x 6⅜ in.)
Stamped, lower left: J. F. M
Lower left: *Vichy*
Gift of Martin Brimmer, 1876
76.424

125
Hillside Meadow with a Twisted Tree
1866-1867
Watercolor and pen and brown ink over
pencil on laid paper
20.7 x 26.5 cm. (8⅛ x 10⅜ in.)
Stamped, lower right: J. F. M
Verso: VENTE MILLET
Gift of Reverend and Mrs. Frederick
Frothingham, 1893
93.1463

126
Landscape with a Church, near Vichy
1866-1867
Watercolor and pen and brown ink on laid
paper
19.5 x 30.2 cm. (7⅝ x 11⅞ in.)
Stamped, lower right: J. F. M
Verso: VENTE MILLET
Gift of Martin Brimmer, 1876
76.427

127
Farmstead near Vichy
1866-1867
Watercolor and pen and brown ink over
pencil on antique laid paper
22.2 x 29.2 cm. (8¾ x 11½ in.)
Stamped, lower right: J. F. M
Bequest of Reverend and Mrs. Frederick
Frothingham, 1894
94.316

Each summer from 1866 to 1868, Millet and his wife spent a month in Vichy in central France, hoping to improve her health with the regimen of mineral waters and fresh air that had made the Vichy spas France's most popular tourist center during the Second Empire. Millet did not enjoy Vichy itself, finding the elaborate development of the city as artificial as much of new Paris, but he spent a great deal of time exploring the surrounding countryside. Since the beautiful sunset-swept pond of *Washerwomen* (cat. no. 62) of the mid-1850s, Millet's interest in landscape painting had strengthened progressively and he was pressing close to pure landscape in many of his Chailly pastels. But it was his walks in Vichy, away from his Barbizon studio (and the unfinished figure paintings there to distract him) that focused his conscious concentration on landscape subjects.

In correspondence with Sensier and Gavet (see letters, below) Millet noted that he had made more than fifty sketches of promise around Vichy in 1866, with an additional two dozen drawn during an excursion to Auvergne. In 1867, he continued making such sketches; his visit in 1868, however, was less productive, as he himself was quite ill for much of the time. The nearly two hundred sketches and polished watercolor drawings that can be connected with his Vichy visits cover an unexpected range of ambition; perhaps as many as fifty of them were turned into completed paintings and pastels at greater leisure in his Barbizon studio.

Farm at Vichy (cat. no. 117), carefully dated June 12, 1866, and identified by an inscription in the artist's hand, is one of his first Vichy drawings, made very shortly after the Millets' arrival. Recorded on the site in pencil, the drawing was reworked in ink, probably back in the Vichy inn, differentiating the various trees and molding the hillsides with the distinctive shorthand of his large etchings (cat. nos. 93 and 106). The boldly empty foreground, into which buildings and trees seem to sink while the hillsides mount almost to the drawing's upper edges, reverses the logic of most landscape drawings which are heavily weighted at their lower edges. Together with the suggestion of the landscape's continuation off both ends of the sketchbook page, this format reflects the confident, idiosyncratic compositions that would characterize Millet's landscape drawings at their best.

Country Road with Culvert (cat. no. 119) is drawn on a page from the same sketchbook as *Farm at Vichy* and, like that sketch, was executed first in pencil, then reworked in ink. But where Millet handled his pen with a measured and careful touch in the first drawing, following the pencil sketch quite closely, he drew *Country Road with Culvert* quite rapidly and freely, overlapping foliage with patterns of shading on the embankment and trees behind without great concern for the minimal pencil work. This may well be a sketch in which Millet began to explore drawing directly from the motif with pen and ink.

Chestnut Trees near Cusset (cat. no. 118) is one of several sketches made outside Vichy (around the smaller town of Cusset) that provided the impetus for finished pastels. While recording the view, Millet made a number of pencil notes: *near-green, dark gray-green, quarry, worked with a hoe in clods, full of tufts*; later, probably in his inn, he reworked the drawing in ink and even added colored pencil, an uncommon touch in his work, where preparatory drawings are almost never colored. In the finished landscape, *Path with Chestnut Trees near Cusset* (private collection, New Hampshire), nearly all of his careful notations are observed and the final composition is wholly congruent with that recorded in the sketch – even the trees are branched in the same patterns. Only a young woman spinning while tending a small herd of cows and sheep was added when the pastel was drawn for Gavet a few months later.

To facilitate drawing on morning walks, or when he and his wife rented a carriage to drive into the countryside, Millet carried sketchbooks, one of them little more than a pocket diary about two by four inches. *Trees along a Rocky Stream Bed, House with a Fence,* and *Trees beside a Pool* (cat. nos. 120-122; along with similar watercolor drawings in the Cabinet des Dessins, Musée du Louvre, Paris, and the Victoria and Albert Museum, London, and elsewhere) are all from one such book. Too tiny and generalized to have served Millet as models for complete landscapes, these colored studies seem mere *souvenirs* of a locale's characteristic elements. (In a letter to Sensier he mentioned sketches thrown down in great haste that he hoped would prove strong enough to refresh his memory later, for his time between activities and meals with his wife left little room for more articulation.)[1]

Such tiny jottings from Millet's *calepins* (pocket-size notebooks) are uncommon, however, for most of his drawings are

120

121

122

much more fully thought out, recording reasonably complete compositions – justified by the directness with which he was able to reuse them later, with little or no addition. Lushly colored, *Road from Malavaux, near Cusset* (cat. no. 123) and *Orchard Fence near Vichy* (cat. no. 124), which probably date from the 1867 visit, are virtually finished landscapes, awaiting only animals or figures to enliven their carefully balanced spaces. Millet had used watercolors occasionally in the 1850s and early 1860s, usually in conjunction with pastels to color finished drawings. The multiple washes of greens and complex earth tones that build the hillsides and thick foliage of his Vichy drawings, however, are as instrumental in his rendering of space as in providing a color record, and in *Hillside Meadow with a Twisted Tree* (cat. no. 125), the broad open spaces of the rising hillside are given order principally by the blues and browns that define the massive rock in the center.

A small number of larger, more finished watercolors resulted from the Vichy trips as well, although these are as likely to have been completed in the Barbizon studio as in his inn. With its buildings glimpsed through masses of trees and hedges and the characteristic organization around a roadway leading into the middle ground, *Landscape with a Church near Vichy* (cat. no. 126) recalls seventeenth-century Dutch compositions as well as the watercolors of Millet's close friend Théodore Rousseau. Distinctly a Millet invention, however, is *Farmstead near Vichy* (cat. no. 127), its broad band of color strung from side to side against the very open sky and foreground, ordering the disparate elements of nature and man's mark on it.

The impact of the Vichy and Auvergne hillsides, rising boldly all around him or disappearing without a vista behind the trees, combined with the necessity of recording spaces and textures rapidly with color even more than line, dramatically consolidated the developing tendencies in Millet's vision and craft; after the summer of 1866, landscape became the principal vehicle for his artistic invention.

Notes

1. Letter from Millet to Alfred Sensier, June 26, 1866, Archives of the Cabinet de Dessins, Musée du Louvre, Paris; quoted in Etienne Moreau-Nélaton, *Millet raconté par lui-même* (Paris: Henri Laurens, 1921), vol. 3, p. 9.

Cat. no. 117:

Provenance

Millet studio sale (Hôtel Drouot, Paris, May 10-11, 1875, no. 209), bought by Richard Hearn for Martin Brimmer, Boston.

Cat. no. 118:

Provenance

Millet studio sale (Hôtel Drouot, Paris, May 10-11, 1875, no. 222), bought by Richard Hearn for Martin Brimmer, Boston.

Related Works

Chestnut Trees near Cusset, cat. no. 118.

Path with Chestnut Trees near Cusset, pastel and black conté crayon on paper, 38.5 x 49.5 cm., private collection, New Hampshire (see letters, below).

Cat. no. 119:

Provenance

Millet studio sale (Hôtel Drouot, Paris, May 10-11, 1875, no. 224), bought by Richard Hearn for Martin Brimmer, Boston.

Cat. no. 120:

Provenance

Millet studio sale (Hôtel Drouot, Paris, May 10-11, 1875, no. 89), bought by Richard Hearn for Martin Brimmer, Boston.

Cat. no. 121:

Provenance

Millet studio sale (Hôtel Drouot, Paris, May 10-11, 1875, no. 88), bought by Reverend Frederick Frothingham, Milton, Massachusetts.

Cat. no. 122:

Provenance

Millet studio sale (Hôtel Drouot, Paris, May 10-11, 1875, no. 75), bought by Richard Hearn for Martin Brimmer, Boston.

Exhibition History

University of Maryland Art Gallery, College Park, "From Delacroix to Cézanne: French Watercolor Landscapes of the Nineteenth Century," 1977-1978, no. 122.

Cat. no. 123:

Provenance

Millet studio sale (Hôtel Drouot, Paris, May 10-11, 1875, no. 91), bought by Richard Hearn for Martin Brimmer, Boston.

Exhibition History

Phillips Collection, Washington, D. C., "Drawings by J. F. Millet," 1956.

Arts Council of Great Britain, London, "Drawings by Jean-François Millet," 1956, no. 64.

University of Maryland Art Gallery, College Park, "From Delacroix to Cézanne: French Watercolor Landscapes of the Nineteenth Century," 1977-1978, no. 120.

Cat. no. 124:

Provenance

Millet studio sale (Hôtel Drouot, Paris, May 10-11, 1875, no. 76), bought by Richard Hearn for Martin Brimmer, Boston.

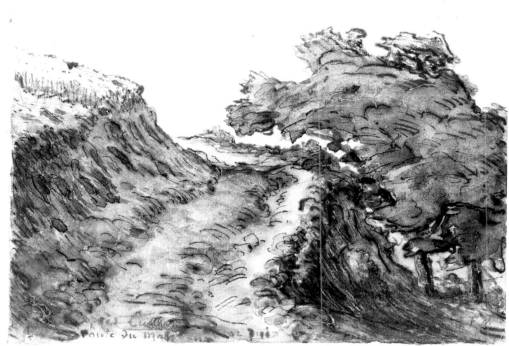

123

124

Exhibition History

University of Maryland Art Gallery, College Park, "From Delacroix to Cézanne: French Watercolor Landscapes of the Nineteenth Century," 1977-1978, no. 119.

125

126

Cat. no. 125:

Provenance

Millet studio sale (Hôtel Drouot, Paris, May 10-11, 1875, no. 101), bought by Reverend Frederick Frothingham, Milton, Massachusetts.

References

Peacock, Netta. *Millet*. London: Methuen & Co., 1905, illus. p. 13.

Cat. no. 126:

Provenance

Millet studio sale (Hôtel Drouot, Paris, May 10-11, 1875, probably no. 253, wrongly identified as *L'Eglise de Gréville*), bought by Richard Hearn for Martin Brimmer, Boston.

Exhibition History

Morgan Library, New York, "Landscape Drawings and Watercolors, Bruegel to Cézanne," 1953, no. 38.

Phillips Collection, Washington, D. C., "Drawings by J.-F. Millet," 1956.

Museum Boymans-von Beuningen, Rotterdam, "French Drawings from American Collections," 1958.

University of Michigan Museum, Ann Arbor, "French Watercolors, 1760-1860," 1965, no. 61.

Grand Palais, Paris, "Jean-François Millet," 1975, no. 205.

University of Maryland Art Gallery, College Park, "From Delacroix to Cézanne: French Watercolors of the Nineteenth Century," 1977-1978, no. 121.

Cat. no. 127:

Provenance

Millet studio sale (Hôtel Drouot, Paris, May 10-11, 1875, no. 104), bought by Reverend Frederick Frothingham, Milton, Massachusetts.

Exhibition History

Phillips Collection, Washington, D. C., "Drawings by J.-F. Millet," 1956.

California Palace of the Legion of Honor, San Francisco, "Drawings of French Masters from Ingres to Seurat," 1947.

127

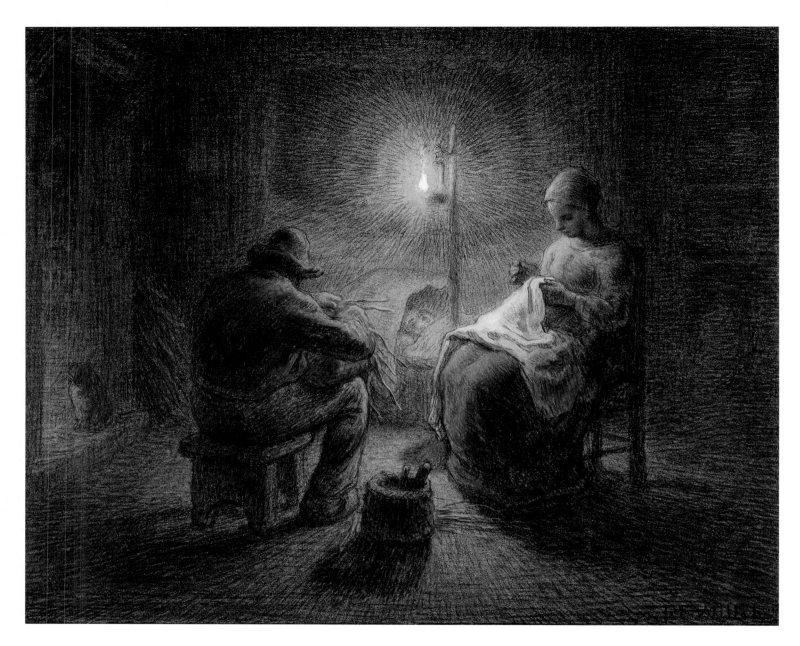

128
Winter Evening
1867
Pastel on pale gray wove paper
44.2 x 54.0 cm. (17⅜ x 21¼ in.) – design
48.3 x 58.8 cm. (19 x 23⅛ in.) – support
Lower right: J. F. Millet
Gift of Quincy Adams Shaw through
Quincy A. Shaw, Jr., and Mrs. Marian
Shaw Haughton, 1917
17.1520

The composition of *Winter Evening* was first created by Millet as part of the series "The Four Hours of Day," engraved on wood by Adrien Lavieille in 1860. Later Millet repeated the composition in this larger pastel for Emile Gavet. In both versions, the seated figures, the sleeping child, and the basket of tools form a tight, central pyramid. With the lamp as the focal point, light radiates in an all-encompassing circular sweep, imbuing the simple domestic scene with a mystical aura in which "Millet's baby...shines in the light of the lamp, like an infant Jesus under the halo."[1]

The interpretation of *Winter Evening* as a secular Holy Family scene is given credence by the fact that the pastel is similar in many respects to Rembrandt's depictions of the Holy Family. Only the use of a subtle halo

distinguishes the figures in several of them from the common man. In one etching, *The Holy Family with Cat, St. Joseph at the Window*, a haloed Virgin sits on the floor before a fireplace, holding her child, and St. Joseph peers through a lower window-pane in the background, his face only partially visible. In *Winter Evening*, the father is also dissociated from his spouse and child, at the edge of the lamplight that floods them. He is hunched over his work, intent on completing a basket – an image that recalls depictions of St. Joseph in which the patron saint of both fathers and manual laborers is revered for his worldly qualities.

Rembrandt was not among the old masters who had so strongly shaped Millet's ambitions at the beginning of his career,

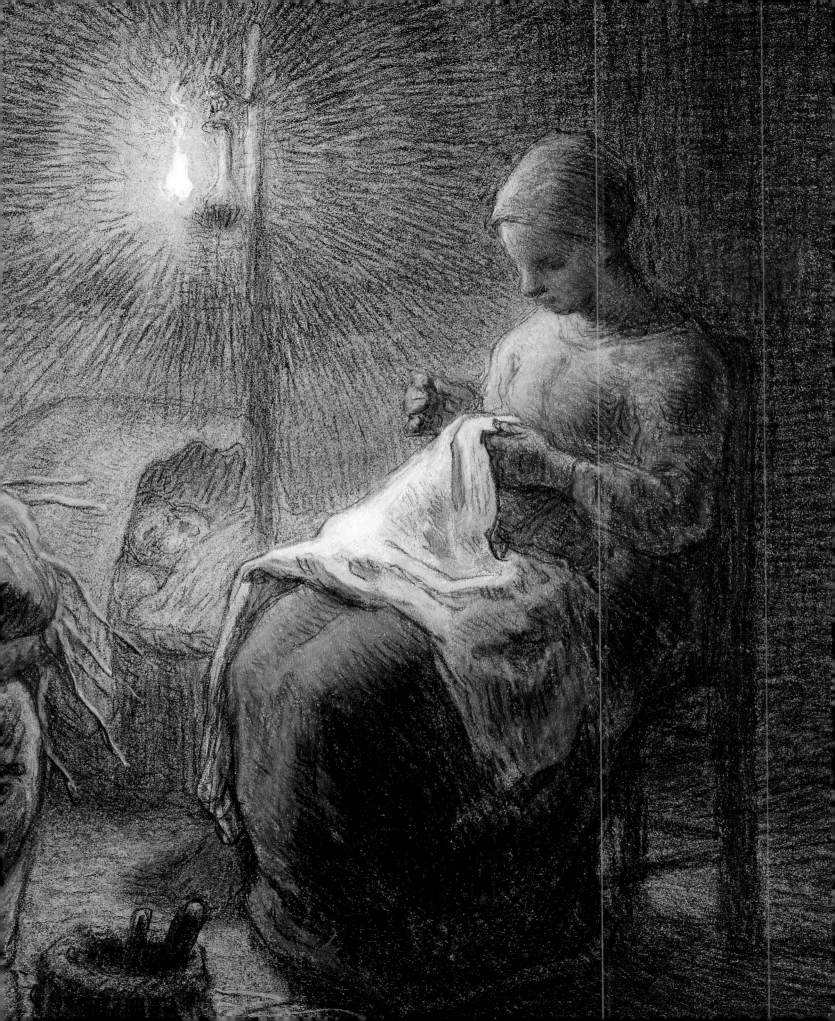

for, as Millet recalled, "…he blinded me. I thought that it would be necessary to make the stations before you could enter thoroughly into the genius of this man."[2] But Millet's interest in Dutch painting increased throughout the 1850s, as he undertook so many interior scenes of his own. And as he moved into the circle of artists leading the nineteenth-century etching revival, Rembrandt's work became increasingly significant for him. That it was Rembrandt as a printmaker who particularly inspired this pastel is suggested by Millet's use of a predominantly black-and-white technique, with only modest touches of color, and the overall, fine cross-hatching that creates the illusion of an etching.[3]

Notes

1. John W. Mollett, *The Painters of Barbizon* (London: Sampson, Low, et al., 1890), p. 31.
2. Alfred Sensier and Paul Mantz, *La Vie et l'oeuvre de J.-F. Millet* (Paris: Quantin, 1881), p. 56.
3. Millet made a further allusion to Rembrandt in the composition's echoes of that master's *Supper at Emmaus* in the Louvre. The Christ in Rembrandt's painting has been replaced by the sleeping child in Millet's image.

Provenance

Commissioned from the artist by Emile Gavet (sold Hôtel Drouot, Paris, June 11-12, 1875, no. 13), bought by Détrimont, probably for Quincy Adams Shaw, Boston.

Exhibition History

Rue St. Georges 7, Paris, "Dessins de Millet provenant de la Collection de M. G.," 1875, no. 27.
Copley Society, Boston, "One Hundred Masterpieces," 1897, no. 39.
Museum of Fine Arts, Boston, "Quincy Adams Shaw Collection," 1918, no. 40.

Related Works

Compositional sketch with bed to the left, black conté crayon on paper, 8.8 x 10.9 cm., Cabinet des Dessins, Musée du Louvre (GM10433).
Compositional sketch with cradle at right, black conté crayon on paper, 5.1 x 7.3 cm., Cabinet des Dessins, Musée du Louvre (GM10682).
Life study of young woman's head, black conté crayon on paper, 19.8 x 15.6 cm., Cabinet des Dessins, Musée du Louvre (GM10683).
Winter Evening, cat. no. 128.

References

Sensier, Alfred, and Mantz, Paul. *La Vie et l'oeuvre de J.-F. Millet*. Paris: A. Quantin, 1881, pp. 301, 346.
Yriarte, Charles. *J.-F. Millet*. Paris: Jules Rouam, 1885, pp. 14, 16.
Mantz, Paul. *Catalogue descriptif…J.-F. Millet*. Paris: Ecole des Beaux-Arts, 1887, pp. 28-29.

Mollett, John W. *The Painters of Barbizon*. London: Sampson, Low, et al., 1890, pp. 31, 36.
Guiffrey, Jean. "Tableaux Français conservés au Musée de Boston et dans quelques collections de cette ville." *Archives de l'art Français* n. s. 7 (1913), p. 547.
Leprieur, Paul, and Cain, Julien. *Millet*. Paris: Librairie Centrale des Beaux-Arts, 1913, p. 99.
Moreau-Nélaton, Etienne. *Millet raconté par lui-même*. Paris: Henri Laurens, 1921, vol. 2, p. 57; vol. 3, pp. 20-21, fig. 244.
The Letters of Vincent van Gogh to his Brother. London: Constable & Co., 1927, vol. 3, nos. 613, 623.
Rosenblum, Robert. *Modern Painting and the Northern Romantic Tradition*. New York: Harper and Row, 1975, p. 92.
Pollock, Griselda. *Millet*. London: Oresko Books, 1977, illus. p. 67.

129
Bird Trapper
1867
Black conté crayon with pastel on pale blue-gray wove paper
57.0 x 45.8 cm. (22⅜ x 18 in.)
Lower right: J. F. Millet
On extended loan from the William I. Koch Foundation

Millet's studied observation of the world around him extended to the works of art he knew from the Louvre or from reproductions – prints and photographs – that he and fellow artists William Perkins Babcock and Théodore Rousseau all collected for study and enjoyment. *Bird Trapper* is one of several pastels of 1867-1868 that enlarge a small sidelight of an old master painting to create an entire image: in this case, *Winter* by Pieter Brueghel the Elder (variously known as *The Skaters* and *The Bird Trap*, private collection, Brussels), of which Millet himself owned a variant.[1] In Brueghel's image, a trap very similar to Millet's is a detail in the landscape, and an unseen trapper pulls the string of his snare from a window in the background. Millet turned Brueghel's detail around, presenting the scene from the side hidden in the older master's work. Crouching in the doorway of a dark barn, Millet's trapper peers into a snowy yard where the birds peck at seeds placed beneath an old wooden shutter, propped by a stick. A string running from the stick to the barn will collapse the trap, crushing the unwary birds. (Piled in the winnowing basket at the young man's side is his previous catch.)

The pastel, completed for Emile Gavet in March of 1867, reworks an image first explored in an earlier black crayon drawing (Wallraf-Richartz Museum, Cologne) dating from 1853.[2] Millet employed the unusual color scheme he had introduced in *Morning Toilette* (cat. no. 82), a mustard-ochre balanced against its complementary gray-blue, within a strong black crayon framework. But with his now very firm mastery of the pastel medium's coloristic potential, he accorded the colors greater intensity and set them off against a more complex black-and-white framework, expanding the lovely vignette of the snowy yard seen through the doorway. His formal interests in the picture have shifted to the complexities of spatial definition in a setting so narrowly defined. One ambiguity of the earlier design is resolved by using the long squiggling rope to suggest the space between the trapper and his prey, and the bar of

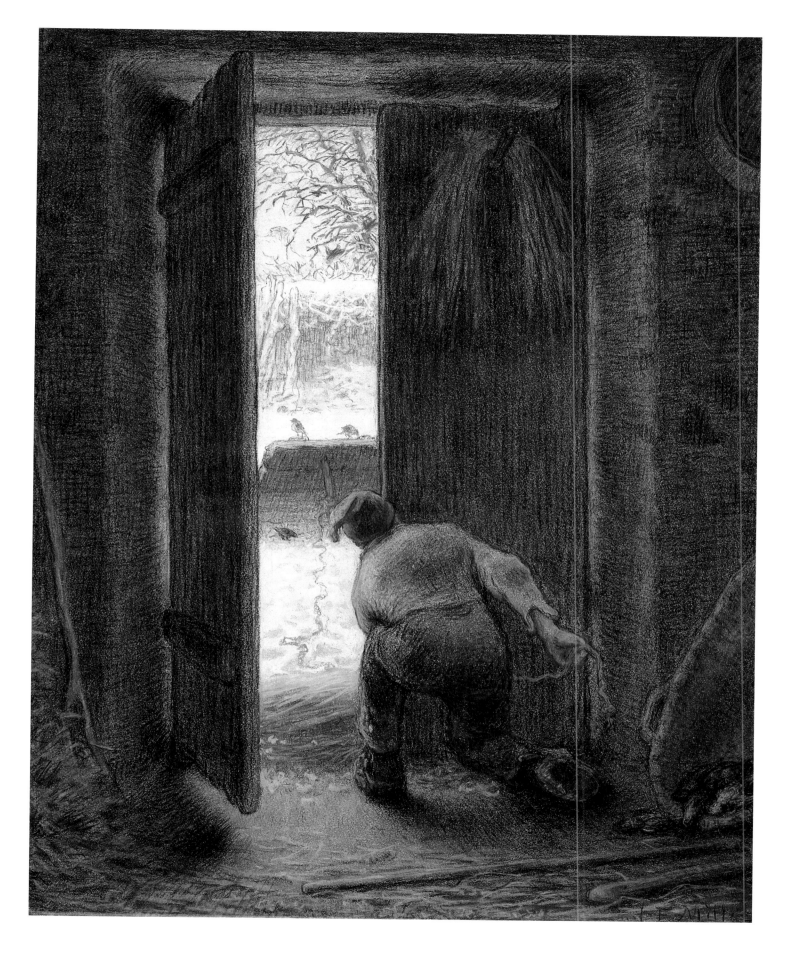

daylit background so strongly contrasted with the background so strongly contrasted with the dark interior is kept in proper visual perspective by the door that opens into the foreground, in turn spatially defined by the light slipping around its edges.

Notes

1. The painting that Millet owned is recorded in a sale following the death of Madame J. F. Millet, Hôtel Drouot, Paris, March 25-26, 1894, no. 232 (as *Les Patineurs*, oil on panel, 53 x 72 cm.). It may be one of a number of variants (created by members of the Brueghel family and followers) of the composition by Brueghel the Elder now in Brussels. It is not known when Millet acquired the painting.
2. The early drawing is dated by an inscription on its mount, indicating that the original owner acquired it from Millet on August 3, 1853.

Provenance

Commissioned from the artist by Emile Gavet (sold Hôtel Drouot, Paris, June 11-12, 1875, no. 41), bought by Haro, Paris; Ferdinand Bischoffsheim, Paris; M. Defoer (sold Georges Petit, Paris, May 22, 1886, no. 46); with Boussod and Valadon (1887); Oliver Ames, Boston (before 1908); Henry B. Cabot, Jr., Boston; acquired through Vose Galleries, Boston by the William I. Koch Foundation (1981).

Exhibition History

Ecole des Beaux-Arts, Paris, "J.-F. Millet," 1887, no. 120.
Copley Society, Boston, "The French School of 1830," 1908, no. 92.

Related Works

Compositional sketch, black conté crayon on paper, 21.7 x 18.2 cm., Cabinet des Dessins, Musée du Louvre, Paris (GM10681).
Finished drawing, black conté crayon with white highlights on paper, 37 x 31 cm., Wallraf-Richartz Museum, Cologne.
Bird Trapper, cat. no. 129.

References

Moreau-Nélaton, Etienne. *Millet raconté par lui-même*. Paris: Henri Laurens, 1921, vol. 2, pp. 20-21, fig. 248.

130
Rabbit Warren, Dawn
1867
Pastel on wove paper
49.5 x 59.5 cm. (19½ x 23⅜ in.) – design
51.8 x 62.4 cm. (20¼ x 24⅝ in.) – support
Lower right: J. F. Millet
Gift of Quincy Adams Shaw through
Quincy A. Shaw, Jr., and Mrs. Marian
Shaw Haughton, 1917
17.1522

Millet was unusual among the artist-*habitués* of Barbizon, most of whom came specifically to paint in the Forest of Fontainebleau; though he loved the Forest, he rarely depicted it, focusing instead upon the human activity visible on the forest fringes, in Barbizon, or on the well-worked Plain of Chailly to the northwest. Among the small number of his works that are identifiable with the Forest is *Rabbit Warren, Dawn*, drawn for Emile Gavet in 1867. It shows three rabbits outside their burrows on a steep and rocky hillside in the Gorges d'Apremont. The Gorges, along with an area called the Bas-Bréau, were the parts of the Forest of Fontainebleau closest to Barbizon and the ones most familiar to Millet, who was accustomed to walking in them daily. Unlike the grove of ancient oaks and beeches that formed the Bas-Bréau, the adjacent Gorges were a more savage, rocky terrain with vertiginous descents and huge anthropomorphic rocks strewn throughout unusual geological formations, both of which made the area a popular tourist spot in the nineteenth century.

In *Rabbit Warren*, Millet, who admitted to sometimes finding the Forest frightening, caught the natural monumentality and intrigue of the Gorges by viewing them from below and setting off a ring of immense stones (recalling the monoliths laid out by ancient peoples) with the preternatural glow of a hidden sunrise. The leftmost of these rocks, perched like a large crouching animal, echoes the pose of the central rabbit, emphasizing the absence of any human observer at this ceremony.

Quietly, in the privacy of early morning, Millet observed the daybreak activities of the animals. An upright rabbit surveys the scene, watching the sunrise or possibly watching for hunters. His companion is more timid, flattened to the ground with one dark, sleepy eye fixing the viewer in place while he nibbles on the ground cover. Millet portrayed his rabbits with a dispassionate affection that distinguishes *Rabbit Warren* from the tradition of hunt pictures that typified Fontainebleau animal painting in its popular form. The Forest of Fontainebleau had been used as a game preserve for centuries, both by the Crown and by generations of poachers, many of whom came from Barbizon. But during the nineteenth century poaching and the steadily increasing number of holiday-seekers so diminished the animal populations that by 1897 rabbits were almost nonexistent in the Forest.[1] By the time Millet drew *Rabbit Warren*, he had been a Forest familiar for nearly twenty years and, with Rousseau, had already taken part in several campaigns to protect the woodland from encroachment. This quiet drawing is a reflection of the majesty and mystery that were daily disappearing from scenes he loved intensely.

Millet himself had invented a title for this pastel, *crépuscule matin*, or morning twilight, recalling his well-established interest in the dulling of color distinctions in the faint light of the fading day. Within an unusual acid-gray harmony, he recorded the striking bright pink and white flowers of several pathside bushes, and he used virtually the full complement of greens available in the pastel medium, modulating them with black crayon drawing and the repeated ochers and siennas that provide the prevailing tone. The pastel, created in his home studio from memory, is virtually a prefiguration of the subtly resolved color effects created by Monet, ten years later in the damp dead of Argenteuil winter.

Notes

1. Alixis Martin, *Promenades et excursions dans les environs de Paris*, vol. 3, *Region de Sud*, (Paris, 1917), p. 115.

Provenance

Emile Gavet (sold Hôtel Drouot, Paris, June 11-12, 1875, no. 70), bought by Durand-Ruel; Quincy Adams Shaw, Boston.

Exhibition History

Rue St. Georges 7, Paris, "Dessins de Millet provenant de la Collection de M. G.," 1875, no. 24.
Museum of Fine Arts, Boston, "Quincy Adams Shaw Collection," 1918, no. 47.

References

Guiffrey, Jean. "Tableaux Français conservés au Musée de Boston et dans quelques collections de cette ville." *Archives de l'art Français* n. s. 7 (1913), p. 547.
Moreau-Nélaton, Etienne. *Millet raconté par lui-même*. Paris: Henri Laurens, 1921, vol. 3, pp. 20-21, fig. 247.

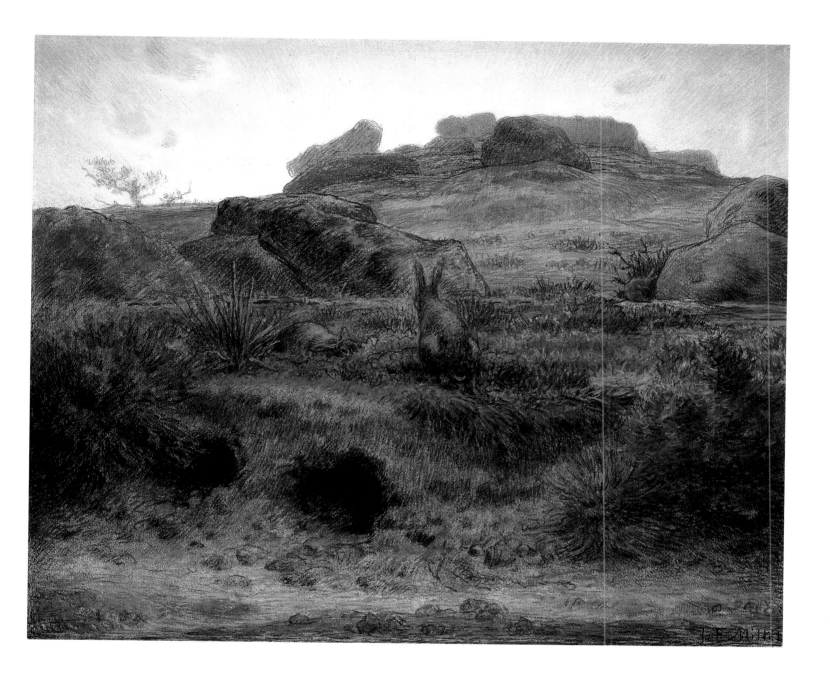

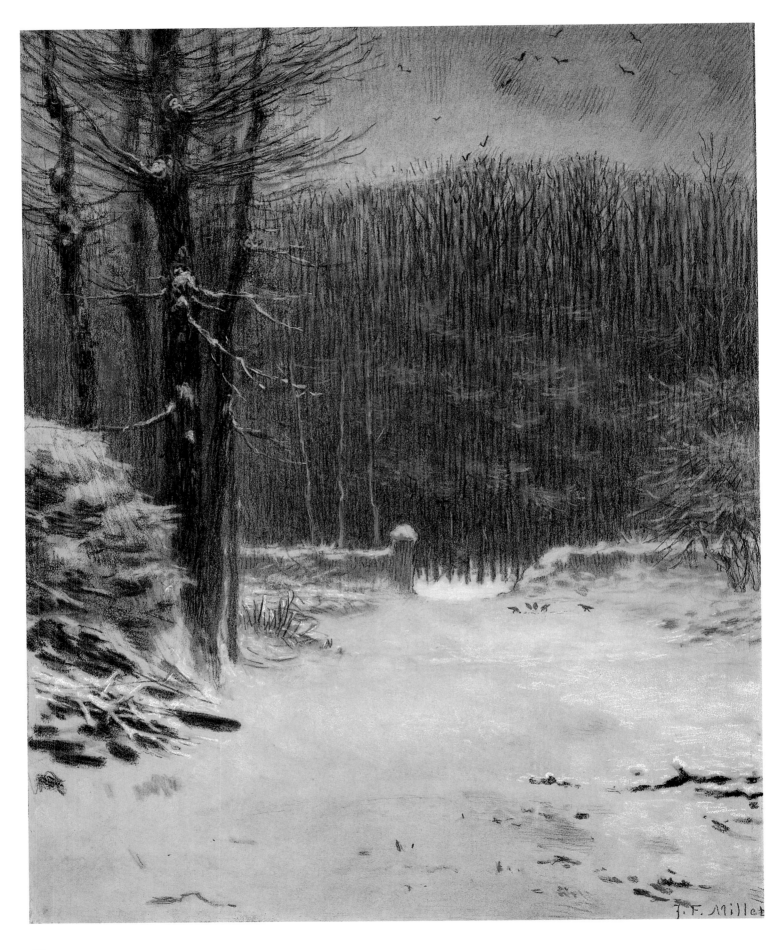

131
*Entrance to the Forest at Barbizon in
Winter (La Porte aux Vaches)*
About 1866-1867
Black conté crayon with pastel on gray-
beige wove paper
51.5 x 40.6 cm. (20¼ x 16 in.) – design
53.9 x 43.3 cm. (21¼ x 17 in.) – support
Lower right: J. F. Millet
Gift of Quincy Adams Shaw through
Quincy A. Shaw, Jr., and Mrs. Marian
Shaw Haughton, 1917
17.1491

During his second winter in Barbizon, Mil-
let had confided to Alfred Sensier that what
he wanted most to do, if he could win
himself some freedom by selling a few
paintings, was to make some pictures of
the winter landscape.[1] As he explained,

> *My desire to make a winter landscape has
> passed to the point of a true compulsion.
> If you could only see how beautiful the
> forest is! I run there whenever I can at
> the end of the day after my day's work is
> done, and every time I come back
> crushed. There's a calm, a grandeur
> that's terrifying, so much so, that I find
> myself really frightened. I do not know
> what these wretched trees are saying to
> each other, but they're saying something
> that we can't comprehend because we
> don't speak the same language. I trust,
> though, that they don't make many
> puns.[2]*

Two years later, his first true landscape
paintings and drawings depicted the Porte
aux Vaches – the Fontainebleau Forest
entrance through which cows belonging to
members of the Barbizon community had
been led to graze for generations – under a
clean blanket of new-fallen snow.[3] In 1866
or 1867, with the assurance of a well-honed
pastel technique, Millet drew *Entrance to
the Forest at Barbizon in Winter*, reworking
the image that had characterized the Forest
for him for nearly twenty years.

On a warm gray paper, using an espe-
cially restrained range of earth-toned pas-
tels to complement the definition of his
ubiquitous black crayon, Millet contrasted
the dense forest wall of interlaced beeches
with the broad, open foreground, softened
by a thin cover of untrampled snow. Dem-
onstrating the range of his draftsmanly skill
are intense streaks of green-black muddy
pastel, manipulated freely to the left and
right of the pathway; unexpected rubbings
and erasings that suggest loose snow blow-
ing across the trees, or being shaken loose
by the bushes in the middle ground;[4] and

the clever "v's" of black crayon that detach
from the uppermost branches of the wood
to form birds sweeping into the sky. The
fine crayon lines conveying the slender
uniformity of the forest have been contin-
ued almost unchanged from the 1853 draw-
ing, but Millet's technical virtuosity gives
this last rendering of a treasured vision a
monumental simplicity that earlier versions
had not attained.

Notes
1. Letter from Millet to Alfred Sensier (winter of
1850-1851; Archives of the Cabinet des Dessins,
Musée du Louvre, Paris).
2. Letter from Millet to Alfred Sensier, dated by
Etienne Moreau-Nélaton to January 25, 1851.
Quoted in Alfred Sensier and Paul Mantz, *La Vie
et l'oeuvre de J.-F. Millet* [Paris: A. Quantin, 1881],
p. 121. In his statement that the trees did not make
puns, whatever their language, Millet was referring
to his own difficult adaptation to the sophistication
of Paris and in particular to the puns and elaborate
word games practiced in Ecole des Beaux-Arts cir-
cles during his student days. Delaroche, in particu-
lar, was known for the puns crafted by his stu-
dents. For Millet, so troubled by his Norman
provincial dialect that he seldom opened his
mouth, puns left him with a profound distaste for
language turned against itself.
3. Finished drawing (Cabinet des Dessins, Musée
du Louvre, Paris) and oil painting (Philadelphia
Museum of Art). Dated to February 1853 by a letter
from Millet to Alfred Sensier, February [24], 1853
(Archives of the Cabinet des Dessins, Musée du
Louvre, Paris).
4. In a letter to Emile Gavet of December 28, 1865
(see letters below), Millet mentioned his experi-
ments to determine whether individual papers
would withstand the erasing and retouching he
expected in his pastels.

Provenance
Commissioned from the artist by Emile Gavet
(sold Hôtel Drouot, Paris, June 11-12, 1875, no. 18),
bought by Durand-Ruel; Quincy Adams Shaw,
Boston.

Exhibition History
Rue St.-Georges 7, Paris, "Dessins de Millet prove-
nant de la Collection de M. G.," 1875, no. 18.
Museum of Fine Arts, Boston, "Quincy Adams
Shaw Collection," 1918, no. 42.

Related Works
Compositional sketch in horizontal format, black
conté crayon on paper, 3⅜ x 5 in., current location
unknown (sold Christie's, November 30, 1965, no.
175).
Compositional sketch in horizontal format, black
conté crayon on paper, 3½ x 5 in., current location
unknown (sold Christie's, November 30, 1965, no.
175).
Solitude: The Porte aux Vaches in the Snow, oil on
canvas, 85.5 x 110.5 cm., Philadelphia Museum of
Art.

Finished drawing in vertical format with hunter
and dog, black conté crayon on beige paper, 28.2 x
22.5 cm., Cabinet des Dessins, Musée du Louvre,
Paris (R.F. 4159).
Entrance to the Forest, oil on panel, 14¼ x 9 in.,
current location unknown (sold Georges Petit,
Paris, June 20-21, 1902, no. 81).
Porte aux Vaches under Snow, oil on canvas, 64 x 53
cm., current location unknown (sold Sotheby
Parke Bernet, London, June 23, 1981, no. 48).
Finished drawing, black conté crayon on paper,
13½ x 10¾ in., current location unknown (sold
Christie's, London, March 23, 1962, no. 56).
*Entrance to the Forest at Barbizon in Winter (La
Porte aux Vaches)*, cat. no. 131.

References
"'Greta's' Boston Letter." *Art Amateur* 5, no. 4
(September 1881), p. 72.
Guiffrey, Jean. "Tableaux Français conservés au
Musée de Boston et dans quelques collections de
cette ville." *Archives de l'art Français* n. s. 7 (1913),
p. 547.

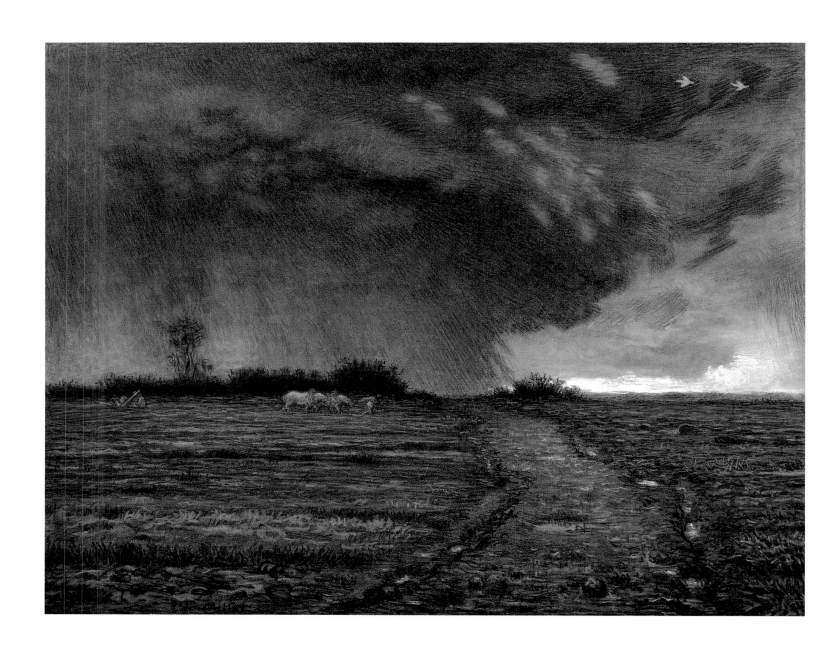

132
Coming Storm
1867-1868
Pastel and black conté crayon on green-brown wove paper
42.0 x 53.7 cm. (16½ x 21⅛ in.) – design
47.7 x 61.5 cm. (18¾ x 24¼ in.) – support
Lower left: J. F. Millet
Bequest of Mrs. Martin Brimmer, 1906
06.2426

As landscape became increasingly important to Millet in the 1860s, his predilection for half-light – at sunset and twilight, by candlelight and moonlight, or in rooms weakly illuminated by small windows – attracted him to the challenge of unusual natural light conditions characteristic of specific seasons or meteorological effects:

The weather is grey and constantly rainy, the sky cloudy and low, but you know I like it better than the sunlight. All is of a rich and melancholy color which leaves my eyes quiet and my head calm.[1]

This association of dim light and rich color is brilliantly demonstrated in *Coming Storm*, representing a dark, cumulonimbus cloud releasing a shower as it travels with the wind across the Plain of Chailly. Limiting his use of pastels to the area below the horizon, Millet offset a complex color study of the landscape with a controlled value study of the sky, dramatizing the interaction of natural forces.

"Explosive swellings. Fuliginosity of a gunpowder factory. Waterspout, volutes of the great storm." Thus did Théophile Silvestre attempt to describe the sky of *Coming Storm* at the Gavet exhibition of 1875.[2] Within a dense linear mesh of black crayon representing the storm, the changing directions of Millet's hatching trace convection patterns from the billowing cloud mass to the windblown rain. The turbulence and the effect of airborne particles (fuliginosity or sootiness) remarked by the critic are suggested by particles of crayon rubbed into the paper along the hatched lines. The impression of motion is enhanced by the dynamic representation of light, in which the now tan color and leathery opacity of paper, suggesting atmospheric heaviness, offset the sharp whites, creams, and pinks along the edge of the breaking storm.

Millet provided the viewer a position at a safe but uncertain distance from the rainfall, measured by the road leading headlong into the landscape, curving gently before meeting the horizon near the center of the picture at the heart of the heaviest downpour. The road is marked by bits of rubble, tufts of grass, and little depressions collecting water. This rough texture, which diminishes with distance, is, like the sky, reduced to black and white, except in the foreground, where lavender, violet, dark green, and brown witness Millet's discovery of chromatic beauty in unlikely places. The fields on either side of the road appear as softened horizontal bands of color, designating the long and narrow strips into which the communal land holdings were divided. The muted tones of the fields – ochers, greens, and blue-greens – are won from a surprising range of distinct hues, including taupe, mauve, brown, black, white, blue, lavender, turquoise, and yellow.

Despite the insistent color of *Coming Storm*, Millet's dramatic conception and ambitious draftmanship make clear that the source of his pastel is a black-and-white Rembrandt etching of similar subject, *Landscape with Three Trees* of 1643. His assimilation, rather than imitation, of Rembrandt's work is indicated by various features of the pastel: the overall dark tonality and the broad large movements of light and shadow; the great curtain of rain pulling away to reveal the bright, clear sky on the right at the horizon; the swelling motion of the clouds and the sensation of buoyancy transmitted by soaring birds; and the diminution of human scale and significance before the grandeur of natural forces. The plain might itself be taken from the panorama in the left distance of Rembrandt's composition.

An influential member of the nineteenth century's etching revival (to which Rembrandt was an important predecessor), Millet collected works by Rembrandt, and his friend William Perkins Babcock owned at least two impressions of *Three Trees*.[3] But Millet's choice of the broader, softer medium of pastel for *Coming Storm* suggests that his appreciation of *Three Trees* was also influenced by the work of a later French painter, Georges Michel (1763-1843), whose charcoal drawings of broad landscapes under stormy skies (many very similar to *Coming Storm*) would have been familiar to Millet through his friend Alfred Sensier.[4]

Notes

1. Letter from Millet to Alfred Sensier, January 30, 1865 (Archives of the Cabinet des Dessins, Musée du Louvre, Paris). Quoted in Alfred Sensier and Paul Mantz, *La Vie et l'oeuvre de J.-F. Millet* (Paris: A. Quantin, 1881), p. 281.

2. Annotated copy of the Gavet exhibition catalogue, see cat. no. 112, n. 2.

3. A native Bostonian, William Perkins Babcock (1826-1899) became a lifelong resident of Barbizon. He studied briefly with Couture in Paris and then followed Millet to Barbizon around 1850. He was a close personal friend of Millet's, with whom he readily shared his large collection of original prints, reproductions, and photographs. Numbering more than 5,000 items, the collection was left to the Museum of Fine Arts on Babcock's death.

4. Alfred Sensier researched the first monograph on Michel, whose example was especially prized by members of the Barbizon artistic community. Sensier's text, moreover, makes clear that Rembrandt's *Three Trees* inspired Michel's depiction of stormy skies (*Etude sur Georges Michel* [Paris: Alphonse Lemerre, 1873]).

Provenance

Commissioned from the artist by Emile Gavet (sold Hôtel Drouot, Paris, June 11-12, 1875, no. 17), bought by Martin Brimmer, Boston; Mrs. Martin Brimmer, 1896.

Exhibition History

Rue St. Georges 7, Paris, "Dessins de Millet provenant de la Collection de M. G.," 1875, no. 17.

References

Strahan, Edward. *Art Treasures of America*. Philadelphia: George Barrie, 1879, vol. 3, p. 82.

Staley, Edgcumbe. *Jean-François Millet*. London: George Bell and Sons, 1903, p. 49.

Guiffrey, Jean. "Tableaux Français conservés au Musée de Boston et dans quelques collections de cette ville." *Archives de l'art Français* n. s. 7 (1913), p. 550.

Leprieur, Paul, and Cain, Julien. *Millet*. Paris: Librairie Centrale des Beaux-Arts, 1913, p. 100, pl. 42.

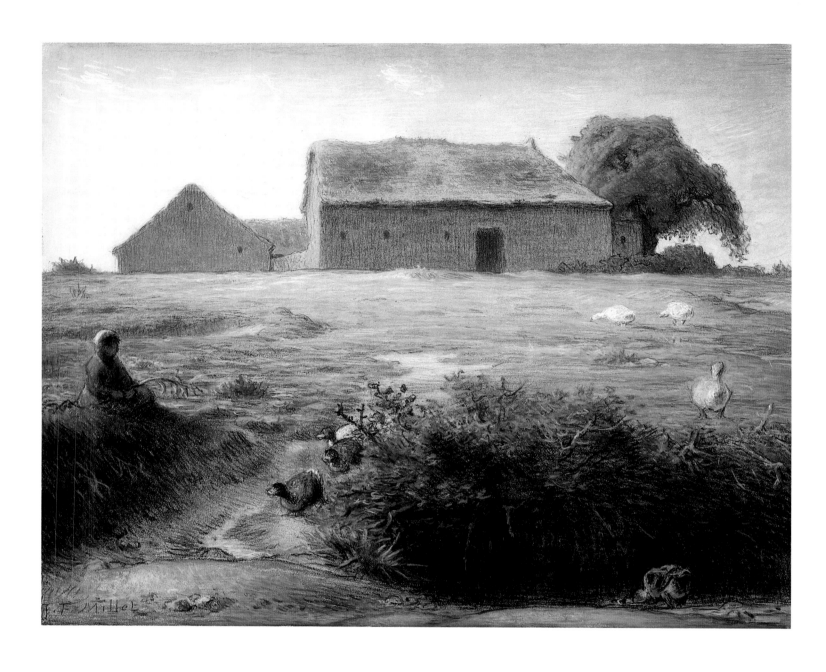

Little Goose Girl
1868
**Pastel and black conté crayon on green
wove paper**
41.6 x 51.8 cm. (16⅜ x 20⅜ in.) – design
43.7 x 53.7 cm. (17¼ x 21⅛ in.) – support
Lower left: J. F. Millet
**Gift of Quincy Adams Shaw through
Quincy A. Shaw, Jr., and Mrs. Marian
Shaw Haughton, 1917**
17.1527

Tending geese was one of the least taxing peasant labors, usually farmed out to small children, since the birds stayed near the coolness of their pond. Unlike sheep- or cow-tending scenes, in which Millet often accented the loneliness, boredom, or poverty of the youthful guardian, his images of goose- and duck-tending were always more lighthearted, emphasizing the playfulness of the birds and the beauty of the pond-centered landscapes. In this pastel, he represented a particularly complacent view of peasant life, with the child well fed and the land abundant. Even humor has a place in the rural setting in his stylized rendering of the geese and ducks. Millet developed a personal vocabulary for many animals, but he was particularly inventive with birds. In a few swift strokes he defined the rounded body, the widely set legs, and outstretched necks of the foraging geese, while he eliminated legs altogether in the ducks. As with cows and goats, so often shown disappearing over the edges of the hillside, he enjoyed depicting birds in upended foreshortening.

Forcing what little action the picture holds far down in the foreground, Millet created a scene whose seeming randomness suggests an artless naturalism that is the antithesis of his powerfully concentrated images of the preceding decade. Relying on only the short path between the young goose girl's perch and the pool as a concession to traditional perspective constructions, Millet forced the viewer to turn to carefully balanced areas of light and shade and to the scattered geese, as a way of progressing through the rising, wall-like landscape.

The unusually high horizon, held down by carefully aligned, blocky farm buildings, and the wide swath of grassy hillside offer a broad screen for the display of bright colors, without the black crayon muting used to order more conventionally established spaces. With a spatial construction similar to that in the following pastel, *Path through the Wheat*, Millet was able to focus on the problems of drawing in color that became steadily more central to his pastel technique during 1867 and 1868. Balancing pure color drawing against color structured with black crayon (at its freest in the foreground), he wove bold strokes of black and some color into the shadowy, impenetrable overgrowth on the bank of the stream. In contrast to this natural snarl, he lightly outlined, with a finely sharpened black crayon, the angular gables and taut walls of the man-made farm buildings in the background. Sandwiched between these contrasting zones is a broad swath of green meadow, free of black except for scattered accents. Individual strokes of green or blue lose autonomy as Millet overlaid and rubbed them together, tightening his typical open "weavings" into a more opaque blanket of color.

Provenance
Commissioned from the artist by Emile Gavet (sold Hôtel Drouot, Paris, June 11-12, 1875, no. 33), bought by Carlin; Quincy Adams Shaw, Boston.

Exhibition History
Museum of Fine Arts, Boston, "Quincy Adams Shaw Collection," 1918, no. 30.

References
Sensier, Alfred, and Mantz, Paul. *La Vie et l'oeuvre de J.-F. Millet*. Paris: A. Quantin, 1881, p. 346.
Guiffrey, Jean. "Tableaux Français conservés au Musée de Boston et dans quelques collections de cette ville." *Archives de l'art Français* n. s. 7 (1913), pp. 547.

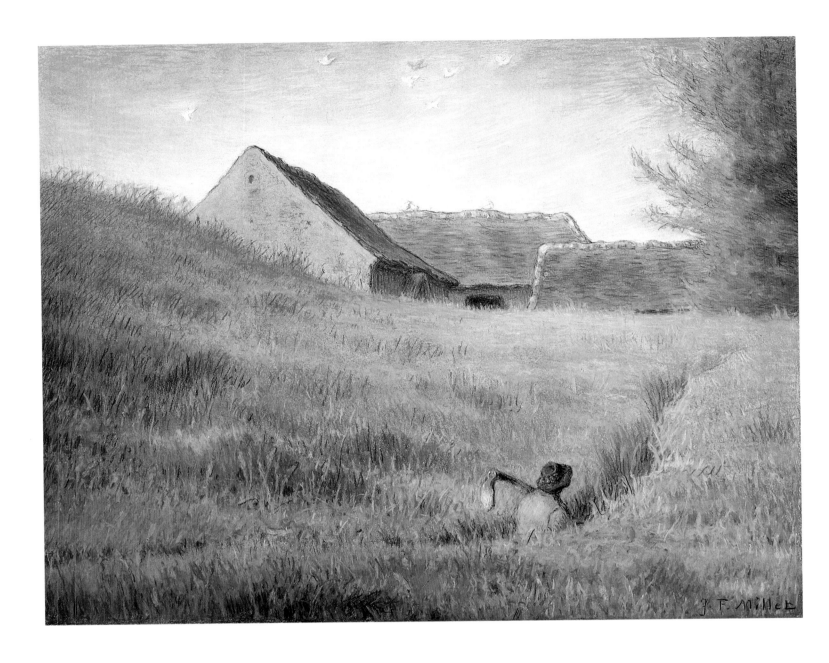

Path through the Wheat
About 1867
Pastel and black conté crayon on gray wove paper
40.3 x 50.6 cm. (15⅞ x 19⅞ in.) – design
44.1 x 53.5 cm. (17⅜ x 21 in.) – support
Lower right: J. F. Millet
Gift of Quincy Adams Shaw through Quincy A. Shaw, Jr., and Mrs. Marian Shaw Haughton, 1917
17.1521

Millet's pastel of a man returning home with a hoe over his shoulder belongs to a group of works from the mid-1860s onward that depict the peasant in harmonious coexistence with an abundant and beautiful nature. Unlike his much-maligned painting of a related subject, *Man with a Hoe* of 1861, in which a tired worker leans heavily on his tool, dissatisfaction written on his troubled face, this picture disdains any such social comment in favor of more modest painterly ambitions.

The unusual design of *Path through the Wheat*, especially the expansive field rising from the foreground to occupy two-thirds of the picture surface, derives from a basic compositional device Millet had employed in his drawings of the hilly terrain of Allier and the Auvergne in 1866. Working from a drawing made near Vichy (private collection, Paris), Millet set farm buildings parallel to the picture plane and upon (or more specifically in this case, somewhat behind and below) the high horizon, rigorously blocking any view into the distance.[1] With their sharply angled, overlapped foreshortening, the buildings provide the only solid measures of scale and distance in the drawing, and seem to anchor the formless field to the picture. The consequent flatness and the deceptive blandness of organization in this work, the field uninterrupted except for the peasant and the hint of the path, posed just the sort of challenge that Millet sought as he began to draw directly in color around 1867. Without the matrix of a more complex composition, he forced himself to animate the field by means of subtle changes in hue and value, primarily through graphic manipulation. The wheat bristles with independent, essentially vertical strokes of color, yet swells gently where Millet rubbed or blended colors softly in broad horizontal passages. In the choice of such a composition and its corresponding emphasis on broad, bold execution, Millet established himself as a major precursor of the Impressionists, in particular Monet, who made similar use of the Normandy landscape in the 1880s.

The particular motif of a man walking along a path through a shoulder-high wheat field is found in a number of sixteenth-century harvesting pictures, probably all deriving from Pieter Brueghel's *Summer*, an engraving certainly known to Millet and perhaps figuring in his own collection of Northern prints.[2] Millet may have discovered the appeal of this detail while working on a roughly contemporary pastel, the *Reaper* (private collection,

Japan). But whereas the *Reaper*, reworking a Millet drawing of 1853, draws on one of the principal foreground figures in the engraving to create a monumental laborer who dominates both the composition and the land he cultivates, *Path through the Wheat* expands a tiny motif from the background of Brueghel's image to create a striking landscape composition, the figure small in scale and nearly swallowed by the unrestrained growth of wheat around him. Although virtually contemporary, the two pastels reflect the considerable change that took place in Millet's subject interests between the 1850s – the period in which the image of the *Reaper* originated – and the late 1860s, each representing different, although complementary, views of man's relationship to the land he worked.

Notes
1. Millet credited his father with first drawing his attention to the picturesque quality of farm buildings that appear half buried in their fields. See Alfred Sensier and Paul Mantz, *La Vie et l'oeuvre de J.-F. Millet* (Paris: A. Quantin, 1886), p. 6.
2. Robert Herbert claims, without citing a source, that Millet owned Brueghel's *Summer (Jean-François Millet* [Paris: Editions des Musées Nationaux, Grand Palais exhibition catalogue, 1975], p. 224); however, even if he did not have his own version of the print at hand, the collection of his friend William Perkins Babcock, with which Millet was quite familiar, included the print (see cat. no. 132, n. 3).

Provenance
Commissioned from the artist by Emile Gavet (sold Hôtel Drouot, Paris, June 11-12, 1875, no. 86), bought by Détrimont, probably for Quincy Adams Shaw, Boston.

Exhibition History
Museum of Fine Arts, Boston, "Quincy Adams Shaw Collection," 1918, no. 31.

Related Works
Landscape study, inscribed *Vichy*, pen and ink with color washes on paper, private collection, Paris.
Path through the Wheat, cat. no. 134.

References
Moreau-Nélaton, Etienne. *Millet raconté par lui-même*. Paris: Henri Laurens, 1921, vol. 3, p. 39, fig. 245.
Heise, Carl Georg. "Amerikanische Museen." *Kunst und Künstler* 23, 6 (March 1925), illus. p. 224.

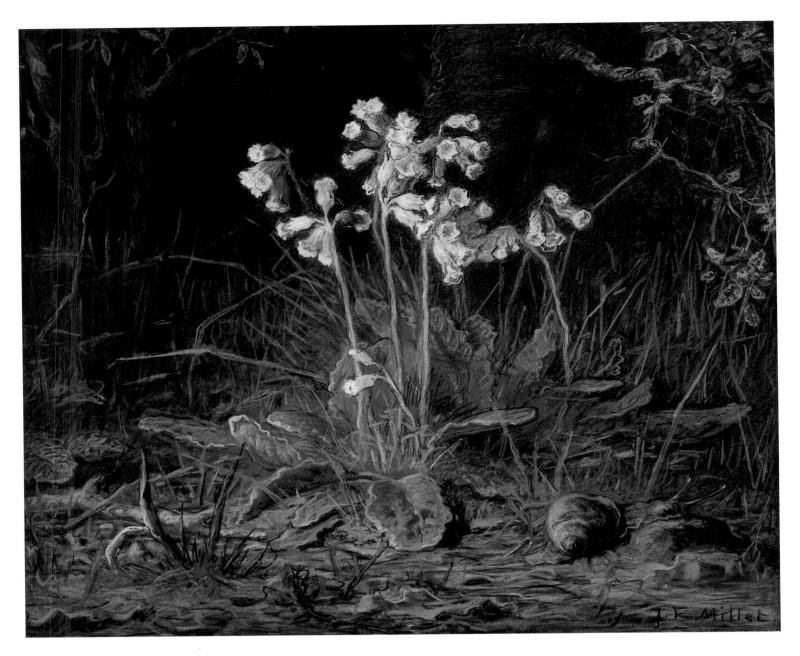

135
Primroses[1]
1867-1868
Pastel on green-brown wove paper
40.2 x 47.8 cm. (15⅞ x 18⅞ in.) – design
43.4 x 51.8 cm. (17⅛ x 20⅜ in.) – support
Lower right: J. F. Millet
Gift of Quincy Adams Shaw through
Quincy A. Shaw, Jr., and Mrs. Marian
Shaw Haughton, 1917
17.1523

136
Dandelions
1867-1868
Pastel on buff wove paper
40.4 x 50.2 cm. (15⅞ x 19¾ in.) – design
43.0 x 52.9 cm. (16⅞ x 20⅞ in.) – support
Lower right: J. F. Millet
Gift of Quincy Adams Shaw through
Quincy A. Shaw, Jr., and Mrs. Marian
Shaw Haughton, 1917
17.1524

Millet took flowers as his subject only four times, rather late in his career, and never made with them a still life in the customary sense. His first efforts, around 1867, resulted in a trio of pastels: Boston's *Primroses* and *Dandelions*, and *Daffodils* (Kunsthalle, Hamburg).[2] These common wildflowers are presented from a low, close vantage point that transforms a small patch of turf into a richly complex landscape.

The primroses stand pale and lamp-like in a dark wood, alongside a trail that cuts across the foreground at an angle. To their right a snail has crawled to the edge of the path. Above, against the brown-black shadows of the trees and bushes, which seem almost unnaturally opaque, the tiny

yellow blossoms stand out with phosphorescent luminosity.

In *Dandelions*, Millet exchanged the complex, predominantly earth-toned palette of *Primroses* for a picture field that is almost entirely green – a primary, emerald green in the wall of clover behind, and a rich medley of yellow-greens in the grassy foreground. Twelve flowers in all phases from bud to seed rise from a stretch of meadow dappled with sunlight and scattered with twigs and stones. Six airy globes of white-plumed seeds dominate the center of the picture, flanked by short-stemmed daisies on either side and, on the left, by small violets.

Millet's flower pastels are neither sketchbook pages nor studies but finished pictures of a scale rivaling his pastels of figures and landscapes. The difficulty of relating them to traditional genres of subject matter (landscape and still-life) has obscured their connections with the rest of his work. Yet, they forthrightly declare themselves not as *nature morte* but *nature vivant*. As details of landscapes (each quite literally Zola's "corner of creation seen across a temperament"[3]), these flower pictures reveal an approach to nature in which scientific consideration balanced by poetic affection is extended even to the humblest details.

As in his more straightforward figure pictures or landscapes, Millet was concerned above all with truthful description. The compositional similarities provide a scaffolding for the differences he emphasized between the flowers and their immediate landscapes. With its cluster of slender, bell-shaped flowers carried on attenuated stems, the primrose appears dainty and fragile. Not only the plant but its habitat is described with a sensitivity that goes beyond the visible to suggest atmosphere, even temperature: a setting woodsy, shady, cool, and damp. At some remove from this sheltered, *sous-bois* (forest depth) location is the sunnier, airier, drier field of dandelions, where the impression received is of being not beneath, but on the fringes of, dense flora.

The critic Théophile Silvestre compared *Dandelions* to drawings by Dürer (namely *Large Turf* of 1853, Albertina, Vienna – available to Millet through a reproduction in the collection on William Perkins Babcock),[4] but Millet's characterization of light-struck, growing flowers deep-set in their environment is at some remove from the precise draftsmanship and evenly lit isolation of Dürer's tuft of grasses and flowers. The intensity of Millet's colors and the

detail of a snail moving across the foreground in *Primroses* suggest an alternative inspiration for these unusual works: the brightly colored faience plates of the sixteenth-century artisan Bernard de Palissey, which featured densely interwoven flora and fauna in high relief. During the mid-1860s, while pondering his own feelings about art in response to inquiries from Alfred Sensier, Millet copied out a number of lines from de Palissey: "I haven't any other book but the sky and earth, which is known to all…" and "I much prefer to speak the truth in my rustic language than to lie in grand rhetoric."[5] Almost concurrently, Millet wrote to his new patron, Emile Gavet, for whom the flower pastels would be destined a year or two later:

> We have had some superb effects of fog and hoarfrost so fairy-like it surpasses all imagination. The forest was marvellously beautiful in this attire, but I am not sure the most modest objects, the bushes and briars, tufts of grass, and little twigs of all kinds were not, in their way, the most beautiful of all. It seems as if Nature wished to give them a chance to show that these poor despised things are inferior to nothing in God's creation. Anyhow, they have had three glorious days.[6]

Notes

1. Numerous viewers have taken exception to this title in the past (as recorded in the files of the Museum of Fine Arts), since the flowers represented are not the primrose widely known in Great Britain and the United States, but a related European flower, the *Primula officinalis*, also known as primrose or cowslip.

2. Millet's fourth flower picture (1871-1874) is a pastel of a stoneware jar filled with field daisies (*marguerites*), paired with an off-center portrait of his daughter Marguerite (Cabinet des Dessins, Musée du Louvre, Paris).

3. Zola's often-quoted definition of a work of art, closing his discussion of the Realists (Salon review, *L'Evenement* [May 11, 1866]).

4. See above, cat. no. 132, n. 3.

5. Manuscript in Millet's hand, with several quotations from de Palissey (Archives of the Cabinet des Dessins, Musée du Louvre, Paris). In addition to taking courage from de Palissey's writings, Millet collected faience with zest.

6. Letter from Millet to Gavet, December 28, 1865 (see letters, below).

Cat. no. 135:
Provenance
Commissioned from the artist by Emile Gavet (sold Hôtel Drouot, Paris, June 11-12, 1975, no. 47), bought by Détrimont, probably for Quincy Adams Shaw, Boston.

Exhibition History
Museum of Fine Arts, Boston, "Quincy Adams Shaw Collection," 1918, no. 49.
Museum of Fine Arts, Boston, "Barbizon Revisited," 1962, no. 75.
Grand Palais, Paris, "Jean-François Millet," 1975, no. 197 (Hayward Gallery, London, 1976, no. 115).

References
Strahan, Edward. *Art Treasures of America*. Philadelphia: George Barrie, 1879, vol. 3, p. 87.
"'Greta' Boston Letter." *Art Amateur* 5, no. 4 (September 1881), p. 72.
Guiffrey, Jean. "Tableaux Français conservés au Musée de Boston et dans quelques collections de cette ville." *Archives de l'art Français* n. s. 7 (1913), p. 547.
"The Quincy Adams Shaw Collection." Boston: Museum of Fine Arts *Bulletin* 16 (April 1918), illus. p. 18.
Cary, Elisabeth Luther. "Millet's Pastels at the Museum of Fine Arts, Boston." *American Magazine of Art* 9 (May 1918), p. 266.
Moreau-Nélaton, Etienne. *Millet raconté par lui-même*. Paris: Henri Laurens, 1921, vol. 3, p. 18, fig. 237.
Durbé, Dario, and Damigella, Anna Maria. *La Scuola di Barbizon*. Milan: Fratelli Fabbri Editore, 1969, p. 22, plate LX.
Pollock, Griselda. *Millet*. London: Oresko Books, 1977, p. 77, no. 54, illus.
Iida, Yuzo. *J.-F. Millet*. Tokyo: Kodansha, 1979, p. 130.

Cat. no. 136:
Provenance
Commissioned from the artist by Emile Gavet (sold Hôtel Drouot, Paris, June 11-12, 1875, no. 94), bought by Carlin; Quincy Adams Shaw, Boston.

Exhibition History
Rue St. Georges 7, Paris, "Dessins de Millet provenant de la Collection de M. G.," 1875, no. 46.
Museum of Fine Arts, Boston, "Quincy Adams Shaw Collection," 1918, nos. 48.
Philadelphia Museum of Art, "Flower Painting," 1963.

References
Burty, Philippe. *Maîtres et petits maîtres*. Paris: G. Charpentier, 1877, p. 308.
Strahan, Edward. *Art Treasures of America*. Philadelphia: George Barrie, 1879, vol. 3, p. 87.
"'Greta' Boston Letter." *Art Amateur* 5, no. 4 (September 1881), p. 72.
Guiffrey, Jean. "Tableaux Français conservés au Musée de Boston et dans quelques collections de cette ville." *Archives de l'art Français* n. s. 7 (1913), p. 547.
Cary, Elisabeth Luther. "Millet's Pastels at the Museum of Fine Arts, Boston." *American Magazine of Art* 9 (May 1918), p. 266.
Moreau-Nélaton, Etienne. *Millet raconté par lui-même*. Paris: Henri Laurens, 1921, vol. 3, p. 18, fig. 239.

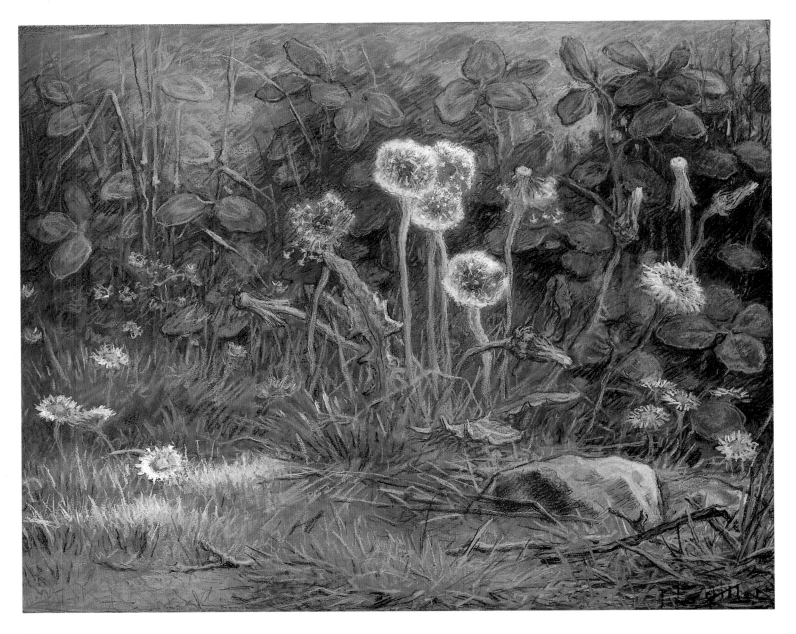

136

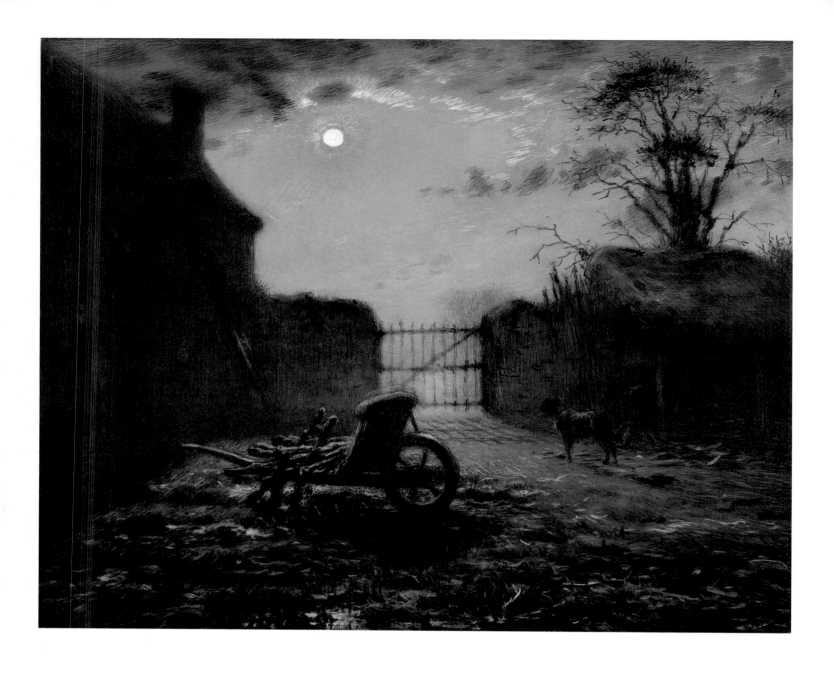

137
Farmyard by Moonlight
1868
Black conté crayon and pastel on buff wove paper
70.9 x 86.7 cm. (27⅞ x 34⅛ in.) – design
73.7 x 92.8 cm. (29 x 36½ in.) – support
Lower right: J. F. Millet
Gift of Quincy Adams Shaw through Quincy A. Shaw, Jr., and Mrs. Marian Shaw Haughton, 1917
17.1525

Ready for Emile Gavet, in the spring of 1868, *Farmyard by Moonlight* marks a startling break in Millet's pastel development, turning back in a rather grand way to his sophisticated black crayon technique of the 1850s. It is essentially a drawing of unusually grand proportions, rather than a pastel; when paired (as it was for Gavet) with *Farmyard in Winter* (cat. no. 138), it should be seen as a confident declaration of Millet's considerable range as a draftsman.

Several years before, Edward Wheelwright had noted Millet's fascination with a line from *Paradise Lost* – "*le silence écoute* "(the silence listens)[1] – and the artist's own notion of silence as a mysterious, fragile quality of great consoling power is noted frequently by other commentators.[2] Silence pervades *Farmyard by Moonlight*, lodged at the very heart of the empty, glowing space beyond the gate, toward which all energy in the picture is drawn. With no effort toward narrative explanation, Millet accented with dramatic light the commonplace details of a quiet farmyard: a dog staring into the distance, a wheelbarrow accorded unexplained prominence in the foreground, a barren tree whose thorny branches pierce the clouds that drift past it. The flood of moonlight radiating across the courtyard wall illuminates the empty middle ground, slipping even into the barren foreground corners and sparkling off the puddle at the center edge. The tension of expectation is made tangible throughout with patterns of lines – in the muddy courtyard, the slatted gate, the scuttling clouds – that all converge beneath the moon on a point hidden by the courtyard wall. Color, its use limited in this drawing, is wholly subservient to line, creating modulations of the background that emphasize drawn details, or picking out tufts of weeds in the foreground.

Alfred Sensier paraphrased, as follows, Millet's intention in drawings such as these: "I want to make those who see my work feel the splendors and the terrors of the night. I want to make them hear the chants, the silences, the rustling of the air, to make them perceive the infinite."[3] And it is as a depiction of atmosphere, not as registered fact, that *Farmyard by Moonlight* should be understood.

Notes

1. As Wheelwright discovered, "*le silence écoute*" is a creation of Milton's French translator, but the phrase was nonetheless apt for Millet (Edward Wheelwright, "Personal Recollections of Jean François Millet," *Atlantic Monthly* 38 [September 1876], p. 273).
2. See Pierre Millet, "Millet's Life at Barbizon," *Century* 47, no. 6 (April 1894), p. 910, and Théophile Silvestre, quoted in John W. Mollett, *The Painters of Barbizon* (London: Sampson, Low, Marston, Searle & Rivington, 1890), p. 43.
3. Alfred Sensier and Paul Mantz, *La Vie et l'oeuvre de J.-F. Millet* (Paris: A. Quantin, 1881), p. 170.

Provenance

Commissioned from the artist by Emile Gavet (sold Hôtel Drouot, Paris, June 11-12, 1875, no. 48), bought by Détrimont, probably for Quincy Adams Shaw, Boston.

Exhibition History

Rue St. Georges 7, Paris, "Dessins de Millet provenant de la Collection de M. G.," 1875, no. 12.
Museum of Fine Arts, Boston, "Quincy Adams Shaw Collection," 1918, no. 44.
National Collection of Fine Arts, Washington, D. C., "American Art in the Barbizon Mood," 1975, no. 9.

References

Strahan, Edward. *Art Treasures of America*. Philadelphia: George Barrie, 1879, vol. 3, p. 86.
"'Greta's' Boston Letter." *Art Amateur* 5, no. 4 (September 1881), p. 72.
Yriarte, Charles. *J.-F. Millet*. Paris: Jules Rouam, 1885, illus. p. 39.
Durand-Gréville, E. "La Peinture aux Etats-Unis." *Gazette des Beaux-Arts* 2nd ser., 36 (July 1887), p. 68.
Mollett, John W. *The Painters of Barbizon*. London: Sampson, Low, Marston, Searle & Rivington, 1890, p. 43.
Guiffrey, Jean. "Tableaux Français conservés au Musée de Boston et dans quelques collections de cette ville." *Archives de l'art Français* n. s. 7 (1913), p. 547.
Moreau-Nélaton, Etienne. *Millet raconté par lui-même*. Paris: Henri Laurens, 1921, vol. 3, pp. 38-39, fig. 252.
Letters of Vincent van Gogh to His Brother. Boston: Houghton Mifflin Co., 1927, vol. 1, p. 170.
Boime, Albert. *Thomas Couture and the Eclectic Vision*. New Haven: Yale University Press, 1980, p. 433.

138
Farmyard in Winter
1868
Pastel and black conté crayon on buff wove paper
68.0 x 88.1 cm. (26¾ x 34⅝ in.) – design
68.2 x 92.8 cm. (26⅞ x 36½ in.) – support
Lower right: J. F. Millet
Gift of Quincy Adams Shaw through Quincy A. Shaw, Jr., and Mrs. Marian Shaw Haughton, 1917
17.1526

Within the gray tonality of a sunless winter day, Millet wrought a complex tapestry of color and texture that places *Farmyard in Winter* at the height of his pastel achievement. A leaden sky, streaked with damp, and a broken layer of heavy wet snow set off with startling crispness basic earth tones of ochers, browns, and red-oranges that gain in the contrast a sparkle usually associated with stronger hues; even the apparently straightforward blacks and whites are actually built of many distinct colors.

Only the new-fallen snow clinging to the smaller branches of the trees is truly white; everywhere else the apparent whiteness is built from the palest shades of green, beige, pink, and blue pastels – overlaid, rubbed into each other, and (in the soggy foreground of the courtyard or on the roof of the poultry hutch) reworked with brush and water. Around the sheaves of yellow-gold grain or along the green-umber fallen fence, the snow glistens and clumps with all the colors Monet or Pissarro ever found in a snow-covered French countryside, expressed with broad strokes of pastel or sharp, strong touches.

Against the snow, the chickens and wild birds swell with softly cross-hatched wisps of intermingled black crayon and pastel color, while an intensely red-breasted robin on the edge of the stone wall glows against the gray sky streaked with blues and whites. Even the damp walls of the enclosure reveal powerful touches of blue-green and green against their softly modeled stones.

Millet's relationship with Emile Gavet, for whom *Farmyard in Winter* and most of the other pastels in the Boston collection were drawn, came very close to his ideal of an exchange between an artist and art lover without the interference of third parties.[1] Gavet paid him fairly (the basic price was renegotiated when others began to demand Millet's pastels) and left him free to choose his subject matter. His interest in Millet's work went beyond the objects he himself

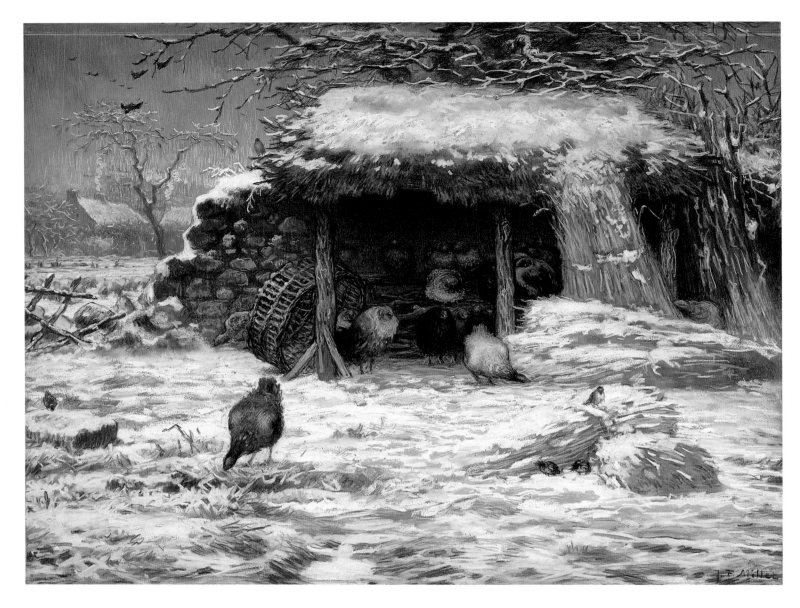

acquired and he seems always to have been supportive. Most important of all, he won a trust that the artist did not grant readily, being given a more intimate view of Millet's love for the natural world or the affairs of his family than he accorded to anyone but Alfred Sensier or Théodore Rousseau (see letters from Millet to Gavet, below). In return, Millet produced for Gavet a body of work in pastel that was without peer in its technical achievement (or in its sensitive advancement of the questions of color and line) until the advent of Degas, and which, in its strong commitment to landscape and the natural world, remains unrivaled.

Notes

1. Letter from Millet to Théophile Silvestre, December 8, 1873 (see letters below).

Provenance

Commissioned from the artist by Emile Gavet (sold Hôtel Drouot, Paris, June 11-12, 1875, no. 10), bought by Durand-Ruel; Quincy Adams Shaw, Boston.

Exhibition History

Museum of Fine Arts, Boston, "Quincy Adams Shaw Collection," 1918, no. 45.

Museum of Fine Arts, Boston, "Barbizon Revisited," 1962, no. 74.

Grand Palais, Paris, "Jean-François Millet," 1975, no. 199 (Hayward Gallery, London, 1976, no. 117).

References

Strahan, Edward. *Art Treasures of America*. Philadelphia: George Barrie, 1879, vol. 3, p. 87.

Guiffrey, Jean. "Tableaux Français conservés au Musée de Boston et dans quelques collections de cette ville." *Archives de l'art Français* n. s. 7 (1913), p. 547.

Moreau-Nélaton, Etienne. *Millet raconté par lui-même*. Paris: Henri Laurens, 1921, vol. 3, fig. 253, p. 39.

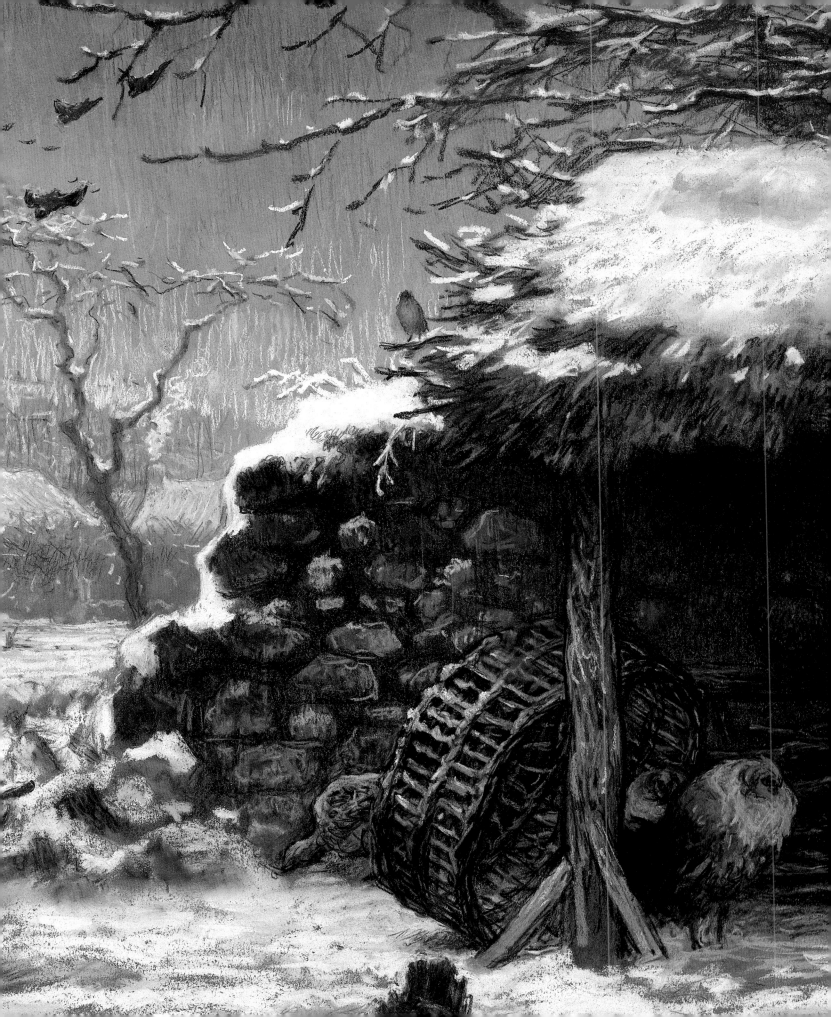

139a
Auvergnat Goatherd Spinning
Delteil 20, only state
1868
Etching on laid paper
20.0 x 12.9 cm. (7⅞ x 5⅛ in.)
Modern Print Fund, 1914
M25337

139b
Auvergnat Goatherd Spinning
Delteil 20, only state
1868
Etching on laid paper with watercolor
20.0 x 12.9 cm. (7⅞ x 5⅛ in.)
Gift of Quincy Adams Shaw through
Quincy A. Shaw, Jr., and Mrs. Marian
Shaw Haughton, 1917
17.1534

Spinner of Auvergne, Millet's last etching, was prepared for a volume organized by Philippe Burty, *Sonnets et eaux-fortes* (Sonnets and Etchings), which featured the work of a number of prominent painter-printmakers: Corot, Daubigny, Manet, and Jongkind, among others. Millet had originally been asked to make an etching based on his pastel *Shepherdesses Watching a Flight of Wild Geese* (see cat. no. 112) to complement the poem matched to his etching by Burty.[1] He preferred, however, to take up a wholly unrelated subject: a goatherd spinning while she tended her animals in the hilly Auvergne region, which he had visited during the preceding summers.[2] *Auvergnat Goatherd* returns to the somewhat looser etching style Millet had favored before *Peasant Couple Going to Work*, with goats and goat girl defined with a casually broken line and landscape details very broadly rendered.

The second impression included here is colored with watercolor. No other handcolored prints by Millet are known, but there is no serious reason to doubt its authenticity. Millet occasionally made one-of-a-kind presentation drawings upon special request or as gifts and this embellished print would seem to fit that category. Its only owner, Quincy Adams Shaw, could have obtained it directly from the artist on one of several trips to Barbizon.

Notes
1. Millet was disturbed by Burty's decision to destroy the plate after a fixed number of impressions in order to ensure the financial value of individual prints. He found the concept of a limited-edition print very troubling but ultimately realized that he had no choice but to acquiesce (letter from Millet to Alfred Sensier, January 15, 1869, Archives of the Cabinet des Dessins, Musée du Louvre,

Paris; quoted in Michel Melot, *L'Oeuvre gravé de Boudin, Corot, Daubigny, Dupré, Jongkind, Millet, Théodore Rousseau* [Paris: Arts et Métiers Graphiques, 1978], p. 289).

2. As he explained to Emile Gavet in a letter of June 17, 1866 (see letters below), the young women spinning with heavy distaffs bore no resemblance to the charming "little shepherdesses spinning with a tiny distaff of the last century."

Cat. nos. 139a and b:

Related Works

Compositional sketch, black conté crayon on paper, 10.6 x 7.0 cm., private collection, Paris.

Auvergnat Goatherd Spinning, pastel with black conté crayon, 92.0 x 55.5 cm., Johnson Collection, Phialdelphia Museum of Art.

Compositional study, black conté crayon on paper, 20 x 13.2 cm., private collection, Japan.

Compositional study squared for transfer, black conté crayon on paper, 30 x 19 cm., private collection, Paris.

Auvergnat Goatherd Spinning, cat. nos. 139a and b.

Cat. no. 139a:

References

Lebrun, Alfred. "Catalogue de l'oeuvre gravé de J.-F. Millet." In Sensier, Alfred, and Mantz, Paul. *La Vie et l'oeuvre de J.-F. Millet*. Paris: A. Quantin, 1881, p. 380, no. 21.

Delteil, Loys. *Le Peintre-graveur illustré (XIX et XX siècles) I, J.-F. Millet, et al.*. Paris: Delteil, 1906, no. 20.

Guiffrey, Jean. "Tableaux Français conservés au Musée de Boston et dans quelques collections de cette ville." *Archives de l'art Français* n. s. 7 (1913), p. 548.

[Herbert, Robert L.]. *Jean-François Millet*. Paris: Editions des Musées Nationaux, Grand Palais exhibition catalogue, 1975, p. 175.

Melot, Michel. *L'Oeuvre gravé de Boudin, Corot, Daubigny, Dupré, Jongkind, Millet, Théodore Rousseau*. Paris: Arts et Métiers Graphiques, 1978, p. 289, no. 20.

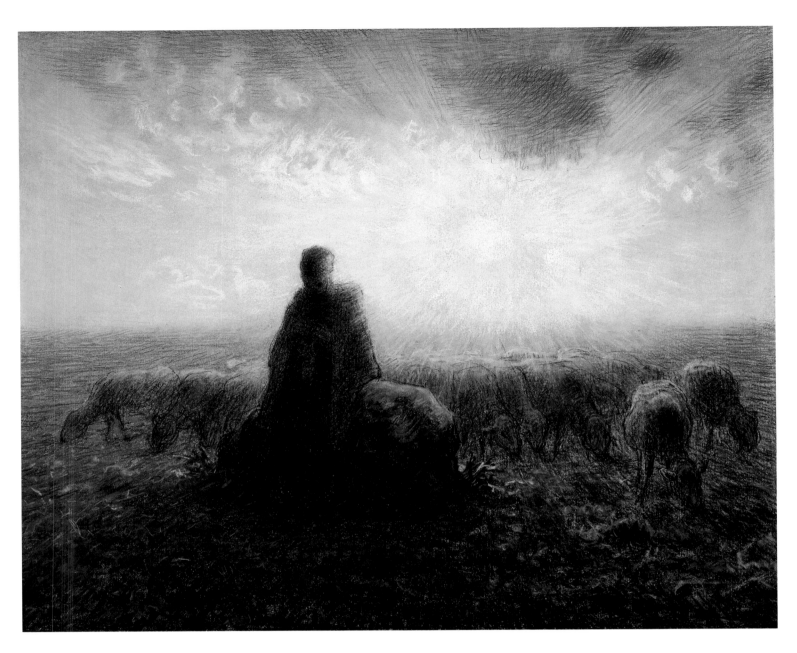

140
Shepherdess and Flock at Sunset
1868-1870
Pastel and black conté crayon on wove
paper
36.7 x 44.3 cm. (14½ x 17⅜ in.) – design
43.5 x 51.3 cm. (17⅛ x 20¼ in.) – support
Lower right: J. F. Millet
Gift of Quincy Adams Shaw through
Quincy A. Shaw, Jr., and Mrs. Marian
Shaw Haughton, 1917
17.1517

The brilliant sinking sun so dramatically dominates *Shepherdess and Flock at Sunset* that the knitting shepherdess and her flock become little more than a pretext here for experimentation with changing light and color effects.

Against the classical armature of a composition familiar since *Shepherdess with Her Flock and Dog* (cat. no. 108) of four or five years earlier, Millet arrayed the flux and color of blinding sunlight to create a virtually abstract pictorial unity. Wrapped in a cloak, the shepherdess forms a solid pyramidal unit with the rock against which she leans. Surrounding her, the sheep ease the transition between her upright form and the spreading fields, heightening the impression of stability and permanence.

But contours blur as form is built with short independent strokes, rather than being contained within continuous outlines, and shepherdess and sheep seem to dissolve where the strong rays of light cut through them. When Millet wanted to maintain a sense of volume, he did so not with conventional interior modeling but by means of concentrated graphic hatchings, mostly black overlaid with strokes of pure color.

If black still plays the major structuring role in the earthly lower half of the image, color reigns unrestrained in the sky above. Millet laid in the sun and its rays in yellow and white, mingling at the outer edges of this rather stylized pattern of radiating lines less regular strokes of pink and orange-

yellow with a hint of turquoise in the upper left corner. Black appears only in the fine, highly animated cross-hatching across the upper edge of the pastel, where night bears down on the the setting sun. Emphasizing change and movement, these black markings temper the extraordinary intensity of the sky and bring it into a more balanced relationship with the earthbound creatures below. It is the sun's rays that graphically unify the image, literally bridging the earth and sky distinctions as they stream across the horizon, merging the mass of sheep in the same high-value yellow, cutting through the shepherdess's silhouette along her left shoulder, and picking out bits of stubble across the plain. With a technique that invested so much descriptive power in graphically expressed color, Millet presaged the critical formal innovations of Impressionism by several years.

Provenance
Commissioned from the artist by Emile Gavet (sold Hôtel Drouot, Paris, June 11-12, 1875, no. 64), bought by Détrimont, probably for Quincy Adams Shaw, Boston.

Exhibition History
Rue St. Georges 7, Paris, "Dessins de Millet provenant de la Collection de M. G.," 1875, no. 28.
Museum of Fine Arts, Boston, "Quincy Adams Shaw Collection," 1918, no. 52.

Related Works
Shepherdess and Flock at Sunset, cat. no. 140.
Shepherdess Guarding her Flock among the Rocks, unfinished oil on canvas, 71.7 x 91.5 cm., Art Institute of Chicago.

References
Cary, Elisabeth Luther. "Millet's Pastels at the Museum of Fine Arts, Boston." *American Magazine of Art* 9 (May 1918), p. 268.
Herbert, Robert L. "Millet Revisited, Part 2." *Burlington Magazine* 104 (September 1962), pp. 381-382, fig. 21.
[Herbert, Robert L.] *Jean-François Millet*. Paris: Editions des Musées Nationaux, Grand Palais exhibition catalogue, 1975, p. 227.

141
Young Shepherdess
About 1870-1873
Oil on canvas
162.0 x 130.0 cm. (63⅞ x 51⅛ in.)
Stamped lower right: J. F. Millet
Gift of Samuel Dennis Warren, 1877
77.249

Life-size, naturalistic figures such as *Young Shepherdess* are virtually unknown in Millet's *oeuvre*, for he consistently preferred a smaller scale of work, even for major Salon paintings such as *Gleaners* (Musée du Louvre, Paris) or *Man with a Hoe* (private collection, United States). Only the large *Sheepshearers* (private collection, Boston, fig. 9) can be compared with the present painting for the sculptural presence of a prominent figure engaging the viewer directly as an equal. In her ambiguous isolation and generalized features, the shepherdess seated on a hillock before the converging fields of the Chailly plain could be a sister to Millet's small *Shepherdess Seated at the Edge of the Forest* (cat. no. 13) of 1849; but whereas that painting was one of the last of Millet's romantic works, *Young Shepherdess* is his most significant effort to monumentalize the figure as an independent formal entity within a contemporary, naturalistic format.

Although *Young Shepherdess* is one of Millet's largest and finest paintings, it cannot be traced to any important commission, nor was it ever exhibited at the Salon.[1] The catalogue of the posthumous Millet studio sale dates it to 1869 – a date accepted by Robert Herbert, although he suggests that Millet was probably still at work on the painting in 1873, when William Low saw it in Millet's studio.[2] The recent discovery of another, earlier painting beneath the surface of *Young Shepherdess* suggests that it should be dated to 1870 or 1871, when Millet's reuse of an earlier canvas can be more readily explained (see below). But whatever the precise date of its conception, the painting dragged on in Millet's studio at least into 1873 (it was unsigned at the time of Millet's death) and it must represent his last effort at a major figure composition. Immediately prior to *Young Shepherdess*, or perhaps concurrent with it, he created two smaller paintings – *Goat Girl of Auvergne* (Musée du Louvre, Paris) and *Shepherdess Seated in the Shade* (cat. no. 147) – that share the artist's concern with a convincing depiction of a large-scale figure out of doors.

But while both of those paintings are

anchored with details of figure type or setting that place them at the border between portraiture and genre painting, *Young Shepherdess* strives for a conflation of modern detail and timeless type that could produce an enduring image of broader significance. Robert Herbert has suggested that the painting may have been inspired by a figure of Ceres, and he further alluded to the young shepherdess's similarity to emblematic representations of the virtue of prudence.[3] Even more significant is her resemblance to multiple images of the Virgin in fifteenth- and sixteenth-century Northern painting, whether enthroned in naturalistic majesty before a vast realistic landscape, or seated upon the ground as the Virgin of Humility. Bright clouds massed behind Millet's shepherdess, as well as the yellow straw hat encircling her face, reinforce a sacred connection, while her distaff – a frequent attribute for both the Virgin and Eve – is, of course, the archetypal emblem of femininity.

Notes
1. The painting is not discussed by either of Millet's major biographers, Alfred Sensier and Etienne Moreau-Nélaton.
2. [Robert L. Herbert], *Jean-François Millet* (Paris: Editions des Musées Nationaux, Grand Palais exhibition catalogue, 1975), p. 209, and William H. Low, "A Century of Painting, Jean-François Millet," *McClure's Magazine* 6 (May 1896), pp. 508-509.
3. The shepherdess's pose is very close to a *Ceres* by Watteau that served as the Summer theme in a similar, early eighteenth-century program of seasons for the dining room of the Crozat townhouse in Paris (National Gallery, Washington, D. C.) (Herbert, op. cit.). Watteau's *Ceres* left France before the nineteenth century, but may have been known to Millet through its engraving in the *Recueil Julienne*, a compendium of engravings after Watteau published in 1726.

Captivity of the Jews in Babylon
1848
Oil on canvas
130.0 x 162.0 cm. (51⅛ x 63⅞ in.)

During the winter of 1983, x-ray examination revealed the existence, beneath the present surface of *Young Shepherdess*, of another image – here identified as Millet's Salon painting of 1848, *Captivity of the Jews in Babylon*. Missing since shortly after the Salon and known only from the comments of contemporary critics and the much later recollection of Alfred Sensier, *Captivity* was Millet's most ambitious attempt to create a large-scale multifigure painting according

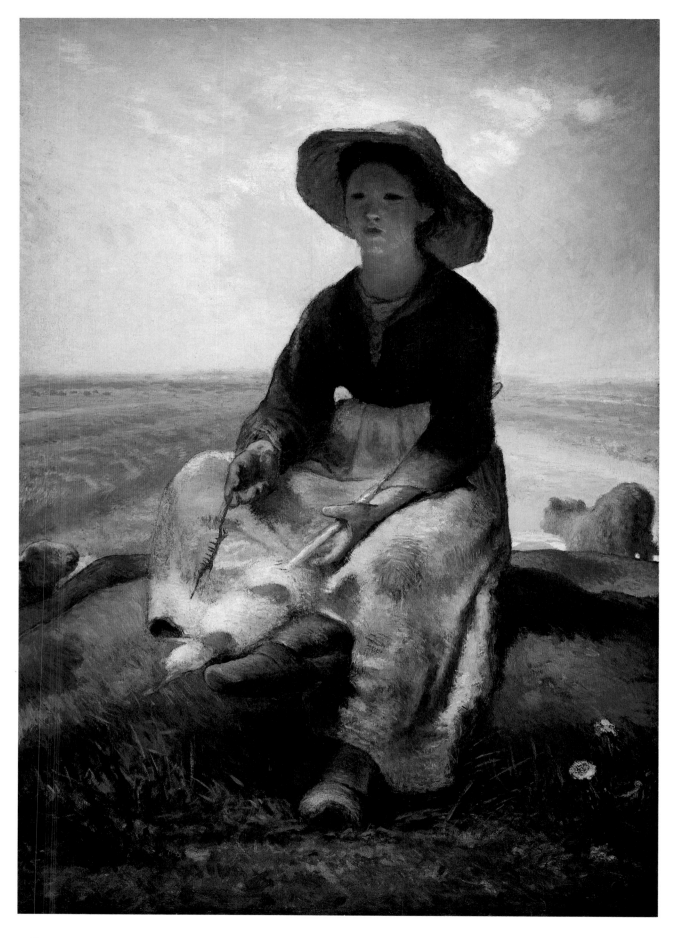

Captivity of the Jews in Babylon (recorded by x-ray photograph), over which Millet painted *Young Shepherdess.*

to academic standards of subject matter, composition, and decorum. In view of his failure to send a competitive painting to the subsequent Salon in 1849 (see cat. no. 13), followed by a dramatic shift to the imagery of peasant life in *The Sower*, (cat. no. 18), submitted to the Salon in 1850-1851, *Captivity of the Jews in Babylon* clearly represented a critical turning in the development of Millet's aspirations to official success.

The fullest description of the painting available to date was left by Millet's biographer, Alfred Sensier: "...a balanced painting conceived in the manner of Poussin."[1] He went on to describe a deep and quiet landscape, crossed by a river and closed with the towering walls of Babylon in the distance. The figures included a group of Assyrian soldiers that Sensier remembered as "more Roman than Asiatic," offering lyres to three women veiled in black. With a grand gesture, one of the captives refused the command to perform.[2] Sensier added that he recalled particularly the graceful, dramatic movement of the young women's arms as they repulsed their captors.

The image available through x-ray fully substantiates Sensier's recollections of the picture, and appears to justify at least some of the remarks recorded by critics, one of whom complained: "The soldiers are pressing the Jewish women...with more vio-

lence than is necessary for recalcitrant virtuosi. They behave as if they were attacking or sacking a city."[3] Most of the critics chastised Millet for his heavily encrusted surfaces (a complaint that continued with *The Sower* [cat. no. 18] in 1850 and *Harvesters Resting* [cat. no. 39] in 1853), while some of the same commentators were able to applaud his power as a colorist – propositions much harder to test with an x-ray image. But of greatest importance is the confirmation of Millet's determined commitment to the prevailing norms of official success.

Taking up the current popular taste for exotic Middle Eastern scenes, Millet demonstrated a certain independence, although by 1848 artists of the stature, if not academic acceptance, of Delacroix had had considerable success with related themes. But by remaining within biblical precedent, he was assured of academic approval for his content. His organization, dependent – as Sensier pointed out – on Poussin, should have assured favorable notice: the soldiers are derived from Poussin's *Death of Germanicus* (Minneapolis Institute of Arts) and *Moses Striking the Rock* (Collection of the Duke of Sutherland), and the Jewish women reflect Poussin types, if they do not copy specific Poussin figures. However, it was in the attitude superimposed on his imagined

characters that Millet failed to answer academic expectations. Théophile Gautier, quoted above, was not the only critic to find the soldiers too violent or too caricatural for their prescribed role. The overall critical reaction, nevertheless, was not condemnatory; while strongly criticizing *Captivity*, nearly every writer also had an encouraging word or two for a young artist they obviously judged worthy of their advice.

When *Captivity of the Jews in Babylon* was found underneath *Young Shepherdess*, the sequence of events surrounding its disappearance fell into place. Desperate for art supplies while waiting out the Franco-Prussian War in Gruchy (1870-1871),[4] Millet must have found it impossible to obtain the amount of canvas needed for a large painting. The old Salon picture, though preserved for over twenty years from the fate of other ignored or rejected Salon pictures by long inaccessibility in the attic or granary of Millet's family's Gruchy homestead (which would explain so much uncertainty about the painting on the part of Millet's Paris and Barbizon friends), was finally sacrificed for *Young Shepherdess*.[5] Traditionally dated to 1869, following the catalogue of the Millet studio sale, *Young Shepherdess* probably did not take form on canvas until the latter part of 1870. Had Millet begun the painting in Barbizon, there would have been little need to scrape off and paint over an earlier image when new canvas would have been readily available.

Notes

1. Alfred Sensier and Paul Mantz, *La Vie et l'oeuvre de J.-F. Millet* (Paris: A. Quantin, 1881), p. 106.
2. The *Captivity's* subject matter, taken from Psalm 137, records the refusal of several Jewish women, abducted to Babylon during an Assyrian assult on Jerusalem in the eighth century B. C., to sing for the entertainment of their captors.
3. Théophile Gautier, Salon review in *La Presse* (May 2, 1868).
4. See Millet's letter to Paul Durand-Ruel, January 9, 1871, archives of the Galerie Durand-Ruel, Paris.
5. *The Temptation of St. Jerome* from the Salon of 1846 was cut up and used for *Oedipus Taken Down from the Tree* in 1847 (National Gallery, Ottawa).

Cat. no. 141:

Provenance

Millet studio sale (Hôtel Drouot, Paris, May 10-11, 1875, no. 35), bought by Durand-Ruel and sold to Samuel Dennis Warren, Boston.

Exhibition History

World's Columbian Exposition, Chicago, "Loan Collection of Foreign Masterpieces," 1893, no. 3060.

Museum of Fine Arts, Boston, "Barbizon Revisited," 1962, no. 77.

Museum of Fine Arts, Boston, "100 Paintings from the Boston Museum," 1970, no. 49.

Grand Palais, Paris, "Jean-François Millet," 1975, no. 168 (Hayward Gallery, London, 1976, no. 90).

National Museum of Western Art, Tokyo, "Human Figure in Fine Art, from the Museum of Fine Arts, Boston," 1978, no. 33.

Related Works

Figure study, black conté crayon on paper, 20.0 x 17.7 cm., Art Institute of Chicago.

Figure study, black conté crayon on paper, 17.1 x 13.4 cm., Cabinet des Dessins, Musée du Louvre, Paris (GM10504).

Figure study squared for transfer, black conté crayon with pastel highlights on paper, 22 x 17 cm., Cabinet des Dessins, Musée du Louvre, Paris (R. F. 30091).

Study for seated shepherdess, crayon on paper, 16 x 10 cm., current location unknown (Montreal art market, 1970s).

Young Shepherdess, cat. no. 141.

References

Mollett, John W. *The Painters of Barbizon*. London: Sampson, Low, Marston, Searle & Rivington, 1890, p. 120.

Cartwright, Julia M. *Jean-Francois Millet, his Life and Letters*. London: Swan Sonnenschein, 1896, p. 184, note.

Low, William H. "A Century of Painting, Jean-François Millet." *McClure Magazine* 6 (May 1896), pp. 508-509.

Naegely, Henry. *J.-F. Millet and Rustic Art*. London: Elliot Stock, 1898, p. 49.

Moore, W. Hudson. "The Barbizon School." *Chautauquan* (January 1903), p. 426.

Peacock, Netta. *Millet*. London: Methuen & Co., 1905, illus. p. 108.

Guiffrey, Jean. "Tableaux Français conservés au Musée de Boston et dans quelques collections de cette ville." *Archives de l'art Français* n. s. 7 (1913), p. 549.

Venturi, Lionello. *Les Archives de l'impressionnisme*. Paris: Éditions Durand-Ruel, 1939, vol. 2, p. 186.

Gosling, Nigel. "Millet's Peasant Revolution." *Observer Magazine* (January 25, 1976), illus. p. 20.

Amaya, Mario. "Millet's Agrarian Classicism." *Art in America* (May/June 1976), illus. p. 58.

142
Buckwheat Harvest
1868-1870
Pastel and black conté crayon on wove paper
74.0 x 95.8 cm. (29⅛ x 37¾ in.) – design
75.8 x 97.8 cm. (29⅞ x 38½ in.) – support
Lower right: J. F. Millet
Bequest of Mrs. Martin Brimmer
06.2425

Described by the French as black wheat, buckwheat produces a poor grade of bread, but, as one of a very small number of foodstuffs that could thrive on the thin soils and short growing seasons of the Northern coast, it was widely cultivated in Normandy during Millet's lifetime. Harvests of buckwheat can be distinguished by the manner in which the flowery tips of the cut stalks are bound into round-headed shocks instead of the cylindrical sheaves characteristic of other grains.[1] Millet's precision in recording the rural scene extends here to the distinctive baskets used for carrying cut grain to the threshing circle in a countryside that could support few work animals, as well as to the pitch-roofed steeple of the church far in the distance, which identifies the building as that at Gruchy (as opposed to the polygonal spire at Chailly; see letters).

The harvesters perform their varied tasks in a sequence that carries the viewer through the harvest rhythm as well as the picture space, from the woman loading the dried grain shocks in the center foreground through the workers who carry the grain to the stack at the far right on into the circle of threshers in the background and the figure lifting away the broken straw with a pitchfork. Such a narrative quality is unusual in Millet's art and, when coupled with the specificity of description in the pastel, it represents an effort to preserve a fading memory. At the time he created this work, Millet had not spent a summer in Gruchy in sixteen years.

Buckwheat Harvest is a large pastel, comparable in size to most of Millet's important paintings, and he relied heavily upon a black crayon drawing to unify the two distinct spaces of the deep composition. Repeated webs of black line draw background and foreground figures together across the open field between, and soften the color of even the foremost figure's costume. Only muted blues in a thresher's pants or harvester's apron or the soft oranges of faded kerchiefs offset the unusually high-key tonality, determined by the white chalky smoke rising from the straw

and chaff burned after the wheat is threshed loose. The grain shocks and broken stubble of the foreground are the sole section in which pastel is worked freely and intensively, although even in this area, a broad, black drawing defines the composition.

Ready for Emile Gavet just before Millet's departure for Cherbourg in 1870,[2] the present work is a variant of a composition that also exists in an oil painting (cat. no. 150). The pictures were executed in quick succession, the pastel serving as the model for the painting that was part of a series of Four Seasons commissioned by Frédéric Hartmann. Unlike the oil version, however, the pastel *Buckwheat Harvest* probably stood alone as an independent composition, rather than as a representation of Summer.

Notes

1. *Encyclopedia Britannica* (Cambridge, 11th ed., 1910), vol 4, p. 733.

2. A manuscript (archives of the Galerie Durand-Ruel, Paris) lists *La Recolte de Sarrasin* (*Buckwheat Harvest*) as one of seven pastels ready to be picked up by Gavet on August 8, 1870.

Provenance

Commissioned from the artist by Emile Gavet (sold Hôtel Drouot, Paris, June 11-12, 1875, no. 52), bought by Martin Brimmer, Boston; Mrs. Martin Brimmer, Boston, 1896.

Exhibition History

Rue St. Georges 7, Paris, "Dessins de Millet provenant de la Collection de M. G.," 1875, no. 6.

Related Works

Figure study of woman picking up sheaf of grain, black conté crayon on paper, private collection, Japan.

Buckwheat Harvest, cat. no. 142.

Buckwheat Harvest, Summer, cat. no. 150.

References

Chesneau, Ernest. "Jean-François Millet." *Gazette des Beaux-Arts* 2nd ser., 11 (May 1875), illus. p. 438.

Guiffrey, Jean. "Tableaux Français conservés au Musée de Boston et dans quelques collections de cette ville." *Archives de l'art Français* n. s. 7 (1913), p. 550.

Pollock, Griselda. *Millet*. London: Oresko Books, 1977, p. 92, pl. VIII.

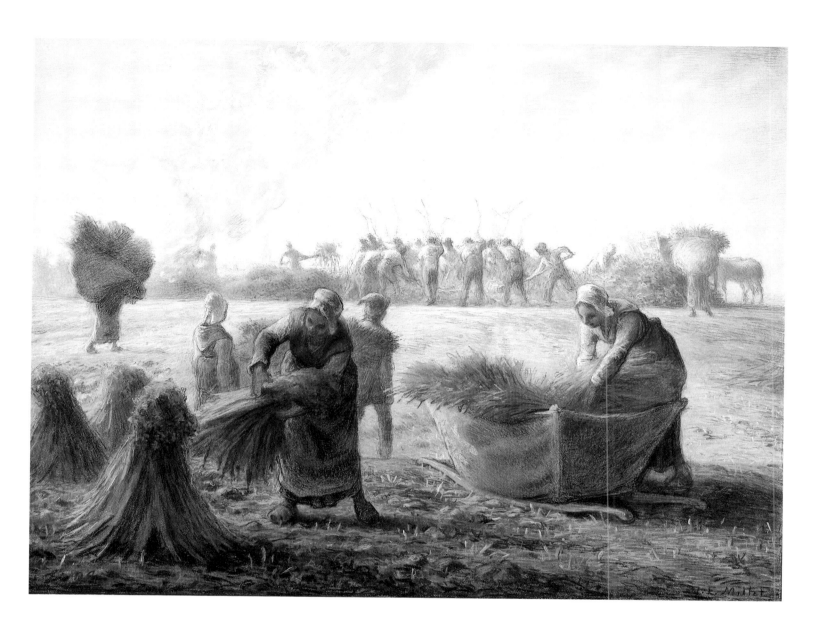

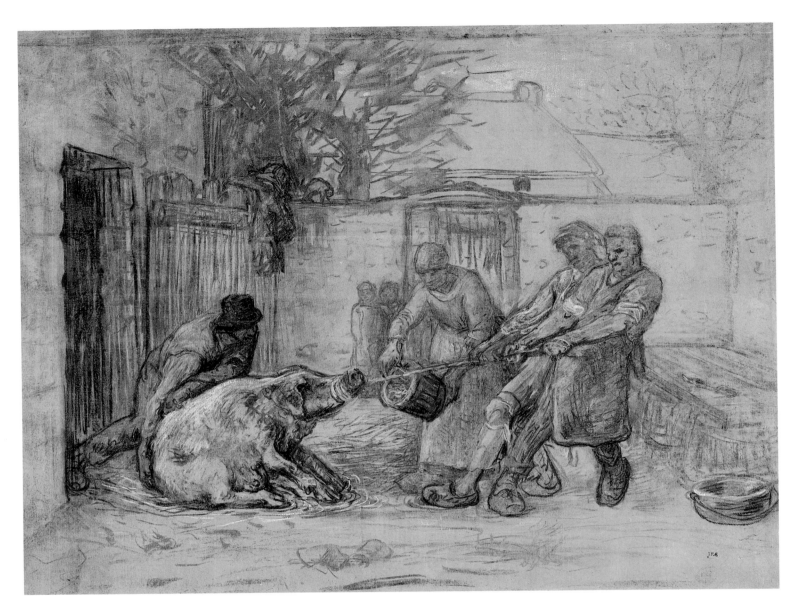

143
Killing the Hog
About 1867-1870
Charcoal and pastel on beige prepared
canvas
68.0 x 88.4 cm. (26¾ x 34¾ in.)
Stamped, lower right: J. F. M
Gift of Mrs. Samuel D. Warren, 1892
92.2640

An unfinished painting rather than the pastel drawing it appears to be at first glance, *Killing the Hog* represents the initial step in the actual execution of a painting, after all the individual study drawings have been made. Drawn on the canvas in charcoal (because it could be easily brushed off or covered by oil paint more readily than the crayon medium Millet generally used for drawing), such a preliminary stage of a painting was not usually colored with pastel; thus the rapidly executed touches of color in cat. no. 143 are probably a later addition. Their fluency suggests that Millet added the pastel himself, perhaps in an effort to make an abandoned painting into a satisfactory drawing.[1]

An activity that since medieval times has been associated with the months of November or December, the slaughter of the fatted hog was a very real event in the lives

of nineteenth-century French peasants. In *Killing the Hog*, Millet focused on the dramatic moment when the stubborn animal resists being pushed, pulled, or coaxed across a courtyard to its slaughter. On the stone slab where the animal will be killed, a knife rests above the empty basin placed to catch the blood that will later be used for sausage. In the background two little children watch in fascination from a safe distance.

The presence of the curious children (as well as the subject matter and general compositional framework) relates *Killing the Hog* to sixteenth-century paintings of peasant life and specifically to the example of Pieter Brueghel the Elder. Brueghel's work was much on Millet's mind in the late 1860s – his visit to Gruchy in 1866 had reminded him of Brueghel's villages, for instance[2] – and *Killing the Hog* represents

his effort to bring the earlier themes up-to-date.

Notes

1. *Killing the Hog* was set aside by Millet when he took up the version of the same theme now in the National Gallery of Canada. The painting in Ottawa differs primarily in the use of a longer, lower courtyard for the setting. Since both canvases share the same basic proportions, the scene could have been redrawn over the Boston work, had Millet wished to do so. The change in canvases can only be accounted for by a desire on Millet's part for a slightly larger format for the painting.

2. Letter from Millet to Alfred Sensier, February 6, 1866 (Archives of the Cabinet des Dessins, Musée du Louvre, Paris), quoted in Etienne Moreau-Nélaton, *Millet raconté par lui-même* (Paris: Henri Laurens, 1921), vol. 3, p. 3.

Provenance

P. Barbédienne (sold Hôtel Drouot, Paris, April 27, 1885, no. 79); R. Austin Robertson, partner in A. A. A. (American Art Association, New York, April 7-8, 1892, no. 41), bought by Mrs. Samuel D. Warren, Boston.

Exhibition History

American Art Association, New York, "The Works of Antoine-Louis Barye...his Contemporaries and Friends," 1889, no. 650.

Related Works

Compositional sketch on a page with several different sketches, pencil on paper, 19.0 x 29.0 cm., Cabinet des Dessins, Musée du Louvre, Paris (GM10691).

Compositional sketch, black conté crayon on paper, 3.3 x 5.2 cm., Cabinet des Dessins, Musée du Louvre, Paris (GM10439).

Compositional sketch, black conté crayon on paper, 5.3 x 8.1 cm., Cabinet des Dessins, Musée du Louvre, Paris (GM10440).

Compositional sketch, black conté crayon on paper, 4.1 x 6.7 cm., Cabinet des Dessins, Musée du Louvre, Paris (GM10441).

Studies of hog, black conté crayon on paper, 31.7 x 20.1 cm., Cabinet des Dessins, Musée du Louvre, Paris (GM10692).

Killing the Hog, cat. no. 143.

The Pig Slaughter, oil on canvas, 73 x 92.7 cm. (28¾ x 36½ in.), National Gallery of Canada, Ottawa.

144
Farm in Normandy
1870-1871
Pen and brown ink over pencil on laid paper
18.0 x 23.6 (7⅛ x 9¼ in.)
Stamped, lower left: J. F. M
Stamped, verso: VENTE MILLET
Gift of Martin Brimmer, 1876
76.428

In August of 1870, as Prussian troops moved toward the heart of France, Millet and his family fled to Cherbourg, staying for the duration of the Franco-Prussian War and the period of the Paris Commune, and returning to Barbizon only in late 1871. In the area around Gruchy, Millet made a number of pen-and-ink drawings of cherished sites that recall his landscape studies in Vichy (cat. nos. 117-127). The identification of this drawing with Normandy is supported by the style of the farm buildings, having gable walls that rise above the roof line, a feature of rural architecture in La Manche.

With its band of densely packed buildings and trees across the center of the sheet, between two equally broad bands of open sky and empty foreground, *Farm in Normandy* finds a precedent in Rembrandt's landscape drawings and etchings of the 1640s. The regularity of Millet's touch throughout the drawing, however, creates an open, ordered view of the landscape at odds with the Dutch master's strongly accented views.

Provenance

Millet studio sale (Hôtel Drouot, Paris, May 10-11, 1875, no. 210), bought by Richard Hearn for Martin Brimmer, Boston.

Exhibition History

Phillips Collection, Washington, D. C., "Drawings by J. F. Millet," 1956.

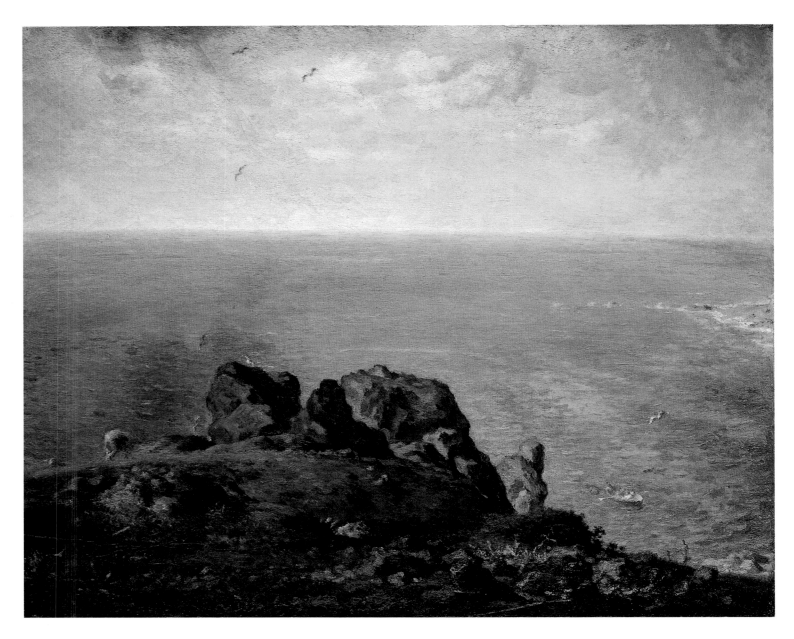

145
Cliffs at Gruchy
1870-1871
Oil on canvas
60.1 x 73.9 cm. (23⅝ x 29⅛ in.)
Lower right: **J. F. Millet**
Verso: *Fait à Cherbourg 1870*
**Gift of Quincy Adams Shaw through
Quincy A. Shaw, Jr., and Mrs. Marian
Shaw Haughton, 1917**
17.1529

The path leading out of Gruchy to the channel coast winds down to the outcropping of rock depicted in *Cliffs at Gruchy*, just at the point where the rugged, rocky pasturelands finally break into a dramatic fall of cliffs, high above the sea. A few feet above and behind these rocks rises another, flatter boulder, providing the natural bench from which Millet recorded the vastness of the sea beneath and before him.[1]

Following his intensive landscape studies in Vichy in 1866, Millet began to force the horizons of his paintings and pastels unusually high or to choose seemingly unpromising viewpoints that resulted in startling juxtapositions of land and sky or land and sea. Such compositions shortened great distances by flattening them against the picture surface. As he minimized spe-

cific details in these landscapes, Millet enriched the colors and explored unusual light effects or complex sky formations. His fifteen-month stay in Cherbourg and Gruchy during 1870-1871 produced several finished landscapes – this one sent to Durand-Ruel in his London gallery at the end of February, 1871[2] – as well as a number on which Millet continued to work back in Barbizon.

With its powerful segmentation of the landscape into three distinct zones, *Cliffs at Gruchy* sets the earth against the sea in dramatic contrast, eliminating any mediating element that might rationalize the exceptional drop from the foreground rocks to the tiny rowboat and its two fishermen. The only human presence in the painting, these figures in the lower corner are no

larger than the seagulls screaming and reeling among the rocks to the other side. Their diminished scale accords the rocks a grandeur well beyond the reality of the site. Carved in hard, glinting angles of grays and blues, rising from the softer greens and browns and umbers of the foreground, the immense boulders stand out forcefully against the measureless spaces of the sea.

Turquoises, lavenders, and greens of all description flash between the surface of the sea and the cloud-filled sky above, broken here or there by a whirling bird, while fading pinks slowly reveal themselves in the softened limits of the sea and the clouds hanging low across the horizon. Anchoring the rising wall of blue-green light from corner to corner, the rocky foreground echoes the slow curve of the horizon. Years before, Millet had emphasized that in a landscape painting "every glimpse of the horizon, however narrow, should be felt to be a segment of the great circle that bounds our vision."[3] And from a natural resting place on the path down the Gruchy cliffs, he celebrated the extraordinary simplicity of nature's immensity. *Cliffs at Gruchy*, which Théophile Silvestre considered "the summit of Millet's career," creates a "passionate triple portrait…of the three solitudes, earth, sky, and sea."[4]

Notes

1. The site is not the great rocky cliff (*Le Castel Vendon* or *Les roches du Castel* – the rocks of the castle) just to the east of the Gruchy coast (see map, below), but a much less imposing outcropping directly below the village.
2. Letter from Millet to Alfred Sensier, February 27, 1871, Archives of the Cabinet des Dessins, Musée du Louvre, Paris; quoted in Etienne Moreau-Nélaton, *Millet raconté par lui-même* (Paris: Henri Laurens, 1921), vol. 3, p. 68. A number of Millet's dramatic Normandy landscapes were handled by Durand-Ruel, who, while staying in London during the Franco-Prussian War, became the dealer for the younger Claude Monet, another Norman, whose own seascapes of the Normandy coast of the 1880s are so indebted to Millet's work.
3. Paraphrased by Edward Wheelwright ("Personal Recollections of Jean François Millet," *Atlantic Monthly* 38 [September 1876], p. 264).
4. Letter of Théophile Silvestre to Monsieur Asselin, February 25, 1871; quoted in Alfred Sensier and Paul Mantz, *La Vie et l'oeuvre de J.-F. Millet* (Paris: A Quantin, 1881), pp. 334-335.

Provenance

With Durand-Ruel, London and Paris (1871); Quincy Adams Shaw, Boston.

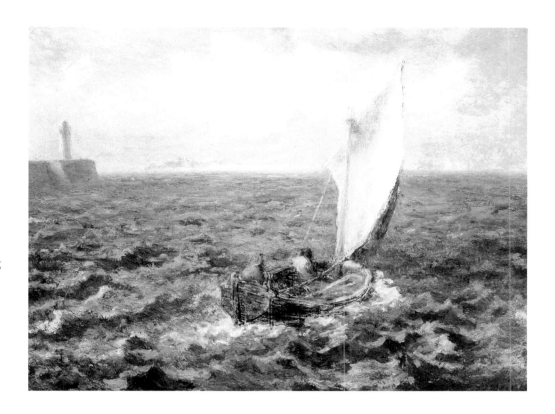

Exhibition History

German Gallery, London, "First Annual Exhibition of the Society of French Artists," organized by Paul Durand-Ruel, 1871, no. 70.
American Art Association, New York, "The Works of Antoine-Louis Barye…his Contemporaries and Friends," 1889, no. 552.
Museum of Fine Arts, Boston, "Quincy Adams Shaw Collection," 1918, no. 26.
Grand Palais, Paris, "Jean-François Millet," 1975, no. 219 (Hayward Gallery, London, no. 133).

References

Sensier, Alfred, and Mantz, Paul. *La Vie et l'oeuvre de J.-F. Millet*. Paris: A. Quantin, 1881, pp. 334-335.
Durand-Gréville, E. "La Peinture aux Etats-Unis." *Gazette des Beaux-Arts* 2nd ser., 36 (1887), p. 68.
Cartwright, Julia M. *Jean-François Millet, his Life and Letters*. London: Swan Sonnenschein & Co., 1896, pp. 330-332.
Peacock, Netta. *Millet*. London: Methuen & Co., 1905, pp. 129-131.
Guiffrey, Jean. "Tableaux Français conservés au Musée de Boston et dans quelques collections de cette ville." *Archives de l'art Français* n. s. 7 (1913), p. 547.
"The Quincy Adams Shaw Collection." Boston: Museum of Fine Arts *Bulletin* 16, no. 94 (April 1918), p. 16, illus.
Moreau-Nélaton, Etienne. *Millet raconté par lui-même*. Paris: Henri Laurens, 1921, vol. 3, p. 69, fig. 263.
Edgell, George Harold. *French Painters in the Museum of Fine Arts: Corot to Utrillo*. Boston: Museum of Fine Arts, 1949, p. 21.

146
Fishing Boat
1871
Oil on canvas
24.7 x 33.0 cm. (9¾ x 13 in.)
Lower right: […]llet
Gift of Quincy Adams Shaw through Quincy A. Shaw, Jr., and Mrs. Marian Shaw Haughton, 1917
17.1530

During the fifteen months Millet spent in Cherbourg, the sea was an ever-present force, newly compelling to him in his recent commitment to landscape painting. He made several paintings of the Channel coast, of which *Fishing Boat*, which balances a strikingly painted sweep of sea with a sky of unusual color and weight, is probably the first.[1]

For the cresting sea, Millet chose a vibrantly blue-green palette, heightened with rapid, choppy strokes of turquoises, green-ochers and emeralds, and softened by lavenders and grays near the horizon, where the distinctive pink-brown sky of the Norman coast dominates the reflections in the water. The whole is executed with a dry crusty pigment built up in thick layers in the foreground and across the sky. The often-remarked relationship to Delacroix bears repeating, for the ensemble is virtually a reprise of one of his popular, repeated compositions, *Christ on the Lake of*

Gennesareth:[2] the color – in the yellow-brown boat lodged in the blue-green sea with a mediating foam of white – is especially reminiscent of the older master. Launching himself on a new phase of painting, Millet followed his familiar pattern of approaching new problems through the experience of a trusted predecessor.

Notes

1. *Fishing Boat* is the "small" second painting sent to Durand-Ruel during February of 1871 (letter from Millet to Alfred Sensier, February 27, 1871, Archives of the Cabinet des Dessins, Musée du Louvre, Paris; quoted in Etienne Moreau-Nélaton, *Millet raconté par lui-même* [Paris: Henri Laurens, 1921], vol. 3, p. 68).

2. Three versions of Delacroix's composition were exhibited in the "Exposition des Oeuvres d'Eugène Delacroix" (1864, 26 Boulevard des Italiens, Paris), which Millet visited at least once (Alfred Sensier and Paul Mantz, *La Vie et l'oeuvre de J.-F. Millet* [Paris: A. Quantin, 1881], p. 257). One of those paintings had belonged to Constant Troyon, a frequenter of Barbizon and a friend and supporter of Millet. Millet himself drew a composition of Christ on the Lake (Cabinet des Dessins, Musée du Louvre, Paris [GM10715]), which is closely dependent upon Delacroix.

Provenance

Probably with Durand-Ruel, London and Paris; Quincy Adams Shaw, Boston.

Exhibition History

American Art Association, New York, "The Works of Antoine-Louis Barye…his Contemporaries and Friends," 1889, no. 552.

Museum of Fine Arts, Boston, "Quincy Adams Shaw Collection," 1918, no. 21.

Museum of Fine Arts, Boston, "Barbizon Revisited," 1962, no. 79.

Wildenstein & Co., London, "J.-F. Millet," 1969, no. 47.

Miami Art Center, "The Artist and the Sea," 1969, no. 27.

Grand Palais, Paris, "Jean-François Millet," 1975, no. 218 (Hayward Gallery, London, 1976, no. 132).

Clark Art Institute, Williamstown, Massachusetts, "Jongkind and the Pre-Impressionists: Painters of the Ecole Saint-Siméon," 1976-1977, no. 88.

Museum of Fine Arts, Boston, "Corot to Braque: French Paintings from the Museum of Fine Arts, Boston," 1979, no. 17.

References

Moreau-Nélaton, Etienne. *Millet raconté par lui-même*. Paris: Henri Laurens, 1921, vol. 3, pp. 70-71, fig. 264.

Barbey d'Aurevilly, J. *Sensations d'art*. Paris, 1857, pp. 120-121.

147
Shepherdess Seated in the Shade
1872
Oil on canvas
65.3 x 54.8 cm. (25¾ x 21⅝ in.)
Lower left: J. F. Millet
Robert Dawson Evans Collection. Bequest of Mrs. Robert Dawson Evans, 1917
17.3235

The spangles of colored light breaking across a young shepherdess's apron and spreading out over the forest floor are as close as Millet would come to the form-destroying effects of bright light that so strongly appealed to the Impressionists. Among his many images of a shepherdess resting in a sheltered spot while her sheep grazed nearby, *Shepherdess Seated in the Shade* marks the first time he moved beyond the basic contrast between light-filled field and dark, shadowed wood to exploit the more complex fragmentation of light as it filters through a screen of foliage. Using the same subject matter with which he first began to unravel the problems of painting in Fontainebleau Forest or amid the scattered copses of the Chailly plain, he took up the challenge of a group of younger artists much admired by his own dealer.

With a varied thickness to his brush strokes and a modulated paint consistency, Millet captured the effect of sunlight changing as it moved across the filtering branches of a tree to highlight the edge of the rock before which the young shepherdess sits. He created a backdrop for her flickering silhouette by softening the color of the rock to emphasize the light catching on her shoulder, along her sleeve, and on the edge of her skirt. But it is in changes in the color of her apron – from the hot salmon-white touches of sunlight to the blue-beige shimmer of the shadows along her side – and in the soft, dissolving quality of beams of light as they finally break up on the irregular surface of grass and moss beside her, that Millet's new interest is most directly asserted. Although the light source softly defining the young woman's face is outside the painting, Millet did take into account its effect in a dark wooded setting, offsetting the pink flush of her cheeks with green-blue reflections and shadows. Such visual problems had been tacitly recognized in many of his paintings and pastels well back into the 1850s – the blue shadows on the face of the young child in *Knitting Lesson* of 1854 can stand against Renoir's records of similar light effects – but as an artist committed to class-

ical values of clear, well-defined form, Millet had never addressed them so directly. *Shepherdess Seated in the Shade* is a studio painting, for, as far as is known, Millet never took up *plein-air* painting. But in his commitment to more accurately observing and recording the effects of changing natural light (rather than a more static studio light), he acknowledged the significance of the Impressionists' tenets.

When the Boston-born painter William Perkins Babcock saw *Shepherdess Seated in the Shade* in the galleries of Durand-Ruel during the spring of 1872, he remarked that the picture surely didn't belong in the art trade, but ought to be with those able to love it.[1] Knowing Millet's art so well, he could readily gauge the important shift that such a painting represented, and it comes as no surprise to learn further that it was Alfred Sensier who acquired it from Durand-Ruel, joining it to so many of Millet's other epoch-defining pictures already in his collection.

Notes

1. Quoted in Etienne Moreau-Nélaton, *Millet raconté par lui-même* (Paris: Henri Laurens, 1921), vol. 3, p. 85.

Provenance

With Durand-Ruel, Paris (1872); Alfred Sensier (sold Hôtel Drouot, Paris, December 10-18, 1877, no. 49); Alexander Young, Scotland (by 1890); Edward Brandus (sold Fifth Avenue Galleries, New York, March 29-30, 1905, no. 189), bought by Eugène Fishoff, Paris; Robert Dawson Evans, Boston (by 1908), Mrs. Robert Dawson Evans (1909), bequeathed to the Museum with life interest to the Misses Abby and Belle Hunt, Boston.

Exhibition History

Royal Academy, Glasgow, "Old Masters," 1896, no. 55.

Copley Society, Boston, "The French School of 1830," 1908, no. 39.

Museum of Fine Arts, Boston, "Evans Memorial Gallery Opening Exhibition," 1915.

Cleveland Museum of Art, "Inaugural Exhibition," 1916, no. 18.

Kunsthalle, Zurich, "Les Chef-d'oeuvres inconnus," 1956.

Grand Palais, Paris, "Jean-François Millet," 1976, no. 234 (Hayward Gallery, London, 1976, no. 142).

Related Works

Compositional sketch, black chalk on paper, 42.0 x 29.2 cm., Whitworth Art Gallery, Manchester.

Study for figure, black conté crayon on paper, 16.6 x 21.8 cm., Cabinet des Dessins, Musée du Louvre (GM10443).

Figure study, black conté crayon on paper, 17.0 x 23.2 cm., private collection, Paris.

Study of shepherdess's face, 22.1 x 17.7 cm. (sight), private collection, London.

Shepherdess Seated in the Shade, cat. no. 147.

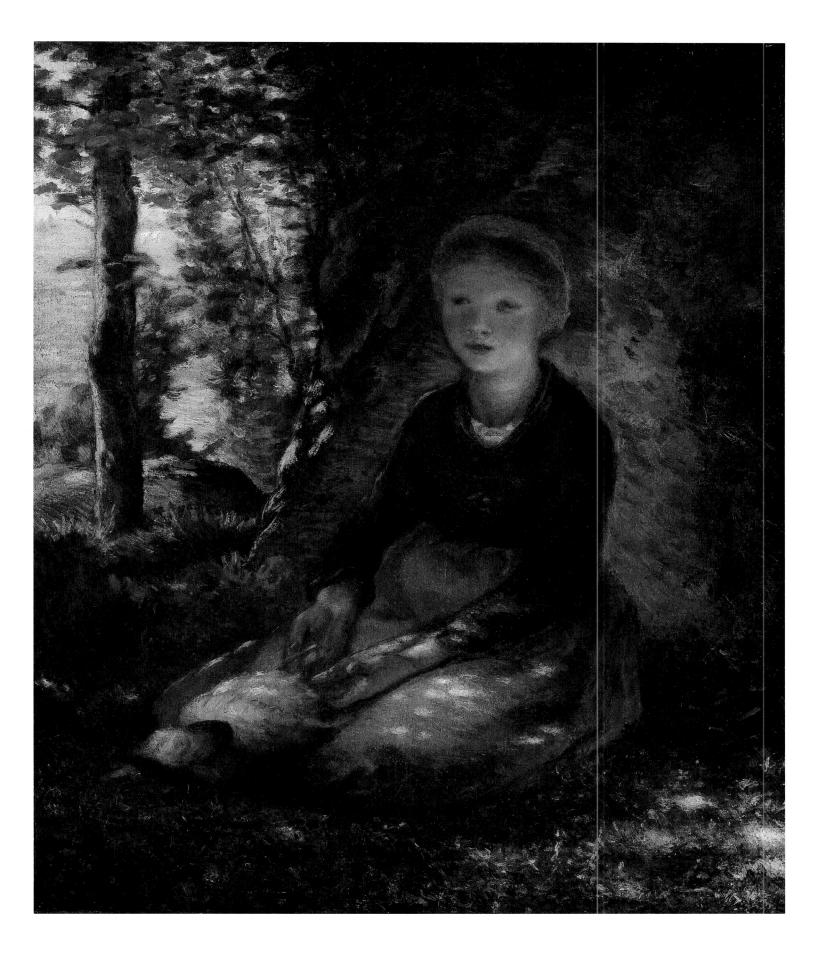

References

Cartwright, Julia M. *Jean-François Millet, his Life and Letters*. London: Swan Sonnenschein, 1896, p. 370.

Thomson, David Croal. *The Barbizon School of Painters*. London: Chapman and Hall, 1902, p. 238 (dated incorrectly to 1863).

Moreau-Nélaton, Etienne. *Millet raconté par lui-même*. Paris: Henri Laurens, 1921, vol. 3, p. 85, fig. 271.

Jaworskaja, N. W. "Die franzosische Kunst von des franzosischen Revolution bis zur Pariser Kommune." *Allgemeine Geschichte der Kunst, VII, Die Kunst des 19 Jh*. Leipzig: E. A. Seeman, 1964, p. 95.

148
Peasant Watering Her Cow, Evening
1873-1874[1]
Oil on canvas
81.5 x 100.3 cm. (32⅛ x 39½ in.)
Gift of Quincy Adams Shaw through Quincy A. Shaw, Jr., and Mrs. Marian Shaw Haughton, 1917
17.1531

The somber landscape, its sky turned a lurid yellow-green by the faint moonlight, provides a desolate setting for one of Millet's often-depicted scenes: a poor young woman tending her single cow. In an earlier painting, cat. no. 105, a similarly composed landscape offered a more welcoming twilight that absorbed the figure and her animal in a peaceful image for the end of the day. But in *Peasant Woman Watering Her Cow, Evening,* the clouds moving rapidly across the olive-tinged sky, the wind-bent tree, and the distracted geese scuttling up the embankment reinforce the tension apparent in the young woman's unbalanced forward movement, as she hurries her animal along. With her cloak tied around her face and the hand with which she supports herself on her staff held closely to her body for warmth, she suggests the approach of winter as well as of evening.

The banal task of following a wandering cow from dawn to dusk, in order to keep it from straying into planted fields or restricted pastures, typified for Millet the dreadful plight of the poorest of the peasantry around Barbizon. As a relatively new chore in their normally unchanging lives, it reflected the impact of a rising class of landowners who profited by closing off fields and forcing the end of many of the communal bonds that once held the rural world together.

Although Millet readily reorganized landscape details to suit the intentions of specific subject matter, he very seldom made so Romantic a use of nature, usually refraining from emphasizing its characteristics forcefully to support a particular image. The preliminary compositional sketch that he used to develop this painting from an earlier pastel features more carefully rendered farm buildings on the horizon and a more stately flock of geese – a far less threatening setting than the larger, colder landscape he finally developed. And unlike earlier versions, which associated a woman watering her cow with characteristics that Millet ordinarily used for the Chailly plain (a shepherd followed by a flock of sheep, a broad flat expanse of land), his peasant woman of 1873 waters her cow in a pond set deep in a hillside that drops far down below the horizon behind. Such is the nature of the rolling landscape of Gruchy, and the single tree bent and broken by the wind is an image Millet specifically associated with Normandy (e.g., *Gust of Wind*; National Museum of Wales, Cardiff). Perhaps the changes that had rocked the Parisian countryside in the 1840s and 1850s were becoming visible in Normandy during his visit of 1870-1871.

Notes

1. Not 1863, as indicated by Etienne Moreau-Nélaton (*Millet raconté par lui-même* [Paris: Henri Laurens, 1921], vol. 2, p. 120). A letter from Millet to Théophile Silvestre (December 8, 1873; see letters below) indicates that Millet had nearly finished a woman watering her cow for Durand-Ruel, undoubtedly this painting.

Provenance

With Durand-Ruel, Paris (1873), Laurent-Richard (sold Hôtel Drouot, Paris, May 23-25, 1878, no. 47); Quincy Adams Shaw, Boston.

Exhibition History

Copley Society, Boston, "100 Masterpieces," 1897, no. 62.

Museum of Fine Arts, Boston, "Quincy Adams Shaw Collection," 1918, no. 7.

Grand Palais, Paris, "Jean-François Millet," 1975, no. 238 (Hayward Gallery, London, no. 143).

Related Works

Compositional sketch, black conté crayon on paper, 19.2 x 20.5 cm., Art Institute of Chicago.

See cat. no. 105.

References

"The Quincy Adams Shaw Collection." Boston: Museum of Fine Arts *Bulletin* 16 (April 1918), illus. p. 13.

Moreau-Nélaton, Etienne. *Millet raconté par lui-même*. Paris: Henri Laurens, 1921, vol. 2, no. 177 (dated incorrectly to 1863).

Venturi, Lionello. *Les Archives de l'impressionnisme*. Paris: Editions Durand-Ruel, 1939, vol. 2, p. 185.

Herbert, Robert L. "Millet Reconsidered." *Museum Studies* (Art Institute of Chicago) 1 (1966), p. 65.

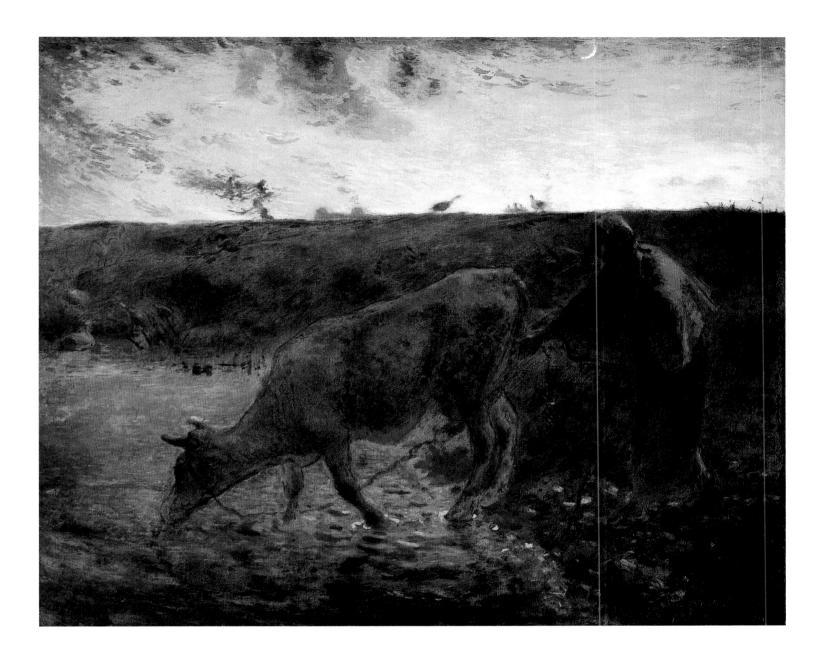

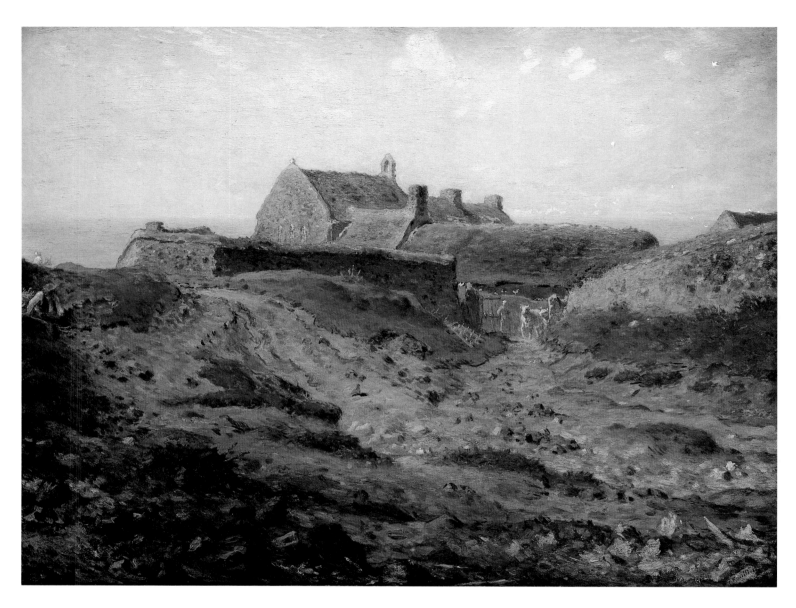

149
Priory at Vauville, Normandy
1872-1874
Oil on canvas
90.0 x 116.7 cm. (35⅜ x 46 in.)
Lower right: J. F. Millet
**Gift of Quincy Adams Shaw through
Quincy A. Shaw, Jr., and Mrs. Marian
Shaw Haughton**, 1917
17.1532

The Priory at Vauville is a cluster of typical Normandy granite farm buildings, set high and isolated among the pasture-covered cliffs on the western side of the Cotentin Peninsula, about six miles from Gruchy. Founded under William the Conqueror in the eleventh century, the priory lost its role as a religious institution during the French Revolution, and in Millet's day the distinctive chapel served as a barn for the resident farmer.[1] Late in the fall of 1871, having

introduced Alfred Sensier to the site during a tour of the area around Gruchy, Millet stayed on to draw the priory from a hillside opposite. When he and his family returned to Barbizon, the priory drawing joined his stock of compositional sketches and landscape studies to be worked into paintings when time or inclination permitted; in 1872, Mr. and Mrs. Quincy Adams Shaw, visiting Barbizon from Boston, commissioned from Millet a painting to be based on the sketch.[2]

Encircled by a high stone wall, the buildings belong to their rocky terrain as if they had grown there. With a careful interworking of similar colors across buildings and landscape, and with a regularity of touch and emphasis throughout, Millet tied hillside and priory together as a single massive unit. Firmly anchoring the structure with the stone wall moving out to left and right

and the horizon carefully aligned behind the chapel roof, Millet brought the seventeenth-century rural architecture of Normandy within the classical French landscape tradition of Poussin. The brushwork of the foreground is free and strong, but the colors of earth, stone and grass are low in key. Only the head of a goose, on the horizon at the left, and the sunlit edges of the cowherd's skirt and kerchief pick up the reds and blues of the sky. Here and there, the random white accents of geese, chickens, cow, and whirling gulls enliven the painted surface.

Notes
1. The priory, like many of the buildings of the Gruchy area depicted by Millet in the 1860s and 1870s, still stands today. Severely damaged during the Second World War, it was reconstructed, exactly as it is depicted in the painting, as a private home.

2. While it is very likely that the Shaws already owned at least one other painting by Millet in 1872, this is the earliest of their acquisitions that can be documented, as well as the only work that they commissioned directly from the artist (letter from Millet to Alfred Sensier, January 8, 1872, Archives of the Cabinet des Dessins, Musée du Louvre, Paris; quoted in part in Etienne Moreau-Nélaton, *Millet raconté par lui-même* [Paris: Henri Laurens, 1921], vol. 3, p. 84). Millet's signed receipt for payment for the painting, dated December 9, 1874, for 15,000 francs is in the Department of Paintings in the Museum of Fine Arts, Boston.

Provenance

Commissioned in 1872 from the artist by Quincy Adams Shaw, Boston (1874).

Exhibition History

Museum of Fine Arts, Boston, "Quincy Adams Shaw Collection," 1918, no. 25.

Related Works

Compositional sketch, black conté crayon on paper, 9 x 13 cm., private collection, Holland.

Studies of woman opening gate for cows, black conté crayon on paper, 26.4 x 18.0 cm., Cabinet des Dessins, Musée du Louvre, Paris (GM10695).

Compositional study, pen and ink with wash on paper, 17 x 24 cm., current location unknown (see Etienne Moreau-Nélaton, *Millet raconté par lui-même* [Paris: Henri Laurens, 1921], vol. 3, fig. 267).

Priory at Vauville, Normandy, cat. no. 149.

A painting of *Priory at Vauville*, oil on canvas, in a private collection is identical to the Boston painting in composition except for different figures and changes in foreground peasants; however, it is not by Millet.

References

Sensier, Alfred, and Mantz, Paul. *La Vie et l'oeuvre de J.-F. Millet*. Paris: A. Quantin, 1881, pp. 348-349, 352, 362-363.

Durand-Gréville, E. "La Peinture aux Etats-Unis." *Gazette des Beaux-Arts* 2nd ser., 36 (July 1887), p. 68.

Mantz, Paul. *Catalogue descriptif. . .J.-F. Millet*. Paris: Ecole des Beaux-Arts, 1887, p. 32.

Cartwright, Julia M. *Jean-François Millet, his Life and Letters*. London: Swan Sonnenschein, 1896, pp. 331-332, 334, 339, 344.

Peacock, Netta. *Millet*. London: Methuen & Co., 1905, p. 132.

"The Quincy Adams Shaw Collection." Boston: Museum of Fine Arts *Bulletin* 16 (April 1918), p. 16, illus. p. 15.

Moreau-Nélaton, Etienne. *Millet raconté par lui-même*. Paris: Henri Laurens, 1921, vol. 3, pp. 78-79, 84, 87, 102, 104, fig. 272.

150

Buckwheat Harvest, Summer
1868-1874
Oil on yellow-ocher prepared canvas
85.5 x 111.1 cm. (33⅝ x 43¾ in.)
Stamped, lower right: J. F. Millet
Gift of Quincy Adams Shaw through Quincy A. Shaw, Jr., and Mrs. Marian Shaw Haughton, 1917
17.1533

Representing Summer[1] in a set of the Four Seasons, *Buckwheat Harvest* depicts a distinctively Norman harvest scene and is based on a pastel of a few years earlier (cat. no. 142). The painting is unfinished – only *Spring* (Musée du Louvre, Paris) and *Haystacks, Autumn* (Metropolitan Museum of Art, New York), were delivered before Millet's death in 1875 – but, as the artist remarked, it needed only "a good push" to complete it.[2] In the broad, dry strokes that summarize the edges of clouds and the umber-green shadow that cools the face of the harvester in the foreground, Millet left several indications of how close that final push would have brought him to the defining characteristics of Impressionist painting.

Frédéric Hartmann, a wealthy industrialist,[3] visited Millet in March of 1868 and left a commission for a Four Seasons series; in April Millet asked Alfred Sensier to order on his behalf four specially prepared canvases, three with a dark lilac-rose ground and one with yellow-ocher, the last the support upon which *Buckwheat Harvest* is painted.[4] Based on a group of pastels that had been individually designed for Emile Gavet (one or two of which *might* have been available for Hartmann to see as prototypes),[5] the series departs from many of the unifying conventions usually associated with the Four Seasons. All four paintings differ substantially in their basic organization: two of the group, *Spring* and *Autumn*, are pure landscapes, while *Buckwheat Harvest, Summer* and *Winter* (National Gallery of Wales, Cardiff) are figural compositions in landscape settings. It is clear that the commission mattered to Millet mainly as an opportunity to improve upon, in large paintings, four landscape compositions of great interest to him.

The pastel version of *Buckwheat Harvest* was finished before Millet and his family fled the advancing Prussian armies to Cherbourg in August of 1870, and its distinctive white-blue color scheme could not have been derived from direct observation. But the long stay in Cherbourg in 1870 and Gruchy during the following summer

would have given him at least one more opportunity to study the Norman peasants harvesting their grain, and many of the small changes that occur between the pastel and the painting suggest careful observation. The most significant difference, the fundamental shift in tonality to an all-pervasive golden-brown that colors even the sky, was planned from the beginning with the deliberate choice of a yellow-ocher canvas for the base of the painting. But the hot, dusty summer effect is heightened throughout with the intensification of red-oranges in the clothing of the foreground women and the reiteration of dry straw colors across the entire harvested field (accented by sharp touches of reds and ruddy-browns – and even several very unusual pairings of yellow and green paint strokes). A more amusing new observation is the racing dogs and children who play tag across the background scene.

The most important question about *Buckwheat Harvest* is precisely how much further Millet would have "pushed" this painting, had he lived. In its present unfinished state, it boldly plays off underdrawing against painted surface in a wholly satisfying manner that recalls the singular *Peasant Watering Her Cow* of 1863 (cat. no. 105). The drawn outlines of the foreground figures enhance the forms without overruling the color, while in the smaller figures across the middle ground, the underlying drawing provides definition and continuity through a complex sequence of poses, while allowing Millet to use color thinly and softly to enhance the effect of the graindust- and smoke-filled atmosphere.

Just how Millet defined a finished painting at this moment, when the Impressionist generation was actively trying to force the French art world to recognize *pochades* (rough, free oil sketches) as works of art and not just as useful tools for the artist, is a question of central importance, thrown into high relief by the Four Seasons commission. The two finished, signed paintings of the series, *Spring* and *Autumn*, represent poles of Millet's art. *Spring* (completed in May 1873) is a brilliantly overwrought painting that sparkles with tiny touches of thick, intensely colored paint, and the interconnections of its various spaces leave little role for line. *Autumn* (essentially complete in March 1874) actively utilizes its lilac-rose ground, leaving large unpainted margins scattered across the canvas, around sheep, haystacks, and distant farmyard; and the revealed drawing, apparently deliber-

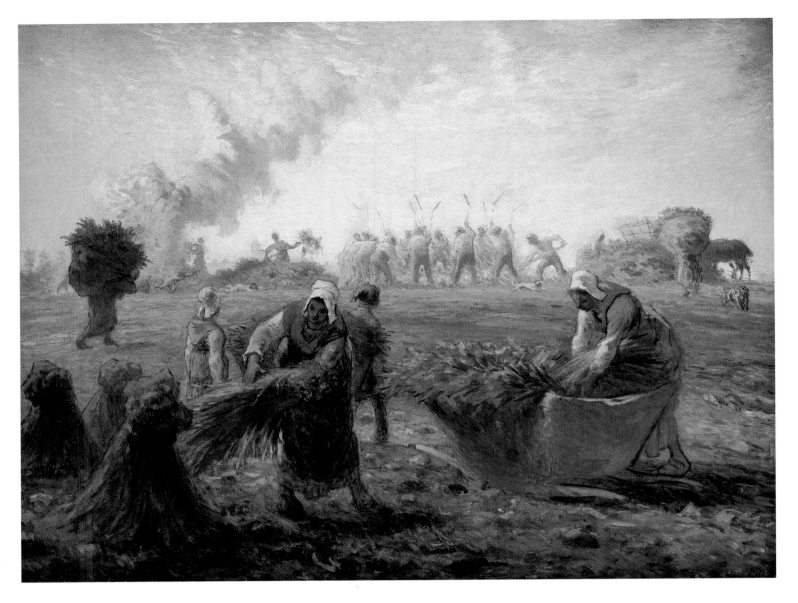

ately strengthened in places, is a necessary organizing tool. By the measure of *Autumn*, *Buckwheat Harvest* is a finished painting that satisfactorily allows line and color independent existence in a completed work of public scale.

Notes

1. Against Etienne Moreau-Nélaton's identification of *Buckwheat Harvest* as *Autumn* in the cycle (*Millet raconté par lui-même* [Paris: Henri Laurens, 1921], vol. 3, p. 41), Robert Herbert argues convincingly that the painting represents *Summer* (*Jean-François Millet* [Paris: Editions des Musées Nationaux, Grand Palais exhibition catalogue, 1975], p. 217).

2. Letter from Millet to Alfred Sensier, March 18, 1873 (Archives of the Cabinet des Dessins, Musée du Louvre, Paris). *Buckwheat Harvest* is not signed, as previous authors have indicated, but bears the stamp put on works left in Millet's studio at the

time of his death. It was not included in the studio sale, but, along with *Winter*, must have been turned over to Hartmann by the artist's family. Moreau-Nélaton, however, claimed that only *Winter* was left with Millet at his death (op. cit., vol. 3, p. 41).

3. Hartmann had been a patron of Théodore Rousseau and Millet's first relationship with the wealthy collector came about when Hartmann asked him to finish some works left incomplete at Rousseau's death in 1867 (Moreau-Nélaton, op cit., vol. 3, pp. 36-37).

4. Canvases prepared with such distinctly colored grounds were not widely used by artists of Millet's generation but could be specifically ordered from obliging art suppliers (letter from Millet to Sensier, April 17, 1868, Archives of the Cabinet des Dessins, Musée du Louvre, Paris; quoted in Moreau-Nélaton, op. cit., p. 40).

5. The pastels were never described as Four Seasons by Millet and, in fact, *Spring* in the group is only half the size of the other three. Since three of the

pastels were available to be collected by Gavet only in 1870, it seems unlikely that Hartmann could have commissioned the paintings on the basis of pastels seen in 1868. See further discussion in Herbert, op. cit., p. 213.

Provenance

Commissioned in 1868 from the artist by Frédéric Hartmann, Munster (sold 18 rue de Courcelles, Paris, May 7, 1881, no. 5); Quincy Adams Shaw, Boston (by 1889).

Exhibition History

Galerie Durand-Ruel, Paris, "Maîtres Modernes," no. 239.

American Art Association, New York, "The Works of Antoine-Louis Barye...his Contemporaries and Friends," 1889, no. 555.

Museum of Fine Arts, Boston, "Barbizon Revisited," 1963, no. 76.

Shepherd Gallery, New York, "The Forest of Fontainebleau, Refuge of Reality," 1972, no. 51.

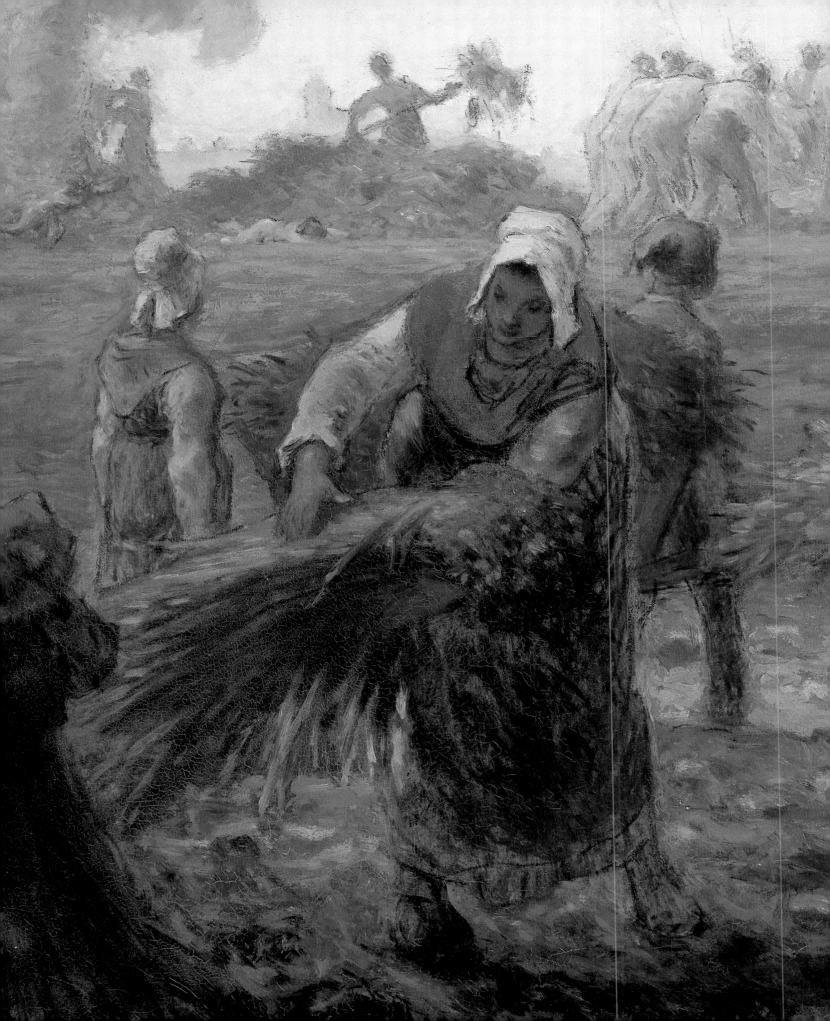

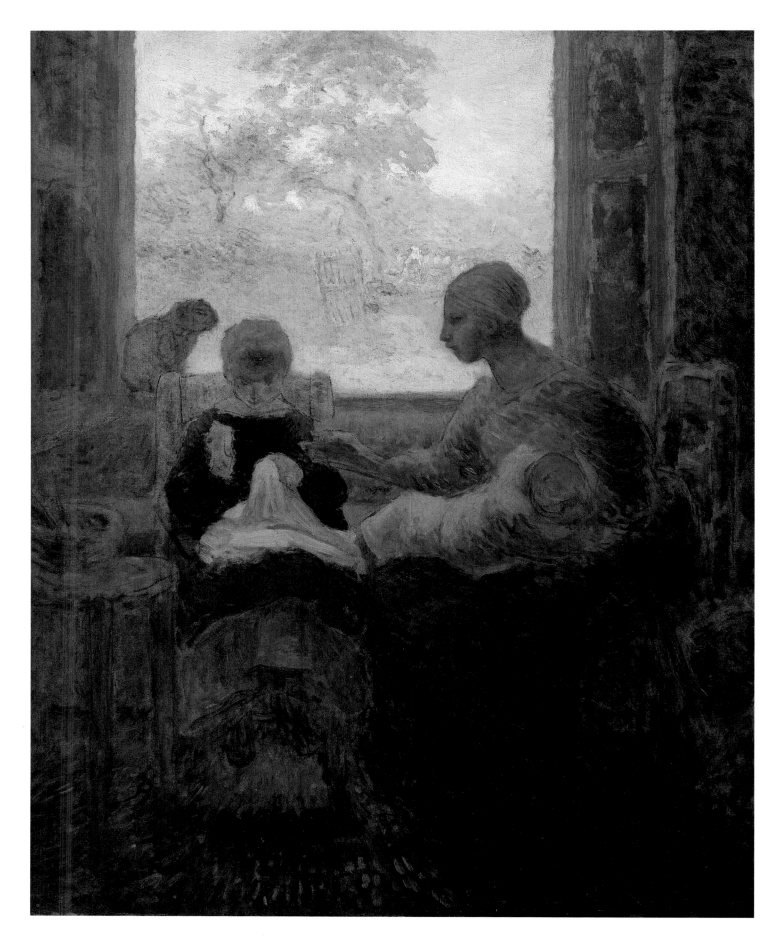

Related Works

See cat. no. 142.

References

Sensier, Alfred, and Mantz, Paul. *La Vie et l'oeuvre de J.-F. Millet*. Paris: A. Quantin, 1881, pp. 360, 362.

Cartwright, Julia M. *Jean-François Millet: His Life and Letters*. London: Swan Sonnenschein, 1896, pp. 332, 341, 344, 370.

Marcel, Henry. *J.-F. Millet*. Paris: Henri Laurens, 1903, p. 102.

Peacock, Netta. *Millet*. London: Methuen & Co., 1905, pp. 134, 136.

Guiffrey, Jean. "Tableaux Français conservés au Musée de Boston et dans quelques collections de cette ville." *Archives de l'art Français* n. s. 7 (1913), p. 547.

"The Quincy Adams Shaw Collection." Boston: Museum of Fine Arts *Bulletin* 16, no. 94 (April 1918), p. 12.

Moreau-Nélaton, Etienne. *Millet raconté par lui-même*. Paris: Henri Laurens, 1921, vol. 2, pp. 91, 97, 102, 111, fig. 284.

Chamboredon, Jean-Claude. "Peinture des rapports sociaux et invention de l'éternel paysan: Les deux manières de Jean-François Millet." *Actes de la recherche en sciences sociales* 17/18 (November 1977), p. 18.

Fermigier, André. *Millet*. Geneva: Skira, 1977, p. 130.

Pollock, Griselda. *Millet*. London: Oresko Books, 1977, p. 92, fig. 69, detail pl. IX.

151
Sewing Lesson
1874
Oil on canvas
81.7 x 65.4 cm. (32⅛ x 25¾ in.)
Stamped, lower right: J. F. Millet
Gift of Martin Brimmer, 1876
76.1

At the time of Millet's death in 1875, a number of works were left unfinished in his studio, *Sewing Lesson* among them. This two-part painting, which frames the heads of the protagonists of an indoor household scene with an uncommonly large view into a garden behind them, provides extremely useful information about Millet's working methods late in his life.

Although the broad theme of a mother passing along specialized skills to her daughter had appeared frequently in Millet's work (see cat. nos. 58 and 80), this final version makes several breaks with earlier imagery. Mother and daughter are no longer joined as one unit, but sit separately, and the mother is less directly involved in the child's work, reaching forward to assist rather than carefully overseeing. As if to demonstrate the greater independence of the young girl, her mother holds a very small child who tries to claim attention. Aligned across the plane of the canvas, in an unusually shallow space, the pair of figures and their dark interior set off a light-filled garden scene placed at some distance behind them. Instead of emphasizing his capacity to create solid figure groups in a discretely lit space, in the manner of both French and Dutch old masters, this *Sewing Lesson* appears to have been designed around a particularly late nineteenth-century artistic problem: the unifying of interior and exterior spaces with very different qualities of light.

In an unusual reversal of common studio practice, the background landscape was rather carefully worked up before the completion of the central figures.[1] The interior was broadly laid out in thin washes of color, to establish the overall color design, and the artist next began to build up the forms of the figures with distinct, shaping strokes of color. Despite their incomplete stage, both mother and child are well defined three-dimensionally. In a manner true of even his earliest paintings, the preliminary paint work remains clear of the outline drawing, protecting its definition until a later stage.

The particularly fascinating aspect of this picture is the beautiful, very high-keyed garden scene. With whites, greens, and yellows of considerable intensity, the garden shimmers with light and with a shifting definition of forms. The very Impressionistic quality is comparable in tone and touch to the contemporary work of Camille Pissarro, although it is not likely to have been painted out of doors in the Impressionist manner. Millet preferred, even as his painting came closer and closer to the *plein-air* interests of the next generation, to study the subject matter intensively on the site, often over many days, and then to execute it in the studio.

Notes

1. Probably reflecting the prominence landscape painting had gained in his work over the last decade at the expense of more figural compositions, a number of Millet's very incomplete works feature carefully detailed or even finished landscape backgrounds.

Provenance

Millet studio sale (Hôtel Drouot, Paris, May 10-11, 1875, no. 55), bought by Richard Hearn, Boston, for Martin Brimmer, Boston.

Related Works

Study of two figures, black conté crayon on paper, 25.6 x 19 cm., private collection, Paris.

Finished drawing, black conté crayon and pastel on paper, 38.1 x 30.5 cm., Crocker Art Museum, Sacramento.

Sewing Lesson, cat. no 151.

References

Sensier, Alfred, and Mantz, Paul. *La Vie et l'oeuvre de J.-F. Millet*. Paris: A. Quantin, 1881, p. 363.

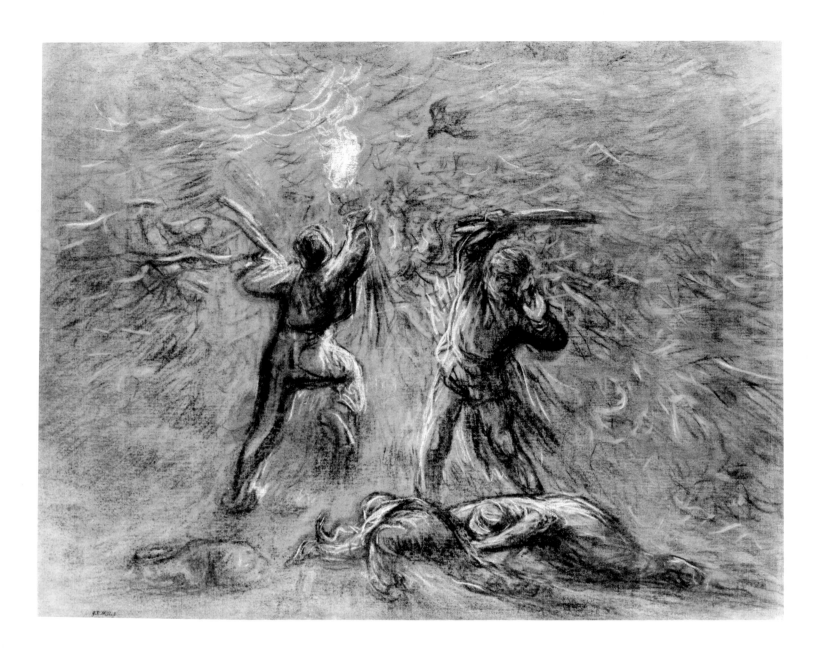

226

152
Hunting Birds by Torchlight
1874
Charcoal and white chalk on rose-gray
prepared canvas
57.0 x 71.0 cm. (22⅜ x 28 in.)
Lower right: J. F. M
On extended loan from the William I.
Koch Foundation, 1983

With a minimum of means – black charcoal, white chalk, and the unusual technique of rubbing away loose charcoal to emphasize the rose-gray canvas – Millet captured the most startling image of his career, a haunting reminiscence of his childhood. Aware that he was dying, and able to work only intermittently, he sought expression for the fascination, the horror, and the anger that absorbed him during the last months of his life.

As he explained to William Low, a young American painter, late in 1874, *Hunting Birds by Torchlight* and the painting for which it is the major preliminary study (*Bird Hunters*; Philadelphia Museum of Art) record an event he had not seen in nearly half a century. During his childhood, when great flights of wild pigeons settled in the trees at night the peasants of Gruchy would go out with torches and clubs, blinding the birds with the light and killing them by the hundreds.[1] When Low asked if he had ever since witnessed such an event, Millet replied, "No, but it all comes back to me as I work."

For thirty-five years, Millet had struggled for success, mastering traditional French artistic values to depict decidedly untraditional French subjects: sowers, gleaners, peasant workers in their fields. He always brought to the most difficult subjects of human life a stoic solidity that spoke of hope and timeless, unchangeable truth. But in placing archetypal images from his own work – the hardworking peasant and the beautiful birds of the field – into direct and uneven conflict in *Hunting Birds by Torchlight*, Millet mustered all the inventiveness at his command to rage against the inevitability of fate and the irony of man's blindness to his own brutality.

Notes

1. William H. Low, "A Century of Painting, Jean-François Millet," *McClure's Magazine* 6 (May 1896), p. 509-510.

Provenance

Mme. J. F. Millet (sold Hôtel Drouot, April 24-25, 1894, no. 11), bought by Félix Gérard; acquired from Artemis, London, by the William I. Koch Foundation, Boston (1983).

Related Works

Night, Hunting Birds, charcoal and white chalk on paper, 47 x 49 cm., current location unknown.

Compositional sketch, black conté crayon on paper, 26.4 x 37.2 cm., Musée Bonnat, Bayonne.

Compositional sketch, black conté crayon on paper, current location unknown (see Lucien Lepoittevin, *Jean-François Millet*, vol. 2, *L'Ambiguité de l'image, essai* [Paris: Léonce Laget, 1973], fig. 121).

Compositional sketch, pen and ink on paper, 20 x 20.3 cm., Cabinet des Dessins, Musée du Louvre, Paris (GM10699).

Compositional sketch, pen and ink on paper, 19.6 x 22.9 cm., Cabinet des Dessins, Musée du Louvre, Paris (GM10700).

Hunting Birds by Torchlight, cat. no. 152.

Figure study for crawling figure, pencil on paper, 9.0 x 13.7 cm., Cabinet des Dessins, Musée du Louvre, Paris (GM10701).

Bird Hunters, oil on canvas, 29 x 36½ in., Philadelphia Museum of Art (E24-3-14).

References

Moreau-Nélaton, Etienne. *Millet raconté par lui-même*. Paris: Henri Laurens, 1921, vol. 3, pp. 97, 104, 125.

[Herbert, Robert L.] *Jean-François Millet*. Paris: Editions des Musées Nationaux, Grand Palais exhibition catalogue, 1975, p. 292.

Bibliography

Agulhon, Maurice. *1848 ou l'apprentissage de la république, 1848-1852*. Paris: Editions du Seuil, 1973.

—. Desert, Gabriel; and Speckin, Robert. *Apogée et crise de la civilisation paysanne, 1789-1914*, vol. 3 of *Histoire de la France rurale* (under direction of Georges Duby and Armand Wallon). Paris: Editions du Seuil, 1976.

Amaya, Mario. "Millet's Agrarian Classicism." *Art in America* (May/June 1976), pp. 59-63.

Angell, Henry C. *Records of William Morris Hunt*. Boston: James R. Osgood, 1881.

Appleton, Thomas G. Book review: *"La Vie et l'oeuvre de J.-F. Millet* par Alfred Sensier." *American Art Review* 2 (April 1881), pp. 245-246.

Bacou, Roseline. *Millet dessins*. Paris: Bibliothèque des Arts, 1975.

Bartlett, Truman H. "Barbizon and Jean-François Millet." *Scribner's Magazine* 7, no. 5 (May 1890), pp. 530-555; (June 1890), pp. 735-755.

—. "Millet's Return to His Old Home, with Letters from Himself and His Son." *Century* 86 (July 1913), pp. 332-339.

Bénédite, Léonce. *The Drawings of Jean François Millet*. London: William Heinemann, 1906, and Philadelphia: J. B. Lippincott, 1906.

—. *La Peinture au XIX siècle d'après les chefs-d'oeuvre des maîtres*. Paris: Flammarion, 1909.

—. *Notre Art, nos maîtres*. Paris: Flammarion, 1923.

Benesch, Otto. "An Altar Project for a Boston Church by Jean-François Millet." *Art Quarterly* 9 (Fall 1946), pp. 300-305.

Bermingham, Peter. *American Art in the Barbizon Mood*. Washington, D.C.: Smithsonian Press, National Collection of Fine Arts exhibition catalogue, 1975.

Bigot, A. "Portraits de Jean-François Millet." *Normannia* 3 (December 1930), pp. 784-788.

Billy, André. *Les Beaux Jours de Barbizon*. Paris: Editions du Pavois, 1947.

Bloch, Marc. *French Rural History: An Essay on its Basic Characteristics*. Translated by Janet Sondheimer. Berkeley: University of California Press, 1966.

Boime, Albert. *Thomas Couture and the Eclectic Vision*. New Haven: Yale University Press, 1980.

Borowitz, Helen. *The Realist Tradition, French Painting and Drawing, 1830-1900, Notes on the Exhibition*. Cleveland: Cleveland Museum of Art, exhibition catalogue, 1980.

Bouret, Jean. *L'Ecole de Barbizon*. Neuchâtel: Editions Ides et Calendes, 1972.

Bouvier, Emile. *La Bataille réaliste, 1844-1857*. Paris: Fontmery, 1913.

Brandt, Paul. *Schaffende Arbeit und Bildende Kunst*. 2 vols. Leipzig: Alfred Kröner, 1927-1928.

Breton, Jules. *La Vie d'un artiste*. Paris: Lemerre, 1890.

—. *Nos Peintres du siècle*. Paris: Société d'Edition Artistique, 1899.

Brettell, Richard R., and Brettell, Caroline B. *Painters and Peasants in the Nineteenth Century*. Geneva: Skira, 1983.

Bryant, Lorinda Munson. *What Pictures to See in America*. New York: John Lane, 1915.

Burty, Philippe. "Les Eaux-fortes de M. J.-F. Millet." *Gazette des Beaux-Arts* 1st ser., 11 (September 1861), pp. 262-266.

—. "The Drawings of J. F. Millet." *Academy* 7 (April 24, 1875), pp. 435-436.

—. *Maîtres et petits maîtres*. Paris: G. Charpentier, 1877.

—. "Croquis d'après nature, notes sur quelques artistes contemporains." *La Revue rétrospective* (1892), pp. 10-15.

Canaday, John. *Mainstreams of Modern Art*. New York: Holt, Rinehart and Winston, 2nd ed., 1981.

Cartwright, Julia M. "The Pastels and Drawings of Millet." *Portfolio* 21 (1890), pp. 191-197, 208-212.

—. *Jean-Francois Millet, his Life and Letters*. London: Swan Sonnenschein, 1896.

—. "The Drawings of Jean-Francois Millet in the Collection of Mr. James Staats-Forbes." *Burlington Magazine* 5 (May 1904), pp. 47-67, 118-159; 6 (June 1905), pp. 192-203, 360-369.

Cary, Elisabeth Luther. "Millet's Pastels at the Museum of Fine Arts, Boston." *American Magazine of Art* 9, no. 7 (May 1918), pp. 261-269.

Chamboredon, Jean-Claude. "Peinture des rapports sociaux et invention de l'éternel paysan: Les deux manières de Jean-François Millet." *Actes de la recherche en sciences sociales* 17/18 (November 1977), pp. 6-21.

Charavay, E. "Lettres de François Millet à Théodore Rousseau." *Cosmopolis* 10 (1898), pp. 129-133.

Chesneau, Ernest. "Jean-François Millet." *Gazette des Beaux-Arts* 2nd ser., 11 (May 1875), pp. 428-441.

—. *Peintres et statuaires romantiques*. Paris: Charavay Frères, 1880.

Chevalier, Louis. "Les Fondements économiques et sociaux de l'histoire politique de la région parisienne (1848-1870)" Ph. D. Thesis, University of Paris, 1951.

Clarétie, Jules. *Peintres et sculpteurs contemporains*. Paris: Librairie des Bibliophiles, 1881, first series.

Clark, Kenneth. *The Romantic Rebellion, Romantic versus Classical Art*. New York: Harper & Row, 1973.

Clark, T. J. *Image of the People: Gustave Courbet and the Second French Republic 1848-1851*. London: Thames and Hudson, 1973.

—. *The Absolute Bourgeois: Artists and Politics in France, 1848-1851*. London: Thames and Hudson, 1973.

Constable, W. G. "A Portrait by Jean François Millet of his First Wife." Boston: Museum of Fine Arts *Bulletin* 43 (February 1945), pp. 1-4.

—. *Art Collecting in the United States of America*. London: Thomas Nelson and Sons, 1964.

Cook, Clarence C. *Art and Artists of our Time*. 3 vols. New York: Selmar Hess, 1888.

Cox, Kenyon. *Artist and Public*. New York: Charles Scribner's Sons, 1914.

Dali, Salvador. "Interprétation Paranoîaque-critique de l'image obsédante de Millet." *Minotaure* 1 (1933), pp. 65-67.

—. *Le Mythe tragique de l'Angélus de Millet*. Paris: J.-J. Pauvert, 1963.

De Forges, Marie-Thérèse. *Barbizon*. Paris: Editions du Temps, 1962 (rev. ed., 1971).

Delteil, Loys. *Le Peintre-graveur illustré (XIX et XX siècles) I, J.-F. Millet, et al.*. Paris: Delteil, 1906.

Diez, Ernst. *Jean-François Millet*. Bielefeld and Leipzig: Velhagen & Klasing, 1912.

Dorbec, Prosper. *L'Art du paysage en France*. Paris: Henri Laurens, 1925

Draper, Benjamin Poff. "American Indians, Barbizon Style, the Collaborative Paintings of Millet and Bodmer." *Antiques* 44 (September 1943), pp. 108-110.

Durand-Gréville, E. "La Peinture aux Etats-Unis." *Gazette des Beaux-Arts* 2nd ser., 36 (July 1887), pp. 65-75; (September 1887), pp. 250-255.

Durbé, Dario. *Courbet e il realismo francese*. Milan: Fratelli Fabbri Editore, 1969.

— and Damigella, Anna Maria. *La Scuola di Barbizon*. Milan: Fratelli Fabbri Editore, 1969.

Eaton, Wyatt. "Recollections of Jean-François Millet with Some Account of His Drawings for His Children and Grandchildren." *Century* 38 (May 1889), pp. 90-104.

Edgell, George Harold. *French Painters in the Museum of Fine Arts: Corot to Utrillo*. Boston: Museum of Fine Arts, 1949.

Emanuelli, F. "Lettres inédites de Jean-François Millet à un ami (E. Onfroy)." *Revue d'études normandes* 2nd ser. (August-September 1908), pp. 361-372; (October 1908), pp. 409-415; 3rd ser. (January-February 1909), pp. 131-136.

Fermigier, André. *Millet*. Geneva: Skira, 1977.

Focillon, Henri. *La Peinture aux XIX et XX siècles, du réalisme à nos jours*. Paris: Librairie Renouard, 1928.

Fontainas, André. *Histoire de la peinture française au XIX siècle*. Paris: Mercure de France, 1906.

Frantz, Henri. "The Rouart Collection, III, The Works of Millet." *International Studio* 50, no. 198 (August 1913), pp. 97-107.

Frémine, Charles. *Au Pays de J.-F. Millet*. Paris: Lemerre [1887].

"From Fontainebleau to the Dark and Bloody Ground." *The Month at Goodspeed's Book Shop* 6-7 (Boston, March-April 1945), pp. 151-155.

Gassies, G. *Le Vieux Barbizon, souvenirs de jeunesse d'un paysagiste 1825-1875*. Paris: Hachette, 1907.

—. *Barbizon au Louvre*. Meaux: G. Lepillet, 1911.

Gaudillot, Jean Marie. "Un Aspect peu connu de Millet, les portraits du Musée de Cherbourg." *Art de Basse-Normandie* 5 (spring 1957), pp. 33-35.

Gensel, Walther. *Millet und Rousseau*. Bielefeld and Leipzig: Velhagen & Klasing, 1902.

Gibson, Frank. *Six French Artists of the Nineteenth Century*. London: R. Scott, 1925.

Gilbert, Ariadne. "The Peasant-Painter: Jean-François Millet." *Popular Biography* 1, no. 5 (March 1930), pp. 76-87.

Gosling, Nigel. "Millet's Peasant Revolution." *Observer Magazine* (January 25, 1976).

"A Great Artist Gone." *Old and New* 11 (April 1875), pp. 495-497.

"'Greta's' Boston Letter." *Art Amateur* 5, no. 4 (September 1881), p. 72.

Gsell, Paul. *Millet*. Translated by J. Lewis May. New York: Dodd, Mead and Co., 1928.

Guiffrey, Jean. "Les Accroissements des musées; la collection Thomy-Thiéry au Musée du Louvre." *Les Arts* 15 (March 1903), pp. 16-25.

—. "Tableaux Français conservés au Musée de Boston et dans quelques collections de cette ville." *Archives de l'art Français* n. s. 7 (1913), pp. 533-552.

— and Marcel, Pierre. *Inventaire général des dessins du Musée du Louvre: l'école française*. Paris: Musée du Louvre and Musée de Versailles, 1928, vol. 10.

Guillaumin, Emile. *La Vie d'un simple*. Paris: Editions Stock, 1943 (reissue of 1904 original edition).

Gurney, John. *Millet*. London: Medici Society, 1954.

Halton, E. G. "The Collection of Mr. Alexander Young, III, Some Barbizon Pictures." *Studio* 30 (January 1907), pp. 193-210.

Heise, Carl Georg. "Amerikanische Museen." *Kunst und Künstler* 23, 6 (March 1925), pp. 219-227.

Henley, William Ernest. *Jean-François Millet, Twenty Etchings and Woodcuts Reproduced in Facsimile*. London: Fine Art Society, 1881.

Herbert, Robert L. *Barbizon Revisited*. Boston: Museum of Fine Arts, exhibition catalogue, 1962.

—. "Millet Revisited." *Burlington Magazine* 104 (July 1962), pp. 294-305; (September 1962), pp. 377-386.

—. "Millet Reconsidered." *Museum Studies* (Art Institute of Chicago) 1 (1966), pp. 29-65.

—. "City vs. Country: The Rural Image in French painting from Millet to Gauguin." *Artforum* 8 (February 1970), pp. 44-55.

—. "Les Faux Millet." *Revue de l'art* (1973), pp. 56-65.

[Herbert, Robert L.] *Jean-François Millet*. Paris: Editions des Musées Nationaux, Grand Palais exhibition catalogue, 1975 (London: Arts Council of Great Britain, Hayward Gallery exhibition catalogue, 1976).

—. "La Laitière normande à Gréville de J.-F. Millet." *La Revue du Louvre et des Musées de France* (February 1980), pp. 14-20.

Hitchcock, R. "Millet and the Children." *St. Nicholas* 14 (January 1887), pp. 166-178.

Hoeber, Arthur. *The Barbizon Painters*. New York: Frederick A. Stokes, 1915.

Hopkins, James Frederick. *Millet*. Boston: Perry Pictures, 1898.

Hunt, James. "Millet at Work, a Chronicle of Friendship." *Art and Progress* (September 1913), pp. 1087-1093; (November 1913), pp. 12-18.

[Hunt, William Morris.] *W. M. Hunt's Talks On Art*. Compiled by Helen M. Knowlton. Boston: Houghton, 1875 and 1883.

Hurll, Estelle M. *Jean-François Millet*. Boston: Houghton Mifflin, 1900.

Huyghe, René. *Millet et Théodore Rousseau*. Geneva: Skira, 1942.

—. *La Relève de l'imaginaire*. Paris: Flammarion, 1976.

Huysmans, J. K. "Millet." *Certains*. Paris: Tresse and Stock, 1889, pp. 185-196.

Jacque, C. "Charles Jacque et F. Millet." *Moniteur des Arts* 34 (September 4, 1891), pp. 757-758.

Jaworskaja, N. W. "Die französische Kunst von des französischen Revolution bis zur Pariser Kommune." *Allgemeine Geschichte der Kunst, VII, Die Kunst des 19 Jh*. Leipzig: E. A. Seemann, 1964, pp. 27-100.

Jolas, Tina, and Zonabend, Françoise. "Tillers of the Fields and Woodspeople." In *Rural Society in France: Selections from "Annales Economies, Sociétés, Civilisations."* Translated by Elborg Forster. Edited by Robert Forster and Orest Ranum. Baltimore and London: Johns Hopkins University Press, 1977, pp. 126-151.

Knowlton, Helen M. *W. M. Hunt's Talks on Art*. Boston: Houghton, 1875 and 1883.

—. *Art-Life of William Morris Hunt*. Boston: Little, Brown and Company, 1899.

Kodera, K. *Recueil important de reproductions des oeuvres de J.-F. Millet dans sa jeunesse*. 3 vols. Tokyo, 1933.

Krügel, Gerhard. *Jean-François Millet*. Mainz: J. Scholz, 1909.

Labrousse, Ernest. "The Evolution of Peasant Society in France from the Eighteenth Century to the Present." Translated by David Landes in *French Society and Culture since the Old Regime*. Edited by Evelyn M. Acomb and Marvin L. Brown, Jr. New York: Holt, Rinehart and Winston, 1966, pp. 43-64.

La Farge, John. *The Higher Life in Art*. New York: McClure, 1908.

Lanoë, Georges, and Brice, Tristan. *Histoire de l'école française de paysage depuis Le Poussin jusqu'à Millet*. Vol. 1. Paris: A. Charles, 1901.

Latourrette, Louis. *Millet à Barbizon*. Barbizon: Douhin and Pontoy, 1927.

Laughton, Bruce. "A Group of Millet Drawings of the Female Nude." *Master Drawings* 17, no. 1 (spring 1979), pp. 44-50.

Léger, Charles. *La Barbizonnière*. Paris: R. Julliard, 1946.

Lepoittevin, Lucien. "Jean-François Millet, cet inconnu." *Art de Basse Normandie* 22 (summer 1961), pp. 9-15.

—. "Millet, peintre et combattant." *Arts* (November 19, 1964), p. 10.

—. "Jean-François Millet, mythe et réalite." *L'Oeil* 119 (November 1964), pp. 28-35.

—. *Jean-François Millet, I, Portraitiste*. Paris: Léonce Laget, 1971; *II, L'Ambiguité de l'image, essai*. Paris: Léonce Laget, 1973.

Leprieur, Paul, and Cain, Julien. *Millet*. Paris: Librairie Centrale des Beaux-Arts, 1913.

Lévêque, Jean-Jacques. *L'Universe de Millet*. Paris: Henri Scrépel, 1975.

Leymarie, Camille. "J.-F. Millet en Auvergne." *L'Art* 55 (1893), pp. 75-78.

Lindsay, Kenneth. "Millet's Lost Winnower Rediscovered." *Burlington Magazine* 116 (May 1974), pp. 239-245.

Le Livre d'or de J.-F. Millet par un ancien ami. Paris: Ferroud, 1891.

Low, William H. "A Century of Painting, Jean-François Millet." *McClure's Magazine* 6 (May 1896), pp. 497-512.

Mack, Gerstle. *Gustave Courbet.* New York: Alfred A. Knopf, 1951.

Marcel, Henry. "Quelques Lettres inédites de J.-F. Millet." *Gazette des Beaux-Arts* 3rd ser., 26 (July 1901), pp. 69-78.

—. *J.-F. Millet.* Paris: Henri Laurens, 1904.

Markham, Edwin. *The Man with the Hoe.* San Francisco: A. M. Robertson, 1899.

Mauclair, Camille. *The Great French Painters.* London: Duckworth & Co., 1903.

McCoubrey, John W. "The Revival of Chardin in French Still-Life Painting, 1850-1870." Art Bulletin 46 (March 1964), pp. 39-53.

Meixner, Laura L. *An International Episode: Millet, Monet and their North American Counterparts.* Memphis: The Dixon Gallery and Gardens, exhibition catalogue, 1982.

Melot, Michel. *L'Oeuvre gravé de Boudin, Corot, Daubigny, Dupré, Jongkind, Millet, Théodore Rousseau.* Paris: Arts et Métiers Graphiques, 1978.

Michel, André. "J.-F. Millet et l'exposition de ses oeuvres à l'Ecole des Beaux-Arts." *Gazette des Beaux-Arts* 2nd ser., 36 (July 1887), pp. 5-24.

—. *Notes sur L'Art Moderne: Peinture.* Paris: Armand Colin, 1896.

Michel, Emile. *La Forêt de Fontainebleau dans la nature, dans l'histoire, dans la littérature et dans l'art.* Paris: H. Renouard, 1909.

Millet, Pierre. "The Story of Millet's Early Life; Millet's Life at Barbizon." *Century* 45 (January 1893), pp. 380-384; 47 (April 1894), pp. 908-915.

Mollett, John W. *The Painters of Barbizon.* London: Sampson, Low, Marston, Searle & Rivington, 1890.

Moreau-Nélaton, Etienne. *Millet raconté par lui-même.* 3 vols. Paris: Henri Laurens, 1921.

Moutard-Uldry, Renée. "A La Recherche du temps de Millet." *Arts* 273 (August 4, 1950), p. 3.

Muther, Richard. *The History of Modern Painting.* London: Henry & Co., 1895-1896.

—. *J.-F. Millet.* Berlin: Julius Bard, 1904.

Naegely, Henry. *J.-F. Millet and Rustic Art.* London: Elliot Stock, 1898.

Nochlin, Linda. *Realism.* Harmondsworth and Baltimore: Penguin Books, 1971.

Peacock, Netta. "Millet's Model." *Artist* 25 (July 1899), pp. 129-134.

—. *Millet.* London: Methuen & Co., 1905.

Peyre, R. "La Peinture française pendant la seconde moitié du XIX siècle, les peintres de la vie rurale, Jean-François Millet, Jules Breton, Bastien-Lepage, Lhermitte." *Etudes d'Art* 5 (1921) (supplement to *Dilecta* 21 [1921]), pp. 1137-1152.

Piedagnel, Alexandre. *J.-F. Millet.* Paris: Cadart, 1876.

Plessis, Alain. *De La Fête impériale au mur des fédérés, 1852-1871.* Paris: Editions du Seuil, 1973.

Pollack, Griselda. *Millet.* London: Oresko Books, 1977.

Reverdy, Anne. *L'Ecole de Barbizon, l'évolution du prix des tableaux de 1850 à 1960.* Paris: Mouton, 1973.

Roger-Miles, L. *Le Paysan dans l'oeuvre de J.-F. Millet.* Paris: Georges Petit, 1895.

Rolland, Romain. *Millet.* London: Duckworth & Co., 1902.

Rosenblum, Robert. *Modern Painting and the Northern Romantic Tradition.* New York: Harper and Row, 1975.

Rouart, Léon. "Les Dessins de J.-F. Millet." *Jardin des arts* (March 1958), pp. 323-328.

Rouchés, Gabriel, and Huyghe, René. *Ecole française de J.-F. Millet à Ch. Muller.* Paris: Cabinet des Dessins du Musée du Louvre, 1928.

Saunier, C. "Jean-François Millet." In Benoît, François. *Histoire du paysage en France.* Paris: Henri Laurens, 1908, pp. 244-265.

Schapiro, Meyer. "Courbet and Popular Imagery: An Essay on Realism and Naiveté." *Journal of the Warburg and Courtauld Institutes* 4 (1941), pp. 164-191.

Schuyler Van Rensselaer, Mrs., and Keppel, Frederick. *Jean-François Millet, Painter-Etcher.* New York: Frederick Keppel & Co., 1907.

Sensier, Alfred. *Souvenirs sur TH. Rousseau.* Paris: Léon Techener, 1872.

— and Mantz, Paul. *La Vie et l'oeuvre de J.-F. Millet.* Paris: A. Quantin, 1881.

Serullaz, Maurice. "Van Gogh et Millet." *Etudes d'Art* 5 (1950), pp. 87-92.

Shoolman, Regina, and Slatkin, Charles. *Six Centuries of French Master Drawings in America.* New York: Oxford University Press, 1950.

Sickert, Walter. *A Free House! or, The Artist as Craftsman.* Edited by Osbert Sitwell. London: MacMillan, 1947.

Silvestre, Théophile. "De Millet et de ses dessins." Introduction, Emile Gavet sale, Hôtel Drouot, Paris, June 11-12, 1875; reprinted in *L'Artiste* 9 (July 1, 1875), pp. 27-34.

Sloane, Joseph C. *French Painting between the Past and the Present.* Princeton: Princeton University Press, 1951.

Smith, Charles Sprague. *Barbizon Days, Millet, Corot, Rousseau, Barye.* New York: A. Wessels, 1902.

Smith, De Cost. "Jean François Millet's Drawings of American Indians." *Century* 80 (May 1910), pp. 78-84.

Soullié, Louis. *Les Grands Peintres aux ventes publiques, vol. 2: Peintures, aquarelles, pastels, dessins de Jean-François Millet relevés dans les catalogues de ventes 1849 à 1900.* Paris: L. Soullié, 1900.

Staley, Edgcumbe. *Jean-François Millet.* London: George Bell and Sons, 1903.

Strahan, Edward. *Art Treasures of America.* 3 vols. Philadelphia: George Barrie, 1879.

Stranahan, Clara Cornelia Harrison. *A History of French Painting.* New York: Charles Scribner's Sons, 1888.

Sutton, Denys. "The Truffle Hunter." *J.-F. Millet.* London: Wildenstein and Co., exhibition catalogue, 1969.

Tabarant, Adolphe. *La Vie artistique au temps de Baudelaire.* Paris: Mercure de France, 1942.

Talbot, William S. "Jean-François Millet: Return from the Fields." *Bulletin of the Cleveland Museum of Art* 60, no. 9 (November 1973), pp. 259-266.

Thomson, David Croal. "The Barbizon School, Jean-François Millet." *Magazine of Art* 12 (1889), pp. 375-384, 397-404.

—. *The Barbizon School of Painters.* London: Chapman and Hall, 1902.

Tillot, Charles. "J. F. Millet." Introduction, Millet studio sale, Hôtel Drouot, Paris, May 10-11, 1875.

Tomson, Arthur. *Jean-François Millet and the Barbizon School.* London: George Bell and Sons, 1903.

Trumble, A. *The Painter of "The Angelus"...Jean-Francois Millet.* New York: American Art Association, 1889.

Turner, Percy M. *Millet.* London: T. C. and E. C. Jack [1910].

Vaillat, L. "Vingt Toiles de Millet dans un grenier." *L'Illustration* 159 (March 11, 1922), p. 237.

Venturi, Lionello. *Les Archives de l'impressionnisme.* 2 vols. Paris: Editions Durand-Ruel, 1939.

Vergnes, P. "Jean-François Millet au Musée National des Beaux-Arts d'Alger." *Etudes d'Art* 6 (1951), pp. 113-124.

Wallis, H. "The Late M. Millet." *Times* (January 23, 1875), p. 12.

Warner, R. J. *Jean-François Millet.* Boston, 1898.

Weber, Eugen. *Peasants into Frenchmen: The Modernization of Rural France, 1870-1914.* Stanford: Stanford University Press, 1976.

Wells, William. "Variations on a Winter Landscape by Millet." *Scottish Art Review* 13 (1972), pp. 5-8, 33.

Wheelwright, Edward. "Personal Recollections of Jean François Millet." *Atlantic Monthly* 38 (September 1876), pp. 257-276.

Wickenden, Robert J. "The Art and Etchings of J. F. Millet." *Print Collector's Quarterly* 2 (1912), pp. 225-250.

—. "Millet's Drawings at the Museum of Fine Arts, Boston." *Print-Collector's Quarterly* 4, part 1 (1914), pp. 1-30.

Yriarte, Charles. *J.-F. Millet.* Paris: Jules Rouam, 1885.

Zeldin, Théodore. *France, 1848-1945.* 2 vols. Oxford: Clarendon Press, 1973.

Letters in the Museum of Fine Arts, Boston

Transcribed and translated by Chantal Mahy-Park

Fig. 17. *Jean-François Millet at Barbizon*, photographic calling card by François Cuvelier (a friend and fellow painter), about 1862.
Millet stands before the garden wall of his Barbizon home in everyday dress that included the much-remarked sabots. His pose prompted a friend to compare him with a rebellious peasant about to be shot by a firing squad, an idea that greatly amused Millet.

LIBRAIRIE UNIVERSELLE
J.-U. CALMETTE
A CAHORS

Religion, Piété, Education, Classiques.
LIVRES POUR LES DISTRIBUTIONS DE PRIX
Littérature, Sciences, Beaux-Arts, Droit, Médecine, Agriculture.
Toutes les nouveautés marquantes sont reçues aussitôt leur mise en vente.
COMMISSION EN LIBRAIRIE
ABONNEMENT A TOUS LES JOURNAUX
Papiers, Fournitures de Bureau et de Dessin.
Imagerie, Carnets, Portefeuilles, Ordo, Annuaire, Calendriers
du Lot, Agendas de poche et de bureau, Almanachs illustrés.
MATÉRIEL DES ÉCOLES. — CARTES A JOUER
Carnets et feuilles de quinzaine, Registres de Mairie,
d'Auberge et d'Hôtel.
Photographies, Cartes, Albums photographiques.
Achat et vente de Bibliothèques et objets d'Art.

Fig. 18. Advertisement for the bookstore of Urbain Calmette of Cahors in southwestern France.
Calmette began his collection of Millet's work by offering to trade a cask of Cahors wine for a painting.

Urbain Calmette

Millet once wrote, "I wish that the sale of pictures could be done from individual to individual," (i.e., without the dealers).[1] He realized this wish when Jean Urbain Calmette, a most unusual collector, wrote him in the fall of 1859, asking Millet to exchange one of his paintings for a cask of good wine from Cahors. Though having never made this sort of arrangement before, Millet accepted. This deal started a long friendship and correspondence between the master and the amateur.

Born in Villeneuve-sur-Lot in 1807, Calmette lived in Cahors (near Bordeaux), where he owned a bookstore, La Librairie Universelle. Cahors, although quite distant from Paris, was then a rather important town of 14,000, economically supported by the production of the *vin de Cahors*.

In many respects, Calmette was a typical provincial bourgeois. He was one of the *électeurs de la chambre de commerce de Cahors*, and was among the founders in 1872 of the *Société des Etudes du Lot*, a literary and scientific club still in existence today. According to the town report of the time, the Calmette family was influential and well respected.

Although living in town, Calmette enjoyed nature and the labors of the fields. In 1843 he bought five acres of vineyards in the Cahors area to produce his own wine. His letters are filled with comments on the seasons, the weather, and their effect on the crops and nature.

Calmette did not limit his activities to his native province. Owning a bookstore, he was more educated and cosmopolitan than the average "Cahorsien," often traveling to Paris[2] and seeming to be quite aware of what went on in the capital. In a letter written to Sensier in July 1860, Millet wondered: "How did Calmette find your address, how did he find that you are a publisher?"[3]

Calmette was the intimate friend of the landscape artist Etienne Sabatier (a former pupil of Gabriel Decamps), who had exhibited at the Paris Salon from 1831 to 1861. Sabatier and Decamps had stayed in contact over the years, and Decamps, who was then working in a village near Barbizon, paid frequent visits to Millet's studio, so it is reasonable to assume that Calmette heard of the Barbizon artist through his friend Sabatier. In the 1850s, Calmette began to collect works of art that he lent to regional exhibitions. His collection, though predominantly Old Masters, contained works from differing periods and countries, including thirteen works by Sabatier and other local, contemporary artists.

Calmette owned at least two Millet oil paintings, *A Shepherdess and her Sheep*[4] and *Sheep Grazing along a Hedge*, as well as an unidentified painted sketch. He probably also owned drawings by other Barbizon artists. Calmette holds a most unusual place among Millet's collectors, for aside from the Americans introduced to the artist by William Morris Hunt, few art lovers outside a very small Parisian circle took much interest in Millet's work prior to his successes at the Salon in the mid-1860s. Most of his supporters were artist-friends or members of a group of enlightened but hardly wealthy, fellow-bureaucrats encouraged by Alfred Sensier. This could explain why little research has been done on Calmette and his collection before the publication of the present series of letters.

On October 25, 1862, Millet wrote a letter to Calmette that summarizes their common ideas on art and nature:

You are very right to surround yourself with works of art. In addition to the direct pleasure they give you, they help you to understand better what you see in Nature. So many people can't see anything.

At the end of his life Calmette tried several times to sell the 112 works of his collection to the museum of the town of Cahors for the small sum of 20,000 francs, even offering to be an unpaid curator. The town was never able to make a decision and Calmette died in 1882 without the consolation of knowing that his collection would be kept in the museum of his hometown.

The collection was auctioned in Paris in November 1883, with a sale catalogue listing only 105 works, none by Millet or any other Barbizon artist. While one can assume that the family kept the paintings for themselves, the present location of those works is unknown.

Notes
1. Letter from Millet to Silvestre, December 8, 1873.

2. When traveling to Paris Calmette stayed in a hotel, which was considered quite extravagant for a nineteenth-century provincial bourgeois.

3. Letter from Millet to Sensier, July 14, 1860 (Cabinet des Dessins, Musée du Louvre, Paris).

4. Exhibited at the 1865 Exposition Artistique et Industrielle de la ville de Cahors (no. 328).

Letters from Millet to Calmette

Barbizon 5 Octobre 1859

Monsieur,

C'est en revenant d'un voyage que je viens de faire, que j'ai pris connaissance de la lettre que vous m'avez fait l'honneur de m'écrire, ce qui explique le retard que j'ai mis à vous répondre.

Quoique que je n'ai pas l'habitude de faire de ces sortes d'arrangements, à cause du désir que vous montrer d'avoir quelque peinture de moi, j'accepte votre proposition d'une pièce de bon vin de votre pays en échange de ce que je vous enverrai. Veuillez donc, Monsieur, adresser votre envoi franc de port à la gare du chemin de fer de Melun.

Agréer, je vous en prie, Monsieur, mes salutations.

J. F. Millet

Barbizon, October 5, 1859

Dear Sir,

It's only on the return from a trip that I was able to read your letter, which explains the tardiness of my answer.

Although I usually don't make this sort of arrangement, you seem to have a great desire to own one of my paintings, so I accept your proposition for a cask of good wine from your area in exchange for the works I will send to you.

Could you please then, send your shipment, paid in advance, to the Melun train station.[1]

With all my best,

J. F. Millet

Notes

1. Melun was the last stop of the Paris train. A scheduled coach completed the journey to Barbizon.

Barbizon 14 Décembre 1859

Monsieur,

La pièce de vin que vous m'envoyez vient d'être à l'instant même descendue dans ma cave, et je m'empresse de vous l'annoncer et de vous remercier. Comme vous voyez, elle a été beaucoup plus de temps à venir que vous ne le supposiez, puisqu'il y aura demain un mois que vous en avez fait l'expedition.

Je suivrai à l'egard de cette pièce de vin toutes les prescriptions que vous avez bien voulu me donner, sans m'en écarter d'un point. J'ajouterai qu'elle est arrivée en parfait état.

Inutile sans doute de la coller puisque vous ne m'en parlez pas.

Le petit tableau que je vous destine est terminé, seulement, Monsieur, je vous prie d'avoir un peu de patience et d'attendre qu'il soit tout à fait sec avant que je vous l'envoie. Vous allez très bien comprendre pourquoi: quand la couleur à l'huile est tout à fait sèche, il est parfaitement indifférent qu'elle reçoive ou non de la poussière, on en est quitte pour la laver; mais quand elle n'est pas bien sèche, la poussière s'y colle et finit par y adhérer complètement, ce qui produit un effet désagréable. Il faudrait bien attendre une huitaine avant que je l'envoie. Je le remettrai comme vous me le demander chez votre ami M'. Sandieu. Ce tableau représente une bergère avec des moutons.

Comptez bien, Monsieur, que ce sera avec un immense plaisir que je vous verrai venir chez moi en personne, quand un hazard quelconque vous amènera à Paris. Ma porte vous est d'avance toute grande ouverte, et à vos amis; vous devez vous en tenir assuré.

Je n'ai pas voulu gôuter votre bon vin tout de suite, secoué qu'il était par le voyage, mais je n'y manquerai pas en le mettant en bouteilles.

Agréer je vous en prie bien, Monsieur, mes salutations empressées.

J. F. Millet

Barbizon, December 14, 1859

Dear Sir,

The cask of wine that you sent me has just been brought down into my cellar. I wanted to let you know at once and thank you. As you can see, it took the shipment much longer to arrive here than you thought.[1] It will be tomorrow a month since you shipped it.

I will follow carefully all the directions regarding the wine that you have been kind enough to give me. I want to add that it arrived in perfect condition. It is unnecessary, I guess, to clarify it since you do not mention it.

The small painting that I intended for you is now finished. I ask you to be a little more patient, since it has to be completely dry before I send it to you. I will explain why: when the oil is completely dry, it does not matter if dust gets on it – all we have to do is wash it – but if it is not completely dry the dust sticks to the paint and eventually adheres to it, which creates an unpleasant effect. So we must wait about another week. I shall ship it, as you asked, to your friend Sandieu's house. The picture represents a *shepherdess with her sheep*.[2] I want you to know, sir, that it will be with immense pleasure that I will welcome you in my house if you ever come to Paris. My door is open to you and to your friends, you may be sure of that.

I did not want to try your good wine since it had been shaken around during its journey, but I certainly will as soon as I bottle it.

With all my best,

J. F. Millet

Notes

1. To travel from Cahors to Barbizon, the wine had to travel through Paris. Trains connected the main cities but a great deal was still done by coaches.
2. Location unknown.

Barbizon 3 Juin 1860

Monsieur Calmette,

J'ai enfin le cadre pour votre tableau! En le recevant hier au soir j'ai reçu avis du doreur que les deux autres (ceux de M'. Sabatier) sont aussi terminés. Vous voudrez bien me dire tout de suite si l'adresse que vous m'aviez donnée pour leur envoi est toujours la même, afin que je la transmette au doreur qui les expédiera de suite à M'. Sabatier. Je vais m'empresser, Monsieur, de faire à votre tableau, dans son cadre définitif, les retouches que je voulais y faire, et vous l'envoyer directement à Cahors. Comptez donc que ce tableau que vous attendez depuis assez de temps sera dans vos mains d'ici à quinze jours. Vous n'imaginez pas comme les doreurs font attendre ce qu'on leur demande. C'est un peu comme les peintres.

A propos d'un album de dessins dont vous m'avez parlé dans une de vos lettres, il y aurait à se bien entendre, car les peintres que je connais sont de ceux dont les oeuvres ont acquis un grand prix. Je suis bien forcé de vous avouer que mes relations sont si peu étendues, que je ne connais cinq ou six peintres seulement. Quand je dis connaître, j'entends dire personnellement. Il faudrait donc savoir quel prix vous pouvez ou voulez mettre pour des dessins afin de manoeuvrer en conséquence. Si jamais vous veniez ici comme vous me l'avez fait espérer, nous en dirions plus long en dix minutes qu'en quinze volumes de lettres, laissons donc cette question et bien d'autres, à vider à notre prochaine rencontre.

N'oubliez donc pas, je vous prie de me dire de nouveau l'adresse de M'. Sabatier pour que je l'envoie au doreur.

Recevez Monsieur je vous en prie l'assurance de ma grande considération.

J. F. Millet

Barbizon, June 3, 1860

Monsieur Calmette,

At last, I have the frame for your painting.[1] The gilder brought it to me yesterday evening and told me that the two others (the ones for M'. Sabatier[2]) are also ready.

Could you please tell me right away if the address that you gave me is still correct, so that I can forward it to the gilder, who will ship the frame immediately to Mr. Sabatier. I will do the touch-up on your painting as fast as I can now that it is in its final frame and I will mail it to you directly in Cahors. You can expect that the painting you have waited so long for will be in your hands within fifteen days. You cannot imagine how much the gilders make you wait for your order. They are as bad as *the painters*.

Concerning the album of drawings mentioned in one of your last letters, we must understand each other well, since the artists with whom I am acquainted[3] sell their works for very high prices. I also have to admit that the range of my acquaintances is very limited and that I know only five or six painters. When I say I know them, I mean personally. I need to have an idea of how much you would like to spend for the drawings in order to act accordingly.

If you ever come here, as you have led me to believe, we will be able to discuss more in ten minutes than in fifteen volumes of letters. Let's keep this subject, as well as many others, to be discussed during your next visit.

Please do not forget again to send me the address of M[r]. Sabatier, so that I can send it to the gilder.

With all my consideration,

J. F. Millet

Notes

1. *The Shepherdess with Her Sheep.*

2. Etienne Sabatier, nineteenth-century landscape and portrait painter.

3. At this time Millet was friendly with Diaz, Tillot, Rousseau, Jacque, and Barye.

Barbizon 29 Décembre 1860

Monsieur,

Je vous envoie votre petit tableau que le courrier de Barbizon va déposer aujourd'hui même au chemin de fer. Je souhaite qu'il vous arrive sans accident et qu'il vous plaise assez pour vous payez en partie de la patience que vous avez mise à l'attendre. Cette peinture va peut-être vous sembler d'une nature bien étrange, mais je ne peux la donner que comme je peux la faire. S'il arrivait que ce tableau ne vous plaise pas, ne vous désolez pas trop, car vous auriez amateur tout de suite. Vous n'auriez qu'à me réexpédier ce tableau en fixant un prix à votre convenance, lequel prix vous serait envoyé tout de suite aussi. C'est un amateur qui me charge de vous dire cela. Dans tous les cas veuillez m'accuser reception de mon envoi, et répondre à la proposition qui vous est faite. Compter aussi que comme je

vous l'ai dit, je vous enverrai dans le courant de l'été prochain une esquisse peinte.

Recevez je vous en prie Monsieur mes bien cordiales salutations.

J. F. Millet

Rappelez vous que mon département est Seine et Marne.

Barbizon, December 29, 1860

Dear Sir,

I have sent your small painting.[1] The Barbizon mailman is bringing it today to the train station. I hope that it will arrive without accident, and that it pleases you enough to repay you for your patience. This painting will perhaps look strange to you, but I can only give it the way I can make it. If by chance you do not like the painting, don't worry, as you would have a buyer right away. You would only have to send it back to me and give me a price that seems fair, then the payment would be mailed to you immediately. The amateur[2] wants you to know all this. In any case, could you please confirm the safe arrival of my shipment and answer the proposition I have made you. As I told you, next summer I will send you a painted sketch.

Cordial salutations,

J. F. Millet

Remember that my *département* is Seine and Marne.[3]

Notes

1. *The Shepherdess with Her Sheep.*

2. The amateur is probably Arthur Stevens, a Belgian dealer who had asked Millet to let him buy all the paintings he could produce. An enthusiastic admirer of Millet, he had trouble paying for the paintings he acquired from the artist. "Really, Stevens is a broken stick, on which no one can lean. Aren't these kind of people distressing?" (letter from Millet to Sensier, January 3, 1860).

3. The district of Barbizon.

Barbizon 5 Janvier 1861

Monsieur,

Votre lettre du 29 Décembre m'apprend que votre petit tableau vous est parvenu en bon état, et que vous avez eu du plaisir à le recevoir, ce qui me donne du contentement. Ce n'a pas été pour mon compte que j'ai parlé en vous disant de fixer un prix à votre tableau au cas où il ne vous contenterait pas, mais bien véritablement de la part d'un amateur qui maintient son dire, et qui était très impatient d'avoir connaissance de votre réponse mais je lui ai communiqué votre NON qui lui prouve du reste combien peu il a à y compter. N'ayez donc aucun scrupule en ne

cédant pas votre tableau. Recevez tous mes remerciements pour la façon désintéressée dont vous me l'auriez cédé à moi. Je ne sais si vous pourrez lire facilement ce que je vous écris, je suis au lit depuis le 31 Décembre avec une fièvre très forte et de grosses douleurs de tête. Je suis cependant un peu mieux aujourd'hui. Voilà pour moi un bon commencement d'année! Vous me demandez si je dois m'absenter de chez moi trois ou quatre jours après les Rois. Quand même je ne serais pas retenu par la maladie je ne prévois pas que je doive faire la moindre absence d'ici à quelque temps.

Je serais content si dans vos arrangements pour être utile à votre confrère vous pouvez gardez mon petit tableau. Cela me prouvera que vous y tenez. Je n'ai pas encore votre affiche, mais elle ne tardera pas sans doute. Je serais heureux le jour que vous viendrez à Barbizon. Recevez mes souhaits de bonne année pour vous et les vôtres.

J. F. Millet

Barbizon, January 5, 1861

Dear Sir,

Your letter dated December 29 tells me that my small picture has arrived in good condition and that you were very pleased to receive it. This makes me very happy.

I did not speak for myself when I asked you to give a price for your painting in case you didn't like it, but for a potential buyer who still maintains his offer and is impatient to hear your answer. I have transmitted your negative answer, which tells him that he should not count on receiving it. Please do not have second thoughts about keeping your painting. I appreciate your unselfish offer to send it back for my own use. I don't know if you will be able to read this letter easily, but I have been in bed since December 31 with a very high fever and fierce headaches, although I feel a little better today. What a way to start the year. You ask me if I have to go away for a few days after Epiphany. Even if I were not kept in bed because of my sickness, I would not expect to be going anywhere for a while.

I would be happy if, in dealing with your confrère, you could keep my small painting. This would be the proof to me that you like it. I still do not have your *affiche*,[1] but it should not be long now. I will be happy the day you come visit us in Barbizon.

Best wishes for the new year to you and your family,

J. F. Millet

Notes

1. The *affiche* was an advertisement for Calmette's bookstore (see fig. above).

233

Barbizon 8 Février 1861

Monsieur,

Permettez moi avant toute autre chose de vous remercier de la gracieuseté que vous m'avez faite en m'envoyant Le Roi des Chapons *qui vraiment méritait bien de l'être, car il était d'un tel volume et d'une si bonne mine, que je doute fort qu'un roi en ait jamais eu un meilleur. Nous l'avons fait attendre (faire attendre un roi!) aussi longtemps que nous avons pu, car la gelée était forte chez nous, et il ne pouvait y avoir danger pour qu'il se gâte. Bref, nous l'avons fait attendre jusqu'à l'arrivée d'un de nos amis que nous tenions à avoir avec nous. Je vous dirai que l'enthousiasme a été général, que ce roi était au moins aussi bon qu'il était beau, ce qui n'est pas peu dire. Puis les abondantes truffes qui le garnissaient étaient de la plus admirable qualité, noires douces et excellentes, mais soyez persuadé que toutes ces qualités n'ont point passé inaperçues. Nous l'avons arrosé avec votre très fameux vin, et vous devez le croire nous n'avons pas manqué de boire à votre santé et à celle de toute votre maison. Enfin je vous dirai que vous avez été proclamé un homme faisant royalement les choses! Recevez dans tous les cas et tout particulièrement mes remerciements, qui pour être faits à batons rompus n'en sont pas moins sincères.*

Il me reste à présent une chose encore plus sérieuse à vous dire: c'est que je souhaite à ceux des vôtres qui se portent bien la continuation de leur bonne santé, et le retour à la santé pour ceux qui sont malades. Puis je compte bien vous voir arriver un de ces jours à Barbizon, mais je réclame plus d'une demi-journée.

Recevez de moi le plus cordial bonjour.

J. F. Millet

Votre vin a été déclaré très très fameux vin par ceux qui en ont gouté!

Barbizon, February 8, 1861

Dear Sir,

First let me thank you for your act of kindness in sending us *The King of the Capons*, which truly deserves its title, since it was of such great size and such good appearance. I really doubt that even a king has ever eaten a better one.[1] We let it wait (let a king wait!) as long as we could, since the frost was very thick here and there was no danger of it spoiling. In short, we had it wait for the arrival of a friend with whom we wanted to share it. I will tell you that the enthusiasm was unanimous; the king was as good as it was beautiful, which says a lot. And the abundant truffles that garnished it were of the most admirable quality, black, sweet and excellent. Be assured that all these delicacies have been noticed. We washed it down with your very excellent wine, and you must believe that we did not forget to drink to your health, as well as to your entire household. Finally, I will tell you that you have been proclaimed a man who does things royally! I send you especially all my thanks, which are maybe a little incoherent but sincere.

I have now one more serious thing to tell you: this is that I wish the members of your family who are healthy the continuation of their good health and the return of good health to the ones who are sick. Also, I hope to see you arrive one of these days at Barbizon, and I want you to stay more than half a day.

I send you a cordial greeting.

J. F. Millet

P.S. Your wine has been declared *very, very fine wine* by those who have tasted it.

Notes

1. In a letter to Rousseau dated October 15, 1861, Millet wished that Madame Rousseau, who had been ill, might become "as fat as a stuffed Capon from Calmette" (Cabinet des Dessins, Musée du Louvre).

Barbizon 22 Mars 1861

Monsieur,

C'est en revenant de Paris où j'étais allé porter mes tableaux pour l'exposition que j'ai eu l'annonce du malheur qui vient de vous frapper ce qui vous explique le retard que j'ai mis à vous dire combien j'apprécie l'état de douleur dans lequel vous devez être. Je ne sais rien dire à ceux qui sont frappés de tels coups sinon résignation et courage, car pour ce qui est des consolations, je n'en connais point, d'autant qu'on ne veut pas être consolé. Le temps seulement adoucit la rudesse du choc, mais heureusement il ne fait pas oublier; il rend au contraire plus distinct le souvenir de ceux qu'on regrette en raison du plus grand calme qu'il nous donne. C'est là ce que je vous souhaite en même temps que je vous envoie mes très cordiales salutations.

J. F. Millet

Barbizon, March 22, 1861

Dear Sir:

It's only when I came back from Paris, where I had brought my paintings for the Salon[1] that I heard about the tragedy that had struck you.[2] This explains the delay of my response, telling you how much I appreciate the pain you must feel. I do not know what to say to those who have had such misfortune. I don't know any consolations, since it is impossible to be consoled. Resignation and courage are the sole answer. Time only can soothe the harshness of the shock, but fortunately time does not make you forget. On the contrary, it makes even more distinct the memories of the ones who are gone, since it gives us a greater calm.

This is what I wish for you at the same time I send you my cordial salutations.

J. F. Millet

Notes

1. Millet had taken three paintings to the Salon du Palais de l'Industrie on May 1, 1861: *Sheepshearers* (fig. no. 9), *Tobit Waiting* (fig. no. 10), and *Woman Feeding her Child* (Musée des Beaux-Arts, Marseille).
2. Millet was referring to the death of Calmette's wife.

Barbizon 25 Mars 1861

Monsieur,

Si j'avais su plutôt que vous desiriez que je mette à l'exposition votre petit tableau je me serai arrangé pour cela, mais il est maintenant trop tard pour y songer. J'ai arrangé mon exposition sans compter sur ce tableau, puis obstacle suprême, les statuts de l'exposition portent qu'un artiste ne pourra exposer plus de trois tableaux. Mais il se fait d'autres expositions à Paris où peut être nous pourrons le mettre, et où il sera presque autant vu qu'à la grande Exposition. Je vous en parlerai très prochainement avec plus de certitude. Il est seulement pour l'instant, inutile faire voyager votre tableau. Mais croyez que je vous suis bon gré d'avoir pensé pour m'être agréable d'abandonner pour assez longtemps votre tableau.

Recevez je vous en prie mes très cordiales salutations.

J. F. Millet

Barbizon, March 25, 1861

Dear Sir:

If I had known sooner that you wanted me to put your small painting in the exhibition I would have made the necessary arrangements, but now it is too late to even think about it. I have organized my exhibition without this painting, and, supreme obstacle, the regulations specify that one artist cannot show more than *three paintings*.[1] But there are other shows in Paris where we will be able to exhibit it, so it will be seen by almost as

many people as it would have been at the Grand Salon. I will talk to you about this very soon with more certainty. For now, it is unnecessary to send your painting on a journey. Be assured that I appreciate the kindness of your thoughts in making your painting available for a while.

Receive my cordial salutations.

J. F. Millet

Notes

1. See note from the preceding letter.

Barbizon 16 Juin 1861

Monsieur,

Compter que ce sera avec le plus grand plaisir que je vous recevrai chez moi. Donc, Mercredi prochain 19. Si vous le pouvez venez me voir, ou tel jour qu'il vous plaira de cette semaine, car je crois bien ne pas être obligé de sortir, cependant le plus tôt sera le plus sûr. Voici la manière de procéder pour venir à Barbizon. Vous trouvez au chemin de fer de Lyon vers les 7 heures moins 1/4 du matin (je dis les 7 heures moins le 1/4 n'étant pas sûr de l'heure juste, mais vous partirai à coup sûr en vous trouvant à cette heure là au chemin de fer quand il faudrait attendre quelque peu) ou bien 3 heures 1/2 de l'après midi, ou encore le soir à 5 heures 1/2. Selon que vous vous trouverez disposé à partir, mais ce sont les trois seuls trains ayant correspondance avec Barbizon.

Demander un billet pour Melun et en même temps (à la même gare de Paris) une correspondance pour Barbizon, pour être sûr de trouver de la place dans la voiture. Cette correspondance coûte 1 franc. Arrivé à Melun, vous demanderez la voiture de Barbizon, et vous n'aurez rien à donner au cocher que le bulletin de correspondance qu'on vous aura donné au chemin de fer, mais vous lui donnerez ce bulletin seulement arrivé à Barbizon. Je ne sais si ce que je vous ai dit est clair, mais résumons les choses principales: prendre au chemin de fer de Lyon un bulletin pour Melun et en même temps une correspondance pour Barbizon. Je crois qu'il vaudrait mieux être le matin au chemin de fer à 6 h.1/2 plutôt qu'à 7h. moins 1/4. S'il ne vous coûte pas trop de vous lever un peu matin, ce serait peut-être la meilleure heure pour avoir plus de temps devant vous. Donc je vous attends presque mercredi matin vers les 9h1/2 à Barbizon. A toute heure du reste vous serez le bien venu.

En attendant le plaisir de vous voir je vous serre la main.

J. F. Millet

Barbizon, June 16, 1861

Dear Sir,

Be assured that it will be with the greatest pleasure that I receive you in my home. So next Wednesday, the 19th, if you can, come see me – or any day you like, for that matter – since I do not have to go anywhere that week, though the sooner the better. Here are the directions to come to Barbizon. You have to be at the Gare de Lyon around quarter of seven in the morning (I say around quarter of seven, not being completely sure of the train schedule, though I think you will be able to catch a train around this time if you don't mind being at the station so early), or 3:30 in the afternoon, or in the evening at 5:30. All depends on when you feel like leaving. There are only three trains that have a connection with Barbizon.

Ask for a ticket to Melun; at the same time (at the same station in Paris) buy the ticket for the connection to Barbizon, so that you will be sure to have a seat in the coach. The ticket price is one franc.[1] Once having arrived in Melun, ask for the coach to Barbizon. You must not pay anything to the driver – you'll already have the ticket for the connection – give him your ticket only at the arrival at Barbizon. I don't know if all these explanations are very clear, so let's summarize the main steps: purchase at the Gare de Lyon a ticket to Melun and at the same time a ticket for the connection to Barbizon. I think it would be better if you could be at the station at 6:30 a.m. rather than a quarter to seven. If you do not mind getting up early, it would be the best time and you would have plenty of time. I will be waiting for you Wednesday morning around 9:30 at Barbizon. Anyway, at any time you will be welcome. Looking forward to seeing you. I shake your hand.

J. F. Millet

Notes

1. At that time, one franc equaled about twenty-five cents.

Barbizon 25 Septembre 1861

Mon cher Monsieur Calmette,

Ne vous étonnez pas trop si je suis un peu de temps sans vous remercier des excellents raisins que vous nous avez envoyés. J'étais à Paris quand ils sont arrivés, et c'est en revenant que j'ai pu les goûter et les apprécier.

Sachez donc que les raisins de Monsieur Calmette ont eu un terrible succès, lequel n'a eu de terme qu'à la fin même des raisins. Aussi suis-je chargé pour vous des remerciements les plus enthousiastes de la part de toute la maison en

bloc. Seulement nous nous réservons, ma femme et moi nos petits remerciements particuliers, qui pour être moins bruyants n'en sont pas moins sincères, et croyez moi bien que nous avons été très sensibles à cette marque d'attention de votre part. Ces raisins ont un goût très savoureux et très délicat qui fait paraitre les nôtres un peu fades.

Ils nous sont arrivés un peu échauffés, car ma femme ne les a reçus que le 20 au soir, mais elle les a mis à l'air, et ils sont parfaitement revenus. Vous pensez bien que nous ne les avons pas mangés d'une façon si égoiste, que nous n'en n'ayons gardé une petite provision pour Rousseau que j'ai laissé à Paris, mais qui va revenir peut-être demain. Madame Rousseau, elle n'en goûtera pas, elle est depuis un mois dans son pays, à Besançon, d'où elle ne reviendra que vers la fin d'Octobre.

Ma femme n'est pas encore accouchée, mais nous attendons ce moment inquiétant d'un instant à l'autre.

En attendant que Rousseau réponde lui-même à votre demande, voici ce que je crois savoir de ses prix: Les petites choses doivent être de 800f. à 1000f. Les choses plus importantes vers les 2000f., pour ce qui est des grandes, nous n'avons pas à nous en occuper. Le tableau de moi dont vous me parler, des moutons broutant le long d'une haie, ne m'appartient pas. Je ne sais si je vous ai dit que quelqu'un me prend tous mes tableaux, par un arrangement fait entre lui et moi. Voulez-vous savoir de ce Monsieur s'il veut céder ce tableau? Je vous enverrai son adresse. Ou bien aimeriez-vous mieux que je vous reproduise ce tableau à mes moments de loisir? Vous me direz cela. Ce sera selon que vous l'aimerez le mieux.

Je comprends que vous soyez très peiné d'avoir perdu votre perroquet. Ces êtres sont pour tout de bon dans la maison et on s'y attache véritablement.

A quoi tient donc que votre récolte de raisin soit devenue mauvaise, quand le temps a paru bon? Ce n'en est pas moins une très grande calamité, et c'est encore heureux que ce qui reste soit de bonne qualité. Je travaille toujours comme un nègre et j'ai toujours de fréquentes migraines. Si vous vous rappelez les noms de nos enfants, ils ne vous ont pas non plus oublié, pas plus Jeanne que les autres. Vous avez du voir du reste que lorsque vous êtes venu, vous ne leur avez pas semble un étranger. Quand nous leur avons dit que c'était vous qui aviez envoyé ces raisins ils se sont écriés: il va donc arriver! et ils se sont mis à sauter.

Recevez tous les bons souhaits que nous faisons pour vous.

J. F. Millet

Barbizon, September 25, 1861

My dear M[r]. Calmette,

Don't be surprised that it took me so long to thank you for the excellent grapes that you sent us. I was in Paris when they arrived and it was only when I came back that I was able to taste and appreciate them. Be assured that the grapes of M[r]. Calmette were a fantastic success, which lasted as long as the grapes themselves. The entire family asked me to convey their most enthusiastic thanks. My wife and I especially thank you, and if we do so in a quieter way we are just as sincere. You must believe that we appreciate your attentiveness. These grapes have a very delicious and delicate taste that makes ours quite bland in comparison. They were a little stale when they arrived on the evening of the 20th, but my wife put them outside for a while and they freshened up again. Don't think that we ate them in such a selfish way that we did not keep any for Rousseau, who is still in Paris, but will return tomorrow. Mme. Rousseau, on the other hand, will not be able to taste them, since she is visiting for a month, in Besancon, from where she will not be returning before the end of October.

My wife has still not had her baby,[1] and we are waiting for the event with anxiety, any time now. While waiting for Rousseau to answer your request, here is what I know about his prices. The small works are sold between 800 and 1,000 francs. The more important works are around 2,000 francs and as far as the large ones are concerned we do not have to bother with them.

Regarding my painting *Sheep Grazing along a Hedge*,[2] it does not belong to me anymore. I do not know if I told you but I have made a deal with a person who now buys all my paintings; you could ask this gentleman if he wants to sell you this particular painting.[3] I will send you his address. Another possibility would be for me to reproduce the painting during my free time. Let me know what you decide. It will be done according to your wishes.

I understand that you are very sad to have lost your parrot. Those creatures become part of the family and we love them dearly.

What caused the ruin of your grape harvest? The weather seems to have been good! It is a real catastrophe and it is fortunate that what's left is of good quality. I still work like a slave, and have frequent headaches. If you remember the names of each of my children, they have not forgotten you either, Jeanne no less than the others. You must have noticed during your visit that you were not a stranger to them. When we told them that Mr. Calmette had sent the grapes, they cried: "Is

he coming again!" and they started to jump up and down. All our best wishes.

J. F. Millet

Notes

1. Catherine was expecting Georges, the Millets' youngest son.

2. Location unknown.

3. In March 1860, Millet had signed a contract with the French dealer Ennemond Blanc and the Belgian dealer Alfred Stevens, in which he agreed to sell them his entire production for the monthly salary of 1,000 francs ($250 dollars). See Etienne Moreau-Nélaton, *Millet raconté par lui-même* (Paris: Henri Laurens, 1921), vol. 2, p. 73.

Barbizon 1er Mai 1862

Mon cher Monsieur Calmette,

Une fois encore me voilà dans le cas de vous demander de faire acte d'indulgence envers moi à cause de ma maudite paresse à écrire. Je tiens seulement à établir une fois pour toutes, et je demande que vous en soyez persuadé, que je ne suis point d'un caractère ou capricieux ou changeant, qui agisse par boutades, je crois être d'une nature assez stable, au contraire: Mettez donc tout simplement sur le compte de ma paresse à écrire, le long-temps qu'il y a que je ne vous ai donné de nos nouvelles. La paresse elle-même est un péché assez capital pour qu'il y ait lieu d'être très coupable et reconnu tel. Je m'en confesse donc et réclame s'il est possible absolution. Et, si cela pouvait un peu atténuer ma faute, j'ai fait de nombreuses pertes d'amis, puis j'ai eu un procès (un procès moi!) qui m'a donné beaucoup de tracasseries, ce qui m'a brouillé la cervelle pour un moment. Le feu n'étant pas plus ennemi de l'eau que je ne le suis de ces choses là. Enfin, j'ai agi par nécessité, et la chose a bien tourné pour moi.

Je vais d'abord vous dire que ma famille va assez bien, car quand on est si nombreux, il y a bien de temps en temps quelque chose qui cloche. L'accouchement de ma femme a été heureux, et l'enfant, qui est un garçon vient admirablement. Mon ami Th. Rousseau va bien aussi, mais Mme Rousseau ne se remet pas, elle est toujours traînante comme quand vous l'avez vue. Ils sont encore à Paris, mais je pense qu'ils vont revenir bientôt. Je vais lui écrire ce que vous me dites à son sujet. Je verrai mon ami Sensier Dimanche prochain ici. Ne croyez pas que j'oublie l'esquisse peinte que je vous ai promise. Vous l'aurez bien gagnée à force de l'attendre.

Je vous l'enverrai en même temps que vos moutons qui paissent le long d'une haie. *Votre cadre n'est pas encore arrivé. Vous avez eu une bonne idée en me l'envoyant, car j'aime beaucoup avoir le cadre d'un tableau pour le terminer. Le tableau est je le crois en bon train. Nous avons eu aussi dernièrement de très fortes gelées, les*

arbres fruitiers sont en partie ruinés. C'est bien triste. Vous avez vous malgré tout, encore belle apparence. Dieu veuille qu'il ne s'ajoute pas encore d'autre mal! Voila bientôt un an que vous êtes venu nous voir. Quand recommencerez-vous? ou M[r]. votre fils? à ce propos, je vous sais gré de l'attention que vous avez eu de m'envoyer le portrait photographique de M[r]. votre fils, avec lequel j'ai fait au moins connaissance en image, en attendant l'occasion de la réalité.

Ayez moi toujours en bon souvenir. Recevez de toute ma famille et particulièrement de ma femme et de moi mille souhaits de bonne santé et désir de vous revoir.

J. F. Millet

Barbizon, May 1, 1862

My dear Monsieur Calmette,

Once again I must ask you to forgive my negligence, caused only by my miserable laziness when it comes to writing. I want you to know once and for all that I am not a capricious, moody, or changeable person, on the contrary, I believe I am of a rather stable nature. It is just my laziness that is the cause of the delay in my response. Laziness is a deadly sin and I should be recognized guilty. I confess it, and I dare ask for your absolution. To lessen my guilt, I must tell you that I lost many friends and that I was involved in a trial[1] (a trial, me!) which caused me a lot of worries and confused my mind for a while, being as opposed to this sort of thing as fire is to water. Anyway, I was forced to defend myself and things finally turned out well for me.

First, I want you to know that my family is quite fine, though with so many people there is always a little something wrong. My wife gave birth to a boy, who is growing nicely. My friend Th. Rousseau is also in good health, but his wife is not yet any better; she is still as weak as when you last saw her. They are still in Paris but should be back soon. I will send him your instructions. I will see my friend Sensier next Sunday in Barbizon. I didn't forget the painted sketch that I promised you. You surely deserve it, having waited for so long. I will ship it with your *Sheep Grazing along a Hedge*.[2] Your frame has not yet arrived. It was a good idea to send it to me, since I like to have the frame before I finish a painting. The painting is, I think, coming along quite well. We had very heavy frost here and almost all the fruit trees are ruined. This is very sad. You, on the other hand, have kept your good looks. Let's hope that God won't send us any more misery!

It will be almost a year since you last visited us. When will you come again? or Monsieur, your son? I appreciate your kind

thought in sending me a photograph of your son; at least I have now met him in image while waiting for the same opportunity in real life.

Please keep me in your memories. My whole family and particularly my wife and I send you thousands of wishes of good health. We are looking forward to your visit.

J. F. Millet

Notes

1. Alfred Stevens and Ennemond Blanc broke their association with Millet in 1861; as a result, Millet was no longer paid his monthly salary. Having no resources to live on, he was forced to go to court and he won. In 1862, he signed a new contract with Blanc only (see Etienne Moreau-Nélaton, *Millet raconté par lui-même* [Paris: Henri Laurens, 1921], vol. 2, p. 105).

2. Millet made a replica for Calmette of *Sheep Grazing along a Hedge*, which he had sold to Stevens and Blanc for 1,500 francs.

Barbizon 24 Aout 1862

Mon cher Monsieur Calmette,

Encore une fois, n'ayez jamais crainte de m'ennuier en m'écrivant. Je suis au contraire toujours très heureux de recevoir vos lettres. Que ce soit donc bien entendu. Depuis déjà longtemps je souffre presque constamment de mes migraines. Elles me donnent si peu de relâche que j'en suis comme ahuri. Ma paresse en est d'autant augmentée, ce qui explique comment je vous ai un peu négligé. Ne viendrez-vous donc point nous voir cette année? Mon ami Th. Rousseau est enfin revenu ici. Il est resté à Paris plus tard que d'habitude à cause de l'état de santé de sa femme qui demandait les soins du médecin. Elle va mieux. Madame Sensier vient aussi d'accoucher d'une fille. Rien de changé chez nous.

Ma femme et moi et tous nos enfants vous faisons toutes sortes d'amitiés et souhaitons vous voir bientôt.

J. F. Millet

Barbizon, August 24, 1862

My dear Calmette,

Once again, please do not believe that your letters are a nuisance. On the contrary, I always look forward to receiving news from you. You may be absolutely sure of that.

I have been suffering from headaches continuously. The pain almost never stops and leaves me in a daze. All this adds to my laziness and explains my negligence. Won't you come to see us sometime this year? At last my friend Rousseau is back. He had to stay in Paris longer than usual, since the health of his wife required the care of a doctor. She is feeling better. Madame Sensier just gave birth to a little girl. Nothing new in our family.

My wife and I and all the children send you our best and hope to see you soon.

J. F. Millet

Barbizon ce 25 Octobre 1862

Mon cher Monsieur Calmette,

Je compte bien que vous me pardonnerez d'avoir été si longtemps sans vous donner signe de vie, quand vous saurez que j'ai été malade à tel point que voilà six semaines que je ne suis même pas entré dans mon atelier! Je ne vais pas vous décrire ce que j'ai souffert, sachez seulement que je vais mieux et que voilà quelques jours que je retravaillotte.

Recevez tous nos remerciements pour vos excellents raisins, au dire de ceux qui les ont mangés, car pour moi, je n'étais pas en état de leur faire honneur, mais toute ma famille, Sensier et Rousseau, me chargent de vous dire toute leur satisfaction. Si je ne puis faire que cela je me porterai garant de leur enthousiasme. Les fromages de Roc-Amadour ont été aussi trouvés excellents quoique d'une manière tout à fait inconnue ici. Je vous en dirai mon opinion personnelle quand je me retrouverai en état de manger comme un homme, car je veux être enfin autre chose que le commissionnaire des opinions des autres. Inutile de vous dire que les répartitions indiquées par vous pour Sensier et Rousseau n'ont pas manquée d'être faites, et encore une fois je suis chargé de leurs remerciements.

Nous serons tous bien contents de vous voir l'année prochaine avec votre ami M^r. *Sabatier, comme vous avez le projet de le faire. Nous vous demandons tous que vous nous donniez le plus de jours possible. A vous de vous arranger pour cela. Je suis très heureux du plaisir que vous a fait le tableau de M*^r. *Sabatier que vous me décrivez. Vous avez raison de vous entourer le plus possible de choses d'art, car outre le plaisir que vous tirer directement d'elles, elles vous font mieux comprendre ce que vous voyez sur la nature, où tant de gens ne voient goutte. Avec ces choses le plaisir du chez-soi est doublé.*

Ma femme a beaucoup souffert de maux de gorge, elle est en voie de mieux.

Ma femme et moi et toute notre famille nous vous faisons mille et mille amitiés.

J. F. Millet

Madame Rousseau n'aura pas mangé de vos raisins, elle est à Besançon depuis deux mois.

Barbizon, October 25, 1862

My dear Monsieur Calmette,

I hope you will forgive me for going so long without sending news when you learn that I have been so sick that for the last six weeks I did not even enter my studio! I cannot begin to describe the pain I was in. I feel a little better now and have started to fiddle about again.

I thank you very much for your grapes, which I heard, from the people who ate them, were excellent. I did not taste any myself, since I was in no condition to appreciate them, but my whole family, Sensier, and Rousseau want me to tell you how much they enjoyed them. If this is all I am able to do at least I can assure you of their enthusiasm. The cheese from Rocamadour,[1] although made in a way totally unknown around here, has also been greatly appreciated. I will give you my own opinion when I am able to eat like a man again, since I want to be something else than the conveyor of other people's opinions. Needless to say, the distributions to Rousseau and Sensier have been made. Once again, everyone thanks you.

We will all be glad to see you next year with your friend M^r. Sabatier. We want you to stay as long as you can. It is up to you to make the necessary arrangements. I am very happy to hear that you enjoy Monsieur Sabatier's painting. You are very right to surround yourself with works of art.[2] In addition to the direct pleasure they give you, they help you to understand better what you see in nature; so many people can't see anything. With them the pleasure of a home is doubled.

My wife had a terrible sore throat, but she is feeling better.

My wife, myself, and the whole family send you our best.

J. F. Millet

Madame Rousseau did not eat your grapes; she has been in Besançon since September.

Notes

1. Rocamadour is a small town in central France famous for its dry goat cheese.

2. Calmette had a collection of 112 works of art of various areas and countries.

Barbizon 2 Juillet 1864

Mon cher Monsieur Calmette,

Ne me tenez point trop rigueur je vous en prie pour mes immenses négligences dont je vous fait toutes sortes d'excuses. Je regrette beaucoup que vous n'ayez pu venir nous voir cette année. J'imagine que nous nous serions quittés très bons amis. Je ne vous dit que ces quelques lignes en

train que je suis de me préparer à partir pour Paris, mais d'ici à une quinzaine vous aurez une longue lettre de moi.

Recevez en attendant une bonne poignée de main et croyez que personne ne vous a oublié.

J. F. Millet

Barbizon, July 2, 1864

My dear Monsieur Calmette,

I beg you not to be upset by my great negligence. I am so sorry that you could not come this year. I imagined our friendship would have grown closer. I write only these few lines, since I am on my way to Paris, but within two weeks you will receive a long letter.

I shake your hand, and be assured that no one has forgotten you.

J. F. Millet

Barbizon 4 Mai 1865

Cher Monsieur Calmette,

Je suis forcé une fois de plus de vous faire mes excuses pour le retard que j'ai mis à vous répondre. J'étais à Paris où j'ai séjourné quelque temps à cause des travaux décoratifs dont je vous ai parlé, puis des affaires de toutes sortes m'ont fait remettre d'un jour à l'autre.

Il m'est impossible de vous envoyer votre tableau pour l'exposition dont vous me parlez, mais je vous l'enverrai dans le courant de l'été. Je suis honteux de temps vous faire attendre. Je vous assure que je porte cela comme un lourd poids. J'espère pourtant que vous êtes plutôt très contrarié d'attendre si longtemps que vous n'êtes sérieusement faché, et je compte bien que si vous venez à Paris cet été vous viendrez tout de même me voir. J'ai été si bousculé que je n'ai rien pu faire pour l'Exposition de cette année. Je tacherai si Dieu le veut de me rattraper l'année prochaine.

Ma femme a été et est encore malade très sérieusement d'une maladie de foie, et dernièrement nous venons de manquer de perdre un petit garçon de sept ans, d'une maladie que les médecins appelle méningite. Nous l'avons cru mort mais heureusement l'heure n'était pas venue.

Nous vous souhaitons tous et aux vôtres la santé. Accepter de moi une bonne poignée de main.

J. F. Millet

Barbizon, May 4, 1865

Dear Monsieur Calmette,

Once again I have to apologize for the delay in my answer to you. I was in Paris, working on the decorative commission[1] I told you about, and business of a different sort forced me to remain longer.

It is impossible to send your painting in time for the exhibition[2] you mentioned, but I will send it to you during the course of next summer. I am ashamed to have kept you waiting so long. I can assure you that it is a heavy weight on my conscience. I hope that your disappointment comes from the frustration of having waited such a long time and that you are not seriously angry with me. I am truly looking forward to seeing you next summer when you come to Paris. I have been so busy around here that I did not have time to prepare anything for this year's Salon. I will try, if God helps me, to do better next year.

My wife is still seriously ill with a liver disease. We almost lost one of our little boys recently. He is seven years old and was stricken by a disease the doctors call meningitis. We expected him to die but fortunately his time had not yet come.

We wish you and your family a very good health.

I send you a cordial handshake.

J. F. Millet

Notes

1. In 1864 Millet was asked by the architect Alfred Feydeau to provide four decorative panels for a house being built for a banker named Thomas in the Boulevard Beaujon (soon after renamed Haussmann). The theme was to be the Four Seasons. After an exchange of letters the terms were finally agreed upon and Millet produced three large paintings, each three meters high, and a ceiling.

2. Calmette was lending paintings to regional exhibitions such as the Cahors Exposition des Beaux-Arts et de l'Industrie in 1873. To this point in the letters, Calmette owned three paintings by Millet.

Barbizon 21 Aout 1867

Mon cher Monsieur Calmette,

J'aurai croyez le bien beaucoup de plaisir à vous voir.

Si j'ai tardé quelques jours à vous répondre c'est que j'étais à Paris quand votre lettre est arrivée ici.

Th. Rousseau est malade chez lui à Paris, et j'étais auprès de lui à le soigner. Une lettre que j'ai reçu d'ici m'apprenant la maladie d'une de nos grandes filles, je suis venu aussitôt mais comme elle va mieux je vais retourner à Paris,

pour ne pas laisser Rousseau plus longtemps seul avec sa garde-malade. Vous devez vous dire: Mais que fait Mme Rousseau pendant ce temps là? Cette pauvre femme a besoin elle-même d'être soignée, elle tourne à l'enfance. Il est question vu la maladie de son mari, de la mettre dans une maison de santé.

Quand je vous verrai à Paris et ce sera prochainement, je vous expliquerai cela plus au long. C'est bien triste. Rousseau, lui, se remettra. Il lui est pour le moment impossible de travailler, parcequ'il ne peut se servir de son bras gauche.

Recevez mon cher Monsieur Calmette en attendant le plaisir de vous revoir, mes compliments et ceux de toute ma famille.

J. F. Millet

Vous voyez comme la maladie vient tout mettre sans dessus dessous.

Barbizon, August 21, 1867

My dear Monsieur Calmette,

I will be very happy to see you again. I was in Paris when your letter arrived; this explains the delay of my answer. Th. Rousseau is very ill in his home in Paris, and I was there taking care of him. I came back to Barbizon in a hurry after receiving a letter telling me that one of our eldest daughters was very sick, but, since she is feeling better now, I will go back to Paris. I do not want to leave Rousseau alone with his nurse any longer. You must be asking yourself: but what is Mrs. Rousseau doing? This poor woman needs to be taken care of; she is regressing to childhood[1]. We will probably have to put her in a nursing home if Rousseau does not recover quickly.

When we meet in Paris I will have time to discuss all this with you. All this is very sad. I am sure Rousseau will get better. For the moment he cannot work, since he has lost the use of his left arm.

Monsieur Calmette, all my best from my family and myself,

J. F. Millet

You see how sickness turns everything upside down.

Notes

1. Mme. Rousseau, who had been suffering from a lingering mental sickness was now completely senile.

Barbizon 19 Janvier 1868

Mon cher Monsieur Calmette,

Quand vous êtes venu à Paris vers la fin de l'été dernier, Rousseau était déjà malade.

Vous devez vous souvenir qu'en réponse à votre lettre je vous avez donné rendez-vous à l'hotel où vous demeuriez, pour un jour indéterminé mais prochain. Et juste à ce moment là, ce pauvre Rousseau fut pris de crises horribles qui eurent sur nous un effet bouleversant.

Tout fut négligé pour être à lui, notre rendez-vous comme beaucoup d'autres choses. Le médecin croyait que l'air de la Suisse pourrait lui faire du bien, et il nous fallut organiser ce voyage dans lequel ma femme et moi devions l'accompagner. Le voyage n'a eu qu'un commencement d'exécution, car d'être allé seulement de Barbizon à Paris ce pauvre Rousseau n'en pouvait plus. Il eut en y arrivant à subir une nouvelle crise. Le médecin dit que le voyage était impossible et qu'il fallait rester à Paris jusqu'à ce qu'il fut possible de le ramener à Barbizon. On l'y a enfin ramené, et comme vous l'imaginez bien nous ne l'avons presque pas quitté jusqu'à sa mort arrivée le 22 Decembre à 9h. du matin. Voilà la trop légitime explication du manquement au rendez-vous donné, et j'imagine que vous ne m'en voudrez pas. Je n'ai pas besoin de vous dire l'impression que cette mort a fait sur nous tous, vous l'imaginez du reste. Depuis cela j'ai vécu comme une âme en peine, absorbée par la douleur et négligeant une infinité de choses.

Je suis de plus ahuri par un rhume horrible. En somme je suis pour le quart d'heure en piteux état.

Toute ma famille se porte assez bien.

Ma femme et moi nous vous disons mon cher Monsieur Calmette le plus cordial bonjour.

J. F. Millet

Barbizon, January 19, 1868

My dear Monsieur Calmette,

When you came to Paris at the end of last summer, Rousseau was already ill. You must remember that we had planned to meet sometime at your hotel. But just around that time, poor Rousseau began to have a horrible attack, which distressed us extremely.

Everything was neglected for him, our rendezvous like everything else. The doctor thought that the air of Switzerland would be good for him, so we had agreed to organize the trip. My wife and I were supposed to accompany him. However we had to cancel the plans, since going from Barbizon to Paris exhausted poor Rousseau. He had another attack when we arrived. The doctor told us to cancel the trip and to remain in Paris until we could transport him back to Barbizon. We brought him back here at last and, as you can imagine, did not leave him until his death on December 22 at nine o'clock in the morning.

This is the unfortunately too-legitimate explanation for missing the rendezvous; I hope that you will understand. I do not have to tell you the impact of this death on all of us; you can well imagine. Since then I have been like a lost soul, overwhelmed by grief, and neglecting an infinity of things.

I am suffering on top of everything else from a terrible cold. Anyway, I am altogether in a pitiful state. My entire family is fine.

My wife and I send you our best regards, my dear Mr. Calmette,

J. F. Millet

Théophile Silvestre

Théophile Silvestre (1823-1876), although a strong supporter of the Republic during the Revolution of 1848, compromised his republicanism over time and eventually moved completely to the side of the emperor, who appointed him *Inspecteur-Général des Beaux Arts*. By the time he began corresponding with Millet, he was a prominent critic and government official, moving at the center of the Parisian art world. He was acquainted with the Comte de Nieuwerkerke (the *Surintendant des Beaux Arts* and the leading art official under Napoléon III) and the Marquis de Chennevières (Nieuwerkerke's successor under the third Republic and the *Directeur des Beaux Arts*), both of whom would be instrumental ultimately in Millet's official recognition. Among his best friends was the powerful Parisian *Préfet de Police*, Pietri.

Silvestre lived in Valmondois, a village north of Paris, where he was in close contact with a group of landscape artists often associated with the Barbizon School, including Jules Dupré and Charles Daubigny, who had settled in the neighboring towns.

Silvestre's main activity was to write articles on Parisian artistic events, which appeared in periodicals such as *Le Figaro*. He also bought and edited a periodical, *Le Nain Jaune*, through which he ardently supported Napoléon III. He published a

Fig. 19. *Théophile Silvestre*, photographed by Nadar (Gaspard-Félix Tournachon), about 1865.

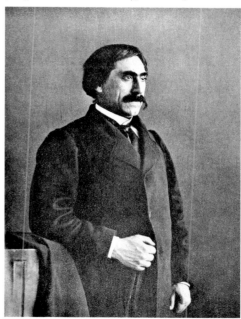

book, *Histoire des artistes vivants*,[1] containing a series of biographies of the most important artists of the nineteenth century.

Despite the assurances of Théodore Rousseau (a painter Silvestre admired) that Millet's paintings had no intended political messages, he had always been disdainful of Millet's so-called socialist work.[2] Following an increasingly liberal attitude in the Beaux Arts administration and after seeing Millet's paintings at the Exposition Universelle in 1867, Silvestre finally accepted Millet's genius. Totally converted, Silvestre decided to write "with enthusiasm in his favor." He visited Alfred Sensier, a long-time friend and supporter of Millet, deploring "his protracted blindness to the greatness of the master," promising "a solemn reparation."[3]

Commissioned by *Figaro* to review the Paris Salon of 1867, Silvestre was determined to pay Millet "the homage he deserved."[4] He also decided to add Millet's biography to his *Artistes vivants*. His style of writing biographies was influenced by the Realist literary movement that was flourishing in France during that peroid. The *d'après nature* [from life] approach explains the lengthy correspondence he exchanged with Millet. In the introduction to his book, Silvestre wrote, "I followed Montaigne's advice: *parler des vents avec les nautonniers* [learn about the winds from the sailor]. I tried to penetrate at the same time the soul of the man and the work of the artist in order to tell my contemporaries what I believe is the truth. I do not want to impose my ideas, but to express them with sincerity in these studies from life." In order to write Millet's biography as objectively as possible, Silvestre spent many hours in conversation with the artist, talking about his paintings and what they meant to him. He visited Millet's birthplace in Normandy and wrote to people who had known him as a young man. Sensier's information was not enough; Silvestre had to go back to the original sources.

Silvestre's research was extensive and thorough (although Millet doubted that the biographer really understood his representation of the rural world[5]), but the public's indifference to his biographical essays forced him to abandon his project before Millet's biography could be included.

Notes

1. *Histoire des artistes vivants* (Paris: Blanchard Edition, 1855), which included biographies of Delacroix, Ingres, Courbet, Barye, Diaz, Rude, Decamps, Chenavard, Préault, Corot, and Vernet. He revised the same book, added several biographies, and retitled it *Les Artistes Français* (Paris: G. Charpentier Edition, 1878). A third edition in two volumes was published in 1926 under the direction of Elie Faure: *Les Artistes Français* (Paris: Bibliothèque Dionysienne les Editions G. Grès et Cie, 1926); vol. 1, *Les Romantiques*; vol. 2, *Eclectiques et Réalistes*.

2. See Millet's letter to Sensier of May 30, 1863 (Cabinet des Dessins, Musée du Louvre).

3. Etienne Moreau-Nélaton, *Millet raconté par lui-même* (Paris: Henri Laurens, 1921), vol. 3, p. 23.

4. Ibid.

5. See Millet's letter to Sensier of April 30, 1867, below.

A letter from Millet to his friend Alfred Sensier provides an important introduction to the correspondence belonging to the Museum of Fine Arts. It is included here with the permission of the Cabinet des Dessins, Musée du Louvre, Paris:

Barbizon, April 30, 1867

My dear Sensier,

When I left you, I found Silvestre with Rousseau, and as Rousseau was going out, I went back with Silvestre, who was anxious that I should revise his descriptions of my pictures. This was decidedly useful. With certain exceptions, his descriptions are on the whole good, but they always lean toward his particular feelings. I tried, timidly and discreetly, to suggest some things as to the sense in which I would like my works to be understood, but when it is a question of oneself, it sounds conceited, and one seems to be making a fuss about nothing. His idea of the peasant is rather like Prudhon's notion. One detail – of no importance for the public, and which has none except in my own head – is that, in describing the *Potato Planters* (cat. no. 97), he speaks of an old piece of sheepskin in the man's *sabots*. If I tried to indicate anything there, it must have been straw. In my country, a man who had lined his *sabots* with sheepskin would have been an object of scorn. I let this little mistake pass, as I did not dare to make any more corrections. What he read me, it is true, were only notes, and not the whole article.

J. F. Millet

Fig. 20. *The Hamlet of Gruchy, Normandy*, pencil on paper, 21.5 x 29 cm., Museum of Fine Arts, Boston. *Drawn by Millet, this map locates many of the sites that he painted around his Normandy birthplace, notably* Cliffs at Gruchy *(cat. no. 145) and* End of the Hamlet of Gruchy *(cat. no. 111). Place names are translated below.*

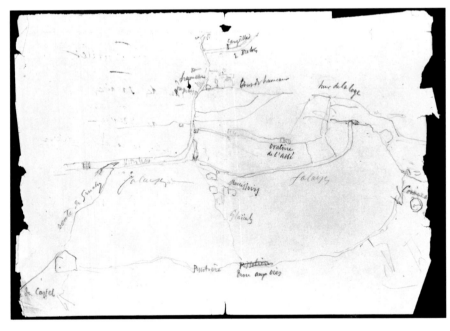

hamlet

well and stables

(see cat. no. 48) the house

end of the village

road to Gruchy

cliffs

the rocks of the castle urinal

Cangville

Breton

(see cat. no. 111) the wall of the loggia

the abbot's shrine

brouissoirs cliffs cornière

gladiolus

cliffs near Gruchy (see cat. no. 145)

the goose pond

Letters from Millet to Silvestre

Barbizon, 21 Aout 1867

Mon cher Silvestre

Je vous suis et nous vous sommes très reconnaissants des offres que vous nous avez faites dans votre lettre. Notre Marguerite est tout à fait hors de danger. Juger si nous en sommes contents. Je vais retourner à Paris de ces jours.

La lettre de Rousseau à l'Empereur commence bien et fait parfaitement image. Elle est bien d'un bout à l'autre. A-t-elle été remise et quel effet a-t-elle produit? Toutes les choses que vous me transcrivez sont très très très bien.

D'après ce que vous m'en dites la lettre à fait son effet. Tant mieux.

Quelqu'un est venu me voir hier. Ce quelqu'un est épouvanté de l'audace qu'il faut pour écrire une telle lettre à un si haut personnage.

Comment ne pas être en crainte après l'avoir si fort mécontenté? Ingres avait aussi une fois écrit contre le même personnage, et Ingres tout Ingres qu'il était a été applati et renfoncé par la puissance à laquelle il avait voulu se frotter. Il ne reste donc qu'une interprétation possible à cela: C'est que les facultés de Rousseau ont énormement baissées, car on ne peut commettre de tels actes qu'à cette condition.

Celui qui m'a dit cela n'est pas malveillant pour Rousseau, il n'est qu'un écho. Il est assez vraissemblable que ne pouvant rien répondre de mieux on va tacher de prendre la chose par ce bout là.

Avis au Secrétaire!

J'oublais de vous dire que celui qui m'a dit cela est un Belge aimant fort Rousseau, mais on peut juger qu'il cultive fort l'autre Monsieur. Que doivent dire les autres Belges n'aimant pas Rousseau et se livrant à la même culture!!!

A bientôt mon cher Silvestre. Sensier et nous tous vous disons bien cordialement bonjour.

J. F. Millet

J'ai reçu le Figaro où est la note.

Barbizon, August 21, 1867

My dear Silvestre,

I am and we are all very thankful for the offers you made in your letter.[1] Our Marguerite[2] is now completely recovered. You can imagine our happiness. I will be back in Paris one of these days.

The letter from Rousseau to the emperor starts off very well and describes the situation aptly.[3] It is excellent from beginning to end. Has it been delivered? and what was the reaction?

All the things you tell me are *very, very good.*[4]

From what you are saying, the letter had the same effect. Good!

Somebody came to see me yesterday, and that somebody was frightened by the audacity required to write such a letter to such a highly placed person.

Ingres[5] once wrote against the same person and Ingres, all Ingres that he was, was flattened and crushed by the power against which he tried to measure himself. I can then offer one possible explanation: that Rousseau's intellectual faculties have enormously deteriorated.[6] Only this could explain such action.

The person who told me all this is not malevolent toward Rousseau, he is only the echo of other people. Since nothing can be done anymore, we will try to take things accordingly.

Secretary beware![7]

I forgot to tell you that the person who told me all this is from Belgium, very fond of Rousseau, but it is easy to see that he is also acquainted with the other party.

What must the other Belgians say, especially the ones who don't like Rousseau!

See you soon, dear Silvestre.

Sensier and all of us send a cordial salute.

J. F. Millet

I received *Le Figaro* with your article.[8]

Notes

1. These offers probably refer either to Millet's *Légion d'honneur*, which Silvestre offered to obtain for him or to the critic's proposition to write articles on Millet's works as well as his biography.

2. Marguerite (born 1850) was Millet's sixth child, who had been ill with croup (see Etienne Moreau-Nélaton, *Millet raconté par lui-même* [Paris: Henri Laurens, 1921], vol. 3, p. 31).

3. Though president of the 1867 Salon jury and winner of one of four prize medals, Rousseau had never received the *Légion d'honneur*. Deeply upset by what he though was an injustice, he wrote a letter to the emperor to express his anger and disappointment. It is to the same document that Millet refers later in the present letter. When Rousseau finally did receive the *Légion d'honneur* on August 7, 1867, he expressed publicly his gratitude to the emperor in a letter published in *Figaro* (August 16-17, 1867).

4. Millet was referring to the Silvestre articles in *Figaro*.

5. Jean Auguste Dominique Ingres (1780-1867), history and portrait painter.

6. Rousseau had been ill and was then having difficulties recognizing his friends at times, often being "in a daze."

7. The caveat is addressed to the emperor's secretary.

8. The article on the 1867 Paris Salon.

Barbizon, 31 Décembre 1867

Mon cher Silvestre

Quand vous recevrez ce petit mot votre demande à l'impératrice vous aura été remise signée.

Je suis très heureux de ce que vous me dites du contentement de M\. Piétri. Il se pourrai bien alors que je sois encore plus content que lui car sans prétendre à obtenir le résultat que vous m'annoncez, j'ai du moins fait tout ce que j'ai pu pour y arriver. Alleluia! Amen!!

J'enverrai bientôt le petit garçon et je l'aurai déjà fait si ces tristes évènements n'étaient venus nous traverser. Depuis je me suis presque trouvé en totale incapacité de travail. La tristesse et l'ennui m'obsède. Il faut pourtant bien de gré ou de force vaincre cette incapacité!

Mon cher Silvestre priez encore un fois M\. Piétri de vouloir bien accepter tout simplement ces deux petits dessins. S'ils lui donnent quelque plaisir, j'en suis dix fois payé!

Croyez-vous que je suis tout tourmenté et inquiet de ce qui peut se passer entre Sensier et vous? Voici quelques mots de lui dans une lettre que j'ai reçu il y a quelques jours: J'ai été bien abimé pendant trois jours, je vais un peu mieux, mais ces évènements récents me labourent les nerfs et me font bien souffrir.

Il faut vraiment mettre ce que vous m'avez raconté sur le compte de ses nerfs, car encore un coup, Sensier est un bon coeur et un ami dévoué et je le sais bien moi qui vous parle. Passez, je vous en supplie sur les incommodités de son caractère. Il a été très malade et il l'est encore. Je voudrais tant jeter de l'eau sur le feu plutôt que de l'huile! Je ne sais quoi vous dire. Tenez-vous à bras-le-corps, et pensez que Sensier est un brave coeur.

Mais tenez moi au courant de tout, je vous en prie.

Encore une année évanouie avec tant d'autres. Qui est assuré de voir la fin de celle qui commencera demain?

Si des souhaits peuvent être bons à quelque chose, croyez bien mon cher Silvestre que nous vous souhaitons et aux vôtres ce qui peut arriver de meilleur.

A vous
J. F. Millet

Barbizon, December 31, 1867

My dear Silvestre,

When you receive this letter your petition[1] to the empress should have come back to you, signed. I am delighted to have pleased M\. Pietri. It is very possible that I will be even happier than he, since, without presuming to obtain the result that you foresee, at least I will have done everything in my power to get it.[2] Alleluia! Amen! I will soon send you *The Little Boy*[3] and I would have already done so

if this sad event[4] had not come upon us. Since, I have not been able to work at all. I am overwhelmed by grief and worries, though I will have to find a way to fight against this incapacity!

My dear Silvestre, once more ask M^r. Pietri to accept these two small drawings.[5] If he gets pleasure from them I will be paid back ten times.

Would you believe that I am tormented and worried by what is happening between Sensier and yourself? Here are few of his words from a letter received a few days ago: "I have been quite sick the last three days, I am a little better now but recent events wrecked my nerves and tortured me."

You can attribute the things you told me to his distress, since, once more, Sensier has a good heart and is a devoted friend. You must believe me. I beg you to overlook the dark side of his character. He has been and still is very sick. I would like so much to throw water rather than oil on the fire. I don't know what else to tell you. Take hold of yourself, and keep in mind that Sensier is a good man. Let me know everything, please. One more year is now vanishing along with so many others. Who is sure to see the end of the one that will start tomorrow?

If wishes can be good for something, believe, my dear Silvestre, that we wish you and your family the best.

Yours,
J. F. Millet

Notes

1. Millet and several other friends had addressed a petition to Empress Eugénie to beg her to use her influence in preserving the picturesque part of the forest near Barbizon known as the Bas Bréau, which the administration had doomed to destruction.

2. Silvestre was asking the *Légion d'honneur* for Millet. In order to get the support of Pietri, Silvestre had suggested that Millet draw two small portraits of Pietri's children and send them as presents. The *préfet* was overwhelmed by Millet's talent and decided to act on Millet's behalf. At a meeting in Fontainebleau, he was able to obtain from the emperor a verbal agreement on conferring the *Légion d'honneur*. Shortly afterward he sent to Napoleon III a note written by Silvestre to force the monarch to a decision (see letter from Silvestre to Millet of July 30, 1868 [Cabinet des Dessins, Musée du Louvre, Paris]).

3. The portrait of Pietri's little boy.

4. Rousseau's death, on December 22, 1867.

5. The portraits of Pietri's children.

Barbizon, 20 Février 1868

Mon cher Silvestre,

Je comptais être à Paris dans le courant de la semaine passée, mais la vente des meubles de Rousseau qui devait se faire Dimanche 16 m'a forcé à rester car je devais acheter certaines choses comme j'ai fait. Cette vente a duré trois jours. On n'imagine pas tout ce qu'il y avait d'emmagasiner dans cette maison.

Je vais enfin partir, peut-être demain. Ce qui veut dire que très prochainement vous m'entendrez frapper à vôtre porte.

A bientôt à vous.

J. F. Millet

J'apporterai avec moi le portrait du petit garçon.

Barbizon, February 20, 1868

My dear Silvestre,

I was hoping to be in Paris in the course of next week but I had to stay here for Rousseau's furniture sale, since I wanted to buy a few things. The sale lasted three days. You cannot imagine all the stuff he had accumulated in that house.

At last, I will probably go tomorrow, which means that you will hear me knock at your door very soon.

I will bring with me the portrait of the little boy. See you soon.

J. F. Millet

Barbizon 18 Avril 1868

Mon cher Silvestre

Tillot qui est venu l'autre jour passer ici quelques instants, m'avait déjà dit que, peut-être vous alliez faire un travail à propos de la vente Marmontel. Je vois que vous allez le faire effectivement. Je vous dirai d'abord que j'ai eu bien du plaisir à vous entendre me dire les impressions que vous avez reçues des choses de moi qui sont là. Je n'ai jamais revu le bout de village depuis qu'il est sorti de chez moi, et vous savez qu'on est pas sans quelques appréhensions sur la physionomie qu'on retrouvera aux choses en les revoyant. Votre impression vient me réconforter.

Voici quelques petits renseignements sur l'endroit de mon village que j'ai voulu représenter:

Ce village est situé au dessus des falaises dans un pli de terrain aboutissant à la mer vis-à-vis le Nord. Les maisons sont presque toutes bâties à hauteur de chambre, couvertes en paille, à l'exception d'une ou deux qui le sont en grosses ardoises. La maçonnerie en est faite en cailloux grisâtres, durs comme de l'acier. Les jambages des portes et des fenêtres et leurs linteaux sont en

granit (gris saumoné) qu'on tire d'une carrière située à peu de distance dans les terres. C'est un évènement de voir dans ce village quelqu'un n'étant pas de l'endroit. Ce lieu est si tranquille et si solitaire que le cri d'une oie ou le caquet d'une poule y prenne une immense importance. La vue, dans le village, est tout naturellement bornée par les maisons, mais en descendant au bout qui est vers la mer on a tout d'un coup en face de soi la grande vue marine et l'horizon sans borne. Auprès de la dernière maison se trouve un vieil orme qui se dresse sur le vide infini. Depuis combien de temps ce pauvre vieil arbre est-il la battu par le vent du Nord? J'ai ouï dire aux anciens du village qu'il l'ont toujours connu tel que je l'ai vu. Il n'est ni bien grand ni bien gros, puisqu'il a toujours été rongé par le vent, mais il est rude et noueux. Il est plus mince du pied qu'un peu plus haut, où il se trouve tout couvert de verrues qui verdissent chaque année et qui lui font comme un manchon. Il est entouré d'un mur grossier et très épais dans lequel on a fait une cabane pour des lapins.

Un ruisseau venant de l'intérieur du village, de l'endroit où est la fontaine et où l'on lave descend dans les prés qui commencent immédiatement au pied de ce mur. Après ces prés commencent les falaises allant à la mer. L'élévation de ce village au-dessus de la mer est à peu près de 300 pieds. Jugez des impressions qu'on peut recevoir d'un pareil endroit. Nuages parcourant les espaces, amoncellement menacants aperçu à l'horizon, navires allant dans des contrées lointaines, tourments, beaux temps etc. etc. etc.

Je viens de faire une bonne poussée au cochon qu'on va tuer. Tableau pour Brame.

Vous me direz si vous avez une réponse de M^r Bruyas et laquelle.

Bonjour de tous à tous et à vous.

J. F. Millet

Barbizon, April 18, 1868

My dear Silvestre,

Tillot[1] came here the other day to spend some time, and told me that you were thinking about writing something on the Marmontel sale.[2] So I see that you are actually doing it.

I was very glad to hear the comments you made on my paintings. I have not seen *End of the Village*[3] since I sold it, and you know how one can worry about seeing works done a long time ago. Your comments made me feel better. Here is some information on the place in the village I wanted to represent:

The village stands on rocky cliffs in a hollow of land opening northward toward the sea. Almost all the houses are one story high, covered with straw except for one or two that are covered with coarse slates. The masonry is of gray stone, as hard as steel. The

door and window jambs and their lintels are made of granite (salmon-gray) that comes from the quarries located nearby inland. It is a real event in this village to see someone who is not from here. The place is so quiet, so lonely, that the cry of a goose or the cackle of a hen takes on an immense importance. The view in the village is obviously obstructed by the houses, but going down toward the sea, suddenly one faces the great marine view and the boundless horizon. Near the last house, an old elm stands against the infinite void. How long has this poor old tree stood there beaten by the north wind? I have heard the old people say that they have always known it as I saw it. It is not very tall, nor very big, since it has always been gnawed by the wind, but it is rugged and knotty. The foot is thinner than the trunk, covered with warty swellings that turn green every year, creating the shape of a muff. It is surrounded by a very thick rough wall in which someone has built a hutch for rabbits.

A brook runs from the fountain and the washhouse in the center of the village toward the fields, which start right behind this wall; after the fields, the cliff stands against the sea. The village lies about 300 feet above the sea. Imagine the impressions that one can get from such a place. Clouds rushing through the sky, menacingly obscuring the horizon, boats sailing to faraway lands, tormented, beautiful, etc., etc.

I have made progress with Brame's painting: *The Pig Slaughter.*[4]

Tell me if you have received an answer from Bruyas, and if so, what is it?[5]

We all send you our best.

J. F. Millet

Notes

1. Charles Victor Tillot, born in 1825, was a landscape and portrait painter, as well as writer. A pupil of Rousseau, he moved to Barbizon with his family in 1855, becoming a close and faithful friend of Millet. After Millet's death, he assisted the family, and wrote the introduction for the catalogue of the Millet sale, at the Hôtel Drouot, Paris, May 11, 1875.

2. Marmontel was a professor at the Paris Conservatory of Music. The Marmontel sale of May 11-14, 1868, consisted of 286 works, among them *End of the Hamlet of Gruchy II* (cat no. 111); *Washerwomen* (cat. no. 62); 2 pastels: *Winnower* and *A Young Shepherdess Guarding Her Sheep*; and seven drawings. Silvestre did not write the introduction to the catalogue.

3. *End of the Hamlet of Gruchy II* (cat. no. 111) was jointly purchased in Rousseau's studio in Paris by Marmontel and Brame, then a young dealer, in 1866 (see Etienne Moreau-Nélaton, *Millet raconté par lui-même* [Paris: Henri Laurens, 1921], vol. 3, p. 5).

4. Brame never bought the painting, which was purchased at the Millet sale (Hôtel Drouot, Paris,

May 10-11, 1875) by Mʳ. Lefèvre for 26,000 francs. It is now at the National Gallery, Ottawa.

5. Alfred Bruyas was a famous collector of Courbet. Through Silvestre he met Millet and commissioned several works, but Millet became ill and never completed them. He bought several works from other sources and donated his collection to the Montpellier Museum, Hérault, France.

Barbizon, 20 Avril 1868

Mon cher Silvestre

Je vous ai l'autre jour parlé un peu de mon village, mais je ne vous ai rien dit de direct sur nom tableau comme vous me demandiez de le faire.

Je n'ai pas grand chose à vous dire puisqu'il est là sous vos yeux.

Mon désir a été de montrer le paisible habituel du lieu qui fait que tout acte qui ne serait rien ailleurs devient ici un èvènement. La femme avait assis son enfant auprès d'elle dans sa petite chaise, pour pouvoir filer mais l'enfant s'est ennuyé, et la femme pour le distraire l'a porté sur le petit mur où il s'amuse peut-être à plumer les feuillettes qui poussent sur le tronc du vieil arbre, ou bien elle lui fait regarder ceci ou cela sur la mer. Je voudrai bien que les deux chaises, la petite et la grande, qui sont auprès du rouet, ne soient point muettes.

Les oies ont bien vite vu que la femme est partie d'auprès de la porte, et comme c'est là leur constant idéal, elles se hatent de s'introduire dans la maison. L'homme a installé sur le bord du courant d'eau qui passe près de la maison, une pierre pour que la femme y puisse laver son menu linge sans plus se déranger.

Je voudrais bien avoir eu la puissance d'obséder vaguement le spectateur de la pensée de ce qui doit entrer pour la vie dans la tête d'un enfant qui n'a reçu jamais d'autres impressions que de cet ordre là, et comme plus tard il doit se trouver dépaysé dans les milieux bruyants.

Ce que j'essaie de vous dire là est sans doute confus et bavard, mais je ne le dis point pour que ce soit écrit en lettre d'or. C'est peut-être bien la botte de foin sans l'aiguille. Vous verrez bien.

Avez-vous fini votre biographie de Rousseau?

Je vous verrai sans doute dimanche prochain. Nous vous disons bonjour et nous vous souhaitons la bonne santé.

A vous.

J. F. Millet.

Barbizon, April 20, 1868

My dear Silvestre,

The other day I talked to you about my village[1] but said nothing directly about my painting as you asked me to.

I have not much to say, since you have it in front of you.

My goal was to show the habitual peacefulness of the place, where each act, which would be nothing anywhere else, here becomes an event. The woman sat her child next to her on a small chair while she was spinning, but the child got bored, and to amuse him the woman picked him up and sat him on the little wall where he plays, maybe plucking the little leaves that grow on the huge elm tree or looking here and there on the ocean. I would like very much that the two chairs, which are near the spinning wheel, the small one and the larger one, do not appear mute.

The geese see very quickly that the woman has left the doorstep and, since it is their constant goal, they rush inside the house.

The man has set a large stone on the bank of the small brook that runs near the house so the woman can wash her small laundry without having to go too far.

I would like to have the power to express for the viewer the thoughts that must enter, for life, the mind of a young child who has never experienced anything other than what I have just described, and how this child, later in his life, will feel completely out of place in a city environment.

You will probably find this confusing and wordy, but I am not asking you to write it all in golden letters. Perhaps you will see for yourself that it is the haystack without the needle.

Did you finish Rousseau's biography?[2] I will probably see you next Sunday.

Have a good day, best wishes.

J. F. Millet

Notes

1. *End of the Hamlet of Gruchy II* (cat. no. 111).
2. Rousseau's biography was never published.

Vichy, 18 Juillet 1868

Mon cher Silvestre

J'ai passé bien gentiment mon temps ici: constamment et souvent très violemment souffrant de maux de tête, d'estomac et d'intestins. Le médecin a dit que j'avais une grande inflammation intérieure. J'ai pris et je prends encore un bain tous les jours, je bois de la tisane, je prends aussi des lavements purgatifs et simples. Quelle jolie litanie! J'ai passé presque tout mon temps dans le lit!

J'étais tout attristé de tant de temps perdu. Moi qui comptais faire pas mal de croquis et quelques aquarelles menées aussi loin que je l'aurai pu, je m'en vois forcé de revenir à vide. Je suis tout mélancolique.

Voici notre saison, Dieu merci, bientôt finie. J'espère bien que dans cinq ou six jours nous serons à Barbizon, ou bien près d'y être. J'imagine que nous nous reverrons bientôt et que nous rebavarderons comme il nous est arrivé déjà (je crois) sur ce qui nous viendra à l'esprit.

J'adresse ce petit mot à Paris pour le cas où vous ne seriez plus à Valmondois. De Paris il peut vous arriver là plus facilement peut-être que de là à Paris.

Ma femme ne va point mal de son foie, mais elle souffre souvent et beaucoup de la tête.

Nous espérons et surtout nous vous souhaitons que vous soyez tous en bonne santé.

Nous vous disons de tout notre coeur, bonjour. A vous

J. F. Millet

Le médecin va nous dire aujourd'hui quand nous pourrons quitter Vichy.
Nous sommes allés chez le médecin, nous pouvons partir mercredi sans délai! Laus Deo!

Vichy,[1] July 18, 1868

My dear Silvestre,

I have spent my time here very quietly suffering from constant and often very violent head, stomach, and intestinal pains. The doctor said that I have a serious internal inflammation. I took and still take a bath everyday, I drink herbal tea, I also take plain and purgative enemas....What a beautiful litany!

I spend almost all my time in bed! All this wasted time saddens me. I had planned to do quite a few sketches and finish watercolors, but I see myself forced to come back empty-handed. I am in a gloomy mood. Thank God our season here is almost finished.[2] I hope that in five or six days we will be back in Barbizon. I expect that we will see each other again and that we will chat as before (I believe) about whatever matter comes to our minds.

I send this letter to your Paris address in case you may have left Valmondois. From Paris it will reach you more easily than it would from Valmondois to Paris.

My wife's liver is better, though she is still suffering from headaches.

All our best hopes and wishes for your good health.

Have a good day.

Yours,

J. F. Millet

The doctor will tell us today when we can leave Vichy.
We went to see the doctor, who said we could leave this Wednesday. Laus Deo!

Notes

1. Millet's wife was taking the waters in Vichy in order to cure a liver disease.
2. While in Vichy, Millet made numerous sketches and pastels of the landscapes and the peasants from the area (see letters to Gavet of June 17, 1866, and June 23, 1867).

Barbizon, 29 Juillet 1868

Mon cher Silvestre

L'état plus ou moins souffrant dans lequel j'ai vécu depuis notre retour de Vichy m'a fait remettre du jour au lendemain à répondre à votre affectueuse lettre. Je compte cependant que vous me pardonnerez car le remords que j'en ai est grand.

Je suis allé à Fontainebleau voir M^r. Nicas auquel j'ai remis ecrites les observations sur moi de M^r. Senac notre médecin de Vichy. M^r. Nicas m'a indiqué une façon de vivre où le plus d'exercice possible entre pour beaucoup. Je vais avoir aussi à me faire verser de l'eau froide sur les reins. Et d'autres choses encore.

Je n'ai pas besoin de vous dire bien longuement le plaisir que j'aurais à faire ce que vous me proposez, d'aller passer quelques jours avec vous. Si cela m'était possible je le ferai tout de suite, mais je vous assure que mon arriéré de travail me pèse à un point que je crois que tout plaisir en serait empoisonné. Si quand j'aurai un peu travaillé, vous êtes encore où vous êtes, peut-être bien que j'irai vous voir. J'aurai l'esprit plus tranquille et alors je serai moins ennuieux que je ne le serais maintenant.

Dans tous les cas il faudra bien que nous nous voyons, soit que j'y aille, soit que vous veniez, l'un pourrait bien ne pas empêcher l'autre.

Vous pouvez compter sur mon mutisme au sujet de ce que vous me dites.

Avez-vous beaucoup travaillé? Quelle nature de choses avez-vous faites? S'il y a possibilité, vous me les ferez connaître.

Le monde des eaux auquel je viens de me frotter me donne de plus en plus l'envie de me recroqueviller, de me ratatiner au plus profond de mon coin. Oh! que j'aime bien mieux les vaches.

Quand je vous verrez nous causerons de tout cela. Les impressions que j'ai seront peut-être endormies, mais pas anéanties. Vous me secouerez un peu et elle se réveilleront.

J'ai recommencé à travaillotter depuis deux jours.

Nous vous souhaitons à tous bonjour et la bonne santé.

A vous

J. F. Millet

Barbizon, July 29, 1868

My dear Silvestre,

Since our return from Vichy I have not been feeling very well. This is why I have kept postponing answering your very affectionate letter. I hope you will forgive me because I feel great remorse.

I went to Fontainebleau, to consult M^r. Nicas.[1] I gave him the written prescriptions of M^r. Senac, our doctor in Vichy. M^r. Nicas prescribed a way of life in which exercise plays an important part. I will also need to have cold water poured over my lower back. As well as many other things.

I do not have to tell you the pleasure it will be for me to comply with your suggestion, to come spend a few days in your company. If it were possible I would go at once, but being so behind in my work puts such a weight on my conscience that I could not enjoy myself totally. If, after I have worked a little, you are still at the same place, perhaps I will go visit you. Then my mind will be at rest and I will be less boring company than I would be right now.

In any case, we must see each other; either I will go or you will come, and one solution does not have to prevent the other. You can count on my silence concerning what you told me. Did you work a lot? What kind of things have you done? If it is possible, let me know.

The people at the baths whom I rubbed against increased my desire to shrivel and curl up in a deep corner. Oh! How I do love cows better! When I see you we will be able to discuss all this. By then my impressions will be perhaps less sharp but not totally vanished. You will just have to shake me a little and they will come back.

I started to work a little bit again two days ago.

We wish all of you a good day and good health.

J. F. Millet

Notes

1. M^r. Nicas was Millet's family doctor in Barbizon.

Barbizon, 27 Aout 1868

Mon cher Silvestre

L'arrivée bien inattendue chez nous d'un de mes frères qui était depuis huit ans en Amérique, a contribué à me faire remettre au lendemain pour vous écrire. J'ai eu aussi à faire de nombreuses lettres en réponse aux félicitations de ceux que je connais plus ou moins, mais la plupart me sont venues de gens inconnus. J'ai

reçu aussi pas mal de cartes, et entre autres celle de Jules Breton, ainsi ordonné :

> Au Maître F. Millet
> Jules Breton
> Bien vives et bien sincères félicitations
> à Douarnenez (Finistère)

Que dites-vous de cela ?

J'ai immédiatement après les modèles reçus, écrit et envoyé les deux lettres que vous savez. J'ai reçu de Mr. Piétri une lettre excessivement affectueuse écrite de sa main, et dans laquelle il pousse la modestie jusqu'à me vouloir insinuer qu'il n'est pour rien ou presque rien dans l'aboutissement de la chose. Je dois vous avouer que malgré tout mon respect pour sa personne et son caractère, je ne me crois point obligé de mettre cette insinuation sur le même rang que les articles de foi. Je vous prie de lui dire à l'occasion, combien je suis touché de le voir tenir compte de moi comme de quelqu'un.

Je pense quelque fois à la reception qui nous a été faite par les petits amis. En voila qui jettent plus d'eau que d'huile sur leur feu ! Je me suis remis autant que possible, à mon travail. J'ai commencé plusieurs choses et j'en ai terminé deux.

Vous pouvez bien compter mon cher Silvestre, que si vous restez un peu tard où vous êtes, j'irai passer quelques jours avec vous, lesquels seront dépensés en bavardage, en travail et en promenades, ce qui est aussi du travail. Heureux si les déclinaisons des coteaux nous font apercevoir autre chose que des personnages du Malade Imaginaire! Dites nous comment vous allez tous, comme aussi ce que vous jugerez bon de me dire.

Bonjour de tous à tous.

> A vous.
> J. F. Millet.

Dites je vous prie à Mr. Dupré que je n'oublie point la cordiale réception qu'il nous a faite, et que j'en ai été très touché.

Fig. 21. Letter from Millet to Silvestre, Barbizon, August 27, 1868.
Millet shared with Silvestre the congratulations he received upon being awarded the Légion d'honneur, copying out a card sent by Jules Breton. A younger artist who made a very successful career out of more prettified versions of Millet's own paintings, Breton had received the same award many years earlier.

Barbizon, August 27, 1868

My dear Silvestre,

The unexpected visit of one of my brothers, who had been in America for the last eight years, has contributed to the delay of my answer.[1] I also had to write many letters to answer the congratulations from people I more or less know, but most of them came from total strangers.[2]

I also received quite a few visiting cards and among them one of Jules Breton,[3] which looked like this

To Master F. Millet
Jules Breton
Happy and sincere congratulations
At Douarnenez, Finistere

What do you think of that?

After reception of the models, I wrote and sent immediately the two letters you know about.

I have received from M[r]. P.[4] an excessively kind letter, written by his own hand, in which he modestly insinuates that he had nothing to do with the result of the whole project. I have to confess that despite the respect I have for this person and his personality, I don't think I ought to put this insinuation on the same level as the articles of faith. I ask you to tell him sometime how touched I am that he regards me as Somebody.

I sometimes think about the reception that the *little friends* gave us.[5] Here are some people who throw more water than oil on their fire!

I am back to work as much as possible. I have begun several things, and I have completed two. If you stay where you are awhile, you have to count, my dear Silvestre, on my visit for several days that we will spend in conversation, work, and walks, which are another way of working.

We will be fortunate if from the slopes of the hills we can perceive something other than the characters of the *Malade Imaginaire!*[6] Tell me how all of you are doing, as well as everything else you like telling me.

Good day from all to all.

Yours,
J. F. Millet

Please tell M[r]. Dupré that I do not forget the cordial reception he gave us and that I was very touched by it.

Notes

1. His brother Pierre, on his return from America, told Millet: "*Les americains sont un peuple plus étrange que plaisant.*" [The Americans are a more strange than pleasant people.] (See Millet letter to Sensier, August 24, 1868, Cabinet des Dessins, Musée du Louvre.)

2. Millet had just received the *Légion d'honneur* and was answering the congratulatory letters.

3. Jules Adolphe Louis Breton (1827-1905) was a younger artist who had made a very successful career by translating Millet's themes and images into less challenging paintings. He had been named an *officer* in the *Légion d'honneur* the year before Mille received the more modest recognition and thought that he was doing Millet a great honor by sending him congratulations on his visiting card.

4. M[r]. Pietri.

5. The little friends mentioned here are the painters from the Auvers/l'Isle Adam colony, to whom Millet had been introduced by Silvestre. Jules Dupré was their leader.

6. A hypochondriac character in Molière's play.

Barbizon, 19 Octobre 1868

Mon cher Silvestre

Me voici revenu à Barbizon. Comme Sensier avait à faire chez Braun à Dornach, M[r]. Hartmann m'a fait engagé à être de ce voyage parce qu'il voulait absolument me faire voir son pays qui n'est pas éloigné de là. Il désirerait que je lui en fasse quelques représentations, tableaux et dessins. Comme je tiens à m'assurer de la besogne en dehors des marchands, et même en dehors de M[r]. Gavet, j'ai pensé qu'il était utile pour moi de faire ce voyage. Je crois qu'en effet cela doit établir entre M[r]. Hartmann et moi de bonnes relations et durables. Ce pays, des Vosges me plaît beaucoup. Je ne vais point vouloir vous le décrire, mais à l'occasion je vous en parlerai. Nous avons voulu étant si près, aller voir certaines choses de la Suisse, mais le mauvais temps nous a beaucoup contrarié. Les montagnes ont été presque continuellement masquées par les nuages. Nous avons vu un peu de Bâle et ses quelques très beaux Holbein, Lucerne, Berne et Zurich. Il y a dans cette patrie de Gessner un Musée que le moins bien assorti des brocanteurs parisiens aurait honte d'avoir fourni. Nous sommes revenus par Strasbourg dont la cathédrale est une bien admirable chose. Nous avons passé par la Lorraine où nous nous sommes arrêtés deux jours, car Sensier voulait voir sa mère qui y demeure dans un endroit appelé Jaulny. Ce pays de Lorraine est très impressionnant, dans un sens mélancolique. Mais voici une autre histoire. Le jour de notre départ de là pour Paris, en m'éveillant le matin je me suis senti sur le visage et surtout sur le nez une forte cuisson, et en y portant la main j'y ai senti des aspérités. Je suis allé bien vite me regarder dans la glace et j'ai été épouvanté en me voyant tout gonflé et tout couvert de mal. J'ai été bien désolé de me voir ainsi comme vous pouvez le croire. Nous sommes partis tout de même pour Paris où j'ai vu un médecin qui m'a dit: vous avez un érésypèle. Il ne faut point du tout aller à l'air, c'est indispensable car cela pourrait devenir très dangereux. Il m'a indiqué des choses pour m'en oindre, et d'autres comme lotion. Voilà en quel bel état j'ai fait ma rentrée à Barbizon. Je suis un monstre, un horrible monstre, agacé et ahuri par cette cuisson incessante de ma peau qui me semble épaisse comme la main et qui est sèche comme un vernis desséché. Je suis d'une apparence aussi disgraciée que celle de certains princes d'autrefois maltraités par les fées. La seule différence qu'il y ait, c'est que je ne suis ni prince ni beau comme le jour. J'ai trouvé en rentrant votre très engageante lettre, et malgré le voyage que je venais de faire, je serais tout de même allé vous voir, mais jugez vous-même! je suis bien sérieusement attristé d'être dans un tel état. Nous avons en plus notre petit Georges qui est malade. Il va un peu mieux, mais il vient d'avoir une horrible fièvre, avec délire et perte totale de connaissance. M[r]. Nicas nous assure que cela n'ira pas plus

loin. Il me recommande à moi comme le médecin de Paris, de ne pas aller à l'air, et comme remède, il me dit d'avoir de la patience. Encore un coup me voilà aussi cloué qu'une vieille chouette à une porte de grange.

J'aurais beaucoup de plaisir à vous voir et à causer avec vous, et je me serais peu inquiété des petits amis que je trouve trop bêtes et pas assez bons.

Nous avons été admirablement bien reçus et traités chez M[r]. Hartmann qui s'est mis avec toute sa maison à notre disposition.

Rien de plus à vous dire sinon que la cuisson de mon visage continue et m'ahurit et que mes yeux sont attristés par ce mal qui les entoure.

Tout le monde excepté Georges et moi va bien et vous dit à tous bien cordialement bonjour.

A vous,
J. F. Millet

Barbizon, October 19, 1868

My dear Silvestre,

Here I am, back in Barbizon. Since Sensier had some business with Braun[1] in Dornach[2], M[r]. Hartmann[3] convinced me to accompany him to show me his own country, which was not far from where we stayed. He would like me to make some paintings and drawings of the area. Since I want to keep working on some commissions outside the dealers and even outside M[r]. Gavet,[4] I thought it would be useful for me to take this trip. I believe, in fact, that it should help to establish between M[r]. Hartmann and myself a good and lasting relationship.

Les Vosges is a superb area, and I like its character very much. I will not start to describe it to you now, but I shall tell you about it eventually. Since we were so close, we also went to see some part of Switzerland, but the bad weather spoiled some of our fun. The mountains were almost continuously hidden by the clouds. We visited Basel and its very beautiful Holbeins,[5] as well as Lucerne, Berne, and Zurich. There is in Gessner's[6] native land a museum that the worst Parisian junk shop owners would be ashamed to have furnished. We came back through Strasbourg, where the cathedral is a wonder. We also passed through the Lorraine area, where we stayed two days because Sensier wanted to visit his mother, who lives in a place called Jaulny. The Lorraine countryside is very impressive and melancholic in a way. But here is another story.

On the day of our departure for Paris, when I woke up in the morning, I felt heat on my face, mostly on my nose, and when I touched it I felt some roughness. I quickly went to look at myself in the mirror and was horrified when I saw my face all puffed up and covered with a rash. I was very dis-

tressed, as you can imagine. Anyway, we left for Paris the same morning. There I saw a doctor who told me: "You have erysipelas."[7] It is imperative that I not go outside at all, because it could be very dangerous. He prescribed ointments and other lotions. It is in this nice state that I came back to Barbizon. I look like a monster, irritated and bewildered by this continuous heat on my skin, which feels as thick as my hand and which is as dry as old varnish. I look like those deformed princes cursed by the fairies. The only difference is that underneath this ugliness I am neither a prince nor beautiful. I found on my return your very supportive letter and despite the trip I just took I would have come to see you for a few days, but judge for yourself! I am very seriously annoyed to find myself in such misery. We also have our little Georges[8] who is sick. He is slightly better now; he had a terrible fever, with delirium and total loss of consciousness. M[r]. Nicas assures us that it is over now. He recommends also, as the Paris doctor did, that I should not go outside and, as a cure, to be patient. Once more, I find myself nailed like an old owl to the door of a barn.

I would be very happy to see all of you again and to chat with you. I would not worry about the little friends,[9] whom I find too stupid and not good enough.

We have been wonderfully entertained by M[r]. Hartmann, who opened his entire house to us.

Nothing more to tell you except that the heat on my face is still very bad and that my eyes are affected by the surrounding rash.

Everyone except Georges and me is doing fine.

Good day,

Yours,
J. F. Millet

Notes

1. Adolphe Braun (1811-1877), a pioneer in the popularization of art works, began as a photographer in Mulhouse in 1848 and later worked in Paris, where he gained the exclusive right to reproduce the paintings in the Louvre. Shortly thereafter, he was photographing paintings in museums all over Europe. In 1896 he published a catalogue containing about 20,000 reproductions. Every year pictures from the Salon were added, and in 1907 he was able to offer nearly 9,000 modern paintings by over 1,000 artists. Braun was the first to photograph Millet's works, beginning while the artist was still alive, and shooting about 150.

2. A village in the Vosges area.

3. Frédéric Hartmann, Rousseau's principal patron, was a manufacturer from Munster who became a collector of Millet's work. He commissioned Millet to do a series of paintings, among them *Buckwheat Harvest, Summer* (cat. no. 150).

4. Emile Gavet was an important collector of Millet's drawings and pastels (see essay preceding Gavet letters).

5. Hans Holbein (the younger, 1497-1543) was a history and portrait painter and engraver. Basel probably holds the largest collection of his works.

6. Salomon Gessner (1730-1887) was one of the first artists on the continent to treat landscapes in a naturalistic way.

7. Erysipelas, a skin infection, was a major problem in the nineteenth century.

8. Georges was Millet's youngest son.

9. See note 5 of preceding letter.

Barbizon, 25 Janvier 1869
Mon cher Silvestre

Je n'avais rien répondu à votre lettre car nous nous attendions à vous voir arriver d'un moment à l'autre, et nous y comptions tant, que ma femme avait acheté un gros dinde [sic] qu'on a fait attendre aussi longtemps que possible en attendant que vous soyez là. Mais le dinde [sic] a voulu enfin être mangé. Nous continuons à vous attendre et nous espérons cette fois vous voir arriver.

Bonjour de tous à tous.
A vous,
J. F. Millet

Barbizon, January 25, 1869
My dear Silvestre,

I did not answer your letter, since we were expecting to see you at any moment, and we were counting on you so much that my wife bought a large turkey that we kept as long as possible while waiting for your visit.

But finally the turkey had to be eaten. We are still waiting for you and we hope this time to see you arrive.

Good day from all to all.

Yours,
J. F. Millet

Barbizon, 26 Janvier 1870
Mon Cher Silvestre

La lettre de Madame Silvestre nous a tiré d'inquiétude à votre sujet puisqu'elle nous apprend que la maladie qui vous a si fort étreint vous a quitté, que vous êtes remis sur vos pieds, que vous commencez à dormir. Il faut croire que d'ici à bien peu de temps vous allez vous trouvez raffermi et consolidé en santé. Nous l'espérons et

surtout le souhaitons bien fort. Mais pour prouver qu'il vous a été dit bien véritablement: Lève-toi et marche, vous nous donnerez vous-même de vos nouvelles un de ces jours.

Voilà bien du temps que nous nous sommes vus, et nous avons eu depuis cela chacun notre accroc, car de mon côté j'ai employé mon temps moins à travailler qu'à souffrir et à geindre. Ne sachant à quel Saint me vouer, puisque je ne pouvais presque plus travailler, j'ai consulté un Somnambule qui m'a fait suivre un traitement dont je me suis très bien trouvé. Je vous dirai comment j'ai été poussé à cela. Après quelque temps de traitement le trouble qui me tenait à commencé à me quitter, et j'ai pu tout en souffrant me remettre à la besogne.

J'ai eu encore une très curieuse consultation de médecin, que je vous dirai aussi.

Il ne faut pas croire que je ne souffre plus, et l'autre jour encore j'avais une très forte migraine, mais le bon est que je peux travailler. Le trouble qui m'annihilait à cesser et j'en suis quitte pour des souffrances franches.

Je ne sais vraiment pas quand je serai à Paris, car je suis très absorbé par les deux tableaux que je désire terminer pour l'Exposition. Mais croyez que ce moment là venu, je n'y serai pas de longtemps sans aller vous voir, et nous renouerons les causeries interrompues que nous allongerons d'un bout qui en vaudra la peine.

L'un de mes tableaux représente une femme qui bat le beurre. L'autre un terrain labouré de l'autre côté duquel s'élève une forte volée de corbeaux auxquels un homme tire un coup de fusil. Voilà le programme, mais hélas! ce n'est point tout!

Encore un coup, mon cher Silvestre dès que ce sera possible donnez-nous de vos nouvelles et arrangez-vous pour quelles soient bonnes.

Nous le désirons bien fort et aussi que Madame Silvestre soit remise de ses fatigues. Que Jeanne soit maintenue en bonne santé.

Amen!
J. F. Millet

Barbizon, January 26, 1870
My dear Silvestre,

Mme. Silvestre's letter has lessened our concerns, since she tells us that the illness that strained you so severely is now gone, that you are back on your feet, that your appetite is back and that you can sleep again. We hope that in a short while you will find yourself strong and healthy again. We wish this fervently. But to prove you have been told "Raise and walk," you will one of these days give us some news yourself.

It has been quite a while since we have seen each other and since then, we have each had our own troubles because, for my part, I have spent more time suffering and moaning

than working. Not knowing which saint to turn to anymore, since I could not work, I consulted a sleepwalker[1] who prescribed for me a treatment that was very helpful. I will tell you how I was pushed to do this. After following this treatment for some time, the trouble that had hold of me started to disappear and I have been able, though still suffering, to begin to work again. I have had another very strange consultation with a doctor; I will also tell you about it.

Do not believe that I don't suffer anymore; just the other day I had a very violent migraine, but the good part is that I can work again. The trouble that immobilized me stopped and I am left with just the pain.

I really don't know when I will go to Paris, since I am very busy with the two paintings that I want to complete for the Salon,[2] but you may believe that when all this is over I will be quick to visit you and we will renew our interrupted conversations and pursue them at length.

One of my pictures represents a *woman churning butter*.[3] On the other, a man fires his gun at a flock of crows, which fly away from a ploughed field.[4] Here is the program, but alas! This is not all!

Once again, my dear Silvestre, send us news as soon as you possibly can, and manage for it to be good news.

We wish this very much, and we also wish better health to Madame Sensier and hope that Jeanne will stay in good health.

Amen

J. F. Millet

Notes

1. "Sleepwalker" was the popular name often given to hypnotists. In nineteenth-century France, *guérisseurs* (healers and folk doctors) and hypnotists were believed to have more knowledge, and were consulted more often than doctors by people with nervous or unknown disorders.

2. The 1870 Salon was Millet's last.

3. In the Malden Public Library, Malden, Massachusetts (see fig. no. 13).

4. Millet was probably describing *November*, the largest landscape he ever painted (now destroyed).

Barbizon, 14 Mars 1873

Mon cher Silvestre

Notre bureau de poste de Chailly n'a point voulu accepter votre volume sur Delacroix, ce qui en a un peu retardé l'envoi.

Je vous l'ai donc envoyé par le chemin de fer qui a du vous le remettre, malgré les lenteurs qu'il se permet quelques fois.

J'étais si souffrant l'autre jour que je n'ai pu qu'à grand peine écrire votre adresse sur la boîte contenant votre Delacroix.

Sans aller bien des fois mieux je peux pourtant aujourd'hui vous adresser ces quelques lignes.

Comment allez-vous tous? et vos clous? vous font-ils moins souffrir?

Ne manquez point je vous en prie de m'envoyer votre travail sur le Sardanapale et aussi sur d'autres sujets si vous en avez fait. Je suis sûr à l'avance que j'aurai du plaisir à les lire, car vous êtes plus qu'un autre renseigné sur Delacroix.

Je suis bien aise que les tableaux de moi que vous avez vu chez Durand-Ruel, vous aient fait plaisir. Il est rare de voir juger les choses par leur physionomie, on s'en occupe guère ordinairement que par rapport à certaines pratiques de peinture, ce qui est bien triste.

Je travaille peu. Mon état de santé est bien pauvre depuis bientôt une année, car la meilleure partie de mon temps se passe en souffrances et en geignements. Je n'ai pas pu encore atteindre à la perfection de la résignation pure, et j'en suis encore à me chagriner et à me tourmenter. Je ne veux pourtant pas vous faire subir une plus longue complainte sur ma mauvaise santé. C'est assez de ceci.

Tout le monde va du reste passablement.

Nous vous souhaitons à tous le bonjour le plus cordial et la meilleure santé.

A vous

J. F. Millet

Barbizon, March 14, 1873

My dear Silvestre,

Our Chailly post office did not accept your volume on Delacroix, which explains the short delay. So I sent it by rail, which should have delivered it by now.

I was so ill the other day that it required the greatest effort to write your address on the package of your Delacroix.

Even though I am not totally recovered today I can send you these few lines. How is your family? And your boils? Are they less painful?

Do not neglect to send me, please, your work on Sardanapalus,[1] as well as any other topics you have written about. In advance I am already sure that I will enjoy reading them, since you know more about Delacroix than anyone else.

I am delighted that my paintings at Durand-Ruel[2] pleased you. It is rare to see things judged by their content, people are usually more concerned about their conformity to some painting technique, which is very sad.

I do not work very much. My state of health has been very poor for almost a year now. The better part of my time is spent in

pain and moans. I have not yet been able to reach the perfection of pure resignation and I am still grieving and torturing myself. But I don't want to impose on you more lamentations about my poor health. That's enough!

Everyone is actually doing reasonably well. We all send you our cordial salutations and wishes for the improvement of your health.

Yours.

J. F. Millet

Notes

1. Delacroix, *The Death of Sardanapalus*, Musée du Louvre, Paris.

2. Durand-Ruel, a Parisian art dealer, who became the main seller of Millet's works beginning in February 1872 (see essay preceding Durand-Ruel letter).

Barbizon, 23 Juillet 1873

Mon cher Silvestre

Je suis coupable excessivement coupable de ne point vous avoir donné de nos nouvelles depuis si longtemps. La maladie m'a rendu inerte. Je n'oublie point pourtant! mais je remets au lendemain.

J'ai commencé par rester couché près d'un mois de temps et aux souffrances que j'avais s'est jointe comme conséquence une hémorragie qui m'a mis à deux doigts de la mort. A peine un peu remis, car je n'ai pu que me traînailler, me voici repris par une bronchite. Il y a quelques jours j'étais chargé de vesicatoires de synapismes et il m'a fallu de nouveau rester couché huit jours. Je me relève cependant, mais si toussant que j'en suis écrasé. Je n'ai ni force ni courage.
Dans quelques jours j'espère pouvoir vous en dire plus long.

Par surcroît ma femme en arrangeant des perchoirs à poules est tombée d'une petite échelle qui a cassé sous elle et elle s'est fait bien mal au genoux droit. Elle remarche mais difficilement. M'. Nicas dit qu'elle en a bien pour trois mois avant d'être passablement remise.

Dites-moi en tout cas ce que vous avez entendu à propos du commerce des tableaux.

Bien à vous.

J. F. Millet

Barbizon, July 23, 1873

My dear Silvestre,

I feel guilty, very guilty, not to have given you any news for such a long time. Sickness takes all my energy away. I do not forget you, though I postpone until the next day!

I started by staying in bed for almost a month and then a hemorrhage added to my

pains and brought me close to death. As soon as I was feeling slightly better I caught a bad case of bronchitis. A few days ago I still had *vesicalries*[1] and *synapismes*[2] and I had to stay eight more days in bed. I am up now but I cough so much that I am overwhelmed by it. I have no strength and no courage left.

In a few days I hope to be able to tell you more.

To top everything, while she was fixing the chicken coops my wife fell from a small ladder, which broke under her weight, and she hurt her right knee quite badly. She can walk again but with great difficulty. M[r]. Nicas says that it will take almost three months to heal.

In any case, tell me what you are hearing about the art market.

Yours,
J. F. Millet

Notes
1. Vesicalries is a blistering agent, which nineteenth-century doctors believed removed infection from the body.
2. *Synapismes*: mustard plaster.

Barbizon 17 Aout 1873

Mon cher Silvestre

Je vous remercie des renseignements que vous me donnez sur le commerce des tableaux. Il est toujours bon de savoir un peu où sont les choses, pour s'arranger autant que possible en raison de ce qu'on sait. Si tout ce qui vous a été dit n'est pas vrai, il doit y en avoir au moins une bonne partie. Un des commis de Durand-Ruel est venu me voir il y a quelque temps, et dans la conversation il a dit en substance: M[r]. Durand a été bien inquiet et bien gêné. Il a été vraiment bien tracassé, mais il y a eu moyen d'arranger les choses, bien naturellement je ne l'ai point questionné, et il n'y en a point eu plus long de dit.

Sans me connaître même un peu en affaires, j'étais épouvanté des immenses acquisitions qu'on me disait que faisait Durand, et je me demandait comment il pouvait avoir d'assez grands bras pour embrasser tout cela et le bien tenir, mais je me disais que sans doute il savait ce qu'il faisait, et qu'il n'allait pas sarcler sans ses mitaines. Je lui souhaite de bien se relever de là, car autant que j'en peux juger, c'est un homme honnête. Il y a bien longtemps que je ne l'ai vu, et bien longtemps que je ne lui ai donné de peintures.

Si j'étais en état d'aller à Paris je ne serai pas fâché de savoir s'il y a quelque chose de changer dans nos rapports. Je ne lui ferais certes pas de questions à ce sujet là, mais je verrai si dans sa conversation il en pointait quelque chose. Je suis toujours languissant, mais je peux travailler un peu à petites doses. C'est une amélioration. J'ai

commencé la petite peinture que je vous destine. Dès qu'elle sera en état de vous être envoyée, je vous l'enverrai.

Ma femme va mieux de son genoux mais c'est une guérison très lente.

Les grandes chaleurs que nous avons eu depuis quelque temps, me mettent à peu près à rien. C'est pour moi une maladie. Dès que je serai un peu plus en état de penser quelque chose avec suite, je vous parlerai des articles du Pays. En attendant je veux vous dire que vous y avez touché les choses bonnes à toucher et très bien.

Nous souhaitons à Madame Silvestre de reprendre enfin des forces. Nous souhaitons que le mauvais vent, le vent d'affliction, ne souffle plus longtemps dans votre porte.

Amitiés de nous à vous.
J. F. Millet

Barbizon, August 17, 1873

My dear Silvestre,

Thank you for the information you gave me on the art market. It is always good to know what's going on, in order to make plans according to what we learn. Even if what was told to you is not completely true, at least we can believe a major part. One of Durand-Ruel's[1] clerks came to see me some time ago and during the conversation he said: "M[r]. Durand-Ruel has been very worried and embarrassed. He really was very disturbed, but there is a way of making things better." Naturally I did not question him and he did not say more.

Without knowing much about business, I was frightened by Durand's enormous acquisitions and wondered how he could have such great arms to hold all this and keep it tight, but I told myself that he certainly knew what he was doing and he was not risking his neck. I hope he will end up fine, since, from what I could judge, he is an honest man. It's been a long time since I last saw him and a long time since I gave him pictures. If I could go to Paris, I would like to see him to find out if anything has changed in our relationship. Obviously, I would not ask him any questions about that, but I would see in his conversation if he indicated anything.

I am still tired and moaning, but I am able to work again for small periods of time. This is an improvement. I have started your small painting. As soon as it is ready to be shipped, I'll send it to you.

My wife's knee is better but the healing is very slow.

The great heat that we have had for some time now is killing me. For me it's a nuisance. As soon as I am able to think straight, I will talk to you about your articles on the country.[2] In the meantime, I want to tell you

that you touched on the right things and that's good.

We wish that Madame Silvestre may regain her strength. We hope that the bad winds, the winds of affliction, do not blow at your door any longer.

Love from us to you,

J. F. Millet

Notes
1. See Millet letter to Silvestre of March 14, 1873, note 3.
2. Probably Millet's birthplace in Normandy, since the French often refer to their birthplace as *le pays* (the country).

Barbizon, 8 Décembre 1873

Mon cher Silvestre

Je vous suis très obligé des avis et des renseignements que vous me donnez dans vos dernières lettres. Je désirerai bien que la vente de mes tableaux se fît tout simplement de la main à la main, mais comme ni les amateurs ni les marchands ne viendront me demander conseil sur leurs opérations, il faudra bien que j'en passe par leurs calculs. Les choses publiques et bruyantes me déplaisent beaucoup en elles-mêmes et il y a toujours quelqu'inquiétude à avoir sur leur résultat. Si pourtant la chose projetée se poursuit, rien ne peut m'être plus agréable que de vous voir écrire ce qui doit me concerner.

Vous me dites que pour ce travail vous auriez besoin de causer longuement avec moi. Mais malheureusement je ne serai pas en état d'ici à je ne sais pas quel moment, d'accomplir cette causerie. Me voici pris d'un mal de gorge qui est une suite de la bronchite qui m'a fait souffrir il y a quelque temps, et qui me donne une grande difficulté à parler. M[r]. Nicas qui est venu, me défend rigoureusement toute conversation. Mais, vous en savez sur moi bien plus qu'il ne vous en faut pour une notice de vente, ce ne serait donc pas une chose devant vous faire défaut pour ce travail. Quand vous en serez à vos Artistes vivants ce sera différent. Du reste dès que je me retrouverai en état de pouvoir causer avec vous, je vous le dirai.

Si d'ici là vous appreniez quelque chose qui vous semble de nature à m'intéresser, je vous serai bien obligé de m'en donner connaissance.

Vous me disiez que M[r]. Haro avait l'intention de m'écrire, mais il ne l'a pas encore fait.

J'ai reçu la Mélodie que vous m'avez envoyée, et je vous en remercie.

J'ai à peu près terminé pour Durand-Ruel, une femme qui fait boire sa vache. Le paysage qui est une vue de mon pays et qui appartient Feuardent est terminé. Feuardent doit venir le prendre dimanche prochain. Voilà les nouvelles de mon atelier.

Tous, nous vous souhaitons à tous la bonne santé.

J. F. Millet

Barbizon, December 8, 1873

My dear Silvestre,

I am very grateful for the opinions and the information that you expressed in your last letters. I wish that the sale of pictures could be done from individual to individual, but since neither the collectors nor the dealers will come to ask me my feelings about their business, I have to go their way.[1] Public and noisy events displease me greatly and, in addition, one must always worry about their results. If, however, our plan is pursued, nothing will please me more than to see you writing about my life.[2]

You tell me that in order to complete your work, you would have to talk to me at length, but, unfortunately, I will not be in condition to do that for awhile. I now have a sore throat, which is the result of the bronchitis from which I had greatly suffered some time ago. M[r]. Nicas, who came to see me, absolutely forbade me to talk. But you know a lot more about me than what is needed for a notice of sale, so you won't miss this too greatly. When you begin your *Artistes vivants*,[3] it will be different. Anyway, as soon as I am able to talk I shall write to you.

If before then you learn something that might interest me, I would be very grateful if you would let me know.

You told me that M[r]. Haro[4] was supposed to write, but he has not done it yet. I received *the Melody* that you sent me. Thank you very much.

I have almost finished a *Woman watering a cow* for Durand-Ruel.[5] The landscape, which is the view of my country and belongs to Feuardent, is completed.[6] Feuardent must come pick it up next Sunday.

That is all the news from my studio. We all wish good health to your entire family.

Yours,

J. F. Millet

Notes

1. In principle, Millet disliked the artistic lifestyle in Paris. He distrusted dealers and their complicated business procedures, preferring instead to sell his paintings directly from his studio to someone he felt could understand them (see Calmette correspondence). In practice, however, and in order to survive, he was forced to comply with some of the art world rules and traditions.

2. The Silvestre biography of Millet was never published; however, the Museum of Fine Arts owns the Silvestre manuscript of the series of articles on Millet's life, published in *Le Figaro* in May of 1867.

3. Theophile Silvestre, *Une Histoire des artistes vivants* (Paris: Emile Blanchard, Editeur Libraire, 1855).

4. M[r]. Haro, an art dealer from Paris, was Millet's paint supplier.

5. *Peasant Watering her Cow, Evening* (cat. no. 148).

6. *The Hamlet Cousin* (Musée Saint Denis, Reims).

Barbizon, 2 Juin 1874

Mon cher Silvestre

J'ai été très content de voir qu'on ait songé à moi pour des travaux de peinture au Panthéon.

Vous pouvez me croire qu'en lisant la lettre qui m'annonçait ces travaux, j'ai cru pour tout bon à une erreur, mais cette lettre paraissait fort en règle pourtant et songeant que tout est possible je me suis dit pourquoi pas?

Je compte aller à Paris un de ces jours pour voir les surfaces à couvrir, et pour savoir les sujets à représenter. Je vous rapporterai les épreuves de votre catalogue que vous m'avez envoyées et nous en causerons. Je veux vous dire en attendant que vous y dites des choses très bien, très bien! *à mon avis.*

Nous espérons tous que la maladie que semblait reprendre Mme. Silvestre n'aura pas eu de suites, et que votre médecin de l'Ile-Adam a prophétisé juste.

Notre Marie est au lit, elle est depuis plus d'un mois très souffrante de rhumatismes, et presque percluse. Elle commence depuis deux jours à aller mieux. Mais M[r]. Nicas lui annoncé que cependant elle restera encore dans son lit à peu près trois semaines. C'est cette maladie qui m'a empêché d'aller plus vite à Paris.

Nous souhaitons la bonne santé à ceux qui ne l'ont pas et nous souhaitons que ceux qui l'ont la conservent.

A vous tous.

J. F. Millet

Barbizon, June 2, 1874

My dear Silvestre,

I was very pleased that people thought of me for the Pantheon commission.[1] You must believe that when I received the letter that announced the works, I thought for certain that it was a mistake, but this letter looked genuine and, thinking that everything is possible, I said to myself: Why not?

I plan to go to Paris one of these days to see the surfaces that will be covered and to find out about the subject of the paintings. I will bring back the proofs of your catalogue and we will talk about them. I want to tell you in the meantime that you *say very good things*, in my opinion.

We hope that Mme. Silvestre's illness will not be of any consequences and that your doctor from l'Isle d'Adam will have prophesied correctly.

Our Marie[2] has been in bed for more than a month, suffering from rheumatism, almost crippled. She has started to feel better the last two days, but M[r]. Nicas tells her that she will have to stay in bed another three weeks.

It is her illness that kept me from going to Paris sooner.

We wish good health to the ones who don't have it and hope that the healthy ones will remain the same.

Yours,

J. F. Millet

Notes

1. In May 1874, the State, represented by Marquis Philippe de Chennevières, commissioned Millet to paint several scenes of St. Geneviève's life for the Pantheon Chapel. But Millet's health was rapidly deteriorating and he completed only a few sketches ([Robert L. Herbert], *Jean-François Millet* [London: Arts Council of Great Britain, Hayward Gallery exhibition catalogue, 1976], p. 30).

2. Marie was Millet's first child.

Barbizon 9 août 1870

Mon cher Monsieur Gavet

Je vous ai terminé Sept Dessins que je vous prie de venir prendre tout desuite si rien ne vous en empêche trop. Je vous prie de venir par la crainte que peut-être les communications entre Paris & nous se trouvent interrompues, & j'aimerais mieux vous savoir possesseur de vos Dessins, puisqu'ils sont prêts. Venez donc encore un coup. Je vous donne mon cher Monsieur Gavet une bonne poignée de Main
J. F. Millet

Fig. 22. Letter from Millet to Gavet, August 9, 1870.
Millet notified Gavet that he had finished seven drawings or pastels and urged him to collect them soon for fear that communications with Paris would be cut by advancing Prussian troops in the Franco-Prussian War.

Emile Gavet

Emile Gavet (1830-1904), a Parisian architect, made his fortune speculating on land and real estate. A major art collector of French and Italian Renaissance furniture and artifacts, he also owned a large painting collection, which included works by Old Masters such as Bosch and Velazquez, as well as contemporary artists, among them Corot, Rousseau, Diaz, Dupré, Barye, and Millet.

By 1865 he had aquired Millet's paintings from various sources (mostly dealers) and he owned several masterpieces, such as *The Angelus*.[1] However, Gavet was mostly interested in the pastels. In September 1865 he visited the artist's studio and convinced him to work almost exclusively for him, and almost exclusively in the pastel medium, for a monthly salary of 1,000 francs. Athough Millet accepted the proposition, he reserved "his liberty both in the choice of his subjects and in working for others."[2] During the next few years Millet created about 95 pastels and drawings for Gavet.

Unfortunately, some disastrous investment made before the Franco-Prussian war of 1870 ruined Gavet, who, to escape bankruptcy, was forced to sell the major part of his collection. Between 1872 and 1874 he sold all his paintings to Durand-Ruel. He delayed the sale of the pastels as long as he possibly could, but was forced to auction them at the Hôtel Drouot on June 11 and 12, 1875. Nearly all of the pastels now in the Museum's collection were bought by Quincy Adams Shaw and other Bostonians at this particular sale. In 1885 Gavet, who had become an antique dealer, sold his entire Renaissance collection. He died in Paris on May 4, 1904.

Notes
1. *The Angelus* is now in the Musée du Louvre, Paris (see fig. 1).
2. From a letter from Millet to his friend Feuardent (December 5, 1865; Cabinet des Dessins, Musée du Louvre, Paris).

Letters from Millet to Gavet

J'ai reçu aussi vos échantillons de papier et je suis en train d'en essayer quelques uns. J'ai mis trois dessins sur le chantier et j'augure que ces trois papiers là seront bons, mais c'est à mesure que les dessins avancent qu'on voit si le papier supporte les recharges et les effacements.

Nous avons eu effectivement des aspects de brouillard superbes et aussi des givres féeriques au delà de toute imagination. La fôret était admirablement belle ainsi ornée, mais je ne sais pas si les choses d'ordinaires plus modestes, comme les buissons de ronces, les touffes d'herbes, et enfin les brindilles de toutes sortes, n'étaient pas proportion gardée les plus belles de toutes. Il semble que la nature leur veuille faire prendre leur revanche et montrer qu'elles ne sont inférieures à rien ces pauvres choses humiliées. Enfin elles viennent d'avoir trois beaux jours.

J'ai terminé le petit tableau de Mʳ. Brame, il l'a chez lui. Je vais me mettre à préparer votre Nuit, puis aussi quelques autres tableaux pour vous, tout en travaillant au tableau de Mʳ. Brame que je compte envoyer à l'exposition. Vous recevrez plusieurs dessins dans le courant de Janvier.

En attendant votre prochaine visite recevez de moi je vous en prie le plus cordial bonjour.

J. F. Millet

Notes

1. The French identified the texture and thickness qualities of drawing papers with numbers.
2. Possibly *Winter Evening* (cat. no. 128).

Barbizon 21 Novembre 1865

Mon cher Monsieur Gavet

Je remets aujourd'hui à la voiture de Barbizon trois dessins à votre adresse. Soyez assez bon quand vous les aurez reçus de m'en donner votre avis. Je souhaite que vous en soyez content.

Je vous écrit comme je peux de mon lit où je suis cloué à cause de grands maux de tête.

Je veux tâcher de vous dire cependant de ne point livrer ces dessins à l'encadreur, mais qu'il vienne chez vous prendre les mesures de ses encadrements et vous les apporte prêts à mettre les dessins dedans. Puisqu'il respecte les mesures que j'ai tracées. Les trois dessins ont 37 c. de hauteur mais il se trouve à chacun une petite différence sur la largeur, et il faut en tenir absolument compte. Veillez je vous prie qu'il ne traine dessus ni ses mains ni ses manches. En somme qu'il n'agisse qu'avec vous présent. Je n'en peux plus.

Recevez je vous en prie l'expression de mes meilleurs sentiments.

J. F. Millet

Barbizon 28 Décembre 1865

Mon cher Monsieur Gavet

J'ai reçu votre lettre du 26 courant et le billet de mille francs qu'elle contenait. Je vous remercie.

Barbizon, December 28, 1865

My dear Monsieur Gavet,

I received your letter dated the 26th of this month and the note of 1,000 francs. Thank you. I have also received the sample of papers and I am right now experimenting with samples of different weight.[1] I have started three drawings and I can predict that these three papers will be fine, but it is while the drawings are progressing that one can see if the paper can take the retouching and erasing.

We have had some superb effects of fog and hoarfrost so fairy-like it surpasses all imagination. The forest was marvelously beautiful in this attire, but I am not sure the most modest objects, the bushes and briars, tufts of grass, and little twigs of all kinds were not, in their way, the most beautiful of all. It seems as if Nature wished to give them a chance to show that these poor despised things are inferior to nothing. Anyhow, they have had three glorious days.

I have finished Mʳ. Brame's little picture. He must have received it by this time. I will start to prepare your *Night*[2] and some other paintings for you, while I go on working on Mʳ. Brame's picture, which I hope to send to the Salon. You will receive more drawings in the course of January.

I look forward to your next visit, and I send you my most cordial salutations.

With all my best,

J. F. Millet

Barbizon, November 21, 1865

My dear Monsieur Gavet,

I will put on the Barbizon stagecoach today three drawings addressed to you. Would you be kind enough to send me your thoughts after reception. I hope that you will be happy with them.

Bad headaches have kept me bedridden, although I am making the effort to write to you, since I want to tell you that it is important that you do not deliver these drawings to the framer, but have him come to your house to take the measurements of the frames, and ask him to bring them back to you made for the drawings to fit inside, since he respects the measurements I have taken. The three drawings are 37 cm. high, but the width varies with each of them and this must absolutely be taken into account. Could you please make sure that he does not put either his hands or his sleeves on them. In short, don't let him touch them unless in your presence. I am exhausted.

I send my best.

J. F. Millet

Barbizon 4 Avril 1866

Mon cher Monsieur Gavet

Je viens de recevoir votre envoi de papier dont je vous remercie. J'ai reçu il y a quelques jours votre billet de mille francs dont aussi je vous remercie. La glace que vous m'avez annoncée n'est pas encore arrivée. Vos jeunes filles regardant passer les oies sont en bon train et seront terminées comme je vous l'ai dit dans le courant de la semaine prochaine et d'autres aussi....

.... Du reste je ne m'épargne pas, et comme je vous l'ai promis, d'ici à quelque temps je vais travailler seulement pour vous.

Je vous donne une très cordiale poignée de main.

J. F. Millet

Barbizon, April 4, 1866

My dear Monsieur Gavet,

Thank you for the shipment of paper, which just arrived, and for the 1,000 francs I received few days ago. The frost that you had announced has not arrived yet. I am working on your *Shepherdess Watching a Flight of Wild Geese*,[1] which should be finished, as I told you, sometime next week, as well as some other things....

...I am working very hard and, as I promised you, I should in the near future work exclusively for you.

I shake your hand,

J. F. Millet

Notes

1. *Shepherdesses Watching a Flight of Wild Geese* (cat. no. 112).

Vichy 17 Juin 1866

Mon cher Monsieur Gavet

Votre lettre m'a été envoyée ici. Je vous remercie des offres que vous me faites, s'il en est besoin je les accepterai. Ma femme est mieux depuis que nous sommes arrivés. Le médecin prétend qu'elle sera non pas absolument guérie mais en bon état à la fin de la saison. Il dit qu'il faudra revenir l'année prochaine, et qu'elle ira

mieux encore, puisque dans deux ans elle sera guérie radicalement.

Je ne me suis guère occupé du monde des eaux, mais j'ai fait un peu connaissance avec les environs de Vichy ou j'ai trouvé de très jolies choses. Je fais autant de croquis que je peux et je compte que cela va me faire faire pour vous des dessins d'une nature autre que ceux que vous avez. Le pays à beaucoup d'égards a des rapports avec pas mal d'endroits de la Normandie, verdure et champs entourés de haies. Comme il y a beaucoup de cours d'eau, il y a beaucoup de moulins. Les femmes gardent leur vaches en filant au fuseau, chose que je ne connaissais pas et dont je compte bien me servir. Cela ne ressemble en rien à la bergerette filant sa quenouillette des pastorales du siècle dernier. Cela n'a rien à démeler avec Florian je vous assure. Ne compter pas beaucoup sur les dessins exécutés ici, je veux me faire une provision aussi nombreuse que possible de documents, et il me faut un peu chercher ne connaissant pas le pays, mais vous aurez quand je serai de retour la primeur de mes impressions. Les petites charrettes des paysans sont attelées de vaches. Les chariots dont ils se servent pour rentrer les foins ont quatre roues et sont attelés ou de boeufs ou de vaches.

Encore un coup, je veux m'approvisionner tant que je pourrai et vous y gagnerez.

Je vous souhaite une bonne santé mon cher Monsieur Gavet et vous donne une très cordiale poignée de main.

J. F. Millet

Fig. 23. *Path with Chestnut Trees near Cusset,* pastel and black conté crayon on paper, 38.0 x 50.1 cm., private collection, New Hampshire.
This richly colored pastel is based on a carefully annotated drawing of the kind Millet made in the countryside around Vichy during the summer of 1866 (see

Millet's letter to Gavet of June 17, 1866, and cat. no. 118). Back in Barbizon, following his precise color notes on the drawing, he created the pastel that was probably lot no. 89, Road in a Hollow, Allier, *in Gavet's sale of 1875 and came to Boston shortly thereafter.*

Vichy, June 17, 1866

My dear Monsieur Gavet,

Your letter has been forwarded to me here. Thank you very much for your offers; I will accept them only if necessary.[1] My wife's health has improved since we have been here. The doctor tells me that she won't be completely cured but at least she will be in better shape by the end of the season. He says that we will have to come back next year and within two years she will be totally cured. I have not troubled myself with the gay world at the Baths, but I have become acquainted with some of the environs of Vichy and have found several very pretty subjects. I make as many sketches as I can, and hope they will supply me with drawings of a different kind from those you already have. This country resembles, in many respects, the part of Normandy that I know, with its meadows enclosed by hedges. There are a good many streams and, consequently, a good many water mills. The women spin with a spindle as they watch their cows, a thing I have never seen before and of which I intend to make use. They do not in the least resemble the little shepherdess spinning with her little distaff, whom you see in the pastorales of the last century, and have nothing to do with

Florian,[2] I can assure you. Do not expect to see many finished drawings on my return. I want to provide myself with as large a store of documents as possible, and I have to look about me, since I do not know the country well. But when I come home you will have the first fruits of my impressions. The small peasant carts here are all drawn by cows. The wagons they use to carry the hay have four wheels and are also drawn by oxen or cows.

Once again, I want to gather as many impressions as I can, and you will benefit from this.

I wish you good health, M[r]. Gavet, and I shake your hand.

J. F. Millet

Notes

1. Gavet asked Millet for an exclusive contract to buy his production of pastels. Remembering the bitter ending of his contract with Stevens and Blanc, Millet declined the offer (letter from Millet to Sensier, July 20, 1866; Cabinet des Dessins, Musée du Louvre, Paris).

2. Jean-Pierre Claris De Florian (1755-1794), a French writer who specialized in writing "delicate and graceful" plays in the spirit of Boucher's and Watteau's paintings (such as *Estelle* in 1788) for aristocratic salons.

Vichy 23 Juin 1867

Mon cher Monsieur Gavet

Je suis bien fâché que vous vous soyez donné toute la peine de venir à Barbizon pour me voir. J'aurai du vous dire quand je partais et je devais le faire, mais je me suis contenté de ma bonne intention. Arrivé ici je me suis trouvé tout souffrant, ma femme aussi était languissante. La chaleur, quoi? Je ne l'ai pas fait.

J'ai travaillé autant que j'ai pu le faire, mais je n'ai pas encore fait beaucoup: une trentaine de croquis seulement. J'ai fait deux ou trois promenades en voiture et j'ai vu des choses que je ne connaissais pas, qui sont superbes. C'est un peu loin de Vichy malheureusement, mais je veux m'arranger pour y passer une journée ou deux et ramasser de quoi vous faire quelques dessins en revenant. Cela me donnera je crois l'occasion d'en faire d'une nature comme vous n'en avez pas. Je souhaite bien fort le beau temps qui ne se décide pas à venir. En arrivant nous étions malades de chaleur, après nous avons eu des froids presque comme en hiver et à présent nous avons en même temps chaud froid et pluie. On ne peut pas du tout compter sur une demie-journée sans pluie et presque chaque fois que j'ai voulu sortir je me suis vu forcer de rentrer. Nous en ferons le plus que nous pourrons, voilà le sûr.

Adressez l'envoi d'argent que vous devez faire pour moi à Barbizon pour la fin du mois: à Monsieur Charles Tillot qui en fera la remise à

Fig. 24. Letter from Millet to Gavet, Vichy,
June 17, 1866.
*Millet and his wife spent the summers of 1866-1868 in
Vichy, in the mountains of central France, in the hope
of improving her health. He made numerous landscape
sketches during their daily drives and recorded details
of peasant life such as the hay cart pulled by cows,
which differed from the horse-drawn carts of Chailly.*

où j'ai trouvé de très-jolies choses. Je fais autant de croquis que je peux & je compte que cela va me faire faire pour vous des dessins d'une nature autre que ceux que vous avez. Le pays, à beaucoup d'égards, a des rapports avec pas mal d'endroits de la Normandie, verdure & champs entourés de haies. Comme il y a beaucoup de cours d'eau, il y a beaucoup de moulins. Les femmes gardent leurs vaches en filant au fuseau, chose que je ne connaissais pas & dont je compte bien me servir. Cela ne ressemble en rien à la bergerette filant la quenouillette des pastorales du siècle dernier. Cela n'a rien à démêler avec Florian je vous assure. Ne comptez pas beaucoup sur les des-

sins exécutés ici, je veux me faire une provision aussi nombreuse que possible de documents, & il me faut un peu chercher ne connaissant pas le pays, mais vous aurez quand je serai de retour la primeur de mes impressions. Les petites charrettes des paysans sont attelées de vaches. Les chariots dont ils se servent pour rentrer les foins ont quatre roues & sont attelés ou de bœufs ou de vaches.

Encore un coup, je veux m'approvisionner tant que je pourrai & vous y gagnerez.

Je vous souhaite une bonne santé mon cher monsieur Gavet & vous donne une très cordiale poignée de main

J. F. Millet

mes enfants. Voici pourquoi cette précaution: Le buraliste de la poste de Chailly est capable de créer des embarras aux enfants, et il peut trop tarder à leur remettre cet envoi. Il est arrivé plusieurs fois pendant que je me trouvais à Paris, qu'il a refusé de remettre à ma femme des lettres de cet ordre là, quoique adressées à M' ou à Mme Millet. Ceci coupera court à tout. Faites je vous en prie que votre lettre arrive bien à temps, car les enfants se trouveraient autrement très embarrassés. Au nom près l'adresse de M'. Tillot est la mienne.

Encore autre chose: Envoyez moi tout de suite ici, je vous en prie bien fort, un somme de 700 francs. Nous sommes partis n'ayant presque que ce qu'il nous fallait pour le voyage, et il va nous falloir payer dans quelques jours une portion de notre dépense. Faites moi cet envoi par un bon sur la poste et non par lettre chargée comme vous le faites pour Barbizon. Je n'ai pas besoin qu'on sache où je loge si je reçois de l'argent ou non! Adressez la lettre qui contiendra le reçu de la poste à ma femme, au cas où je ne serais pas là quand la lettre arrivera. Notre adresse est: rue Lucas chez M' Roux marchand. à Vichy (allier).

Votre petite bergère est finie sauf les raccords qu'il faudra refaire dans le cadre. Je devais vous envoyer la mesure pour le trouver fait en revenant de Vichy, et j'ai oublié. Du reste une fois revenu ce sera vite fait.

Recevez mon cher Monsieur Gavet une bonne poignée de main.

J. F. Millet

Ma femme ne va pas mal, sauf le trouble provenant des eaux.

Vichy, June 23, 1867

My dear Monsieur Gavet:

I am sorry that you took all the trouble to come to Barbizon to see me. I should have written to you that we were leaving. I meant to do it. Upon arrival, I started to feel unwell, and the heat made my wife uncomfortable. Anyway, I did not do it.

I have worked as much as I could, but I made only about 30 sketches.

I took two or three drives around Vichy, and I saw some wonderful things that I would never have suspected. Unfortunately, it is quite far from Vichy, but I will try to go back and spend one or two days gathering subjects for drawings once back here, which will be a different kind from the ones you already have.

I'm praying for nice weather, which does not seem to want to come. When we arrived the heat made us sick. Then the weather became wintry and, right now, it is at the same time hot, cold, and rainy. We cannot count on a half day without rain. Almost every time I tried to go out, I was forced to

come back in. I will still work as much as I can, that's for sure.

Please mail the money that you owe me to Barbizon before the end of the month and address it to Monsieur Charles Tillot,[1] who will give it to the children. Let me tell you why I took this precaution: the clerk from the Chailly post office sometimes makes things difficult for the children and delays the payment. On several occasions while I was in Paris, he refused to give my wife letters that were addressed to Mr. and Mme. Millet. This way everything will be simpler. Please make sure that your letter arrives in time so the children don't have to be troubled. Mr. Tillot's address is the same as mine.

Something else: I beg you to send me here about 700 francs right away. We left with only the money necessary for the trip, and we will have to pay part of our expenses in a few days. Send me a money order and not a letter with cash as you do in Barbizon. People where I stay do not have to know if I receive money. Send the letter with the receipt to my wife in case I am not at home when it arrives.

Our address is c/o Monsieur Roux
 Rue Lucas Vichy
 (Allier)

Your *Small Shepherdess*[2] is finished. I will still have to touch it up once it is in its frame. I wanted to give you the measurements before leaving, but I forgot. Anyway it will be completed once I get back.

Receive, my dear Monsieur Gavet, a good hand shake.

J. F. Millet

My wife is fine except for the "trouble" caused by the waters.

Notes

1. Charles Victor Tillot (see Millet's letter to Silvestre, April 18, 1868, note 1).

2. Probably *Shepherdess Sitting on a Fence*. See Etienne Moreau-Nélaton, *Millet raconté par lui-même* (Paris: Henri Laurens, 1921), vol. 3, illus. p. 226.

Barbizon 12 Octobre 1868

Mon cher Monsieur Gavet

Me voici de retour depuis avant hier, mais comme toujours j'ai du accomplir une migraine en revenant. J'ai trouvé votre lettre au bureau de poste de Chailly, et je vous remercie des mille francs qu'elle contenait.

J'ai vu de bien belles choses surtout dans les Vosges, mais le mauvais temps nous a fait bien du tort surtout pour voir la Suisse. Nous avons eu souvent d'horribles pluies qui ne se contentaient pas de nous mouiller, mais qui nous cachaient le pays quelques fois complètement. Nous sommes contents cependant. J'ai fait quel-

ques croquis bien rapides. J'espère pourtant qu'ils pourront aider ma mémoire. Je viens de commencer un grand dessin, un paturage sur le haut d'une montagne des Vosges.

Quand vous viendrez, vous me trouverez un vrai monstre. Deux jours avant ma rentrée ici, je me suis réveillé un matin avec un érésypèle sur le visage. Outre que c'est affreux à voir, c'est d'une cuisson très douloureuse. J'ai vu un médecin à Paris qui m'a ordonné ce qu'il croit bon de faire. D'abord il ne faut pas que je sorte pendant neuf jours. Bien heureusement encore que cela m'a pris en rentrant! Que serais-je devenu en route avec cela?

Mon cher Monsieur Gavet, je vous serre bien cordialement la main.

J. F. Millet

Barbizon, October 12, 1868

My dear Monsieur Gavet:

We came back two days ago,[1] and as usual I suffered from terrible headaches during the journey. I found your letter at the Chailly post office. Thank you for the 1,000 francs.

I have seen many pretty sights, especially Les Vosges, though the bad weather made sightseeing difficult, especially in Switzerland.[2] The rain was often pouring, getting us all wet and hiding the countryside. We had a good time anyway. I have made a few very quick sketches, hoping that they will help my memory. I started a large drawing, a meadow on a mountaintop in Les Vosges.

When you come here, you will find me looking like a monster. Two days before our return, I woke up one morning with erysipelas[3] all over my face. Not only do I look terrible, but it hurts tremendously. I saw a doctor yesterday in Paris who told me not to go out for nine days. Luckily it started when I was on my way back. What would I have done traveling like this?

My dear Monsieur Gavet, I shake your hand cordially,

J. F. Millet

Notes

1. The manufacturer and art collector Frédéric Hartmann had invited Millet and his friend Sensier to visit him in his town of Munster, in the eastern part of France (see Millet's letter to Silvestre of October 19, 1868, note 3).

2. See Millet's letter to Silvestre of October 19, 1868.

3. Ibid., note 7.

Fig. 25. *Animals Grazing at the Edge of a Pine Forest, Vosges*, pastel on paper, 68 x 93 cm., private collection, Chicago.

Pine trees are almost unknown in Millet's art, as they are not typical of the countryside he knew best in Gruchy or Barbizon. But during a brief visit in the autumn of 1868 to the Vosges mountains, an area loved by his close friend Théodore Rousseau, he made the sketch on which this beautiful pastel is based. The pastel itself was finished for Gavet back in Barbizon later that fall (see letter to Gavet, October 31, 1868). It was acquired on behalf of Quincy Adams Shaw at the Gavet sale in 1875.

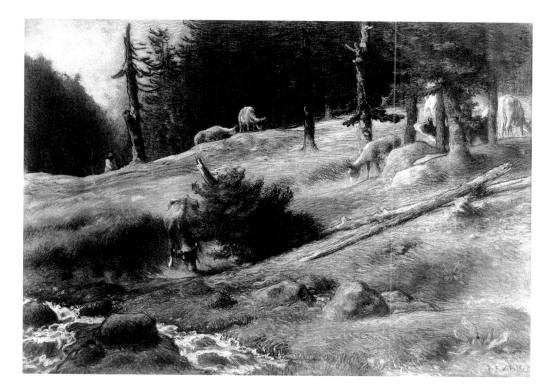

Fig. 26. *The Church at Chailly*, pastel on paper, 28½ x 33½ in., Minneapolis Institute of Arts.
Chailly was a large village, about a mile from Barbizon, on which the smaller community depended for church and post office. The church usually figures in Millet's work from the other side, seen across the plain separating the two communities. The narrow plowed plot in the foreground is typical of the small patches between trees and rocky waste that were cultivated by the peasants of both towns. Millet drew the pastel for Gavet in the winter of 1868 (see letter, December 14, 1868).

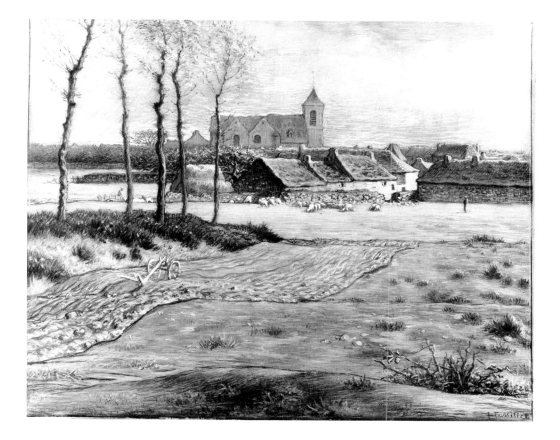

Barbizon 31 Octobre 1868

Mon cher Monsieur Gavet

J'ai reçu votre envoi de mille francs et je vous en remercie.

Malgré mon érésypèle j'ai pu vous terminé un dessin représentant un dessus de montagne que j'ai vu dans les Vosges. C'est un paturage avec des vaches et le chalet pour les abriter. J'en ai un autre en train: des vaches et des ânes paissant dans une éclaircie de sapinière. Vous en remporterez un de ceux là à coup sûr, puisqu'il est maintenant terminé. Avec les trois qui étaient fait avant mon départ pour les Vosges, cela fera naturellement quatre.

Je vais mieux. Si cela continue, je serai à peu près débarrassé dans une huitaine.

Je compte bien, mon cher Monsieur Gavet, vous voir prochainement comme vous me l'annoncez.

En attendant, je vous donne une bonne poignée de main.

J. F. Millet

Barbizon, October 31, 1868

My dear Monsieur Gavet,

Thank you for the 1,000 francs. Despite my erysipelas, I have been able to finish a drawing of a mountaintop from Les Vosges; it represents cows grazing in a meadow with a stable to shelter them.[1] I am also working on another one: cows and donkeys grazing in the clearing of a pine forest.[2] You may choose one of them and, including the three drawings I completed before my departure, this will bring the number of works awaiting you to four.

I am now feeling better and hope to be completely recovered in a week.

I hope to see you soon.

I shake your hand.

J. F. Millet

Notes

1. Gavet Sale Cat. No. 58: *Paturage dans les montagnes des Vosges.*

2. See fig. no. 25.

Barbizon 14 Décembre 1868

Mon cher Monsieur Gavet

Je n'étais pas à Barbizon quand vous m'avez fait votre envoi de mille francs, ce qui doit vous expliquer comment je ne vous ai pas plus tôt remercié. Recevez-en bien je vous prie toutes mes excuses.

Nous étions allés ma femme et moi à Paris avec une de nos petites filles et voilà que dès en arrivant elle a été prise de la fièvre scarlatine. Nous avons donc été forcés de rester là pour la

soigner jusqu'a ce qu'elle ait été en état d'être transportée ici, ce qui vient d'être fait. C'est en revenant que le buraliste de Chailly m'a remis votre lettre qui était demeurée chez lui.

En même temps que notre petite fille était prise de la fièvre scarlatine, j'ai été repris moi du même mal au visage que j'ai eu il y a quelque temps, de sorte que je n'ai pas osé bouger pour deux raisons. La première, c'est que je ne tenais guère à me montrer comme je l'étais, l'autre parce que je craignais le contact de l'air.

J'ai donc passé mon temps le plus tristement et le plus stérilement qui soit possible.

Je suis bien attristé. Je vais mieux et je travaille à ma vue de Chailly.

La petite fille est en bonne convalescence mais il y a à craindre que la maladie qui est contagieuse ne prenne les autres enfants.

Recevez mon cher Monsieur Gavet une bonne poignée de main.

J. F. Millet

Barbizon, December 14, 1868

My dear Monsieur Gavet:

I was not in Barbizon when your 1,000 francs arrived, which explains my tardiness in thanking you. Please accept my apologies.

I went to Paris with my wife and one of my little girls, who developed scarlet fever as soon as we arrived. Consequently we had to remain there to take care of her and wait until she could travel back to Barbizon. It was on our return that the clerk of the Chailly post office gave me your letter

At the same time, the skin disease that covered my face a little while ago reappeared. I had to stay inside the house for two reasons: the first was that I did not want anybody to see my monstrous face, and the second was that I did not think being exposed to fresh air would do me any good.

So I had to spend my time in the most dull and sterile way.

All this makes me quite sad, though I have begun to feel better. I am working on my view of Chailly.[1] Our little girl is now convalescing, but we are still worried, since it is a contagious disease, that the other children might catch it.

My dear Monsieur Gavet, I shake your hand.

J. F. Millet

Notes

1. Now in the Minneapolis Institute of Arts (see fig. above).

Barbizon 9 Aout 1870

Mon cher Monsieur Gavet

Je vous ai terminé sept dessins que je vous prie de venir prendre tout de suite si rien ne vous en empêche trop. Je vous prie de venir par la crainte que peut-être les communications entre Paris et nous se trouvent interrompues, et j'aimerai mieux vous savoir possesseur de vos dessins, puisqu'ils sont prêts.

Venez donc encore un coup.

Je vous donne mon cher Monsieur Gavet une bonne poignée de main.

J. F. Millet

Barbizon, August 9, 1870

My dear Monsieur Gavet:

I have just finished seven drawings that I beg you to come pick up right away, if you can. I ask you to come because I am afraid that the communication between Paris and Barbizon will soon be interrupted,[1] and I would feel better if the drawings were in your hands, since they are ready.

Again, come at once.

I give you, M.r Gavet, a good handshake,

J. F. Millet

Notes

1. The Franco-Prussian war had begun.

Paul Durand-Ruel

Paul Durand-Ruel (1831-1921), son of the founder of the now world-famous gallery, began working in his father's business in 1865. The Durand-Ruel firm had been instrumental in the recognition of the School of 1830 and Paul became an early and strong supporter of Impressionist artists. His efforts on behalf of two generations of controversial French painters led him to bankruptcy, from which he recovered partially upon the opening of his New York Gallery in 1888. From there, he and his sons Joseph and Georges became the principal suppliers of Barbizon and Impressionist paintings for a receptive American public.

Deeply committed to Millet, he was the artist's most important supporter in the late 1860s and became the virtually exclusive dealer for Millet's works after the Franco-Prussian War, acquiring the better part of the Gavet collection between 1872 to 1874, and the entire Sensier collection (167 works, of which there are 34 paintings and 19 pastels by Millet) in March 1873.

An additional group of manuscripts relating to the Quincy Adams Shaw Collection was donated to the Museum of Fine Arts by the Quincy Adams Shaw family. It includes:

A letter from A. Legrand (an art dealer) to Quincy Adams Shaw (Conflans, January 21, 1881).

A letter from A. de Villedieu (a writer) to A. Legrand (Paris, January 15, 1881).

A series of Salon reviews and other articles on Millet from 1844 to 1873 collected by A. de Villedieu.

A letter from Alfred Sensier to Théophile Silvestre (Paris, April 27, 1867).

A letter from Ernest Onfroy (a friend of Millet's family) to Silvestre (Cherbourg, May 17, 1875).

The twenty-eight-page manuscript of Millet's biography written by Silvestre for *Le Figaro* (May 1867).

Barbizon, April 5, 1872

My dear Monsieur Durand-Ruel:

I have here two pictures waiting for you: a landscape representing a bare field and a small shepherdess in the shade.[1] I have declined to be a member of the jury in the next Salon. I don't have the heart to leave my wife and children, who are still suffering from scarlet fever.

I am looking forward to seeing you.

I shake your hand.

J. F. Millet

Notes

1. See cat. no. 147.

Barbizon 5 Avril 1872

Mon cher Monsieur Durand Ruel:

Voici deux tableaux qui attendent que vous veniez les prendre: le paysage representant un terrain nu, et la petite bergère à l'ombre.

Je n'ai point accepté les fonctions de Juré pour le prochain Salon. Je n'ai pas eu le courage de laisser ma femme et mes enfants encore mal remis de leur fièvre scarlatine.

En attendant le plaisir de vous voir recevez cher Monsieur Durand-Ruel une bonne poignée de main.

J. F. Millet

DATE DUE